GARDNER'S

ART THROUGH THE

AGES

GARDNER'S

ART

THROUGH THE

AGES

THE WESTERN PERSPECTIVE

THIRTEENTH EDITION

BACKPACK EDITION

The Middle Ages

FRED S. KLEINER

Gardner's Art through the Ages: The Western Perspective, Thirteenth Edition, The Middle Ages, Book B

Fred S. Kleiner

Publisher: Clark Baxter

Senior Development Editor: Sharon Adams Poore

Assistant Editor: Kimberly Apfelbaum

Editorial Assistant: Nell Pepper

Senior Media Editor: Wendy Constantine

Senior Marketing Manager: Diane Wenckebach

Marketing Communications Manager: Heather Baxley

Senior Project Manager, Editorial Production: Lianne Ames

Senior Art Director: Cate Rickard Barr

Senior Print Buyer: Judy Inouye

Production Service/Layout: Joan Keyes,

Dovetail Publishing Services

Text Designer: tani hasegawa

Photo Researchers: Sarah Evertson, Stephen Forsling

Cover Designer: tani hasegawa

Cover Image: Rufillus, Initial R, folio 244 recto of a Passional, from Weissenau, Germany, ca. 1170–1200. Bodmer Library photo, codex no. 127. Foundation Martin

Bodmer, Cologny (Geneve).

Compositor: Thompson Type

© 2010, 2006 Wadsworth, Cengage Learning

ALL RIGHTS RESERVED. No part of this work covered by the copyright herein may be reproduced, transmitted, stored, or used in any form or by any means graphic, electronic, or mechanical, including but not limited to photocopying, recording, scanning, digitizing, taping, Web distribution, information networks, or information storage and retrieval systems, except as permitted under Section 107 or 108 of the 1976 United States Copyright Act, without the prior written permission of the publisher.

For product information and technology assistance, contact us at Cengage Learning Academic Resource Center, 1-800-423-0563

For permission to use material from this text or product, submit all requests online at www.cengage.com/permissions.

Further permissions questions can be emailed to permissionrequest@cengage.com

Library of Congress Control Number: 2008938882

ISBN-13: 978-0-495-79452-3 ISBN-10: 0-495-79452-X

Wadsworth

25 Thomson Place Boston, MA 02210-1202 USA

Cengage Learning products are represented in Canada by Nelson Education, Ltd.

For your course and learning solutions, visit academic.cengage.com

Purchase any of our products at your local college store or at our preferred online store **www.ichapters.com**

About the Author

FRED S. KLEINER (Ph.D., Columbia University) is the co-author of the 10th, 11th, and 12th editions of *Art through the Ages* and more than a hundred publications on Greek and Roman art and architecture, including *A History of Roman Art*, also published by Wadsworth. He has taught the art history survey course for more than three decades, first at the University of Virginia and, since 1978, at Boston University, where he is currently Professor of Art History and Archaeology and Chair of the Art History Department. Long recognized for his inspiring lectures and devotion to students, Professor Kleiner won Boston University's Metcalf Award for Excellence in Teaching as well as the College Prize for Undergraduate Advising in the Humanities in 2002 and is a two-time winner of the Distinguished Teaching Prize in the College of Arts and Sciences Honors Program. He was Editor-in-Chief of the *American Journal of Archaeology* from 1985 to 1998.

A History of Roman Art (Wadsworth 2007; ISBN 0534638465)

Gardner's Art through the Ages: Non-Western Perspectives, Thirteenth Edition (Wadsworth 2010; ISBN 0495573671)

About the Cover Art

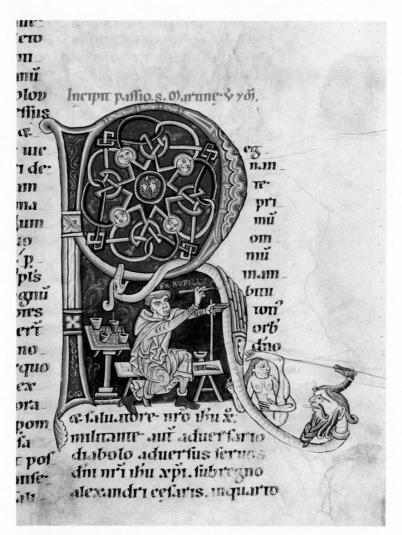

RUFILLUS, Initial R, folio 244 recto of a Passional, from Weissenau, Germany, ca. 1170–1200. Bibliotheca Bodmeriana, Geneva.

The number of medieval artists who signed their work is tiny, especially before the Romanesque period. A notable exception is Brother Rufillus, who not only signed his name—FR(ater) RVFILLVS—on one page of a late-12th century Passional (a book of saints' lives) produced at an abbey in Weissenau, Germany, but also portrayed himself, with tonsured head, at work painting the initial R. He wears the white robe of a canon of the Premonstratensian order founded by Saint Norbert of Xanten (ca. 1080–1134) in 1120. Rufillus sits on a bench in the abbey's scriptorium with his equipment on two tables to his left and right, including several cups of different colored pigments. Obviously proud of his accomplishments as a painter, Rufillus also depicted himself at work as an illuminator in a second Weissenau manuscript now in the Bibliothèque Municipale in Amiens.

The names of several other Romanesque artists are known, but before the 14th century, most artists toiled in anonymity in the service of their patrons, whether Egyptian pharaohs, Roman emperors, or medieval bishops. *Art through the Ages* surveys the art of all periods from prehistory to the present and examines how artworks of all kinds, anonymous or signed, have always reflected the historical contexts in which they were created.

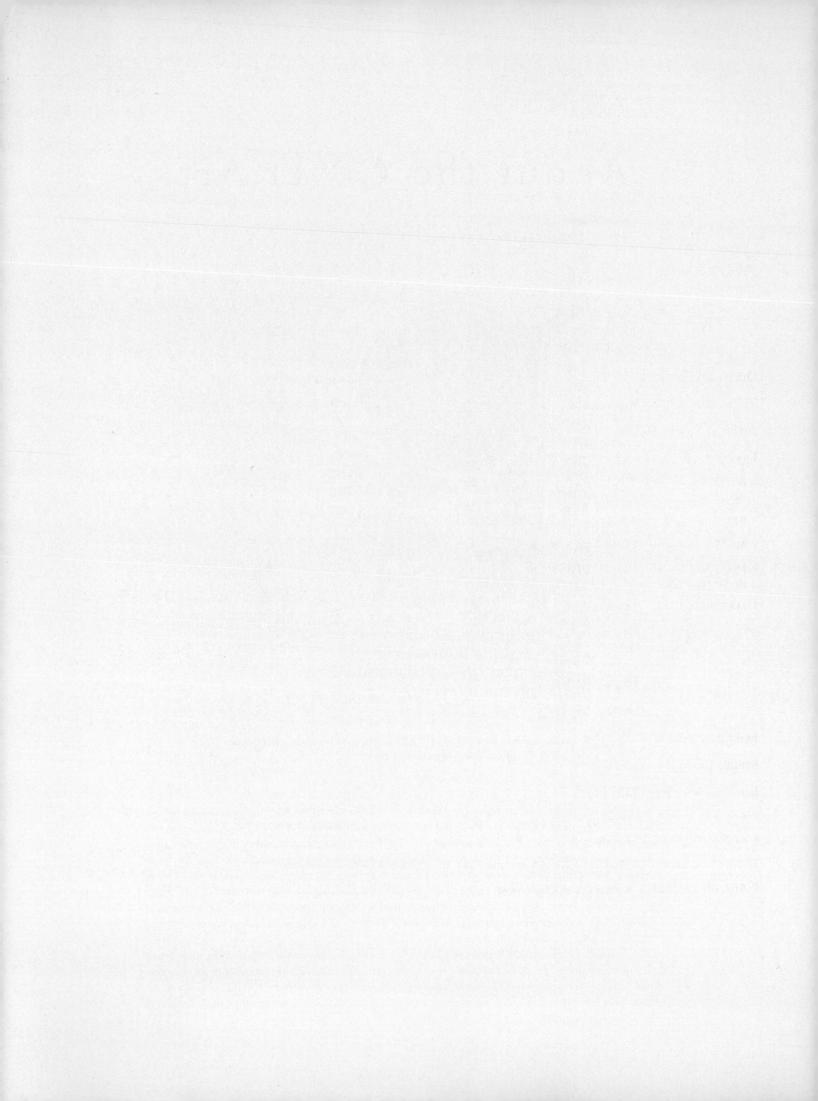

CONTENTS

PREFACE xi

CHAPTER 8 LATE ANTIQUITY 209

Dura-Europos 209

The Catacombs and Funerary Art 211

Architecture and Mosaics 215

Luxury Arts 224

- RELIGION AND MYTHOLOGY: Jewish Subjects in Christian Art 213
- RELIGION AND MYTHOLOGY: The Life of Jesus in Art 216
- MATERIALS AND TECHNIQUES: Mosaics 223
- MATERIALS AND TECHNIQUES: Medieval Manuscript Illumination 225
- MATERIALS AND TECHNIQUES: Ivory Carving 227

THE BIG PICTURE 229

CHAPTER 9 BYZANTIUM 231

Early Byzantine Art 232

Middle Byzantine Art 247

Late Byzantine Art 255

- ARCHITECTURAL BASICS: Pendentives and Squinches 235
- ART AND SOCIETY: Theodora, a Most Unusual Empress 240
- WRITTEN SOURCES: The Emperors of New Rome 243
- ART AND SOCIETY: Icons and Iconoclasm 246

THE BIG PICTURE 259

CHAPTER 10 THE ISLAMIC WORLD 261

Early Islamic Art 262

Later Islamic Art 272

- RELIGION AND MYTHOLOGY: Muhammad and Islam 263
- ARCHITECTURAL BASICS: The Mosque 265
- ARTISTS ON ART: Sinan the Great and the Mosque of Selim II 274
- MATERIALS AND TECHNIQUES: Islamic Tilework 277
- ART AND SOCIETY: Christian Patronage of Islamic Art 282

THE BIG PICTURE 283

CHAPTER 11 EARLY MEDIEVAL EUROPE 285

Art of the Warrior Lords 285

Christian Art: Scandinavia, British Isles, Spain 288

Carolingian Art 293

Ottonian Art 300

- ART AND SOCIETY: Medieval Books 289
- RELIGION AND MYTHOLOGY: The Four Evangelists 290
- ART AND SOCIETY: Charlemagne's Renovatio Imperii Romani 294
- RELIGION AND MYTHOLOGY: Medieval Monasteries and Benedictine Rule 298
- ART AND SOCIETY: Theophanu, a Byzantine Princess in Ottonian Germany 306

THE BIG PICTURE 307

CHAPTER 12

ROMANESQUE EUROPE 309

France and Northern Spain 311

Holy Roman Empire 323

Italy 328

Normandy and England 331

■ ART AND SOCIETY: Pilgrimages and the Cult of Relics 310

■ WRITTEN SOURCES: Timber Roofs and Stone Vaults 313

WRITTEN SOURCES: Bernard of Clairvaux on Cloister Sculpture 316

■ ARCHITECTURAL BASICS: The Romanesque Church Portal 317

■ RELIGION AND MYTHOLOGY: The Crusades 320

ART AND SOCIETY: Romanesque Countesses, Queens, and Nuns 326

MATERIALS AND TECHNIQUES: Embroidery and Tapestry 334

THE BIG PICTURE 337

CHAPTER 13 GOTHIC EUROPE 339

French Gothic 340

Gothic outside of France 364

WRITTEN SOURCES: Abbot Suger and the Rebuilding of Saint-Denis 341

■ ARCHITECTURAL BASICS: The Gothic Rib Vault 342

ART AND SOCIETY: Scholasticism and Gothic Art and Architecture 344

■ ARCHITECTURAL BASICS: The Gothic Cathedral 347

■ MATERIALS AND TECHNIQUES: Stained-Glass Windows 350

■ ART AND SOCIETY: Louis IX, the Saintly King 360

THE BIG PICTURE 373

CHAPTER 14

ITALY, 1200 TO 1400 375

The 13th Century 375

The 14th Century 380

■ ART AND SOCIETY: Italian Artists' Names 376

RELIGION AND MYTHOLOGY: The Great Schism, Mendicant Orders, and Confraternities 379

■ MATERIALS AND TECHNIQUES: Fresco Painting 382

WRITTEN SOURCES: Artists' Guilds, Commissions, and Contracts 384

■ ART AND SOCIETY: Artistic Training in Renaissance Italy 388

THE BIG PICTURE 395

NOTES 396

GLOSSARY 397

BIBLIOGRAPHY 406

CREDITS 410

INDEX 411

PREFACE

When Helen Gardner published the first edition of *Art through* the Ages in 1926, she could not have imagined that more than 80 years later instructors all over the world would still be using her textbook in their classrooms. Indeed, if she were alive today, she would not recognize the book that long ago became—and remains—the most widely read introduction to the history of art and architecture in the English language. During the past half century, successive authors have constantly reinvented Helen Gardner's groundbreaking survey, always keeping it fresh and current, and setting an ever-higher standard in both content and publication quality with each new edition. I hope both professors and students will agree that this 13th edition lives up to that venerable tradition.

Certainly, this latest edition offers much that is fresh and new (enumerated below), but some things have not changed, including the fundamental belief that guided Helen Gardner—namely, that the primary goal of an introductory art history textbook should be to foster an appreciation and understanding of historically significant works of art of all kinds from all periods. Because of the longevity and diversity of the history of art, it is tempting to assign responsibility for telling its story to a large team of specialists. The Gardner publishers themselves took this approach for the first edition they produced after Helen Gardner's death, and it has now become the norm for introductory art history surveys. But students overwhelmingly say that the very complexity of the history of art makes it all the more important for the story to be told with a consistent voice if they are to master so much diverse material. I think Helen Gardner would be pleased to know that this new edition of Art through the Ages once again has a single storyteller.

Along with the late Richard Tansey and my more recent collaborator, Christin Mamiya, with whom I had the honor and pleasure of working on the 10th, 11th, and 12th editions, I continue to believe that the most effective way to tell the story of art through the ages, especially to someone studying art history for the first time, is to organize the vast array of artistic monuments according to the civilizations that produced them and to consider each work in roughly chronological order. This approach has not merely stood the test of time. It is the most appropriate way to narrate the *history* of art. The principle that underlies my approach to every period of art history is that the enormous variation in the form and meaning of the paintings, sculptures, buildings, and other artworks men and women have produced over the past 30,000 years is largely the result of the constantly changing contexts in which artists and architects worked. A historically based

narrative is therefore best suited for a comprehensive history of art because it permits the author to situate each work discussed in its historical, social, economic, religious, and cultural context. That is, after all, what distinguishes art history from art appreciation.

In the first (1926) edition of Art through the Ages, Helen Gardner discussed Henri Matisse and Pablo Picasso in a chapter entitled "Contemporary Art in Europe and America." Since then many other artists have emerged on the international scene, and the story of art through the ages has grown longer and even more complex. More important, perhaps, the discipline of art history has changed markedly in recent decades, and so too has Helen Gardner's book. The 13th edition fully reflects the latest art historical research emphases while maintaining the traditional strengths that have made previous editions of Art through the Ages so popular. While sustaining attention to style, chronology, iconography, and technique, I also ensure that issues of patronage, function, and context loom large in every chapter. I treat artworks not as isolated objects in sterile 21stcentury museum settings but with a view toward their purpose and meaning in the society that produced them at the time they were produced. I examine not only the role of the artist or architect in the creation of a work of art or a building, but also the role of the individuals or groups who paid the artists and influenced the shape the monuments took. Further, I devote more space than previously to the role of women and women artists in diverse societies over time. In every chapter, I have tried to choose artworks and buildings that reflect the increasingly wide range of interests of scholars today, while not rejecting the traditional list of "great" works or the very notion of a "canon." Consequently, the selection of works in this edition encompasses every artistic medium and almost every era and culture in the Western world, and includes many works that until recently art historians would not have considered to be "art" at all.

The 12th edition of *Art through the Ages* was the number-one choice for art history survey courses and the best-selling version of the book in its long history, and for this 13th edition I have retained all of the features that made its predecessor so successful. Once again, this edition, which contains 25 chapters on the Western tradition and its roots in the ancient Near East and Egypt, plus a chapter on Islamic art and architecture, boasts roughly 1,100 photographs, plans, and drawings, virtually all in color and reproduced according to the highest standards of clarity and color fidelity. The 13th edition, however, also features hundreds of new or upgraded photos by a host of new photographers as well as redesigned maps and plans

and an extraordinary new set of architectural drawings prepared exclusively for *Art through the Ages* by John Burge.

The captions to the illustrations in this edition of Art through the Ages, as before, contain a wealth of information, including the name of the artist or architect, if known; the formal title (printed in italics), if assigned, description of the work, or name of the building; the provenance or place of production of the object or location of the building; the date; the material(s) used; the size; and the current location if the work is in a museum or private collection. As in previous editions, scales accompany all plans, but for the first time scales now also appear next to each photograph of a painting, statue, or other artwork. The works illustrated vary enormously in size, from colossal sculptures carved into mountain cliffs and paintings that cover entire walls or ceilings to tiny figurines, coins, and jewelry that one can hold in the hand. Although the captions contain the pertinent dimensions, it is hard for students who have never seen the paintings or statues in person to translate those dimensions into an appreciation of the real size of the objects. The new scales provide an effective and direct way to visualize how big or how small a given artwork is and its relative size compared with other objects in the same chapter and throughout the book.

Also new to this edition are the Quick-Review Captions that students found so useful when these were introduced in 2006 in the first edition of Art through the Ages: A Concise History. These brief synopses of the most significant aspects of each artwork or building illustrated accompany the captions to all images in the book. They have proved invaluable to students preparing for examinations in onesemester art history survey courses, and I am confident they will be equally useful to students enrolled in yearlong courses. In the 13th edition, however, I have provided two additional tools to aid students in reviewing and mastering the material. Each chapter now ends with a full-page feature called The Big Picture, which sets forth in bulletpoint format the most important characteristics of each period or artistic movement discussed in the chapter. Small illustrations of characteristic works discussed accompany the summary of major points. Finally, I have attempted to tie all of the chapters together by providing with each copy of Art through the Ages a poster-size Global Timeline. This too features illustrations of key monuments of each age and geographical area as well as a brief enumeration of the most important art historical developments during that period. The timeline is global in scope to permit students in Western art courses to place developments in Europe and America in a worldwide context. The poster has four major horizontal bands corresponding to Europe, the Americas, Asia, and Africa, and 34 vertical columns for the successive chronological periods from 30,000 BCE to the present.

Another pedagogical tool not found in any other introductory art history textbook is the *Before 1300* section that appears at the beginning of Books C and D. Because many students taking the second half of a yearlong survey course will not have access to Books A and B, I have provided a special set of concise primers on religion and mythology and on architectural terminology and construction methods in the ancient and medieval worlds—information that is essential for understanding the history of Western art after 1300. The subjects of these special boxes are The Gods and Goddesses of Mount Olympus; The Life of Jesus in Art; Greco-Roman Temple Design and the Classical Orders; Arches and Vaults; and Medieval Church Design.

Boxed essays once again appear throughout the book as well. This popular feature first appeared in the 11th edition of *Art through the Ages*, which won both the Texty and McGuffey Prizes of the Text and Academic Authors Association for the best college textbook of 2001 in the humanities and social sciences. In this edition the essays are

more closely tied to the main text than ever before. Consistent with that greater integration, most boxes now incorporate photographs of important artworks discussed in the text proper that also illustrate the theme treated in the boxed essays. These essays fall under six broad categories, one of which is new to the 13th edition.

Architectural Basics boxes provide students with a sound foundation for the understanding of architecture. These discussions are concise explanations, with drawings and diagrams, of the major aspects of design and construction. The information included is essential to an understanding of architectural technology and terminology. The boxes address questions of how and why various forms developed, the problems architects confronted, and the solutions they used to resolve them. Topics discussed include how the Egyptians built the pyramids, the orders of classical architecture, Roman concrete construction, and the design and terminology of mosques and Gothic cathedrals.

Materials and Techniques essays explain the various media artists employed from prehistoric to modern times. Since materials and techniques often influence the character of artworks, these discussions contain essential information on why many monuments appear as they do. Hollow-casting bronze statues; fresco painting; Islamic tile work; embroidery and tapestry; perspective; engraving, etching, and lithography; and daguerreotype and calotype photography are among the many subjects treated.

Religion and Mythology boxes introduce students to the principal elements of great religions, past and present, and to the representation of religious and mythological themes in painting and sculpture of all periods and places. These discussions of belief systems and iconography give readers a richer understanding of some of the greatest artworks ever created. The topics include the gods and goddesses of Egypt, Mesopotamia, Greece, and Rome; the life of Jesus in art; and Muhammad and Islam.

Art and Society essays treat the historical, social, political, cultural, and religious context of art and architecture. In some instances, specific monuments are the basis for a discussion of broader themes, as when the Hegeso stele serves as the springboard for an exploration of the role of women in ancient Greek society. Another essay discusses how people's evaluation today of artworks can differ from those of the society that produced them by examining the problems created by the contemporary market for undocumented archaeological finds. Other subjects include Egyptian mummification, Etruscan women, Byzantine icons and iconoclasm, artistic training in Renaissance Italy, 19th-century academic salons and independent art exhibitions, and public funding of controversial art.

Written Sources present and discuss key historical documents illuminating important monuments of art and architecture throughout the Western world. The passages quoted permit voices from the past to speak directly to the reader, providing vivid and unique insights into the creation of artworks in all media. Examples include Bernard of Clairvaux's treatise on sculpture in medieval churches, Giovanni Pietro Bellori's biographies of Annibale Carracci and Caravaggio, Jean François Marmontel's account of 18th-century salon culture, as well as texts that bring the past to life, such as eyewitness accounts of the volcanic eruption that buried Roman Pompeii and of the fire that destroyed Canterbury Cathedral in medieval England.

A new category is *Artists on Art* in which artists and architects throughout history discuss both their theories and individual works. Examples include Sinan the Great discussing the mosque he designed for Selim II, Leonardo da Vinci and Michelangelo debating the relative merits of painting and sculpture, Artemisia Gentileschi talking about the special problems she confronted as a woman artist, Jacques-Louis David on Neoclassicism, Gustave Courbet on Realism, Henri

Matisse on color, Pablo Picasso on Cubism, Diego Rivera on art for the people, and Judy Chicago on her seminal work *The Dinner Party*.

Instructors familiar with previous editions of Art through the Ages will also find that many of the chapters in the 13th edition have been reorganized, especially in volume two. For example, the treatment of European 17th-century art now appears in two discrete chapters, one devoted to Baroque Italy and Spain, the other to Northern Europe. A single chapter is devoted to the 18th century, another to the period from 1800 to 1870, and a third to 1870 to 1900. In addition, in recognition that different instructors at different colleges and universities end the first semester and begin the second semester at different points, for the first time two volumes of Art through the Ages include Chapter 14 on Italian art from 1200 to 1400. And The Western Perspective is now also available in this special backpack edition consisting of four, rather than the traditional two, paperback volumes: Book A (Antiquity: Chapters 1-7), Book B (The Middle Ages: Chapters 8-14), Book C (Renaissance and Baroque: Chapters 14-20), and Book D (Modern Europe and America: Chapters 21-25). These books can also be purchased separately.

Rounding out the features in the book itself is a Glossary containing definitions of all terms introduced in the text in italics and a Bibliography of books in English, including both general works and a chapter-by-chapter list of more focused studies. In this edition I have also taken care to italicize and define in the text all Glossary terms that appear in Books C and D even if they have been used and defined in Books A and B, because many students enrolled in the second semester of a yearlong course will not have taken the first semester and will not be familiar with those terms.

The 13th edition of *Art through the Ages* is not, however, a standalone text, but one element of a complete package of learning tools. In addition to the Global Timeline, every new copy of the book comes with a password to *ArtStudy Online*, a web site with access to a host of multimedia resources that students can employ throughout the entire course, including image flashcards, tutorial quizzes, podcasts, vocabulary, and more. Instructors have access to a host of teaching materials, including digital images with zoom capabilities, video, and Google™ Earth coordinates.

A work as extensive as this history of art could not be undertaken or completed without the counsel of experts in all areas of Western art. As with previous editions, the publisher has enlisted more than a hundred art historians to review every chapter in order to ensure that the text lived up to the Gardner reputation for accuracy as well as readability. I take great pleasure in acknowledging here the invaluable contributions to the 13th edition of Art through the Ages: The Western Perspective made by the following for their critiques of various chapters: Charles M. Adelman, University of Northern Iowa; Kirk Ambrose, University of Colorado-Boulder; Susan Ashbrook, Art Institute of Boston; Zainab Bahrani, Columbia University; Susan Bakewell, University of Texas-Austin; James J. Bloom, Florida State University; Suzaan Boettger, Bergen Community College; Colleen Bolton, Mohawk Valley Community College; Angi Elsea Bourgeois, Mississippi State University; Kimberly Bowes, Fordham University; Elizabeth Bredrup, St. Christopher's School; Lawrence E. Butler, George Mason University; Alexandra Carpino, Northern Arizona University; Jane Carroll, Dartmouth College; Hipolito Rafael Chacon, The University of Montana; Catherine M. Chastain, North Georgia College & State University; Violaine Chauvet, Johns Hopkins University; Daniel Connolly, Augustana College; Michael A. Coronel, University of Northern Colorado; Nicole Cox, Rochester Institute of Technology; Jodi Cranston, Boston University; Giovanna De Appolonia, Boston University; Marion de Koning, Grossmont College; John J. Dobbins, University of Virginia; Erika Doss, University of Colorado-Boulder;

B. Underwood DuRette, Thomas Nelson Community College; Lisa Farber, Pace University; James Farmer, Virginia Commonwealth University; Sheila ffolliott, George Mason University; Ferdinanda Florence, Solano Community College; William B. Folkestad, Central Washington University; Jeffery Fontana, Austin College; Mitchell Frank, Carleton University; Sara L. French, Wells College; Norman P. Gambill, South Dakota State University; Elise Goodman, University of Cincinnati; Kim T. Grant, University of Southern Maine; Elizabeth ten Grotenhuis, Silk Road Project; Sandra C. Haynes, Pasadena City College; Valerie Hedquist, The University of Montana; Susan Hellman, Northern Virginia Community College; Marian J. Hollinger, Fairmont State University; Cheryl Hughes, Alta High School; Heidrun Hultgren, Kent State University; Joseph M. Hutchinson, Texas A&M University; Julie M. Johnson, Utah State University; Sandra L. Johnson, Citrus College; Deborah Kahn, Boston University; Fusae Kanda, Harvard University; Catherine Karkov, Miami University; Wendy Katz, University of Nebraska-Lincoln; Nita Kehoe-Gadway, Central Wyoming College; Nancy L. Kelker, Middle Tennessee State University; Cathie Kelly, University of Nevada-Las Vegas; Katie Kempton, Ohio University; John F. Kenfield, Rutgers University; Herbert L. Kessler, Johns Hopkins University; Monica Kjellman-Chapin, Emporia State University; Ellen Konowitz, State University of New York-New Paltz; Kathryn E. Kramer, State University of New York-Cortland; Carol Krinsky, New York University; Lydia Lehr, Atlantic Cape Community College; Krist Lien, Shelton State Community College; Ellen Longsworth, Merrimack College; David A. Ludley, Clayton State University; Henry Luttikhuizen, Calvin College; Christina Maranci, University of Wisconsin-Milwaukee; Dominic Marner, University of Guelph; Jack Brent Maxwell, Blinn College; Anne McClanan, Portland State University; Brian McConnell, Florida Atlantic University; Heather McPherson, University of Alabama-Birmingham; Cynthia Millis, Houston Community College-Southwest; Cynthia Taylor Mills, Brookhaven College; Keith N. Morgan, Boston University; Johanna D. Movassat, San Jose State University; Helen Nagy, University of Puget Sound; Heidi Nickisher, Rochester Institute of Technology; Bonnie Noble, University of North Carolina-Charlotte; Abigail Noonan, Rochester Institute of Technology; Marjorie Och, University of Mary Washington; Karen Michelle O'Day, University of Wisconsin-Eau Claire; Edward J. Olszewski, Case Western Reserve University; Allison Lee Palmer, University of Oklahoma; Martin Patrick, Illinois State University; Glenn Peers, University of Texas-Austin; Jane Peters, University of Kentucky; Julie Anne Plax, University of Arizona; Frances Pohl, Pomona College; Virginia C. Raguin, College of the Holy Cross; Donna Karen Reid, Chemeketa Community College; Albert W. Reischuch, Kent State University; Jonathan Ribner, Boston University; Cynthea Riesenberg, Washington Latin School; James G. Rogers Jr., Florida Southern College; Carey Rote, Texas A&M University-Corpus Christi; David J. Roxburgh, Harvard University; Conrad Rudolph, University of California-Riverside; Catherine B. Scallen, Case Western Reserve University; Denise Schmandt-Besserat, University of Texas-Austin; Natasha Seaman, Berklee College of Music; Malia E. Serrano, Grossmont College; Laura Sommer, Daemen College; Natasha Staller, Amherst College; Nancy Steele-Hamme, Midwestern State University; Andrew Stewart, University of California-Berkeley; Francesca Tronchin, Ohio State University; Frances Van Keuren, University of Georgia; Kelly Wacker, University of Montevallo; Carolynne Whitefeather, Utica College; Nancy L. Wicker, University of Mississippi; Alastair Wright, Princeton University; John G. Younger, University of Kansas; Michael Zell, Boston University.

I am also happy to have this opportunity to express my gratitude to the extraordinary group of people at Wadsworth involved with the editing, production, and distribution of *Art through the Ages*. Some of them I have now worked with on various projects for more than a decade and feel privileged to count among my friends. The success of the Gardner series in all of its various permutations depends in no small part on the expertise and unflagging commitment of these dedicated professionals: Sean Wakely, executive vice president, Cengage Arts and Sciences; P. J. Boardman, vice president, editor-in-chief of Cengage Learning Arts and Sciences; Clark Baxter, publisher; Sharon Adams Poore, senior development editor; Helen Triller-Yambert, development editor; Lianne Ames, senior content project manager; Wendy Constantine, senior media editor; Kimberly Apfelbaum, assistant editor; Nell Pepper, editorial assistant; Cate Rikard Barr, senior art director; Scott Stewart, vice president managing director sales; Diane Wenckebach, senior marketing manager; as well as Kim Adams, Heather Baxley, William Christy, Doug Easton, tani hasegawa, Cara Murphy, Ellen Pettengell, Kathryn Stewart, and Joy Westberg.

I am also deeply grateful to the following for their significant contributions to the 13th edition of *Art through the Ages*: Joan Keyes, Dovetail Publishing Services; Ida May Norton, copy editor; Sarah Evertson and Stephen Forsling, photo researchers; Pete Shanks and Jon Peck, accuracy readers; Pat Lewis, proofreader; John Pierce, Thompson Type; Rick Stanley, Digital Media Inc., U.S.A; Don Larson, Mapping Specialists; Anne Draus, Scratchgravel; Cindy Geiss, Graphic World; and, of course, John Burge, for his superb architectural drawings. I also wish to acknowledge my debt to Edward Tufte for an illuminating afternoon spent discussing publication design and production issues and for his invaluable contribution to the creation of the scales that accompany all reproductions of paintings, sculptures, and other artworks in this edition.

Finally, I owe thanks to my colleagues at Boston University and to the thousands of students and the scores of teaching fellows in my art history courses during the past three decades. From them I have learned much that has helped determine the form and content of *Art through the Ages* and made it a much better book than it otherwise might have been.

Fred S. Kleiner

RESOURCES

FOR FACULTY

PowerLecture with Digital Image Library and JoinIn™ on Turning Point®

ISBN 0495792888

Bring digital images into the classroom with this one-stop lecture and class presentation tool that makes it easy to assemble, edit, and present customized lectures for your course using Microsoft Power-Point™. Available on the PowerLecture DVD, the Digital Image Library provides high-resolution images (maps, illustrations, and fine art images from the text) for lecture presentations, either in an easyto-use PowerPoint presentation format, or in individual file formats compatible with other image-viewing software. The zoom feature allows you to magnify selected portions of an image for more detailed display, and another setting enables you to show images side by side for purposes of comparison. You can readily customize your classroom presentation by adding your personal visuals to those from the text. The PowerLecture also includes Google™Earth coordinates that allow you to zoom in on an entire city, as well as key monuments and buildings within it. Also included are panoramic video clips of architectural landmarks in New York City discussed in the text. Using a navigation bar on the video, you can move around the structure and zoom in/out, and right/left, to add a three-dimensional experience to your presentation.

This PowerLecture DVD also includes a Resource Integration Guide, an electronic Instructor's Manual, and a Test Bank with multiple-choice, matching, short-answer, and essay questions in ExamView® computerized format.

Text-specific Microsoft PowerPoint slides have been created for use with JoinIn™ software for classroom personal response systems ("clickers").

WebTutor on Blackboard or WebCT

WebCT ISBN: 0495792608 BlackBoard ISBN: 0495792586

This package allows you to assign preformatted, text-specific content that is available as soon as you log on, or customize the learning environment in any way you choose—from uploading images and other resources, to adding Web links to create your own practice materials.

Contact your Wadsworth representative.

FOR STUDENTS

ArtStudy Online

This tool gives access to a host of multimedia resources, including **flashcards** of works in the text, and a compare-and-contrast feature, where two works are displayed side by side for more in-depth analysis. Other features include critical-thinking questions, interactive

maps, architectural basics materials, big picture overviews, multimedia mini-lectures, video clips of select architectural monuments, museum guide with links, **Google™Earth** coordinates, Student Test Packet, audio study tools, vocabulary of art history, a guide to researching art history online, tips on becoming a successful student and links to beneficial Web sites on art, artists, architecture and more, and tips on becoming a successful student of art and art history.

Slide Guide Contact your Wadsworth representative.

This lecture companion allows students to take notes alongside representations of the art images shown in class. New to this edition's slide guide are two features—the use of **Google™Earth** coordinates to link satellite images of historic sites and images to textual references, and end-of-chapter questions.

Web Site

Instructors and students have access to a comprehensive array of teaching and learning resources, including chapter-by-chapter online tutorial quizzes, a final exam, chapter reviews, chapter-by-chapter Web links, glossary flashcards, and more.

If you are interested in bundling any of the preceding student resources with the text, contact your Wadsworth sales representative.

To order student editions packaged with the Timeline and ArtStudy Online at no extra cost to students, use the following ISBNs:

Gardner's Art through the Ages: The Western Perspective, 13e ISBN: 0495573558

Gardner's Art through the Ages: The Western Perspective, 13e Volume I

ISBN: 0495573604

Gardner's Art through the Ages: The Western Perspective, 13e Volume II

ISBN: 0495573647

Gardner's Art through the Ages: The Western Perspective, 13e

Backpack edition ISBN: 049579442

To order the Backpack edition (Books A, B, C, and D):

Gardner's Art through the Ages: The Western Perspective, 13e Book A Antiquity

ISBN: 0495794481

Gardner's Art through the Ages: The Western Perspective, 13e Book B The Middle Ages

ISBN: 049579452X

Gardner's Art through the Ages: The Western Perspective, 13e Book C Renaissance and Baroque

ISBN: 0495794562

Gardner's Art through the Ages: The Western Perspective, 13e Book D Modern Europe and America

ISBN: 0495794627

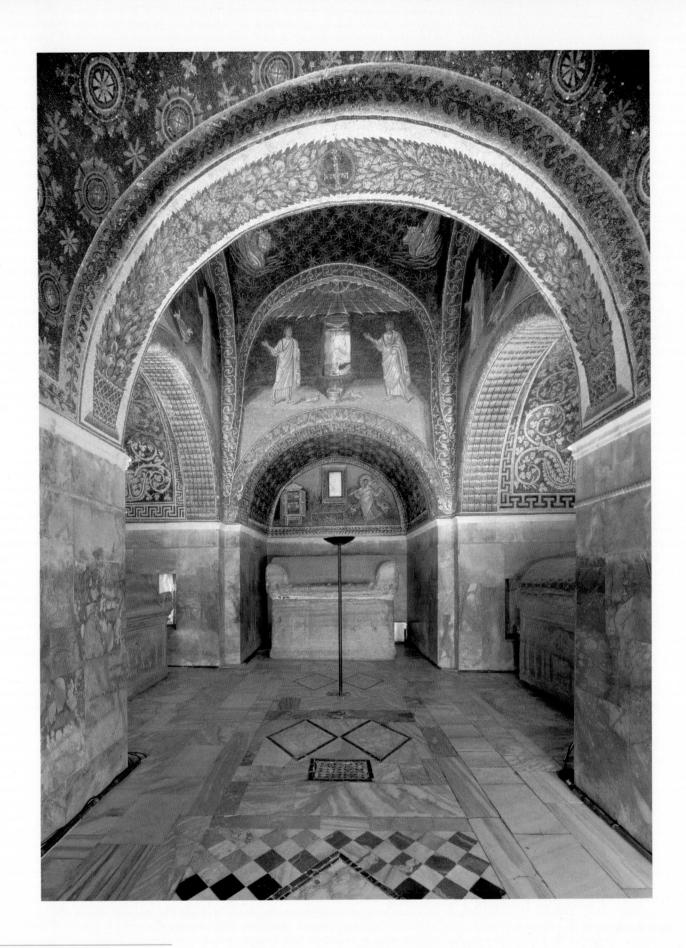

8-1 Interior of the Mausoleum of Galla Placidia, Ravenna, Italy, ca. 425.

Before Late Antiquity, mosaics were usually confined to floors. In the so-called Mausoleum of Galla Placidia (FIG. 8-15), mosaics cover every square inch of the interior above the marble-faced walls.

LATE ANTIQUITY

The Roman Empire was home to an extraordinarily diverse population. In Rome alone on any given day, someone walking through the city's various quarters would have encountered people of an astonishing range of social, ethnic, racial, linguistic, and religious backgrounds. The multicultural character of Roman society became even more pronounced as the Romans expanded their territories throughout Europe, Africa, and the Near East (MAP 7-1). The previous chapter focused on the public and private art and architecture of the pagan Roman world. During the third and fourth centuries, a rapidly growing number of Romans rejected *polytheism* (belief in multiple gods) in favor of *monotheism* (the worship of a single all-powerful god)—but they did not stop commissioning works of art. Jewish and Christian art of the Late Antique period is no less Roman than are sarcophagi with mythological scenes. Indeed, the artists may in some cases have been the same. The Jewish and Christian sculptures, paintings, and buildings of Late Antiquity are Roman in style and technique, but they differ in subject and function from contemporaneous Roman secular and religious art and architecture. For that reason, and because these Late Antique artworks and sacred buildings formed the foundation of the art and architecture of the Middle Ages, they are examined separately in this chapter.

DURA-EUROPOS

The powerful religious crosscurrents of Late Antiquity may be seen in microcosm in a distant outpost of the Roman Empire on a promontory overlooking the Euphrates River in Syria (MAP 8-1). Called Europos by the Greeks and Dura by the Romans, the town probably was founded shortly after the death of Alexander the Great by one of his successors. By the end of the second century BCE, Dura-Europos was in the hands of the Parthians. Trajan captured the city in 115,* but Dura reverted to Parthian control shortly thereafter. In 165, under Marcus Aurelius, the Romans retook the city and placed a permanent garrison there. Dura-Europos fell in 256 to Rome's new enemy in the East, the Sasanians, heirs to the Parthian Empire (see Chapter 2). The Sasanian siege of Dura is an important fixed point in the chronology of Late Antiquity because the inhabitants evacuated the town, leaving its buildings largely intact. This "Pompeii of the desert" has revealed the

^{*}In this chapter, all dates are CE unless otherwise indicated.

8-5 The Good Shepherd, the story of Jonah, and orants, painted ceiling of a cubiculum in the Catacomb of Saints Peter and Marcellinus, Rome, Italy, early fourth century.

Catacomb paintings mixed Old and New Testament themes. Jonah was a popular subject because he was swallowed by a sea monster and emerged safely after three days, prefiguring Christ's Resurrection.

In accordance with Roman custom, Christians had to be buried outside a city's walls on private property, usually purchased by a *confraternity*, or association, of Christian families pooling funds. Each of the catacombs was initially of modest extent. First, the builders dug a gallery three to four feet wide around the perimeter of the burial ground at a convenient level below the surface. In the walls of these galleries, they cut *loculi* (openings to receive the bodies of the dead, one above another, like shelves). Often, small rooms carved out of the rock, called *cubicula* (as in Roman houses of the living), served as mortuary

chapels. Once the original perimeter galleries were full of loculi and cubicula, the Christians excavated other galleries at right angles to them. This process continued as long as lateral space permitted, at which point they opened lower levels connected by staircases to those above. Some catacomb systems extended as deep as five levels. When adjacent burial areas belonged to members of the same Christian confraternity, or by gift or purchase fell into the same hands, the owners cut passageways between the respective cemeteries. The galleries thus spread laterally and gradually occupied a vast expanse. After Christianity received official approval, churches rose on the land above the catacombs so that the pious could worship openly at the burial sites of some of the earliest Christian *martyrs* (individuals who chose to die rather than deny their religious beliefs; the Church declared many of them *saints*).

Painting

As already noted, Early Christian art is Roman in style but Christian in subject. The painted ceiling (FIG. 8-5) of a cubiculum in the Catacomb of Saints Peter and Marcellinus in Rome, for example, is similar in format to the painted vaults of some third-century apartment houses at Ostia that have a circular frame with a central medallion and *lunettes* (semicircular frames) around the circumference. The lunettes in this Early Christian cubiculum contain the key episodes from the Old Testament story of Jonah. The sailors throw him from his ship on the left. He emerges on the right from the "whale." (The Greek word is *ketos*, or sea dragon, and that is how the artist represented the monstrous marine creature that swallowed Jonah; compare the sea creature, FIG. 7-30, *right*.) Safe on land at the bottom, Jonah contemplates the miracle of his salvation and the mercy of God. Jonah was a popu-

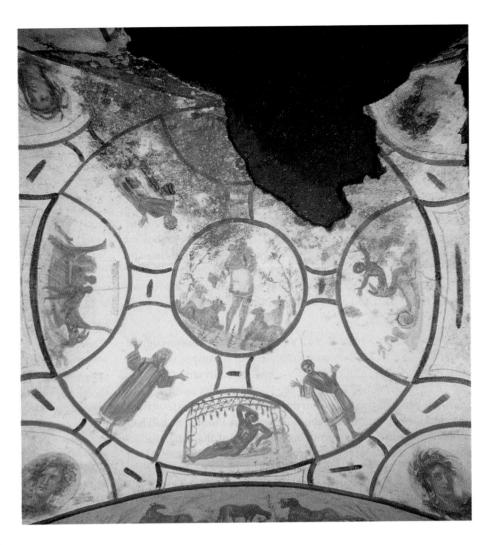

lar figure in Early Christian painting and sculpture, especially in funerary contexts. The Christians honored him as a *prefiguration* (prophetic forerunner) of Christ, who rose from death as Jonah had been delivered from the belly of the ketos, also after three days. Old Testament miracles prefiguring Christ's Resurrection abound in the catacombs and in Early Christian art in general (see "Jewish Subjects in Christian Art," page 213).

A man, a woman, and at least one child occupy the compartments between the Jonah lunettes. They are orants (praying figures), raising their arms in the ancient attitude of prayer. Together they make up a cross-section of the Christian family seeking a heavenly afterlife. The central medallion shows Christ as the Good Shepherd, whose powers of salvation are underscored by his juxtaposition with Jonah's story. The motif can be traced to Archaic Greek art, but there the pagan calf bearer (FIG. 5-9) offered his animal in sacrifice to Athena. In Early Christian art, Christ is the youthful and loyal protector of the Christian flock, who said to his disciples, "I am the good shepherd; the good shepherd gives his life for the sheep" (John 10:11). In the Christian motif, the sheep on Christ's shoulders is one of the lost sheep he has retrieved, symbolizing a sinner who has strayed and been rescued. Early Christian artists almost invariably represented Christ either as the Good Shepherd or as a teacher. Only after Christianity became the Roman Empire's official religion in 380 did representations of Christ in art take on such imperial attributes as the halo, the purple robe, and the throne, which denoted rulership. Eventually artists depicted Christ with the beard of a mature adult, which has been the standard form for centuries, supplanting the youthful imagery of most Early Christian portrayals of the Savior.

Jewish Subjects in Christian Art

rom the beginning, the Old Testament played an important role in Christian life and Christian art, in part because Jesus was a Jew and so many of the first Christians were converted Jews, but also because Christians came to view many of the persons and events of the Old Testament as prefigurations of New Testament persons and events. Christ himself established the pattern for this kind of biblical interpretation, called typology, when he compared Jonah's three-day stay in the belly of the sea monster (usually translated as "whale" in English) to the comparable time he would be entombed in the earth before his Resurrection (Matt. 12:40). In the fourth century, Saint Augustine (354-430) confirmed the validity of this typological approach to the Old Testament when he stated that "the New Testament is hidden in the Old; the Old is clarified by the New."* Thus the Old Testament figured prominently in Early Christian art in all media. Biblical tales of Jewish faith and salvation were especially common in funerary contexts but appeared also in churches and on household objects.

The following are four of the most popular Old Testament stories depicted in Early Christian art:

■ Adam and Eve Eve, the first woman, tempted by a serpent, ate the forbidden fruit of the tree of knowledge and fed some to Adam, the first man. As punishment, God expelled Adam and Eve from Paradise. This "Original Sin" ultimately led to Christ's sacrifice on the cross so that all humankind could be saved. Christian

- theologians often consider Christ the new Adam and his mother, Mary, the new Eve.
- Sacrifice of Isaac God instructed Abraham, the father of the Hebrew nation, to sacrifice Isaac, his only son, as proof of his faith. When it became clear that Abraham would obey, the Lord sent an angel to restrain him and provided a ram for sacrifice in Isaac's place. Christians view this episode as a prefiguration of the sacrifice of God's only son, Jesus.
- Jonah The Old Testament prophet Jonah had disobeyed God's command. In his wrath, the Lord caused a storm while Jonah was at sea. Jonah asked the sailors to throw him overboard, and the storm subsided. A sea dragon then swallowed Jonah, but God answered his prayers, and the monster spat out Jonah after three days and nights, foretelling Christ's Resurrection.
- Daniel When Daniel, one of the most important Jewish prophets, violated a Persian decree against prayer, the Persians threw him into a den of lions. God sent an angel to shut the lions' mouths, and Daniel emerged unharmed. Like Jonah's story, this is an Old Testament salvation tale, a precursor of Christ's triumph over death.

Sculpture

Most Christians rejected cremation, and the wealthiest Christian faithful, like their pagan contemporaries, favored impressive marble sarcophagi for burial. Many of these coffins have survived in catacombs and elsewhere. Predictably, the most common themes painted on the walls and vaults of the Roman subterranean cemeteries were also the subjects that appeared on Early Christian sarcophagi. Often, the decoration of the marble coffins was a collection of significant Christian themes, just as on the painted ceiling (FIG. 8-5) in the Catacomb of Saints Peter and Marcellinus.

SANTA MARIA ANTIQUA SARCOPHAGUS On the front of a sarcophagus (FIG. 8-6) in Santa Maria Antiqua in Rome, the story of Jonah occupies the left one-third. At the center are an orant and a seated philosopher, the latter a motif borrowed directly from contemporary pagan sarcophagi (FIG. 7-71). The heads of both the praying woman and the seated man reading from a scroll are unfinished. Roman workshops often produced sarcophagi before knowing who would purchase them. The sculptors added the portraits at the time of burial, if they added them at all. This practice underscores the universal appeal of the themes chosen. At the right

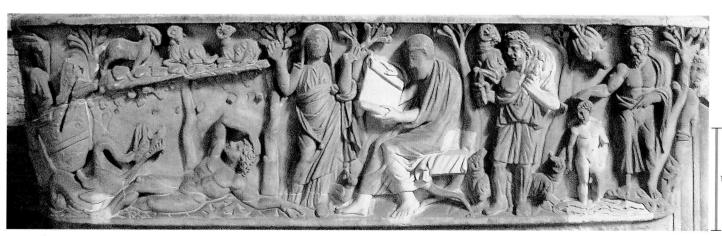

ft.

8-6 Sarcophagus with philosopher, orant, and Old and New Testament scenes, ca. 270. Marble, $1' 11\frac{1}{4}" \times 7' 2"$. Santa Maria Antiqua, Rome.

This Early Christian sarcophagus depicts the salvation of Jonah, Christ as Good Shepherd, and the baptism of Christ. The two figures with unfinished heads were intended as portraits of the deceased.

^{*}Augustine, City of God, 16.26.

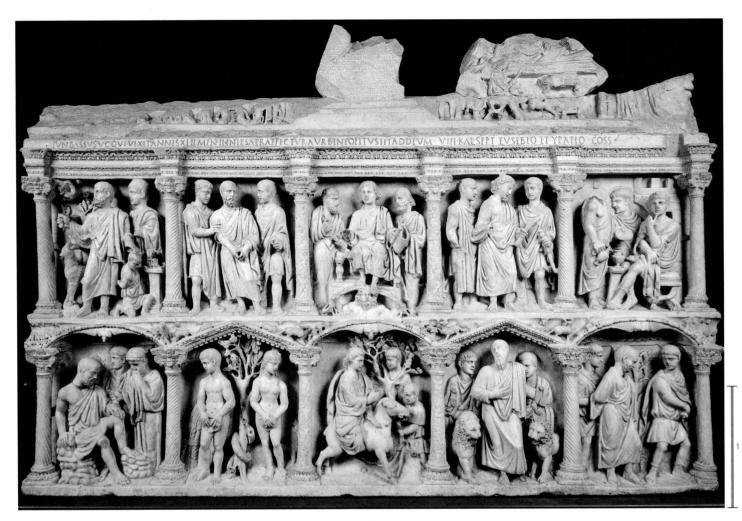

8-7 Sarcophagus of Junius Bassus, from Rome, Italy, ca. 359. Marble, 3' $10\frac{1}{2}$ " \times 8'. Museo Storico del Tesoro della Basilica di San Pietro, Rome.

The wealthiest Christians, like the recently converted city prefect Junius Bassus, favored elaborately decorated sarcophagi. Here, biblical episodes from Adam and Eve to Christ before Pilate appear in 10 niches.

are two different, yet linked, representations of Jesus—as the Good Shepherd and as a child receiving baptism in the Jordan River, though he really was baptized at age 30 (see "The Life of Jesus in Art," pages 216–217). The sculptor suggested the future ministry of the baptized Jesus by turning the child's head toward the Good Shepherd and by placing his right hand on one of the sheep. In the early centuries of Christianity, baptism was usually delayed almost to the moment of death because it cleansed the Christian of all sin. One of those who was baptized on his deathbed was the emperor Constantine (see Chapter 7).

JUNIUS BASSUS SARCOPHAGUS Another pagan convert to Christianity was the city prefect of Rome, Junius Bassus, who, according to the inscription on his sarcophagus (FIG. 8-7), was baptized just before he died in 359. The sarcophagus is of eclectic format—decorated only on three sides in the western Roman manner (see Chapter 7), but divided into two registers of five compartments, each framed by columns in the tradition of Asiatic sarcophagi (FIG. 7-61). In contrast to the Santa Maria Antiqua sarcophagus (FIG. 8-6), the deceased does not appear on the body of the coffin. Instead, stories from the Old and New Testaments fill the niches. Christ has pride of place and appears in the central compartment of each register: as a teacher enthroned between his chief

apostles, Saints Peter and Paul (above), and triumphantly entering Jerusalem on a donkey (below). Appropriately, the sculptor placed the scene of Christ's heavenly triumph above that of his earthly triumph. Both compositions owe a great deal to official Roman art. In the center of the upper zone, Christ, like an enthroned Roman emperor, sits above a personification of the sky god holding a billowing mantle over his head, indicating that Christ is ruler of the universe. The scene below derives from portrayals of Roman emperors entering cities on horseback, but Christ's steed and the absence of imperial attributes contrast sharply with the imperial models the sculptor used as compositional sources.

All of the Old Testament scenes on the Junius Bassus sarcophagus are precursors of New Testament events (see "Jewish Subjects in Christian Art," page 213). Adam and Eve, for example, are in the second niche from the left on the lower level. Their Original Sin of eating the apple in the Garden of Eden ultimately necessitated Christ's sacrifice for the salvation of humankind. To the right of the entry into Jerusalem is Daniel, unscathed by flanking lions, saved by his faith. At the upper left, Abraham is about to sacrifice Isaac. Christians believe this Old Testament story was a prefiguration of God's sacrifice of his own son, Jesus.

The Crucifixion itself, however, does not appear on the Junius Bassus sarcophagus. Indeed, the subject was very rare in Early Chris-

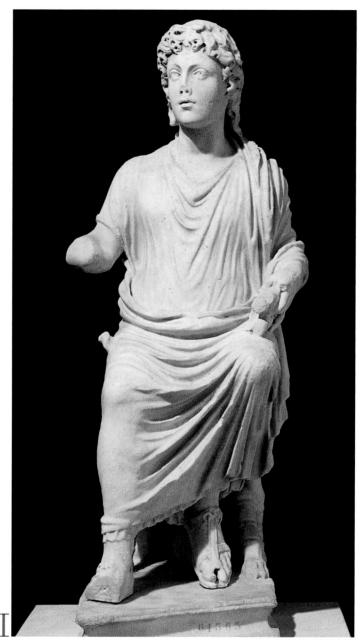

8-8 Christ seated, from Civita Latina, Italy, ca. 350–375. Marble, 2' $4\frac{1}{2}$ " high. Museo Nazionale Romano–Palazzo Massimo alle Terme, Rome.

The earliest representations of Jesus show him as a young man. Statues of Christ are rare during the Early Christian period, however, because of the Second Commandment prohibition of idol worship.

tian art and unknown prior to the fifth century. Artists emphasized Christ's divinity and exemplary life as teacher and miracle worker, not his suffering and death at the hands of the Romans. This sculptor, however, alluded to the Crucifixion in the scenes in the two niches at the upper right depicting Jesus being led before Pontius Pilate for judgment. The Romans condemned Jesus to death, but he triumphantly overcame it. Junius Bassus and other Christians, whether they were converts from paganism or from Judaism, hoped for a similar salvation.

STATUETTE OF CHRIST Apart from the reliefs on privately commissioned sarcophagi, monumental sculpture became increasingly uncommon in the fourth century. The authorities continued to erect portrait statues of Roman emperors and other officials, and

artists still made statues of pagan gods and mythological figures, but the number of statues decreased sharply. In his *Apologia*, Justin Martyr, a second-century philosopher who converted to Christianity and was mindful of the Second Commandment's admonition to shun graven images, accused the pagans of worshiping statues as gods. Christians tended to suspect the freestanding statue, linking it with the false gods of the pagans, so Early Christian houses of worship had no "cult statues." Nor did the first churches have any equivalent of the pedimental statues and relief friezes of Greco-Roman temples.

The Greco-Roman experience, however, was still a living part of the Mediterranean mentality, and many Christians like Junius Bassus were recent converts from paganism who retained some of their classical values. This may account for those rare instances of freestanding Early Christian sculpture, such as the marble statuette (FIG. 8-8) of Christ seated from Civita Latina. Less than three feet tall, the figure closely resembles the Christ situated between Saints Peter and Paul on the Junius Bassus sarcophagus (FIG. 8-7, top center). As on the relief, Christ's head is that of a long-haired Apollo-like youth, but the Romans employed the statuary type only for bearded philosophers of advanced age. Like those learned men, Christ wears the Roman tunic, toga, and sandals and holds an unopened scroll in his left hand. The piece is unique, and unfortunately its original context and function are unknown. Several third- and fourth-century marble statuettes of Christ as the Good Shepherd and of Jonah also survive, but they too are exceptional.

ARCHITECTURE AND MOSAICS

Although some Christian ceremonies were held in the catacombs, regular services took place in private community houses of the type found at Dura-Europos (FIG. 8-4). Once Christianity achieved imperial sponsorship under Constantine, an urgent need suddenly arose to construct churches. The new buildings had to meet the requirements of Christian *liturgy* (the official ritual of public worship), provide a suitably monumental setting for the celebration of the Christian faith, and accommodate the rapidly growing numbers of worshipers.

Constantine was convinced that the Christian god had guided him to victory over Maxentius, and in lifelong gratitude he protected and advanced Christianity throughout the Empire as well as in the obstinately pagan capital city of Rome. As emperor, he was, of course, obliged to safeguard the ancient Roman religion, traditions, and monuments, and, as noted in Chapter 7, he was (for his time) a builder on a grand scale in the heart of the city. But eager to provide buildings to house the Christian rituals and venerated burial places, especially the memorials of founding saints, Constantine also was the first major patron of Christian architecture. He constructed elaborate basilicas, memorials, and mausoleums not only in Rome but also in Constantinople, his "New Rome" in the East, and at sites sacred to Christianity, most notably Bethlehem, the birthplace of Jesus, and Jerusalem, the site of the Crucifixion.

Rome

The major Constantinian churches in Rome stood on sites associated with the graves of Christian martyrs, which, in keeping with Roman custom, were all on the city's outskirts. The decision to erect churches at those sites also permitted Constantine to keep the new Christian shrines out of the city center and to avoid any confrontation between Rome's Christian and pagan populations.

The Life of Jesus in Art

hristians believe that Jesus of Nazareth is the son of God, the Messiah (Savior, Christ) of the Jews prophesied in the Old Testament. His life—his miraculous birth from the womb of a virgin mother, his preaching and miracle working, his execution by the Romans and subsequent ascent to Heaven—has been the subject of countless artworks from Roman times through the present day. The primary literary sources for these representations are the Gospels of the New Testament attributed to the Four Evangelists, Saints Matthew, Mark, Luke, and John (see "The Four Evangelists," Chapter 11, page 290); later apocryphal works; and medieval theologians' commentaries on these texts.

The life of Jesus dominated the subject matter of Christian art to a far greater extent than Greco-Roman religion and mythology ever did classical art. Whereas images of athletes, portraits of statesmen and philosophers, narratives of war and peace, genre scenes, and other secular subjects were staples of the classical tradition, Christian iconography held a near-monopoly in the art of the Western world in the Middle Ages.

Although many of the events of Jesus' life were rarely or never depicted during certain periods, the cycle as a whole has been one of the most frequent subjects of Western art, even after the revival of classical and secular themes in the Renaissance. Thus it is useful to summarize the entire cycle of events as they usually appear in the artworks.

INCARNATION AND CHILDHOOD

The first "cycle" of the life of Jesus consists of the events of his conception (Incarnation), birth, infancy, and childhood.

- Annunciation to Mary The archangel Gabriel announces to the Virgin Mary that she will miraculously conceive and give birth to God's son Jesus. Artists sometimes indicate God's presence at the Incarnation by a dove, the symbol of the Holy Spirit, the third "person" of the *Trinity* with God the Father and Jesus.
- **Visitation** The pregnant Mary visits Elizabeth, her older cousin, who is pregnant with the future Saint John the Baptist. Elizabeth is the first to recognize that the baby Mary is bearing is the Son of God, and they rejoice.
- Nativity, Annunciation to the Shepherds, and Adoration of the Shepherds Jesus is born at night in Bethlehem and placed in a basket. Mary and her husband Joseph marvel at the newborn in a stable or, in Byzantine art, in a cave. An angel announces the birth of the Savior to shepherds in the field, who rush to Bethlehem to adore the child.
- Adoration of the Magi A bright star alerts three wise men (magi) in the East that the King of the Jews has been born. They travel 12 days to find the Holy Family and present precious gifts to the infant Jesus.
- Presentation in the Temple In accordance with Jewish tradition, Mary and Joseph bring their firstborn son to the temple in

Jerusalem, where the aged Simeon, who God said would not die until he had seen the Messiah, recognizes Jesus as the prophesied Savior of humankind.

- Massacre of the Innocents and Flight into Egypt King Herod, fearful that a rival king has been born, orders the massacre of all infants in Bethlehem, but an angel warns the Holy Family and they escape to Egypt.
- Dispute in the Temple Joseph and Mary travel to Jerusalem for the feast of Passover (the celebration of the release of the Jews from bondage to the pharaohs of Egypt). Jesus, only 12 years old at the time, engages in learned debate with astonished Jewish scholars in the temple, foretelling his ministry.

PUBLIC MINISTRY

The public-ministry cycle comprises the teachings of Jesus and the miracles he performed.

- Baptism The beginning of Jesus' public ministry is marked by his baptism at age 30 by John the Baptist in the Jordan River, where the dove of the Holy Spirit appears and God's voice is heard proclaiming Jesus as his son.
- Calling of Matthew Jesus summons Matthew, a tax collector, to follow him, and Matthew becomes one of his 12 disciples, or apostles (from the Greek for "messenger"), and later the author of one of the four Gospels.
- Miracles In the course of his teaching and travels, Jesus performs many miracles, revealing his divine nature. These include acts of healing and raising the dead, turning water into wine, walking on water and calming storms, and creating wondrous quantities of food. In the miracle of loaves and fishes, for example, Jesus transforms a few loaves of bread and a handful of fishes into enough food to feed several thousand people.
- Delivery of the Keys to Peter The fisherman Peter was one of the first men Jesus summoned as a disciple. Jesus chooses Peter (whose name means "rock") as his successor. He declares that Peter is the rock on which his church will be built and symbolically delivers to Peter the keys to the kingdom of Heaven.
- *Transfiguration* Jesus scales a high mountain and, in the presence of Peter and two other disciples, James and John the Evangelist, is transformed into radiant light. God, speaking from a cloud, discloses that Jesus is his son.
- Cleansing of the Temple Jesus returns to Jerusalem, where he finds money changers and merchants conducting business in the temple. He rebukes them and drives them out of the sacred precinct.

PASSION

The Passion (from Latin *passio*, "suffering") cycle includes the events leading to Jesus' death, Resurrection, and ascent to Heaven.

- *Entry into Jerusalem* On the Sunday before his Crucifixion (Palm Sunday), Jesus rides triumphantly into Jerusalem on a donkey, accompanied by disciples. Crowds of people enthusiastically greet Jesus and place palm fronds in his path.
- Last Supper and Washing of the Disciples' Feet In Jerusalem, Jesus celebrates Passover with his disciples. During this Last Supper, Jesus foretells his imminent betrayal, arrest, and death and invites the disciples to remember him when they eat bread (symbol of his body) and drink wine (his blood). This ritual became the celebration of Mass (Eucharist) in the Christian Church. At the same meal, Jesus sets an example of humility for his apostles by washing their feet.
- Agony in the Garden Jesus goes to the Mount of Olives in the Garden of Gethsemane, where he struggles to overcome his human fear of death by praying for divine strength. The apostles who accompanied him there fall asleep despite his request that they stay awake with him while he prays.
- Betrayal and Arrest One of the disciples, Judas Iscariot, agrees to betray Jesus to the Jewish authorities in return for 30 pieces of silver. Judas identifies Jesus to the soldiers by kissing him, and Jesus is arrested. Later, a remorseful Judas hangs himself from a tree.
- Trials of Jesus and Denial of Peter Jesus is brought before Caiaphas, the Jewish high priest, and is interrogated about his claim to be the Messiah. Meanwhile, the disciple Peter thrice denies knowing Jesus, as Jesus predicted he would. Jesus is then brought before the Roman governor of Judaea, Pontius Pilate, on the charge of treason because he had proclaimed himself King of the Jews. Pilate asks the crowd to choose between freeing Jesus or Barabbas, a murderer. The people choose Barabbas, and the judge condemns Jesus to death. Pilate washes his hands, symbolically relieving himself of responsibility for the mob's decision.
- Flagellation and Mocking The Roman soldiers who hold Jesus captive whip (flagellate) him and mock him by dressing him as King of the Jews and placing a crown of thorns on his head.
- Carrying of the Cross, Raising of the Cross, and Crucifixion The Romans force Jesus to carry the cross on which he will be crucified from Jerusalem to Mount Calvary (Golgotha, the "place of the

- skull," where Adam was buried). He falls three times and his robe is stripped off along the way. Soldiers erect the cross and nail his hands and feet to it. Jesus' mother, John the Evangelist, and Mary Magdalene mourn at the foot of the cross, while soldiers torment Jesus. One of them (the centurion Longinus) stabs Jesus in the side with a spear. After suffering great pain, Jesus dies. The Crucifixion occurred on a Friday, and Christians celebrate the day each year as Good Friday.
- Deposition, Lamentation, and Entombment Two disciples, Joseph of Arimathea and Nicodemus, remove Jesus' body from the cross (the Deposition); sometimes those present at the Crucifixion look on. They take Jesus to the tomb Joseph had purchased for himself, and Joseph, Nicodemus, the Virgin Mary, Saint John the Evangelist, and Mary Magdalene mourn over the dead Jesus (the Lamentation). (When in art the isolated figure of the Virgin Mary cradles her dead son in her lap, it is called a Pietà—Italian for "pity.") In portrayals of the Entombment, his followers lower Jesus into a sarcophagus in the tomb.
- Descent into Limbo During the three days he spends in the tomb, Jesus (after death, Christ) descends into Hell, or Limbo, and triumphantly frees the souls of the righteous, including Adam, Eve, Moses, David, Solomon, and John the Baptist. In Byzantine art, this episode is often labeled Anastasis (Greek, "resurrection"), although the term refers to events preceding Christ's emergence from the tomb and reappearance on earth.
- Resurrection and Three Marys at the Tomb On the third day (Easter Sunday), Christ rises from the dead and leaves the tomb while the guards outside are sleeping. The Virgin Mary, Mary Magdalene, and Mary, the mother of James, visit the tomb, find it empty, and learn from an angel that Christ has been resurrected.
- Noli Me Tangere, Supper at Emmaus, and Doubting of Thomas During the 40 days between Christ's Resurrection and his ascent to Heaven, he appears on several occasions to his followers. Christ warns Mary Magdalene, weeping at his tomb, with the words "Don't touch me" (Noli me tangere in Latin), but he tells her to inform the apostles of his return. At Emmaus he eats supper with two of his astonished disciples. Later, Thomas, who cannot believe that Christ has risen, is invited to touch the wound in his side that Longinus inflicted at the Crucifixion.
- Ascension On the 40th day, on the Mount of Olives, with his mother and apostles as witnesses, Christ gloriously ascends to Heaven in a cloud.

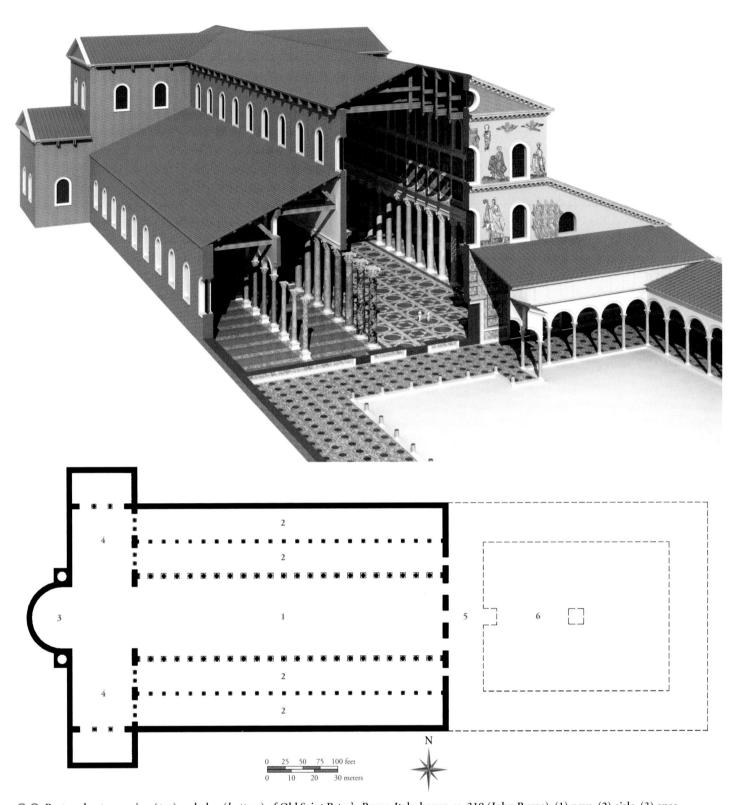

8-9 Restored cutaway view (top) and plan (bottom) of Old Saint Peter's, Rome, Italy, begun ca. 319 (John Burge). (1) nave, (2) aisle, (3) apse, (4) transept, (5) narthex, (6) atrium.

Erected by Constantine, the first imperial patron of Christianity, this huge church stood on the spot of Saint Peter's grave. The building's plan and elevation resemble those of Roman basilicas, not pagan temples.

OLD SAINT PETER'S The greatest of Constantine's churches in Rome was Old Saint Peter's (FIG. 8-9), probably begun as early as 319. The present-day church (FIG. 19-4), one of the masterpieces of Italian Renaissance and Baroque architecture, is a replacement for the Constantinian structure. Old Saint Peter's stood on the western side of the Tiber River on the spot where Constantine and Pope Sylvester believed Peter, the first apostle and founder of the Christian

community in Rome, had been buried. Excavations in the Roman cemetery beneath the church have in fact revealed a second-century memorial erected in honor of the Christian martyr at his reputed grave. The great Constantinian church, capable of housing 3,000 to 4,000 worshipers at one time, was raised upon a terrace over the ancient cemetery on the irregular slope of the Vatican Hill. It enshrined one of the most hallowed sites in Christendom, second only to the

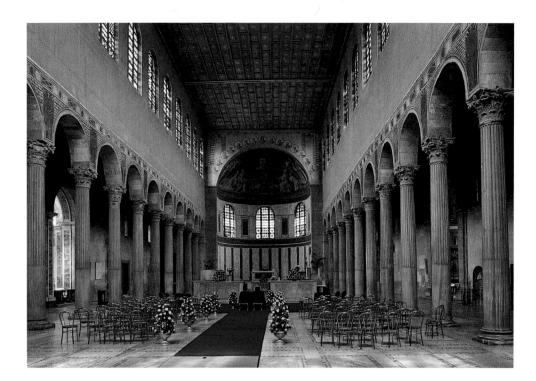

8-10 Interior of Santa Sabina, Rome, Italy, 422–432.

Early Christian basilican churches like Santa Sabina were timber roofed and illuminated by clerestory windows. The Corinthian columns of the nave focused attention on the apse, which framed the altar.

Holy Sepulchre in Jerusalem, the site of Christ's Resurrection. The project also fulfilled the figurative words Christ himself said to the first disciple: "Thou art Peter, and upon this rock I will build my church" (Matt. 16:18). Peter was Rome's first bishop and also the head of the long line of popes that extends to the present.

The plan and elevation of Old Saint Peter's resemble those of Roman basilicas and audience halls, such as the Basilica Ulpia (FIG. 7-43, no. 4) in the Forum of Trajan and Constantine's own Aula Palatina (FIGS. 7-79 and 7-80) at Trier, rather than the design of any Greco-Roman temple. The Christians, understandably, did not want their houses of worship to mimic the look of pagan shrines, but practical considerations also contributed to their shunning the form of pagan temples. Greco-Roman temples housed only the cult statue of the deity. All rituals took place outside at open-air altars. The classical temple, therefore, could have been adapted only with great difficulty as a building that accommodated large numbers of people within it. The Roman basilica, in contrast, was ideally suited as a place for congregation.

Like Roman basilicas, Old Saint Peter's had a wide central nave (FIG. 8-9, no. 1) with flanking aisles (FIG. 8-9, no. 2) and an apse (FIG. 8-9, no. 3) at the end. But unlike pagan basilicas, which sometimes had doorways on one long side, opening onto an aisle (FIG. 7-43, no. 4), all Early Christian basilicas had a pronounced longitudinal axis. Worshipers entered the basilica through a narthex (FIG. 8-9, no. 5), or vestibule. When they emerged in the 300-foot-long nave, they had an unobstructed view of the altar in the apse, framed by the *chancel arch* dividing the nave from the transept (FIG. 8-9, no. 4). The transept, or transverse aisle, an area perpendicular to the nave between the nave and apse, was a special feature of the Constantinian church. It housed the relics of Saint Peter that hordes of pilgrims came to see. (Relics are the body parts, clothing, or objects associated with a saint or Christ himself; see "Pilgrimages and the Cult of Relics," Chapter 12, page 310.) The transept became a standard design element in Western churches only much later, when it also took on, with the nave and apse, the symbolism of the Christian cross. Saint Peter's basilica also had an open colonnaded courtyard in front of the narthex, very much like the forum proper in the Forum of Trajan (FIG. 7-43, no. 5) but called an *atrium* (FIG. 8-9, no. 6), like the central room in a Roman private house (FIG. 7-16, no. 2).

Unlike pagan temples, Old Saint Peter's was not adorned with lavish exterior sculptures. Its brick walls were as austere as those of the Aula Palatina (FIG. 7-79). Inside, however, were frescoes and mosaics, marble columns (taken from pagan buildings, as was customary at the time), and costly ornaments. The *Liber pontificalis*, or *Book of the Pontiffs* (Popes), compiled by an anonymous sixthcentury author, lists Constantine's gifts to Old Saint Peter's. They included altars, chandeliers, candlesticks, pitchers, goblets, and plates fashioned of gold and silver and sometimes embellished with jewels and pearls, as well as jeweled altar cloths for use in the Mass and gold foil to sheathe the vault of the apse. A huge marble *baldacchino* (domical canopy over an altar), supported by four spiral porphyry columns, marked the spot of Saint Peter's tomb.

SANTA SABINA Some idea of the character of the timberroofed interior of Old Saint Peter's can be gleaned from the interior (FIG. 8-10) of Santa Sabina in Rome. Santa Sabina, built a century later, is a basilican church of much more modest proportions, but it still retains its Early Christian character. The Corinthian columns of its *nave arcade* (a series of arches supported by columns separating the nave from the aisles) produce a steady rhythm that focuses all attention on the chancel arch and the apse, which frame the altar. In Santa Sabina, as in Old Saint Peter's, the nave is drenched with light from the *clerestory* windows piercing the thin upper wall beneath the timber roof. The same light would have illuminated the frescoes and mosaics that commonly adorned the nave and apse of Early Christian churches. Outside, Santa Sabina has plain brick walls. They closely resemble the exterior of Trier's Aula Palatina (FIG. 7-79).

SANTA COSTANZA The rectangular basilican church design was long the favorite of the Western Christian world, but Early Christian architects also adopted another classical architectural type: the *central-plan* building. The type is so named because the building's parts are of equal or almost equal dimensions around the center. Roman central-plan buildings were usually round or polygonal domed structures. Byzantine architects developed this form to

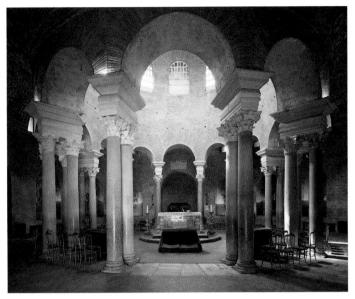

8-11 Interior of Santa Costanza, Rome, Italy, ca. 337–351.

Possibly built as the mausoleum of Constantine's daughter, Santa Costanza later became a church. Its central plan, featuring a domed interior, would become the preferred form for Byzantine churches.

monumental proportions and amplified its theme in numerous ingenious variations (see Chapter 9). In the West, builders generally used the central plan for structures adjacent to the main basilicas, such as mausoleums, baptisteries, and private chapels, rather than for churches, as in the East.

A highly refined example of the central-plan design is Santa Costanza (FIGS. 8-11 and 8-12), built on the northern outskirts of Rome in the mid-fourth century, possibly as the mausoleum for Constantina, the emperor Constantine's daughter. Recent excavations have called the traditional identification into question, but Constantina's monumental porphyry sarcophagus stood in the building, even if the structure was not originally her tomb. The mausoleum, later converted into a church, stood next to the basilican church of

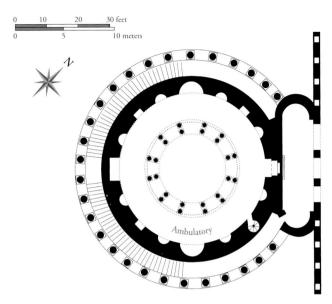

8-12 Plan of Santa Costanza, Rome, Italy, ca. 337-351.

Santa Costanza has antecedents in the domed temples (FIG. 7-51) and mausoleums (FIG. 7-74) of the Romans, but its plan, with 12 pairs of columns and an ambulatory, is unique.

Saint Agnes, who was buried in a nearby catacomb. Santa Costanza has antecedents traceable to the tholos tombs (FIGS. 4-20 and 4-21) of the Mycenaeans, but its immediate predecessors were the domed structures of the Romans, such as the Pantheon (FIGS. 7-49 to 7-51) and, especially, imperial mausoleums such as Diocletian's (FIG. 7-74) at Split. At Santa Costanza, the architect modified the interior design of the Roman buildings to accommodate an *ambulatory*, a ringlike barrel-vaulted corridor separated from the central domed cylinder by a dozen pairs of columns.

Like Early Christian basilicas, Santa Costanza has a severe brick exterior. Its interior was once richly adorned with mosaics, although most are lost. Old and New Testament themes appeared side by side, as in the catacombs and on Early Christian sarcophagi. The Santa

8-13 Detail of vault mosaic in the ambulatory of Santa Costanza, Rome, Italy, ca. 337–351.

The vault mosaics of Santa Costanza depict putti harvesting grapes and producing wine, motifs associated with Bacchus, but for a Christian such scenes brought to mind the Eucharist and Christ's blood.

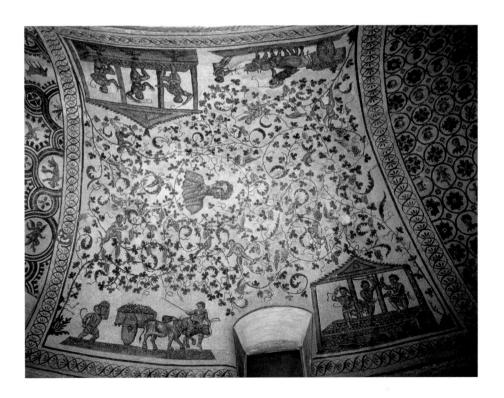

Costanza mosaic program, however, also included subjects common in Roman funerary art, although they were susceptible to a Christian interpretation. In one section (FIG. 8-13) of the mosaic in the ambulatory vault, for example, are scenes of putti harvesting grapes and producing wine. (Similar scenes decorate Constantina's sarcophagus.) A portrait bust is at the center of a rich vine scroll. There is a second bust in another section of the mosaic vault, but both are heavily restored, and the identification of the pair as Constantina and her husband is uncertain. In the Roman world, wine was primarily associated with Bacchus, but for a Christian, the vineyards brought to mind the wine of the Eucharist and the blood of Christ.

SANTA MARIA MAGGIORE Mosaic decoration (see "Mosaics," page 223) played an important role in the interiors of Early Christian buildings of all types. In churches, mosaics not only provided a beautiful setting for the Christian liturgy, but also were vehicles for instructing the congregation about biblical stories and Christian dogma. Old Testament themes are the focus of the extensive fifth-century mosaic cycle in the nave of the basilican church of Santa Maria Maggiore in Rome, the first major church in the West dedicated to the Virgin Mary. Construction of the church began in 432, the year after Mary had been officially designated as the Mother of God (*Theotokos*, "bearer of god" in Greek) at the Council of Ephesus. The council had been convened to debate whether Mary had given birth to the man Jesus or to God as man. It ruled that the divine and human coexisted in Christ and that Mary was indeed the Mother of God.

One of the mosaic panels (FIG. **8-14**) in Santa Maria Maggiore dramatically represents the parting of Abraham and his nephew Lot, as set forth in Genesis, the Bible's opening book. Agreeing to disagree, Lot leads his family and followers to the right, toward the city of Sodom, while Abraham heads for Canaan, moving toward a basilicalike building (perhaps symbolizing the Christian Church) on the left. Lot's is the evil choice, and the instruments of the evil (his two daughters) are in front of him. The figure of the yet-unborn Isaac, the instrument of good (and, as noted earlier, a prefiguration of Christ), stands before his father, Abraham.

The cleavage of the two groups is emphatic, and the mosaicist represented each group using a shorthand device that could be called a "head cluster," which had precedents in antiquity and had a long history in Christian art. The figures engage in a sharp dialogue of glance and gesture. The wide eyes turn in their sockets, and the enlarged hands make broad gestures. This kind of simplified motion, which is characteristic of Late Antique narrative art of both Roman and Christian subject matter, has great power to communicate without ambiguity. But the Abraham and Lot mosaic also reflects the heritage of classical art. The town in the background would not be out of place in a Pompeian mural (FIG. 7-19, left), and the figures themselves are modeled in light and dark, cast shadows, and still loom with massive solidity. Another century had to pass before Western Christian mosaicists portrayed figures entirely as flat images, rather than as three-dimensional bodies, finally rejecting the norms of classical art in favor of a style better suited for a focus on the spiritual instead of the natural world. Early Christian art, like Late Antique Roman art in general, vacillates between these two stylistic poles.

Ravenna

In the decades after the founding in 324 of Constantinople, the New Rome in the East, and the death of Constantine in 337, the pace of Christianization of the Roman Empire quickened. In 380 the emperor Theodosius I issued an edict finally establishing Christianity as the state religion. In 391 he enacted a ban against pagan worship, and in 394 he abolished the Olympic Games, the enduring symbol of the classical world and its values. Theodosius died in 395, and imperial power passed to his two sons, Arcadius, who became Emperor of the East, and Honorius, Emperor of the West. In 404, when the Visigoths, under their king, Alaric, threatened to overrun Italy from the northwest, Honorius moved his capital from Milan to Ravenna, an ancient Roman city (perhaps founded by the Etruscans) near Italy's Adriatic coast, some 80 miles south of Venice. In 410, Rome fell to Alaric, and in 476, Ravenna fell to Odoacer, the first Germanic king of Italy. Odoacer was overthrown in turn by Theodoric, king of the Ostrogoths, who established his capital at Ravenna in 493. Ravenna fell to the Byzantine emperor Justinian in 539, and the subsequent history of the city belongs with that of Byzantium (see Chapter 9).

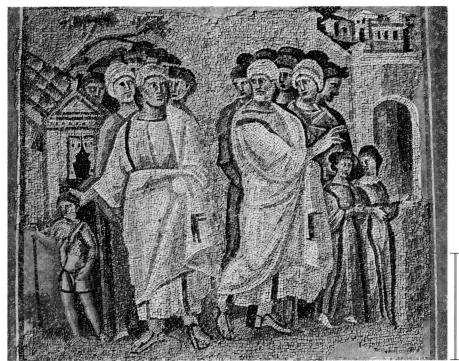

8-14 The parting of Abraham and Lot, nave of Santa Maria Maggiore, Rome, Italy, 432–440. Mosaic, 3' 4" high.

In this mosaic panel representing the Old Testament parting of Abraham and Lot, the artist included the figure of the yet-unborn Isaac because of his importance as a prefiguration of Christ.

8-15 Mausoleum of Galla Placidia, Ravenna, Italy, ca. 425.

This cruciform chapel with a domed crossing is an early example of the combination of central and longitudinal plans. The unadorned brick shell encloses a rich ensemble of mosaics (FIG. 8-1).

MAUSOLEUM OF GALLA PLACIDIA The so-called Mausoleum of Galla Placidia, Honorius's half-sister, is a rather small *cruciform* (cross-shaped) structure (FIG. 8-15) with barrel-vaulted arms and a tower at the *crossing*. Built shortly after 425, almost a quarter century before Galla Placidia's death in 450, it was probably intended as a chapel to the martyred Saint Lawrence. The building was once thought, however, to be Galla Placidia's tomb, hence its name today. Originally, the chapel adjoined the narthex of the now greatly altered palace-church of Santa Croce (Holy Cross), which was also cruci-

form in plan. The chapel's cross arms are of unequal length, so that the building has a longitudinal orientation, unlike the centrally planned Santa Costanza (FIGS. 8-11 and 8-12), but since all four arms are very short, the emphasis is on the tall *crossing tower* with its vault resembling a dome. This small, unassuming building thus represents one of the earliest successful fusions of the two basic Late Antique plans—the longitudinal, used for basilican churches, and the central, used primarily for baptisteries and mausoleums. It introduced, on a small scale, a building type that was to have a long history in church architecture: the longitudinally planned building with a vaulted or domed crossing.

The chapel's unadorned brick shell encloses one of the richest mosaic ensembles (FIG. 8-1) in Early Christian art. Mosaics (see "Mosaics," page 223) cover every square inch of the interior surfaces

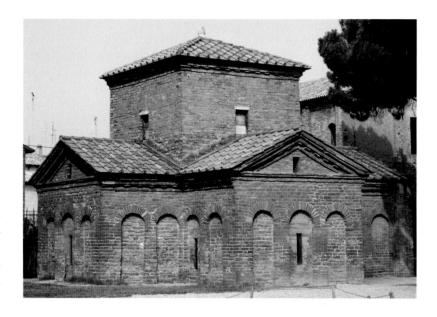

above the marble-faced walls. Garlands and decorative medallions resembling snowflakes on a dark blue ground adorn the barrel vaults of the nave and cross arms. The tower has a large golden cross set against a star-studded sky. Representations of saints and apostles cover the other surfaces. At the end of the nave is a mosaic representing Saint Lawrence next to the gridiron on which he was tortured. The martyred saint carries a cross, suggesting that faith in Christ led to his salvation.

Christ as Good Shepherd is the subject of the lunette (FIG. **8-16**) above the entrance. No earlier version of the Good Shepherd is as regal as this one. Instead of carrying a lamb on his shoulders, Jesus sits among his flock, haloed and robed in gold and purple. To his left and right, the sheep are distributed evenly in groups of three. But their arrangement is rather loose and informal, and they occupy a

8-16 Christ as the Good Shepherd, mosaic from the entrance wall of the Mausoleum of Galla Placidia, Ravenna, Italy, ca. 425.

Jesus sits among his flock, haloed and robed in gold and purple. The landscape and the figures, with their cast shadows, are the work of a mosaicist still deeply rooted in the naturalistic classical tradition.

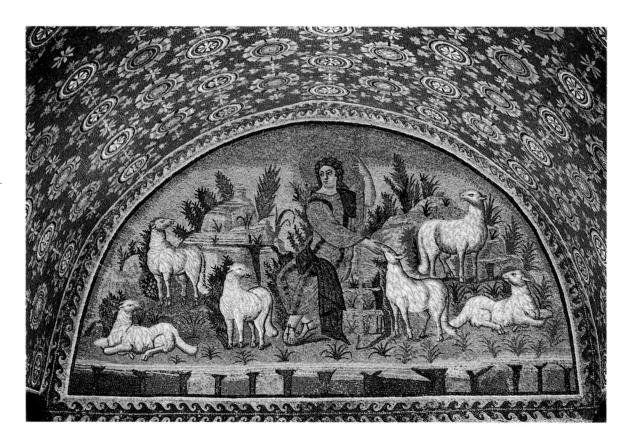

Mosaics

s an art form, *mosaic* had a rather simple and utilitarian beginning, seemingly invented primarily to provide an inexpensive and durable flooring. Originally, small beach pebbles were set, unaltered from their natural form and color, into a thick coat of cement. Artisans soon discovered, however, that the stones could be arranged in decorative patterns. At first, these *pebble mosaics* were uncomplicated and were confined to geometric shapes. Generally, the artists used only black and white stones. Examples of this type, dating to the eighth century BCE, have been found at Gordion in Asia Minor. Eventually, artists arranged the stones to form more complex pictorial designs, and by the fourth century BCE, the technique had developed to a high level of sophistication. Mosaicists depicted elaborate figural scenes using a broad range of colors—yellow, brown, and red in addition to black, white, and gray—and shaded the figures, clothing, and setting to suggest volume. Thin strips of lead provided linear definition (FIG. 5-68).

By the middle of the third century BCE, artists had invented a new kind of mosaic that permitted the best mosaicists to create designs more closely approximating true paintings. The new technique employed *tesserae* (Latin for "cubes" or "dice"). These tiny cut stones gave the artist much greater flexibility because their size and shape could be adjusted at will, eliminating the need for lead strips to indicate contours and interior details. Much more gradual gradations of color also became possible (FIG. 5-70), and mosaicists finally could aspire to rival the achievements of painters.

In Early Christian mosaics (FIGS. 8-1, 8-13, 8-14, and 8-16 to 8-18), the tesserae were usually made of glass, which reflects light and makes the surfaces sparkle. Ancient mosaicists occasionally used glass tesserae, but the Romans preferred opaque marble pieces. Mosaics quickly became the standard means of decorating walls and vaults in Early Christian buildings, although mural paintings were also popular. The mosaics caught the light flooding through the windows in vibrant reflection, producing sharp contrasts and concentrations of color that could focus attention on a composition's central, most relevant features. Mosaics worked in the Early Christian manner were not meant to incorporate the subtle tonal changes a naturalistic painter's approach would require. Color was "placed," not blended. Bright, hard, glittering texture, set within a rigorously simplified pattern, became the rule. For mosaics situated high in an apse or ambulatory vault or over the nave colonnade, far above the observer's head, as in the church of Sant'Apollinare Nuovo (FIG. 8-17) in Ravenna, the painstaking use of tiny tesserae seen in Roman floor and wall mosaics (FIGS. 5-70 and 7-24) would be meaningless. Early Christian mosaics, designed to be seen from a distance, employed larger tesserae. The pieces were also set unevenly so that their surfaces could catch and reflect the light. Artists favored simple designs for optimal legibility. For several centuries, mosaic, in the service of Christian theology, was the medium of some of the supreme masterpieces of medieval art.

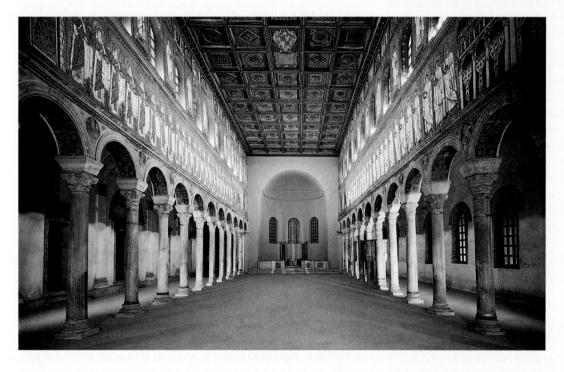

8-17 Interior of Sant'Apollinare Nuovo, Ravenna, Italy, dedicated 504.

Theodoric, king of the Ostrogoths, established his capital at Ravenna in 493. His palace-church features an extensive series of mosaics depicting Old Testament prophets and scenes from the life of Christ.

carefully described landscape that extends from foreground to background beneath a blue sky. As at Santa Maria Maggiore (FIG. 8-14), all the forms have three-dimensional bulk and are still deeply rooted in the classical tradition.

SANT'APOLLINARE NUOVO Around 504, soon after Theodoric settled in Ravenna, he ordered the construction of his own palace-church, a three-aisled basilica (FIG. 8-17) dedicated to

the Savior. In the ninth century, the relics of Saint Apollinaris were transferred to this church. The building has been known since that time as Sant'Apollinare Nuovo.

The rich mosaic decorations of the nave walls are divided into three zones. Only the upper two date from Theodoric's time. Old Testament patriarchs and prophets stand between the clerestory windows. Above them, scenes from Christ's life alternate with decorative panels. the persistence of classical motifs and stylistic modes in Early Christian art. Contemporaneous with, but radically different from, the mosaic panels (FIG. 8-17) of Sant'Apollinare Nuovo, the *Vienna Genesis* incorporates many anecdotal details, such as the drinking camel and Rebecca bracing herself with her raised left foot on the rim of the well as she tips up her jug for Eliezer. Nonetheless, the figures are seen against a blank landscape except for the miniature city and the road to the well. As at Ravenna, everything necessary for bare narrative is present and nothing else.

ROSSANO GOSPELS Closely related to the Vienna Genesis is another early-sixth-century Greek manuscript, the Rossano Gospels, the earliest preserved illuminated book that contains illustrations of the New Testament. By this time a canon of New Testament iconography had been fairly well established. As in the Vienna Genesis, the text of the Rossano Gospels is in silver on purple vellum. The Rossano artist, however, attempted with considerable success to harmonize the colors with the purple background. The subject of folio 8 (FIG. 8-21) is the appearance of Jesus before Pilate, who asks the Jews to choose between Jesus and Barabbas (Matt. 27: 2–26). The vividly gesturing figures are on two levels separated by a simple ground line. In the upper level, Pilate presides over the tribunal. He sits on an elevated dais, following a long-established pattern in Roman art (FIG. 7-76). The people form an arch around

Pilate (the artist may have based the composition on a painting in an apse) and demand the death of Jesus, while a court scribe records the proceedings. Jesus (here a bearded adult, as soon became the norm for medieval and later depictions of Christ) and the bound Barabbas appear in the lower level. The painter explicitly labeled Barabbas to avoid any possible confusion so that the picture would be as readable as the text. Pilate on his magistrate's dais, flanked by painted imperial portraits, and the haloed Christ needed no further identification.

Ivory Carving

Among the other important luxury arts of Late Antiquity was ivory carving, which has an even longer history in the ancient world than manuscript illustration (see "Ivory Carving," page 227).

CRUCIFIXION OF CHRIST A century before the pages of the *Rossano Gospels* were illuminated with scenes from the Passion cycle, a Roman or northern Italian sculptor produced a series of ivory plaques for a small box that dramatically recount the suffering and triumph of Christ. The narrative on the box begins with Pilate washing his hands, Jesus carrying the cross on the road to Calvary, and Peter denying Jesus, all compressed into a single panel.

The next plaque in the sequence (FIG. 8-22) shows, at the left, Judas hanging from a tree with his open bag of silver dumped on the

8-21 Christ before Pilate, folio 8 verso of the *Rossano Gospels*, early sixth century. Tempera on purple vellum, $11'' \times 10\frac{1}{4}''$. Museo Diocesano d'Arte Sacra, Rossano.

The sources for medieval manuscript illustrations were diverse. The way the people form an arch around Pilate on this page suggests that the composition derives from a painting in a church apse.

1 in.

Ivory Carving

vory has been prized since the earliest times, when Ice Age artists fashioned the tusks of European mammoths into pendants, beads, and other items for body adornment, and, occasionally, statuettes (Fig. 1-4). The primary ivory sources in the historical period have been the elephants of India and especially Africa, where the species is larger than the Asian counterpart and the tusks longer, heavier, and of finer grain. African elephant tusks 5 to 6 feet in length and weighing 10 pounds are common, but tusks of male elephants can be 10 feet long or more and weigh more than 100 pounds. Carved ivories are familiar, if precious, finds at Mesopotamian and Egyptian sites, and ivory objects were manufactured and coveted in the prehistoric Aegean and throughout the classical world. Most frequently employed then for household objects, small votive offerings, and gifts to the deceased, ivory also could be used for grandiose statues such as Phidias's *Athena Parthenos* (Fig. 5-46).

The Greeks and Romans admired ivory both for its beauty and because of its exotic origin. Elephant tusks were costly imports, and Roman generals proudly displayed them in triumphal processions when they paraded the spoils of war before the people. (In FIG. 9-14

a barbarian brings tribute to a Byzantine emperor in the form of an ivory tusk.)

Adding to the expense of the material itself was the fact that only highly skilled artisans were capable of working in ivory. The tusks were very hard and of irregular shape, and the ivory workers needed a full toolbox of saws, chisels, knives, files, and gravers close at hand to cut the tusks into blocks for statuettes or thin plaques decorated with relief figures and ornament.

In Late Antiquity and the early medieval period, ivory was employed most frequently for book covers, chests and boxes (FIG. 8-22), and diptychs (FIGS. 8-23 and 9-15). A *diptych* is a pair of hinged tablets, usually of wood, with a wax layer on the inner sides for writing letters and other documents. (Both the court scribe recording Jesus' trial in the *Rossano Gospels*, FIG. 8-21, and the woman in a painted portrait from Pompeii, FIG. 7-25, hold wooden diptychs.) Diptychs fashioned out of ivory generally were created for ceremonial and official purposes—for example, to announce the election of a consul or a marriage between two wealthy families or to commemorate the death of an elevated member of society.

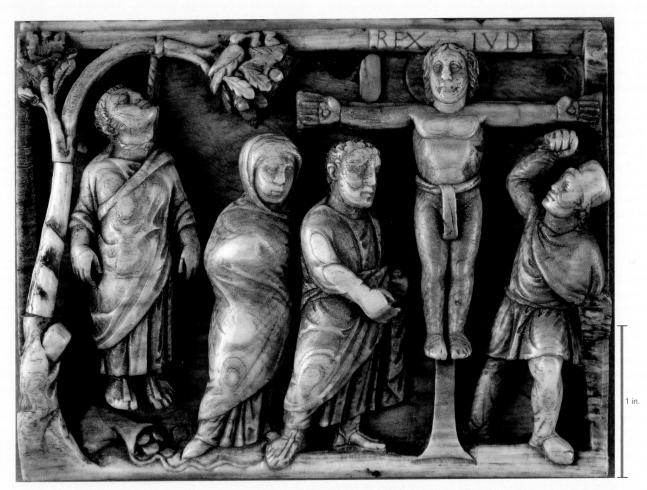

8-22 Suicide of Judas and Crucifixion of Christ, plaque from a box, ca. 420. Ivory, $3'' \times 3\frac{7}{8}''$. British Museum, London.

This plaque from a luxurious ivory box is the first known representation of the Crucifixion. Christ is a beardless youth who experiences no pain. At the left, Judas, his betrayer, hangs himself.

8-23 Woman sacrificing at an altar, right leaf of the diptych of the Nicomachi and the Symmachi, ca. 400. Ivory, $11\frac{3}{4}'' \times 5\frac{1}{2}''$. Victoria & Albert Museum, London.

Even after Theodosius banned all pagan cults in 391, some Roman families still practiced the ancient rites. The sculptor who carved this ivory plaque also carried on the classical artistic style.

ground beneath his feet. The Crucifixion is at the right. The Virgin Mary and Joseph of Arimathea are to the left of the cross. On the other side Longinus thrusts his spear into the side of the "King of the Jews" (*REX IVD* is inscribed above Jesus' head). The two remaining panels show two Marys and two soldiers at the open doors of a tomb with an empty coffin within and the doubting Thomas touching the wound of the risen Christ.

The series is one of the oldest cycles of Passion scenes preserved today. The artist who fashioned the ivory box helped establish the iconographical types for medieval narratives of Christ's life. On these plaques, Jesus always appears as a beardless youth. In the Crucifixion (FIG. 8-22), the earliest known rendition of the subject in the history of art, he exhibits a superhuman imperviousness to pain. The Savior is a muscular, nearly nude, heroic figure who appears virtually weightless. He does not *hang* from the cross; he is *displayed* on it, a divine being with open eyes who has conquered death. The striking contrast between the powerful frontal, serenely calm Jesus on the cross and the limp hanging body of his betrayer with his snapped neck is highly effective, both visually and symbolically.

DIPTYCH OF THE SYMMACHI Although after Constantine all the most important architectural projects in Italy were Christian in character, not everyone converted to the new religion, even after Theodosius closed all temples and banned all pagan cults in 391.

An ivory plaque (FIG. 8-23), probably produced in Rome around 400, strikingly exhibits the endurance of pagan themes and patrons and of the classical style. The ivory, one of a pair of leaves of a diptych, may commemorate either the marriage of members of two powerful Roman families of the senatorial class, the Nicomachi and the Symmachi, or the passing within a decade of two prominent male members of the two families. Whether or not the diptych relates to any specific event(s), the Nicomachi and the Symmachi here ostentatiously reaffirmed their faith in the old pagan gods. Certainly, the families favored the aesthetic ideals of the classical past, as exemplified by such works as the stately processional friezes of the Greek Parthenon (FIG. 5-50) and the Roman Ara Pacis (FIG. 7-31).

The leaf inscribed "of the Symmachi" (FIG. 8-23) represents a woman sacrificing at an altar in front of a tree. She wears ivy in her hair and seems to be celebrating the rites of Bacchus, although scholars dispute the identity of the divinity honored. The other diptych panel, inscribed "of the Nicomachi," also shows a woman at an open-air altar. On both panels, the precise yet fluent and graceful lines, the relaxed poses, and the mood of spiritual serenity reveal an artist who practiced within a still-vital classical tradition that idealized human beauty as its central focus. The great senatorial magnates of Rome, who resisted the empire-wide imposition of the Christian faith at the end of the fourth century, probably deliberately sustained the classical tradition.

Despite the widespread adoption during the third and fourth centuries of the new non-naturalistic Late Antique aesthetic featur-

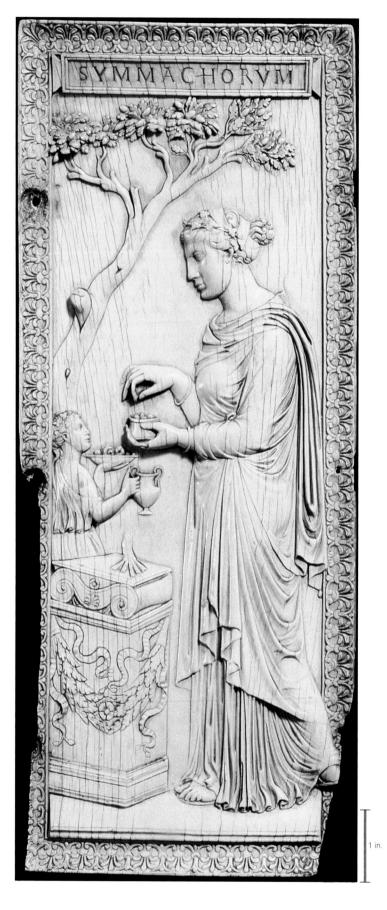

ing wafer-thin frontal figures, the classical tradition in art lived on and was never fully extinguished in the Middle Ages. Classical art survived in intermittent revivals, renovations, and restorations side by side and in contrast with the opposing nonclassical medieval styles until it rose to dominance once again in the Renaissance.

LATE ANTIQUITY

THIRD CENTURY CE

- Christ was crucified ca. 29, but very little Christian art or architecture survives from the first centuries of Christianity. "Early Christian art" means the earliest art of Christian content, not the art of Christians at the time of Jesus.
- The Second Commandment prohibition against graven images once led scholars to think that the Jews of the Roman Empire had no figural art, but the synagogue at Dura-Europos contains biblical mural paintings.
- Excavators have also uncovered the remains of a Christian community house of the mid-third century at Dura-Europos.
- At about the same time, sarcophagi with a mixture of Old and New Testament scenes began to appear.

Synagogue, Dura-Europos, ca. 245–256

Sarcophagus with Old and New Testament scenes, ca. 270

CHRISTIAN ART UNDER CONSTANTINE, 306-337

- Constantine's Edict of Milan of 313 granted Christianity legal status equal or superior to paganism. The emperor was the first great patron of Christian art and built the first churches in Rome, including Old Saint Peter's.
- In a Christian ceremony, Constantine dedicated Constantinople as the new capital of the Roman Empire in 330. He was baptized on his deathbed in 337.
- Early Christian artists produced mural and ceiling paintings in the catacombs and sarcophagi depicting Old and New Testament stories in great numbers.

Catacomb of Saints Peter and Marcellinus, early fourth century

CHRISTIAN ART, 337-526

- The emperor Theodosius I (r. 379–395) proclaimed Christianity the official religion of the Roman Empire in 380 and banned pagan worship in 391.
- Honorius (r. 395–423) moved the capital of his Western Roman Empire to Ravenna in 404. Rome fell to the Visigothic king Alaric in 410.
- Mosaics became a major vehicle for the depiction of Christian themes in churches. Extensive mosaic cycles are preserved in Santa Maria Maggiore in Rome and in Sant'Apollinare Nuovo in Rayenna.
- The first manuscripts with illustrations of the Old and New Testaments, for example, the *Vienna Genesis*, date to the early sixth century. Illuminated manuscripts would become one of the major art forms of the Middle Ages.

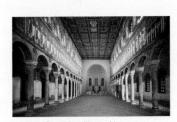

Sant' Apollinare Nuovo, Ravenna, 504

Vienna Genesis, early sixth century

9-1 Christ as Pantokrator, dome mosaic in the Church of the Dormition, Daphni, Greece, ca. 1090–1100.

This dome mosaic of Christ as Last Judge of humankind is like a gigantic Byzantine icon hovering dramatically in space, connecting the awestruck worshiper below with Heaven through Christ.

BYZANTIUM

When Constantine I founded a "New Rome" in the East in 324 on the site of the ancient Greek city of Byzantium and called it Constantinople in honor of himself, he legitimately could claim to be ruler of a united Roman Empire. But when Theodosius I (r. 379–395) died, he bequeathed the Empire to his two sons, Arcadius, the elder, who became Emperor of the East, and Honorius, who became Emperor of the West. The Emperor of the East ruled from Constantinople. After the sack of Rome in 410, Honorius moved the western capital to Milan and later to Ravenna. Though not formally codified, Theodosius's division of the Empire (which paralleled Diocletian's century-earlier division of administrative responsibility) became permanent. Centralized government soon disintegrated in the western half and gave way to warring kingdoms (see Chapter 11). The eastern half of the Roman Empire, only loosely connected by religion to the West and with only minor territorial holdings there, had a long and complex history of its own. Centered at New Rome, the Eastern Christian Empire remained a cultural and political entity for a millennium, until the last of a long line of Eastern Roman emperors, ironically named Constantine XI, died at Constantinople in 1453, defending it in vain against the Ottoman Turks.

Historians refer to that Eastern Christian Roman Empire as Byzantium (MAP 9-1), employing Constantinople's original name, and use the term *Byzantine* to identify whatever pertains to Byzantium—its territory, its history, and its culture. The Byzantine emperors, however, did not use these terms to define themselves. They called their empire Rome and themselves Romans. Though they spoke Greek and not Latin, the Eastern Roman emperors never relinquished their claim as the legitimate successors to the ancient Roman emperors. During the long course of its history, Byzantium was the Christian buffer against the expansion of Islam into central and northern Europe, and its cultural influence was felt repeatedly in Europe throughout the Middle Ages. Byzantium Christianized the Slavic peoples of the Balkans and of Russia, giving them its Orthodox religion and alphabet, its literary culture, and its art and architecture. Byzantium's collapse in 1453 brought the Ottoman Empire into Europe as far as the Danube River, but Constantinople's fall made an impact even farther to the west. The westward flight of Byzantine scholars from the Rome of the East introduced the study of classical Greek to Italy and helped inspire there the new consciousness of antiquity that historians call the Renaissance.

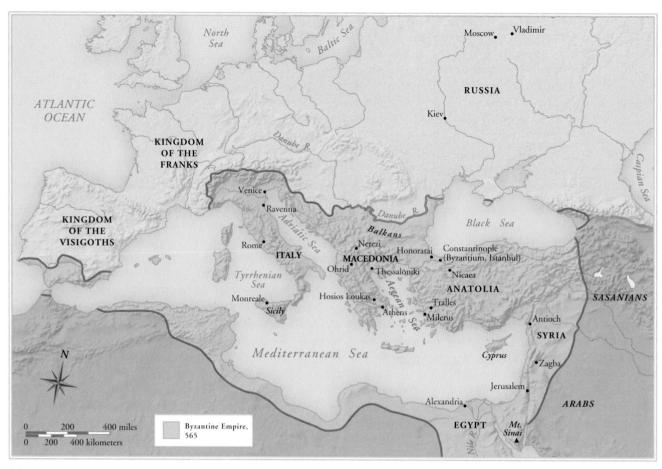

MAP 9-1 The Byzantine Empire at the death of Justinian in 565.

Constantine recognized Christianity at the beginning of the fourth century, Theodosius established it as the Roman Empire's official religion at the end of the fourth century, and Justinian, in the sixth century, proclaimed it New Rome's only lawful religion. By that time it was not simply the Christian religion but the Orthodox Christian doctrine that the Byzantine emperor asserted as the only permissible creed for his subjects. In Orthodox Christianity, the central article of faith is the equality of the three aspects of the Trinity of Father, Son, and Holy Spirit (as stated in Roman Catholic, Protestant, and Eastern Orthodox creeds today). All other versions of Christianity were heresies, especially the Arian, which asserted that the Father and Son were distinct entities and that the Father created the Son and therefore Christ was not equal to God. Also classified as a heresy was the Monophysite view that Christ had only one nature, which was divine, contrary to both the Orthodox and Arian belief that Christ had a dual divine-human nature. Justinian considered it his first duty not only to stamp out the few surviving pagan cults but also to crush all those who professed any Christian doctrine other than the Orthodox.

Art historians divide the history of Byzantine art into the three periods of its greatest glory, sometimes referred to as "golden ages." The first, Early Byzantine, extends from the accession of Justinian in 527 to the onset of *iconoclasm* (the destruction of images used in religious worship) under Leo III in 726. The Middle Byzantine period begins with the renunciation of iconoclasm in 843 and ends with the western Crusaders' occupation of Constantinople in 1204. Late Byzantine corresponds to the two centuries after the Byzantines recaptured Constantinople in 1261 until its final loss in 1453 to the Ottoman Turks and the conversion of many churches to mosques (see Chapter 10).

EARLY BYZANTINE ART

The emperor Justinian (r. 527–565) briefly restored much of the Roman Empire's power and extent (MAP 9-1). His generals, Belisarius and Narses, drove the Ostrogoths out of Italy, expelled the Vandals from the African provinces, routed the Bulgars on the northern frontier, and held the Sasanians at bay on the eastern borders. At home, the emperor quelled a dangerous rebellion in 532 of political and religious factions in the city (the Nika revolt), and Orthodoxy triumphed over the Monophysite heresy. Justinian also supervised the codification of Roman law in a great work known as the Corpus juris civilis (Code of Civil Law), which became the foundation of the law systems of many modern European nations. Justinian could claim, with considerable justification, to have revived the glory of "Old Rome" in New Rome. Under Justinian, Byzantine art emerged as a recognizably novel and distinctive style, leaving behind the uncertainties and hesitations of Early Christian artistic experiment. Though still reflecting its sources in Late Antique art, it definitively expressed, with a new independence and power of invention, the unique character of the Eastern Christian culture centered at Constantinople.

Architecture and Mosaics

In Constantinople alone, Justinian built or restored more than 30 churches of the Orthodox faith, and his activities as builder extended throughout the Byzantine Empire. The historian of his reign, Procopius, declared that the emperor's ambitious building program was an obsession that cost his subjects dearly in taxation. But his grand monuments defined the Byzantine style in architecture forever after.

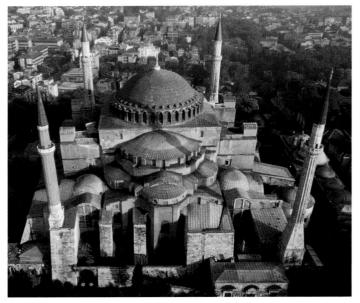

9-2 Anthemius of Tralles and Isidorus of Miletus, aerial view of Hagia Sophia (looking north), Constantinople (Istanbul), Turkey, 532–537.

The reign of Justinian marks the beginning of the first golden age of Byzantine art. Hagia Sophia was the most magnificent of the more than 30 churches that Justinian built or restored in Constantinople alone.

HAGIA SOPHIA The most important monument of Early Byzantine art is Hagia Sophia (FIG. 9-2), the Church of Holy Wisdom, in Constantinople. Anthemius of Tralles and Isidorus of Miletus, a mathematician and a physicist—neither man an architect in the modern sense of the word—designed and built the church for Justinian between 532 and 537. They began work immediately after fire destroyed an earlier church on the site during the Nika riot in January 532. Justinian intended the new church to rival all other churches ever built and even to surpass in scale and magnificence the Temple of Solomon in Jerusalem. The result was Byzantium's grandest building and one of the supreme accomplishments of world architecture.

Hagia Sophia's dimensions are formidable for any structure not built of steel. In plan (FIG. 9-3, *top*), it is about 270 feet long and 240 feet wide. The dome is 108 feet in diameter, and its crown rises some 180 feet above the pavement (FIG. 9-3, *bottom*). (The first dome collapsed in 558. Its replacement required repair in the 9th and 14th centuries. The present dome is greater in height and more

9-3 ANTHEMIUS OF TRALLES and ISIDORUS OF MILETUS, plan (top) and restored cutaway view (bottom) of Hagia Sophia, Constantinople (Istanbul), Turkey, 532–537 (John Burge).

In Hagia Sophia, Justinian's architects succeeded in fusing two previously independent architectural traditions: the vertically oriented central-plan building and the longitudinally oriented basilica.

stable than the original.) In scale, Hagia Sophia rivals the architectural wonders of Rome: the Pantheon, the Baths of Caracalla, and the Basilica of Constantine (see Chapter 7). In exterior view (FIG. 9-2), the great dome dominates the structure, but the building's present external aspects are much changed from their original appearance. Huge buttresses were added to the Justinianic design, and after the Ottoman conquest of 1453, when Hagia Sophia became a mosque, the Turks constructed four towering minarets. The building, secularized in the 20th century, is now a museum.

The characteristic Byzantine plainness and unpretentiousness of the exterior (which in this case also disguise the massive scale) scarcely prepare visitors for the building's interior (FIG. 9-4). A poet and member of Justinian's court, Paul the Silentiary (an usher responsible for maintaining silence in the palace), vividly described the original magnificence of Hagia Sophia's interior:

Who ... shall sing the marble meadows gathered upon the mighty walls and spreading pavement.... [There is stone] from the green flanks of Carystus [and] the speckled Phrygian stone, sometimes rosy mixed with white, sometimes gleaming with purple and silver

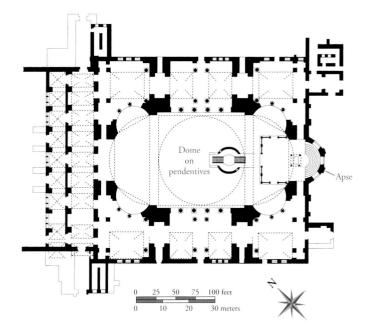

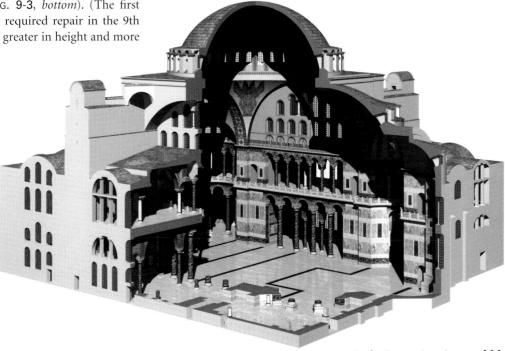

9-4 Anthemius of Tralles and Isidorus of Miletus, interior of Hagia Sophia (looking southwest), Constantinople (Istanbul), Turkey, 532–537.

Pendentive construction made possible Hagia Sophia's lofty dome, which seems to ride on a halo of light. A contemporary said the dome seemed to be suspended by "a golden chain from Heaven."

flowers. There is a wealth of porphyry stone, too, besprinkled with little bright stars. . . . You may see the bright green stone of Laconia and the glittering marble with wavy veins found in the deep gullies of the Iasian peaks, exhibiting slanting streaks of blood-red and livid white; the pale yellow with swirling red from the Lydian headland; the glittering crocus-like golden stone [of Libya]; . . . glittering [Celtic] black [with] here and there an abundance of milk; the pale onyx with glint of precious metal; and [Thessalian marble] in parts vivid green not unlike emerald. . . . It has spots resembling snow next to flashes of black so that in one stone various beauties mingle. 1

The feature that distinguishes Hagia Sophia from equally lavish Roman buildings such as the Pantheon (FIG. 7-51) is the special mystical quality of the light that floods the interior (FIG. 9-4). The soaring canopy-like dome that dominates the inside as well as the outside of the church rides on a halo of light from windows in the dome's base. Visitors to Hagia Sophia from Justinian's time to today have been struck by the light within the church and its effect on the human spirit. The 40 windows at the base of the dome create the illusion that the dome is resting on the light that pours through them. Procopius, who wrote at the emperor's request a treatise on his ambitious building program, observed that the dome looked as if it were suspended by "a golden chain from Heaven." Said he: "You might say that the space is not illuminated by the sun from the outside, but that the radiance is generated within, so great an abundance of light bathes this shrine all around."²

Paul the Silentiary compared the dome to "the firmament which rests on air" and described the vaulting as covered with "gilded tesserae from which a glittering stream of golden rays pours abundantly and strikes men's eyes with irresistible force. It is as if one were gazing at the midday sun in spring." Thus, Hagia Sophia has a vastness of space shot through with light, and a central dome that appears to be supported by the light it admits. Light is the mystical element—light that glitters in the mosaics, shines forth from the marble-clad walls and floors, and pervades and defines spaces that, in themselves, seem to escape definition. Light seems to dissolve material substance and transform it into an abstract spiritual vision. Pseudo-Dionysius, perhaps the most influential mystic philosopher of the age, wrote in *The Divine Names*: "Light comes from the Good and . . . light is the visual image of God." ⁴

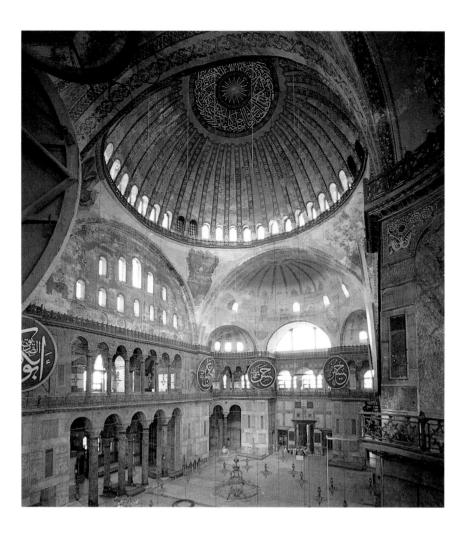

PENDENTIVES To achieve this illusion of a floating "dome of Heaven," Justinian's architects used *pendentives* (see "Pendentives and Squinches," page 235) to transfer the weight from the great dome to the piers beneath, rather than to the walls. With pendentives (FIG. **9-5**, *left*), not only could the space beneath the dome be unobstructed but scores of windows also could puncture the walls themselves. Pendentives created the impression of a dome suspended above, not held up by, walls. Experts today can explain the technical virtuosity of Anthemius and Isidorus, but it remained a mystery to their contemporaries. Procopius communicated the sense of wonderment experienced by those who entered Justinian's great church: "No matter how much they concentrate their attention on this and that, and examine everything with contracted eyebrows, they are unable to understand the craftsmanship and always depart from there amazed by the perplexing spectacle."⁵

By placing a hemispherical dome on a square base instead of on a circular base, as in the Pantheon, Anthemius and Isidorus succeeded in fusing two previously independent and seemingly mutually exclusive architectural traditions: the vertically oriented central-plan building and the longitudinally oriented basilica. Hagia Sophia is, in essence, a domed basilica (FIG. 9-3)—a uniquely successful conclusion to several centuries of experimentation in Christian church architecture. However, the thrusts of the pendentive construction at Hagia Sophia made external buttresses necessary, as well as huge internal northern and southern wall piers and eastern and western half-domes (FIG. 9-4). The semidomes' thrusts descend, in turn, into still smaller half-domes surmounting columned exedrae that give a curving flow to the design.

Pendentives and Squinches

erhaps the most characteristic feature of Byzantine architecture is the placement of a dome, which is circular at its base, over a square, as in the Justinianic church of Hagia Sophia (FIGS. 9-2 to 9-4) and countless later structures (for example, FIGS. 9-22 and 9-24). Two structural devices that are hallmarks of Byzantine engineering made this feat possible: *pendentives* and *squinches*.

In pendentive construction (from the Latin *pendere*, "to hang") a dome rests on what is, in effect, a second, larger dome (FIG. 9-5, *left*). The top portion and four segments around the rim of the larger dome are omitted so that four curved triangles, or pendentives, are formed. The pendentives join to form a ring and four arches whose planes bound a square. The weight of the dome is thus transferred not to the walls but rather through the pendentives and arches to the four piers from which the arches spring. The first use of pendentives on a monumental scale was in Hagia Sophia (FIG. 9-4) in the mid-sixth century, although Near Eastern architects had experimented with them earlier. In Roman and Early Christian central-plan buildings, such as the Pantheon (FIGS. 7-50 and 7-51) and Santa Costanza (FIG. 8-11), the domes spring directly from the circular top of a cylinder (FIG. 7-6*a*).

The pendentive system is a dynamic solution to the problem of setting a round dome over a square. The device made possible a union of centralized and longitudinal or basilican structures. A similar effect can be achieved using squinches (FIG. 9-5, *right*)—arches, corbels, or lintels—that bridge the corners of the supporting walls

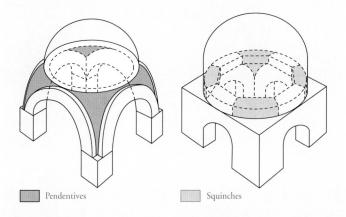

9-5 Dome on pendentives (left) and on squinches (right).

Pendentives (triangular sections of a sphere) make it possible to place a dome on a ring over a square. Squinches achieve the same goal by bridging the corners of the square to form an octagonal base.

and form an octagon inscribed within a square (FIG. 9-22). To achieve even greater height, a builder can rest a dome on a cylindrical drum that in turn rests on either pendentives or squinches, but the principle of supporting a dome over a square is the same.

The diverse vistas and screenlike ornamented surfaces mask the structural lines. The columnar arcades of the nave and second-story galleries have no real structural function. Like the walls they pierce, they are only part of a fragile "fill" between the huge piers. Structurally, although Hagia Sophia may seem Roman in its great scale and majesty, it does not have Roman organization of its masses. The very fact that the "walls" in Hagia Sophia are actually concealed (and barely adequate) piers indicates that the architects sought Roman monumentality as an *effect* and did not design the building according to Roman principles. Using brick in place of concrete marked a further departure from Roman practice and characterizes Byzantine architecture as a distinctive structural style. Hagia Sophia's eight great supporting piers are ashlar masonry, but the screen walls are brick, as are the vaults of the aisles and galleries and the dome and semicircular half-domes.

The ingenious design of Hagia Sophia provided the illumination and the setting for the solemn liturgy of the Orthodox faith. Through the large windows along the rim of the great dome, light poured down upon the interior's jeweled splendor, where priests staged the sacred spectacle. Sung by clerical choirs, the Orthodox equivalent of the Latin Mass celebrated the sacrament of the Eucharist at the altar in the apsidal sanctuary, in spiritual reenactment of Jesus' Crucifixion. Processions of chanting priests, accompanying the patriarch (archbishop) of Constantinople, moved slowly to and from the sanctuary and the vast nave. The gorgeous array of their vestments rivaled the interior's polychrome marbles; finely wrought, gleaming candlesticks and candelabra; the illuminated books bound in gold or ivory and inlaid with jewels and enamels; and the crosses, sacred vessels,

and processional banners. Each feature, with its great richness of texture and color, glowing in shafts of light from the dome, contributed to the majestic ambience of Justinian's great church.

The nave of Hagia Sophia was reserved for the clergy. The laity, segregated by sex, were confined to the shadows of the aisles and galleries, restrained in most places by marble parapets. The complex spatial arrangement allowed only partial views of the brilliant ceremony. The emperor was the only layperson privileged to enter the sanctuary. When he participated with the patriarch in the liturgical drama, standing at the pulpit beneath the great dome, his rule was again sanctified and his person exalted. Church and state were symbolically made one. The church building was then the earthly image of the court of Heaven, its light the image of God and God's holy wisdom.

At Hagia Sophia, the intricate logic of Greek theology, the ambitious scale of Rome, the vaulting tradition of the Near East, and the mysticism of Eastern Christianity combined to create a monument that is at once a summation of antiquity and a positive assertion of the triumph of Christian faith.

RAVENNA In 493, Theodoric, the Ostrogoths' greatest king, chose the Italian city of Ravenna as the capital of his kingdom, which encompassed much of the Balkans and all of Italy (see Chapter 8). During the short history of Theodoric's unfortunate successors, the importance of the city declined. But in 539, Justinian's general Belisarius captured Ravenna, initiating the third and most important stage of the city's history. Ravenna remained the Eastern Roman Empire's foothold in Italy for two centuries, until the Lombards and

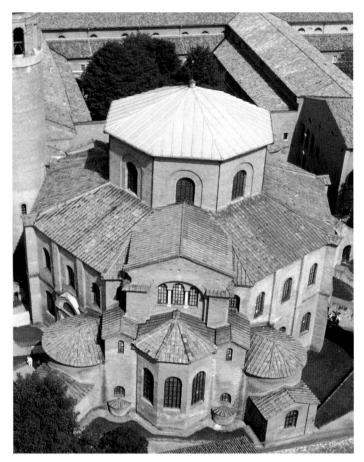

9-6 Aerial view of San Vitale (looking northwest), Ravenna, Italy, 526–547.

Justinian's general Belisarius captured Ravenna from the Ostrogoths. The city became the seat of Byzantine dominion in Italy. San Vitale honored Saint Vitalis, who was martyred at Ravenna.

then the Franks overtook it. During Justinian's reign, Ravenna enjoyed its greatest cultural and economic prosperity—at a time when repeated sieges, conquests, and sackings threatened the "eternal city" of Rome with extinction. As the seat of Byzantine dominion in Italy, Ravenna and its culture became an extension of Constantinople. Its art, even more than that of the Byzantine capital (where little other than architecture has survived), clearly reveals the transition from the Early Christian to the Byzantine style.

SAN VITALE San Vitale (FIGS. 9-6 and 9-7), dedicated by Bishop Maximianus in 547 in honor of Saint Vitalis, who was martyred at Ravenna in the second century, is the most spectacular building in Ravenna. The church is an unforgettable experience for all who have entered it and marveled at its intricate design and magnificent golden mosaics. Construction of San Vitale began under Bishop Ecclesius shortly after Theodoric's death in 526. Julianus Argentarius (Julian the Banker) provided the 26,000 gold coins (weighing more than 350 pounds) required to proceed with the work. The church is unlike any of the other sixth-century churches of Ravenna (FIG. 8-17). Indeed, it is unlike any other church in Italy. San Vitale is not a basilica. It is centrally planned, like Justinian's churches in Constantinople, and it seems, in fact, to have been loosely modeled on the earlier Church of Saints Sergius and Bacchus there.

The design features two concentric octagons. The dome-covered inner octagon rises above the surrounding octagon to provide the interior with clerestory lighting. The central space is defined by eight large piers that alternate with curved, columned exedrae that push

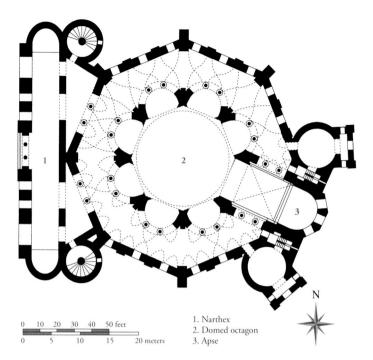

9-7 Plan of San Vitale, Ravenna, Italy, 526–547.

Centrally planned like Justinian's churches in Constantinople, San Vitale is unlike any other church in Italy. The design features two concentric octagons. A dome crowns the taller, inner octagon.

outward into the surrounding two-story ambulatory and create, on the plan, an intricate leafed design (FIG. 9-7). The exedrae closely integrate the inner and outer spaces that otherwise would have existed simply side by side as independent units. A cross-vaulted *choir* preceding the apse interrupts the ambulatory and gives the plan some axial stability. Weakening this effect, however, is the off-axis placement of the narthex, whose odd angle never has been explained fully. (The atrium, which no longer exists, may have paralleled a street that ran in the same direction as the angle of the narthex.)

San Vitale's intricate plan and elevation combine to produce an effect of great complexity. The exterior's octagonal regularity is not readily apparent inside (FIG. 9-8). A rich diversity of ever-changing perspectives greets visitors walking through the building. Arches looping over arches, curving and flattened spaces, and wall and vault shapes seem to change constantly with the viewer's position. Light filtered through alabaster-paned windows plays over the glittering mosaics and glowing marbles that cover the building's complex surfaces, producing a sumptuous effect.

The mosaics that decorate San Vitale's choir and apse (FIG. 9-9), like the building itself, must be regarded as among the most climactic achievements of Byzantine art. Completed less than a decade after the Ostrogoths surrendered Ravenna, the apse and choir decorations form a unified composition, whose theme is the holy ratification of Justinian's right to rule.

In the apse vault, Christ, youthful in the Early Christian tradition, holds a scroll with seven seals (Rev. 5:1) and sits on the orb of the world at the time of his Second Coming. The four rivers of Paradise flow beneath him, and rainbow-hued clouds float above. Christ extends the golden martyr's wreath to Vitalis, the patron saint of the church, whom an angel introduces. At Christ's left, another angel presents Bishop Ecclesius, in whose time the church foundations were laid. Ecclesius offers a model of San Vitale to Christ. The arrangement recalls Christ's prophecy of the last days of the world: "And then shall they see the Son

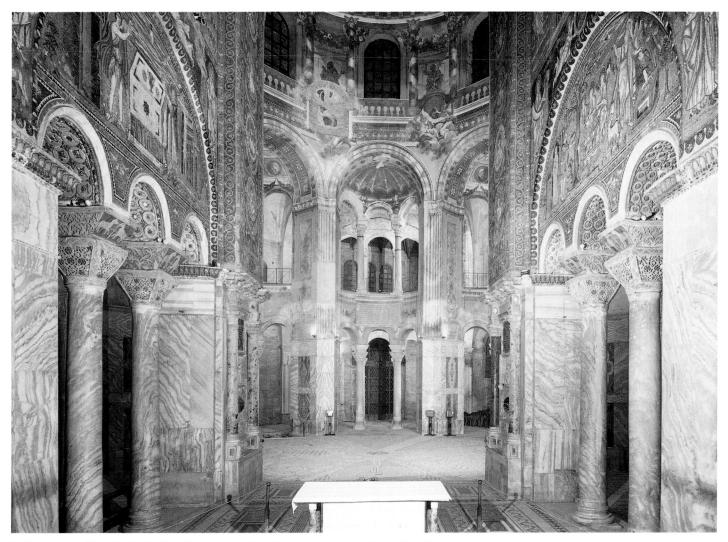

9-8 Interior of San Vitale (looking from the apse into the choir), Ravenna, Italy, 526-547.

Light filtered through alabaster-paned windows plays over the glittering mosaics and glowing marbles that cover San Vitale's complex wall and vault shapes, producing a sumptuous effect.

of Man coming in the clouds with great power and glory. And then shall he send his angels, and shall gather together his elect from the four winds, from the uttermost part of Heaven" (Mark 13:26–27).

Images and symbols covering the entire sanctuary express the single idea of Christ's redemption of humanity and the reenactment of it in the Eucharist. Below the apse mosaic (at the right in FIG. 9-8), for example, the lunette mosaic over the two columns of the choir depicts the story of Abraham and the three angels. Sarah, Abraham's wife, was 90 years old and childless when three angels visited Abraham. They announced that Sarah would bear a son, and she later miraculously gave birth to Isaac. Christians believe the Old Testament angels symbolized the Holy Trinity. Immediately to the right in the lunette is the sacrifice of Isaac, a prefiguration of Christ's Crucifixion (see "Jewish Subjects in Christian Art," Chapter 8, page 213).

JUSTINIAN AND THEODORA On the choir wall to the left of the apse mosaic appears Justinian (FIG. 9-10) and on the right wall is his empress, Theodora (FIG. 9-11). Justinian stands on the Savior's right side (FIG. 9-9). The two are united visually and symbolically by the imperial purple they wear and by their halos. A dozen attendants accompany Justinian, paralleling Christ's 12 apostles. Thus, the mosaic program underscores the dual political and religious roles of the Byzantine emperor. The laws of the Eastern Church and the laws of

the state, united in the laws of God, were manifest in the person of the emperor, whose right to rule was God-given.

The positions of the figures are all-important. They express the formulas of precedence and rank. Justinian is at the center, distinguished from the other dignitaries by his purple robe and halo. At his left (at right in the mosaic) is Bishop Maximianus, the man responsible for San Vitale's completion. The mosaicist stressed the bishop's importance by labeling his figure with the only identifying inscription in the composition. Some scholars have identified the figure behind and between Justinian and Maximianus as Julianus Argentarius, the church's benefactor. The artist divided the figures into three groups: the emperor and his staff; the clergy; and the imperial guard, bearing a shield with the *chi-rho-iota* (*\forall) monogram of Christ.

Each group has a leader whose feet precede (by one foot overlapping) the feet of those who follow. The positions of Justinian and Maximianus are curiously ambiguous. Although the emperor appears to be slightly behind the bishop, the golden *paten* (large shallow bowl or plate for the Eucharist bread) he carries overlaps the bishop's arm. Thus, symbolized by place and gesture, the imperial and churchly powers are in balance. Justinian's paten, Maximianus's cross, and the attendant clerics' book and censer produce a slow forward movement that strikingly modifies the scene's rigid formality. No background is indicated. The artist wished the observer to understand the procession

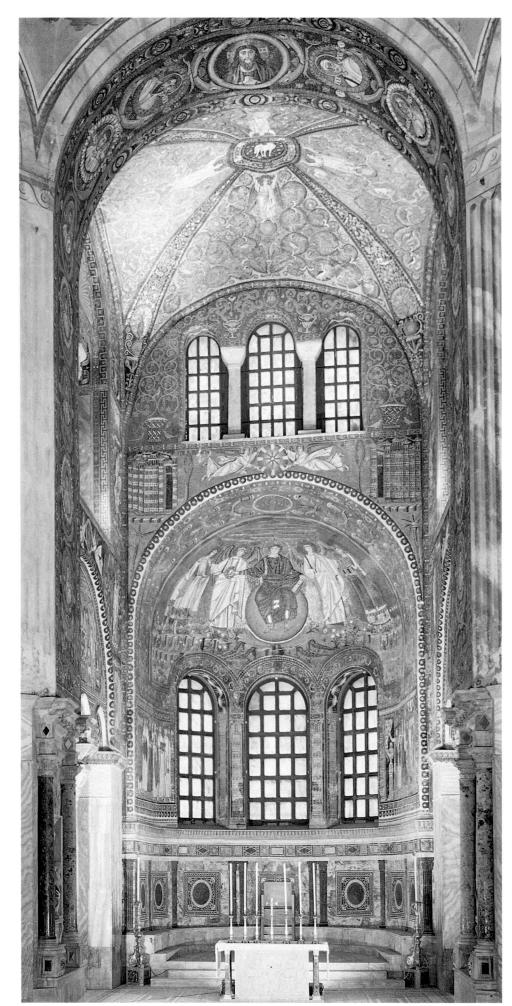

9-9 Choir and apse of San Vitale with mosaic of Christ between two angels, Saint Vitalis, and Bishop Ecclesius, Ravenna, Italy, 526–547.

In the apse vault, a youthful Christ, seated on the orb of the world at the time of his Second Coming, extends the golden martyr's wreath to Saint Vitalis. Bishop Ecclesius offers Christ a model of San Vitale.

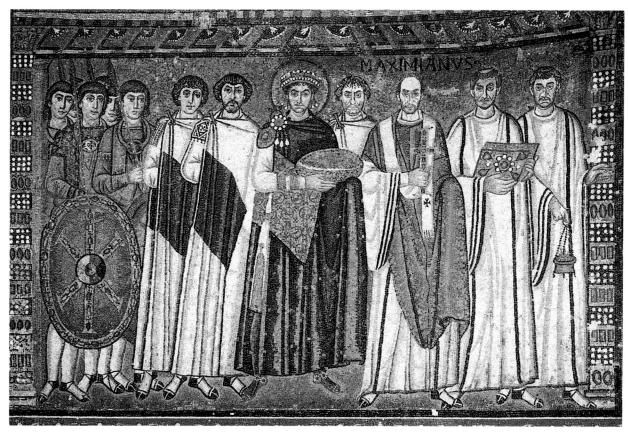

9-10 Justinian, Bishop Maximianus, and attendants, mosaic on the north wall of the apse, San Vitale, Ravenna, Italy, ca. 547. San Vitale's mosaics reveal the new Byzantine aesthetic. Justinian is foremost among the weightless and speechless frontal figures hovering before the viewer, their positions in space uncertain.

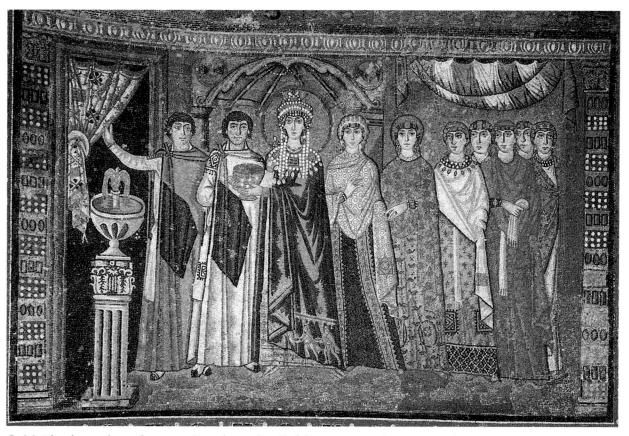

9-11 Theodora and attendants, mosaic on the south wall of the apse, San Vitale, Ravenna, Italy, ca. 547.

Justinian's counterpart on the opposite wall is the empress Theodora, a powerful figure at the Byzantine court. Neither she nor Justinian ever visited Ravenna. San Vitale's mosaics are proxies for the absent sovereigns.

Theodora, a Most Unusual Empress

Theodora (FIG. 9-11), wife of Justinian and empress of Byzantium, was not born into an aristocratic family. Her father, who died when she was a child, was the "keeper of bears" for one of the circus factions (teams distinguished by color) at Constantinople. His responsibility was to prepare these animals for bear fights, bear hunts, and acrobatic performances involving bears in a long tradition rooted in ancient Rome. Theodora's mother was an actress, and after the death of her father the young Theodora took up the same career. Acting was not a profession the highborn held in esteem. At Byzantium, actresses often doubled as prostitutes, and the beautiful Theodora was no exception. In fact, actresses were so low on the Byzantine social ladder that the law prohibited senators from marrying them.

Justinian met Theodora when he was about 40 years old, she only 25. She became his mistress, but before they could wed, as they did in 525, ignoring all the social norms of the day, Justinian's uncle, the emperor Justin, first had to rewrite the law against senatorial

marriages to actresses to permit wedlock with an ex-actress. When Justin died in April 527, the patriarch of Constantinople crowned Justinian emperor, and Theodora became empress of Byzantium, capping what can be fairly described as one of the most remarkable and improbable "success stories" of any age. By all accounts, even of those openly hostile to the imperial couple, Justinian and Theodora remained faithful to each other for the rest of their lives.

It was not Theodora's beauty alone that attracted Justinian. John the Lydian, a civil servant at Constantinople at the time, described her as "surpassing in intelligence all men who ever lived." As her husband's trusted adviser, she repaid him for elevating her from poverty and disgrace to riches and prestige. During the Nika revolt in Constantinople in 532, when all of her husband's ministers counseled flight from the city, Theodora, by the sheer force of her personality, persuaded Justinian and his generals to hold their ground. The revolt was suppressed.

as taking place in this very sanctuary. Thus, the emperor appears forever as a participant in the sacred rites and as the proprietor of this royal church and the ruler of the Western Empire.

The procession at San Vitale recalls but contrasts with that of Augustus and his entourage (FIG. 7-31) on the Ara Pacis, erected more than a half millennium earlier in Rome. There the fully modeled marble figures have their feet planted firmly on the ground. The Romans talk among themselves, unaware of the viewer's presence. All is anecdote, all very human and of this world, even if the figures themselves conform to a classical ideal of beauty that cannot be achieved in reality. The frontal figures of the Byzantine mosaic, by comparison, hover before viewers, weightless and speechless, their positions in space uncertain. Tall, spare, angular, and elegant, the figures have lost the rather squat proportions characteristic of much Early Christian work. The garments fall straight, stiff, and thin from the narrow shoulders. The organic body has dematerialized, and, except for the heads, some of which seem to be true portraits, viewers see a procession of solemn spirits gliding silently in the presence of the sacrament. Indeed, the theological basis for this approach to representation was the principle that the divine is invisible and that the purpose of religious art is to stimulate spiritual seeing. Theodulf of Orleans summed up this idea around 790, when he wrote "God is beheld not with the eyes of the flesh but only with the eye of the mind." 6 The mosaics of San Vitale reveal this new Byzantine aesthetic, one very different from that of the classical world but equally compelling. Blue sky has given way to heavenly gold, and matter and material values are disparaged. Byzantine art is an art without solid bodies or cast shadows, with blank golden spaces, and with the perspective of Paradise, which is nowhere and everywhere.

Justinian's counterpart on the opposite wall of the apse is Theodora (FIG. 9-11), one of the most remarkable women of the Middle Ages (see "Theodora, a Most Unusual Empress," above). The empress too is accompanied by her retinue. Both processions move into the apse, Justinian proceeding from left to right and Theodora from right to left, in order to take part in the Eucharist. Justinian carries the paten containing the bread, and Theodora the golden cup

with the wine. The portraits in the Theodora mosaic exhibit the same stylistic traits as those in the Justinian mosaic, but the women are represented within a definite architecture, perhaps the atrium of San Vitale. The empress stands in state beneath an imperial canopy, waiting to follow the emperor's procession. An attendant beckons her to pass through the curtained doorway. The fact that she is outside the sanctuary in a courtyard with a fountain and only about to enter attests that, in the ceremonial protocol, her rank was not quite equal to her consort's. But the very presence of Theodora at San Vitale is significant. Neither she nor Justinian ever visited Ravenna. Their participation in the liturgy at San Vitale is pictorial fiction. The mosaics are proxies for the absent sovereigns. Justinian was represented because he was the head of the Byzantine state, and by his presence he exerted his authority over his territories in Italy. But Theodora's portrayal is more surprising and testifies to her unique position in Justinian's court. Theodora's prominent role in the mosaic program of San Vitale is proof of the power she wielded at Constantinople and, by extension, at Ravenna. In fact, the representation of the three magi on the border of her robe suggests that she belongs in the elevated company of the three monarchs who approached the newborn Jesus bearing gifts.

SANT'APOLLINARE IN CLASSE Until the ninth century, Sant'Apollinare in Classe housed the body of Saint Apollinaris, who suffered his martyrdom in Classe, Ravenna's port. The church itself is Early Christian in type, a basilica with a nave and flanking aisles, like Theodoric's palace-church (FIG. 8-17) dedicated to the same saint in Ravenna. As in the earlier church, the Justinianic building's exterior is plain and unadorned, but sumptuous mosaics decorate the interior, although in this case they are confined to the apse (FIG. 9-12).

The mosaic decorating the semidome above the apse probably was completed by 549, when the church was dedicated. (The mosaics of the framing arch are of later date.) Against a gold ground, a large medallion with a jeweled cross dominates the composition. This may represent the cross Constantine erected on the hill of Calvary to commemorate the martyrdom of Jesus. Visible just above the

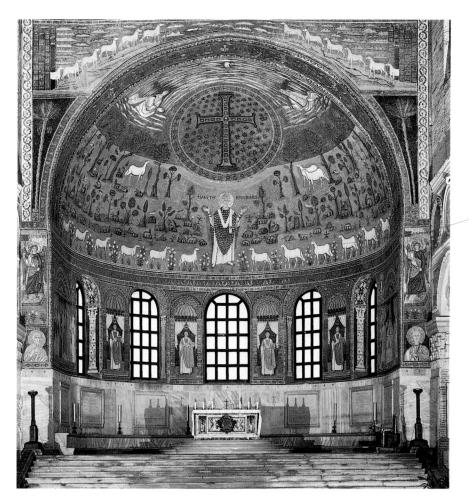

9-12 Saint Apollinaris amid sheep, apse mosaic, Sant'Apollinare in Classe, Ravenna, Italy, ca. 533–549.

Saint Apollinaris stands beneath Christ's Cross with his arms raised in prayer. Although the scene is set in a landscape, the Byzantine artist rejected the classical illusionism of early mosaics (compare FIG. 8-16).

cross is the hand of God. On either side of the medallion, in the clouds, are the Old Testament prophets Moses and Elijah, who appeared before Jesus during his Transfiguration. Below these two figures are three sheep, symbols of the disciples John, Peter, and Paul, who accompanied Jesus to the foot of the mountain he ascended in order to converse with the prophets. Beneath, amid green fields with trees, flowers, and birds, stands the church's patron saint, Apollinaris. The mosaicist portrayed him in the Early Christian manner as an orant with uplifted arms. Accompanying Apollinaris are 12 sheep, perhaps representing the Christian congregation under the saint's protection, and forming, as they march in regular file across the apse, a wonderfully decorative base.

Comparison of the Early Byzantine Sant'Apollinare in Classe mosaic with the Galla Placidia mosaic (FIG. 8-16) from the Early Christian period at Ravenna shows how the style and artists' approach to the subject changed during the course of a century. Both mosaics portray a human figure and some sheep in a landscape. But in Classe, in the mid-sixth century, the artist did not try to re-create a segment of the physical world, instead telling the story in terms of flat symbols, lined up side by side. The mosaicist carefully avoided overlapping in what must have been an intentional effort to omit all reference to the three-dimensional space of the material world and physical reality. Shapes have lost the volume seen in the earlier mosaic and instead are flat silhouettes with linear details. The effect is that of an extremely rich, flat tapestry without illusionistic devices. This new Byzantine style became the ideal vehicle for conveying the extremely complex symbolism of the fully developed Christian dogma.

The Sant'Apollinare in Classe apse mosaic, for example, carries much more meaning than first meets the eye. The cross symbolizes not only Christ's own death, with its redeeming consequences, but

also the death of his martyrs (in this case, Saint Apollinaris). The lamb, also a symbol of martyrdom, appropriately represents the martyred apostles. The whole scene expands above the altar, where the priests celebrated the sacrament of the Eucharist—the miraculous recurrence of the supreme redemptive act. The very altars of Christian churches were, from early times, sanctified by the bones and relics of martyrs (see "Pilgrimages and the Cult of Relics," Chapter 12, page 310). Thus,

the mystery and the martyrdom were joined in one concept. The death of the martyr, in imitation of Christ, is a triumph over death that leads to eternal life. The images above the altar present an inspiring vision to the eyes of believers, delivered with overwhelming force. Looming above their eyes is the apparition of a great mystery, ordered to make perfectly simple and clear that humankind's duty is to seek salvation. Even the illiterate, who might not grasp the details of the complex theological program, could understand that the way of the martyr is open to the Christian faithful and that the reward of eternal life is within their reach.

MOUNT SINAI During Justinian's reign, building continued almost incessantly, not only in Constantinople and Ravenna but all over the Byzantine Empire. At about the time mosaicists in Ravenna were completing their work at San Vitale and Sant'Apollinare in Classe, Justinian's builders were reconstructing an important early *monastery* (an enclosed compound for monks) at Mount Sinai in Egypt where Moses received the Ten Commandments from God. Now called Saint Catherine's, the monastery marked the spot at the foot of the mountain where the Bible says God first spoke to the Hebrew prophet from a burning bush.

Monasticism began in Egypt in the third century and spread rapidly to Palestine and Syria in the East and as far as Ireland in the West. It began as a migration to the wilderness by those who sought a more spiritual way of life, far from the burdens, distractions, and temptations of town and city. In desert locations, these refuge seekers lived austerely as hermits, in contemplative isolation, cultivating the soul's perfection. So many thousands fled the cities that the authorities became alarmed—noting the effect on the tax base, military recruitment, and business in general.

9-13 Transfiguration of Jesus, apse mosaic, Church of the Virgin, monastery of Saint Catherine, Mount Sinai, Egypt, ca. 548-565.

Unlike the Sant'Apollinare mosaicist, this Mount Sinai artist swept away all traces of landscape for a depthless field of gold. The prophets and disciples cast no shadows even though bathed in divine light.

The origins of the monastic movement are associated with Saint Anthony and Saint Pachomius in Egypt in the fourth century. By the fifth century, regulations governing monastic life began to be codified. Individual monks came together to live according to a rule within a common enclosure, a community under the direction of an abbot (see "Medieval Monasteries and Benedictine Rule," Chapter 11, page 298). The monks typically lived in a walled monastery, an architectural complex that included the monks' residence (an alignment of single cells), an *oratory* (monastic church), a *refectory* (dining hall), a kitchen, storage and service quarters, and a guest house for pilgrims (FIG. 11-19).

Justinian rebuilt the monastery at Mount Sinai between 548 and 565 and erected imposing walls around it. The site had been an important pilgrimage destination since the fourth century, and Justinian's fortress was intended to protect not only the hermit-monks but also the lay pilgrims during their visits. The Mount Sinai church was dedicated to the Virgin Mary, whom the Orthodox Church had officially recognized in the mid-fifth century as the Mother of God (*Theotokos*), putting to rest a controversy about the divine nature of Christ. The church's apse mosaic (FIG. 9-13) depicts the Transfiguration. (Other mosaics in the church depict Moses receiving the Law and standing before the burning bush.) Jesus appears in a deep-blue almond-shaped mandorla (almond-shaped aureole of light). At his feet are John, Peter, and James. At the left and right are Elijah and Moses. Portrait busts of saints and prophets in medallions frame the whole scene. The artist stressed the intense whiteness of Jesus' transfigured, spiritualized form, from which rays stream down on the disciples. The stately figures of the prophets and the static frontality of Jesus set off the frantic terror and astonishment of the gesticulating disciples. These characteristics effectively contrast the eternal composure of heavenly beings with the distraught responses of the earthbound.

In this apse the mosaicist swept away all traces of landscape and architectural setting for a depthless field of gold, fixing the figures and their labels in isolation from one another. A rainbow band of colors graduating from yellow to blue bounds the golden field at its base. The figures are ambiguously related to this multicolor ground line. Sometimes they are placed behind it. Sometimes they overlap it. The bodies cast no shadows, even though supernatural light streams over them. This is a world of mystical vision, where the artist subtracted all substance that might suggest the passage of time or motion through physical space. In the absence of such physicality, the devout can contemplate the eternal and motionless world of religious truth.

Ivory Carving and Painting

As in the Early Christian period, ivory carving and manuscript painting were important art forms during the Early Byzantine era. Most of the finest examples date to the sixth century. They feature both secular and religious subjects.

BARBERINI IVORY Carved in five parts (one is lost), the ivory plaque known today as the *Barberini Ivory* (FIG. 9-14)—it was once part of the 17th-century collection of Cardinal Barberini in Rome—shows at the center an emperor, usually identified as Justinian, riding triumphantly on a rearing horse, while a startled, half-

The Emperors of New Rome

yzantine art is generally, and properly, considered to belong to the Middle Ages rather than to the ancient world, but the emperors of Byzantium, New Rome, considered themselves the direct successors of the emperors of Old Rome. Although the official state religion was Christianity and all pagan cults were suppressed, the political imagery of Byzantine art displays a striking continuity between ancient Rome and medieval Byzantium. Artists continued to portray emperors sitting on thrones holding the orb of the earth in their hands, battling foes while riding on mighty horses, and receiving tribute from defeated enemies. In the Early Byzantine period, official portraits continued to be set up in great numbers throughout the terri9-14 Justinian as world conqueror (*Barberini Ivory*), mid-sixth century. Ivory, 1' $1\frac{1}{2}$ " \times $10\frac{1}{2}$ ". Louvre, Paris.

Classical style and motifs lived on in Byzantine art in ivories such as this one, where Justinian rides a rearing horse accompanied by personifications of Victory and Earth. Above, Christ blesses the emperor.

tories Byzantium controlled. But, as was true of the classical world, much of imperial Byzantine statuary is forever lost. Nonetheless, some of the lost portraits of the Byzantine emperors can be visualized from miniature versions of them on ivory reliefs such as the *Barberini Ivory* (FIG. 9-14) and from descriptions in surviving texts.

One especially impressive portrait in the Roman imperial tradition, melted down long ago, depicted the emperor Justinian on horseback atop a grandiose column. Cast in glittering bronze, like the equestrian statue of Marcus Aurelius (FIG. 7-59) set up nearly 400 years earlier, it attested to the continuity between the art of New Rome and Old Rome, where pompous imperial images were commonly displayed at the apex of freestanding columns. (Compare FIG. 7-44 where a statue of Saint Peter has replaced a lost statue of the emperor Trajan.) Procopius, Justinian's official historian, described the equestrian portrait:

Finest bronze, cast into panels and wreaths, encompasses the stones [of the column] on all sides, both binding them securely together and covering them with adornment. . . . This bronze is in color softer than pure gold, while in value it does not fall much short of an equal weight of silver. At the summit of the column stands a huge bronze horse turned towards the east, a most noteworthy sight. . . . Upon this horse is mounted a bronze image of the Emperor like a colossus. . . . He wears a cuirass in heroic fashion and his head is covered with a helmet . . . and a kind of radiance flashes forth from there. . . . He gazes towards the rising sun, steering his course, I suppose, against the Persians. In his left hand he holds a globe, by which

the sculptor has signified that the whole earth and sea were subject to him, yet he carries neither sword nor spear nor any other weapon, but a cross surmounts his globe, by virtue of which alone he has won the kingship and victory in war. Stretching forth his right hand towards the regions of the East and spreading out his fingers, he commands the barbarians that dwell there to remain at home and not to advance any further.*

Statues such as this are the missing links in an imperial tradition that never really died and that lived on also in the Holy Roman Empire (FIG. 11-12) and in Renaissance Italy (FIGS. 16-15 and 16-16).

*Cyril Mango, trans., *The Art of the Byzantine Empire, 312–1453: Sources and Documents* (reprint of 1972 ed., Toronto: Toronto University Press, 1986), 110–111.

hidden barbarian recoils in fear behind him. The dynamic twisting postures of both horse and rider and the motif of the equestrian emperor thrusting his spears are survivals of the pagan Roman Empire (see "The Emperors of New Rome," above), as are the personifications of bountiful Earth (below the horse) and palm-bearing Victory (flying in to crown the conqueror). Also borrowed from pagan art are the barbarians at the bottom of the plaque bearing tribute and seeking clemency. They are juxtaposed with a lion, an elephant, and

a tiger—exotic animals native to Africa and Asia, sites of Justinian's conquests. At the left, a Roman soldier carries a statuette of another Victory, reinforcing the central panel's message. The source of the emperor's strength, however, comes not from his earthly armies but from God. The uppermost panel depicts two angels holding aloft a youthful image of Christ carrying a cross in his left hand. Christ blesses Justinian with a gesture of his right hand, indicating approval of the emperor's rule.

ARCHANGEL MICHAEL IVORY Another ivory panel (FIG. **9-15**), created somewhat earlier than the *Barberini Ivory* and likewise carved in the Eastern Christian Empire, perhaps in Constantinople, offers further evidence of the persistence of classical art. The panel, the largest extant Byzantine ivory, is all that is preserved from a hinged diptych in the Early Christian tradition. It depicts Saint Michael the Archangel, patron of the imperial church of Hagia Sophia. The inscription opens with the words "Receive these gifts." The dedication is perhaps a reference to the cross-surmounted orb of power the archangel once offered to a Byzantine emperor depicted on the missing diptych leaf. The prototype of Michael must have been a pagan winged Victory, although Victory was personified as a woman in Greco-Roman art and usually carried a palm branch, as does the Victory on the *Barberini Ivory*. The Christian artist here ingeniously adapted a pagan motif and imbued it with new meaning.

The archangel's flowing drapery, which reveals the body's shape, the delicately incised wings, and the facial type and coiffure are other indications that the artist who carved this ivory was still working in the tradition of classical art. Nonetheless, the Byzantine ivory carver had little concern for the rules of naturalistic representation. The archangel dwarfs the architectural setting. Michael's feet, for example, rest on three steps at once, and his upper body, wings, and arms are in front of the column shafts while his lower body is behind the column bases at the top of the receding staircase. These spatial ambiguities, of course, do not detract from the figure's striking beauty, but they do signify the emergence of the same new aesthetic already noted in the mosaics of Ravenna. Here, as there, the Byzantine artist rejected the goal of most classical artists: to render the three-dimensional world in convincing and consistent fashion and to people that world with fully modeled figures firmly rooted on the ground. Michael seems more to float in front of the architecture than to stand in it.

VIENNA DIOSKORIDES The physical world was the focus, however, of one of the rare secular books to survive from the early Middle Ages, either in Byzantium or the West. In the mid-first century, a Greek physician named Dioskorides compiled an encyclopedia of medicinal herbs called De materia medica. An early-sixthcentury copy of this manual, nearly a thousand pages in length, is in the Austrian National Library. The Vienna Dioskorides, as it is called, was a gift from the people of Honoratai, near Constantinople, to Anicia Juliana, daughter of the short-lived Emperor of the West, Anicias Olybrias (r. 472). Anicia Juliana was a leading patron of the arts and had built a church dedicated to the Virgin Mary at Honoratai in 512. She also provided the funds to erect Saint Polyeuktos in Constantinople between 524 and 527. The excavated ruins of that church indicate that it was a domed basilica—an important forerunner of the pioneering design of Justinian's Hagia Sophia.

The Vienna Dioskorides contains 498 illustrations, almost all images of plants rendered with a scientific fidelity to nature that stands in stark contrast to contemporary Byzantine paintings and mosaics of religious subjects. It is likely that the Vienna Dioskorides

9-15 Saint Michael the Archangel, right leaf of a diptych, early sixth century. Ivory, 1' $5'' \times 5\frac{1}{2}''$. British Museum, London.

The sculptor who carved this largest extant Byzantine ivory panel modeled Saint Michael on a classical winged Victory, but the archangel seems to float in front of the architecture rather than stand in it.

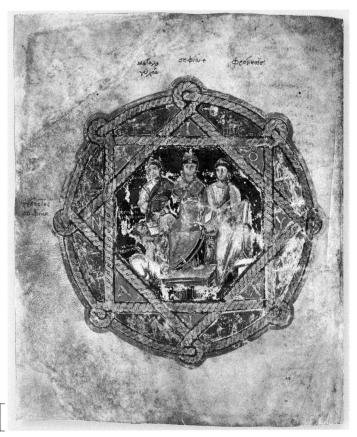

9-16 Anicia Juliana between Magnanimity and Prudence, folio 6 verso of the *Vienna Dioskorides*, from Honoratai, near Constantinople (Istanbul), Turkey, ca. 512. Tempera on parchment, $1'\ 3'' \times 1'\ 11''$. Österreichische Nationalbibliothek, Vienna.

In gratitude for her generosity, the people of Honoratai presented Anicia Juliana, a great art patron, with a book in which she appears enthroned with personifications of Magnanimity and Prudence.

painters copied the illustrations as well as the text of a classical manuscript. One page, however, cannot be a copy—the dedication page (FIG. 9-16) featuring a portrait of Anicia Juliana in an eight-pointed star and circle frame. This earliest known illustrated dedication page shows Anicia Juliana enthroned between personifications of Magnanimity and Prudence, with a kneeling figure labeled Gratitude of the Arts at her feet. The shading and modeling of the figures, the heads posed at oblique angles, the perspectival rendering of the throne's footstool, and the use of personifications establish that the painter still worked in the classical tradition that most other Byzantine artists by then had rejected.

RABBULA GOSPELS One of the essential Christian beliefs is that following his Crucifixion and entombment, Christ rose from the dead after three days and, on the 40th day, ascended from the Mount of Olives to Heaven. The Ascension is the subject of a full-page painting (FIG. 9-17) in a manuscript known as the Rabbula Gospels. Written in Syriac by the monk Rabbula at the monastery of Saint John the Evangelist at Zagba, Syria, it dates to the year 586. The composition shows Christ, bearded and surrounded by a mandorla, as in the Mount Sinai Transfiguration (FIG. 9-13), but the mandorla is here borne aloft by angels. Below, Mary, other angels, and various apostles look on. The artist set the figures into a mosaic-like frame

(compare FIGS. 9-10 and 9-11), and many art historians think the model for the manuscript page was a mural painting or mosaic in a Byzantine church somewhere in the Eastern Empire.

The account of Christ's Ascension is not part of the accompanying text of the Rabbula Gospels but is borrowed from the biblical book of Acts. And even Acts omits mention of the Virgin's presence at the miraculous event. Here, however, the Theotokos occupies a very prominent position, central and directly beneath Christ. It is an early example of the important role the Mother of God played in later medieval art, in both the East and the West. Frontal, with a nimbus, and posed as an orant, Mary stands apart from the commotion all about her and looks out at the viewer. Other details also depart from the Gospel texts. Christ, for example, does not rise in a cloud. Rather, as in the vision of Ezekiel in the book of Revelation, he ascends in a mandorla above a fiery winged chariot. The chariot carries the symbols of the Four Evangelists—the man, lion, ox, and eagle (see "The Four Evangelists," Chapter 11, page 290). This page therefore does not illustrate the Gospels but presents one of the central tenets of Christian faith. Similar compositions appear on pilgrims' flasks from Palestine that were souvenir items reproducing important monuments visited. They reinforce the theory that the Ascension page of the Rabbula Gospels was based on a lost painting or mosaic in a major church.

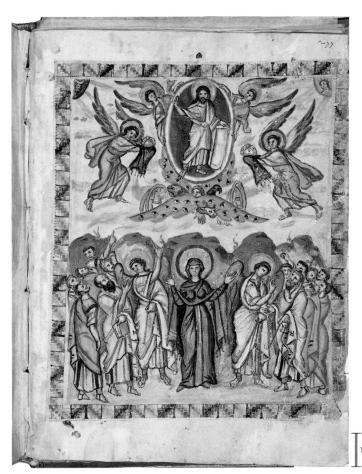

9-17 *Ascension of Christ*, folio 13 verso of the *Rabbula Gospels*, from Zagba, Syria, 586. Tempera on parchment, $1'1'' \times 10\frac{1}{2}''$. Biblioteca Medicea-Laurenziana, Florence.

The Gospels do not mention the Virgin Mary as a witness of Christ's Ascension. Her prominent position in the *Rabbula Gospels* is an early example of the important role Mary played in later medieval art.

Icons and Iconoclasm

pyzantine *icons* ("images" in Greek) are small portable paintings depicting Christ, the Virgin, or saints (or a combination of all three, as in FIG. 9-18). Icons survive from as early as the fourth century. From the sixth century on, they became enormously popular in Byzantine worship, both public and private. Eastern Christians considered icons a personal, intimate, and indispensable medium for spiritual transaction with holy figures. Some icons (for example, FIG. 9-29) came to be regarded as wonder-working, and believers ascribed miracles and healing powers to them.

Icons were by no means universally accepted, however. From the beginning, many Christians were deeply suspicious of the practice of imaging the divine, whether on portable panels, on the walls of churches, or especially as statues that reminded them of pagan idols. The opponents of Christian figural art had in mind the Old Testament prohibition of images the Lord dictated to Moses in the Second Commandment: "Thou shalt not make unto thee any graven image or any likeness of anything that is in heaven above, or that is in the earth beneath, or that is in the water under the earth. Thou shalt not bow down thyself to them, nor serve them" (Exod. 20:4, 5). For example, early in the fourth century, Constantia, sister of the emperor Constantine, requested an image of Christ from Eusebius, the first great historian of the Christian Church. He rebuked her, referring to the Second Commandment:

Can it be that you have forgotten that passage in which God lays down the law that no likeness should be made of what is in heaven or in the earth beneath?... Are not such things banished and excluded from churches all over the world, and is it not common knowledge that such practices are not permitted to us...lest we appear, like idol worshipers, to carry our God around in an image?*

Opposition to icons became especially strong in the eighth century, when the faithful often burned incense and knelt before them in prayer to seek protection or a cure for illness. Although icons were intended only to evoke the presence of the holy figures addressed in prayer, in the minds of many people, icons became identified with the personages represented. Icon veneration became confused with idol worship, and this brought about an imperial ban on the making of icons, followed by the wholesale wreckage of sacred images (*iconoclasm*). The *iconoclasts* (breakers of images) and the *iconophiles* (lovers of images) became bitter and irreconcilable enemies. The anguish of the latter can be gleaned from a graphic description of the deeds of the iconoclasts, written in about 754:

In every village and town one could witness the weeping and lamentation of the pious, whereas, on the part of the impious, [one saw] sacred things trodden upon, [liturgical] vessels turned to other use, churches scraped down and smeared with ashes because they contained holy images. And wherever there were venerable images of Christ or the Mother of God or the saints, these were consigned to the flames or were gouged out or smeared over.

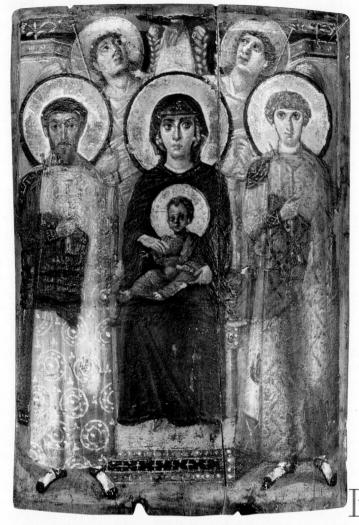

9-18 Virgin (Theotokos) and Child between Saints Theodore and George, icon, sixth or early seventh century. Encaustic on wood, $2' 3'' \times 1' 7\frac{3}{8}''$. Monastery of Saint Catherine, Mount Sinai, Egypt.

Byzantine icons continued the Roman tradition of painting on wood panels (FIGS. 7-62 and 7-63), but their style as well as the Christian subjects broke sharply from classical models.

The consequences of iconoclasm for the history of Byzantine art are difficult to overstate. For more than a century, not only did the portrayal of Christ, the Virgin, and the saints cease, but the iconoclasts also destroyed countless works from the early centuries of Christendom. Assembling a complete history of Early Byzantine art presents a great challenge to art historians.

^{*} Cyril Mango, trans., The Art of the Byzantine Empire, 312–1453: Sources and Documents (reprint of 1972 ed., Toronto: University of Toronto Press, 1986), 17–18.

[†] Ibid., 152.

ICONS Gospel books such as the Rabbula Gospels played an important role in monastic religious life. So, too, did icons, which also figured prominently in private devotion (see "Icons and Iconoclasm," page 326). Unfortunately, few early icons survive. Some of the finest early examples come from Saint Catherine's monastery at Mount Sinai. The one illustrated here (FIG. 9-18) was painted in encaustic on wood, continuing a tradition of panel painting in Egypt that, as true of so much else in the Byzantine world, has roots in the Roman Empire (FIGS. 7-62 and 7-63). In a composition reminiscent of the portrait of Anicia Juliana (FIG. 9-16) in the Vienna Dioskorides, the Sinai icon painter represented the enthroned Theotokos and Child with Saints Theodore and George. The two guardian saints intercede with the Virgin on the viewer's behalf. Behind them, two angels gaze upward to a shaft of light where the hand of God appears. The foreground figures are strictly frontal and have a solemn demeanor. Background details are few and suppressed. The forward plane of the picture dominates. Space is squeezed out. Traces of the Greco-Roman illusionism noted in the Anicia Juliana portrait remain in the Virgin's rather personalized features, in her sideways glance, and in the posing of the angels' heads. But the painter rendered the saints' bodies in the new Byzantine manner.

ICONOCLASM The preservation of the Early Byzantine icons at the Mount Sinai monastery is fortuitous but ironic, for opposition to icon worship was especially prominent in the Monophysite provinces of Syria and Egypt. There, in the seventh century, a series of calamities erupted, indirectly causing the imperial ban on images. The Sasanians (see Chapter 2), chronically at war with Rome, swept into the eastern provinces early in the seventh century. Between 611 and 617, they captured the great cities of Antioch, Jerusalem, and Alexandria. The Byzantine emperor Heraclius (r. 610-641) had barely defeated them in 627 when a new and overwhelming power appeared unexpectedly on the stage of history. The Arabs, under the banner of the new Islamic religion, conquered not only Byzantium's eastern provinces but also Persia itself, replacing the Sasanians in the age-old balance of power with the Christian West (see Chapter 10). In a few years the Arabs were launching attacks on Constantinople, and Byzantium was fighting for its life.

These were catastrophic years for the Eastern Roman Empire. They terminated once and for all the long story of imperial Rome, closed the Early Byzantine period, and inaugurated the medieval era of Byzantine history. Almost two-thirds of the Byzantine Empire's territory was lost-many cities and much of its population, wealth, and material resources. The shock of these events may have persuaded the emperor Leo III (r. 717–741) that God was punishing the Christian Roman Empire for its idolatrous worship of icons by setting upon it the merciless armies of the infidel—an enemy that, moreover, shunned the representation not only of God but of all living things in holy places (see Chapter 10). Some scholars believe that another motivation for Leo's 726 ban on picturing the divine was to assert the authority of the state over the Church. In any case, for more than a century, Byzantine artists produced little new religious figurative art. In place of images of holy figures, the iconoclasts used symbolic forms already familiar in Early Christian art, for example, the Cross (FIG. 9-12).

MIDDLE BYZANTINE ART

In the ninth century, a powerful reaction against iconoclasm set in. The destruction of images was condemned as a heresy, and restoration of the images began in 843. Shortly thereafter, under a new line of emperors, art, literature, and learning sprang to life once again. In

this great "renovation," as historians have called it, Byzantine culture returned to its ancient Hellenistic sources and accommodated them to the forms inherited from the Justinianic age. Basil I (r. 867–886), head of the new Macedonian dynasty, regarded himself as the restorer of the Roman Empire. He denounced as usurpers the Carolingian monarchs of the West (see Chapter 11) who, since 800, had claimed the title "Roman Empire" for their realm. Basil bluntly reminded their emissary that the only true emperor of Rome reigned in Constantinople. The Carolingians were not Roman emperors but merely "kings of the Germans." Iconoclasm had forced Byzantine artists westward, where doubtless they found employment at the courts of these Germanic kings (see "Theophanu, a Byzantine Princess in Ottonian Germany," Chapter 11, page 306). They strongly influenced the character of Western European art.

Architecture and Mosaics

The triumph of the iconophiles over the iconoclasts meant that Byzantine mural painters, mosaicists, book illuminators, ivory carvers, and metalworkers once again received plentiful commissions. Basil I and his successors also undertook the laborious and costly task of refurbishing the churches the iconoclasts had defaced and neglected.

THEOTOKOS, HAGIA SOPHIA In 867, the Macedonian dynasty dedicated a new mosaic (FIG. 9-19) depicting the enthroned Virgin with the Christ Child in her lap in the apse of the Justinianic church of Hagia Sophia. In the vast space beneath the dome

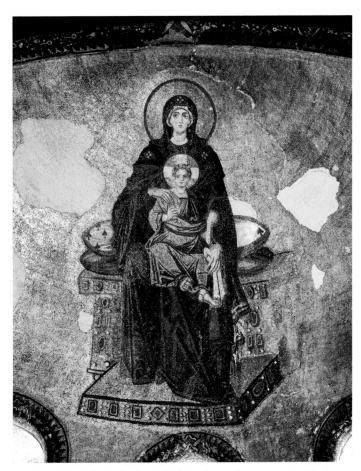

9-19 Virgin (Theotokos) and Child enthroned, apse mosaic, Hagia Sophia, Constantinople (Istanbul), Turkey, dedicated 867.

Shortly after the repeal of iconoclasm, the emperor Basil I dedicated a huge new mosaic in the apse of Hagia Sophia depicting the Virgin and Child enthroned. It replaced one the iconoclasts had destroyed.

9-20 Katholikon, Hosios Loukas, Greece, first quarter of 11th century.

Middle Byzantine churches typically are small and high shouldered, with a central dome on a drum and exterior wall surfaces with decorative patterns, probably reflecting Islamic architecture.

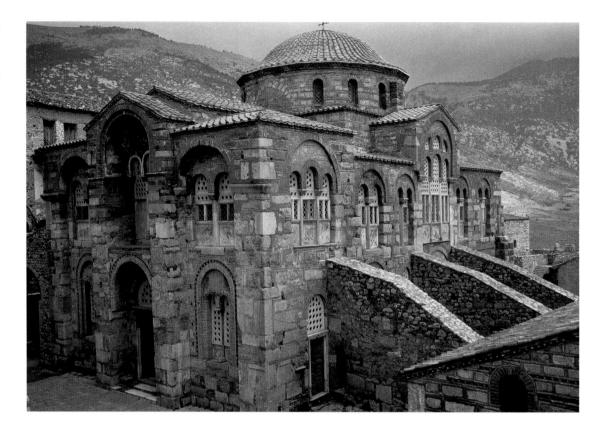

9-21 Plan of the Church of the Theotokos (top) and the Katholikon (bottom), Hosios Loukas, Greece, second half of 10th and first quarter of 11th centuries. (1) Dome on pendentives, (2) dome on squinches.

The plans of the pair of monastic churches at Hosios Loukas in Greece take the form of a domed square at the center of a cross with four equallength vaulted arms (the Greek cross).

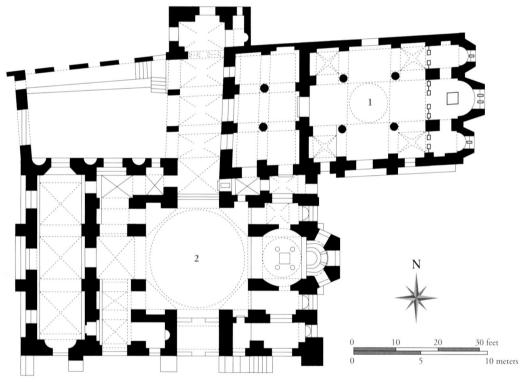

of the great church, the figures look undersized, but the seated Theotokos is more than 16 feet tall. An accompanying inscription, now fragmentary, announced that "pious emperors" (the Macedonians) had commissioned the mosaic to replace one the "impostors" (the iconoclasts) had destroyed.

The original mosaic's subject is uncertain, but the ninth-century work echoes the style and composition of the Early Byzantine icon (FIG. 9-18) at Mount Sinai of the Theotokos, Christ, and saints. In the mosaic, however, the angular placement of the throne and footstool

alleviate the strict frontality of Mother and (much older) Child. The mosaicist rendered the furnishings in a perspective that, although imperfect, recalls once more the Greco-Roman roots of Byzantine art. The treatment of the folds of Christ's robes is, by comparison, even more schematic and flatter than in earlier mosaics. These seemingly contradictory stylistic features are not uncommon in Byzantine paintings and mosaics. Most significant about the images in the Hagia Sophia apse is their very existence, marking the end of iconoclasm in the Byzantine Empire.

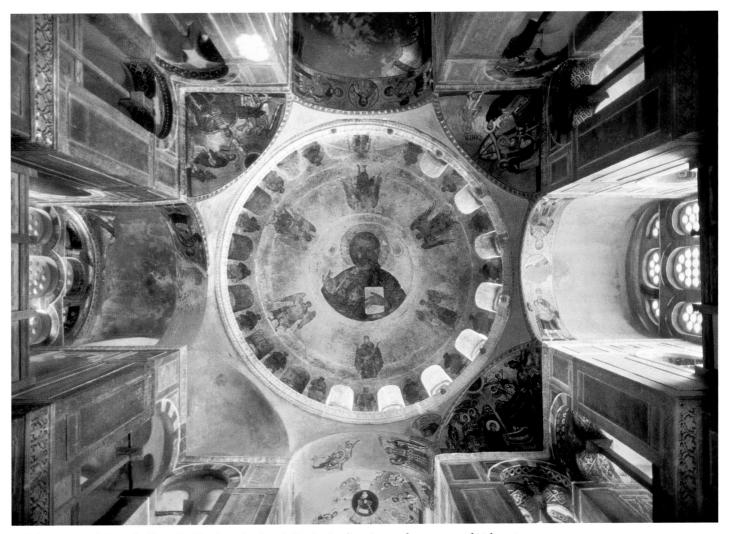

9-22 Interior of the Katholikon (looking into the dome), Hosios Loukas, Greece, first quarter of 11th century.

The dome of the Katholikon rests on an octagon formed by squinches, which play the same role as pendentives in making the transition from a square base to a round dome but create a different visual effect.

HOSIOS LOUKAS Although the new emperors did not wait long to redecorate the churches of their predecessors, they undertook little new church construction in the decades following the renunciation of iconoclasm in 843. But in the 10th century and through the 12th, a number of monastic churches arose that are the flowers of Middle Byzantine architecture. They feature a brilliant series of variations on the domed central plan. From the exterior, the typical Middle Byzantine church building is a domed cube, with the dome rising above the square on a kind of cylinder or *drum*. The churches are small, vertical, high shouldered, and, unlike earlier Byzantine buildings, have exterior wall surfaces decorated with vivid patterns, probably reflecting Islamic architecture.

The Katholikon (FIGS. 9-20 and 9-21, bottom) at Hosios Loukas (Saint Luke) in Greece, near ancient Delphi, dates to the early 11th century. One of two churches at the site—the other is the Church of the Theotokos (FIG. 9-21, top) built during the second half of the 10th century—the Katholikon exemplifies church design during this second golden age of Byzantine art and architecture. Light stones framed by dark red bricks—the so-called cloisonné technique, a term borrowed from enamel work (FIG. 11-3)—make up the walls. The interplay of arcuated windows, projecting apses, and varying roof lines further enhances this surface dynamism. The plans of both Hosios Loukas churches (FIG. 9-21) show the form of a domed cross in square with four equal-length, vaulted cross arms

(the *Greek cross*). The dome of the smaller Church of the Theotokos rests on pendentives. In the case of the larger and later Katholikon, the architect placed the dome (FIG. 9-22) over an octagon inscribed within a square. Forming the octagon are squinches (FIG. 9-5, *right*), which play the same role as pendentives in making the transition from a square base to a round dome but create a different visual effect on the interior. This arrangement departs from the older designs, such as Santa Costanza's circular plan (FIG. 8-12), San Vitale's octagonal plan (FIG. 9-7), and Hagia Sophia's dome on pendentives rising from a square (FIG. 9-3). The Katholikon's complex core lies within two rectangles. The outer one forms the exterior walls. Thus, in plan from the center out, a circle-octagon-square-oblong series exhibits an intricate interrelationship that is at once complex and unified.

The interior elevation of the Katholikon reflects its involved plan. Like earlier Byzantine buildings, the church creates a mystery out of space, surface, light, and dark. High and narrow, it forces the viewer's gaze to rise and revolve. The eye is drawn upward toward the dome (FIG. 9-22), but much can distract it in the interplay of flat walls and concave recesses; wide and narrow openings; groin and barrel vaults; single, double, and triple windows; and illuminated and dark spaces. Middle Byzantine architects seem to have aimed for the creation of complex interior spaces with dramatically shifting perspectives.

9-23 Crucifixion, mosaic in the Church of the Dormition, Daphni, Greece, ca. 1090–1100.

The Daphni Crucifixion is a subtle blend of Hellenistic style and the more abstract Byzantine manner. The Virgin Mary and Saint John point to Christ on the Cross as if to a devotional object.

DAPHNI Much of the original mosaic decoration of the Hosios Loukas Katholikon does not survive, but at Daphni, near Athens, the mosaics produced during Byzantium's second golden age fared much better. In the Church of the Dormition (from the Latin for "sleep," referring to the ascension of the Virgin Mary to Heaven at the moment of her death), at the Daphni monastery, the main elements of the late-11th-century pictorial program are intact, although the mosaics were restored in the 19th century. Gazing down from on high in the central dome (FIG. 9-1) is the fear-

some image of Christ as *Pantokrator* (literally "ruler of all" in Greek but usually applied to Christ in his role as Last Judge of humankind). The dome mosaic is the climax of an elaborate hierarchical pictorial program including several New Testament episodes below. The Daphni Pantokrator is like a gigantic icon hovering dramatically in space. The mosaic serves to connect the awestruck worshiper in the church below with Heaven through Christ. The Pantokrator theme was a common one in churches throughout the Byzantine Empire. There was also a mosaic of the Pantokrator in the dome of the Hosios Loukas Katholikon. Today a painting (FIG. 9-22) replaces it.

On one of the walls below the Daphni dome, beneath the barrel vault of one arm of the Greek cross, an unknown artist depicted Christ's Crucifixion (FIG. 9-23) in a pictorial style characteristic of the posticonoclastic Middle Byzantine period. Like the Pantokrator mosaic in the dome, the Daphni Crucifixion is a subtle blend of the painterly Hellenistic style and the later more abstract and formalistic Byzantine style. The Byzantine artist fully assimilated classicism's simplicity, dignity, and grace into a perfect synthesis with Byzantine piety and pathos. The figures have regained the classical organic structure to a surprising degree, particularly compared with Justinianic figures (FIGS. 9-10 and 9-11). The style is a masterful adaptation of classical statuesque qualities to the linear Byzantine manner.

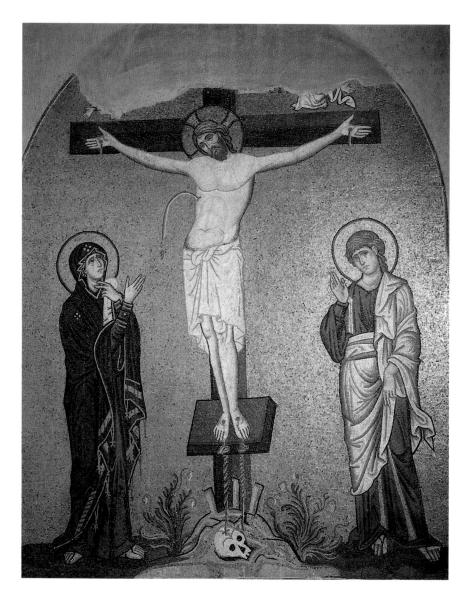

In quiet sorrow and resignation, the Virgin and Saint John flank the crucified Christ. A skull at the foot of the cross indicates Golgotha, the "place of skulls." The artist needed nothing else to set the scene. Symmetry and closed space combine to produce an effect of the motionless and unchanging aspect of the deepest mystery of the Christian religion, as recalled in the ceremony of the Eucharist. The picture is not a narrative of the historical event of the Crucifixion, the approach taken by the carver of the Early Christian ivory panel (FIG. 8-22) examined in the previous chapter. Nor is Christ a triumphant, beardless youth, oblivious to pain and defiant of the laws of gravity. Rather, he has a tilted head and sagging body, and although the Savior is not overtly in pain, blood and water spurt from the wound Longinus inflicted on him, as recounted in Saint John's gospel. The Virgin and John point to the figure on the cross as if to a devotional object. They act as intercessors between the viewer below and Christ, who, in the dome, appears as the Last Judge of all humans. The mosaic decoration of the church is the perfect complement to Christian liturgy.

SAINT MARK'S, VENICE The revival on a grand scale of church building, featuring vast stretches of mosaic-covered walls, was not confined to the Greek-speaking Byzantine East in the 10th to 12th centuries. A resurgence of religious architecture and of the

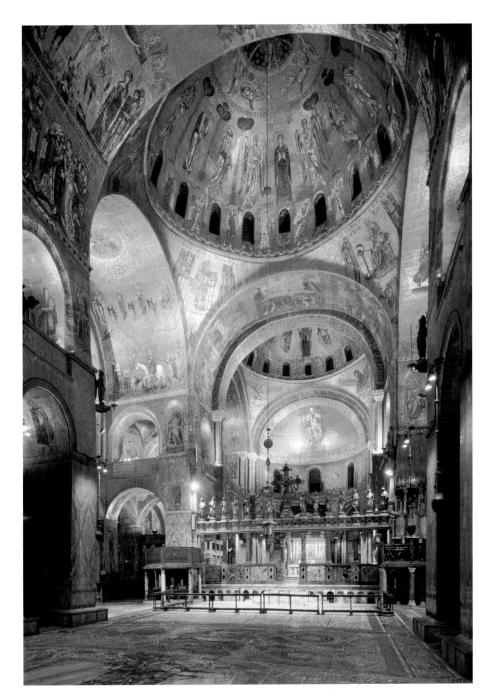

9-24 Interior of Saint Mark's (looking east), Venice, Italy, begun 1063.

Saint Mark's has a central dome over the crossing and four other domes over the four equal arms of the Greek cross. The walls and vaults are covered with 40,000 square feet of dazzling mosaics.

mosaicist's art also occurred in areas of the former Western Roman Empire where the ties with Constantinople were the strongest. In the Early Byzantine period, Venice, about 80 miles north of Ravenna on the eastern coast of Italy, was a dependency of that Byzantine stronghold. In 751, Ravenna fell to the Lombards, who wrested control of most of northern Italy from Constantinople. Venice, however, became an independent power. Its *doges* (dukes) enriched themselves and the city through seaborne commerce, serving as the crucial link between Byzantium and the West.

Venice had obtained the relics of Saint Mark from Alexandria in Egypt in 829, and the doges constructed the first Venetian shrine dedicated to the evangelist—a palace chapel and *martyrium* (martyr's shrine)—shortly thereafter. Fire destroyed the ninth-century chapel in 976. The Venetians then built a second shrine on the site, but a grandiose new church begun in 1063 by Doge Domenico Contarini (r. 1043–1071) replaced it. This building was modeled on the Church of the Holy Apostles at Constantinople, built in Justinian's

time. That church no longer exists, but its key elements were a cruciform plan with a central dome over the crossing and four other domes over the four equal arms of the Greek cross, as at Saint Mark's. Because of its importance to the city, the doges repeatedly remodeled the 11th-century structure, in time disguising its lower levels with Romanesque and Gothic additions. In 1807, Saint Mark's became the Cathedral of Venice.

The interior (FIG. 9-24) of Saint Mark's is, like its plan, Byzantine in effect. Light enters through a row of windows at the bases of all five domes, vividly illuminating a rich cycle of mosaics. Both Byzantine and local artists worked on Saint Mark's mosaics over the course of several centuries. Most of the mosaics date to the 12th and 13th centuries. Cleaning

and restoration on a grand scale have returned the mosaics to their original splendor, enabling visitors to experience the full radiance of mosaic (some 40,000 square feet of it) as it covers the walls, arches, vaults, and domes, as if it were a gold-brocaded figured fabric.

In the vast central dome, 80 feet above the floor and 42 feet in diameter, Christ ascends to Heaven in the presence of the Virgin Mary and the 12 apostles. The great arch framing the church crossing bears a narrative of the Crucifixion and Resurrection of Christ and of his liberation from death (Anastasis) of Adam and Eve, Saint John the Baptist, and other biblical figures. The mosaics have explanatory labels in both Latin and Greek, reflecting Venice's position as the key link between eastern and western Christendom in the later Middle Ages. The insubstantial figures on the walls, vaults, and domes appear weightless, and they project no farther from their flat field than do the elegant Latin and Greek letters above them. Nothing here reflects on the world of matter, of solids, of light and shade, of perspective space. Rather, the mosaics reveal the mysteries of the Christian faith.

9-25 Pantokrator, Theotokos and Child, angels, and saints, apse mosaic in the cathedral at Monreale (Sicily), Italy, ca. 1180–1190.

In centrally planned Byzantine churches, the image of the Pantokrator usually appears in the main dome, but the Monreale cathedral is a longitudinal basilica and the semidome of the apse is its only vault.

NORMAN SICILY Venetian success was matched in the western Mediterranean by the Normans, the northern French descendants of the Vikings (see Chapter 11) who, having driven the Arabs from Sicily, set up a powerful kingdom there. Though they were the enemies of Byzantium, the Normans, like the Venetians, assimilated Byzantine culture and even employed Byzantine artisans. The Normans also incorporated in their monuments elements of the Islamic art of the Arabs they had defeated (see Chapter 10). The Normans' Palatine (palace) Chapel at Palermo, with its prismatic (*muqarnas*) ceiling, a characteristic Muslim form (FIG. 10-17), is one example of the rich interplay of Western Christian, Byzantine, and Islamic cultures in Norman Sicily.

The mosaics of the great basilican church of Monreale, not far from Palermo, are striking evidence of Byzantine influence. They rival those of Saint Mark's in both quality and extent. One scholar has estimated that more than 100 million glass and stone tesserae were required for the Monreale mosaics. The Norman king William II paid for them, and he is portrayed twice, continuing the theme of royal presence and patronage of the much earlier Ravenna portraits of Justinian and Theodora (FIGS. 9-10 and 9-11) at San Vitale. In one panel, William, clearly labeled, unlike Justinian or his consort, stands next to the enthroned Christ, who places his hand on William's crown. In the second, the king kneels before the Virgin and presents her with a model of the Monreale church, a role that Bishop Ecclesius (FIG. 9-9), rather than the emperor or empress, played at San Vitale. As in the Ravenna church, the Monreale mosaic program commemorates both the piety and power of the ruler who reigns with divine authority.

The apse mosaics (FIG. **9-25**) are especially impressive. The image of Christ as Pantokrator, as ruler and judge of Heaven and Earth, is in the vault. It served also as a colossal allusion to William's kingly power and a challenge to all who would dispute the royal right. In Byzantium proper, the Pantokrator's image usually appears in the main dome of centralized churches such as those at Daphni (FIG. **9-1**) and Hosios Loukas (FIG. **9-22**), but the Greek churches are monastic churches and were not built for the glorification of monarchs. Monreale, moreover, is a basilica—longitudinally planned in the Western tradition. The semidome of the apse, the only vault in

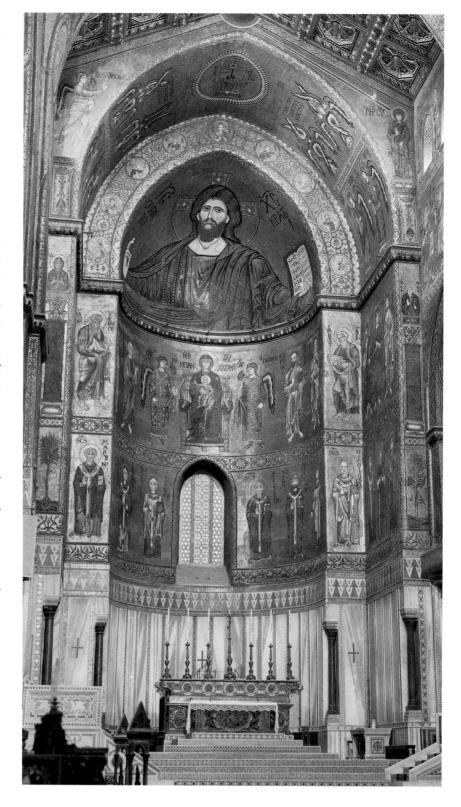

the building and its architectural focus, was the most conspicuous place for the vast image with its political overtones. Below the Pantokrator in rank and dignity, the enthroned Theotokos is flanked by archangels and the 12 apostles, symmetrically arranged in balanced groups. Lower on the wall (and less elevated in the hierarchy) are popes, bishops, and other saints. The artists observed the stern formalities of Byzantine style here, far from Constantinople. The Monreale mosaics, like those at Saint Mark's (FIG. 9-24) in Venice, testify to the stature of Byzantium and of Byzantine art in medieval Italy.

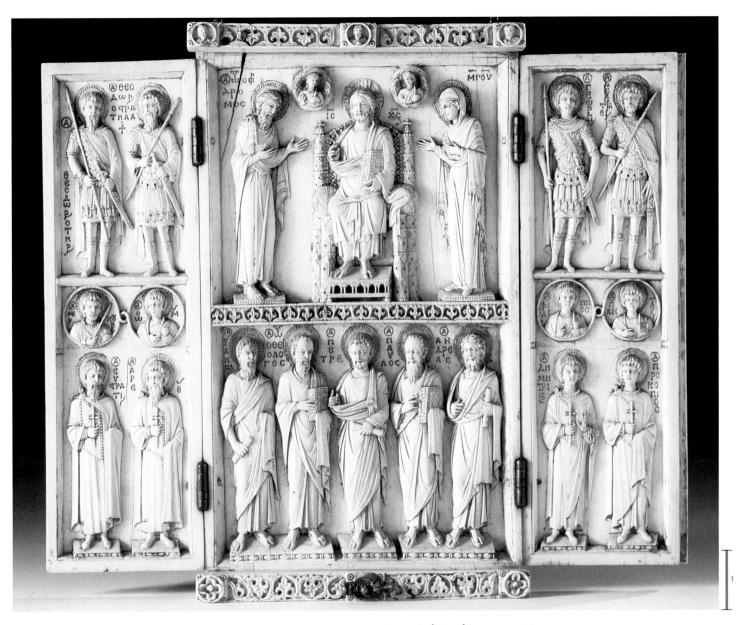

9-26 Christ enthroned with saints (*Harbaville Triptych*), ca. 950. Ivory, central panel $9\frac{1}{2}$ " $\times 5\frac{1}{2}$ ". Louvre, Paris.

In this small three-part shrine with hinged wings used for private devotion, the ivory carver depicted the figures with looser, more classical stances in contrast to the frontal poses of most Byzantine figures.

Ivory Carving and Painting

Costly carved ivories also were produced in large numbers in the Middle Byzantine period, when the three-part *triptych* replaced the earlier diptych as the standard format for ivory panels.

HARBAVILLE TRIPTYCH One example of this type is the Harbaville Triptych (FIG. 9-26), a portable shrine with hinged wings used for private devotion. Ivory triptychs were very popular—among people who could afford such luxurious items—and they often replaced icons for use in personal prayer. Carved on the wings of the Harbaville Triptych, both inside and out, are four pairs of full-length figures and two pairs of medallions depicting saints. A cross dominates the central panel on the back of the triptych (not illustrated). On the inside is a scene of Deësis (supplication). Saint John the Baptist and the Theotokos appear as intercessors, praying on behalf of the viewer to the enthroned Savior. Below them are five apostles.

The formality and solemnity usually associated with Byzantine art, visible in the mosaics of Ravenna and Monreale, yielded here to a softer, more fluid technique. The figures may lack true classical contrapposto, but the looser stances (most stand on bases, like free-standing statues) and three-quarter views of many of the heads relieve the hard austerity of the customary frontal pose. This more natural, classical spirit was a second, equally important, stylistic current of the Middle Byzantine period. It also surfaced in mural painting and book illumination. When the emperors lifted the ban against religious images and again encouraged religious painting at Constantinople, the impact was felt far and wide. The style varied from region to region, but a renewed enthusiasm for picturing the key New Testament figures and events was universal.

NEREZI In 1164, at Nerezi in Macedonia, Byzantine painters embellished Saint Pantaleimon with murals of great emotional power. One of these represents the Lamentation over the dead Christ

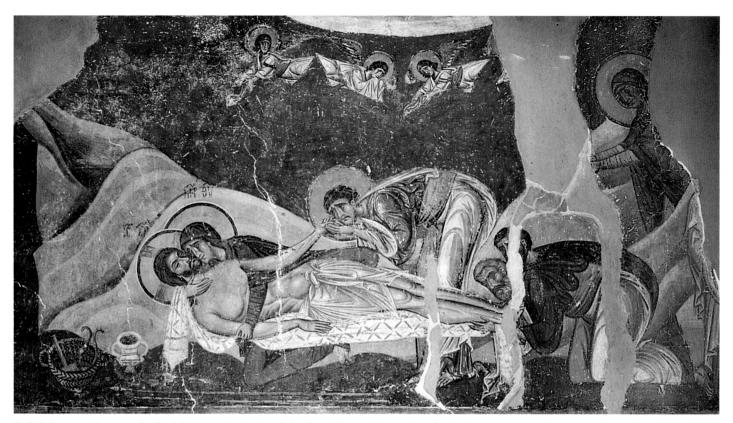

9-27 Lamentation over the dead Christ, wall painting, Saint Pantaleimon, Nerezi, Macedonia, 1164.

Working in the Balkans in an alternate Byzantine mode, this painter staged the emotional scene of the Lamentation in a hilly landscape below a blue sky and peopled it with fully modeled figures.

(FIG. 9-27). It is an image of passionate grief. The artist captured Christ's followers in attitudes, expressions, and gestures of quite human bereavement. Joseph of Arimathea and the disciple Nicodemus kneel at his feet, while Mary presses her cheek against her dead son's face and Saint John clings to Christ's left hand. In the Gospels, neither Mary nor John was present at the entombment of Christ. Their inclusion here, as elsewhere in Middle Byzantine art, intensified for the viewer the emotional impact of Christ's death. Representations such as these parallel the development of liturgical hymns recounting the Virgin's lamenting her son's death on the Cross.

At Nerezi, the painter set the scene in a hilly landscape below a blue sky—a striking contrast to the abstract golden world of the mosaics favored for church walls elsewhere in the Byzantine Empire. The artist strove to make utterly convincing an emotionally charged realization of the theme by staging the Lamentation in a more natural setting and peopling it with fully modeled actors. This alternate representational mode is no less Byzantine than the frontal, flatter figures of Ravenna. In time, this more naturalistic style would also be emulated in Italy (FIG. 14-9).

PARIS PSALTER Another example of this classical-revival style is a page from a book of the Psalms of David. The so-called *Paris Psalter* (FIG. 9-28) reasserts the artistic values of the Greco-Roman past

9-28 David composing the Psalms, folio 1 verso of the *Paris Psalter*, ca. 950–970. Tempera on vellum, 1′ $2\frac{1}{8}$ ″ \times $10\frac{1}{4}$ ″. Bibliothèque Nationale, Paris.

During the so-called Macedonian Renaissance, Byzantine painters revived the classical style. David is here portrayed as if a Greek hero and is accompanied by personifications of Melody, Echo, and Bethlehem.

1 in

with astonishing authority. Art historians believe the manuscript dates from the mid-10th century—the so-called Macedonian Renaissance, a time of enthusiastic and careful study of the language and literature of ancient Greece, and of humanistic reverence for the classical past. It was only natural that artists would once again draw inspiration from the Hellenistic naturalism of the pre-Christian Mediterranean world.

David, the psalmist, surrounded by sheep, goats, and his faithful dog, plays his harp in a rocky landscape with a town in the background. Similar settings appeared frequently in Pompeian murals. Befitting an ancient depiction of Orpheus, the Greek hero who could charm even inanimate objects with his music, allegorical figures accompany the Old Testament harpist. Melody looks over his shoulder, and Echo peers from behind a column. A reclining male figure points to a Greek inscription that identifies him as representing the mountain of Bethlehem. These allegorical figures do not appear in the Bible. They are the stock population of Greco-Roman painting. Apparently, the artist had seen a work from Late Antiquity or perhaps earlier and partly translated it into a Byzantine pictorial idiom. In works such as this, Byzantine artists kept the classical style alive in the Middle Ages.

VLADIMIR VIRGIN Nothing in Middle Byzantine art better demonstrates the rejection of the iconoclastic viewpoint than the painted icon's return to prominence. After the restoration of images, icons multiplied by the thousands to meet public and private demand. In the 11th century, the clergy began to display icons in hierarchical order (Christ, the Theotokos, John the Baptist, and then other saints, as on the Harbaville Triptych) in tiers on the templon, the low columnar screen separating the sanctuary from the main body of a Byzantine church.

The renowned Vladimir Virgin (FIG. 9-29) is a masterpiece of Middle Byzantine icon painting. Descended from works such as the Mount Sinai icon (FIG. 9-18), the Vladimir Virgin clearly reveals the stylized abstraction resulting from centuries of working and reworking the conventional image. The artist was probably a Constantinopolitan painter, and this icon exhibits all the characteristic Byzantine traits: the Virgin's long, straight nose and small mouth; the golden rays in the infant's drapery; the decorative sweep of the unbroken contour that encloses the two figures; and the flat silhouette against the golden ground. But the Vladimir Virgin is a much more tender and personalized image of the Theotokos than that in the Mount Sinai icon. Here Mary appears as the Virgin of Compassion, who presses her cheek against her son's in an intimate portrayal of Mother and Child. The image is also infused with a deep pathos as Mary contemplates the future sacrifice of her son. (The back of the icon bears images of the instruments of Christ's Passion.)

The *Vladimir Virgin*, like most icons, has seen hard service. Placed before or above altars in churches or private chapels, the icon became blackened by the incense and smoke from candles that burned before or below it. It was frequently repainted, often by inferior artists, and only the faces show the original surface. First painted in the late 11th or early 12th century, it was taken to Kiev (Ukraine) in 1131, then to Vladimir (Russia) in 1155 (hence its name), and in 1395, as a wonder-working image, to Moscow to protect that city from the Mongols. The Russians believed that the sacred picture saved the city of Kazan from later Tartar invasions and all of Russia from the Poles in the 17th century. The *Vladimir Virgin* is a historical symbol of Byzantium's religious and cultural mission to the Slavic world.

9-29 Virgin (Theotokos) and Child, icon (*Vladimir Virgin*), late 11th to early 12th centuries. Tempera on wood, original panel $2' 6\frac{1}{2}'' \times 1' 9''$. Tretyakov Gallery, Moscow.

In this icon, the artist depicted Mary as the Virgin of Compassion, who presses her cheek against her son's as she contemplates his future. The reverse side shows the instruments of Christ's Passion.

LATE BYZANTINE ART

When rule passed from the Macedonian to the Comnenian dynasty in the later 11th and the 12th centuries, three events of fateful significance changed Byzantium's fortunes for the worse. The Seljuk Turks conquered most of Anatolia. The Byzantine Orthodox Church broke finally with the Church of Rome. And the Crusades brought the Latins (a generic term for the peoples of the West) into Byzantine lands on their way to fight for the Cross against the Saracens (Muslims) in the Holy Land (see "The Crusades," Chapter 12, page 320).

Crusaders had passed through Constantinople many times en route to "smite the infidel" and had marveled at its wealth and magnificence. Envy, greed, religious fanaticism (the Latins called the Greeks "heretics"), and even ethnic enmity motivated the Crusaders when, during the Fourth Crusade in 1203 and 1204, the Venetians persuaded them to divert their expedition against the Muslims in Palestine and to attack Constantinople instead. The Crusaders took the city and sacked it. Nicetas Choniates, a contemporaneous historian, expressed the feelings of the Byzantines toward their attackers: "The

accursed Latins would plunder our wealth and wipe out our race.... Between us there can be only an unbridgeable gulf of hatred.... They bear the Cross of Christ on their shoulders, but even the Saracens are kinder."⁷

The Latins set up kingdoms within Byzantium, notably in Constantinople itself. What remained of Byzantium split into three small states. The Palaeologans ruled one of these, the kingdom of Nicaea. In 1261, Michael VIII Palaeologus (r. 1259–1282) succeeded in recapturing Constantinople. But his empire was no more than a fragment, and even that disintegrated during the next two centuries. Isolated from the Christian West by Muslim conquests in the Balkans and besieged by Muslim Turks to the east, Byzantium sought help from the West. It was not forthcoming. In 1453, the Ottoman Turks, then a formidable power, took Constantinople and brought to an end the long history of Byzantium (see Chapter 10). But despite the state's grim political condition under the Palaeologan dynasty, the arts flourished well into the 14th century.

Painting

During the 14th and 15th centuries, artists throughout the Byzantine world produced masterpieces of mural and icon painting rivaling those of the earlier periods. Four characteristic examples from

the old capital of Constantinople and as far away as Russia can serve to illustrate the range and quality of painting during the Late Byzantine period.

CHRIST IN CHORA A fresco (FIG. 9-30) in the abse of the parekklesion (side chapel, in this instance a funerary chapel) of the Church of Christ in Chora in Constantinople depicts the Anastasis. One of many subsidiary subjects that made up the complex mosaic program of Saint Mark's (FIG. 9-24) in Venice, the Anastasis is here central to a cycle of pictures portraying the themes of human mortality and redemption by Christ and of the intercession of the Virgin, both appropriate for a funerary chapel. Christ, trampling Satan and all the locks and keys of his prison house of Hell, raises Adam and Eve from their tombs. Looking on are John the Baptist, King David, and King Solomon on the left, and various martyr saints on the right. Christ, central and surrounded by a luminous mandorla, reaches out equally to Adam and Eve. The action is swift and smooth, the supple motions executed with the grace of a ballet. The figures float in a spiritual atmosphere, spaceless and without material mass or shadow-casting volume. This same smoothness and lightness can be seen in the modeling of the figures and the subtly nuanced coloration. The jagged abstractions of drapery found in

9-30 Anastasis, apse fresco in the parekklesion of the Church of Christ in Chora (now the Kariye Museum), Constantinople (Istanbul), Turkey, ca. 1310–1320.

In this Late Byzantine funerary chapel, Christ, a white apparition surrounded by a luminous mandorla, raises Adam and Eve from their tombs as John the Baptist and Kings David and Solomon look on.

many earlier Byzantine frescoes and mosaics are gone in a return to the fluid delineation of drapery characteristic of the long tradition of classical illusionism.

Throughout the centuries, Byzantine artists looked back to Greco-Roman illusionism. But unlike classical artists, Byzantine painters and mosaicists were not concerned with the systematic observation of material nature as the source of their representations of the eternal. They drew their images from a persistent and conventionalized vision of a spiritual world unsusceptible to change. That consistent vision is what unites works as distant in time as the sixth-century apse mosaic (FIG. 9-13) at Mount Sinai and the 14th-century fresco in the Church of Christ in Chora.

OHRID ICONS Byzantine spirituality was perhaps most intensely revealed in icon painting. In the Late Byzantine period, the Early Byzantine templon developed into an *iconostasis*, a high screen with doors and tiers of icons. As its name implies, the iconostasis supported tiers of painted devotional images, which began to be produced again in large numbers, both in Constantinople and throughout the diminished Byzantine Empire.

One example (FIG. 9-31), notable for the lavish use of finely etched silver foil to frame the painted figure of Christ as Savior of

Souls, dates to the beginning of the 14th century. It comes from Saint Clement at Ohrid in Macedonia, where many Late Byzantine icons imported from the capital have been preserved. The painter of the Ohrid Christ, in a manner consistent with Byzantine art's conservative nature, adhered to an iconographical and stylistic tradition traceable to the earliest icons from the monastery at Mount Sinai. As elsewhere (for example, FIG. 9-1), the Savior holds a bejeweled Bible in his left hand while he blesses the faithful with his right hand. The style is typical of Byzantine eclecticism. Note especially the juxtaposition of Christ's fully modeled head and neck, which reveal the Byzantine painter's Greco-Roman heritage, with the schematic linear folds of Christ's garment, which do not envelop the figure but rather seem to be placed in front of it.

In the Late Byzantine period, icons often were painted on two sides because they were intended to be carried in processions. When deposited in the church, the icons were not mounted on the iconostasis but were exhibited on stands so worshipers could view both sides. The Ohrid icon of Christ has a painting of the Crucifixion on its reverse. Another double icon from Saint Clement's, also imported from Constantinople, represents the Virgin on the front as Christ's counterpart as Savior of Souls. The Annunciation (FIG. 9-32) appears on the reverse. With a commanding gesture of heavenly

9-31 Christ as Savior of Souls, icon from Saint Clement, Ohrid, Macedonia, early 14th century. Tempera, linen, and silver on wood, $3'\frac{1}{4''} \times 2'2\frac{1}{2''}$. Icon Gallery of Saint Clement, Ohrid.

Notable for the lavish use of finely etched silver foil, this icon typifies Byzantine eclecticism. Christ's fully modeled head and neck contrast with the schematic linear folds of his garment.

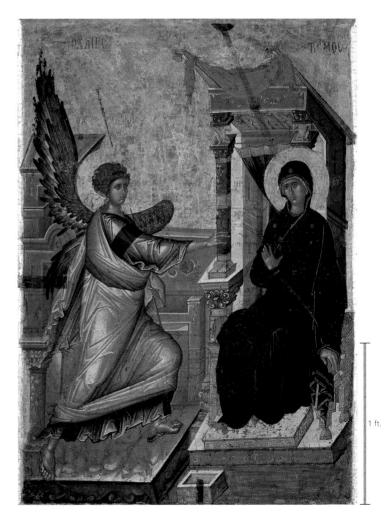

9-32 Annunciation, reverse of two-sided icon from Saint Clement, Ohrid, Macedonia, early 14th century. Tempera and linen on wood, $3'\frac{1}{4}'' \times 2'2\frac{3}{4}''$. Icon Gallery of Saint Clement, Ohrid.

Late Byzantine icons often were painted on two sides because they were intended to be carried in processions. On this icon the Virgin Mary appears on the front and this Annunciation scene on the back.

9-33 Andrei Rublyev, Three angels (Old Testament Trinity), ca. 1410. Tempera on wood, $4' 8'' \times 3' 9''$. Tretyakov Gallery, Moscow.

This exceptionally large icon, which features subtle lines and intensely vivid colors, is one of the masterworks of Russian painting. It depicts the three angels who appeared to Abraham, prefiguring the Trinity.

1 ft.

authority, the angel Gabriel announces to Mary that she is to be the Mother of God. She responds with a simple gesture conveying both astonishment and acceptance. The gestures and attitudes of the figures are again conventional, as are the highly simplified architectural props. The painter rendered the latter in inconsistent perspective derived from classical prototypes, but set the sturdy three-dimensional forms against an otherworldly gold sky, suggesting the sacred space in which the narrative unfolds. This icon also exemplifies the eclecticism that characterizes Byzantine art throughout its long history.

ANDREI RUBLYEV In Russia, icon painting flourished for centuries, extending the life of the Byzantine painting style well beyond the collapse of the Byzantine Empire in 1453. Russian paintings usually had strong patterns, firm lines, and intense contrasting colors. All served to heighten the legibility of the icons in the wavering candlelight and clouds of incense that worshipers encountered in church interiors. For many art historians, Russian painting reached a climax in the work of Andrei Rublyev (ca. 1370–1430). His nearly five-foot-tall panel (FIG. 9-33) depicting the three Old Testament angels who appeared to Abraham is a work of great spiritual power. It is also an unsurpassed example of subtle line in union with intensely vivid color. The angels sit about a table, each framed

with a halo and sweeping wings, three nearly identical figures distinguished only by their garment colors. The light linear play of the draperies sets off the tranquil demeanor of the figures. Color defines the forms and becomes more intense by the juxtaposition of complementary hues. The intense blue and green folds of the central figure's cloak, for example, stand out starkly against the deep-red robe and the gilded orange of the wings. In the figure on the left, the highlights of the orange cloak are an opalescent blue green. The unmodulated saturation, brilliance, and purity of the color harmonies are the hallmark of Rublyev's style.

THE THIRD ROME With the fall of Constantinople in 1453, Russia became Byzantium's self-appointed heir, defending Christendom against the infidel. The court of the tsar (the title derives from "Caesar") declared: "Because the Old Rome has fallen, and because the Second Rome, which is Constantinople, is now in the hands of the godless Turks, thy kingdom, O pious Tsar, is the Third Rome.... Two Romes have fallen, but the Third stands, and there shall be no more." Rome, Byzantium, Russia—Old Rome, New Rome, and Third Rome—were a continuum, spanning two and a half millennia during which artists and architects produced many of the most significant paintings, sculptures, and buildings in the long history of art through the ages.

BYZANTIUM

EARLY BYZANTINE ART, 527-726

- The reign of Justinian (r. 527–565) opened the first golden age of Byzantine art. Justinian was a great patron of the arts, and in Constantinople alone he built or restored more than 30 churches.
- Constructed in only five years, Hagia Sophia, a brilliant fusion of central and longitudinal plans, rivaled the architectural wonders of Rome. Its 180-foot-high dome rests on pendentives but seemed to contemporaries to be suspended "by a golden chain from Heaven."
- The seat of Byzantine power in Italy was Ravenna, which enjoyed its greatest prosperity under Justinian. San Vitale is Ravenna's greatest church. Its mosaics, with their weightless, hovering, frontal figures against a gold background, reveal the new Byzantine aesthetic.
- Justinian also rebuilt the monastery at Mount Sinai in Egypt, where the finest Early Byzantine icons are preserved. In 726, however, Leo III (r. 717–741) enacted a ban against picturing the divine, initiating the era of iconoclasm (726–843).

Hagia Sophia, Constantinople, 532–537

San Vitale, Ravenna, 526-547

MIDDLE BYZANTINE ART, 843-1204

- In 867, Basil I (r. 867–886) dedicated a new mosaic depicting the Theotokos (Mother of God) in Hagia Sophia. It marked the triumph of the iconophiles over the iconoclasts.
- Middle Byzantine art is stylistically eclectic. Mosaics with otherworldly golden backgrounds were common, but some paintings, for example those in the *Paris Psalter*, revived the naturalism of classical art.
- Middle Byzantine churches like those at Hosios Loukas have highly decorative exterior walls and feature domes that rest on drums above the center of a Greek cross. The climax of the interior mosaic programs was often an image of Christ as Pantokrator in the dome.

Paris Psalter, ca. 950-970

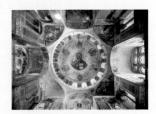

Katholikon, Hosios Loukas, first quarter of 11th century

LATE BYZANTINE ART, 1261-1453

- In 1204, Latin Crusaders sacked Constantinople, bringing to an end the second golden age of Byzantine art. In 1261, Michael VIII Palaeologus (r. 1259–1282) succeeded in retaking the city. Constantinople remained in Byzantine hands until the Ottoman Turks captured it in 1453.
- Important mural paintings of the Late Byzantine period are in the Constantinopolitan Church of Christ in Chora. An extensive picture cycle portrays Christ as Redeemer; in the apse he raises Adam and Eve from their tombs.
- Late Byzantine icons were displayed in tiers on an iconostasis or on individual stands so that the paintings on both sides could be seen. The great painting centers during this period were in Constantinople and Russia. The work of Andrei Rublyev is notable for its great spiritual power and intense colors.

Andrei Rublyev, Three angels, ca. 1410

10-1 Court of the Lions, Palace of the Lions, Alhambra, Granada, Spain, 1354–1391.

The Palace of the Lions, named for its fountain's unusual statues, is distinctly Islamic in the use of multilobed pointed arches and the interweaving of Arabic calligraphy and abstract ornament in its stuccoed walls.

THE ISLAMIC WORLD

The religion of Islam (an Arabic word meaning "submission to God") arose among the peoples of the Arabian Peninsula early in the seventh century (see "Muhammad and Islam," page 263). At the time, the Arabs were nomadic herders and caravan merchants traversing the vast Arabian desert and settling and controlling its coasts. They were peripheral to the Byzantine and Persian empires. Yet within little more than a century, the eastern Mediterranean, which Byzantium once ringed and ruled, had become an Islamic lake, and the armies of Islam had subdued the Middle East, long the seat of Persian dominance and influence.

The swiftness of the Islamic advance is among the wonders of world history. By 640, Muslims ruled Syria, Palestine, and Iraq in the name of Allah. In 642, the Byzantine army abandoned Alexandria, marking the Muslim conquest of Lower (northern) Egypt. In 651, the successors of Muhammad ended more than 400 years of Sasanian rule in Iran (see Chapter 2). All of North Africa was under Muslim control by 710. A victory at Jerez de la Frontera in southern Spain in 711 seemed to open all of western Europe to the Muslims. By 732, they had advanced north to Poitiers in France, but an army of Franks under Charles Martel, the grandfather of Charlemagne, opposed them successfully (see Chapter 11), halting Muslim expansion at the Pyrenees. In Spain, in contrast, the Islamic rulers of Córdoba flourished until 1031, and not until 1492 did Muslim influence and power end in the Iberian Peninsula. That year the army of King Ferdinand and Queen Isabella, the sponsors of Columbus's voyage to the New World, overthrew the caliphs of Granada. In the East, the Muslims reached the Indus River by 751, and only in Anatolia could stubborn Byzantine resistance slow their advance. Relentless Muslim pressure against the shrinking Byzantine Empire eventually caused its collapse in 1453, when the Ottoman Turks entered Constantinople (see Chapter 9).

Military might alone, however, cannot account for the relentless and far-ranging sweep of Islam from Arabia to India to North Africa and Spain (MAP 10-1). That Islam endured in the conquered lands for centuries after the initial victories can be explained only by the nature of the Islamic faith and its appeal to millions of converts. Islam remains today one of the world's great religions, with adherents

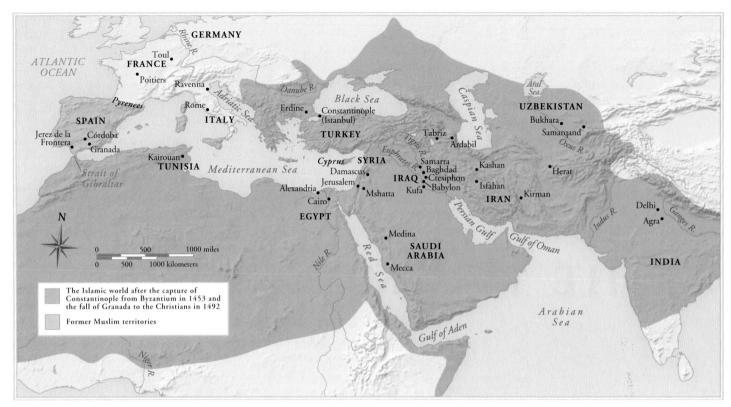

MAP 10-1 The Islamic world around 1500.

on all continents. Its sophisticated culture has had a profound impact around the globe. Arab scholars laid the foundations of arithmetic and algebra and made significant contributions to astronomy, medicine, and the natural sciences. Christian scholars in the West during the 12th and 13th centuries eagerly studied Arabic translations of Aristotle and other Greek writers of antiquity. Arabic love lyrics and poetic descriptions of nature inspired the early French troubadours.

The triumph of Islam also brought a new and compelling tradition to the history of world art and architecture. Like Islam itself, Islamic art spread quickly both eastward and westward from the land once inhabited by the peoples of the ancient Near East. In the Middle East and North Africa, Islamic art largely replaced Late Antique art. From a foothold in the Iberian Peninsula, Islamic art influenced Western medieval art. Islamic artists and architects also brought their distinctive style to South Asia, where a Muslim sultanate was established at Delhi in India in the early 13th century. In fact, perhaps the most famous building in Asia, the Taj Mahal at Agra, is an Islamic mausoleum.

EARLY ISLAMIC ART

During the early centuries of Islamic history, the Muslim world's political and cultural center was the Fertile Crescent of ancient Mesopotamia (see Chapter 2). The caliphs of Damascus (capital of modern Syria) and Baghdad (capital of Iraq) appointed provincial governors to rule the vast territories they controlled. These governors eventually gained relative independence by setting up dynasties in various territories and provinces: the Umayyads in Syria (661–750) and in Spain (756–1031), the Abbasids in Iraq (750–1258, largely nominal after 945), the Fatimids in Egypt (909–1171), and so on.

Architecture

Like other potentates before and after, the Muslim caliphs were builders on a grand scale. The first Islamic buildings, both religious and secular, are in the Middle East, but important early examples of Islamic architecture still stand also in North Africa, Spain, and Central Asia.

DOME OF THE ROCK The first great Islamic building is the Dome of the Rock (FIG. 10-2) in Jerusalem. The Muslims had taken the city from the Byzantines in 638, and the Umayyad caliph Abd al-Malik (r. 685–705) erected the monumental shrine between 687 and 692 as an architectural tribute to the triumph of Islam. The Dome of the Rock marked the coming of the new religion to the city that was—and still is—sacred to both Jews and Christians. The structure rises from a huge platform known as the Noble Enclosure, where in ancient times the Hebrews built the Temple of Solomon that the Roman emperor Titus destroyed in 70 (see Chapter 7). In time, the site took on additional significance as the reputed place where Adam was buried and where Abraham prepared to sacrifice Isaac. The rock that gives the building its name also later came to be identified with the spot from which Muhammad miraculously journeyed to Heaven and then, in the same night, returned to his home in Mecca.

As Islam took much of its teaching from Judaism and Christianity, so, too, its architects and artists borrowed and transformed design, construction, and ornamentation principles long applied in Byzantium and the Middle East. The Dome of the Rock is a domed octagon resembling San Vitale (FIG. 9-6) in Ravenna in its basic design. In all likelihood, a neighboring Christian monument, Constantine's Church of the Holy Sepulchre, a domed rotunda, inspired the Dome of the Rock's designers. That fourth-century rotunda bore a family resemblance to the roughly contemporary Constantinian

Muhammad and Islam

uhammad, founder of Islam and revered as its Final Prophet, was a native of Mecca on the west coast of Arabia. Born around 570 into a family of merchants in the great Arabian caravan trade, Muhammad was inspired to prophesy. Critical of the polytheistic religion of his fellow Arabs, he preached a religion of the one and only God ("Allah" in Arabic), whose revelations Muhammad received beginning in 610 and for the rest of his life. Opposition to Muhammad's message among the Arabs was strong enough to prompt the Prophet and his followers to flee from Mecca to a desert oasis eventually called Medina ("City of the Prophet"). Islam dates its beginnings from this flight in 622, known as the Hijra ("emigration").* Barely eight years later, in 630, Muhammad returned to Mecca with 10,000 soldiers. He took control of the city, converted the population to Islam, and destroyed all the idols. But he preserved as the Islamic world's symbolic center the small cubical building that had housed the idols, the Kaaba (from the Arabic for "cube"). The Arabs associated the Kaaba with the era of Abraham and Ishmael, the common ancestors of Jews and Arabs. Muhammad died in Medina in 632.

The essential meaning of Islam is acceptance of and submission to Allah's will. Believers in Islam are called Muslims ("those who submit"). Islam requires them to live according to the rules laid down in the collected revelations communicated through Muhammad during his lifetime. The *Koran*, Islam's sacred book, codified by the Muslim ruler Uthman (r. 644–656), records Muhammad's revelations. The word "Koran" means "recitations"—a reference to the archangel Gabriel's instructions to Muhammad in 610 to "recite in the name of Allah." The Koran is composed of 114 *surahs* ("chapters") divided into verses.

The profession of faith in the one God, Allah, is the first of five obligations binding all Muslims. In addition, the faithful must worship five times daily facing in Mecca's direction, give alms to the poor, fast during the month of Ramadan, and once in a lifetime—if possible—make a pilgrimage to Mecca. The revelations in the Koran are not the only guide for Muslims. Muhammad's exemplary ways and customs, collected in the *Sunnah*, offer models to the faithful on ethical problems of everyday life. The reward for the Muslim faithful is Paradise.

Islam has much in common with Judaism and Christianity. Its adherents think of it as a continuation, completion, and in some sense a reformation of those other great monotheisms. Islam incorporates many of the Old Testament teachings, with their sober ethical standards and rejection of idol worship, and those of the New Testament Gospels. Muslims acknowledge Adam, Abraham, Moses, and Jesus as the prophetic predecessors of Muhammad, the final and greatest of the prophets. Muhammad did not claim to be divine, as did Jesus. Rather, he was God's messenger, the purifier and perfecter of the common faith of Jews, Christians, and Muslims in one God. Islam also differs from Judaism and Christianity in its simpler organization. Muslims worship God directly, without a hierarchy of rabbis, priests, or saints acting as intermediaries.

In Islam, as Muhammad defined it, religious and secular authority were united even more completely than in Byzantium. Muhammad established a new social order, replacing the Arabs' old decentralized tribal one, and took complete charge of his community's temporal as well as spiritual affairs. After Muhammad's death, the *caliphs* (from the Arabic for "successor") continued this practice of uniting religious and political leadership in one ruler.

*Muslims date events beginning with the Hijra in the same way Christians reckon events from Christ's birth, and the Romans before them began their calendar with Rome's founding by Romulus and Remus in 753 BCE. The Muslim year, however, is a 354-day year of 12 lunar months, and dates cannot be converted by simply subtracting 622 from Christian-era dates.

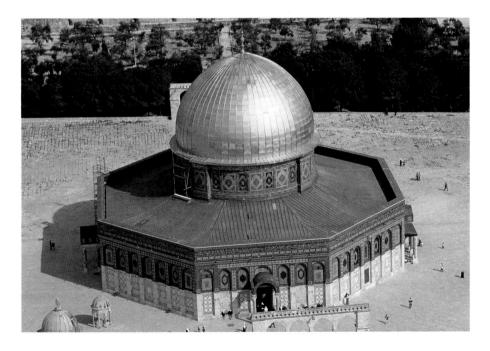

10-2 Aerial view of the Dome of the Rock, Jerusalem, 687–692.

Abd al-Malik erected the Dome of the Rock to mark the triumph of Islam in Jerusalem on a site sacred to Muslims, Christians, and Jews. The shrine takes the form of an octagon with a towering dome.

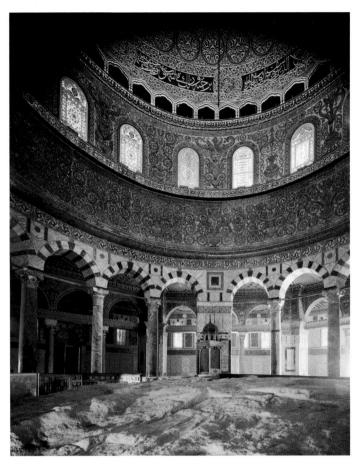

10-3 Interior of the Dome of the Rock, Jerusalem, 687–692.

Tiles from the 16th century adorn the exterior of the Dome of the Rock, but the interior's original mosaic ornament is preserved. The mosaics conjure the imagery of Paradise awaiting Muslims.

mausoleum later dedicated as Santa Costanza (FIGS. 8-11 and 8-12) in Rome. The Dome of the Rock is a member of the same extended family. Its double-shelled wooden dome, however, some 60 feet across and 75 feet high, so dominates the elevation as to reduce the octagon to function merely as its base. This soaring, majestic unit creates a decidedly more commanding effect than that produced by Late Roman and Byzantine domical structures (FIGS. 9-2 and 9-6). The silhouettes of those domes are comparatively insignificant when seen from the outside.

The building's exterior has been much restored. Tiling from the 16th century and later has replaced the original mosaic. Yet the vivid, colorful patterning that wraps the walls like a textile is typical of Islamic ornamentation. It contrasts markedly with Byzantine brickwork and Greco-Roman sculptured decoration. The interior's rich mosaic ornament (FIG. 10-3) has been preserved and suggests the original appearance of the exterior walls. Islamic practice does not significantly distinguish interior and exterior decor.

GREAT MOSQUE, DAMASCUS The Umayyads transferred their capital from Mecca to Damascus in 661. There, Abd al-Malik's son, the caliph al-Walid (r. 705–715), purchased a Byzantine church (formerly a Roman temple) and built an imposing new mosque for the expanding Muslim population (see "The Mosque," page 265). The Umayyads demolished the church, but they used the Roman precinct walls as a foundation for their own construction. Like the Dome of

the Rock, Damascus's Great Mosque (FIGS. 10-4 and 10-5) owes much to Roman and Early Christian architecture. The Islamic builders incorporated stone blocks, columns, and capitals salvaged from the earlier structures on the land al-Walid acquired for his mosque. Pier arcades reminiscent of Roman aqueducts frame the courtyard (FIG. 10-5). The minarets, two at the southern corners and one at the northern side of the enclosure—the earliest in the Islamic world—are modifications of the preexisting Roman square towers. The grand prayer hall, taller than the rest of the complex, is on the south side of the courtyard (facing Mecca). Its main entrance is distinguished by a facade with a pediment and arches, recalling Roman and Byzantine models. The facade faces into the courtyard, like a Roman forum temple (FIG. 7-12), a plan maintained throughout the long history of mosque architecture. The Damascus mosque synthesizes elements received from other cultures into a novel architectural unity, which includes the distinctive Islamic elements of mihrab, mihrab dome, minbar, and minaret.

An extensive cycle of mosaics once covered the walls of the Great Mosque. In one of the surviving sections (FIG. 10-4), a conchshell niche "supports" an arcaded pavilion with a flowering rooftop flanked by structures shown in classical perspective. Like the architectural design, the mosaics owe much to Roman, Early Christian, and Byzantine art. Indeed, some evidence indicates that the Great Mosque mosaics were the work of Byzantine mosaicists. Characteristically, temples, clusters of houses, trees, and rivers compose the

10-4 Detail of a mosaic in the courtyard arcade of the Great Mosque, Damascus, Syria, 706–715.

The mosaics of the Great Mosque at Damascus are probably the work of Byzantine artists and include buildings and landscape elements common in Late Antique art, but exclude any zoomorphic forms.

The Mosque

slamic religious architecture is closely related to Muslim prayer, an obligation laid down in the Koran for all Muslims. In Islam, worshiping can be a private act and requires neither prescribed ceremony nor a special locale. Only the *qibla*—the direction (toward Mecca) Muslims face while praying—is important. But worship also became a communal act when the first Muslim community established a simple ritual for it. To celebrate the Muslim sabbath, which occurs on Friday, the community convened each Friday at noon, probably in the Prophet's house in Medina. The main feature of Muhammad's house was a large square court with rows of palm trunks supporting thatched roofs along the north and south sides. The southern side, which faced Mecca, was wider and had a double row of trunks. The *imam*, or leader of collective worship, stood on a stepped pulpit, or *minbar*, set up in front of the southern (qibla) wall.

These features became standard in the Islamic house of worship, the *mosque* (from Arabic "masjid," a place of prostration), where the faithful gathered for the five daily prayers. The *congregational mosque* (also called the *Friday mosque* or *great mosque*) was ideally large enough to accommodate a community's entire population for the Friday noon prayer. A very important feature both of ordinary mosques and of congregational mosques is the *mihrab* (FIG. 10-8, no. 2), a semicircular niche usually set into the qibla wall. Often a dome over the bay in front of it marked its position (FIGS. 10-5 and 10-8, no. 3). The niche was a familiar Greco-Roman architectural feature, generally enclosing a statue. Scholars still debate its origin,

purpose, and meaning in Islamic architecture. The mihrab originally may have honored the place where the Prophet stood in his house at Medina when he led communal worship.

In some mosques, a *maqsura* precedes the mihrab. The maqsura is the area generally reserved for the ruler or his representative and can be quite elaborate in form (FIG. 10-12). Many mosques also have one or more *minarets* (FIGS. 10-5, 10-9, AND 10-20), towers used to call the faithful to worship. When buildings of other faiths were converted into mosques, the Muslims clearly signaled the change on the exterior by the erection of minarets (FIG. 9-2). *Hypostyle halls*, communal worship halls with roofs held up by a multitude of columns (FIGS. 10-8, no. 4, and 10-11), are characteristic features of early mosques. Later variations include mosques with four *iwans* (vaulted rectangular recesses), one on each side of the courtyard (FIGS. 10-22 and 10-23), and *central-plan* mosques with a single large dome-covered interior space (FIGS. 10-20 and 10-21), as in Byzantine churches, some of which later became mosques (FIG. 9-4).

The mosque's origin is still in dispute, although one prototype may well have been the Prophet's house in Medina. Today, despite many variations in design and detail and the employment of modern building techniques and materials unknown in Muhammad's day, the mosque's essential features are unchanged. All mosques, wherever they are built and whatever their plan, are oriented toward Mecca, and the faithful worship facing the qibla wall.

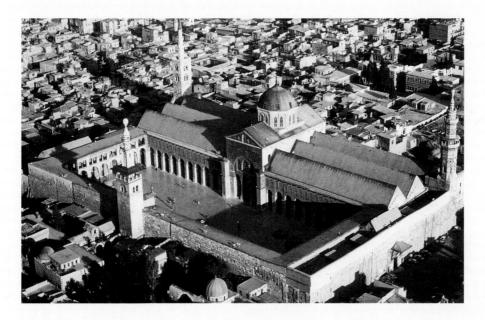

10-5 Aerial view of the Great Mosque, Damascus, Syria, 706–715.

The hypostyle type of mosque most closely recalls the layout of Muhammad's house in Medina. Damascus's Great Mosque also owes a debt to Roman and Early Christian architecture in its plan and decoration.

pictorial fields, bounded by stylized vegetal designs also found in Roman, Early Christian, and Byzantine ornament. No zoomorphic forms, human or animal, appear in either the pictorial or ornamental spaces. This is true of all the mosaics in the Great Mosque as well as the mosaics in the earlier Dome of the Rock (FIG. 10-3). Islamic tradition shuns the representation of fauna of any kind in sacred

places. Accompanying (but now lost) inscriptions explained the world shown in the Damascus mosaics, suspended miragelike in a featureless field of gold, as an image of Paradise. Many passages from the Koran describe the gorgeous places of Paradise awaiting the faithful—gardens, groves of trees, flowing streams, and "lofty chambers."

UMAYYAD PALACE, MSHATTA

The Umayyad rulers of Damascus constructed numerous palatial residences throughout their domains. The urban palaces are lost, but some rural palaces survive. The latter were not merely idyllic residences removed from the congestion, noise, and disease of the cities. They seem to have served as nuclei for the agricultural development of acquired territories and possibly as hunting lodges. In addition, the Islamic palaces were symbols of authority over new lands as well as expressions of their owners' wealth.

One of the most impressive Umayyad palaces, despite the fact that it was never completed, is at Mshatta in the Jordanian desert. Its plan (FIG. 10-6) resembles that of Diocletian's palace (FIG. 7-74) at Split, which in turn reflects the layout of a Roman fortified camp. The high

walls of the Mshatta palace incorporate 25 towers but lack parapet walkways for patrolling guards. The walls, nonetheless, offered safety from marauding nomadic tribes and provided privacy for the caliph and his entourage. Visitors entered the palace through a large portal on the south side. To the right was a mosque (FIG. 10-6, no. 2; the plan shows the mihrab niche in the qibla wall), in which the rulers and their guests could fulfill their obligation to pray five times a day. A small ceremonial area and an immense open courtyard separated the mosque from the palace's residential wing and official audience hall. Most Umayyad palaces also boasted fairly elaborate bathing facilities that displayed technical features, such as heating systems, adopted from Roman baths. Just as under the Roman Empire, these baths probably served more than merely hygienic purposes. Indeed, in several Umayyad palaces, excavators have uncovered in the baths paintings and sculptures of hunting and other secular themes, including depictions of dancing women—themes traditionally associated with royalty in the Near East. Large halls frequently attached to many of these baths seem to have been used as places of entertainment, as was the case in Roman times. Thus, the bath-spa as social center, a characteristic amenity of Roman urban culture that died out in the Christian world, survived in Islamic culture.

A richly carved stone frieze (FIG. 10-7) more than 16 feet high enlivens the facade of the Mshatta palace. Triangles contain large rosettes projecting from a field densely covered with curvilinear,

SHATTA constructed ughout their st, but some re not merely et congestion,

The fortified palace at Mshatta resembled Diocletian's palace (FIG. 7-74) at Split and incorporated the amenities of Roman baths but also housed a mosque in which the caliph could worship five times daily.

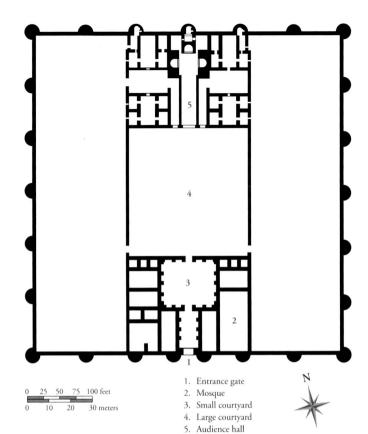

vegetal designs. No two triangles are exactly alike. Animals appear in some of them. Similar compositions of birds, felines, and vegetal scrolls can be found in Roman, Byzantine, and Sasanian art. The Mshatta frieze, however, in keeping with Islam's disavowal of representing living things in sacred contexts, has no animal figures to the right of the entrance portal—that is, on the part of the facade corresponding to the mosque's qibla wall.

BAGHDAD In 750, after years of civil war, the Abbasids, who claimed descent from Abbas, an uncle of Muhammad, overthrew the Umayyad caliphs. The new rulers moved the capital from Damascus to a site in Iraq near the old Sasanian capital of Ctesiphon (FIG. 2-27). There the caliph al-Mansur (r. 754–775) established a new capital, Baghdad, which he called Madina al-salam, the City of Peace. The city was laid out in 762 at a time astrologers determined as favorable. It

10-7 Frieze of the Umayyad palace, Mshatta, Jordan, ca. 740–750. Limestone, 16′ 7″ high. Museum für Islamische Kunst, Staatliche Museen, Berlin.

A long stone frieze richly carved with geometric, plant, and animal motifs decorated the facade of the Mshatta palace. No animals appear, however, on the exterior wall of the palace's mosque.

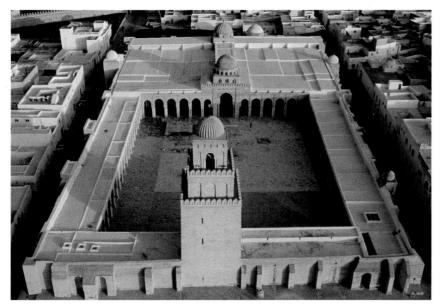

10-8 Aerial view (left) and plan (right) of the Great Mosque, Kairouan, Tunisia, ca. 836-875.

The arcaded forecourt in front of the hypostyle hall of the Kairouan mosque resembles a Roman forum (FIG. 7-43), but it incorporates the distinctive Islamic elements of mihrab, mihrab dome, minbar, and minaret.

- Qibla wall
- Mihrab
- Entrance dome
- Mihrab dome 4. Hypostyle prayer hall 8. Minaret
- Forecourt

was round in plan, about a mile and a half in diameter. The shape signified that the new capital was the center of the universe. At the city's center was the caliph's palace, oriented to the four compass points. For almost 300 years Baghdad was the hub of Arab power and of a brilliant Islamic culture. The Abbasid caliphs were renowned throughout the world and even established diplomatic relations with Charlemagne in Germany. The Abbasids lavished their wealth on art, literature, and science and were responsible for the translation of numerous Greek texts that otherwise would have been lost. Many of these works were introduced to the medieval West through their Arabic versions.

GREAT MOSQUE, KAIROUAN Of all the variations in mosque plans, the hypostyle mosque most closely reflects the mosque's supposed origin, Muhammad's house in Medina (see "The Mosque," page 265). One of the finest hypostyle mosques, still in use today, is the mid-eighth-century Great Mosque (FIG. 10-8) at Kairouan in Abbasid Tunisia. It still houses its carved wooden minbar of 862, the oldest known. The precinct takes the form of a slightly askew parallelogram of huge scale, some 450×260 feet. Built of stone, its walls have sturdy buttresses, square in profile. A series of lateral entrances on the east and west lead to an arcaded forecourt (FIG. 10-8, no. 7) resembling a Roman forum (FIG. 7-43), oriented north-south on axis with the mosque's impressive minaret (no. 8) and the two domes of the hypostyle prayer hall (no. 4). The first dome (no. 6) is over the entrance bay, the second (no. 3) over the bay that fronts the mihrab (no. 2) set into the gibla wall (no. 1). A raised nave connects the domed spaces and prolongs the north-south axis of the minaret and courtyard. Eight columned aisles flank the nave on either side, providing space for a large congregation.

MALWIYA MINARET, SAMARRA The three-story minaret of the Kairouan mosque is square in plan, and scholars believe it is a near copy of a Roman lighthouse, but minarets can take a variety of forms. Perhaps the most striking and novel is that of the immense (more than 45,000 square yards) Great Mosque at Samarra, Iraq, the largest mosque in the world. The Abbasid caliph al-Mutawakkil (r. 847–861) erected it between 848 and 852. Known as the Malwiya ("snail shell" in Arabic) Minaret (FIG. 10-9) and more than 165 feet

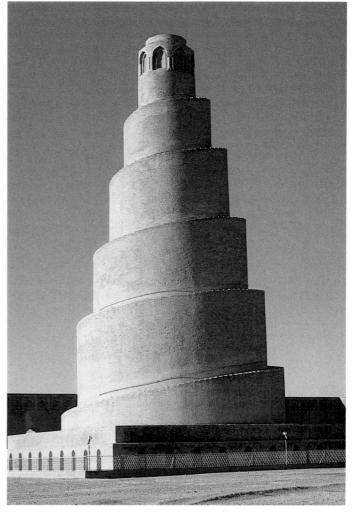

10-9 Malwiya Minaret, Great Mosque, Samarra, Iraq, 848–852.

The unique spiral Malwiya (snail shell) Minaret of Samarra's Great Mosque is more than 165 feet tall and can be seen from afar. It served to announce the presence of Islam in the Tigris Valley.

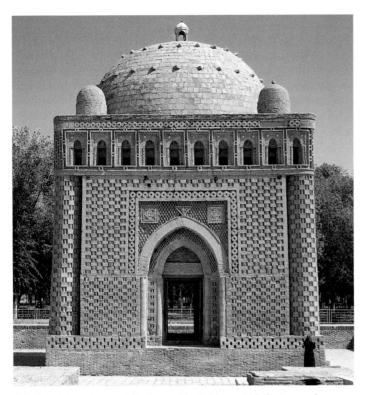

10-10 Mausoleum of the Samanids, Bukhara, Uzbekistan, early 10th century.

Monumental tombs were virtually unknown in the early Islamic period. The Samanid mausoleum at Bukhara is one of the oldest. Its dome-on-cube form had a long afterlife in Islamic funerary architecture.

tall, it now stands alone, but originally a bridge linked it to the mosque. The distinguishing feature of the brick tower is its stepped spiral ramp, which increases in slope from bottom to top. Once thought to be an ancient Mesopotamian *ziggurat*, the Samarra minaret inspired some European depictions of the biblical Tower of

Babel (Babylon's ziggurat; see "Babylon, City of Wonders," Chapter 2, page 34). Too tall to have been used to call Muslims to prayer, the Malwiya Minaret, visible from a considerable distance in the flat plain around Samarra, was probably intended to announce the presence of Islam in the Tigris Valley. Unfortunately, in 2005 the minaret suffered some damage during the Iraqi insurgency.

SAMANID MAUSOLEUM, BUKHARA Dynasties of governors who exercised considerable independence while recognizing the ultimate authority of the Baghdad caliphs oversaw the eastern realms of the Abbasid Empire. One of these dynasties, the Samanids (r. 819–1005), presided over the eastern frontier beyond the Oxus River (Transoxiana) on the border with India. In the early 10th century, they erected an impressive domed brick mausoleum (FIG. 10-10) at Bukhara in modern Uzbekistan. Monumental tombs were virtually unknown in the early Islamic period. Muhammad opposed elaborate burials and instructed his followers to bury him in a simple unmarked grave. In time, however, the Prophet's resting place in Medina acquired a wooden screen and a dome. By the ninth century, Abbasid caliphs were laid to rest in dynastic mausoleums.

The Samanid mausoleum at Bukhara is one of the earliest preserved tombs in the Islamic world. Constructed of baked bricks, it takes the form of a dome-capped cube with slightly sloping sides. With exceptional skill, the builders painstakingly shaped the bricks to create a vivid and varied surface pattern. Some of the bricks form engaged columns (half-round, attached columns) at the corners. A brick blind arcade (a series of arches in relief, with blocked openings) runs around all four sides. Inside, the walls are as elaborate as the exterior. The brick dome rests on arcuated brick squinches (see "Pendentives and Squinches," Chapter 9, page 235) framed by engaged colonnettes (thin columns). The dome-on-cube form had a long and distinguished future in Islamic funerary architecture (FIG. 10-18).

GREAT MOSQUE, CÓRDOBA At the opposite end of the Muslim world, Abd al-Rahman I, the only eminent Umayyad to escape the Abbasid massacre of his clan in Syria, fled to Spain in 750. There, the Arabs had overthrown the Christian kingdom of the

Visigoths in 711. The Arab military governors of the peninsula accepted the fugitive as their overlord, and he founded the Spanish Umayyad dynasty, which lasted almost three centuries. The capital of the Spanish Umayyads was Córdoba, which became the center of a brilliant culture rivaling that of the Abbasids at Baghdad and exerting major influence on the civilization of the Christian West.

The jewel of the capital at Córdoba was its Great Mosque, begun in 784 and enlarged several times during the 9th and 10th centuries. It eventually became one of the largest mosques in the Islamic West. The hypostyle prayer hall (FIG. 10-11) has 36

10-11 Prayer hall of the Great Mosque, Córdoba, Spain, 8th to 10th centuries.

Córdoba was the capital of the Umayyad dynasty in Spain. In the Great Mosque's hypostyle prayer hall, 36 piers and 514 columns support a unique series of doubletiered horseshoe-shaped arches.

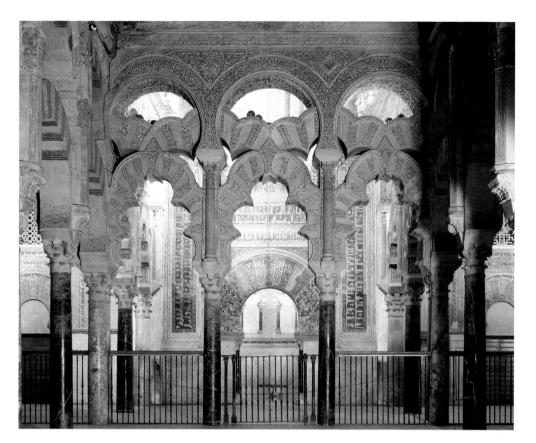

10-12 Maqsura of the Great Mosque, Córdoba, Spain, 961–965.

The magsura of the Córdoba mosque was reserved for the caliph and connected to his palace. Its design is a prime example of Islamic experimentation with highly decorative multilobed arches.

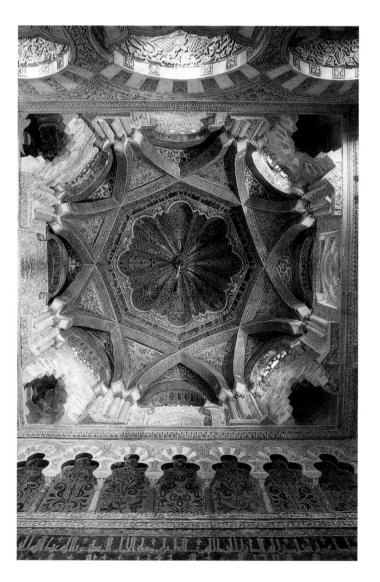

piers and 514 columns topped by a unique system of double-tiered arches that carried a wooden roof (later replaced by vaults). The two-story system was the builders' response to the need to raise the roof to an acceptable height using short columns that had been employed earlier in other structures. The lower arches are horseshoe-

shaped, a form perhaps adapted from earlier Near Eastern architecture or of Visigothic origin (FIG. 11-10). In the West, the horseshoe arch quickly became closely associated with Muslim architecture. Visually, these arches seem to billow out like windblown sails, and they contribute greatly to the light and airy effect of the Córdoba mosque's interior.

The caliph al-Hakam II (r. 961–976) undertook major renovations to the mosque. His builders expanded the prayer hall and added a series of domes. They also erected the elaborate maqsura (FIG. 10-12), the area reserved for the caliph and connected to his palace by a corridor in the qibla wall. The Córdoba maqsura is a prime example of Islamic experimentation with highly decorative, multilobed arches. The builders created rich and varied abstract patterns and further enhanced the magnificent effect of the complex arches by sheathing the walls with marbles and mosaics. The mosaicists and even the tesserae were brought to Spain from Constantinople by al-Hakam II, who wished to emulate the great mosaic-clad monuments his Umayyad predecessors had erected in Jerusalem (FIG. 10-3) and Damascus (FIG. 10-4).

The same desire for decorative effect also inspired the design of the dome (FIG. 10-13) that covers the area in front of the mihrab. One of the four domes built during the 10th century to emphasize the axis leading to the mihrab, the dome rests on an octagonal base of arcuated squinches. Crisscrossing ribs form an intricate pattern centered on two squares set at 45-degree angles to each other. The mosaics are the work of the same Byzantine artists responsible for the magsura's decoration.

10-13 Dome in front of the mihrab of the Great Mosque, Córdoba, Spain, 961–965.

The dome in front of the Córdoba mihrab rests on an octagonal base of arcuated squinches. Crisscrossing ribs form an intricate decorative pattern. Byzantine artists fashioned the mosaic ornament.

Luxury Arts

The furnishings of Islamic mosques and palaces reflect a love of sumptuous materials and rich decorative patterns. Muslim artisans skillfully worked metal, wood, glass, and ivory into a great variety of objects for sacred spaces or the home. Glass workers used colored glass with striking effect in mosque lamps. Artisans produced numerous ornate ceramics of high quality and created basins, ewers, jewel cases, writing boxes, and other decorative items from bronze or brass, often engraving these pieces and adding silver inlays. Artists employed silk and wool to fashion textiles featuring both abstract and pictorial motifs. Because wood is scarce in most of the Islamic world, the kinds of furniture used in the West—beds, tables, and chairs—are rare in Muslim buildings. Movable furnishings, therefore, do not define Islamic architectural spaces. A room's function (eating or sleeping, for example) can be changed simply by rearranging the carpets and cushions.

SILK Silk textiles are among the glories of Islamic art. Unfortunately, because of their fragile nature, early Islamic textiles are rare today and often fragmentary. Silk thread was also very expensive. Silkworms, which can flourish only in certain temperate regions, produce silk. Silk textiles were manufactured first in China in the third millennium BCE. They were shipped over what came to be called the Silk Road through Asia to the Middle East and Europe.

One of the earliest Islamic silks (FIG. 10-14) is today in Nancy, France, and probably dates to the eighth century. Unfortunately, the textile is fragmentary, and its colors, once rich blues, greens, and oranges, faded long ago. Said to come from Zandana near Bukhara, the precious fabric survives because of its association

10-14 Confronting lions and palm tree, fragment of a textile said to be from Zandana, near Bukhara, Uzbekistan, eighth century. Silk compound twill, $2' 11'' \times 2' 9\frac{1}{2}''$. Musée Historique de Lorraine, Nancy.

Early examples of Islamic silk textiles are rare because of their fragile nature. This fragmentary fabric from Uzbekistan features animal motifs that were common in secular contexts but shunned for mosques.

with the relics of Saint Amon housed in Toul Cathedral. It may have been used to wrap the treasures when they were transported to France in 820. The design, perhaps based on Sasanian models, consists of repeated medallions with confronting lions flanking a palm tree. Other animals scamper across the silk between the *roundels* (*tondi*, or circular frames). Such zoomorphic motifs are foreign to the decorative vocabulary of mosque architecture, but they could be found in Muslim households—even in Muhammad's in Medina. The Prophet, however, objected to curtains decorated with human or animal figures and permitted only cushions adorned with animals or birds.

METALWORK One of the most striking examples of Islamic metalwork is the cast brass ewer (FIG. 10-15) in the form of a bird signed by Sulayman and dated 796. Some 15 inches tall, the ewer is nothing less than a freestanding statuette, although the holes between the eyes and beak function as a spout and betray its utilitarian purpose. The decoration on the body, which bears traces of silver and copper inlay, takes a variety of forms. In places, the incised lines seem to suggest natural feathers, but the rosettes on the neck,

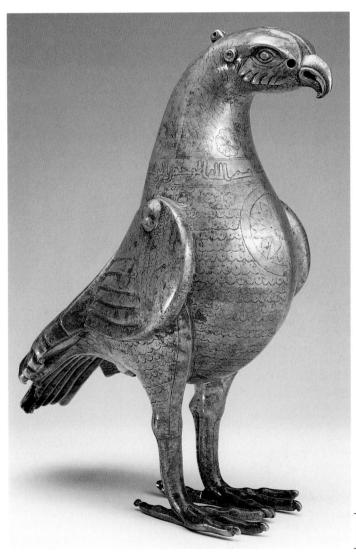

10-15 SULAYMAN, Ewer in the form of a bird, 796. Brass with silver and copper inlay, 1′ 3″ high. Hermitage, Saint Petersburg.

Signed and dated by its maker, this utilitarian bird ewer resembles a freestanding statuette. The engraved decoration of the body combines natural feathers with abstract motifs and Arabic calligraphy.

10-16 Koran page with the beginning of surah 18, "Al-Kahf" (The Cave), 9th or early 10th century. Ink and gold on vellum, $7\frac{1}{4}'' \times 10\frac{1}{4}''$. Chester Beatty Library and Oriental Art Gallery, Dublin.

The stately rectilinear Kufic script was used in the oldest known Korans. This page has five text lines and a palm-tree finial but characteristically does not include any depictions of animals or humans.

the large medallions on the breast, and the inscribed collar have no basis in anatomy. Similar motifs appear in Islamic textiles, pottery, and architectural tiles. The ready adaptability of motifs to various scales and techniques illustrates both the flexibility of Islamic design and the relative independence of the motifs from the surfaces they decorate.

CALLIGRAPHY In the Islamic world, the art of *calligraphy*, ornamental writing, held a place of honor even higher than the art of textiles. The faithful wanted to reproduce the Koran's sacred words in as beautiful a script as human hands could contrive. Passages from the Koran appeared not only on the fragile pages of books but also on the walls of buildings, for example, in the mosaic band above the outer ring of columns inside the Dome of the Rock (FIG. **10-3**). The practice of calligraphy was itself a holy task and required long and arduous training. The scribe had to possess exceptional spiritual refinement, as attested by an ancient Arabic proverb that proclaims "Purity of writing is purity of soul." Only in China does calligraphy hold as elevated a position among the arts.

Arabic script predates Islam. It is written from right to left with certain characters connected by a baseline. Although the chief Islamic book, the sacred Koran, was codified in the mid-seventh century, the earliest preserved Korans are datable to the ninth century. Koran pages were either bound into books or stored as loose sheets in boxes. Most of the early examples feature texts written in the script form called *Kufic*, after the city of Kufa, one of the renowned centers of Arabic calligraphy. Kufic script is quite angular, with the uprights forming almost right angles with the baseline. As with Hebrew and other Semitic languages, the usual practice was to write in consonants only. But to facilitate recitation of the Koran, scribes often indicated vowels by red or yellow symbols above or below the line.

All of these features can be seen on a 9th- or early-10th-century page (FIG. 10-16) now in Dublin that carries the heading and opening lines of surah 18 of the Koran. Five text lines in black ink with red vowels appear below a decorative band incorporating the chapter title in gold and ending in a palm-tree *finial* (a crowning ornament). This approach to page design has parallels at the extreme northwestern corner of the then-known world—in the early medieval manuscripts of the British Isles, where text and ornament are similarly united (FIG. 11-8). But the stylized human and animal forms that populate those Christian books never appear in Korans.

LATER ISLAMIC ART

The great centers of early Islamic art and architecture continued to flourish in the second millennium, but important new regional artistic centers emerged, especially in Turkey and South Asia. The discussion here centers on the later art and architecture of the Islamic Middle East, Spain, and Turkey.

Architecture

In the early years of the 11th century, the Umayyad caliphs' power in Spain unraveled, and their palaces fell prey to Berber soldiers from North Africa. The Berbers ruled southern Spain for several generations but could not resist the pressure of Christian forces from the north. Córdoba fell to the Christians in 1236. From then until the final Christian triumph in 1492, the Nasrids, an Arab dynasty that had established its capital at Granada in 1230, ruled the remaining Muslim territories in Spain.

ALHAMBRA On a rocky spur at Granada, the Nasrids constructed a huge palace-fortress called the Alhambra ("the Red" in Arabic) because of the rose color of the stone used for its walls and 23 towers. By the end of the 14th century, the complex, a veritable city with a population of 40,000, included at least a half dozen royal residences. Only two of these fared well over the centuries. Paradoxically, they owe their preservation to the Christian victors, who

maintained a few of the buildings as trophies commemorating the expulsion of the Nasrids. The two palaces present a vivid picture of court life in Islamic Spain before the Christian reconquest.

The Palace of the Lions takes its name from its courtyard (FIG. 10-1) that boasts a fountain with marble lions carrying a water basin on their backs. Colonnaded courtyards with fountains and statues have a long history in the Mediterranean world, especially in the houses and villas of the Roman Empire (see Chapter 7). The Alhambra's lion fountain is an unusual instance of freestanding stone sculpture in the Islamic world, unthinkable in a sacred setting. But the design of the courtyard is distinctly Islamic and features many multilobed pointed arches and lavish stuccoed walls in which calligraphy and abstract motifs are interwoven. The palace was the residence of Muhammad V (r. 1354–1391), and its courtyards, lush gardens, and luxurious carpets and other furnishings served to conjure the image of Paradise.

The Palace of the Lions is noteworthy also for its elaborate stucco ceilings. A spectacular example is the dome (FIG. 10-17) of the so-called Hall of the Abencerrajes. The dome rests on an octagonal drum supported by squinches and pierced by eight pairs of windows, but its structure is difficult to discern because of the intricate carved stucco decoration. The ceiling is covered with some 5,000 muqarnas—tier after tier of stalactite-like prismatic forms that seem aimed at denying the structure's solidity. The muqarnas ceiling was intended to catch and reflect sunlight as well as form beautiful

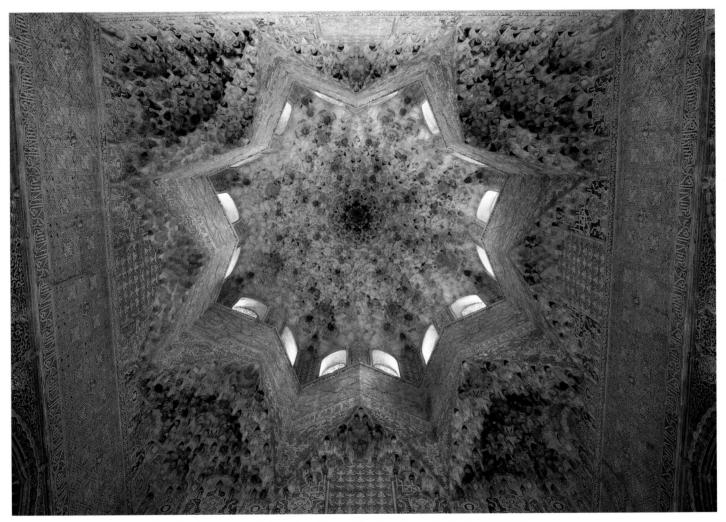

10-17 Mugarnas dome, Hall of the Abencerrajes, Palace of the Lions, Alhambra, Granada, Spain, 1354-1391.

The structure of this dome on an octagonal drum is difficult to discern because of the intricately carved stucco muqarnas decoration. The prismatic forms catch and reflect sunlight, creating the effect of a starry sky.

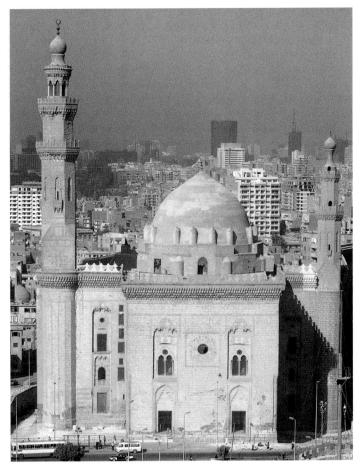

10-18 Madrasa-mosque-mausoleum complex of Sultan Hasan (looking northwest with the mausoleum in the foreground), Cairo, Egypt, begun 1356.

Hasan's mausoleum is a gigantic version of the much earlier Samanid mausoleum (FIG. 10-10). Because of its location directly south of the complex's mosque, praying Muslims faced the Mamluk sultan's tomb.

abstract patterns. The lofty vault in this hall and others in the palace symbolized the dome of Heaven. The flickering light and shadows create the effect of a starry sky as the sun's rays glide from window to window during the day. To underscore the symbolism, the palace walls bear inscriptions with verses by the court poet Ibn Zamrak (1333–1393), who compared the Alhambra's lacelike muqarnas ceilings to "the heavenly spheres whose orbits revolve."

MAUSOLEUM OF SULTAN HASAN In the mid-13th century, under the leadership of Genghis Khan, the Mongols from east-central Asia conquered much of the eastern Islamic world. The center of Islamic power moved from Baghdad to Egypt. The lords of Egypt at the time were former Turkish slaves ("mamluks" in Arabic) who converted to Islam. The capital of the Mamluk *sultans* (rulers) was Cairo, which became the largest Muslim city of the late Middle Ages. The Mamluks were prolific builders, and Sultan Hasan, although not an important figure in Islamic history, was the most ambitious of all. He ruled briefly as a child and was deposed, but regained the sultanate in 1354. He was assassinated in 1361.

Hasan's major building project in Cairo was a huge madrasa complex (FIGS. 10-18 and 10-19) on a plot of land about 8,000 square yards in area. A *madrasa* ("place of study" in Arabic) is a theological college devoted to the teaching of Islamic law. Hasan's complex was so large that it housed not only four such colleges for the study of the four major schools of Islamic law but also a mosque,

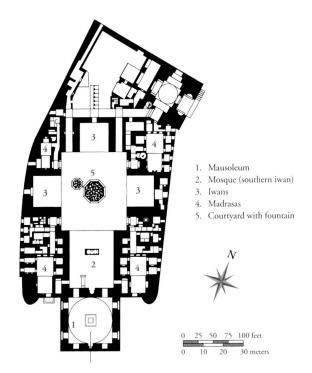

10-19 Plan of the madrasa-mosque-mausoleum complex of Sultan Hasan, Cairo, Egypt, begun 1356.

Sultan Hasan's complex comprised four madrasas as well as a mosque, his tomb, and various other buildings. The plan with four iwans opening onto a central courtyard derives from that of Iranian mosques.

mausoleum, orphanage, and hospital, as well as shops and baths. Like all Islamic building complexes incorporating religious, educational, and charitable functions, this one was supported by an endowment funded by rental properties. The income from these paid the salaries of attendants and faculty, provided furnishings and supplies such as oil for the lamps or free food for the poor, and supported scholarships for needy students.

The grandiose structure has a large central courtyard (FIG. 10-19, no. 5) with a monumental fountain in the center and four vaulted iwans opening onto it, a design used earlier for Iranian mosques (see "The Mosque," page 265). In each corner of the main courtyard, between the iwans (FIG. 10-19, no. 3), is a madrasa (no. 4) with its own courtyard and four or five stories of rooms for the students. The largest iwan (no. 2) in the complex, on the southern side, served as a mosque. Contemporaries believed the soaring vault that covered this iwan was taller than the arch of the Sasanian palace (FIG. 2-27) at Ctesiphon, which was then one of the most admired engineering feats in the world. Behind the gibla wall stands the sultan's mausoleum (FIGS. 10-18 and 10-19, no. 1), a gigantic version of the type of the Samanid tomb (FIG. 10-10) at Bukhara. The builders intentionally placed the dome-covered cube south of the mosque so that the prayers of the faithful facing Mecca would be directed toward Hasan's tomb. (Only the sultan's two sons are buried there, however. Hasan's body was not returned when he was killed.)

A muqarnas cornice crowns the exterior walls of the complex, and marble plaques of several colors cover the mihrab in the mosque and the walls of Hasan's mausoleum. But the complex as a whole is relatively austere, characterized by its massiveness and geometric clarity. It presents a striking contrast to the filigreed elegance of the contemporary Alhambra (FIGS. 10-1 and 10-17) and testifies to the diversity of regional styles within the Islamic world, especially after the end of the Umayyad and Abbasid dynasties.

Sinan the Great and the Mosque of Selim II

inan (ca. 1491–1588), called Sinan the Great, was truly the greatest Ottoman architect. Born a Christian, he was recruited for service in the Ottoman government, converted to Islam, and was trained in engineering and the art of building while in the Ottoman army. Officials quickly recognized his talent and entrusted him with increasing responsibility until, in 1538, he was appointed the chief court architect for Suleyman the Magnificent (r. 1520–1566), a generous patron of art and architecture. Architectural historians have attributed to Sinan hundreds of building projects, both sacred and secular, although he could not have been involved with all that bear his name.

The capstone of Sinan's distinguished career was the Edirne mosque (FIGS. 10-20 and 10-21) of Suleyman's son, Selim II, which Sinan designed when he was almost 80 years old. In this masterwork, he sought to surpass the greatest achievements of Byzantine architects, just as Sultan Hasan's builders in Cairo attempted to rival and exceed the Sasanian architects of antiquity. Sa'i Mustafa Çelebi, Sinan's biographer, recorded the architect's accomplishment in his own words:

Sultan Selim Khan ordered the erection of a mosque in Edirne.... His humble servant [I, Sinan] prepared for him a drawing depicting,

10-20 Sinan, Mosque of Selim II, Edirne, Turkey, 1568-1575.

The Ottomans developed a new type of mosque with a square prayer hall covered by a dome. Sinan's Mosque of Selim II has a taller dome than Hagia Sophia's (FIG. 9-4) and is an engineering triumph.

on a dominating site in the city, four minarets on the four corners of a dome. . . . Those who consider themselves architects among Christians say that in the realm of Islam no dome can equal that of the Hagia Sophia; they claim that no Muslim architect would be able to build such a large dome. In this mosque, with the help of God and the support of Sultan Selim Khan, I erected a dome six cubits higher and four cubits wider than the dome of the Hagia Sophia.*

The Edirne dome is, in fact, higher than Hagia Sophia's (FIG. 9-4) when measured from its base, but its crown is not as far above the pavement. Nonetheless, Sinan's feat won universal acclaim as a triumph. The Ottomans considered the Mosque of Selim II proof that they finally had outshone the Christian emperors of Byzantium in the realm of architecture.

*Aptullah Kuran, Sinan: The Grand Old Master of Ottoman Architecture (Washington, D.C.: Institute of Turkish Studies, 1987), 168–169.

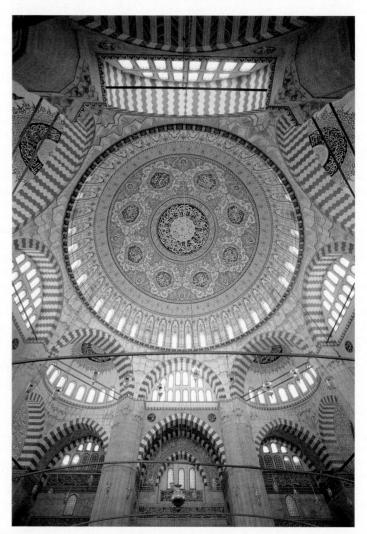

10-21 Sinan, interior of the Mosque of Selim II, Edirne, Turkey, 1568–1575.

The interior of Sinan's Edirne mosque is a fusion of an octagon and a dome-covered square with four half-domes at the corners. The plan features geometric clarity and precise numerical ratios.

OTTOMAN EMPIRE During the course of the 9th to 11th centuries, the Turkic people, of central Asian origin, largely converted to Islam. They moved into Iran and the Near East in the 11th century, and by 1055 the Seljuk Turkish dynasty had built an extensive, although short-lived, empire that stretched from India to western Anatolia. By the end of the 12th century, this empire had broken up into regional states, and in the early 13th century it came under the sway of the Mongols, led by Genghis Khan. After the downfall of the Seljuks, several local dynasties established themselves in Anatolia, among them the Ottomans, founded by Osman I (r. 1281–1326). Under Osman's successors, the Ottoman state expanded for two and a half centuries throughout vast areas of Asia, Europe, and North Africa to become, by the middle of the 15th century, one of the great world powers.

The Ottoman emperors were lavish patrons of architecture. Ottoman builders developed a new type of mosque with a square prayer hall covered by a dome as its core. In fact, the dome-covered square, which had been a dominant form in Iran and was employed for the 10th-century Samanid mausoleum (FIG. 10-10), became the nucleus of all Ottoman architecture. The combination had an appealing geometric clarity. At first used singly, the domed units came to be used in multiples, a turning point in Ottoman architecture.

After the Ottoman Turks conquered Constantinople (Istanbul) in 1453, they firmly established their architectural code. The new lords of Constantinople were impressed by Hagia Sophia (FIGS. 9-2 to 9-4), which, in some respects, conformed to their own ideals. They converted the Byzantine church into a mosque with minarets. But the longitudinal orientation of Hagia Sophia's interior never satisfied Ottoman builders, and Anatolian development moved instead toward the central-plan mosque.

SINAN THE GREAT The first examples of the central-plan mosque were built in the 1520s, eclipsed later only by the works of the most famous Ottoman architect, SINAN (ca. 1491–1588). A contemporary of the great Italian Renaissance sculptor, painter, and architect Michelangelo (see Chapter 17), and with equal aspirations to immortality, Sinan perfected the Ottoman architectural style. By his time, Ottoman builders almost universally were using the basic domed unit, which they could multiply, enlarge, contract, or combine as needed. Thus, the typical Ottoman building of Sinan's time was a creative assemblage of domical units and artfully juxtaposed geometric spaces.

Builders usually erected domes with an extravagant margin of structural safety that has since served them well in earthquake-prone Istanbul and other Ottoman cities. (Vivid demonstration of the sound construction of Ottoman mosques came in August 1999 when a powerful earthquake centered 65 miles east of Istanbul toppled hundreds of modern buildings and killed thousands of people but caused no damage to the centuries-old mosques.) Working within this architectural tradition, Sinan searched for solutions to the problems of unifying the additive elements and of creating a monumental centralized space with harmonious proportions.

Sinan's vision found ultimate expression in the Mosque of Selim II (FIG. 10-20) at Edirne, which had been the capital of the Ottoman Empire from 1367 to 1472 and where Selim II (r. 1566-1574) maintained a palace. There, Sinan designed a mosque with a massive dome set off by four slender pencil-shaped minarets (each more than 200 feet high, among the tallest ever constructed). The dome's height surpasses that of Hagia Sophia (see "Sinan the Great and the Mosque of Selim II," page 274). But it is the organization of the Edirne mosque's interior space (FIG. 10-21) that reveals the genius of its builder. The mihrab is recessed into an apselike alcove deep enough to permit window illumination from three sides, making the brilliantly colored tile panels of its lower walls sparkle as if with their own glowing light. The plan of the main hall is an ingenious fusion of an octagon with the dome-covered square. The octagon, formed by the eight massive dome supports, is pierced by the four halfdome-covered corners of the square. The result is a fluid interpenetration of several geometric volumes that represents the culminating solution to Sinan's lifelong search for a monumental unified interior space. Sinan's forms are clear and legible, like mathematical equations. Height, width, and masses are related to one another in a simple but effective ratio of 1:2, and precise numerical ratios also characterize the complex as a whole. The forecourt of the building, for example, covers an area equal to that of the mosque proper. The Mosque of Selim II is generally regarded as the climax of Ottoman architecture. Sinan proudly proclaimed it his masterpiece.

GREAT MOSQUE, ISFAHAN The Mosque of Selim II at Edirne was erected during a single building campaign under the direction of a single master architect, but the construction of many other major Islamic architectural projects extended over several centuries. A case in point is the Great Mosque (FIG. 10-22) at Isfahan

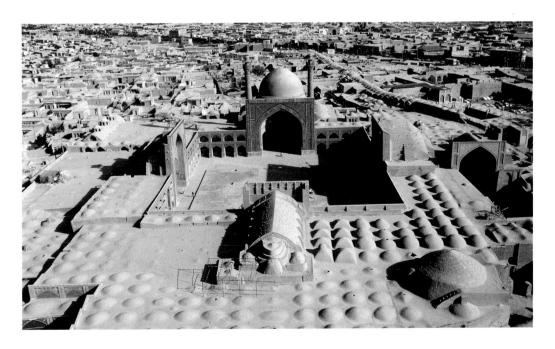

10-22 Aerial view (looking southwest) of the Great Mosque, Isfahan, Iran, 11th to 17th centuries.

The typical Iranian mosque plan with four vaulted iwans and a courtyard may have been employed for the first time in the mosque Sultan Malik Shah I built in the late 11th century at his capital of Isfahan.

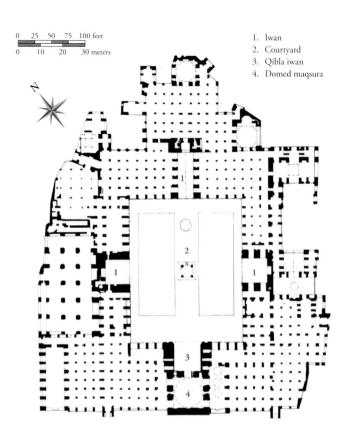

10-23 Plan of the Great Mosque, Isfahan, Iran, 11th to 17th centuries.

In the Great Mosque at Isfahan, as in other four-iwan mosques, the qibla iwan is the largest. Its size and the dome-covered maqsura in front of it indicated the proper direction for Muslim prayer.

in Iran. The earliest mosque on the site, of the hypostyle type, dates to the eighth century, during the Abbasid caliphate. But Sultan Malik Shah I (r. 1072–1092), whose capital was at Isfahan, transformed the structure in the 11th century. Later remodeling further altered the mosque's appearance. The present mosque, which retains its basic 11th-century plan (FIG. 10-23), consists of a large courtyard bordered by a two-story arcade on each side. As in the 14th-century complex (FIG. 10-19) of Sultan Hasan in Cairo, four iwans open onto the courtyard, one at the center of each side. The southwestern iwan (FIG. 10-23, no. 3) leads into a dome-covered room (no. 4) in front of the mihrab. It functioned as a maqsura reserved for the sultan and his attendants. It is uncertain whether this plan, with four iwans and a dome in front of the mihrab, was employed for the first time in the Great Mosque at Isfahan, but it became standard in Iranian mosque design. In four-iwan mosques, the qibla iwan is always the largest. Its size (and the dome that often accompanied it) immediately indicated to worshipers the proper direction for prayer.

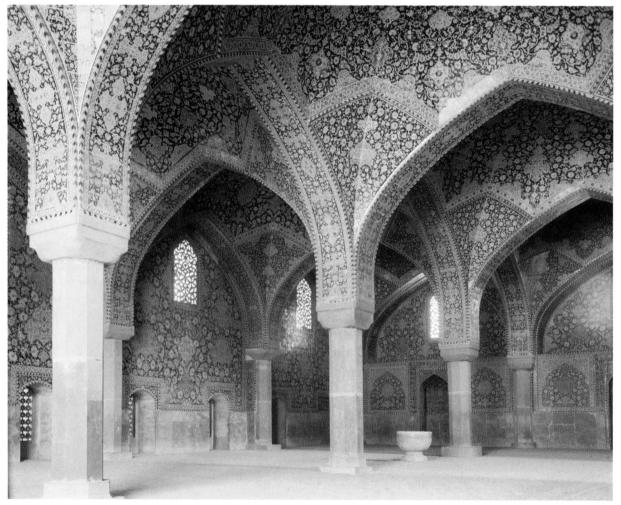

10-24 Winter prayer hall of the Shahi (Imam) Mosque, Isfahan, Iran, 1611-1638.

The ceramists who produced the cuerda seca tiles of this Isfahan mosque's winter prayer hall had to manufacture a wide variety of shapes with curved surfaces to cover the hall's arches and vaults.

Islamic Tilework

rom the Dome of the Rock (FIGS. 10-2 and 10-3), the earliest major Islamic building, to the present day, architects have used mosaics or ceramic tiles to decorate the walls and vaults of mosques, madrasas, palaces, and tombs. The golden age of Islamic tilework was the 16th and 17th centuries. At that time, Islamic artists used two basic techniques to enliven building interiors with brightly colored tiled walls and to sheathe their exteriors with gleaming tiles that reflected the sun's rays.

In *mosaic tilework* (for example, FIG. **10-25**), large ceramic panels of single colors are fired in the potter's kiln and then cut into smaller pieces and set in plaster in a manner similar to the laying of mosaic tesserae of stone or glass (see "Mosaics," Chapter 8, page 223).

Cuerda seca (dry cord) tilework was introduced in Umayyad Spain during the 10th century—hence its Spanish name even in Middle Eastern and Central Asian contexts. Cuerda seca tiles (for example, FIG. 10-24) are polychrome and can more easily bear complex geometric and vegetal patterns as well as Arabic script. They are more economical to use because vast surfaces can be covered with large tiles much more quickly than they can with thousands of smaller mosaic tiles. But when such tiles are used to sheathe curved surfaces, the ceramists must fire the tiles in the exact shape required. Polychrome tiles have other drawbacks. Because all the glazes are fired at the same temperature, cuerda seca tiles are not as brilliant in color as mosaic tiles and do not reflect light the way the more irregular surfaces of tile mosaics do. The preparation of the multicolored tiles also requires greater care. To prevent the colors from running together during firing, the potters must outline the motifs on cuerda seca tiles with greased cords containing manganese, which leaves a matte black line between the colors after firing.

10-25 Mihrab from the Madrasa Imami, Isfahan, Iran, ca. 1354. Glazed mosaic tilework, 11' 3" \times 7' 6". Metropolitan Museum of Art, New York.

The Madrasa Imami mihrab is a masterpiece of mosaic tilework. Every piece had to be cut to fit its specific place in the design. It exemplifies the perfect aesthetic union between Islamic calligraphy and ornament.

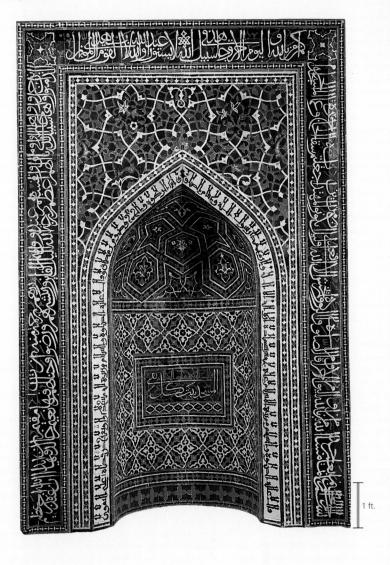

IRANIAN TILEWORK The iwans of the Isfahan mosque feature soaring pointed arches framing tile-sheathed muqarnas vaults. The muqarnas ceilings probably date to the 14th century, and the ceramic-tile revetment on the walls and vaults is the work of the 17th-century Safavid rulers of Iran. The use of glazed tiles has a long history in the Middle East. Even in ancient Mesopotamia, builders sometimes covered gates and walls with colorful baked bricks (FIG. **2-24**). In the Islamic world, the art of ceramic tilework reached its peak in the 16th and 17th centuries in Iran and Turkey (see "Islamic Tilework," above). Employed as a veneer over a brick core, tiles could sheathe entire buildings, including domes and minarets.

SHAHI MOSQUE, ISFAHAN The Shahi (or Royal) Mosque in Isfahan, now known as the Imam Mosque, which dates from the early 17th century, is widely recognized as one of the masterpieces of Islamic tilework. Its dome is a prime example of tile mosaic, and its winter prayer hall (FIG. 10-24) houses one of the finest ensembles

of cuerda seca tiles in the world. Covering the walls, arches, and vaults of the prayer hall presented a special challenge to the Isfahan ceramists. They had to manufacture a wide variety of shapes with curved surfaces to sheathe the complex forms of the hall. The result was a technological triumph as well as a dazzling display of abstract ornament.

MADRASA IMAMI, ISFAHAN As already noted, verses from the Koran appeared in the mosaics of the Dome of the Rock (Fig. 10-3) in Jerusalem and in mosaics and other media on the walls of countless later Islamic structures. Indeed, some of the masterworks of Arabic calligraphy are not in manuscripts but on walls. A 14th-century mihrab (Fig. 10-25) from the Madrasa Imami in Isfahan exemplifies the perfect aesthetic union between the Islamic calligrapher's art and abstract ornament. The pointed arch that immediately frames the mihrab niche bears an inscription from the Koran in Kufic, the stately rectilinear script used in the ninth-century Koran (Fig. 10-16) discussed earlier. Many supple cursive styles also

make up the repertoire of Islamic calligraphy. One of these styles, known as Muhaqqaq, fills the mihrab's outer rectangular frame. The mosaic tile ornament on the curving surface of the niche and the area above the pointed arch are composed of tighter and looser networks of geometric and abstract floral motifs. The mosaic technique is masterful. Every piece had to be cut to fit its specific place in the mihrab—even the tile inscriptions. The framed inscription in the center of the niche—proclaiming that the mosque is the domicile of the pious believer—is smoothly integrated with the subtly varied patterns. The mihrab's outermost inscription—detailing the five pillars of Islamic faith—serves as a fringelike extension, as well as a boundary, for the entire design. The calligraphic and geometric elements are so completely unified that only the practiced eye can distinguish them. The artist transformed the architectural surface into a textile surface—the three-dimensional wall into a two-dimensional hanging—weaving the calligraphy into it as another cluster of motifs within the total pattern.

Luxury Arts

The tile-covered mosques of Isfahan, Sultan Hasan's madrasa complex in Cairo, and the architecture of Sinan the Great in Edirne are enduring testaments to the brilliant artistic culture of the Safavid,

Mamluk, and Ottoman rulers of the Muslim world. Yet these are only some of the most conspicuous public manifestations of the greatness of later Islamic art and architecture. In the smaller-scale, and often private, realm of the luxury arts, Muslim artists also excelled. From the vast array of manuscript paintings, ceramics, textiles, and metalwork, six masterpieces may serve to suggest both the range and the quality of the inappropriately dubbed Islamic "minor arts" of the 13th to 16th centuries.

TIMURID *BUSTAN* In the late 14th century, a new Islamic empire arose in Central Asia under the leadership of Timur (r. 1370–1405), known in the Western world as Tamerlane. Timur, a successor of the Mongol Genghis Khan, quickly extended his dominions to include Iran and parts of Anatolia. The Timurids ruled until 1501 and were great patrons of art and architecture in cities such as Herat, Bukhara, and Samarqand. Herat in particular became a leading center for the production of luxurious books under the patronage of the Timurid sultan Husayn Mayqara (r. 1470–1506).

The most famous Persian painter of his age was BIHZAD, who worked at the Herat court and illustrated the sultan's copy of Sadi's *Bustan* (*Orchard*). One page (FIG. 10-26) represents a story in both the Bible and the Koran—the seduction of Yusuf (Joseph) by

10-26 Bihzad, Seduction of Yusuf, folio 52 verso of the Bustan of Sultan Husayn Mayqara, from Herat, Afghanistan, 1488. Ink and color on paper, $11\frac{7}{8}'' \times 8\frac{5}{8}''$. National Library, Cairo.

The most famous
Timurid manuscript
painter was Bihzad.
This page displays
vivid color, intricate
decorative detailing,
and a brilliant
balance between
two-dimensional
patterning and
perspective.

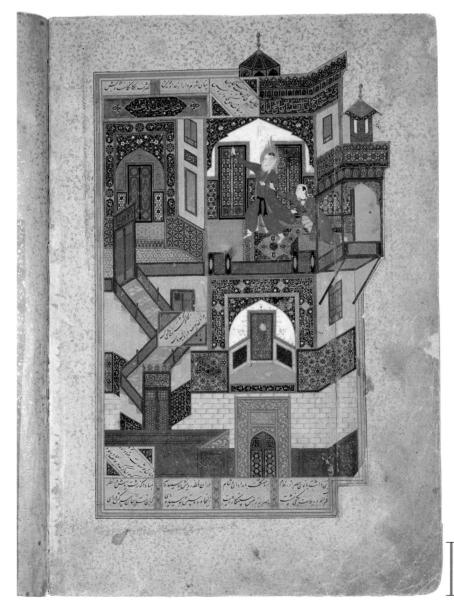

1 in

Potiphar's wife Zulaykha. Sadi's text is dispersed throughout the page in elegant Arabic script in a series of beige panels. According to the tale as told by Jami (1414–1492), an influential mystic theologian and poet whose Persian text appears in blue in the white pointed arch at the lower center of the composition, Zulaykha lured Yusuf into her palace and led him through seven rooms, locking each door behind him. In the last room she threw herself at Yusuf, but he resisted and was able to flee when the seven doors opened miraculously. Bihzad's painting of the story is characterized by vivid color, intricate decorative detailing suggesting luxurious textiles and tiled walls, and a brilliant balance between two-dimensional patterning and perspectival depictions of balconies and staircases.

SAFAVID *SHAHNAMA* The successors of the Timurids in Iran were the Safavids. Shah Tahmasp (r. 1524–1576) was a great patron of books. Around 1525 he commissioned an ambitious decade-long project to produce an illustrated 742-page copy of the *Shahnama* (*Book of Kings*). The *Shahnama* is the Persian national epic poem by Firdawsi (940–1025). It recounts the history of Iran from the Creation until the Muslim conquest. Tahmasp's *Shahnama* contains 258 illustrations by many artists, including some of the most renowned painters of the day. It was eventually presented as a gift to Selim II, the Ottoman sultan who was the patron of Sinan's

mosque (FIGS. 10-20 and 10-21) at Edirne. The manuscript later entered a private collection in the West and ultimately was auctioned as a series of individual pages, destroying the work's integrity but underscoring that Western collectors viewed each page as a masterpiece.

The page reproduced here (FIG. 10-27) is the work of Sultan-MUHAMMAD and depicts Gayumars, the legendary first king of Iran, and his court. According to tradition, Gayumars ruled from a mountaintop when humans first learned to cook food and clothe themselves in leopard skins. In Sultan-Muhammad's representation of the story, Gayumars presides over his court (all the figures wear leopard skins) from his mountain throne. The king is surrounded by light amid a golden sky. His son and grandson perch on multicolored rocky outcroppings to the viewer's left and right, respectively. The court encircles the ruler and his heirs. Dozens of human faces appear within the rocks themselves. Many species of animals populate the lush landscape. According to the Shahnama, wild beasts became instantly tame in the presence of Gayumars. Sultan-Muhammad rendered the figures, animals, trees, rocks, and sky with an extraordinarily delicate touch. The sense of lightness and airiness that permeate the painting is enhanced by its placement on the page—floating, off center, on a speckled background of gold leaf. The painter gave his royal patron a singular vision of Iran's fabled past.

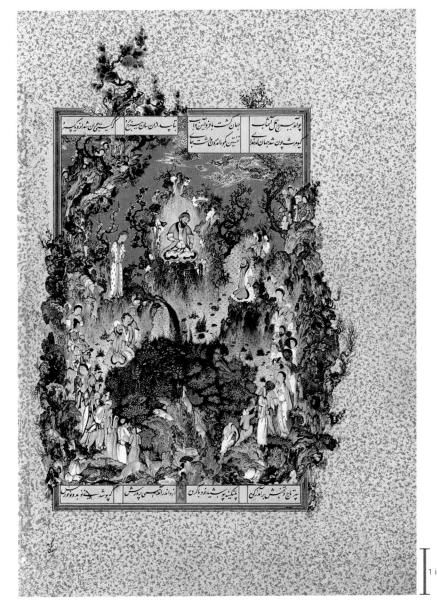

10-27 SULTAN-MUHAMMAD, Court of Gayumars, folio 20 verso of the Shahnama of Shah Tahmasp, from Tabriz, Iran, ca. 1525–1535. Ink, watercolor, and gold on paper, 1' 1" × 9". Prince Sadruddin Aga Khan Collection, Geneva.

Sultan-Muhammad painted the story of the legendary king Gayumars for the Safavid ruler Shah Tahmasp. The off-center placement on the page enhances the sense of lightness that permeates the painting.

10-28 Maqsud of Kashan, carpet from the funerary mosque of Shaykh Safi al-Din, Ardabil, Iran, 1540. Knotted pile of wool and silk, 34' $6'' \times 17'$ 7''. Victoria & Albert Museum, London.

Maqsud of Kashan's enormous Ardabil carpet required roughly 25 million knots. It presents the illusion of a heavenly dome with mosque lamps reflected in a pool of water with floating lotus blossoms.

ARDABIL CARPETS Tahmasp also elevated carpet weaving to a national industry and set up royal factories at Isfahan, Kashan, Kirman, and Tabriz. Two of the masterworks of carpet weaving that date to his reign are the pair of carpets from the two-centuries older funerary mosque of Shaykh Safi al-Din (1252–1334), the founder of the Safavid line. The name Magsud of Kashan is woven into the design of the carpet illustrated here (FIG. 10-28). He must have been the designer who supplied the master pattern to two teams of royal weavers (one for each of the two carpets). The carpet, almost 35×18 feet, consists of roughly 25 million knots, some 340 to the square inch. (Its twin has even more knots.)

The design consists of a central sunburst medallion, representing the inside of a dome, surrounded by 16 pendants. Mosque lamps (appropriate motifs for the Ardabil funerary mosque) are suspended from two pendants on the long axis of the carpet. The lamps are of different sizes. This may be an optical device to make the two appear equal in size when viewed from the end of the carpet at the room's threshold (the bottom end in FIG. 10-28). The rich blue background is covered with leaves and flowers attached to delicate stems that spread over the whole field. The entire composition presents the illusion of a heavenly dome with lamps reflected in a pool of water full of floating lotus blossoms. No human or animal figures appear, as befits a carpet intended for a mosque, although they can be found on other Islamic textiles used in secular contexts, both earlier (FIG. 10-14) and later.

MOSQUE LAMPS Mosque lamps were often made of glass and highly decorated. Islamic artists perfected this art form and fortunately, despite their exceptionally fragile nature, many examples survive, in large part because the lamps were revered by those who han-

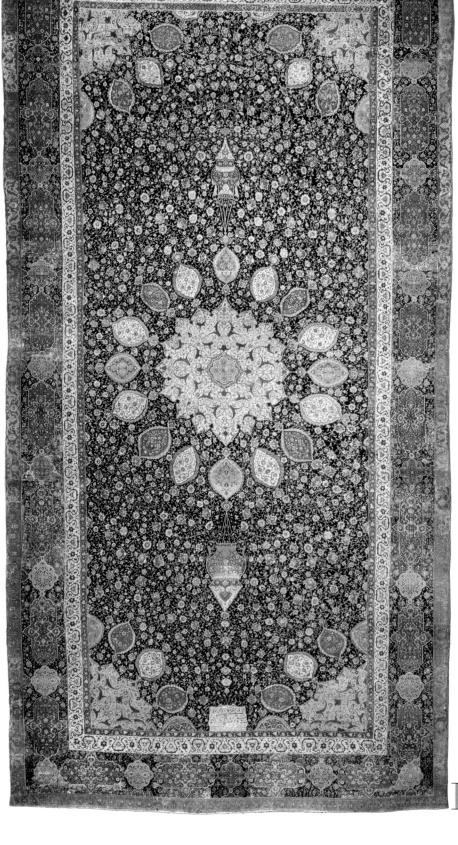

dled them. One of the finest is the mosque lamp (FIG. 10-29) made for Sayf al-Din Tuquztimur (d. 1345), an official in the court of the Mamluk sultan al-Nasir Muhammad. The glass lamps hung on chains from the mosque's ceilings. The shape of Tuquztimur's lamp

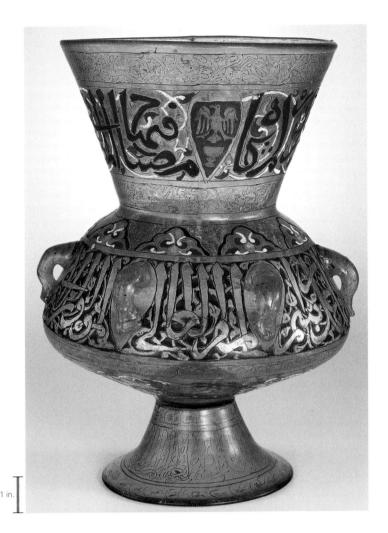

10-29 Mosque lamp of Sayf al-Din Tuquztimur, from Egypt, 1340. Glass with enamel decoration, 1' 1" high. British Museum, London.

The enamel decoration of this glass mosque lamp includes a quotation from the Koran comparing God's light to the light in a lamp. The burning wick dramatically illuminated the sacred verse.

is typical of the period, consisting of a conical neck, wide body with six vertical handles, and a tall foot. Inside, a small glass container held the oil and wick. The *enamel* decoration (colors fused to the surfaces) includes Tuquztimur's emblem—an eagle over a cup (Tuquztimur served as the sultan's cup-bearer). Cursive Arabic calligraphy, also in enamel, gives the official's name and titles as well as a quotation of the Koranic verse (24:35) comparing God's light to the light in a lamp. When the lamp was lit, the verse (and Tuquztimur's name) would have been dramatically illuminated.

BAPTISTÈRE DE SAINT LOUIS Metalwork was another early Islamic art form (FIG. 10-15) that continued to play an important role in the later period. An example of the highest quality is a brass basin (FIG. 10-30) from Egypt inlaid with gold and silver and signed—six times—by the Mamluk artist MUHAMMAD IBN AL-ZAYN. The basin, used for washing hands at official ceremonies, must have been fashioned for a specific Mamluk patron. Some scholars think a court official named Salar ordered the piece as a gift for his sultan, but no inscription identifies him. The central band depicts Mamluk hunters and Mongol enemies. Running animals fill the friezes above and below. Stylized vegetal forms of inlaid silver fill the background of all the bands and roundels. Figures and animals also decorate the inside and underside of the basin. This Mamluk basin has long been

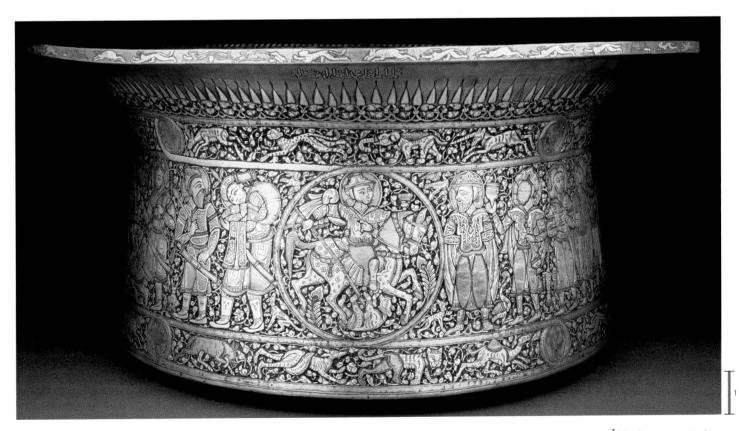

10-30 Muhammad IBN AL-ZAYN, basin (Baptistère de Saint Louis), from Egypt, ca. 1300. Brass, inlaid with gold and silver, $8\frac{3}{4}$ " high. Louvre, Paris. Muhammad ibn al-Zayn proudly signed (six times) this basin used for washing hands at official ceremonies. The central band, inlaid with gold and silver, depicts Mamluk hunters and Mongol enemies.

Christian Patronage of Islamic Art

uring the 11th, 12th, and 13th centuries, large numbers of Christians traveled to Islamic lands, especially to the Christian holy sites in Jerusalem and Bethlehem, either as pilgrims (see "Pilgrimages," Chapter 12, page 310) or as Crusaders (see "The Crusades," Chapter 12, page 320). Many returned with mementos of their journey, usually in the form of inexpensive mass-produced souvenirs. But some wealthy individuals commissioned local Muslim artists to produce custom-made pieces using costly materials.

A unique brass canteen (FIG. 10-31) inlaid with silver and decorated with scenes of the life of Christ appears to be the work of a 13th-century Ayyubid metalsmith in the employ of a Christian patron. The canteen is a luxurious version of the "pilgrim flasks" Christian visitors to the Holy Land often brought back to Europe. Four inscriptions in Arabic promise eternal glory, secure life, perfect prosperity, and increasing good luck to the canteen's owner, who is unfortunately not named. That the owner was a Christian is sug-

gested not only by the type of object but also by the choice of scenes engraved into the canteen. The Madonna and Christ Child appear enthroned in the central medallion, and three panels depicting New Testament events (see "The Life of Jesus in Art," Chapter 8, pages 216–217) fill most of the band around the medallion. The narrative unfolds in a counterclockwise sequence (Arabic is read from right to left), beginning with the Nativity (at 2 o'clock) and continuing with the Presentation in the Temple (10 o'clock) and the Entry into Jerusalem (6 o'clock). The scenes may have been chosen because the patron had visited their locales (Bethlehem and Jerusalem), Most scholars believe that the artist used Syrian Christian manuscripts as the source for the canteen's Christian iconography. Many of the decorative details, however, are common in contemporary Islamic metalwork inscribed with the names of Muslim patrons. Whoever the owner was, the canteen testifies to the fruitful artistic interaction between Christians and Muslims in 13th-century Syria.

10-31 Canteen with episodes from the life of Christ, from Syria, ca. 1240–1250. Brass, inlaid with silver, $1' 2\frac{1}{2}''$ high. Freer Gallery of Art, Washington, D.C.

This unique canteen is the work of an Ayyubid metalsmith in the employ of a Christian pilgrim to the Holy Land. The three scenes from the life of Jesus appear in counterclockwise sequence.

1 in

known as the *Baptistère de Saint Louis*, but the association with the famous French king (see "Louis IX, the Saintly King," Chapter 13, page 360) is a myth. Louis died before the piece was made. Nonetheless, the *Baptistère*, brought to France long ago, was used in the baptismal rites of newborns of the French royal family as early as the

17th century. Like the Zandana silk (FIG. 10-14) from Toul Cathedral and a canteen (FIG. 10-31) adorned with scenes of the life of Christ (see "Christian Patronage of Islamic Art," above), Muhammad ibn al-Zayn's basin testifies to the prestige of Islamic art well outside the boundaries of the Islamic world.

THE ISLAMIC WORLD

UMAYYAD SYRIA AND ABBASID IRAQ, 661-1258

- The Umayyads (r. 661–750) were the first Islamic dynasty and ruled from their capital at Damascus in Syria until they were overthrown by the Abbasids (r. 750–1258), who established their capital at Baghdad in Iraq.
- The first great Islamic building is the Dome of the Rock. The domed octagon commemorated the triumph of Islam in Jerusalem, which the Muslims captured from the Byzantines in 638.
- Umayyad and Abbasid mosques, for example, those in Damascus and in Kairouan (Tunisia), are of the hypostyle-hall type and incorporate arcaded courtyards and minarets. The mosaic decoration of early mosques was often the work of Byzantine artists but excludes zoomorphic forms.
- The earliest preserved Korans date to the 9th century and feature Kufic calligraphy and decorative motifs but no figural illustrations.

Dome of the Rock, Jerusalem, 687–692

ISLAMIC SPAIN, 756-1492

- Abd-al-Rahman I established the Umayyad dynasty (r. 756–1031) in Spain after he escaped the Abbasid massacre of his clan in 750.
- The Umayyad capital was at Córdoba, where the caliphs erected and expanded the Great Mosque between the 8th and 10th centuries. The mosque features horseshoe and multilobed arches and mosaic-clad domes that rest on arcuated squinches.
- The last Spanish Muslim dynasty was the Nasrid (r. 1230–1492), whose capital was at Granada. The Alhambra is the best surviving example of Islamic palace architecture. It is famous for its stuccoed walls and arches and its mugarnas vaults and domes.

Great Mosque, Córdoba, 8th to 10th centuries

ISLAMIC EGYPT, 909-1517

- The Fatimids (r. 909–1171) established their caliphate in Egypt in 909 and ruled from their capital in Cairo. They were succeeded by the Ayyubids (r. 1171–1250) and the Mamluks (r. 1250–1517).
- The most ambitious Mamluk builder was Sultan Hasan, whose madrasa-mosque-mausoleum complex in Cairo is based on Iranian four-iwan mosque designs.
- Among the greatest works of the Islamic metalsmith's art is Muhammad ibn al-Zayn's brass basin inlaid with gold and silver and engraved with figures of Mamluk hunters and Mongol enemies.

Muhammad ibn al-Zayn, brass basin, ca. 1300

TIMURID AND SAFAVID IRAN AND CENTRAL ASIA, 1370-1732

- The Timurid (r. 1370–1501) and Safavid (r. 1501–1732) dynasties ruled Iran and Central Asia for almost four centuries and were great patrons of art and architecture.
- The Timurid court at Herat, Afghanistan, employed the most famous painters of the day, who specialized in illustrating books.
- Persian painting also flourished in Safavid Iran under Shah Tahmasp (r. 1524–1576), who in addition set up royal carpet factories in several cities.
- The art of tilework reached its peak under the patronage of the Safavid dynasty, when builders frequently used mosaic and cuerda seca tiles to cover the walls and vaults of mosques, madrasas, palaces, and tombs.

Sultan-Muhammad, Court of Gayumars, ca. 1525–1535

OTTOMAN TURKEY, 1281-1924

- Osman I (r. 1281–1326) founded the Ottoman dynasty in Turkey. By the middle of the 15th century, the Ottomans had become a fearsome power and captured Byzantine Constantinople in 1453.
- The greatest Ottoman architect was Sinan (ca. 1491–1588), who perfected the design of the domed central-plan mosque. His Mosque of Selim II at Edirne is also an engineering triumph. It has a dome taller than that of Hagia Sophia.

Sinan, Mosque of Selim II, Edirne, 1568–1575

11-1 Cross-inscribed carpet page, folio 26 verso of the *Lindisfarne Gospels*, from Northumbria, England, ca. 698–721. Tempera on vellum, $1'1\frac{1''}{2}\times9\frac{1''}{4}$. British Library, London.

Missionaries brought Christianity to the British Isles. The greatest examples of Hiberno-Saxon art are the Gospel books in which illuminators married Christian imagery with the native animal-interlace style.

EARLY MEDIEVAL EUROPE

The half millennium between 500 and 1000 was the great formative period of western medieval art,* a time of great innovation that produced some of the most extraordinary artworks in world history. Early medieval art in western Europe (MAP 11-1) was the result of a unique fusion of the Greco-Roman heritage of the former northwestern provinces of the Roman Empire, the cultures of the non-Roman peoples north of the Alps, and Christianity. Although the Romans called everyone who lived beyond the classical world's frontiers "barbarians," many northerners had risen to prominent positions within the Roman army and government during the later Roman Empire. Others established their own areas of rule, sometimes with Rome's approval, sometimes in opposition to imperial authority. Over the centuries the various population groups merged, and a new order gradually replaced what had been the Roman Empire, resulting eventually in the foundation of today's European nations.

ART OF THE WARRIOR LORDS

As Rome's power waned in Late Antiquity, armed conflicts and competition for political authority became commonplace among the Huns, Vandals, Merovingians, Franks, Goths, and other non-Roman peoples of Europe. As soon as one group established itself in Italy or in one of Rome's European provinces, another often pressed in behind and compelled it to move on. The Visigoths, for example, who at one time controlled part of Italy and formed a kingdom in what is today southern France, were forced southward into Spain under pressure from the Franks, who had crossed the lower Rhine River and established themselves firmly in France, Switzerland, the Netherlands, and parts of Germany. The Ostrogoths moved from Pannonia (at the junction of modern Hungary, Austria, and the former Yugoslavia) to Italy. Under Theodoric, they established their kingdom there, only to have it fall less than a century later to the Lombards, the last of the early Germanic powers to occupy land within the limits of the old Roman Empire

^{*}The adjective *medieval* and the noun *Middle Ages* are very old terms stemming from an outmoded view of the roughly 1,000 years between the adoption of Christianity as the Roman Empire's official religion and the rebirth (Renaissance) of interest in classical antiquity. Earlier historians, following the lead of the humanist scholars of Renaissance Italy, viewed this period as a long and artistically crude interval between (in the middle of) two great civilizations. The force of tradition dictates the retention of both terms to describe this period and its art, although scholars long ago ceased to see medieval art as unsophisticated or inferior.

(see Chapter 9). Anglo-Saxons controlled what had been Roman Britain. Celts inhabited France and parts of the British Isles, including Ireland. In Scandinavia, the seafaring Vikings held sway.

Art historians do not know the full range of art and architecture these non-Roman peoples produced. What has survived is not truly representative and consists almost exclusively of small portable "status symbols"—weapons and lavish items of personal adornment such as bracelets, pendants, and belt buckles that archaeologists have discovered buried with the dead. Earlier scholars, who viewed medieval art through a Renaissance lens, ignored these "minor arts" because of their small scale, seeming utilitarian nature, and abstract ornament, and because the people who made them rejected the classical notion that the representation of organic nature should be the focus of artistic endeavor. In their own time, people regarded these objects, which often display a high degree of technical and stylistic sophistication, as treasures. They enhanced the prestige of their owners and testified to the stature of those buried with them. In the great early (possibly seventh-century) Anglo-Saxon epic Beowulf, his comrades cremate the hero and place his ashes in a huge tumulus (burial mound) overlooking the sea. As an everlasting tribute to Beowulf's greatness, they "buried rings and brooches in the barrow, all those adornments that brave men had brought out from the hoard after Beowulf died. They bequeathed the gleaming gold, treasure of men, to the earth."1

MEROVINGIAN FIBULAE Most characteristic, perhaps, of the prestige adornments was the fibula, a decorative pin the Romans wore (and the Etruscans before them; FIG. 6-2). Men and women alike used fibulae to fasten their garments. Made of bronze, silver, or gold, the pins often feature profuse decoration, sometimes incorporating inlaid precious or semiprecious stones. The pair of fibulae illustrated here (FIG. 11-2) is part of a larger find of jewelry of the mid-sixth century, when Merovingian kings (r. 482-751) ruled large parts of what is France today. The pins once must have been the proud possession of a wealthy Merovingian woman and seem to have been buried with her. They resemble, in general form, the roughly contemporaneous but plain fibulae used to fasten the outer garments of some of the attendants flanking the Byzantine emperor Justinian in the apse mosaic (FIG. 9-10) of San Vitale in Ravenna. (Note how much more elaborate is the emperor's clasp. In Rome, Byzantium, and early medieval Europe alike, these fibulae were emblems of office and of prestige.)

Covering almost the entire surface of each of the Merovingian fibulae are decorative patterns adjusted carefully to the basic shape of the object. They thus describe and amplify the fibula's form and structure, becoming an organic part of the pin itself. Often the early medieval metalworkers so successfully integrated zoomorphic elements into this type of highly disciplined, abstract decorative design that the animal forms became almost unrecognizable. For example, the fibulae in FIG. 11-2 incorporate a fish just above the center of each pin. The looped forms around the edges are stylized eagles' heads with red garnets forming the eyes.

SUTTON HOO SHIP BURIAL The *Beowulf* saga also recounts the funeral of the warrior lord Scyld, who was laid to rest in a

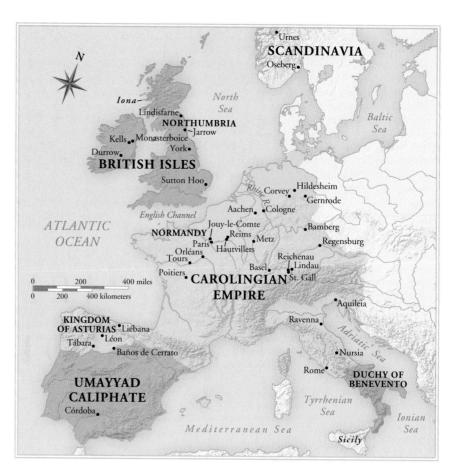

MAP 11-1 The Carolingian Empire at the death of Charlemagne in 814.

11-2 Pair of Merovingian looped fibulae, from Jouy-le-Comte, France, mid-sixth century. Silver gilt worked in filigree, with inlays of garnets and other stones, 4" high. Musée d'Archéologie nationale, Saint-Germain-en-Laye.

Jeweled fibulae were status symbols among the warlords of the early Middle Ages. This pair belonged to a Merovingian woman and features eagle heads and fish integrated into a highly decorative design.

11-3 Purse cover, from the Sutton Hoo ship burial in Suffolk, England, ca. 625. Gold, glass, and cloisonné garnets, $7\frac{1}{2}$ long. British Museum, London.

This purse cover is one of many treasures found in a ship beneath a royal burial mound. The combination of abstract interlace ornament with animal figures is the hallmark of early medieval art in western Europe.

ship set adrift in the North Sea overflowing with arms and armor and costly adornments:

They laid their dear lord, the giver of rings, deep within the ship by the mast in majesty; many treasures and adornments from far and wide were gathered there. I have never heard of a ship equipped more handsomely with weapons and war-gear, swords and corselets; on his breast lay countless treasures that were to travel far with him into the waves' domain.²

In 1939, archaeologists uncovered a treasure-laden ship in a burial mound at Sutton Hoo, near the sea, in Suffolk, England. Although the Sutton Hoo ship was not sent out to sea, it epitomizes the early medieval tradition of burying great lords in ships with rich furnishings, as recorded in *Beowulf*. Among the many precious finds were a gold belt buckle, 10 silver bowls, a silver plate with the imperial stamp of the Byzantine emperor Anastasius I (r. 491–518), and 40 gold coins (perhaps to pay the 40 oarsmen who would row the deceased across the sea on his final voyage). Also placed in the ship were two silver spoons inscribed "Saulos" and "Paulos," Saint Paul's names in Greek before and after his baptism. They may allude to a conversion to Christianity. Some historians have associated the site with the East Anglian king Raedwald (r. 599?–625), who was baptized a Christian before his death in 625, but the identity of the king buried at Sutton Hoo is uncertain.

Most extraordinary of all the Sutton Hoo finds is a purse cover (FIG. 11-3) decorated with *cloisonné* plaques. The cloisonné technique, a favorite of the early medieval "treasure givers," is documented at least as early as the New Kingdom in Egypt. Metalworkers produced cloisonné jewelry by soldering small metal strips, or *cloisons* (French for "partitions"), edge up, to a metal background, and then filling the

compartments with semiprecious stones, pieces of colored glass, or glass paste fired to resemble sparkling jewels. The edges of the cloisons are an important part of the design. Cloisonné is a cross between mosaic (see "Mosaics," Chapter 8, page 223) and stained glass (see "Stained-Glass Windows," Chapter 13, page 350), but medieval artists used it only on a miniature scale.

On the Sutton Hoo purse cover, four symmetrically arranged groups of figures make up the lower row. The end groups consist of a man standing between two beasts. He faces front, and they appear in profile. This heraldic type of grouping has a venerable heritage in the ancient world (FIG. 2-10, right), but must have delivered a powerful contemporary message. It is a pictorial parallel to the epic sagas of the era in which heroes like Beowulf battle and conquer horrific monsters. The two center groups represent eagles attacking ducks. The animal figures are cunningly composed. For example, the convex beaks of the eagles (compare the Merovingian fibulae, FIG. 11-2) fit against the concave beaks of the ducks. The two figures fit together so snugly that they seem at first to be a single dense abstract design. This is true also of the man-animals motif.

Above these figures are three geometric designs. The outer ones are purely linear, although they also rely on color contrasts for their effect. In the central design, an interlace pattern, the interlacements evolve into writhing animal figures. Elaborate intertwining linear patterns are characteristic of many times and places, notably in the art of the Islamic world (see Chapter 10). But the combination of interlace with animal figures was uncommon outside the realm of the early medieval warlords. In fact, metalcraft with interlace patterns and other motifs beautifully integrated with the animal form was, without doubt, the premier art of the early Middle Ages in western Europe. Interest in it was so great that artists imitated the colorful

effects of jewelry designs in the painted decorations of manuscripts, in the masonry of churches, and in sculpture in stone and in wood, the last an especially important medium of Viking art.

VIKINGS In 793 the pre-Christian traders and pirates of Scandinavia known as Vikings (named after the *viks*—coves or "trading places"—of the Norwegian shoreline) landed in the British Isles. They destroyed the Christian monastic community on Lindisfarne Island off the Northumbrian (northeastern) coast of England. Shortly after, these Norsemen (North men) attacked the monastery at Jarrow in England as well as that on Iona Island, off the west coast of Scotland. From this time until the mid-11th century, the Vikings were the terror of western Europe. From their great ships they seasonally harried and plundered European coasts, harbors, and river settlements. Their fast, seaworthy longboats took them on wide-ranging voyages, from Ireland eastward to Russia and westward to Iceland and Greenland and even, briefly, to Newfoundland in North America, long before Columbus arrived in the "New World."

The Vikings were not intent merely on a hit-and-run strategy of destruction but on colonizing the lands they occupied by conquest. Their exceptional talent for organization and administration, as well as for war, enabled them to take and govern large territories in Ireland, England, and France, as well as in the Baltic regions and Russia. For a while, in the early 11th century, the whole of England was part of a Danish empire. When Vikings settled in northern France in the early 10th century, their territory came to be called Normandy—home of the Norsemen who became Normans. (Later, a Norman duke, William the Conqueror, sailed across the English Channel and invaded and became the master of Anglo-Saxon England; FIG. 12-35.)

OSEBERG SHIP BURIAL Much of the preserved art of the Viking sea rovers consists of decoration of their great wooden ships. Striking examples of Viking woodcarving come from a ship burial near the sea at Oseberg, Norway. The ship, discovered beneath an

11-4 Animal-head post, from the Viking ship burial, Oseberg, Norway, ca. 834. Wood, head 5" high. Viking Ship Museum, University of Oslo, Bygdoy.

The Vikings were master wood carvers. This post from a Viking ship combines in one composition the head of a roaring beast with surface ornamentation in the form of tightly interwoven writhing animals.

earthen mound as was the earlier Sutton Hoo burial, was more than 70 feet long. The vessel contained the remains of two women. The size of the burial alone and the lavishly carved wooden ornament of the sleek ship attest to the importance of those laid to rest there. The vessel also once must have carried many precious objects that robbers removed long before its modern discovery.

An animal-head post (FIG. 11-4) is characteristic of the masterfully carved wood ornamentation of the Oseberg ship. It combines in one composition the image of a roaring beast with protruding eyes and flaring nostrils and the deftly carved, controlled, and contained pattern of tightly interwoven animals that writhe, gripping and snapping, in serpentine fashion. The Oseberg animal head is a powerfully expressive example of the union of two fundamental motifs of warrior-lord art on the northern frontiers of the former Roman Empire—the animal form and the interlace pattern.

CHRISTIAN ART: SCANDINAVIA, BRITISH ISLES, SPAIN

At the same time that powerful warlords were amassing artworks dominated by abstract and animal motifs, elsewhere in northern Europe Christian missionaries were establishing monasteries and sponsoring artworks of Christian content. The early medieval art of northern Europe, however, is dramatically different in character from contemporaneous works produced in Italy and the Byzantine Empire. These Christian artworks are among the most distinctive ever created and testify to the fruitful fusion of native and imported artistic traditions.

STAVE CHURCH, URNES By the 11th century, much of Scandinavia had become Christian, but Viking artistic traditions persisted. Nowhere is this more evident than in the decoration of the portal (FIG. 11-5) of the stave church (*staves* are wedge-shaped timbers placed vertically) at Urnes, Norway. The portal and a few staves are almost all that remain from a mid-11th-century church whose fragments were incorporated in the walls of a 12th-century church. Gracefully elongated animal forms intertwine with flexible plant stalks and tendrils in spiraling rhythm. The effect of natural growth is astonishing, yet the designer subjected it to a highly refined abstract sensibility. This intricate Urnes style was the culmination of three centuries of Viking inventiveness.

HIBERNO-SAXON ART In Ireland, the Christianization of the Celts began in the fifth century. The new converts, although nominally subject to the popes of Rome, quickly developed a form of monastic organization that differed from the Church of Rome. The relative independence of the Irish monasteries was due in part to their isolation. The monks often selected inaccessible and inhospitable places where they could carry on their duties far from worldly temptations and distractions. Before long, Irish monks, filled with missionary zeal, set up monastic establishments in Britain and Scotland. In 563, Saint Columba founded an important monastery on the Scottish island of Iona, where he successfully converted the native Picts to Christianity. Iona monks established the monastery at Lindisfarne off the northern coast of Britain in 635. These foundations became great centers of learning as well as the most important centers of artistic production of the early medieval period in northern Europe.

A style that art historians designate as *Hiberno-Saxon* (Hibernia was the Roman name of Ireland), or sometimes as *Insular* to denote

Medieval Books

The central role books played in the medieval Christian Church led to the development of a large number of specialized types for priests, monks and nuns, and laypersons.

The primary sacred text came to be called the Bible ("the Book"), consisting of the Old Testament of the Jews, originally written in Hebrew, and the Christian New Testament, written in Greek. In the late fourth century, Saint Jerome produced the canonical Latin, or Vulgate (vulgar, or common tongue), version of the Bible, which incorporates 46 Old and 27 New Testament books. Before the invention of the printing press in the 15th century, all books were written by hand ("manuscripts," from the Latin *manu scriptus*). Bibles were extremely difficult to produce, and few early medieval monasteries possessed a complete Bible. Instead, scribes often gathered several biblical books in separate volumes.

The *Pentateuch* contains the first five books of the Old Testament, beginning with the Creation of Adam and Eve (Genesis). The *Gospels* ("good news") are the New Testament works of Saints Matthew, Mark, Luke, and John (see "The Four Evangelists," page 290) and tell the story of the life of Christ (see "The Life of Jesus in Art," Chapter 8,

pages 216–217). Medieval Gospel books often contained *canon tables*—a concordance, or matching, of the corresponding passages of the four Gospels that Eusebius of Caesarea compiled in the fourth century. *Psalters* contained the 150 psalms of King David, written in Hebrew and translated into both Greek and Latin.

The Church also frequently employed other types of books. The *lectionary* contains passages from the Gospels reordered to appear in the sequence that priests read them during the celebration of Mass throughout the year. *Breviaries* include the texts required for the monks' daily recitations. *Sacramentaries* incorporate the prayers priests recite during Mass. *Benedictionals* contain bishops' blessings. In the later Middle Ages, scribes developed books for the private devotions of the laity, patterned after monks' readers. The most popular was the *Book of Hours*, so called because it contains the prayers to be read at specified times of the day.

Scribes produced many other types of books in the Middle Ages—theological treatises, secular texts on history and science, and even some classics of Greco-Roman literature—but these contained illustrations less frequently than the various sacred texts.

the Irish-English islands where it was produced, flourished within the monasteries of the British Isles. Its most distinctive products were the illuminated manuscripts of the Christian Church (see "Medieval Books," above). Books were the primary vehicles in the effort to Christianize the British Isles. They literally brought the Word of God to a predominantly illiterate population who regarded the monks' sumptuous volumes with awe. Books were scarce and jealously guarded treasures of the libraries and *scriptoria* (writing studios) of monasteries and major churches. Illuminated books are the most important extant monuments of the brilliant artistic culture that flourished in Ireland and Northumbria during the seventh and eighth centuries.

BOOK OF DURROW Among the earliest Hiberno-Saxon illuminated manuscripts is the *Book of Durrow*, a Gospel book that may have been written and decorated in the monastic scriptorium at Iona, although its provenance is not documented. In the late Middle Ages it was in the monastery in Durrow, Ireland—hence its modern name. The Durrow Gospels already display one of the most characteristic features of Insular book illumination: full pages devoted neither to text nor to illustration but to pure embellishment. The Hiberno-Saxon painters must have felt that such ornament lent prestige to books just as ornamental jewelry lent status to those who wore it. Interspersed between the Durrow text pages are so-called *carpet pages*, resembling textiles, made up of decorative panels of abstract and zoomorphic forms (compare FIG. 11-1). The *Book of Durrow*

11-5 Wooden portal of the stave church at Urnes, Norway, ca. 1050–1070.

By the 11th century, Scandinavia had become mostly Christian, but Viking artistic traditions persisted, as seen in the intertwining animal-and-plant decoration of the portal of this Norwegian church.

The Four Evangelists

The English word *evangelist* derives from the Greek word for "one who announces good news," namely the Gospel of Christ. The authors of the Gospels, the first four books of the New Testament, are Saints Matthew, Mark, Luke, and John, collectively known as the Four Evangelists. The Gospel books provide the authoritative account of the life of Jesus, differing in some details but together constituting the literary basis for the iconography of Christian art (see "The Life of Jesus in Art," Chapter 8, pages 216–217). Each evangelist has a unique symbol derived from passages in Ezekiel (1:5–14) and the Apocalypse (4:6–8).

- Matthew was a tax collector in Capernaum before Jesus called him to become one of his apostles. Little else is known about him, and there are differing accounts as to how he became a martyr. Matthew's symbol is the winged man or angel, because his Gospel opens with a description of the human ancestry of Christ.
- *Mark* was the first bishop of Alexandria in Egypt, where he suffered martyrdom. He was a companion of both Saint Peter and Saint Paul. One tradition says that Peter dictated the Gospel to Mark, or at least inspired him to write it. Because Mark's Gospel begins with a voice crying in the wilderness, his symbol is the lion, the king of the desert.
- Luke was a disciple of Saint Paul, who refers to him as a physician. A later tradition says that Luke painted a portrait of the Virgin Mary and the Christ Child. Consequently, late-medieval painters' guilds often chose Luke as their patron saint. Luke's symbol is the ox, because his Gospel opens with a description of the priest Zacharias sacrificing an ox.
- I John was one of the most important apostles. He sat next to Jesus at the Last Supper and was present at the Crucifixion, Lamentation, and Transfiguration. John was also the author of the Apocalypse, the last book of the New Testament, which he wrote in exile on the Greek island of Patmos. The Apocalypse records John's visions of the end of the world, the Last Judgment, and the Second Coming. John's symbol is the eagle, the soaring bird connected with his apocalyptic visions.

The Four Evangelists appear frequently in medieval art, especially in illuminated Gospel books where they regularly serve as frontispieces to their respective Gospels. Often, artists represented them as seated authors, with or without their symbols (FIGS. I-7, 11-7,

11-6 Man (symbol of Saint Matthew), folio 21 verso of the *Book of Durrow*, possibly from Iona, Scotland, ca. 660–680. Ink and tempera on parchment, $9\frac{5}{8}$ " $\times 6\frac{1}{8}$ ". Trinity College Library, Dublin.

The early Hiberno-Saxon *Book of Durrow* includes four pages devoted to the symbols of the Four Evangelists. The cloak of Saint Matthew's man resembles a cloisonné brooch filled with abstract ornament.

11-13, and 11-14). In some instances, all Four Evangelists appear together (FIG. I-7). Frequently, both in painting and in sculpture, artists represented only the symbols (FIGS. 9-17, 11-6, 12-1, 12-7, 12-17, and 13-6).

also contains pages where the illuminator enormously enlarged the initial letters of an important passage of sacred text and transformed those letters into elaborate decorative patterns (compare FIG. 11-8). These kinds of manuscript pages have no precedents in classical art. They reveal the striking independence of Insular artists from the classical tradition.

In the *Book of Durrow*, each of the four Gospel books has a carpet page facing a page dedicated to the symbol of the evangelist who wrote that Gospel. An elaborate interlace design like those found on contemporaneous belt buckles and brooches frames each symbol. These pages served to highlight the major divisions of the text. The

symbol of Saint Matthew (FIG. 11-6) is a man (more commonly represented later as winged; see "The Four Evangelists," above), but the only human parts that the artist, a seventh-century monk, chose to render are a schematic frontal head and two profile feet. A cloak of yellow, red, and green squares resembling cloisons filled with intricate abstract designs and outlined in dark brown or black envelops the rest of the "body." The *Book of Durrow* weds the abstraction of early medieval personal adornment with Early Christian pictorial imagery. The vehicle for the transmission of those Mediterranean forms was the illustrated book itself, which Christian missionaries brought to northern Europe.

LINDISFARNE GOSPELS The marriage between Christian imagery and the animal-interlace style of the northern warlords is evident in the cross-inscribed carpet page (FIG. 11-1) of the Lindisfarne Gospels. Produced in the Northumbrian monastery on Lindisfarne Island, the book contains several ornamental pages and exemplifies Hiberno-Saxon art at its best. According to a later colophon (an inscription, usually on the last page, providing information regarding a book's manufacture), Eadfrith, bishop of Lindisfarne between 698 and his death in 721, wrote the Lindisfarne Gospels "for God and Saint Cuthbert." Cuthbert's relics (see "Pilgrimages and the Cult of Relics," Chapter 12, page 310) recently had been deposited in the Lindisfarne church.

The patterning and detail of the Lindisfarne ornamental page are much more intricate than those of the *Book of Durrow*. Serpentine interlacements of fantastic animals devour each other, curling over and returning on their writhing, elastic shapes. The rhythm of expanding and contracting forms produces a most vivid effect of motion and change, but the painter held it in check by the regularity of the design and by the dominating motif of the inscribed cross. The cross—the all-important symbol of the imported religion—stabilizes the rhythms of the serpentines and, perhaps by contrast with its heavy immobility, seems to heighten the effect of motion. The illu-

11-7 Saint Matthew, folio 25 verso of the *Lindisfarne Gospels*, from Northumbria, England, ca. 698–721. Tempera on vellum, $1'\frac{1}{2}'' \times 9\frac{1}{4}''$. British Library, London.

The inspiration for this author portrait may have been a Mediterranean book. The illuminator converted the model's fully rounded forms into the linear flat-color idiom of northern European art.

minator placed the motifs in detailed symmetries, with inversions, reversals, and repetitions that the viewer must study closely to appreciate not so much their variety as their mazelike complexity. The zoomorphic forms intermingle with clusters and knots of line, and the whole design vibrates with energy. The color is rich yet cool. The painter adroitly adjusted shape and color to achieve a smooth and perfectly even surface.

Like most Hiberno-Saxon artworks, the Lindisfarne cross page displays the artist's preference for small, infinitely complex, and painstaking designs. Even the Matthew symbol (FIG. 11-6) in the Book of Durrow reveals that the illuminator's concern was abstract design, not the depiction of the natural world. But exceptions exist. In some Insular manuscripts, the northern artists based their compositions on classical pictures in imported Mediterranean books. This is the case with the author portrait of Saint Matthew (FIG. 11-7) in the Lindisfarne Gospels. The Hiberno-Saxon illuminator's model must have been one of the illustrated Gospel books a Christian missionary brought from Italy to England. Author portraits were familiar features of Greek and Latin books, and similar representations of seated philosophers or poets writing or reading (FIGS. 7-71 and 8-6) abound in ancient art. The Lindisfarne Matthew sits in his study composing his account of the life of Christ. A curtain sets the scene indoors, as in classical art (FIG. 5-58), and the evangelist's seat is at an angle, which also suggests a Mediterranean model employing classical perspective. The painter (or the scribe) labeled Matthew in a curious combination of Greek (O Agios, saint—written, however, using Latin rather than Greek letters) and Latin (Mattheus), perhaps to lend the prestige of two classical languages to the page. The former was the language of the New Testament, the latter that of the Church of Rome. Accompanying Matthew is his symbol, the winged man (labeled imago hominis, image of the man). The identity of the figure—actually just a disembodied head and shoulders—behind the curtain is uncertain. Among the possibilities are Christ, Saint Cuthbert, and Moses holding the closed book of the Old Testament in contrast with the open book of Matthew's New Testament, a common juxtaposition in medieval Christian art and thought.

Although a southern manuscript inspired the Lindisfarne composition, the Northumbrian painter's goal was not to copy the model faithfully. Instead, uninterested in the emphasis on volume, shading, and perspective that are the hallmarks of the pictorial illusionism of Greco-Roman painting, the Lindisfarne illuminator conceived his subject in terms of line and color exclusively. In the Hiberno-Saxon manuscript, the drapery folds are a series of sharp, regularly spaced, curving lines filled in with flat colors. The painter converted fully modeled forms bathed in light into the linear idiom of northern art. The result is a vivid new vision of Saint Matthew.

BOOK OF KELLS The greatest achievement of Hiberno-Saxon art is the *Book of Kells*, which boasts an unprecedented number of full-page illuminations, including carpet pages, evangelist symbols, portrayals of the Virgin Mary and of Christ, New Testament narrative scenes, canon tables, and several instances of monumentalized and embellished words from the Bible. One medieval commentator described the *Book of Kells* in the *Annals of Ulster* for the year 1003 as "the chief relic of the western world." The manuscript (named after the monastery in central Ireland that owned it) was written and decorated either at Iona or a closely related Irish monastery. From an early date, the book was housed in an elaborate metalwork box, befitting a greatly revered "relic." The monks probably displayed the book on a church altar.

11-8 Chi-rho-iota (XPI) page, folio 34 recto of the *Book of Kells*, probably from Iona, Scotland, late eighth or early ninth century. Tempera on vellum, $1' 1'' \times 9\frac{1}{2}''$. Trinity College Library, Dublin.

In this opening page to the Gospel of Saint Matthew, the painter transformed the biblical text into abstract pattern, literally making God's words beautiful. The intricate design recalls early medieval metalwork.

The page reproduced here (FIG. 11-8) opens the account of the nativity of Jesus in the Gospel of Saint Matthew. The initial letters of Christ in Greek (XPI, chi-rho-iota) occupy nearly the entire page, although two words—autem (abbreviated simply as h) and generatio appear at the lower right. Together they read: "Now this is how the birth of Christ came about." The page corresponds to the opening of Matthew's Gospel, the passage read in church on Christmas Day. The illuminator transformed the holy words into extraordinarily intricate abstract designs that recall Celtic and Anglo-Saxon metalwork. But the cloisonné-like interlace is not purely abstract pattern. The letter rho, for example, ends in a male head, and animals are at its base to the left of h generatio. Half-figures of winged angels appear to the left of chi, accompanying the monogram as if accompanying Christ himself. Close observation reveals many other figures, human and animal. When the priest Giraldus Cambrensis visited Ireland in 1185, he described a manuscript he saw that, if not the Book of Kells itself, must have been very similar:

Fine craftsmanship is all about you, but you might not notice it. Look more keenly at it and you . . . will make out intricacies, so delicate and subtle, so exact and compact, so full of knots and links, with colors so fresh and vivid, that you might say that all this was the work of an angel, and not of a man. For my part, the oftener I see the book, the more carefully I study it, the more I am lost in ever fresh amazement, and I see more and more wonders in the book.³

11-9 *High Cross of Muiredach* (east face), Monasterboice, Ireland, 923. Sandstone, 18' high.

Early medieval Irish high crosses are exceptional in size. Muiredach's cross marked his grave and bears reliefs depicting the Crucifixion and Last Judgment, themes suited to a Christian funerary monument.

HIGH CROSS OF MUIREDACH As noted, the preserved art of the early Middle Ages consists almost exclusively of small and portable works. The high crosses of Ireland and northern England, erected between the 8th and 10th centuries, are exceptional in their mass and scale. These majestic monuments, some more than 20 feet in height, preside over burial grounds adjoining monasteries. Freestanding and unattached to any architectural fabric, the high crosses have the imposing unity, weight, and presence of both building and statue—architecture and sculpture combined.

The High Cross of Muiredach (FIG. 11-9) at Monasterboice, Ireland, is one of the largest and finest early medieval crosses. An inscription on the bottom of the west face of the shaft asks a prayer for a man named Muiredach. Most scholars identify him as the influential Irish cleric of the same name who was abbot of Monasterboice and died in 923. The monastery he headed was one of Ireland's oldest, founded in the late fifth century. The cross probably marked the abbot's grave. The concave arms of Muiredach's cross are looped by four arcs that form a circle. The arms expand into squared terminals (compare FIG. 11-1). The circle intersecting the cross identifies the type as Celtic. At the center of the west side is a depiction of the crucified Christ. On the east side (FIG. 11-9) the risen Christ stands as judge of the world, the hope of the dead. Below him the souls of the dead are being weighed on scales—a theme that sculptors of 12thcentury church portals (FIGS. I-6 and 12-12) pursued with extraordinary intensity.

11-10 San Juan Bautista, Baños de Cerrato, Spain, 661.

This three-aisled basilican church dedicated to Saint John the Baptist is typical of Visigothic architecture in Spain. It features three square apses and an entrance portal crowned by a horseshoe arch.

VISIGOTHIC SPAIN When Muslim armies crossed into Spain from North Africa in 711 (see Chapter 10), they brought Islam to a land the Romans had ruled for centuries. Roman sovereignty had brought new roads to the Iberian Peninsula and new cities with Roman temples, forums, theaters, and aqueducts. But in the early fifth century, the Roman cities fell to Germanic invaders, most notably the Visigoths, who had converted to Christianity. Many of the stone churches the Visigoths built in the sixth and seventh centuries still stand. An outstanding example is the church of San Juan Bautista (Saint John the Baptist, FIG. 11-10) at Baños de Cerrato, which the Visigothic king Recceswinth (r. 649-672) erected in 661 in thanksgiving for a cure after bathing in the waters there. The Visigothic churches are basilican in form but often have multiple square apses. (The Baños de Cerrato church has three.) They also regularly incorporate horseshoe arches, a form usually associated with Islamic architecture (FIG. 10-11) but that in Spain predates the Muslim conquest.

MOZARABIC SPAIN Although the Islamic caliphs of Córdoba swept the Visigoths from power, they never succeeded in gaining control of the northernmost parts of the peninsula. There, the Christian culture called Mozarabic (referring to Christians living in Arab territories) continued to flourish. One northern Spanish monk, Beatus, abbot of San Martín at Liébana, wrote Commentary on the Apocalypse around 776. This influential work was widely copied and illustrated in the monastic scriptoria of medieval Europe. One copy was produced at the monastery of San Salvador at Tábara in the kingdom of Léon in 970. The colophon (FIG. 11-11) to the illustrated Commentary presents the earliest known depiction of a medieval scriptorium. Because the artist provided a composite of exterior and interior views of the building, it is especially informative. At the left is a great bell tower with a monk on the ground floor ringing the bells. The painter carefully recorded the Islamicstyle glazed-tile walls of the tower, its interior ladders, and its elegant windows with their horseshoe arches, the legacy of the Visigoths. To the right, in the scriptorium proper, three monks perform their respective specialized duties. The colophon identifies the two monks in the main room as the scribe Senior and the painter EMETERIUS. To the right, a third monk uses shears to cut sheets of parchment. The colophon also pays tribute to Magius, "the worthy master

11-11 EMETERIUS, the tower and scriptorium of San Salvador de Tábara, colophon (folio 168) of the *Commentary on the Apocalypse* by Beatus, from Tábara, Spain, 970. Tempera on parchment, 1' $2\frac{1}{8}$ " \times 10". Archivo Histórico Nacional, Madrid.

In this earliest known depiction of a medieval scriptorium, the painter carefully recorded the Islamic-style glazed-tile walls of the tower and its elegant windows with their horseshoe arches, a legacy of the Visigoths.

painter . . . May he deserve to be crowned with Christ,"⁴ who died before he could complete his work on the book. His pupil Emeterius took his place and brought the project to fruition. He must be the painter of the colophon.

CAROLINGIAN ART

On Christmas Day of the year 800, Pope Leo III crowned Charles the Great (Charlemagne), king of the Franks since 768, as emperor of Rome (r. 800–814). In time, Charlemagne came to be seen as the first Holy (that is, Christian) Roman Emperor, a title his successors did not formally adopt until the 12th century. The setting for Charlemagne's coronation, fittingly, was Saint Peter's basilica (FIG. 8-9) in Rome, built by Constantine, the first Roman emperor to embrace Christianity. Born in 742, when northern Europe was still in chaos, Charlemagne consolidated the Frankish kingdom his father and grandfather bequeathed him and defeated the Lombards in Italy (MAP 11-1). He thus united Europe and laid claim to reviving the glory of the ancient Roman Empire. He gave his name (Carolus Magnus in Latin) to an entire era, the *Carolingian* period.

Charlemagne's Renovatio Imperii Romani

harlemagne's official seal bore the words *renovatio imperii* Romani (renewal of the Roman Empire). As the papally designated Roman emperor, Charlemagne sought to revive the glory of Early Christian Rome. He accomplished this in part through artistic patronage, commissioning imperial portrait statues (FIG. 11-12) and large numbers of illustrated manuscripts (FIG. 11-13), but also by fostering a general revival of learning.

To make his empire as splendid as Rome's, Charlemagne invited to his court at Aachen the best minds and the finest artisans of western Europe and the Byzantine East. Among them were Paulinus of Aquileia (ca. 726–804), Theodulf of Orléans (ca. 750–821), and Alcuin (ca. 735–804), master of the cathedral school at York, the center of Northumbrian learning. Alcuin brought Anglo-Saxon scholarship to the Carolingian court.

Charlemagne himself, according to Einhard, his biographer, could read and speak Latin fluently, in addition to Frankish, his native tongue. He also could understand Greek, and he studied rhetoric and mathematics with the learned men he gathered around him. But he never learned to write properly. That was a task best left to professional scribes. In fact, one of Charlemagne's dearest projects was the recovery of the true text of the Bible, which, through centuries of errors in copying, had become quite corrupt. Various scholars undertook the great project, but Alcuin of York's revision of the Bible, prepared at the new monastery at Tours, became the most widely used.

Charlemagne's scribes also were responsible for the development of a new, more compact, and more easily written and legible version of Latin script called *Caroline minuscule*. The letters on this page are descendants of the alphabet Carolingian scribes perfected. Later generations also owe to Charlemagne's patronage the restoration and copying of important classical texts. The earliest known manuscripts of many Greek and Roman authors are Carolingian in date.

11-12 Equestrian portrait of Charlemagne or Charles the Bald, from Metz, France, ninth century. Bronze, originally gilt, $9\frac{1}{2}$ high. Louvre, Paris.

The Carolingian emperors sought to revive the glory and imagery of the ancient Roman Empire. This equestrian portrait depicts a crowned emperor holding a globe, the symbol of world dominion.

The "Carolingian Renaissance" was a remarkable historical phenomenon, an energetic, brilliant emulation of the art, culture, and political ideals of Early Christian Rome (see "Charlemagne's *Renovatio Imperii Romani*," above). Charlemagne's (Holy) Roman Empire, waxing and waning for a thousand years and with many hiatuses, existed in central Europe until Napoleon destroyed it in 1806.

Sculpture and Painting

When Charlemagne returned home from his coronation in Rome, he ordered the transfer of an equestrian statue of the Ostrogothic king Theodoric from Ravenna to the Carolingian palace complex at Aachen. That portrait is lost, as is the grand gilded-bronze statue of the Byzantine emperor Justinian that once crowned a column in Constantinople (see "The Emperors of New Rome," Chapter 9, page 243). But in the early Middle Ages, both statues stood as reminders of ancient Rome's glory and of the pretensions and aspirations of the medieval successors of Rome's Christian emperors.

EQUESTRIAN STATUETTE The portrait of Theodoric may have been the inspiration for a ninth-century bronze statuette (FIG. 11-12) of a Carolingian emperor on horseback. Charlemagne greatly admired Theodoric, the first Germanic ruler of Rome. Many scholars have identified the small bronze figure as Charlemagne himself, although others think it portrays his grandson, Charles the Bald (r. 840–877). The ultimate model for the statuette was the equestrian portrait (FIG. 7-59) of Marcus Aurelius in Rome. In the Middle Ages, people mistakenly thought the bronze statue represented Constantine, another revered predecessor of Charlemagne and his Carolingian successors. Both the Roman and the medieval sculptor portrayed their emperor as overly large so that the ruler, not the horse, is the center of attention. But unlike Marcus Aurelius, who extends his right arm in a gesture of clemency to a foe who once cowered beneath the raised foreleg of his horse, Charlemagne (or Charles the Bald) is on parade. He wears imperial robes rather than a general's cloak, although his sheathed sword is visible. On his head is a crown, and in his outstretched left hand he holds a globe, symbol of world domin-

11-13 Saint Matthew, folio 15 recto of the *Coronation Gospels* (*Gospel Book of Charlemagne*), from Aachen, Germany, ca. 800–810. Ink and tempera on vellum, $1^{'}\frac{3}{4}^{''}\times 10^{''}$. Schatzkammer, Kunsthistorisches Museum, Vienna.

The painted manuscripts produced for Charlemagne's court reveal the legacy of classical art. The Carolingian painter used light and shade and perspective to create the illusion of three-dimensional form.

ion. The portrait proclaimed the *renovatio* of the Roman Empire's power and trappings.

CORONATION GOSPELS Charlemagne was a sincere admirer of learning, the arts, and classical culture. He, his successors, and the scholars under their patronage placed high value on books, both sacred and secular, importing many and producing far more. One of these is the purple vellum Coronation Gospels (also known as the Gospel Book of Charlemagne), which has a text written in handsome gold letters. The major full-page illuminations show the four Gospel authors at work. The page depicting Saint Matthew (FIG. 11-13) reveals that the Carolingian painter's technique differs markedly from that of the Northumbrian painter of the Matthew portrait (FIG. 11-7) in the Lindisfarne Gospels. Deft, illusionistic brushwork defines the massive drapery folds wrapped around the body beneath. The Carolingian illuminator used color and modulation of light and shade, not line, to create shapes. The cross-legged chair, the lectern, and the saint's toga are familiar Roman accessories. The landscape background has many parallels in Roman painting, and the frame consists of the kind of acanthus leaves found in Roman temple capitals and friezes (FIG. 7-32). Almost nothing is known in the Hiberno-Saxon British Isles or Frankish Europe that could have prepared the way for this portrayal of Saint Matthew. If a Frank, rather than an Italian or a Byzantine, painted the Saint Matthew and the other evangelist portraits of the Coronation Gospels, the Carolingian artist had fully absorbed the classical manner. Classical painting style was one of the many components of Charlemagne's program to establish Aachen as the capital of a renewed Christian Roman Empire.

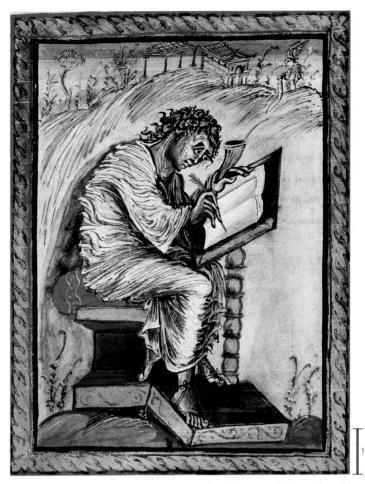

11-14 Saint Matthew, folio 18 verso of the *Ebbo Gospels* (*Gospel Book of Archbishop Ebbo of Reims*), from Hautvillers (near Reims), France, ca. 816–835. Ink and tempera on vellum, $10\frac{1}{4}'' \times 8\frac{3}{4}''$. Bibliothèque Municipale, Épernay.

Saint Matthew writes frantically, and the folds of his drapery writhe and vibrate. Even the landscape behind him rears up alive. The painter merged classical illusionism with the northern linear tradition.

EBBO GOSPELS The classical-revival style evident in the Coronation Gospels was by no means the only one that appeared suddenly in the Carolingian world. Court schools and monasteries employed a wide variety of styles derived from Late Antique prototypes. Another Saint Matthew (FIG. 11-14), in a Gospel book made for Archbishop Ebbo of Reims, France, may be an interpretation of an author portrait very similar to the one the Coronation Gospels master used as a model. The Ebbo Gospels illuminator, however, replaced the classical calm and solidity of the Coronation Gospels evangelist with an energy that amounts to frenzy. Matthew (the winged man in the upper right corner identifies him) writes in frantic haste. His hair stands on end, his eyes open wide, the folds of his drapery writhe and vibrate, the landscape behind him rears up alive. The painter even set the page's leaf border in motion. Matthew's face, hands, inkhorn, pen, and book are the focus of the composition. This presentation contrasts strongly with the settled pose of the Saint Matthew of the Coronation Gospels with its even stress so that no part of the composition jumps out at viewers to seize their attention. Just as the painter of the Lindisfarne Gospels Matthew (FIG. 11-7) transformed an imported model into an original Hiberno-Saxon idiom, so the Ebbo Gospels artist translated a classical prototype into a new Carolingian vernacular. This master painter brilliantly merged classical illusionism and the northern linear tradition.

11-15 Psalm 44, detail of folio 25 recto of the *Utrecht Psalter*, from Hautvillers (near Reims), France, ca. 820–835. Ink on vellum, full page, $1'1'' \times 9\frac{7}{8}"$; detail, $4\frac{1}{2}''$ high. University Library, Utrecht.

The drawings in the *Utrecht Psalter* are rich in anecdotal detail and show figures acting out—literally—King David's psalms. The vivid animation resembles that of the *Ebbo Gospels* Saint Matthew (FIG. 11-14).

1 in.

UTRECHT PSALTER One of the most extraordinary medieval manuscripts is the *Utrecht Psalter*. The text reproduces the Psalms of David in three columns of Latin capital letters emulating the script and page organization of ancient books. The artist illustrated each psalm with a pen-and-ink drawing stretching across the entire width of the page. Some scholars have argued that the costumes and other details indicate that the artist followed one or more manuscripts compiled 400 years before. Even if the *Utrecht Psalter* is not a copy, the artist's intention was to evoke earlier artworks and to make the book appear "ancient."

The painter of the Utrecht Psalter displays a genius for anecdotal detail throughout the manuscript. On one page (FIG. 11-15) the figures act out—literally—Psalm 44 (Psalm 43 of the Vulgate text of the Carolingian era), in which the psalmist laments the plight of the oppressed Israelites. Where the text says, "we are counted as sheep for slaughter," the artist drew some slain sheep fallen to the ground in front of a walled city reminiscent of cities on the Column of Trajan (FIG. 7-44) in Rome and in Early Christian mosaics and manuscripts (FIG. 8-20). At the left, the faithful grovel on the ground before a temple because the psalm reads "our soul is bowed down to the dust; our belly cleaveth unto the earth." The artist's response to "Awake, why sleepest thou, O Lord" was to depict the Lord (as Christ instead of the Hebrew God, complete with cruciform halo), flanked by six pleading angels, reclining in a canopied bed overlooking the slaughter below. The drawing shows a vivid animation of much the same kind as in the Saint Matthew of the Ebbo Gospels (FIG. 11-14). The bodies of the Utrecht Psalter figures are tense, shoulders hunched, heads thrust forward. As in the Ebbo Gospels, even the earth heaves up around the figures. The rapid, sketchy techniques used to render the figures convey the same nervous vitality as the Ebbo evangelists.

LINDAU GOSPELS The taste for sumptuously wrought and portable objects, shown previously in the art of the early medieval warlords, persisted under Charlemagne and his successors. They commissioned numerous works employing costly materials, including book covers made of gold and jewels and sometimes also ivory or pearls. Gold and gems not only glorified the Word of God but also evoked the heavenly Jerusalem. One of the most luxurious Carolingian book covers (FIG. 11-16) is the one later added to the Lindau Gospels. The gold cover, fashioned in one of the workshops of Charles the Bald's court, is monumental in conception. A youthful Christ in the Early Christian tradition, nailed to the cross, is the central motif.

Surrounding Christ are pearls and jewels (raised on golden claw feet so that they can catch and reflect the light even more brilliantly and protect the delicate metal relief from denting). The statuesque openeyed figure, rendered in *repoussé* (hammered or pressed relief), brings to mind the beardless unsuffering Christ of the fifth-century

1 in

11-16 Crucifixion, front cover of the *Lindau Gospels*, from Saint Gall, Switzerland, ca. 870. Gold, precious stones, and pearls, $1' 1\frac{3}{8}'' \times 10\frac{3}{8}''$. Pierpont Morgan Library, New York.

This sumptuous Carolingian book cover revives the Early Christian imagery of the youthful Christ. The statuesque figure of the crucified Savior, heedless of pain, is classical in both conception and execution.

ivory plaque (FIG. 8-22) from Italy in the British Museum. In contrast, the four angels and the personifications of the Moon and the Sun above and the crouching figures of the Virgin Mary and Saint John (and two other figures of uncertain identity) in the quadrants below display the vivacity and nervous energy of the *Utrecht Psalter* figures. This eclectic work highlights the stylistic diversity of early medieval art in Europe. Here, however, the translated figural style of the Mediterranean prevails, in keeping with the classical tastes and imperial aspirations of the Frankish "emperors of Rome."

Architecture

In his eagerness to reestablish the imperial past, Charlemagne also encouraged the use of Roman building techniques. In architecture, as in sculpture and painting, innovations made in the reinterpretation of earlier Roman Christian sources became fundamental to the subsequent development of northern European architecture. For his models, Charlemagne went to Rome and Ravenna. One was the former heart of the Roman Empire, which he wanted to "renew." The other was the long-term western outpost of Byzantine might and splendor, which he wanted to emulate in his capital at Aachen, a site chosen because of its renowned hot springs.

AACHEN Charlemagne often visited Ravenna, and the equestrian statue of Theodoric he brought from there to display in his palace complex at Aachen served as a model for Carolingian equestrian portraits (Fig. 10-12). Charlemagne also imported porphyry (purple marble) columns from Ravenna to adorn his Palatine Chapel, and historians long have thought he chose one of Ravenna's churches as the model for the new structure. The plan (Fig. 11-17) of the Aachen chapel resembles that of San Vitale (Fig. 9-7), and a direct relationship very likely exists between the two.

A comparison between the Carolingian chapel, the first vaulted structure of the Middle Ages north of the Alps, and its southern counterpart is instructive. The Aachen plan is simpler. Omitted were San Vitale's apselike extensions reaching from the central octagon into the ambulatory. At Aachen, the two main units stand in greater independence of each other. This solution may lack the subtle sophis-

11-17 Restored plan of the Palatine Chapel of Charlemagne, Aachen, Germany, 792–805.

Charlemagne often visited Ravenna and sought to emulate Byzantine splendor in Germany. The plan of his Aachen palace chapel is based on that of San Vitale (FIG. 9-7), but the Carolingian plan is simpler.

tication of the Byzantine building, but the Palatine Chapel gains geometric clarity. A view of the interior (FIG. 11-18) of the Palatine Chapel shows that the architect converted the "floating" quality of San Vitale (FIG. 9-8) into massive geometric form.

The Carolingian conversion of a complex, subtle Byzantine prototype into a building that expresses robust strength and clear structural articulation foreshadows the architecture of the 11th and 12th centuries and the style called Romanesque (see Chapter 12). So, too, does the treatment of the Palatine Chapel's exterior, where two cylindrical towers with spiral staircases flank the entrance portal (FIG. 11-17). This was a first step toward the great dual-tower facades of western European churches from the 10th century to the present. Above the portal, Charlemagne could appear in a large framing arch and be seen by those gathered in the atrium in front of the chapel. (The plan includes only part of the atrium.) Directly behind that second-story arch was Charlemagne's marble throne. From there he could peer down at the altar in the apse. Charlemagne's imperial gallery followed the model of the imperial gallery at Hagia Sophia (FIGS. 9-3 and 9-4) in Constantinople. The Palatine Chapel was in every sense a royal chapel. The coronation of Charlemagne's son, Louis the Pious (r. 814–840), took place there when he succeeded his father as emperor.

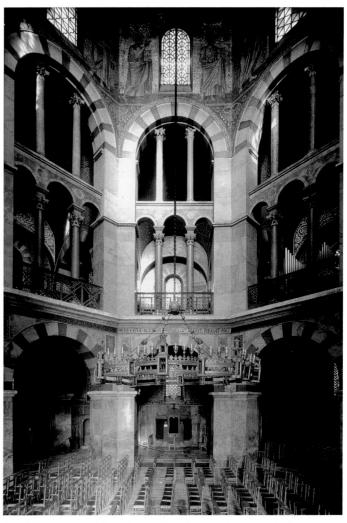

11-18 Interior of the Palatine Chapel of Charlemagne, Aachen, Germany, 792–805.

Charlemagne's palace chapel is the first vaulted structure of the Middle Ages north of the Alps. The architect transformed the complex, glittering interior of San Vitale (FIG. 9-8) into simple and massive geometric form.

Medieval Monasteries and Benedictine Rule

onastic foundations appeared in western Europe beginning in Early Christian times. The monks who established monasteries also made the rules that governed them. The most significant of these monks was Benedict of Nursia (Saint Benedict), who founded the Benedictine order in 529. By the ninth century, the "Rule" Benedict wrote (*Regula Sancti Benedicti*) had become standard for all European monastic establishments, in part because Charlemagne had encouraged its adoption throughout the Frankish territories.

Saint Benedict believed the corruption of the clergy that accompanied the increasing worldliness of the Christian Church had is roots in the lack of firm organization and regulation. As he saw it, idleness and selfishness had led to neglect of the commandments of God and of the Church. The cure for this was communal association in an *abbey* under the absolute rule of an *abbot* the monks elected (or an *abbess* the nuns chose), who would see to it that the monks

spent each hour of the day in useful work and in sacred reading. The emphasis on work and study and not on meditation and austerity is of great historical significance. Since antiquity, manual labor had been considered disgraceful, the business of the lowborn or of slaves. Benedict raised it to the dignity of religion. The core idea of what many people today call the "work ethic" found early expression here as an essential feature of spiritual life. By thus exalting the virtue of manual labor, Benedict not only rescued it from its age-old association with slavery but also recognized it as the way to self-sufficiency for the entire religious community.

11-19 Schematic plan for a monastery at Saint Gall, Switzerland, ca. 819. Red ink on parchment, $2' 4'' \times 3' 8\frac{1}{8}''$. Stiftsbibliothek, Saint Gall.

The purpose of this plan for an ideal, self-sufficient Benedictine monastery was to separate the monks from the laity. Near the center stands the church with its cloister, an earthly paradise reserved for the monks.

Whereas some of Saint Benedict's followers emphasized spiritual "work" over manual labor, others, most notably the Cistercians (see "Bernard of Clairvaux," Chapter 12, page 316), put his teachings about the value of physical work into practice. These monks reached into their surroundings and helped reduce the vast areas of daunting wilderness of early medieval Europe. They cleared dense forest teeming with wolves, bear, and wild boar; drained swamps and cultivated wastelands; and built roads, bridges, and dams as well as monastic churches and their associated living and service quarters.

The ideal monastery (FIG. 11-19) provided all the facilities necessary for the conduct of daily life—a mill, bakery, infirmary, vegetable garden, and even a brewery—so that the monks felt no need to wander outside its protective walls. These religious communities

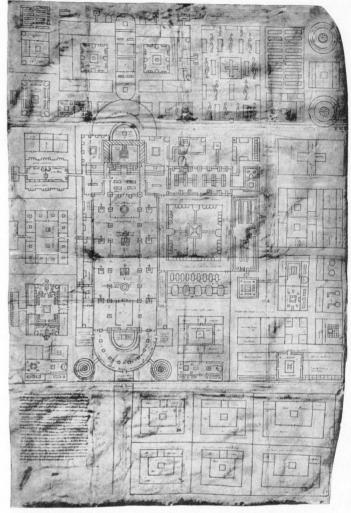

 I_1 in.

were centrally important to the revival of learning. The clergy, who were also often scribes and scholars, had a monopoly on the skills of reading and writing in an age of almost universal illiteracy. The monastic libraries and scriptoria (FIG. 11-11), where the monks read, copied, illuminated, and bound books with ornamented covers, became centers of study. Monasteries were almost the sole repositories of what remained of the literary culture of the Greco-Roman world and early Christianity. Saint Benedict's requirements of manual labor and sacred reading came to include writing and copying books, studying music for chanting the day's offices, and—of great significance—teaching. The monasteries were the schools of the early Middle Ages as well as self-sufficient communities and production centers.

SAINT GALL The construction and expansion of many monasteries also characterized the Carolingian period. A unique document, the ideal plan (FIG. 11-19) for a Benedictine monastery (see "Medieval Monasteries and Benedictine Rule," above) at Saint Gall in Switzerland, provides precious information about the design of Carolingian monastic communities. Haito, the abbot of Reichenau and bishop of Basel, commissioned the drawing and sent it to the abbot of

Saint Gall around 819 as a guide for the rebuilding of the Saint Gall monastery. The design's fundamental purpose was to separate the monks from the laity (nonclergy) who also inhabited the community. Variations of the scheme may be seen in later monasteries all across western Europe. Near the center, dominating everything, was the church with its *cloister*, a colonnaded courtyard not unlike the Early Christian atrium (FIG. 8-9) but situated to the side of the church

rather than in front of its main portal. Reserved for the monks alone, the cloister, a kind of earthly paradise removed from the world at large, provided the peace and quiet necessary for contemplation. Clustered around the cloister were the most essential buildings: dormitory, refectory, kitchen, and storage rooms. Other structures, including an infirmary, school, guest house, bakery, brewery, and workshops, were grouped around this central core of church and cloister.

Haito invited the abbot of Saint Gall to adapt the monastery plan as he saw fit, and, indeed, the Saint Gall builders did not follow the Reichenau model exactly. Nonetheless, if the abbot had wished, Haito's plan could have served as a practical guide for the Saint Gall masons because it was laid out using a *module* (standard unit) of two and a half feet. Parts or multiples of this module were employed consistently throughout the plan. For example, the nave's width, indicated on the plan as 40 feet, was equal to 16 modules; the length of each monk's bed to two and a half modules; and the width of paths in the vegetable garden to one and a quarter modules.

The models that carried the greatest authority for Charlemagne and his builders were those from the Christian phase of the Late Roman Empire. The widespread adoption of the Early Christian basilica, at Saint Gall and elsewhere, rather than the domed central plan of Byzantine churches, was crucial to the subsequent development of western European church architecture. Unfortunately, no Carolingian basilica has survived in anything approaching its original form. Nevertheless, it is possible to reconstruct the appearance of some of the structures with fair accuracy. Several appear to have followed their Early Christian models quite closely. But in other instances, Carolingian builders significantly modified the basilica plan, converting it into a much more complex form. The monastery church at Saint Gall, for example, was essentially a traditional basilica, but it had features not found in any Early Christian church. Most obvious is the addition of a second apse on the west end of the building, perhaps to accommodate additional altars and relics (see "Pilgrimages and the Cult of Relics," Chapter 12, page 310). Whatever its purpose, this feature remained a characteristic regional element of German churches until the 11th century.

Not quite as evident but much more important to the subsequent development of church architecture north of the Alps was the presence of a transept at Saint Gall, a very rare feature but one that characterized the two greatest Early Christian basilicas in Rome, Saint Peter's (FIG. 8-9) and Saint Paul's. The Saint Gall transept is as wide as the nave on the plan and was probably the same height. Early Christian builders had not been concerned with proportional relationships. On the Saint Gall plan, however, the various parts of the building relate to one another by a geometric scheme that ties them together into a tight and cohesive unit. Equalizing the widths of nave and transept automatically makes the area where they cross (the crossing) a square. Most Carolingian churches shared this feature. But Haito's planner also used the crossing square as the unit of measurement for the remainder of the church plan. The transept arms are equal to one crossing square, the distance between transept and apse is one crossing square, and the nave is four and a half crossing squares long. The fact that the two aisles are half as wide as the nave integrates all parts of the church in a rational and orderly plan.

The Saint Gall plan also reveals another important feature of many Carolingian basilicas: towers framing the end(s) of the church. Haito's plan shows only two towers, both cylindrical and on the west side of the church, as at Charlemagne's Palatine Chapel (FIG. 11-17), but they stand apart from the church facade. If a tower existed above the crossing, the silhouette of Saint Gall would have shown three towers altering the horizontal profile of the traditional basilica and identifying the church even from afar.

CORVEY Other Carolingian basilicas had towers incorporated in the fabric of the west end of the building, thereby creating a unified monumental facade that greeted all those who entered the church. Architectural historians call this feature of Carolingian and some later churches the westwork (German Westwerck, "western entrance structure"). In contemporaneous documents, writers refer to it as a castellum (Latin, "castle" or "fortress") or turris ("tower"). The sole surviving example is the abbey church (FIG. 11-20) at Corvey. The uppermost parts are 12th-century additions (easily distinguishable from the original westwork by the differing masonry technique). Stairs in each tower provided access to the upper stories of the westwork. On the second floor was a two-story chapel with an aisle and a gallery on three sides. As at Aachen, the chapel opened onto the nave, and from it, on occasion, the emperor and his entourage could watch and participate in the service below. Not all Carolingian westworks, however, served as seats for the visiting emperor. They also functioned as churches within churches, housing a second altar for special celebrations on major feast days. Boys' choirs stationed in the westwork chapel participated from above in the services conducted in the church's nave.

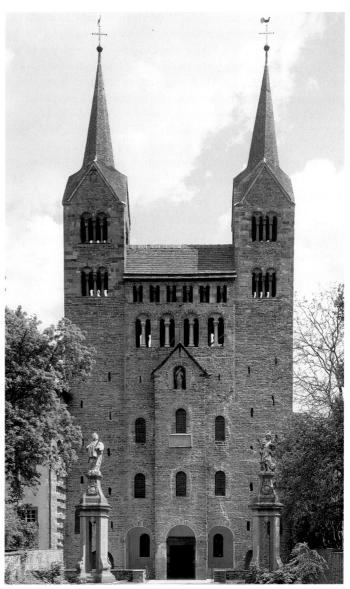

11-20 Westwork of the abbey church, Corvey, Germany, 873-885.

An important new feature of Carolingian church architecture is the westwork, a monumental western facade incorporating two towers. The sole surviving example is the abbey church at Corvey.

OTTONIAN ART

Charlemagne was buried in the Palatine Chapel at Aachen. His empire survived him by fewer than 30 years. When his son Louis the Pious died in 840, Louis's sons—Charles the Bald, Lothair, and Louis the German—divided the Carolingian Empire among themselves. After bloody conflicts, the brothers signed a treaty at Verdun in 843 partitioning the Frankish lands into western, central, and eastern areas, very roughly foreshadowing the later nations of France and Germany and a third realm corresponding to a long strip of land stretching from the Netherlands and Belgium to Rome. Intensified Viking incursions helped bring about the collapse of the Carolingians. The empire's breakup into weak kingdoms, ineffectual against the invasions, brought a time of confusion to Europe. Complementing the Viking scourge in Europe were the invasions of the Magyars in the Byzantine East and the plundering and piracy of the Saracens (Muslims) in the Mediterranean.

Only in the mid-10th century did the eastern part of the former empire consolidate under the rule of a new Saxon line of German emperors called, after the names of the three most illustrious family members, the Ottonians. The pope crowned the first Otto (r. 936–973) in Rome in 962, and Otto assumed the title of emperor of Rome that Charlemagne's weak successors held during most of the previous century. The three Ottos made headway against the invaders from the East, remained free from Viking attacks, and not only preserved but also enriched the culture and tradition of the Carolingian period. The Christian Church, which had become corrupt and disorganized, recovered in the 10th century under the influence of a great monastic reform that the Ottonians encouraged and sanctioned. The new German emperors also cemented ties with Italy and the papacy. By the time the last of the Ottonian line, Henry II, died in the early 11th century, the pagan marauders had become Christianized and settled, and the monastic reforms had been highly successful.

Architecture

Ottonian architects followed the course of their Carolingian predecessors, building basilican churches with towering spires and imposing westworks, but they also introduced new features that would have a long future in western European church architecture.

GERNRODE The best preserved 10th-century Ottonian basilica is Saint Cyriakus at Gernrode. The church was the centerpiece of a convent founded in 961. Construction of the church began the same year. In the 12th century, a large apse replaced the western entrance, but the upper parts of the westwork, including the two cylindrical towers, were left intact. The interior (FIG. 11-21), although heavily restored in the 19th century, retains its 10th-century character. Saint Cyriakus reveals how Ottonian architects enriched the form of the Early Christian basilica. The church has a transept at the east with a square choir in front of the apse. The nave is one of the first in western Europe to incorporate a gallery between the ground-floor arcade and the clerestory, a design that became very popular in the succeeding Romanesque era (see Chapter 12). Scholars have reached no consensus on the function of these galleries in Ottonian churches. They cannot have been reserved for women, as some think they were in Byzantium, because Saint Cyriakus is a nuns' church. One suggestion is that the galleries housed additional altars, as in the westwork at Corvey. They may also have been where the choirs sang. The Gernrode builders also transformed the nave arcade itself by adopting the alternate-support system, in which heavy square piers alternate with columns, dividing the nave into vertical units. The division continues into the gallery level, breaking the smooth rhythm of the

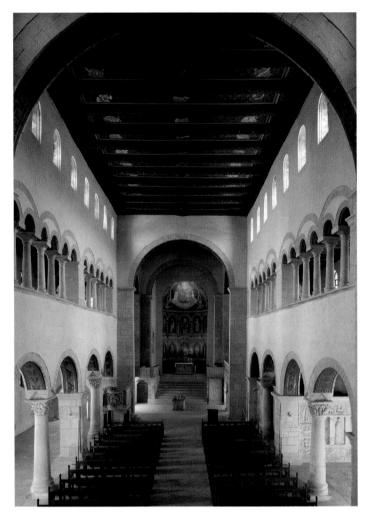

11-21 Nave of the church of Saint Cyriakus, Gernrode, Germany, 961–973.

Ottonian builders modified the interior elevation of the Early Christian basilica. The Gernrode designer added a gallery above the nave arcade and adopted an alternate-support system of piers and columns.

all-column arcades of Early Christian and Carolingian basilicas and leading the eye upward. Later architects would carry this "verticalization" of the basilican nave much further (FIG. 13-19).

HILDESHEIM One of the great patrons of Ottonian art and architecture was Bishop Bernward of Hildesheim, Germany. He was the tutor of Otto III (r. 983–1002) and builder of the abbey church of Saint Michael (FIG. 11-22) at Hildesheim. Bernward, who made Hildesheim a center of learning, was an eager scholar, a lover of the arts, and, according to Thangmar of Heidelberg, his biographer, an expert craftsman and bronze caster. In 1001, Bernward traveled to Rome as the guest of Otto III. During this stay, he studied at first hand the monuments of the empire the Carolingian and Ottonian emperors revered.

Constructed between 1001 and 1031 (and rebuilt after being bombed during World War II), Saint Michael's has a double-transept plan (FIG. 11-23, *bottom*), tower groupings, and a westwork. The two transepts create eastern and western centers of gravity. The nave merely seems to be a hall that connects them. Lateral entrances leading into the aisles from the north and south additionally make for an almost complete loss of the traditional basilican orientation toward the east. Some ancient Roman basilicas, such as the Basilica Ulpia (FIG. 7-43, no. 4) in Trajan's Forum, also had two apses and en-

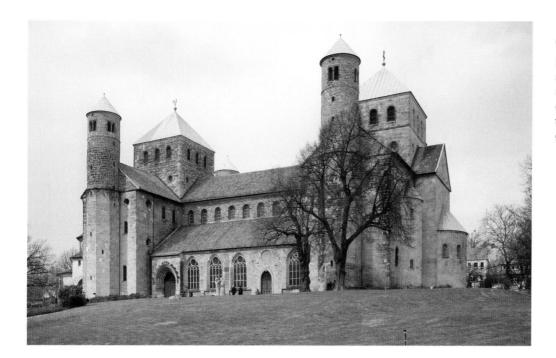

11-22 Saint Michael's, Hildesheim, Germany, 1001–1031.

Built by Bishop Bernward, a great art patron, Saint Michael's is a masterpiece of Ottonian basilica design. The church's two apses, two transepts, and multiple towers give it a distinctive profile.

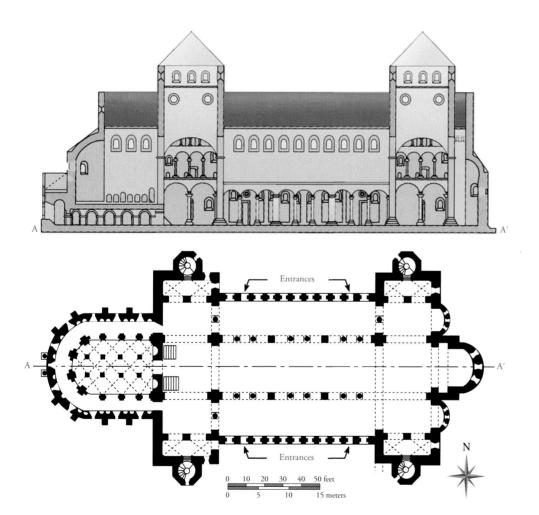

11-23 Longitudinal section (*top*) and plan (*bottom*) of the abbey church of Saint Michael's, Hildesheim, Germany, 1001–1031.

Saint Michael's entrances are on the side. Alternating piers and columns divide the space in the nave into vertical units. These features transformed the tunnel-like horizontality of Early Christian basilicas.

trances on the side, and Bernward probably was familiar with this variant basilican plan.

At Hildesheim, as in the plan of the monastery at Saint Gall (FIG. 11-19), the builders adopted a modular approach. The crossing squares, for example, are the basis for the nave's dimensions—three

crossing squares long and one square wide. The placement of heavy piers at the corners of each square gives visual emphasis to the three units. These piers alternate with pairs of columns (FIG. 11-23, *top*) as wall supports in a design similar to that of Saint Cyriakus (FIG. 11-21) at Gernrode.

Sculpture and Painting

In 1001, when Bishop Bernward was in Rome visiting the young Otto III, he resided in Otto's palace on the Aventine Hill in the neighborhood of Santa Sabina (FIG. 8-10), an Early Christian church renowned for its carved wooden doors. Those doors, decorated with episodes from both the Old and New Testaments, may have inspired the remarkable bronze doors the bishop had cast for his new church in Germany.

HILDESHEIM DOORS The colossal doors (FIG. 11-24) for Saint Michael's, dated by inscription to 1015, are more than 16 feet tall. Each was cast in a single piece with the figural sculpture, a technological marvel. Carolingian sculpture, like most sculpture since Late Antiquity, consisted primarily of small-scale art executed in ivory and precious metals, often for book covers (FIG. 11-16). The Hildesheim doors are huge in comparison, but the 16 individual panels stem from this tradition.

Bernward placed the bronze doors at the entrance to Saint Michael's from the cloister, where the monks would see them each time they walked into the church. The panels of the left door illustrate highlights from the biblical book of Genesis, beginning with the creation of Eve (at the top) and ending with the murder of Adam and Eve's son Abel by his brother Cain (at the bottom). The right door recounts the life of Christ (reading from the bottom up), starting with the Annunciation and terminating with the appearance to Mary Magdalene of Christ after the Resurrection (see "The Life of Jesus in Art," Chapter 8, pages 216–217). Together, the doors tell the story of Original Sin and ultimate redemption, showing the expulsion from the Garden of Eden and the path back to Paradise through the Christian Church. As in Early Christian times, the Old Testament was interpreted as prefiguring the New Testament (see "Jewish Subjects in Christian Art," Chapter 8, page 213). The panel depicting the Fall of Adam and Eve, for example, is juxtaposed with the Crucifixion on the other door. Eve nursing the infant Cain is opposite Mary with the Christ Child in her lap.

The composition of many of the scenes on the doors derives from Carolingian manuscript illumination, and the style of the figures has an expressive strength that brings to mind the illustrations in the Utrecht Psalter (FIG. 11-15). For example, in the fourth panel from the top on the left door, God, portrayed as a man, accuses Adam and Eve after their fall from grace. He jabs his finger at them with the force of his whole body. The force is concentrated in the gesture, which becomes the psychic focus of the whole composition. The frightened pair crouch, not only to hide their shame but also to escape the lightning bolt of divine wrath. Each passes the blame—Adam pointing backward to Eve and Eve pointing downward to the deceitful serpent. The starkly flat setting throws into relief the gestures and attitudes of rage, accusation, guilt, and fear. The sculptor presented the story with simplicity, although with great emotional impact, as well as a flair for anecdotal detail. Adam and Eve both struggle to point with one arm while attempting to shield their bodies from sight with the other. With an instinct for expressive pose and gesture, the artist brilliantly communicated their newfound embarrassment at their nakedness and their unconvincing denials of wrongdoing.

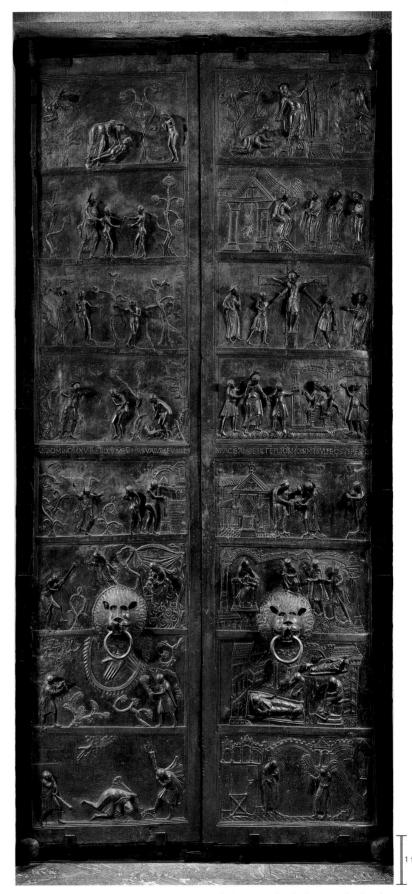

11-24 Doors with relief panels (Genesis, left door; life of Christ, right door), commissioned by Bishop Bernward for Saint Michael's, Hildesheim, Germany, 1015. Bronze, 16′ 6″ high. Dom-Museum, Hildesheim.

Bernward's doors vividly tell the story of Original Sin and ultimate redemption, and draw parallels between the Old and New Testaments, as in the expulsion from Paradise and the infancy and suffering of Christ.

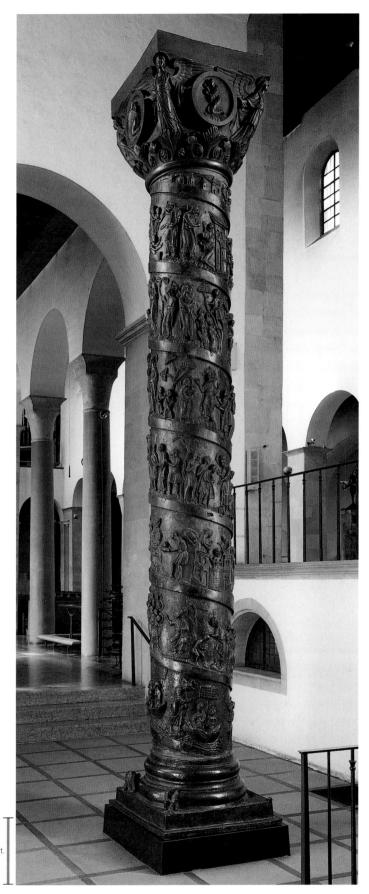

11-25 Column with reliefs illustrating the life of Christ, commissioned by Bishop Bernward for Saint Michael's, Hildesheim, Germany, ca. 1015–1022. Bronze, 12′ 6″ tall. Dom-Museum, Hildesheim.

Modeled on the Column of Trajan (FIG. 7-44) in Rome, the seven spiral bands of the Hildesheim column relate the life of Jesus from his baptism to his entry into Jerusalem, episodes Bernward's doors omitted.

11-26 Crucifix commissioned by Archbishop Gero for Cologne Cathedral, Cologne, Germany, ca. 970. Painted wood, height of figure 6' 2". Cathedral, Cologne.

In this early example of the revival of monumental sculpture in the Middle Ages, an Ottonian sculptor depicted with unprecedented emotional power the intense agony of Christ's ordeal on the cross.

HILDESHEIM COLUMN The great doors of Saint Michael's were not the only large-scale examples of bronze-casting Bernward commissioned. Within the church stood a bronze spiral column (FIG. 11-25) that survives intact, save for its later capital and missing surmounting cross. The seven spiral bands of relief tell the story of Jesus' life in 24 scenes, beginning with his baptism and concluding with his entry into Jerusalem. These are the missing episodes from the story told on the church's doors. The narrative reads from bottom to top, exactly as on the Column of Trajan (FIG. 7-44) in Rome. That triumphal column was unmistakably the model for the Hildesheim column, even though the Ottonian narrative unfolds from right to left instead of from left to right. Once again, a monument in Rome provided the inspiration for the Ottonian artists working under Bernward's direction. Both the doors and the column of Saint Michael's lend credence to the Ottonian emperors' claim to be the heirs to Charlemagne's renovatio imperii Romani.

GERO CRUCIFIX Nowhere was the revival of interest in monumental sculpture more evident than in the crucifix (FIG. 11-26) Archbishop Gero commissioned and presented to Cologne Cathedral

11-27 Abbess Uta dedicating her codex to the Virgin, folio 2 recto of the *Uta Codex*, from Regensburg, Germany, ca. 1025. Tempera on parchment, $9\frac{5}{8}" \times 5\frac{1}{8}"$. Bayerische Staatsbibliothek, Munich.

The *Uta Codex* illustrates the important role that women could play both in religious life and as patrons of the arts. The dedicatory page shows Uta presenting her codex to the Virgin Mary.

their limit—those of his right shoulder and chest seem almost to rip apart. The halo behind Christ's head may foretell his subsequent Resurrection, but all the worshiper can sense is his pain. Gero's crucifix is the most powerful characterization of intense agony of the

early Middle Ages.

in 970. Carved in oak and then painted and gilded, the six-foot-tall image of Christ nailed to the cross is both statue and *reliquary* (a shrine for sacred relics; see "Pilgrimages and the Cult of Relics," Chapter 12, page 310). A compartment in the back of the head held the Host. A later story tells how a crack developed in the wood of Gero's crucifix but miraculously healed. Similar tales of miracles are attached to many sacred Christian objects, for example, some Byzantine icons (see "Icons and Iconoclasm," Chapter 9, page 246).

The Gero crucifix presents a dramatically different conception of the Savior from that seen on the *Lindau Gospels* cover (FIG. 11-16), with its Early Christian imagery of the youthful Christ triumphant over death. The bearded Christ of the Cologne crucifix is more akin to Byzantine representations (FIG. 9-23) of the suffering Jesus, but the emotional power of the Ottonian work is greater still. The sculptor depicted Christ as an all-too-human martyr. Blood streaks down his forehead from the (missing) crown of thorns. His eyelids are closed, and his face is contorted in pain. Christ's body sags under its own weight. The muscles stretch to

UTA CODEX Ottonian artists carried on the Carolingian tradition of producing sumptuous books for the clergy and royalty alike. One of the finest is the lectionary produced at Regensburg, Germany, for Uta, abbess of Niedermünster. The Uta Codex illustrates the important role that women could play both in religious life and as patrons of the arts during the early Middle Ages. Uta was instrumental in bringing Benedictine reforms to the Niedermünster convent, whose nuns were usually the daughters of the local nobility. Uta herself was well known in Ottonian royal circles. Near the end of her life, she presented the nunnery with a luxurious codex containing many full-page illuminations interspersed with Gospel readings. The lectionary's gold, jewel, and enamel case also survives, underscoring the

11-28 Annunciation to the Shepherds, folio in the Lectionary of Henry II, from Reichenau, Germany, 1002-1014. Tempera on vellum, $1'5'' \times 1'1''$. Bayerische Staatsbibliothek, Munich.

The golden background of the illuminations in the Lectionary of Henry II reveals Byzantine influence on Ottonian art, which received added impetus when Otto II married the Byzantine princess Theophanu.

nature of medieval books as sacred objects to be venerated in their own right as well as embodiments of the eternal Word of God.

The dedicatory page (FIG. 11-27) at the front of the *Uta Codex* depicts the Virgin Mary with the Christ Child in her lap in the central medallion. Labeled Virgo Virginum (Virgin of Virgins), Mary is the model for Uta and the Niedermünster nuns. Uta is the full-length figure presenting a new book—this book—to the Virgin. An inscription accompanies the dedicatory image: "Virgin Mother of God, happy because of the divine Child, receive the votive offerings of your Uta of ready service." The artist painted Uta last, superimposing her figure upon the design and carefully placing it so that Uta's head touches the Virgin's medallion but does not penetrate it, suggesting the interplay between, but also the separation of, the divine and human realms.

LECTIONARY OF HENRY II Uta presented her codex to the Niedermünster convent about the time the last Ottonian emperor, Henry II (r. 1002–1024), died. The Lectionary of Henry II, a book of Gospel readings for the Mass, was a gift to Bamberg Cathedral. In the

full-page illumination (FIG. 11-28) of the Annunciation of Christ's birth to the shepherds, the angel has just alighted on a hill, his wings still beating, and the wind of his landing agitates his robes. The angel looms immense above the startled and terrified shepherds, filling the golden sky, as he extends his hand in a gesture of authority and instruction. Emphasized more than the message itself are the power and majesty of God's authority. The painting is a highly successful fusion of the Carolingian-Ottonian anecdotal narrative tradition, elements derived from

Late Antique painting—for example, the rocky landscape setting with grazing animals (FIG. 8-16)—and the golden background of Byzantine book illumination and mosaic decoration. Byzantine influence on Ottonian art had received added impetus when Otto II (r. 973-983) married a Byzantine princess (see "Theophanu: A Byzantine Princess in Ottonian Germany," page 306).

GOSPEL BOOK OF OTTO III Henry II's predecessor was his cousin, Otto III, son of Otto II and Theophanu. Of the three Ottos, the last dreamed the most of a revived Christian Roman Empire. Indeed, it was his life's obsession. Otto III was keenly aware of his descent from both German and Byzantine imperial lines. It is said that he was prouder of his Constantinopolitan than his German roots. He moved his court, with its Byzantine rituals, to Rome and there set up theatrically the symbols and trappings of Roman imperialism. Otto's romantic dream of imperial unity for Europe never materialized. He died prematurely, at age 21, and, at his own request, was buried beside Charlemagne at Aachen.

Theophanu, a Byzantine Princess in Ottonian Germany

The bishop of Mainz crowned Otto I king of the Saxons at Aachen in 936, but it was not until 962 that Pope John XII conferred the title of emperor of Rome upon him in Saint Peter's basilica. Otto, known as the Great, had ambitions to restore the glory of Charlemagne's Christian Roman Empire and to enlarge the territory under his rule. In 951 he defeated a Roman noble who had taken prisoner Adelaide, the widow of the Lombard king Lothar. Otto then married Adelaide, assumed the title of king of the Lombards, and extended his power south of the Alps. Looking eastward, in 972 he arranged the marriage of his son, Otto II, to Theophanu (ca. 955–991), the niece of the Byzantine emperor Nikephoros II Phokas. Otto was 60, Theophanu 17. They wed in Saint Peter's, with Pope John XIII presiding. When Otto the Great died the next year, Otto II succeeded him. The second Otto died in Italy in 983 and was buried in the atrium of Saint

Peter's. His son, Otto III, only three years old at the time, nominally became king, but it was his mother, Theophanu, co-regent with Adelaide until 985 and sole regent thereafter, who wielded power in the Ottonian Empire until her own death in 991. Adelaide then served as regent until Otto III was old enough to rule on his own. He became emperor of Rome in 996.

Theophanu brought not only the prestige of Byzantium to Germany but also Byzantine culture and art. The Ottonian court emulated much of the splendor and pomp of Constantinople and imported Byzantine luxury goods in great quantities. One surviving ivory panel, probably carved in the West but of Byzantine style and labeled in Greek, depicts Christ simultaneously blessing Otto II and Theophanu. The impact of Byzantine art in Ottonian Germany can also be seen in manuscript illumination (FIG. 11-28).

Otto III is portrayed in a Gospel book (FIG. 11-29) that takes his name. The illuminator represented the emperor enthroned, holding the scepter and cross-inscribed orb that represent his universal authority, conforming to a Christian imperial iconographic tradition that went back to Constantine (FIG. 7-81, right). At his sides are the clergy and the barons (the Christian Church and the state), both aligned in his support. On the facing page (not illustrated), also derived from ancient Roman sources, female personifications of Slavinia, Germany, Gaul, and Rome—the provinces of the Ottonian Empire—bring tribute to the young emperor.

The ideal of a Christian Roman Empire gave partial unity to western Europe from the 9th through early 11th centuries. To this extent, ancient Rome lived on to the millennium, culminating in the frustrated ambition of Otto III. But with the death of Henry II in 1024, a new age began, and Rome ceased to be the deciding influence. Romanesque Europe instead found unity in a common religious heritage (see Chapter 12).

11-29 Otto III enthroned, folio 24 recto of the *Gospel Book of Otto III*, from Reichenau, Germany, 997–1000. Tempera on vellum, $1' 1'' \times 9\frac{3}{8}''$. Bayerische Staatsbibliothek, Munich.

Emperor Otto III, descended from both German and Byzantine imperial lines, appears in this Gospel book enthroned and holding the scepter and cross-inscribed orb that signify his universal authority.

1 in

EARLY MEDIEVAL EUROPE

ART OF THE WARRIOR LORDS, 5th to 10th Centuries

- After the fall of Rome in 410, the Huns, Vandals, Merovingians, Franks, Goths, and other non-Roman peoples competed for power and territory in the former northwestern provinces of the Roman Empire.
- The surviving art of this period consists almost exclusively of small-scale status symbols, especially portable items of personal adornment such as bracelets, pins, and belt buckles, often featuring cloisonné ornament. The decoration of these early medieval objects displays a variety of abstract and zoomorphic motifs. Especially characteristic are intertwined animal and interlace patterns.

Sutton Hoo purse cover, ca. 625

CHRISTIAN ART: SCANDINAVIA, BRITISH ISLES, SPAIN, 6th to 10th Centuries

- The Christian art of the early medieval British Isles is called Hiberno-Saxon (or Insular). The most important extant artworks are the illuminated manuscripts produced in the monastic scriptoria of Ireland and Northumbria. The most distinctive features of these Insular books are the full pages devoted neither to text nor to illustration but to pure embellishment in the form of carpet pages made up of decorative panels of abstract and zoomorphic motifs. Some Hiberno-Saxon books also have full pages depicting each of the Four Evangelists or their symbols. Text pages often feature enlarged initial letters of important passages transformed into elaborate decorative patterns.
- In Spain, Visigothic churches of the sixth and seventh centuries were basilican in plan but had square apses and often incorporated horseshoe arches, a form usually associated with Islamic architecture.
- Scandinavian churches of the 11th century are notable for their carved wooden decoration recalling the pre-Christian art of the Vikings.

Lindisfarne Gospels, ca. 698-721

CAROLINGIAN ART, 768-877

- Charlemagne, king of the Franks since 768, expanded the territories he inherited from his father, and in 800, Pope Leo III crowned him emperor of Rome (r. 800–814). Charlemagne reunited much of western Europe and initiated a revival of the art and culture of Early Christian Rome.
- Carolingian illuminators merged the illusionism of classical painting with the northern linear tradition, replacing the calm and solid figures of their models with figures that leap from the page with frenzied energy.
- Carolingian sculptors revived the imperial Roman tradition of equestrian ruler portraiture and the Early Christian tradition of depicting Christ as a statuesque youth.
- Carolingian architects looked to Ravenna and Early Christian Rome for models, but transformed their sources, introducing, for example, the twin-tower western facade for basilicas and employing strict modular plans in their buildings.

Charlemagne or Charles the Bald, ninth century

OTTONIAN ART, 919-1024

- In the mid-10th century, a new line of emperors, the Ottonians, consolidated the eastern part of Charlemagne's former empire and sought to preserve and enrich the culture and tradition of the Carolingian period.
- Ottonian architects built basilican churches with the towering spires and imposing westworks of their Carolingian models but introduced the alternate-support system and galleries into the interior elevation of the nave.
- Ottonian sculptors also began to revive the art of monumental sculpture in works such as the Gero crucifix and the colossal bronze doors of Saint Michael's at Hildesheim.
- Ottonian painting combines motifs and landscape elements from Late Antique art with the golden backgrounds of Byzantine art. Byzantine influence on Ottonian art became especially pronounced after Otto II married Theophanu in 972.

Saint Michael's, Hildesheim, 1001–1031

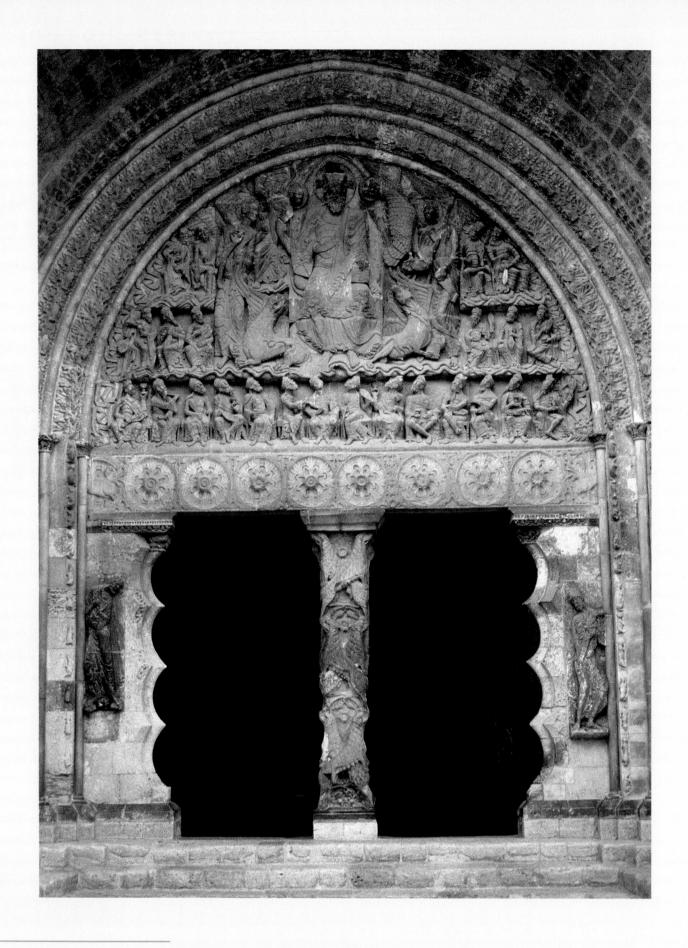

12-1 South portal of Saint-Pierre, Moissac, France, ca. 1115-1135.

Art historians first used the term *Romanesque* (Roman-like) to describe stone-vaulted churches of the 11th and 12th centuries, but the adjective also applies to the revival of monumental stone sculpture.

ROMANESQUE EUROPE

The Romanesque era is the first since Archaic and Classical Greece to take its name from an artistic style rather than from politics or geography. Unlike Carolingian and Ottonian art, named for emperors, or Hiberno-Saxon art, a regional term, *Romanesque* is a title art historians invented to describe medieval art that appeared "Roman-like." Architectural historians first employed the adjective in the early 19th century to describe European architecture of the 11th and 12th centuries. Scholars noted that certain architectural elements of this period, principally barrel and groin vaults based on the round arch, resembled those of ancient Roman architecture. Thus, the word distinguished most Romanesque buildings from earlier medieval timber-roofed structures, as well as from later Gothic churches with vaults resting on pointed arches (see Chapter 13). Scholars in other fields quickly borrowed the term. Today "Romanesque" broadly designates the history and culture of western Europe between about 1050 and 1200 (MAP 12-1).

In the early Middle Ages, the focus of life was the *manor*, or estate, of a landholding *liege lord*, who might grant rights to a portion of his land to *vassals*. The vassals swore allegiance to their liege and rendered him military service in return for use of the land and the promise of protection. But in the Romanesque period, a sharp increase in trade encouraged the growth of towns and cities, gradually displacing *feudalism* as the governing political, social, and economic system of late medieval Europe. Feudal lords granted independence to the new towns in the form of charters, which enumerated the communities' rights, privileges, immunities, and exemptions beyond the feudal obligations the vassals owed the lords. Often located on navigable rivers, the new urban centers naturally became the nuclei of networks of maritime and overland commerce.

Separated by design from the busy secular life of Romanesque towns were the monasteries (see "Medieval Monasteries," Chapter 11, page 298) and their churches. During the 11th and 12th centuries, thousands of ecclesiastical buildings were remodeled or newly constructed. This immense building enterprise was in part a natural by-product of the rise of independent cities and the prosperity they enjoyed. But it also was an expression of the widely felt relief and thanksgiving that the conclusion of the first Christian millennium in the year 1000 had not brought an end to the world, as many had feared. In the Romanesque age, the construction of churches became almost an obsession. Raoul Glaber (ca. 985–ca. 1046), a monk

Pilgrimages and the Cult of Relics

he cult of *relics* was not new in the Romanesque era. For centuries, Christians had traveled to sacred shrines that housed the body parts of, or objects associated with, the holy family or the saints. The faithful had long believed that bones, clothing, instruments of martyrdom, and the like had the power to heal body and soul. The veneration of relics reached a high point in the 11th and 12th centuries.

In Romanesque times, pilgrimage was the most conspicuous feature of public devotion, proclaiming the pilgrim's faith in the power of saints and hope for their special favor. The major shrines—Saint Peter's and Saint Paul's in Rome and the Church of the Holy Sepulchre in Jerusalem—drew pilgrims from all over Europe, just as Muslims journeyed from afar to Mecca (see "Muhammad and Islam," Chapter 10, page 263). To achieve salvation, Christian pilgrims braved bad roads and hostile wildernesses infested with robbers who preyed on innocent travelers. The journeys could take more than a year to completewhen they were successful. People often undertook pilgrimage as an act of repentance or as a last resort in their search for a cure for some physical disability. Hardship and austerity were means of increasing pilgrims' chances for the remission of sin or of dis-

ease. The distance and peril of the pilgrimage were measures of pilgrims' sincerity of repentance or of the reward they sought.

For those with insufficient time or money to make a pilgrimage to Rome or Jerusalem (in short, for most people at the time), holy destinations could be found closer to home. In France, for example, the church at Vézelay housed the bones of Mary Magdalene. Pilgrims could also view Saint Foy's remains at Conques, Lazarus's at Autun, Saint Martin's at Tours, and Saint Saturninus's at Toulouse. Each of these great shrines was also an important way station en route to the most venerated Christian shrine in western Europe, the tomb of Saint James at Santiago de Compostela in northwestern Spain.

Large crowds of pilgrims paying homage to saints placed a great burden on the churches that stored their relics and led to changes in church design, principally longer and wider naves and aisles, transepts and ambulatories with additional chapels (FIG. 12-5), and secondstory galleries (FIG. 12-6). Pilgrim traffic also established the routes that later became the major avenues of commerce and communication in western Europe. The popularity of pilgrimages gave rise to travel guides akin to modern guidebooks. These provided pilgrims with information about saints and shrines and also about roads, accommodations, food, and drink. How widely circulated these handwritten books were is a matter of debate, but the information they provide modern scholars is still invaluable. The most famous Romanesque guidebook described the four roads leading to Santiago de Compostela through Arles and Toulouse, Conques and Moissac, Vézelay and Périgueux, and Tours and Bordeaux (MAP 12-1). Saint James was the symbol of Christian resistance to Muslim expansion in western Europe, and his relics, discovered in the ninth century, drew pilgrims to Santiago de Compostela from far and wide. The guidebook's anonymous 12th-century author, possibly Aimery Picaud, a Cluniac

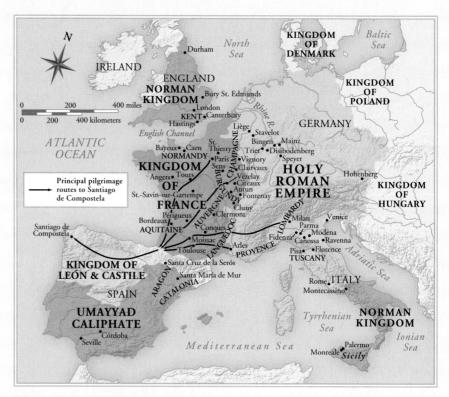

MAP 12-1 Western Europe around 1100.

monk, was himself a well-traveled pilgrim. According to the guide, the author wrote it "in Rome, in the lands of Jerusalem, in France, in Italy, in Germany, in Frisia and mainly in Cluny."*

Pilgrims reading the guidebook learned about the saints and their shrines at each stop along the way to Spain. Saint Saturninus of Toulouse, for example, endured a martyr's death at the hands of pagans when he

was tied to some furious and wild bulls and then precipitated from the height of the citadel. . . . His head crushed, his brains knocked out, his whole body torn to pieces, he rendered his worthy soul to Christ. He is buried in an excellent location close to the city of Toulouse where a large basilica [FIGS. 12-4 to 12-6] was erected by the faithful in his honor.

Given the competition among monasteries and cities for the possession of saints' relics, the *Pilgrim's Guide to Santiago de Compostela* also included comments on authenticity. For example, about Saint James's tomb, the author stated:

May therefore the imitators from beyond the mountains blush who claim to possess some portion of him or even his entire relic. In fact, the body of the Apostle is here in its entirety, divinely lit by paradisiacal carbuncles, incessantly honored with immaculate and soft perfumes, decorated with dazzling celestial candles, and diligently worshipped by attentive angels.[‡]

^{*} William Melczer, The Pilgrim's Guide to Santiago de Compostela (New York: Italica Press, 1993), 133.

[†] Ibid., 103.

[‡] Ibid., 127.

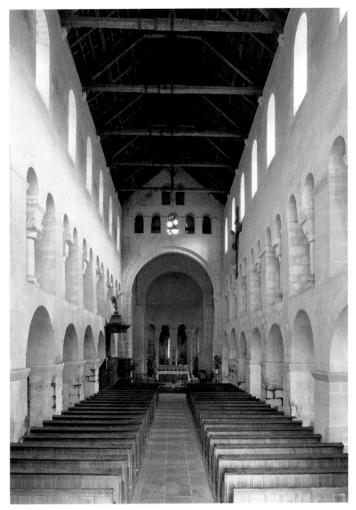

12-2 Interior of Saint-Étienne, Vignory, France, 1050-1057.

The timber-roofed abbey church of Saint Stephen at Vignory reveals a kinship with the three-story naves of Ottonian churches (FIG. 11-21), which also feature an alternate-support system of piers and columns.

who witnessed the coming of the new millennium, described the sudden boom in church building:

[After the] year of the millennium, which is now about three years past, there occurred, throughout the world, especially in Italy and Gaul, a rebuilding of church basilicas. Notwithstanding, the greater number were already well established and not in the least in need, nevertheless each Christian people strove against the others to erect nobler ones. It was as if the whole earth, having cast off the old by shaking itself, were clothing itself everywhere in the white robe of the church.¹

The enormous investment in ecclesiastical buildings and furnishings also reflected a significant increase in pilgrimage traffic in Romanesque Europe (see "Pilgrimages and the Cult of Relics," page 310). Pilgrims, along with wealthy landowners, were important sources of funding for monasteries that possessed the relics of venerated saints. The clergy of these monasteries vied with one another to provide magnificent settings for the display of their relics. Justification for such heavy investment in buildings and furnishings could be found in the Bible itself, for example in Psalm 26:8, "Lord, I have loved the beauty of your house, and the place where your glory dwells." Traveling pilgrims fostered the growth of towns as well as monasteries. Pilgrimages were, in fact, a major economic as well as conceptual catalyst for the art and architecture of the Romanesque period.

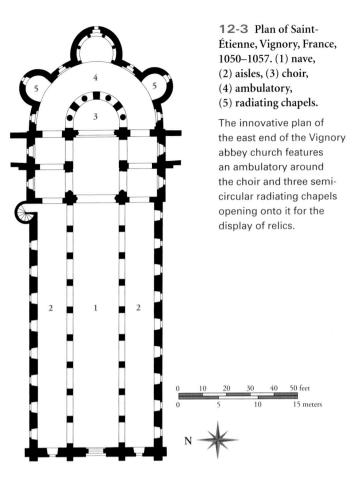

FRANCE AND NORTHERN SPAIN

Although art historians use the adjective "Romanesque" to describe 11th- and 12th-century art and architecture throughout Europe, pronounced regional differences exist. The discussion in this chapter deals in turn with Romanesque France and Spain, the Holy Roman Empire, Italy, and Normandy and England. To a certain extent, Romanesque art and architecture parallel European Romance languages, which vary regionally but have a common core in Latin, the language of the Romans.

Architecture and Architectural Sculpture

The regional diversity of the Romanesque period is very evident in architecture. For example, some Romanesque churches, especially in Italy, retained the wooden roofs of their Early Christian predecessors long after stone vaulting had become commonplace elsewhere. Even in France and northern Spain, home of many of the most innovative instances of stone vaulting, some Romanesque architects still built timber-roofed churches.

SAINT-ÉTIENNE, VIGNORY The mid-11th-century church of Saint-Étienne (Saint Stephen) at Vignory in the Champagne region of central France has strong ties to Carolingian-Ottonian architecture but already incorporates features that became widely adopted only in later Romanesque architecture. The interior (FIG. **12-2**) reveals a kinship with the three-story wooden-roofed churches of the Ottonian era, for example, Saint Cyriakus (FIG. **11-21**) at Gernrode. At Vignory, however, the second story is not a true *tribune* (upper gallery over the aisle opening onto the nave) but rather a screen with alternating piers and columns opening onto very tall flanking aisles. The east end of the church, in contrast, has an innovative plan (FIG. **12-3**) with an

Bernard of Clairvaux on Cloister Sculpture

The most influential theologian of the Romanesque era was Bernard of Clairvaux (1090–1153). A Cistercian monk and abbot of the monastery he founded at Clairvaux in northern Burgundy, he embodied not only the reforming spirit of the Cistercian order but also the new religious fervor awakening in western Europe. Bernard's impassioned eloquence made him a European celebrity and drew him into the stormy politics of the Romanesque era. He intervened in high ecclesiastical and secular matters, defended and sheltered embattled popes, counseled kings, denounced heretics, and preached Crusades against the Muslims (see "The Crusades," page 320)—all in defense of papal Christianity and spiritual values. The Church declared Bernard a saint in 1174, barely two decades after his death.

In a letter Bernard wrote in 1127 to William, abbot of Saint-Thierry, he complained about the rich outfitting of non-Cistercian churches in general and the sculptural adornment of monastic cloisters in particular:

I will overlook the immense heights of the places of prayer, their immoderate lengths, their superfluous widths, the costly refinements,

and painstaking representations which deflect the attention... of those who pray and thus hinder their devotion.... But so be it, let these things be made for the honor of God.... [But] in the cloisters, before the eyes of the brothers while they read—what... are the filthy apes doing there? The fierce lions? The monstrous centaurs? The creatures, part man and part beast?... You may see many bodies under one head, and conversely many heads on one body. On one side the tail of a serpent is seen on a quadruped, on the other side the head of a quadruped is on the body of a fish. Over there an animal has a horse for the front half and a goat for the back.... Everywhere so plentiful and astonishing a variety of contradictory forms is seen that one would rather read in the marble than in books, and spend the whole day wondering at every single one of them than in meditating on the law of God. Good God! If one is not ashamed of the absurdity, why is one not at least troubled at the expense?*

* Apologia 12.28–29. Translated by Conrad Rudolph, The "Things of Greater Importance": Bernard of Clairvaux's Apologia and the Medieval Attitude toward Art (Philadelphia: University of Pennsylvania Press, 1990), 279, 283.

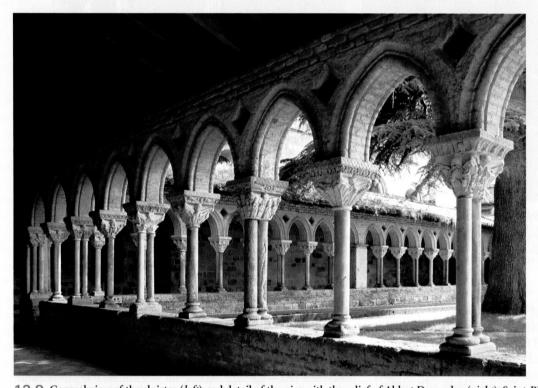

1 ft.

12-9 General view of the cloister (*left*) and detail of the pier with the relief of Abbot Durandus (*right*), Saint-Pierre, Moissac, France, ca. 1100–1115. Relief: limestone, 6' high.

The revived tradition of stonecarving seems to have begun with decorating capitals with reliefs. The most extensive preserved ensemble of sculptured early Romanesque capitals is in the Moissac cloister.

The monastery cloisters of the 12th century are monuments to the vitality, popularity, and influence of monasticism at its peak.

Moissac's cloister sculpture program consists of large figural reliefs on the piers as well as *historiated* (ornamented with figures) capitals on the columns. The pier reliefs (FIG. **12-9**, *right*) portray the 12 apostles and the first Cluniac abbot of Moissac, Durandus

(1047–1072), who was buried in the cloister. The 76 capitals alternately crown single and paired column shafts. They are variously decorated, some with abstract patterns, many with biblical scenes or the lives of saints, others with fantastic monsters of all sorts—basilisks, griffins, lizards, gargoyles, and more. *Bestiaries*—collections of illustrations of real and imaginary animals—became very

The Romanesque Church Portal

ne of the most significant and distinctive features of Romanesque art is the revival of monumental sculpture in stone. Large-scale carved Old and New Testament figures were extremely rare in Christian art before the Romanesque period. But in the late 11th and early 12th centuries, rich ensembles of figural reliefs began to appear again, most often in the grand stone portals (FIG. 12-1) through which the faithful had to pass. The clergy had placed sculpture in church doorways before. For example, carved wooden doors greeted Early Christian worshipers as they entered Santa Sabina in Rome, and Ottonian bronze doors (FIG. 11-24) decorated with Old and New Testament scenes marked the entrance to Saint Michael's at Hildesheim. But these were exceptions, and in the Romanesque era (and during the Gothic period that followed), sculpture usually appeared in the area surrounding the doors, not on them.

Shown in FIG. **12-10** are the parts of church portals that Romanesque sculptors regularly decorated with figural reliefs:

- *Tympanum* (FIGS. 12-1, 12-12, and 12-13), the prominent semi-circular *lunette* above the doorway proper, comparable in importance to the triangular pediment of a Greco-Roman temple.
- *Voussoirs* (FIG. 12-13), the wedge-shaped blocks that together form the *archivolts* of the arch framing the tympanum.
- *Lintel* (FIGS. 12-12 and 12-13), the horizontal beam above the doorway.
- *Trumeau* (FIGS. 12-1 and 12-11), the center post supporting the lintel in the middle of the doorway.
- **■** *Jambs* (FIG. 12-1), the side posts of the doorway.

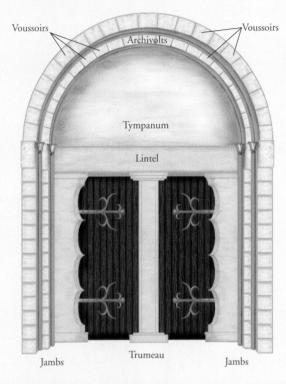

12-10 The Romanesque church portal.

The clergy considered the church doorway the beginning of the path to salvation through Christ. Many Romanesque churches feature didactic sculptural reliefs above and beside the entrance portals.

popular in the Romanesque age. The monstrous forms were reminders of the chaos and deformity of a world without God's order. Medieval artists delighted in inventing composite beasts, often with multiple heads, and other fantastic creations. Historiated capitals were also a feature of Moissac's mother church, Cluny III, and were common in Cluniac monasteries.

Not everyone shared the enthusiasm of the Cluniac monks for stone sculpture. One group of Benedictine monks founded a new order at Cîteaux in eastern France in 1098. The Cistercians (so called from the Latin name for Cîteaux) split from the Cluniac order to return to the strict observance of the Rule of Saint Benedict, changing the color of their habits from Cluniac black to unbleached white. These so-called White Monks emphasized productive manual labor, and their systematic farming techniques stimulated the agricultural transformation of Europe. The Cistercian movement expanded with astonishing rapidity. Within a half century, more than 500 Cistercian monasteries had been established. The Cistercians rejected figural sculpture as a distraction from their devotions. The most outspoken Cistercian critic of church sculpture was Abbot Bernard of Clairvaux (see "Bernard of Clairvaux on Cloister Sculpture," page 316).

SOUTH PORTAL, MOISSAC Bernard directed his tirade against figural sculpture primarily at monks who allowed the carvings to distract them from their meditations. But at Moissac and other Cluniac churches, sculpture also appears outside the cloister. Saint-Pierre's south portal (FIG. **12-1**), facing the town square, fea-

tured even more lavish decoration than did its cloister. The portal's vast tympanum (see "The Romanesque Church Portal," above) depicts the Second Coming of Christ as King and Judge of the world in its last days. As befits his majesty, the enthroned Christ is at the center, reflecting a compositional rule followed since Early Christian times. The signs of the four evangelists flank him. To one side of each pair of signs is an attendant angel holding scrolls to record human deeds for judgment. The figures of crowned musicians, which complete the design, are the 24 elders who accompany Christ as the kings of this world and make music in his praise. Each turns to face him, much as would the courtiers of a Romanesque monarch in attendance on their lord. Two courses of wavy lines symbolizing the clouds of Heaven divide the elders into three tiers.

Christ was the most common central motif in sculptured Romanesque portals. The pictorial programs of Romanesque church facades reflect the idea—one that dates to Early Christian times—that Christ is the door to salvation ("I am the door; who enters through me will be saved"—John 10:9). An inscription on the tympanum of the late 11th-century monastic church of Santa Cruz de la Serós in Spain made this message explicit: "I am the eternal door. Pass through me faithful. I am the source of life."²

Many variations exist within the general style of Romanesque sculpture, as within Romanesque architecture. The figures of the Moissac tympanum (FIG. 12-1) contrast sharply with those of the Saint-Sernin ambulatory reliefs (FIG. 12-7). The extremely elongated bodies of the recording angels, the cross-legged dancing pose of

12-11 Lions and Old Testament prophet (Jeremiah or Isaiah?), trumeau of the south portal of Saint-Pierre, Moissac, France, ca. 1115–1130.

This animated prophet displays the scroll recounting his vision. His position below the apparition of Christ as Last Judge is in keeping with the tradition of pairing Old and New Testament themes.

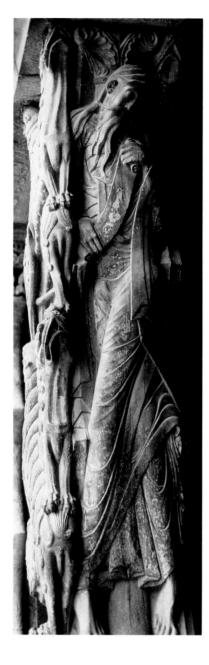

Saint Matthew's angel, and the jerky, hinged movement of the elders' heads are characteristic of the nameless Moissac master's style of representing the human figure. The zigzag and dovetail lines of the draperies, the bandlike folds of the torsos, the bending back of the hands against the body, and the wide cheekbones are also common features of this distinctive style. The animation of the individual figures, however, contrasts with the stately monumentality of the composition as a whole, producing a dynamic tension in the tympanum.

Below the tympanum are a richly decorated trumeau (FIG. 12-11) and elaborate door jambs with scalloped contours (FIG. 12-1), the latter a borrowing from Islamic architecture (FIG. 10-12). On the trumeau's right face is a prophet identified as Jeremiah by some scholars, as Isaiah by others. Whoever the prophet is, he displays the scroll where his prophetic vision is written. His position below the apparition of Christ as the apocalyptic Judge is yet another instance of the pairing of Old and New Testament themes. This is in keeping with an iconographic tradition established in Early Christian times (see "Jewish Subjects in Christian Art," Chapter 8, page 213). The prophet's figure is very tall and thin, in the manner of the tympanum angels, and, like Matthew's angel, he executes a cross-legged

step. The animation of the body reveals the passionate nature of the soul within. The flowing lines of the drapery folds ultimately derive from manuscript illumination and here play gracefully around the elegant figure. The long, serpentine locks of hair and beard frame an arresting image of the dreaming mystic. The prophet seems entranced by his vision of what is to come, the light of ordinary day unseen by his wide eyes.

Six roaring interlaced lions fill the trumeau's outer face (FIG. 12-1). The animal world was never far from the medieval mind, and people often associated the most fiercely courageous animals with kings and barons—for example, Richard the Lionhearted, Henry the Lion, and Henry the Bear. Lions were the church's ideal protectors. In the Middle Ages, people believed lions slept with their eyes open. But the notion of placing fearsome images at the gateways to important places is of ancient origin. Ancestors of the interlaced lions at Moissac include the lions and composite monsters that guarded the palaces of Near Eastern and Mycenaean kings (FIGS. 2-18, 2-21, and 4-19) and the panthers and leopards in Greek temple pediments (FIG. 5-17) and Etruscan tombs (FIG. 6-9).

SAINT-LAZARE, AUTUN In 1132, the Cluniac bishop Étienne de Bage consecrated the Burgundian cathedral of Saint-Lazare (Saint Lazarus) at Autun. For its tympanum (FIG. 12-12), he commissioned the sculptor GISLEBERTUS to carve a dramatic vision of the Last Judgment, which four trumpet-blowing angels announce. In the tympanum's center, far larger than any other figure, is Christ, enthroned in a mandorla. He dispassionately presides over the separation of the Blessed from the Damned. At the left, an obliging angel boosts one of the Blessed into the heavenly city. Below, the souls of the dead line up to await their fate. Two of the men near the center of the lintel carry bags emblazoned with a cross and a shell. These are the symbols of pilgrims to Jerusalem and Santiago de Compostela. Those who had made the difficult journey would be judged favorably. To their right, three small figures beg an angel to intercede on their behalf. The angel responds by pointing to the Judge above. On the right side (FIG. I-6) are those who will be condemned to Hell. Giant hands pluck one poor soul from the earth. Directly above, in the tympanum, is one of the most unforgettable renditions of the weighing of souls in the history of art (compare FIG. 11-9). Angels and devils compete at the scales, each trying to manipulate the balance for or against a soul. Hideous demons guffaw and roar. Their gaunt, lined bodies, with legs ending in sharp claws, writhe and bend like long, loathsome insects. A devil, leaning from the dragon mouth of Hell, drags souls in, while above him a howling demon crams souls headfirst into a furnace. The resources of the Romanesque imagination conjured an appalling scene.

The Autun tympanum must have inspired terror in the believers who passed beneath it as they entered the cathedral. Even those who could not read could, in the words of Bernard of Clairvaux, "read in the marble." For the literate, the Autun clergy composed explicit written warnings to reinforce the pictorial message and had the words engraved in Latin on the tympanum. For example, beneath the weighing of souls (FIG. I-6), the inscription reads, "May this terror terrify those whom earthly error binds, for the horror of these images here in this manner truly depicts what will be." The admonition echoes the sentiment expressed in the colophon of a mid-10th-century illustrated copy of Beatus of Liébana's Commentary on the Apocalypse. There, the painter Magius (teacher of Emeterius; see FIG. 11-11) explained the purpose of his work: "I have painted a series of pictures for the wonderful words of [the Apocalypse] stories, so that the wise may fear the coming of the future judgment of the world's end."4

12-12 GISLEBERTUS, Last Judgment, west tympanum of Saint-Lazare, Autun, France, ca. 1120–1135. Marble, 21' wide at base.

Christ in a mandorla presides over the separation of the Blessed from the Damned in this dramatic vision of the Last Judgment, designed to terrify those guilty of sin and beckon them into the church.

LA MADELEINE, VÉZELAY While Gislebertus was at work at Autun, nearby at the church of La Madeleine (Mary Magdalene) at Vézelay an unnamed sculptor was busy carving an even more elaborate tympanum (FIG. 12-13) over the central portal to the church's narthex. Vézelay is more closely associated with the Crusades (see "The Crusades," page 320) than any other church in Europe. Pope Urban II had intended to preach the launching of the First Crusade at Vézelay in 1095, although he delivered the sermon at Clermont instead. In 1147, Bernard of Clairvaux called for the Second Crusade at Vézelay, and King Louis VII of France took up the

12-13 Pentecost and Mission of the Apostles, tympanum of the center portal of the narthex of La Madeleine, Vézelay, France, 1120-1132.

The light rays emanating from Christ's hands represent the instilling of the Holy Spirit in the apostles. On the lintel and in eight compartments around the tympanum, the heathen wait to be converted.

319

The Crusades

n 1095, Pope Urban II (r. 1088–1099) delivered a stirring sermon at the Council of Clermont in which he called for an assault on the Holy Land:

[Y]our brethren who live in the East are in urgent need of your help ... [because] the Turks and Arabs have attacked them ... They have killed and captured many, and have destroyed the churches ... I, or rather the Lord, beseech you as Christ's heralds ... to persuade all people of whatever rank, foot-soldiers and knights, poor and rich, to carry aid promptly to those Christians and to destroy that vile race from the lands of our friends.... All who die by the way ... shall have immediate remission of sins.... Let those who go not put off the journey, but rent their lands and collect money for their expenses ... [and] eagerly set out on the way with God as their guide.*

Between 1095 and 1190, Christians launched three great Crusades from France. The *Crusades* ("taking of the Cross") were mass armed pilgrimages whose stated purpose was to wrest the Christian shrines of the Holy Land from Muslim control. Similar vows bound Crusaders and pilgrims. They hoped not only to atone for sins and win salvation but also to glorify God and extend the power of the Christian Church. The joint action of the papacy and the mostly French feudal lords in this type of holy war strengthened papal authority over the long run and created an image of Christian solidarity.

The symbolic embodiment of the joining of religious and secular forces in the Crusades was the Christian warrior, the fighting

* As recorded by Fulcher of Chartres (1059–ca. 1127). Translated by O. J. Thatcher and E. H. McNeal, quoted in Roberta Anderson and Dominic Aidan Bellenger, eds., *Medieval Worlds: A Sourcebook* (New York: Routledge, 2003), 88–90.

priest, or the priestly fighter. From the early medieval warrior evolved the Christian knight, who fought for the honor of God rather than in defense of his chieftain. The first and most typical of the crusading knights were the Knights Templar. After the Christian conquest of Jerusalem in 1099, they stationed themselves next to the Dome of the Rock (FIG. 10-2), that is, on the site of Solomon's Temple, the source of their name. Their mission was to protect pilgrims visiting the recovered Christian shrines. Formally founded in 1118, the Knights Templar order received the blessing of Bernard of Clairvaux, who gave them a rule of organization based on that of his own Cistercians. Bernard justified their militancy by declaring that "the knight of Christ" is "glorified in slaying the infidel . . . because thereby Christ is glorified," and the Christian knight then wins salvation. The Cistercian abbot saw the Crusades as part of the general reform of the Church and as the defense of the supremacy of Christendom. He himself called for the Second Crusade in 1147. For the Muslims, however, the Crusaders were nothing more than violent invaders who slaughtered the population of Jerusalem (Jewish as well as Muslim) when they took the city in July 1099.

In the end, the Muslims expelled the Christian armies. The Crusaders failed miserably in their attempt to regain the Holy Land. But in western Europe, the Crusades had much greater impact by increasing the power and prestige of the towns. Italian maritime cities such as Pisa (FIG. 12-25) thrived on the commercial opportunities presented by the transportation of Crusaders overseas. Many communities purchased their charters from the barons who owned their land when the latter needed to finance their campaigns in the Holy Land, and a middle class of merchants and artisans arose to rival the power of the feudal lords and the great monasteries.

cross there. Finally, the Vézelay church was the site where King Richard the Lionhearted of England and King Philip Augustus of France set out on the Third Crusade in 1190.

The Vézelay tympanum depicts the Pentecost and the Mission of the Apostles. As related in Acts 1:4–9, Christ foretold that the 12 apostles would receive the power of the Holy Spirit and become the witnesses of the truth of the Gospels throughout the world. The light rays emanating from Christ's hands represent the instilling of the Holy Spirit in the apostles (Acts 2:1–42) at the Pentecost (the seventh Sunday after Easter). The apostles, holding the Gospel books, receive their spiritual assignment to preach the Gospel to all nations. The Christ figure is a splendid essay in calligraphic line. The drapery lines shoot out in rays, break into quick zigzag rhythms, and spin into whorls, wonderfully conveying the spiritual light and energy that flow from Christ over and into the equally animated apostles. The overall composition, as well as the detailed treatment of the figures, contrasts with the much more sedate representation of the Second Coming (FIG. 12-1) at Moissac, where a grid of horizontal and vertical lines contains almost all the figures. The sharp differences between the two tympana once again highlight the regional diversity of Romanesque art.

The world's heathen peoples, the objects of the apostles' mission, appear on the lintel below and in eight compartments around the tympanum. The portrayals of the yet-to-be-converted constitute

a medieval anthropological encyclopedia. Present are the legendary giant-eared Panotii of India, Pygmies (who require ladders to mount horses), and a host of other races, some characterized by a dog's head, others by a pig's snout, and still others by flaming hair. The assembly of agitated figures also includes hunchbacks, mutes, blind men, and lame men. Humanity, still suffering, awaits the salvation to come. As at Moissac and Autun, as worshipers entered the building, the tympanum established God's omnipotence and presented the Church as the road to salvation.

NOTRE-DAME, FONTENAY Although the costly decoration of Cluniac churches like those at Moissac, Autun, and Vézelay appalled Bernard of Clairvaux, Cistercian monks were themselves great builders. Some of their churches were among the largest erected in Romanesque Europe. Nonetheless, the austerity of their buildings reflects the Cistercians' rejection of worldly extravagance and their emphasis on poverty, labor, and prayer. The abbey at Cîteaux itself no longer stands, but at nearby Fontenay, the church of Notre-Dame (FIG. 12-14) does. It is representative of the Cistercian approach to architectural design. The church has a square east end without an ambulatory or chapels. The walls are devoid of ornament, and the column capitals are plain. The nave has a single-story elevation with neither clerestory nor gallery. Light, however, reaches the nave

12-14 Interior of the abbey church of Notre-Dame, Fontenay, France, 1139–1147.

The Cistercians were great builders but rejected sculptural ornament. The Fontenay church is typically austere, with its single-story nave and square east end lacking ambulatory or chapels.

through the large windows in the flat east wall and because the aisle bays have *transverse barrel vaults* (tunnel-like vaults perpendicular to the nave) that channel light from outside to the center of the building. The architect used *pointed arches*—a feature of Cluny III (FIG. 12-8)—both in the nave arcade and in the barrel vaults. Romanesque builders may have thought this feature gave churches the look and feel of the architecture of the Holy Land, but pointed arches also brought structural advantages. Pointed arches transfer the thrust of the vaults more directly downward to the piers and require less buttressing on the sides than do round arches. This forward-looking structural device would permit Gothic architects to increase the height of the nave dramatically (see Chapter 13).

Painting and Other Arts

Unlike the practices of placing vaults over naves and aisles and decorating building facades with monumental stone reliefs, the art of painting did not need to be "revived" in the Romanesque period. Monasteries produced illuminated manuscripts in large numbers in the early Middle Ages, and even the Roman tradition of mural painting had never died. But the quantity of preserved frescoes and illustrated books from the Romanesque era is unprecedented.

MORALIA IN JOB One of the major Romanesque scriptoria was at the abbey of Cîteaux, mother church of the Cistercian order. Just

before Bernard joined the monastery in 1112, the monks completed work on an illuminated copy of Saint Gregory's (Pope Gregory the Great, r. 590-604) Moralia in Job. It is an example of Cistercian illumination before Bernard's passionate opposition to figural art in monasteries led in 1134 to a Cistercian ban on elaborate paintings in manuscripts as well as sculptural ornamentation in monasteries. After 1134 the Cistercian order prohibited full-page illustrations, and even initial letters had to be nonfigurative and of a single color. The historiated initial reproduced here (FIG. 12-15) clearly would have been in violation of Bernard's ban had it not been painted before his prohibitions took effect. A knight, his squire, and two roaring dragons form an intricate letter R, the initial letter of the salutation Reverentissimo. This page is the opening of Gregory's letter to "the very reverent" Leander (ca. 534–600), bishop of Seville, Spain. The knight is a slender, regal figure who raises his shield and sword against the dragons while the squire, crouching beneath him, runs a lance through one of the monsters. Although the clergy viewed the duel between knight and dragons as an allegory of the spiritual struggle of monks against the devil for the salvation of souls, Bernard opposed this kind of illumination, just as he condemned carvings of monstrous creatures and "fighting knights" on contemporary cloister capitals (see "Bernard of Clairvaux on Cloister Sculpture," page 316).

Ornamented initials date to the Hiberno-Saxon period (FIG. 11-8), but in the *Moralia in Job* the artist translated the theme into

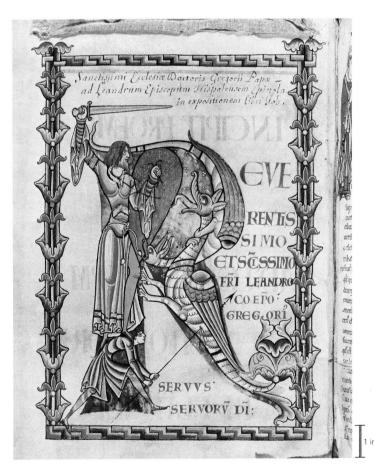

12-15 Initial *R* with knight fighting dragons, folio 4 verso of the *Moralia in Job*, from Cîteaux, France, ca. 1115–1125. Ink and tempera on vellum, 1' $1\frac{3}{4}$ " × $9\frac{1}{4}$ ". Bibliothèque Municipale, Dijon.

Ornamented initials date to the Hiberno-Saxon era (FIG. 11-8), but this artist translated the theme into Romanesque terms. The duel between knight and dragons symbolized a monk's spiritual struggle.

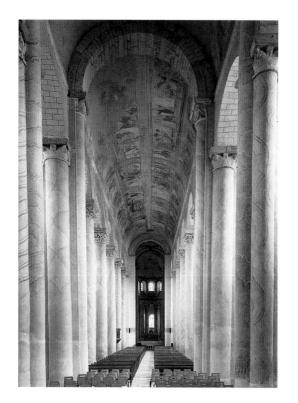

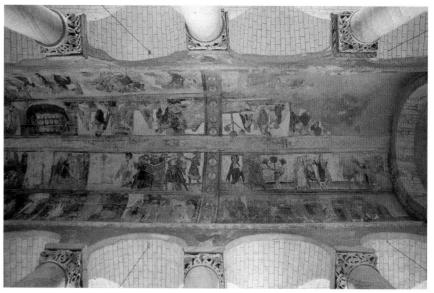

12-16 Nave (*left*) and painted nave vault (*right*) of the abbey church, Saint-Savinsur-Gartempe, France, ca. 1100.

Saint-Savin is a hall church with aisles approximately the same height as the nave. The tall aisle windows provide ample illumination for the biblical paintings on the nave's continuous barrel vault.

Romanesque terms. The page with the initial *R* may be a reliable picture of a medieval baron's costume. The typically French Romanesque banding of the torso and partitioning of the folds are evident (compare FIG. 12-11), but the master painter deftly avoided stiffness and angularity. The partitioning actually accentuates the knight's verticality and elegance and the thrusting action of his servant. The flowing sleeves add a spirited flourish to the swordsman's gesture. The knight, handsomely garbed, cavalierly wears no armor and calmly aims a single stroke, unmoved by the ferocious dragons lunging at him.

SAINT-SAVIN-SUR-GARTEMPE Although the art of fresco painting never died in early medieval Europe, the murals (not true frescoes, however) of the Benedictine abbey church of Saint-Savinsur-Gartempe have no Carolingian or Ottonian parallels, because the murals decorate the church's stone-vaulted nave (FIG. 12-16). Saint-Savin is a hall church (from German Hallenkirche), a church where the aisles are approximately the same height as the nave. The tall windows in the aisles provided more illumination to the nave than in churches that had low aisles and tribunes. The abundant light coming into the church may explain why the monks chose to decorate the nave's continuous barrel vault with paintings. (They also painted the nave piers to imitate rich veined marble.) The subjects of Saint-Savin's nave paintings all come from the Pentateuch, the opening five books of the Old Testament, but New Testament themes appear in the transept, ambulatory, and chapels, where the painters also depicted the lives of Saint Savin and another local saint. The elongated, agitated cross-legged figures have stylistic affinities both to the reliefs of southern French portals and to illuminated manuscripts such as the Moralia in Job.

SANTA MARÍA DE MUR In the Romanesque period, northern Spain, home to the great pilgrimage church of Saint James at Santiago de Compostela, was an important regional artistic center. In fact, Catalonia in northeastern Spain has more Romanesque mural paintings today than anywhere else. One of the most

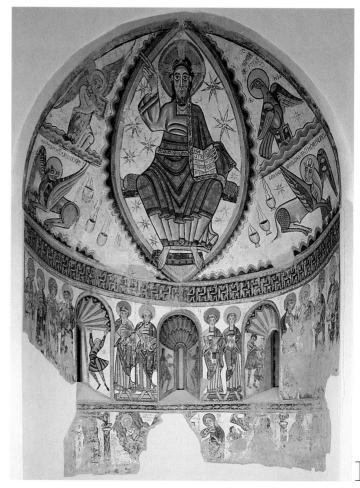

12-17 Christ in Majesty, apse, Santa María de Mur, near Lérida, Spain, mid-12th century. Fresco, 24′ × 22′. Museum of Fine Arts, Boston.

The Apocalypse fresco of the Santa María de Mur apse resembles the reliefs of French and Spanish Romanesque tympana. Christ appears in a mandorla between the signs of the four evangelists.

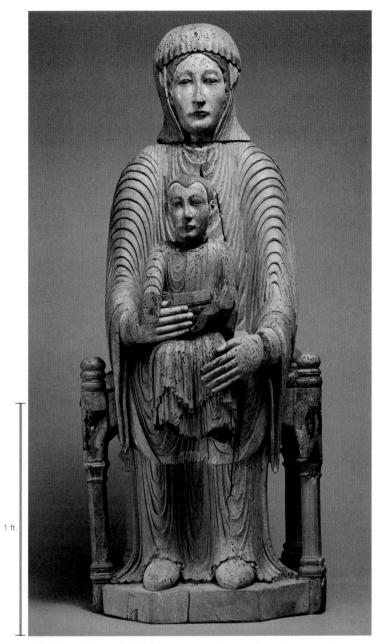

12-18 Virgin and Child (*Morgan Madonna*), from Auvergne, France, second half of 12th century. Painted wood, 2′ 7″ high. Metropolitan Museum of Art, New York (gift of J. Pierpont Morgan, 1916).

The veneration of relics brought with it a demand for small-scale images of the holy family and saints to be placed on chapel altars. This wooden statuette depicts the Virgin as the Throne of Wisdom.

impressive is the fresco (FIG. 12-17), now in Boston, that once filled the apse of Santa María de Mur, a monastery church not far from Lérida. The formality, symmetry, and placement of the figures are Byzantine (compare FIGS. 9-13 and 9-25). But the Spanish artist rejected Byzantine mosaic in favor of direct painting on plaster-coated walls.

The iconographic scheme in the semidome of the apse echoes the designs of contemporary French and Spanish Romanesque church tympana (FIG. 12-1). The signs of the four evangelists flank Christ in a star-strewn mandorla—the Apocalypse theme that so fascinated the Romanesque imagination. Seven lamps between Christ and the evangelists' signs symbolize the seven Christian com-

munities where Saint John addressed his revelation (the Apocalypse) at the beginning of his book (Rev. 1:4, 12, 20). Below stand apostles, paired off in formal frontality, as in the Monreale Cathedral apse (FIG. 9-25). The Spanish painter rendered the principal figures with partitioning of the drapery into volumes, here and there made tubular by local shading, and stiffened the irregular shapes of actual cloth into geometric patterns. The effect overall is one of simple, strong, and even blunt directness of statement, reinforced by harsh, bright color, appropriate for a powerful icon.

MORGAN MADONNA Despite the widespread use of stone relief sculptures to adorn Romanesque church portals, resistance to the creation of statues in the round—in any material—continued. The avoidance of creating anything that might be construed as an idol was still the rule, in keeping with the Second Commandment. Two centuries after Archbishop Gero commissioned a monumental wooden image of the crucified Christ (FIG. 11-26) for Cologne Cathedral, freestanding statues of Christ, the Virgin Mary, and the saints were still quite rare. The veneration of relics, however, brought with it a demand for small-scale images of the holy family and saints to be placed on the chapel altars of churches along the pilgrimage roads. Artisans began producing reliquaries in the form of saints (or parts of saints), tabletop crucifixes, and small wooden devotional images in great numbers.

One popular type, a specialty of the workshops of Auvergne, France, was a wooden statuette depicting the Virgin Mary with the Christ Child in her lap. The Morgan Madonna (FIG. 12-18), so named because it once belonged to the American financier and art collector J. Pierpont Morgan, is one example. The type, known as the Throne of Wisdom—sedes sapientiae in Latin—is a western European freestanding version of the Byzantine Theotokos theme popular in icons and mosaics (FIGS. 9-18 and 9-19). Christ holds a Bible in his left hand and raises his right arm in blessing (both hands are broken off). He is the embodiment of the divine wisdom contained in the Holy Scriptures. His mother, seated on a wooden chair, is in turn the Throne of Wisdom because her lap is the Christ Child's throne. As in Byzantine art, both Mother and Child sit rigidly upright and are strictly frontal, emotionless figures. But the intimate scale, the gesture of benediction, the once-bright coloring of the garments, and the soft modeling of the Virgin's face make the group seem much less remote than its Byzantine counterparts.

HOLY ROMAN EMPIRE

The Romanesque successors of the Ottonians were the Salians (r. 1027–1125), a dynasty of Franks of the Salian tribe. They ruled an empire that corresponds roughly to present-day Germany and the Lombard region of northern Italy (MAP 12-1). Like their predecessors, the Salian emperors were important patrons of art and architecture, although, as elsewhere in Romanesque Europe, the monasteries remained great centers of artistic production.

Architecture

The continuous barrel-vaulted naves of Saint James at Santiago de Compostela, Cluny III (FIG. 12-8), Saint-Sernin (FIG. 12-6) at Toulouse, and Notre-Dame (FIG. 12-14) at Fontenay admirably met the goals that northern Spanish and French Romanesque architects had of making the house of the Lord beautiful and providing excellent acoustics for church services. In addition, the churches were relatively fireproof compared with timber-roofed structures such as Saint-Étienne (FIG. 12-2) at Vignory. But the barrel vaults often failed in one critical

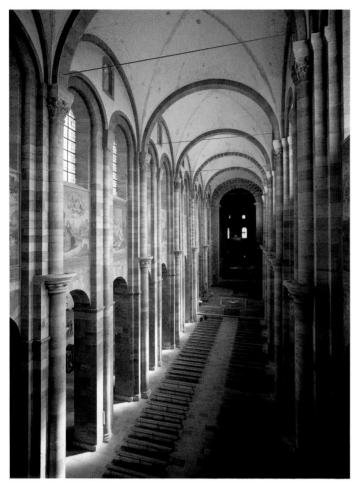

12-19 Interior of Speyer Cathedral, Speyer, Germany, begun 1030; nave vaults, ca. 1082–1105.

The imperial cathedral at Speyer is one of the earliest examples of the use of groin vaulting in a nave. Groin vaults made possible the insertion of large clerestory windows above the nave arcade.

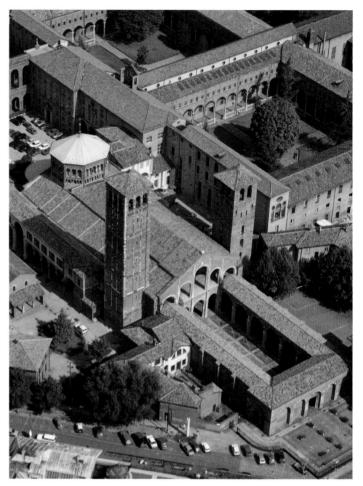

12-20 Aerial view of Sant'Ambrogio, Milan, Italy, late 11th to early 12th century.

With its atrium and low, broad proportions, Sant'Ambrogio recalls Early Christian basilicas. Over the nave's east end, however, is an octagonal tower that resembles Ottonian crossing towers.

requirement—lighting. Due to the great outward thrust barrel vaults exert along their full length, even when pointed instead of semicircular, a clerestory is difficult to construct. (The Santiago de Compostela, Toulouse, and Fontenay designers did not even attempt to introduce a clerestory, although their counterparts at Cluny III did and succeeded.) Structurally, the central aim of northern Romanesque architects was to develop a masonry vault system that admitted light and was also aesthetically pleasing.

Covering the nave with groin vaults instead of barrel vaults became the solution. Ancient Roman builders had used the groin vault widely, because they realized that its concentration of thrusts at four supporting points permitted clerestory windows (FIGS. 7-6*b*–*c*, 7-67, and 7-78). The great Roman vaults were made possible by the use of concrete, which could be poured into forms, where it solidified into a homogeneous mass (see "Roman Concrete Construction," Chapter 7, page 161). But the technique of mixing concrete had not survived into the Middle Ages. The technical problems of building groin vaults of cut stone and heavy rubble, which had very little cohesive quality, at first limited their use to the covering of small areas, such as the individual bays of the aisles of Saint-Sernin (FIG. 12-5). But during the 11th century, masons in the Holy Roman Empire, using cut-stone blocks joined by mortar, developed a groin vault of monumental dimensions.

SPEYER CATHEDRAL Construction of Speyer Cathedral (FIG. 12-19) in the German Rhineland, far from the pilgrimage routes of southern France and northern Spain, began in 1030. The church was the burial place of the Holy Roman emperors until the beginning of the 12th century, and funding for the building campaign came from imperial patrons, not traveling pilgrims and local landowners. Like all cathedrals, Speyer was also the seat (cathedra in Latin) of the powerful local bishop. In its earliest form, Speyer Cathedral was a timber-roofed structure. When the emperor Henry IV (r. 1084-1105) rebuilt it between 1082 and 1105, his masons covered the nave with stone groin vaults. The large clerestory windows above the nave arcade provided ample light to the interior. Scholars disagree about where the first comprehensive use of groin vaulting occurred in Romanesque times, and nationalistic concerns sometimes color the debate. But no one doubts that the large groin vaults covering the nave of Speyer Cathedral represent one of the most daring and successful engineering experiments of the time. The nave is 45 feet wide, and the crowns of the vaults are 107 feet above the floor.

Speyer Cathedral employs an alternate-support system in the nave, as in the Ottonian churches of Saint Cyriakus (FIG. 11-21) at Gernrode and Saint Michael's (FIG. 11-23) at Hildesheim. At Speyer, however, the alternation continues all the way up into the vaults, with the nave's more richly molded compound piers marking the

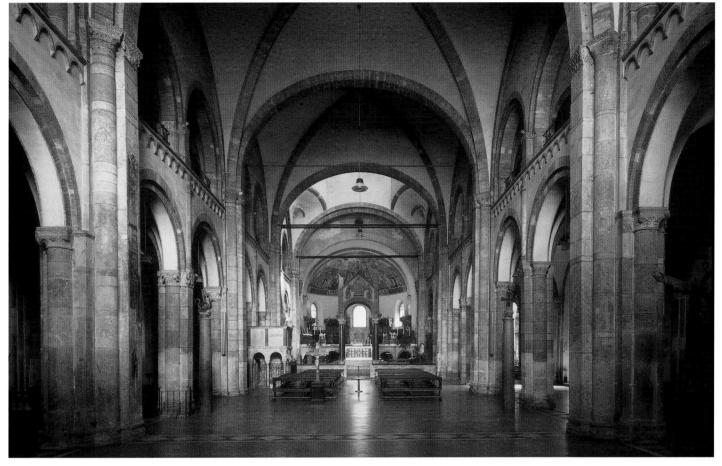

12-21 Interior of Sant'Ambrogio, Milan, Italy, late 11th to early 12th century.

Sant'Ambrogio's nave reveals the northern character of Lombard architecture. Each groin-vaulted nave bay corresponds to two aisle bays. The alternate-support system complements this modular plan.

corners of the groin vaults. Speyer's interior shows the same striving for height and the same compartmentalized effect seen in Saint-Sernin (FIG. 12-6), but by virtue of the alternate-support system, the rhythm of the Speyer nave is more complex. Because each compartment is individually vaulted, the effect of a sequence of vertical spatial blocks is even more convincing.

SANT'AMBROGIO, MILAN After Charlemagne crushed the Lombards in 773, German kings held sway over Lombardy, and the Rhineland and northern Italy cross-fertilized each other artistically. No agreement exists as to which source of artistic influence was dominant in the Romanesque age, the northern or the southern. The question, no doubt, will remain the subject of controversy until the construction date of Sant'Ambrogio (FIG. 12-20) in Milan can be established unequivocally. The church, erected in honor of Saint Ambrose, Milan's first bishop (d. 397), is the central monument of Lombard Romanesque architecture. Some scholars think the church was a prototype for Speyer Cathedral, but Sant'Ambrogio is a remarkable structure even if it wasn't a model for Speyer's builders. The Milanese church has an atrium in the Early Christian tradition (FIG. 8-9)—one of the last to be built—and a two-story narthex pierced by arches on both levels. Two bell towers (campaniles) join the building on the west. The shorter one dates to the 10th century, and the taller north campanile is a 12th-century addition. Over the nave's east end is an octagonal tower that recalls the crossing towers of Ottonian churches (FIG. 11-22).

Sant'Ambrogio has a nave (FIG. 12-21) and two aisles but no transept. Each bay consists of a full square in the nave flanked by two small squares in each aisle, all covered with groin vaults. The main vaults are slightly domical, rising higher than the transverse arches. The windows in the octagonal dome over the last bay—probably here, as elsewhere, a reference to the Dome of Heaven—provide the major light source (the building lacks a clerestory) for the otherwise rather dark interior. The emphatic alternate-support system perfectly reflects the geometric regularity of the plan. The lightest pier moldings are interrupted at the gallery level, and the heavier ones rise to support the main vaults. At Sant'Ambrogio, the compound piers even continue into the ponderous vaults, which have supporting arches, or *ribs*, along their groins. This is one of the first instances of rib vaulting, a salient characteristic of mature Romanesque and of later Gothic architecture (see "The Gothic Rib Vault," Chapter 13, page 342).

The regional diversity of Romanesque architecture becomes evident by comparing the proportions of Sant'Ambrogio with those of both Speyer Cathedral (FIG. 12-19) and Saint-Sernin (FIGS. 12-4 to 12-6) at Toulouse. The Milanese building does not aspire to the soaring height of the French and German churches. Save for the later of the two towers, Sant'Ambrogio's proportions are low and broad and remain close to those of Early Christian basilicas. Italian architects, even those working within the orbit of the Holy Roman Empire, had firm roots in the venerable Early Christian style and never accepted the verticality found in northern architecture, not even during the Gothic period.

Romanesque Countesses, Queens, and Nuns

man's world, but women could and did have power and influence. Countess Matilda of Canossa (1046–1115), who ruled Tuscany after 1069, was sole heiress of vast holdings in northern Italy. She was a key figure in the political struggle between the popes and the German emperors who controlled Lombardy. With unflagging resolution, she defended Pope Gregory's reforms and at her death willed most of her lands to the papacy.

More famous and more powerful was Eleanor of Aquitaine (1122–1204), wife of Henry II of England. She married Henry after the annulment of her marriage to Louis VII, king of France.

She was queen of France for 15 years and queen of England for 35 years. During that time she bore three daughters and five sons. Two became kings—Richard I (the Lionhearted) and John. She prompted her sons to rebel against their father, so Henry imprisoned her. Released at Henry's death, she lived on as dowager queen, managing England's government and King John's holdings in France.

Of quite different stamp was Hildegard of Bingen (1098–1179), the most prominent nun of the 12th century and one of the greatest religious figures of the Middle Ages. Hildegard was born into an aristocratic family that owned large estates in the German Rhineland. At a very early age she began to have visions. When she was eight, her parents placed her in the Benedictine double monastery (for both monks and nuns) at Disibodenberg. She became a nun at 15. In 1141, God instructed Hildegard to disclose her visions to the world. Before then she had revealed them only to close confidants at the monastery. One of these was the monk Volmar, and Hildegard chose to dictate her visions to him (FIG. 12-22) for posterity. No less a figure than Bernard of Clairvaux certified in 1147 that her visions were authentic, and Archbishop Heinrich of Mainz joined in the endorsement. In 1148 the Cistercian pope Eugenius III (r. 1145-1153) formally authorized Hildegard "in the name of Christ and Saint Peter to publish all that she had learned from the Holy Spirit." At this time Hildegard became the abbess of a new convent built for her near Bingen. As reports of Hildegard's visions spread, kings, popes, barons, and prelates sought her counsel. All of them were attracted by her spiritual insight into the truth of the mysteries of the Christian faith. In addition to her visionary works—the most important is

12-22 Hildegard receives her visions, detail of a facsimile of a lost folio in the Rupertsberger *Scivias* by Hildegard of Bingen, from Trier or Bingen, Germany, ca. 1150–1179. Abbey of St. Hildegard, Rüdesheim/Eibingen.

Hildegard of Bingen, the most prominent nun of her time, experienced divine visions, shown here as five tongues of fire entering her brain. She also composed music and wrote scientific treatises.

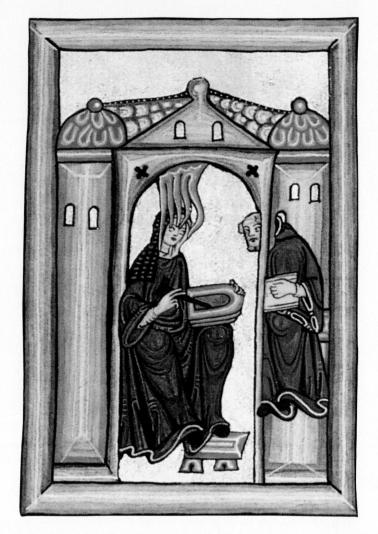

the *Scivias* (FIG. **12-22**)—Hildegard wrote two scientific treatises. *Physica* is a study of the natural world, and *Causae et curae* (*Causes and Cures*) is a medical encyclopedia. Hildegard also composed the music and wrote the lyrics of 77 songs, which appeared under the title *Symphonia*.

Hildegard was the most famous Romanesque nun, but she was by no means the only learned woman of her age. A younger contemporary, the abbess Herrad (d. 1195) of Hohenberg, Austria, was also the author of an important medieval encyclopedia. Herrad's *Hortus deliciarum* (*Garden of Delights*) is a history of the world intended for instructing the nuns under her supervision, but it reached a much wider audience.

Painting and Other Arts

The number and variety of illuminated manuscripts dating to the Romanesque era attest to the great demand for illustrated religious tomes in the abbeys of western Europe. The extraordinarily productive scribes and painters who created these books were almost exclusively monks and nuns working in the scriptoria of those same isolated religious communities.

HILDEGARD OF BINGEN One of the most interesting of these religious manuscripts is the *Scivias* (*Know the Ways* [*Scite vias*] of *God*) of Hildegard of Bingen. Hildegard was a German nun and eventually the abbess of the convent at Disibodenberg in the Rhineland (see "Romanesque Countesses, Queens, and Nuns," above). The manuscript, lost in 1945, exists today only in a facsimile. The original probably was written and illuminated at the monastery of Saint

Matthias at Trier between 1150 and Hildegard's death in 1179, but it is possible that Hildegard supervised production of the book at Bingen. The *Scivias* contains a record of Hildegard's vision of the divine order of the cosmos and of humankind's place in it. The vision came to her as a fiery light that poured into her brain from the open vault of Heaven.

On the opening page (FIG. 12-22) of the Trier manuscript, Hildegard sits within the monastery walls, her feet resting on a footstool, in much the same way the painters of the *Coronation* and *Ebbo Gospels* (FIGS. 11-13 and 11-14) represented the evangelists. This Romanesque page is a link in a chain of author portraits with roots in classical antiquity. The artist showed Hildegard experiencing her divine vision by depicting five long tongues of fire emanating from above and entering her brain, just as she describes the experience in the accompanying text. Hildegard immediately sets down what has been revealed to her on a wax tablet resting on her left knee. Nearby, the monk Volmar, Hildegard's confessor, copies into a book all she has written. Here, in a singularly dramatic context, is a picture of the essential nature of ancient and medieval book manufacture—individual scribes copying and recopying texts by hand (compare FIG. 11-11).

RAINER OF HUY In the Holy Roman Empire, as in France, the names of some Romanesque sculptors are known. One is RAINER OF HUY, a bronzeworker from the Meuse River valley in Belgium, an area renowned for its metalwork. Art historians have attributed an 1118 bronze baptismal font (FIG. 12-23) to him. Made for Notre-Dame-des-Fonts in Liège, the bronze basin rests on the foreparts of a

12-23 RAINER OF HUY, baptism of Christ, baptismal font from Notre-Dame-des-Fonts, Liège, Belgium, 1118. Bronze, 2' 1" high. Saint-Barthélémy, Liège.

In the work of Rainer of Huy, the classical style and the classical spirit lived on in the Holy Roman Empire. His baptismal font at Liège features idealized figures and even a nude representation of Christ.

dozen oxen. The oxen refer to the "molten sea . . . on twelve oxen" cast in bronze for King Solomon's Temple (1 Kings 7:23–25). The Old Testament story prefigured Christ's baptism (medieval scholars equated the oxen with the 12 apostles), which is the central scene on the Romanesque font. Rainer's work, as that of so many earlier artists in the Holy Roman Empire beginning in Carolingian times, revived the classical style and the classical spirit. The figures are softly rounded, with idealized bodies and faces and heavy clinging drapery. One figure (at the left in FIG. 12-23) is even shown in a three-quarter view from the rear, a popular motif in classical art, and some of Rainer's figures, including Christ himself, are naked. Nudity is very rare in the art of the Middle Ages. Adam and Eve (FIGS. 8-7 and 11-24) are exceptions, but medieval artists represented the first man and woman as embarrassed by their nudity, the opposite of the value the classical world placed on the beauty of the human body.

RELIQUARY OF SAINT ALEXANDER As noted, Romanesque church officials competed with one another in the display of relics and often expended large sums on elaborate containers to house them. The reliquary of Saint Alexander (FIG. 12-24), made in 1145 for Abbot Wibald of Stavelot in Belgium to house the hallowed

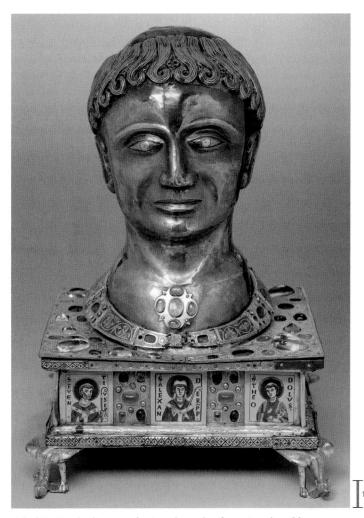

12-24 Head reliquary of Saint Alexander, from Stavelot Abbey, Belgium, 1145. Silver repoussé (partly gilt), gilt bronze, gems, pearls, and enamel, 1' 5 $\frac{1}{2}$ " high. Musées Royaux d'Art et d'Histoire, Brussels.

Saint Alexander's reliquary is typical in the use of costly materials. The combination of an idealized classical head with Byzantine-style enamels underscores the stylistic diversity of Romanesque art.

pope's relics, is one of the finest examples. The almost life-size head, fashioned in repoussé silver with bronze gilding for the hair, gives worshipers the impression that the saint is alive and present. The idealized head resembles portraits of youthful Roman emperors such as Augustus (FIG. I-9) and Constantine (FIG. 7-77), and the Romanesque metalworker may have used an ancient sculpture as a model. The saint wears a collar of jewels and enamel plaques around his neck. Enamels and gems also adorn the box on which the head is mounted. The reliquary rests on four bronze dragons—mythical animals of the kind that populated Romanesque cloister capitals. Not surprisingly, Bernard of Clairvaux was as critical of lavish church furnishings like the Alexander reliquary as he was of Romanesque cloister sculpture:

[Men's] eyes are fixed on relics covered with gold and purses are opened. The thoroughly beautiful image of some male or female saint is exhibited and that saint is believed to be the more holy the more highly colored the image is. People rush to kiss it, they are invited to donate, and they admire the beautiful more than they venerate the sacred.... O vanity of vanities, but no more vain than insane! The Church... dresses its stones in gold and it abandons its children naked. It serves the eyes of the rich at the expense of the poor.⁵

The central plaque on the front of the Stavelot reliquary depicts Pope Alexander II (r. 1061–1073). Saints Eventius and Theodolus flank him. The nine plaques on the other three sides represent female allegorical figures—Wisdom, Piety, and Humility among them. Although a local artist produced these enamels in the Meuse River region, the models were surely Byzantine. Saint Alexander's reliquary underscores the multiple sources of Romanesque art as well as its stylistic diversity. Not since antiquity had people journeyed as exten-

sively as they did in the Romanesque period, and artists regularly saw works of wide geographic origin. Abbot Wibald himself epitomized the well-traveled 12th-century clergyman. He was abbot of Montecassino in southern Italy and participated in the Second Crusade. Frederick Barbarossa (Holy Roman Emperor, r. 1152–1190) sent him to Constantinople to arrange Frederick's wedding to the niece of the Byzantine emperor Manuel Comnenus. (Two centuries before, another German emperor, Otto II, married the Byzantine princess Theophanu, which also served to promote Byzantine style in the Holy Roman Empire; see "Theophanu," Chapter 11, page 306.)

ITALY

Nowhere is the regional diversity of Romanesque art and architecture more readily apparent than in Italy, where the ancient Roman and Early Christian heritage was strongest. Although Tuscany, the ancient Etruscan heartland (see Chapter 6), and other regions south of Lombardy were part of the territory of the Salian emperors, Italy south of Milan represents a distinct artistic zone during the Romanesque period.

Architecture and Architectural Sculpture

Italian Romanesque architects designed buildings that were for the most part structurally less experimental than those erected in Germany and Lombardy. Italian builders adhered closely to the Early Christian basilican type of church.

PISA CATHEDRAL COMPLEX The cathedral complex (FIG. 12-25) at Pisa dramatically testifies to the prosperity that busy maritime city enjoyed. The spoils of a naval victory over the

12-25 Cathedral complex, Pisa, Italy; cathedral begun 1063; baptistery begun 1153; campanile begun 1174.

Pisa's cathedral more closely resembles Early Christian basilicas than the structurally more experimental northern Romanesque churches. Separate bell towers and baptisteries are characteristically Italian.

12-26 Baptistery of San Giovanni, Florence, Italy, dedicated 1059.

The Florentine baptistery is a domed octagon descended from Roman and Early Christian central-plan buildings. The distinctive Tuscan Romanesque marble paneling stems from Roman wall designs.

began a daring project to remove soil from beneath the north side of the tower. The soil extraction has already moved the tower more than an inch closer to vertical and ensured the stability of the structure for at least 300 years. (Because of the touristic appeal of the Leaning Tower, there are no plans to restore the campanile to its original upright position.)

BAPTISTERY, FLORENCE The public always associates Florence with the Renaissance of the 15th and 16th centuries, but Florence was already an important independent city-state in the Romanesque period. The gem of Florentine Romanesque architecture is the baptistery (FIG.

12-26) of San Giovanni (Saint John), the city's patron saint. Pope Nicholas II dedicated the building in 1059. It thus predates Pisa's baptistery (FIG. 12-25, *left*), but construction of the Florentine baptistery continued into the next century. Both baptisteries face their city's cathedral. These freestanding Italian baptisteries are unusual and reflect the great significance the Florentines and Pisans attached to baptisms. On the day of a newborn child's anointment, the citizenry gathered in the baptistery to welcome a new member into the community. The Tuscan baptisteries therefore were important civic as well as religious structures. Some of the most renowned artists of the late Middle Ages and the Renaissance provided the Florentine and Pisan baptisteries with pulpits (FIG. 14-2), bronze doors (FIGS. 16-2, 16-3, and 16-10), and mosaics.

The simple and serene classicism of San Giovanni's design recalls ancient Roman architecture. The baptistery stands in a direct line of descent from the Pantheon (FIG. 7-49) and imperial mausoleums such as Diocletian's (FIG. 7-74), the Early Christian Santa Costanza (FIG. 8-11), the Byzantine San Vitale (FIG. 9-6), and other central-plan structures, pagan or Christian, including Charlemagne's Palatine Chapel (FIG. 11-18) at Aachen. The distinctive Tuscan Romanesque marble incrustation that patterns the walls stems ultimately from Roman wall designs (FIGS. 7-17 and 7-51). The simple oblong and arcuated panels assert the building's structural lines and its elevation levels. In plan, San Giovanni is a domed octagon, wrapped on the exterior by an elegant arcade, three arches to a bay. It has three entrances, one each on the north, south, and east sides. On the west side an oblong sanctuary replaces the original semicircular apse. The domical vault is some 90 feet in diameter, its construction a remarkable feat for its time.

Muslims off Palermo in Sicily in 1062 provided the funds for the Pisan building program. The cathedral, its freestanding bell tower, and the baptistery, where infants and converts were initiated into the Christian community, present a rare opportunity to study a coherent group of three Romanesque buildings. Save for the upper portion of the baptistery, with its remodeled Gothic exterior, the three structures are stylistically homogeneous.

Construction of Pisa Cathedral began first—in 1063, the same year work began on Saint Mark's (FIG. 9-24) in Venice, another powerful maritime city. Pisa Cathedral is large, with a nave and four aisles, and is one of the most impressive and majestic of all Romanesque churches. According to a document of the time, the Pisans wanted their bishop's church not only to be a monument to the glory of God but also to bring credit to the city. At first glance, the cathedral resembles an Early Christian basilica with a timber roof, columnar arcade, and clerestory. But the broadly projecting transept with apses, the crossing dome, and the facade's multiple arcaded galleries distinguish it as Romanesque. So too does the rich marble incrustation (wall decoration consisting of bright panels of different colors, as in the Pantheon's interior, FIG. 7-51). The cathedral's campanile, detached in the standard Italian fashion, is Pisa's famous Leaning Tower (FIG. 12-25, right). Graceful arcaded galleries mark the tower's stages and repeat the cathedral's facade motif, effectively relating the round campanile to its mother building. The tilted vertical axis of the tower is the result of a settling foundation. The tower began to "lean" even while under construction and by the late 20th century had inclined some 5.5 degrees (about 15 feet) out of plumb at the top. In 1999 an international team of scientists

12-27 Interior of San Miniato al Monte, Florence, Italy, ca. 1062-1090.

The design of San Miniato is close to that of Early Christian basilicas, but diaphragm arches divide the nave into three equal compartments, and compound piers alternate with columns in the arcade.

SAN MINIATO AL MONTE Contemporaneous with the San Giovanni baptistery and also featuring elaborate marble incrustation is the Benedictine abbey church of San Miniato al Monte (FIG. 12-27). It sits, as its name implies, on a hillside overlooking the Arno River and the heart of Florence. The builders completed the body of the church by 1090, its facade not until the early 13th century. Even more than Pisa Cathedral, the structure recalls the Early Christian basilica, but *diaphragm arches* divide its nave into

three equal compartments. The arches rise from compound piers and brace the rather high, thin walls. They also provide firebreaks beneath the wooden roof and compartmentalize the basilican interior in the manner so popular with most Romanesque builders. The compound piers alternate with pairs of simple columns with Roman-revival Composite capitals.

MODENA CATHEDRAL Despite the pronounced structural differences between Italian Romanesque churches and those of France, Spain, and the Holy Roman Empire, Italian church officials also frequently employed sculptors to adorn the facades of their buildings. In fact, one of the first examples of fully developed narrative relief sculpture in Romanesque art is the marble frieze (FIG. 12-28) on the facade of Modena Cathedral in northern Italy. Carved around 1110, it represents scenes from Genesis set against an architectural backdrop of a type common on Roman and Early Christian sarcophagi, which were plentiful in the area. The segment in FIG. 12-28 illustrates the creation and temptation of Adam and Eve (Gen. 2, 3:1-8), the theme employed almost exactly a century earlier on Bishop Bernward's bronze doors (FIG. 11-24) at Hildesheim. At Modena, as at Saint Michael's, the faithful entered the Lord's house with a reminder of Original Sin and the suggestion that the only path to salvation is through the Christian Church.

On the Modena frieze, Christ is at the far left, framed by a mandorla held up by angels—a variation on the motif of the Saint-Sernin ambulatory relief (FIG. 12-7). The creation of Adam, then Eve, and the serpent's temptation of Eve are to the right. The relief carving is high, and some parts are almost entirely in the round. The frieze is the work of a master craftsman whose name, WILIGELMO, is given in an inscription on another relief on the facade. There he boasts, "Among sculptors, your work shines forth, Wiligelmo." The inscription is also an indication of the pride Wiligelmo's patrons had in obtaining the services of such an accomplished sculptor for their city's cathedral.

BENEDETTO ANTELAMI The reawakening of interest in stone sculpture in the round also may be seen in northern Italy, where the sculptor Benedetto Antelami was active in the last quarter of the 12th century. Several reliefs by his hand exist, including Parma Cathedral's pulpit and the portals of that city's baptistery. But his most unusual works are the monumental marble statues of two Old Testament figures he carved for the west facade of Fidenza Cathedral. Benedetto's King David (FIG. 12-29) seems confined within his niche, and he holds his elbows close to his body. Absent is

12-28 WILIGELMO, creation and temptation of Adam and Eve, detail of the frieze on the west facade, Modena Cathedral, Modena, Italy, ca. 1110. Marble, 3' high.

For Modena's cathedral, Wiligelmo represented scenes from Genesis against an architectural backdrop of a type common on Roman and Early Christian sarcophagi, which were plentiful in the area.

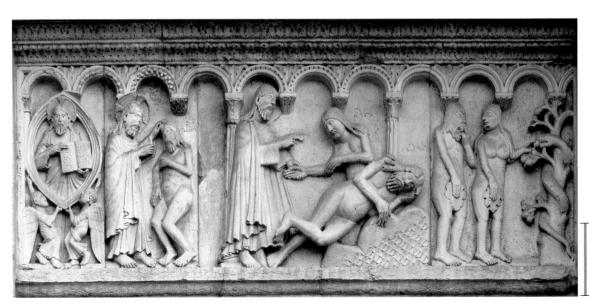

1 ft.

12-29 BENEDETTO ANTELAMI, King David, statue in a niche on the west facade of Fidenza Cathedral, Fidenza, Italy, ca. 1180–1190. Marble, life-size.

Benedetto Antelami's King David on the facade of Fidenza Cathedral is a rare example of life-size statuary in the Romanesque period. The style is unmistakably rooted in Greco-Roman art.

the weight shift that is the hallmark of classical statuary. Yet the sculptor's conception of this prophet is unmistakably rooted in Greco-Roman art. Comparison of the Fidenza David with the prophet on the Moissac trumeau (FIG. 12-11), who also displays an unfurled scroll, reveals how much the Italian sculptor freed his figure from its architectural setting. Other sculptors did not immediately emulate Antelami's classical approach to portraying biblical figures in stone. But the idea of placing freestanding statues in niches would be taken up again in Italy by Early Renaissance sculptors (FIGS. 16-4 to 16-6).

12-30 West facade of Saint-Étienne, Caen, France, begun 1067.

The division of Saint-Étienne's facade into three parts corresponding to the nave and aisles reflects the methodical planning of the entire structure. The towers also have a tripartite design.

NORMANDY AND ENGLAND

After their conversion to Christianity in the early 10th century, the Vikings (see Chapter 11) settled on the northern coast of France in present-day Normandy. Almost at once, they proved themselves not only aggressive warriors but also skilled administrators and builders, active in Sicily (FIG. 9-25) as well as in northern Europe.

Architecture

The Normans quickly developed a distinctive Romanesque architectural style that became the major source of French Gothic architecture.

SAINT-ÉTIENNE, CAEN Most critics consider the abbey church of Saint-Étienne at Caen the masterpiece of Norman Romanesque architecture. Begun by William of Normandy (William the Conqueror; see page 333) in 1067, work must have advanced rapidly, because he was buried there in 1087. Saint-Étienne's west facade (FIG. **12-30**) is a striking design rooted in the tradition of Carolingian and Ottonian westworks, but it reveals a new unified

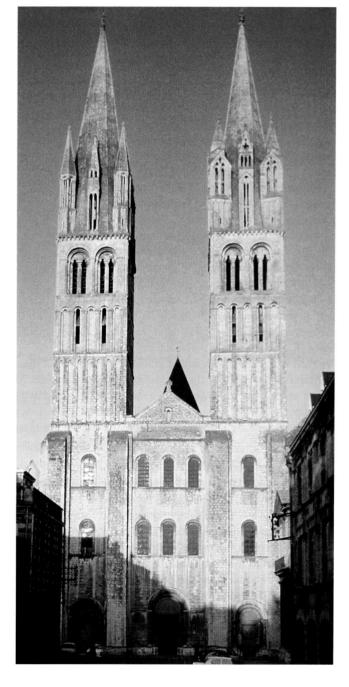

Embroidery and Tapestry

The most famous embroidery of the Middle Ages is, ironically, known as the *Bayeux Tapestry* (FIG. 12-35). Embroidery and tapestry are related but different means of decorating textiles. *Tapestry* designs are woven on a loom as part of the fabric. *Embroidery* patterns are sewn onto fabric with threads.

The needleworkers who fashioned the *Bayeux Tapestry* were either Norman or English women. They employed eight colors of dyed wool—two varieties of blue, three shades of green, yellow, buff, and terracotta red—and two kinds of stitches. In *stem stitching*, short overlapping strands of thread form jagged lines. *Laid-and-*

couched work creates solid blocks of color. In the latter technique, the needleworker first lays down a series of parallel and then a series of cross stitches. Finally, the stitcher tacks down the cross-hatched threads using couching (knotting). On the *Bayeux Tapestry*, the embroiderers left the natural linen color exposed for the background, human flesh, building walls, and other "colorless" design elements. Stem stitches define the contours of figures and buildings and delineate interior details, such as facial features, body armor, and roof tiles. The clothing, animal bodies, and other solid areas are laid-and-couched work.

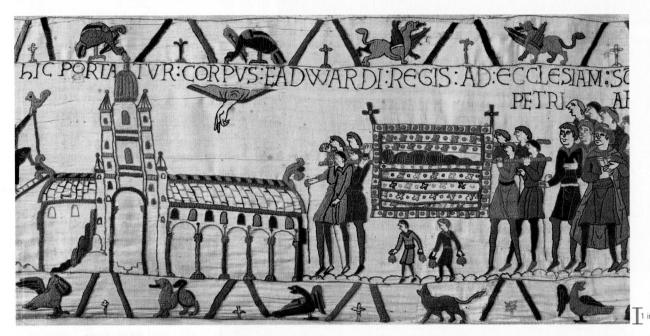

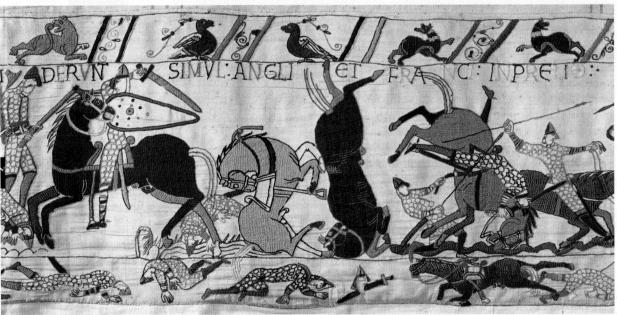

12-35 Funeral procession to Westminster Abbey (*top*) and Battle of Hastings (*bottom*), details of the *Bayeux Tapestry*, from Bayeux Cathedral, Bayeux, France, ca. 1070–1080. Embroidered wool on linen, 1' 8" high (entire length of fabric 229' 8"). Centre Guillaume le Conquérant, Bayeux.

The Bayeux Tapestry is unique in medieval art. Like historical narratives in ancient Roman art, it depicts contemporaneous events in full detail, as in the scroll-like frieze of Trajan's Column (Fig. 7-44).

Painting and Other Arts

Many of the finest illustrated manuscripts of the Romanesque age were the work of monks in English scriptoria, following in the tradition of Hiberno-Saxon book production (see Chapter 16). But the most famous work of English Romanesque art is neither a book nor Christian in subject.

BAYEUX TAPESTRY The so-called Bayeux Tapestry (FIG. 12-35) is unique in medieval art. It is an embroidered fabric—not, in fact, a woven tapestry—made of wool sewn on linen (see "Embroidery and Tapestry," page 334). Closely related to Romanesque manuscript illumination, its borders contain the kinds of real and imaginary animals found in contemporaneous books, and an explanatory Latin text sewn in thread accompanies many of the pictures. Some 20 inches high and about 230 feet long, the Bayeux Tapestry is a continuous, friezelike, pictorial narrative of a crucial moment in England's history and of the events that led up to it. The Norman defeat of the Anglo-Saxons at Hastings in 1066 brought England under the control of the Normans, uniting all of England and much of France under one rule. The dukes of Normandy became the kings of England. Commissioned by Bishop Odo, the half brother of the conquering Duke William, the embroidery may have been sewn by women at the Norman court. Many art historians, however, believe it was the work of English stitchers in Kent, where Odo was earl after the Norman conquest. Odo donated the work to Bayeux Cathedral (hence its nickname), but it is uncertain whether it was originally intended for display in the church's nave, where the theme would have been a curious choice.

The circumstances leading to the Norman invasion of England are well documented. In 1066, Edward the Confessor, the Anglo-Saxon king of England, died. The Normans believed Edward had recognized William of Normandy as his rightful heir. But the crown went to Harold, earl of Wessex, the king's Anglo-Saxon brother-inlaw, who had sworn allegiance to William. The betrayed Normans, descendants of the seafaring Vikings, boarded their ships, crossed the English Channel, and crushed Harold's forces.

Illustrated here are two episodes of the epic tale as represented in the Bayeux Tapestry. The first detail (FIG. 12-35, top) depicts King Edward's funeral procession. The hand of God points the way to the church in London where he was buried—Westminster Abbey, consecrated December 28, 1065, just a few days before Edward's death. The church was one of the first Romanesque buildings erected in England, and the embroiderers took pains to record its main features, including the imposing crossing tower and the long nave with tribunes. Here William was crowned king of England on Christmas Day, 1066. (The coronation of every English monarch since then also has occurred in Westminster Abbey.) The second detail (FIG. 12-35, bottom) shows the Battle of Hastings in progress. The Norman cavalry cuts down the English defenders. The lower border is filled with the dead and wounded, although the upper register continues the animal motifs of the rest of the embroidery. The Romanesque artist co-opted some of the characteristic motifs of Greco-Roman battle scenes, for example, the horses with twisted necks and contorted bodies (compare FIG. 5-70). But the artists rendered the figures in the Romanesque manner. Linear patterning and flat color replaced classical three-dimensional volume and modeling in light and dark hues.

The *Bayeux Tapestry* stands apart from all other Romanesque artworks in that it depicts an event in full detail at a time shortly after it occurred, recalling the historical narratives of ancient Roman art. Art historians have often likened the Norman embroidery to the scroll-like frieze of the Column of Trajan (FIG. 7-44). Like the Roman account, the story told on the *Bayeux Tapestry* is the conqueror's version

of history, a proclamation of national pride. And as in the ancient frieze, the narrative is not confined to battlefield successes. It is a complete chronicle of events. Included are the preparations for war, with scenes depicting the felling and splitting of trees for ship construction, the loading of equipment onto the vessels, the cooking and serving of meals, and so forth. In this respect, the *Bayeux Tapestry* is the most *Roman*-esque work of Romanesque art.

BURY BIBLE The Bury Bible (FIG. 12-36), produced at the Bury Saint Edmunds abbey in England around 1135, exemplifies the sumptuous illustration common to the large Bibles produced in wealthy Romanesque abbeys not subject to the Cistercian ban on luxurious illuminated manuscripts. These costly books lent prestige to monasteries that could afford them (see "Medieval Books," Chapter 11, page 289). The artist responsible for the Bury Bible is known: Master Hugo, who was also a sculptor and metalworker. With Bernardus Gelduinus (FIG. 12-7), Gislebertus (FIG. 12-12), Rainer of Huy (FIG. 12-23), Wiligelmo (FIG. 12-28), and Benedetto Antelami (FIG. 12-29),

12-36 Master Hugo, Moses expounding the Law, folio 94 recto of the *Bury Bible*, from Bury Saint Edmunds, England, ca. 1135. Ink and tempera on vellum, $1' 8'' \times 1' 2''$. Corpus Christi College, Cambridge.

Master Hugo was a rare Romanesque lay artist, one of the emerging class of professional artists and artisans who depended for their livelihood on commissions from well-endowed monasteries.

Hugo is one of the small but growing number of Romanesque artists who signed their works or whose names were recorded. In the 12th century, artists, illuminators as well as sculptors, increasingly began to identify themselves. Although most medieval artists remained anonymous, the contrast of the Romanesque period with the early Middle Ages is striking. Hugo seems to have been a secular artist, one of the emerging class of professional artists and artisans who depended for their livelihood on commissions from well-endowed monasteries. These artists resided in towns rather than within secluded abbey walls, and they traveled frequently to find work. They were the exception, however, and the typical Romanesque scribes and illuminators continued to be monks and nuns working anonymously in the service of God. The Benedictine Rule, for example, specified that "artisans in the monastery . . . are to practice their craft with all humility, but only with the abbot's permission."

One page (FIG. 12-36) of the Bury Bible shows two scenes from Deuteronomy framed by symmetrical leaf motifs in softly glowing harmonized colors. The upper register depicts Moses and Aaron proclaiming the Law to the Israelites. Master Hugo represented Moses with horns, consistent with Saint Jerome's translation of the Hebrew word that also means "rays" (compare Michelangelo's similar conception of the Hebrew prophet, FIG. 17-15). The lower panel portrays Moses pointing out the clean and unclean beasts. The slow, gentle gestures convey quiet dignity. The figures of Moses and Aaron seem to glide. This presentation is quite different from the abrupt emphasis and spastic movement seen in earlier Romanesque paintings. The movements of the figures appear more integrated and smooth. Yet patterning remains in the multiple divisions of the draped limbs, the lightly shaded volumes connected with sinuous lines and ladderlike folds. Hugo still thought of the drapery and body as somehow the same. The frame has a quite definite limiting function, and the painter carefully fit the figures within it.

EADWINE PSALTER The Eadwine Psalter is the masterpiece of an English monk known as Eadwine the Scribe. It contains 166 illustrations, many of which are variations of those in the Carolingian Utrecht Psalter (Fig. 11-15). The last page (Fig. 12-37), however, presents a rare picture of a Romanesque artist at work. The style of the Eadwine portrait resembles that of the Bury Bible, but although the patterning is still firm (notably in the cowl and the thigh), the drapery falls more softly and follows the movements of the body beneath it. Here, the abstract patterning of many Romanesque painted and sculpted garments yielded slightly, but clearly, to the requirements of more naturalistic representation. The Romanesque artist's instinct for decorating the surface remained, as is apparent in the gown's whorls and spirals. Significantly, however, the artist painted in those interior lines very lightly so that they would not conflict with the functional lines that contain them.

The "portrait" of Eadwine—it is probably a generic type and not a specific likeness—is in the long tradition of author portraits in ancient and medieval manuscripts (FIGS. 11-7, 11-13, 11-14, and 12-22), although the true author of the *Eadwine Psalter* is King David. Eadwine

12-37 EADWINE THE SCRIBE, Eadwine the Scribe at work, folio 283 verso of the *Eadwine Psalter*, ca. 1160–1170. Ink and tempera on vellum. Trinity College, Cambridge.

Although he humbly offered his book as a gift to God, the English monk Eadwine added an inscription to his portrait declaring himself a "prince among scribes" whose fame would endure forever.

exaggerated his importance by likening his image to that of an evangelist writing his gospel and by including an inscription within the inner frame that identifies him and proclaims himself a "prince among scribes." He declares that, due to the excellence of his work, his fame will endure forever and that he can offer his book as an acceptable gift to God. Eadwine, like other Romanesque sculptors and painters who signed their works, may have been concerned for his fame, but these artists, whether monks or laity, were not yet aware of the concepts of fine art and fine artist. To them, their work existed not for its own sake but for God's. Nonetheless, works such as this one are an early sign of a new attitude toward the role of the artist in society that presages the emergence of the notion of individual artistic genius in the Renaissance.

ROMANESQUE EUROPE

FRANCE AND NORTHERN SPAIN

- Romanesque takes its name from the Roman-like barrel and groin vaults based on round arches employed in many European churches built between 1050 and 1200. Romanesque vaults, however, are made of stone, not concrete.
- Numerous churches sprang up along the pilgrimage roads leading to the shrine of Saint James at Santiago de Compostela. These churches were large enough to accommodate crowds of pilgrims who came to view the relics displayed in radiating chapels off the ambulatory and transept.
- The Romanesque period also brought the revival of monumental stone relief sculpture, especially on church facades, where scenes of Christ as Last Judge often greeted the faithful as they entered the doorway to salvation.
- The leading patrons of Romanesque sculpture and painting were the monks of the Cluniac order. The Cistercians, under the leadership of Bernard of Clairvaux, condemned figural art in churches and religious books.

HOLY ROMAN EMPIRE

- In the Romanesque period, the Salian dynasty (r. 1027–1125) ruled an empire that corresponds roughly to present-day Germany and northern Italy.
- Architects in the Holy Roman Empire built structurally innovative churches. Speyer Cathedral and Sant'Ambrogio in Milan are two of the earliest examples of the use of groin vaults in naves.
- In Belgium, sculptors excelled in metalwork, producing costly reliquaries of silver, jewels, and enamel. Rainer of Huy, one of several Romanesque artists whose name is known, cast a baptismal font in a single piece.

ITALY

- The regional diversity of Romanesque art and architecture is especially evident in Italy, where the ancient Roman and Early Christian heritage was strongest.
- Romanesque churches in Pisa and Florence have wooden roofs in contrast to the vaulted interiors of northern buildings. The exteriors often feature marble paneling of different colors. Church campaniles were usually freestanding, and baptisteries were independent central-plan buildings facing the cathedral.

NORMANDY AND ENGLAND

- After their conversion to Christianity in the early 10th century, the Vikings settled on the northern coast of France. From there, Duke William of Normandy crossed the channel and conquered England in 1066. The Bayeux Tapestry chronicles that war—a unique example of contemporaneous historical narrative art in the Middle Ages.
- Norman and English Romanesque architects introduced new features to church design that greatly influenced French Gothic architecture. Saint-Étienne at Caen and Durham Cathedral are the earliest examples of the use of rib groin vaults over a three-story nave elevation (arcade-tribune-clerestory). The Durham builders also experimented with quadrant arches in the tribune to buttress the nave vaults.

Saint-Sernin, Toulouse, ca. 1070–1120

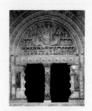

Saint-Pierre, Moissac ca. 1115–1135

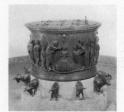

Rainer of Huy, baptismal font,

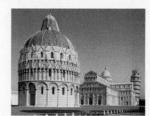

Cathedral complex, Pisa, 11th–12th centuries

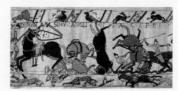

Bayeux Tapestry, ca. 1070-1080

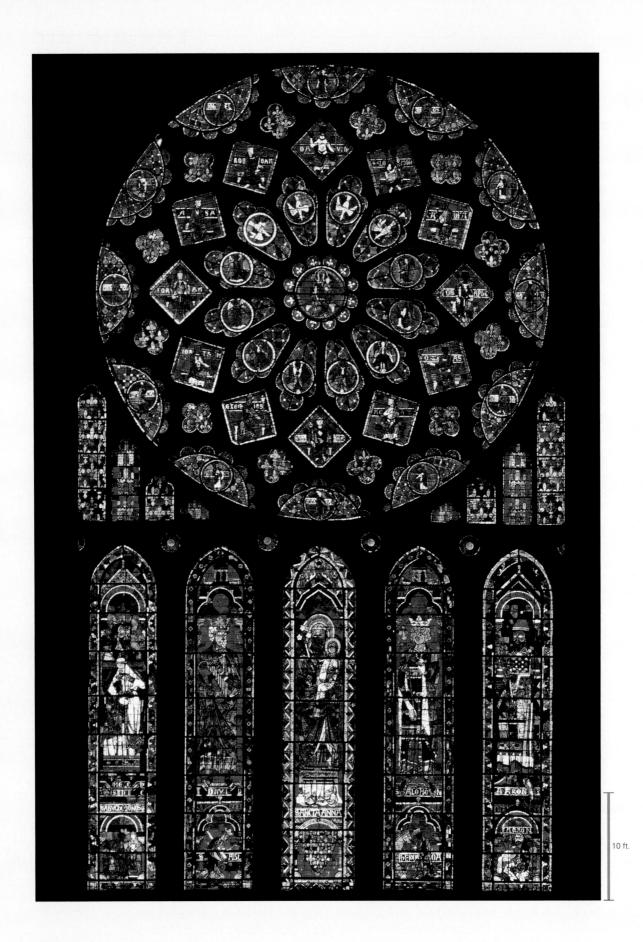

13-1 Rose window and lancets, north transept, Chartres Cathedral, Chartres, France, ca. 1220. Stained glass, rose window 43' in diameter.

The use of flying buttresses in Gothic cathedrals made possible the replacement of stone walls with immense stained-glass windows, which transformed natural sunlight into Abbot Suger's divine *lux nova*.

GOTHIC EUROPE

In 1550, Giorgio Vasari (1511–1574), the "father of art history," first used *Gothic* as a term of ridicule to describe late medieval art and architecture, which he attributed to the Goths and regarded as "monstrous and barbarous." With the publication in that year of his influential *Introduction to the Three Arts of Design*, Vasari codified for all time the notion the early Renaissance artist Lorenzo Ghiberti (1378–1455) had already advanced in his *Commentarii*, namely, that the Middle Ages was a period of decline. The humanists of the Italian Renaissance, who placed Greco-Roman art on a pedestal, believed that the uncouth Goths were responsible for both the downfall of Rome and the destruction of the classical style in art and architecture. They regarded "Gothic" art with contempt and considered it ugly and crude. In the 13th and 14th centuries, however, when the Gothic style was the rage in most of Europe, contemporaries admired Gothic buildings as *opus modernum* ("modern work"). The clergy and the lay public alike recognized that the great cathedrals towering over their towns displayed an exciting new style. For them, Gothic cathedrals were not distortions of the classical style but images of the City of God, the Heavenly Jerusalem, which they were privileged to build on earth.

As in the Romanesque period, the great artistic innovations of the Gothic age were in part the outgrowth of widespread prosperity, but the era was also a time of turmoil in Europe (MAP 13-1). In 1337 the Hundred Years' War began, shattering the peace between France and England. In the 14th century, a great plague, the Black Death, swept over western Europe and killed at least a quarter of its people. From 1378 to 1417, opposing popes resided in Rome and in Avignon in southern France during the political-religious crisis known as the Great Schism (see "The Great Schism," Chapter 14, page 379). Above all, the Gothic age was a time of profound change in European society. The focus of both intellectual and religious life shifted definitively from monasteries in the countryside to rapidly expanding secular cities. In these new Gothic urban centers, prosperous merchants made their homes and *guilds* (professional associations) of scholars founded the first modern universities. Although the papacy was at the height of its power, and knights throughout Europe still gathered to wage Crusades against the Muslims, the independent secular nations of modern Europe were beginning to take shape. Foremost among them was France.

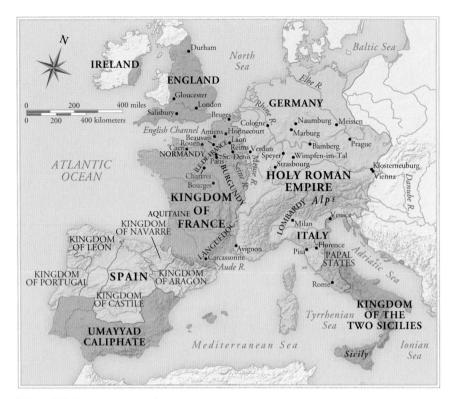

MAP 13-1 Europe around 1200.

FRENCH GOTHIC

The Gothic style first appeared in northern France around 1140, and some late medieval writers called Gothic art in general *opus francigenum* ("French work"). By the 13th century, the opus modernum of the region around Paris had spread throughout western Europe, and in the next century it expanded still farther. Saint Vitus Cathedral in Prague (Czech Republic), for example, begun in 1344, closely emulates French Gothic architecture. Today, Gothic architecture lives on in the chapels, academic buildings, and dormitories of college campuses throughout North America. But although the Gothic style achieved international acclaim, it was a regional phenomenon. To the east and south of Europe, the Byzantine and Islamic styles still held sway. And many regional variants existed within European Gothic, just as distinct regional styles characterized the Romanesque period.

Architecture and Architectural Decoration

Art historians generally agree that the birthplace of Gothic architecture was at Saint-Denis, a few miles north of Paris. Saint Dionysius (Denis in French) was the apostle who brought Christianity to Gaul and who died a martyr's death there in the third century. The Benedictine order founded the abbey at Saint-Denis in the seventh century on the site of the saint's burial. In the ninth century, the monks constructed a basilica at Saint-Denis, which housed the saint's tomb and those of almost all of the French kings dating back to the sixth century, as well as the crimson military banner said to have belonged to Charlemagne. The Carolingian basilica became France's royal church, the very symbol of the monarchy (just as Speyer Cathedral, FIG. 12-19, was the burial place of the German rulers of the Holy Roman Empire).

SUGER AND SAINT-DENIS By 1122, when a monk named Suger became abbot of Saint-Denis, the old church was in disrepair and had become too small to accommodate the growing number of pilgrims. Suger also believed the basilica was of insufficient grandeur to serve as the official church of the French kings (see "Abbot Suger

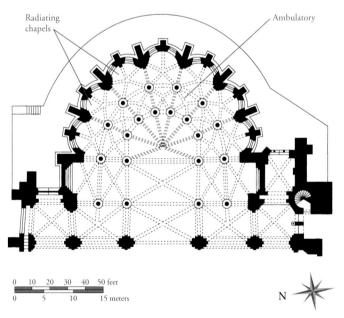

13-2 Plan of the east end, abbey church, Saint-Denis, France, 1140–1144 (after Sumner Crosby).

The innovative plan of the east end of Saint-Denis dates to Abbot Suger's lifetime. By using lightweight rib vaults, the builders were able to eliminate the walls between the radiating chapels.

Abbot Suger and the Rebuilding of Saint-Denis

bbot Suger of Saint-Denis (1081–1151) rose from humble parentage to become the right-hand man of both Louis VI (r. 1108–1137) and Louis VII (r. 1137–1180). When the latter, accompanied by his queen, Eleanor of Aquitaine, left to join the Second Crusade (1147–1149), Suger served as regent of France. From his youth, Suger wrote, he had dreamed of the possibility of embellishing the church in which most French monarchs had been buried for nearly 500 years. Within 15 years of becoming abbot of Saint-Denis, Suger began rebuilding its Carolingian basilica. In Suger's time, the power of the French kings, except for scattered holdings, extended over an area not much larger than the Île-de-France, the region centered on Paris. But the kings had pretensions to rule all of France. Suger aimed to increase the prestige both of his abbey and of the monarchy by rebuilding France's royal church in grand fashion.

Suger wrote three detailed treatises about his activities as abbot of Saint-Denis. He recorded that he summoned masons and artists

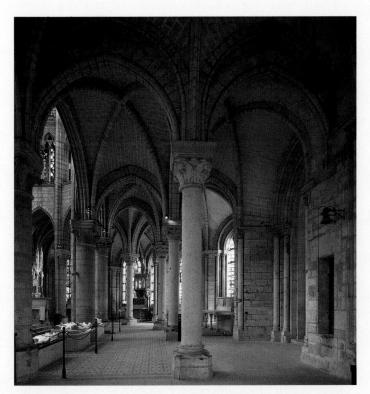

13-3 Ambulatory and radiating chapels, abbey church, Saint-Denis, France, 1140–1144.

Abbot Suger's remodeling of Saint-Denis marked the beginning of Gothic architecture. Rib vaults with pointed arches spring from slender columns. The radiating chapels have stained-glass windows.

from many regions to help design and construct his new church. In one important passage, he described the special qualities of the new east end (FIGS. 13-2 and 13-3) dedicated in 1144:

[I]t was cunningly provided that—through the upper columns and central arches which were to be placed upon the lower ones built in the crypt—the central nave of the old [Carolingian church] should be equalized, by means of geometrical and arithmetical instruments, with the central nave of the new addition; and, likewise, that the dimensions of the old side-aisles should be equalized with the dimensions of the new side-aisles, except for that elegant and praiseworthy extension in [the form of] a circular string of chapels, by virtue of which the whole [church] would shine with the wonderful and uninterrupted light of most sacred windows, pervading the interior beauty.*

The abbot's brief discussion of Saint Denis's new ambulatory and chapels is key to the understanding of Early Gothic architecture. But he wrote at much greater length about his church's glorious golden and gem-studded furnishings. Here, for example, is Suger's description of the *altar frontal* (the decorative panel on the front of the altar) in the choir:

Into this panel, which stands in front of [Saint Denis's] most sacred body, we have put . . . about forty-two marks of gold [and] a multifarious wealth of precious gems, hyacinths, rubies, sapphires, emeralds and topazes, and also an array of different large pearls.[†]

The costly furnishings and the light-filled space caused Suger to "delight in the beauty of the house of God" and "called [him] away from external cares." The new church made him feel as if he were "dwelling... in some strange region of the universe which neither exists entirely in the slime of the earth nor entirely in the purity of Heaven." In Suger's eyes, then, his splendid new church, permeated with light and outfitted with gold and precious gems, was a way station on the road to Paradise, which "transported [him] from this inferior to that higher world." He regarded a lavish investment in art as a spiritual aid, not as an undesirable distraction for the pious monk, as did Bernard of Clairvaux (see "Bernard of Clairvaux," Chapter 12, page 316). Suger's forceful justification of art in the church set the stage for the proliferation of costly stained-glass windows and sculptures in the cathedrals of the Gothic age.

and the Rebuilding of Saint-Denis," above). Thus, Suger began to rebuild the church in 1135 by erecting a new west facade with sculptured portals. In 1140 work began on the east end (FIGS. 13-2 and 13-3). Suger died before he could remodel the nave, but he attended the dedication of the new choir, ambulatory, and radiating

chapels on June 11, 1144. Also in attendance were King Louis VII of France, Queen Eleanor of Aquitaine, and five archbishops.

Because the French considered the old church a relic in its own right, the new east end had to conform to the dimensions of the crypt below it. Nevertheless, the remodeled portion of Saint-Denis

^{*} Translated by Erwin Panofsky, Abbot Suger on the Abbey Church of Saint-Denis and Its Art Treasures, 2d ed. (Princeton: Princeton University Press, 1979), 101.

[†] Ibid., 55.

[‡] Ibid., 65.

The Gothic Rib Vault

"he ancestors of the Gothic rib vault are the Romanesque vaults found at Caen (FIG. 12-31), Durham (FIG. 12-33), and elsewhere. The rib vault's distinguishing feature is the crossed, or diagonal, arches under its groins, as seen in the Saint-Denis ambulatory and chapels (FIG. 13-3; compare FIG. 13-20). These arches form the armature, or skeletal framework, for constructing the vault. Gothic vaults generally have more thinly vaulted webs (the masonry between the ribs) than found in Romanesque vaults. But the chief difference between the two styles of rib vaults is the pointed arch, an integral part of the Gothic skeletal armature. The first wide use of pointed arches was in Sasanian architecture (FIG. 2-27), and Islamic builders later adopted them. French Romanesque architects (FIGS. 12-1 and 12-14) borrowed the form from Muslim Spain and passed it to their Gothic successors. Pointed arches allowed Gothic builders to make the crowns of all the vault's arches approximately the same level, regardless of the space to be vaulted. The Romanesque architects could not achieve this with their semicircular arches.

The drawings here (FIG. 13-4) illustrate this key difference. In FIG. 13-4a, the rectangle ABCD is an oblong nave bay to be vaulted. AC and DB are the diagonal ribs; AB and DC, the transverse arches; and AD and BC, the nave arcade's arches. If the architect uses semi-

circular arches (*AFB*, *BJC*, and *DHC*), their radii and, therefore, their heights (*EF*, *IJ*, and *GH*) will be different, because the width of a semicircular arch determines its height. The result will be a vault (FIG. 13-4b) with higher transverse arches (*DHC*) than the arcade's arches (*CJB*). The vault's crown (*F*) will be still higher. If the builder uses pointed arches (FIG. 13-4c), the transverse (*DLC*) and arcade (*BKC*) arches can have the same heights (*GL* and *IK* in FIG. 13-4a). The result will be a Gothic rib vault where the points of the arches (*L* and *K*) are at the same level as the vault's crown (*F*).

A major advantage of the Gothic vault is its flexibility, which permits the vaulting of compartments of varying shapes, as may be seen at Saint-Denis (FIG. 13-2). Pointed arches also channel the weight of the vaults more directly downward than do semicircular arches. The vaults therefore require less buttressing to hold them in place, in turn permitting builders to open up the walls and place large windows beneath the arches. Because pointed arches also lead the eye upward, they make the vaults appear taller than they are. In FIG. 13-4, the crown (F) of both the Romanesque (b) and Gothic (c) vaults is the same height from the pavement, but the Gothic vault seems taller. Both the physical and visual properties of rib vaults with pointed arches aided Gothic builders in their quest for soaring height in church interiors.

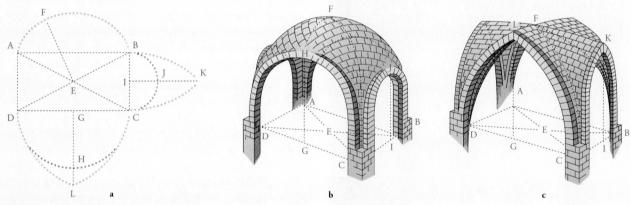

13-4 Diagram (a) and drawings of rib vaults with semicircular (b) and pointed (c) arches.

Pointed arches channel the weight of the rib vaults more directly downward than do semicircular arches, requiring less buttressing. Pointed arches also make the vaults appear taller than they are.

represented a sharp break from past practice. Innovative rib vaults resting on pointed, or *ogival*, arches (see "The Gothic Rib Vault," above, and Fig. 13-4) cover the ambulatory and chapels (Fig. 13-3). These pioneering, exceptionally lightweight vaults spring from slender columns in the ambulatory and from the thin masonry walls framing the chapels. The lightness of the vaults enabled the builders to eliminate the walls between the chapels (Fig. 13-2) and open up the outer walls and fill them with stained-glass windows (see "Stained-Glass Windows," page 350). Suger and his contemporaries marveled at the "wonderful and uninterrupted light" that poured in through the "most sacred windows." The abbot called the colored light *lux nova*, "new light." The multicolored rays coming through the windows shone on the walls and columns, almost dissolving them. Both the new type of vaulting and the use of stained glass became hallmarks of French Gothic architecture.

Saint-Denis is also the key monument of Early Gothic sculpture. Little of the sculpture that Suger commissioned for the west facade of the abbey church survived the French Revolution of the late 18th century (see Chapter 21), but much of the mid-12th-century structure is intact. It consists of a double-tower westwork, as at Saint-Étienne (Fig. 12-30) at Caen, and has massive walls in the Romanesque tradition. A restored large central *rose window* (a circular stained-glass window), a new feature that became standard in French Gothic architecture, punctuates the facade's upper story. For the three portals, Suger imported sculptors to carry on the rich Romanesque heritage of southern France (see Chapter 12). But at Saint-Denis, the sculptors introduced statues of Old Testament kings, queens, and prophets attached to columns, which screened the jambs of all three doorways.

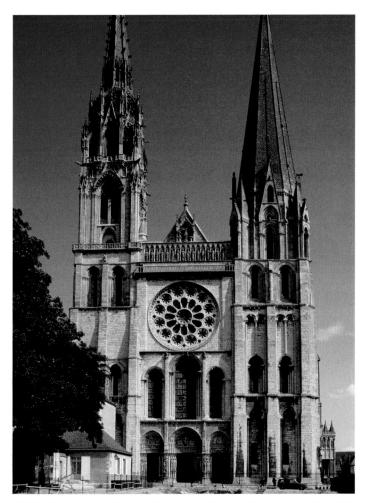

13-5 West facade, Chartres Cathedral, Chartres, France, ca. 1145–1155.

The Early Gothic west facade was all that remained of Chartres Cathedral after the fire of 1194. The design still has much in common with Romanesque facades. The rose window is an example of plate tracery.

ROYAL PORTAL, CHARTRES This innovative treatment of the portals of Suger's church appeared immediately afterward at Chartres, also in the Île-de-France, in the new cathedral dedicated to Notre Dame ("Our Lady," that is, the Virgin Mary). Work on the west facade (FIG. 13-5) began around 1145. The lower parts of the massive west towers at Chartres and the portals between them are all that remain of the cathedral destroyed by fire in 1194 before it had been completed. Reconstruction of the church began immediately but in the High Gothic style (discussed later). The west entrance, the Royal Portal (FIG. 13-6; so named because of the statue-columns of kings and queens flanking its three doorways) constitutes the most complete surviving ensemble of Early Gothic sculpture. Thierry of Chartres, chancellor of the Cathedral School of Chartres from 1141 until his death 10 years later, may have conceived the complex iconographical program. The archivolts of the right portal, for example, depict the seven female Liberal Arts and their male champions. The figures represent the core of medieval learning and symbolize human knowledge, which Thierry and other "Schoolmen" believed led to true faith (see "Scholasticism and Gothic Art and Architecture," page 344).

The sculptures of the Royal Portal (FIG. 13-6) proclaim the majesty and power of Christ. To unite the three doorways iconographically and visually, the sculptors carved episodes from Christ's life on the capitals, which form a kind of frieze linking one entrance to the next. In the tympanum of the right portal, Christ appears in the lap of the Virgin Mary (Notre Dame). Scenes of his birth and early life fill the lintel below. The tympanum's theme and composition recall Byzantine representations of the Theotokos (FIGS. 9-18 and 9-19), as well as the Romanesque Throne of Wisdom (FIG. 12-18). But Mary's prominence on the Chartres facade has no parallel in the decoration of Romanesque church portals. At Chartres the designers gave her a central role in the sculptural program, a position she maintained throughout the Gothic period. The cult of the Virgin Mary reached a high point in the Gothic age. As the Mother of Christ, she stood compassionately between the Last Judge and the horrors of Hell, interceding for all her faithful. Worshipers in the later 12th and 13th centuries

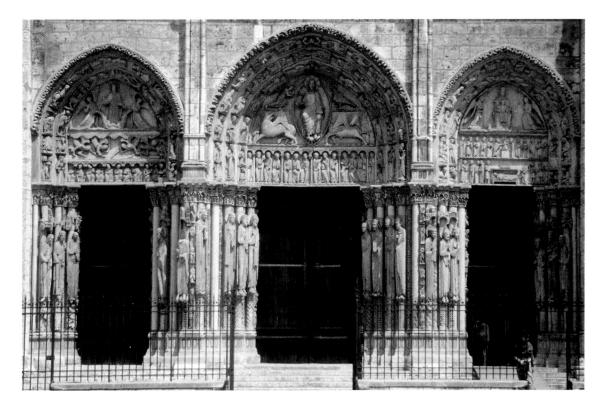

13-6 Royal Portal, west facade, Chartres Cathedral, Chartres, France, ca. 1145–1155.

The sculptures of the Royal Portal proclaim the majesty and power of Christ. The tympana depict, from left to right, Christ's Ascension, the Second Coming, and Jesus in the lap of the Virgin Mary.

Scholasticism and Gothic Art and Architecture

few years before the formal consecration of the church altar at Notre-Dame (FIG. 13-11) in Paris, Philip II Augustus (r. 1180–1223) succeeded to the French throne. Philip brought the feudal barons under his control and expanded the royal domains to include Normandy in the north and most of Languedoc in the south, laying the foundations for the modern nation of France. Renowned as "the maker of Paris," he gave the city its walls, paved its streets, and built the palace of the Louvre (now one of the world's great museums) to house the royal family. Although Rome remained the religious center of Western Christendom, Paris became its intellectual capital. The University of Paris attracted the best minds from all over Europe. Virtually every thinker of note in the Gothic world at some point studied or taught at Paris.

Even in the Romanesque period, Paris was a center of learning. Its Cathedral School professors, known as Schoolmen, developed the philosophy called Scholasticism. The greatest of the early Schoolmen was Peter Abelard (1079-1142), a champion of logical reasoning. Abelard and his contemporaries had been introduced to the writings of the Greek philosopher Aristotle through the Arabic scholars of Islamic Spain. Abelard applied Aristotle's system of rational inquiry to the interpretation of religious belief. Until the 12th century, both clergy and laymen considered truth the exclusive property of divine revelation as given in the Holy Scriptures. But the Schoolmen, using Aristotle's method, sought to demonstrate that reason alone could lead to certain truths. Their goal was to prove the central articles of Christian faith by argument (disputatio). A person using Scholastic argument first states a possibility, then cites an authoritative view in objection, next reconciles the positions, and, finally, offers a reply to each of the rejected original arguments.

One of Abelard's greatest critics was Bernard of Clairvaux (see "Bernard of Clairvaux," Chapter 12, page 316), who believed Scholas-

ticism was equivalent to questioning Christian dogma. Although Bernard succeeded in 1140 in having the Catholic Church officially condemn Abelard's doctrines, the Schoolmen's philosophy developed systematically until it became the dominant Western philosophy of the late Middle Ages. By the 13th century, the Schoolmen of Paris already had organized as a professional guild of master scholars, separate from the numerous Church schools the bishop of Paris oversaw. The structure of the Parisian guild served as the model for many other European universities.

The greatest exponent of Abelard's Scholasticism was Thomas Aquinas (1225–1274), an Italian monk who became a saint in 1323. Aquinas settled in Paris in 1244. There, the German theologian Albertus Magnus instructed him in Aristotelian philosophy. Aquinas went on to become an influential teacher at the University of Paris. His most famous work, *Summa Theologica* (left unfinished at his death), is a model of the Scholastic approach to knowledge. Aquinas divided his treatise into books, the books into questions, the questions into articles, each article into objections with contradictions and responses, and, finally, answers to the objections. He set forth five ways to prove the existence of God by rational argument. Aquinas's work remains the foundation of contemporary Catholic teaching.

The earliest manifestations of the Gothic spirit in art and architecture—the sculptured portals and vaulted east end of Suger's Saint-Denis (FIGS. 13-2 and 13-3)—appeared concurrently with the first stages of Scholastic philosophy. Both originated in Paris and its environs. Many art historians have noted the parallels between them—how the logical thrust and counterthrust of Gothic construction, the geometric relationships of building parts, and the systematic organization of the iconographical programs of Gothic church portals coincide with Scholastic principles and methods. No documents exist, however, linking the scholars, builders, and sculptors.

sang hymns to her, put her image everywhere, and dedicated great cathedrals to her. Soldiers carried the Virgin's image into battle on banners, and her name joined that of Saint Denis as part of the French king's battle cry. Mary became the spiritual lady of chivalry, and the Christian knight dedicated his life to her. The severity of Romanesque themes stressing the Last Judgment yielded to the gentleness of Gothic art, in which Mary is the kindly Queen of Heaven.

Christ's Ascension into Heaven appears in the tympanum of the left portal. All around, in the archivolts, are the signs of the zodiac and scenes representing the various labors of the months of the year. They are symbols of the cosmic and earthly worlds. The Second Coming is the subject of the central tympanum. The signs of the four evangelists, the 24 elders of the Apocalypse, and the 12 apostles appear around Christ or on the lintel. The Second Coming—in essence, the Last Judgment theme—was still of central importance, as it was in Romanesque portals. But at Early Gothic Chartres, the theme became a symbol of salvation rather than damnation.

Statues of Old Testament kings and queens decorate the jambs flanking each doorway of the Royal Portal (FIGS. 13-6 and 13-7). They are the royal ancestors of Christ and, both figuratively and literally, support the New Testament figures above the doorways. They wear 12th-century clothes, and medieval observers also regarded

them as images of the kings and queens of France. (This was the motivation for vandalizing the comparable figures at Saint-Denis during the French Revolution.) The figures stand rigidly upright with their elbows held close against their hips. The linear folds of their garments-inherited from the Romanesque style, along with the elongated proportions—generally echo the vertical lines of the columns behind them. (In this respect, Gothic jamb statues differ significantly from classical caryatids; FIG. 5-54. The Gothic figures are attached to columns; the classical statues replaced the columns.) And yet, within and despite this architectural straitjacket, the statues display the first signs of a new naturalism. The sculptors conceived and treated the figures as three-dimensional volumes, not reliefs, and they stand out from the plane of the wall. As was true of all stone sculpture on church facades, artists originally painted the Royal Portal statues in vivid colors, enhancing their lifelike appearance. The new naturalism is noticeable particularly in the statues' heads, where kindly human faces replace the masklike features of most Romanesque figures. At Chartres, a personalization of appearance began that led first to idealized portraits of the perfect Christian and finally, by 1400, into the portraiture of specific individuals. The sculptors of the Royal Portal statues initiated an era of artistic concern with personality and individuality.

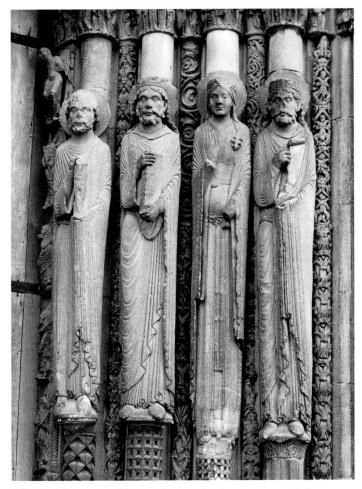

13-7 Old Testament kings and queen, jamb statues, central doorway of Royal Portal, Chartres Cathedral, Chartres, France, ca. 1145–1155.

The biblical kings and queens of the Royal Portal are the royal ancestors of Christ. These Early Gothic statue-columns display the first signs of a new naturalism in European sculpture.

LAON CATHEDRAL Both Chartres Cathedral and the abbey church of Saint-Denis had long construction histories, and only small portions of the structures date to the Early Gothic period. Laon Cathedral (FIGS. 13-8 and 13-9), however, completed shortly after 1200, provides a comprehensive picture of French church architecture of the second half of the 12th century. Although the Laon builders retained many Romanesque features in their design, they combined them with the rib vault resting on pointed arches, the essential element of Early Gothic architecture.

Among the Laon plan's Romanesque features are the nave bays with their large sexpartite rib vaults, flanked by two small groin-vaulted squares in each aisle. The vaulting system (except for the pointed arches), as well as the vaulted gallery above the aisles, derived from Norman Romanesque churches such as Saint-Étienne (FIG. 12-31) at Caen. The Laon architect also employed the Romanesque alternate-support system of compound and simple piers in the nave arcade. Above, alternating bundles of three and five shafts frame the aisle bays. A new feature found in the Laon interior, however, is the *triforium*, the band of arcades below the clerestory

13-9 Interior of Laon Cathedral (looking northeast), Laon, France, begun ca. 1190.

The insertion of a triforium at Laon broke up the nave wall and produced the characteristic four-story Early Gothic interior elevation: nave arcade, vaulted gallery, triforium, and clerestory.

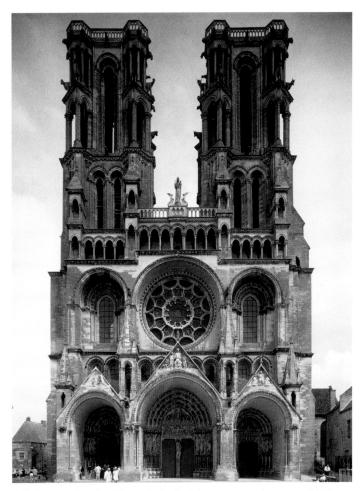

13-8 West facade of Laon Cathedral, Laon, France, begun ca. 1190.

The huge central rose window, the deep porches in front of the doorways, and the open structure of the towers distinguish Laon's Early Gothic facade from Romanesque church facades.

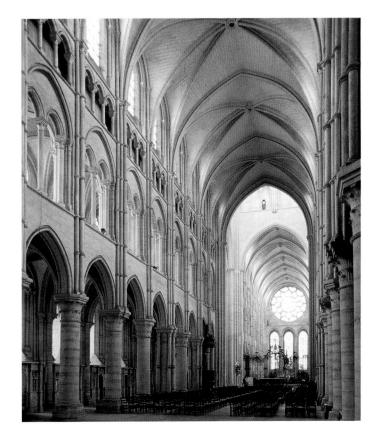

13-10 Nave elevations of four French Gothic cathedrals at the same scale (after Louis Grodecki).

Gothic nave designs evolved from the Early Gothic fourstory elevation to the High Gothic three-story elevation (arcade, triforium, and clerestory). The height of the vaults also increased from 80 to 144 feet.

(FIGS. 13-9 and 13-10a). The triforium occupies the space corresponding to the exterior strip of wall covered by the sloping timber roof above the galleries. The insertion of the triforium into the Romanesque threestory nave elevation reflected a growing desire to break up all continuous wall surfaces. The new horizontal zone produced the characteristic four-story Early Gothic interior elevation: nave arcade, vaulted gallery, triforium, and clerestory with single lancets (tall, narrow windows ending in pointed arches). Shown in FIG. 13-10 is a comparison of the Laon nave elevation

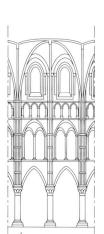

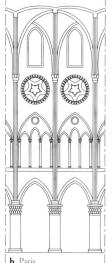

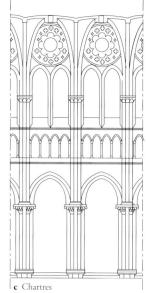

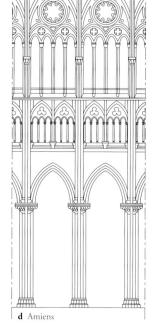

with that of another four-story Early Gothic cathedral (FIG. 13-10*b*) and with elevations of two three-story High Gothic cathedrals (FIGS. 13-10*c* and 13-10*d*).

Laon Cathedral's west facade (FIG. 13-8) signals an even more pronounced departure from the Romanesque style still lingering at Saint-Denis and the Chartres Royal Portal. Typically Gothic are the huge central rose window, the deep porches in front of the doorways, and the open structure of the towers. A comparison of the facades of Laon Cathedral and Saint-Étienne (FIG. 12-30) at Caen reveals a much deeper penetration of the wall mass in the later building. At Laon, as in Gothic architecture generally, the guiding principle was to reduce sheer mass and replace it with intricately framed voids.

NOTRE-DAME, PARIS About 1130, Louis VI moved his official residence to Paris, spurring much commercial activity and a great building boom. Paris soon became the leading city of France, indeed of all northern Europe, making a new cathedral a necessity. Notre-Dame (FIG. 13-11) occupies a picturesque site on an island in the Seine River called the Île-de-la-Cité. The Gothic church, which replaced a

large Merovingian basilica, has a complicated building history. The choir and transept were completed by 1182, the nave by about 1225, and the facade not until around 1250–1260. Sexpartite vaults cover the nave, as at Laon. The original elevation (the builders modified the design as work progressed) had four stories, but the scheme (FIG. 13-10*b*) differed from Laon's (FIG. 13-10*a*). In place of the triforium over the gallery, stained-glass *oculi* (singular *oculus*, a small round window) open up the wall below the clerestory lancets. As a result, windows fill two of the four stories, further reducing the

13-11 Notre-Dame (looking north), Paris, France, begun 1163; nave and flying buttresses, ca. 1180–1200; remodeled after 1225.

Architects first used flying buttresses on a grand scale in the Cathedral of Notre-Dame in Paris. The buttresses countered the outward thrust of the nave vaults and held up the towering nave walls.

masonry area. (This four-story nave elevation can be seen in only one bay in FIG. 13-11, immediately to the right of the south transept and partially hidden by it.)

To hold the much thinner—and taller (compare FIGS. 13-10a and 13-10b)—walls of Notre-Dame in place, the unknown architect introduced flying buttresses, exterior arches that spring from the lower roofs over the aisles and ambulatory (FIG. 13-11) and counter the outward thrust of the nave vaults. Gothic builders employed flying buttresses as early as 1150 in a few smaller churches, but at Notre-Dame in Paris they circle a great urban cathedral. At Durham, the internal quadrant arches (FIG. 12-33, right) beneath the aisle roofs, also employed at Laon, perform a similar function and may be regarded as precedents for exposed Gothic flying buttresses. The combination of precisely positioned flying buttresses and rib vaults with pointed arches was the ideal solution to the problem of constructing towering naves with huge windows. The flying buttresses, like slender extended fingers holding up the walls, are key components of the distinctive "look" of Gothic cathedrals (see "The Gothic Cathedral," page 347, and FIG. 13-12).

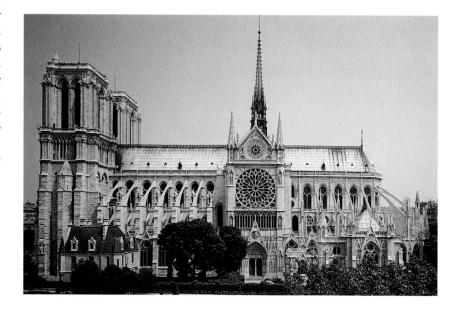

The Gothic Cathedral

These towering structures are eloquent testimonies to the extraordinary skill of the architects, engineers, carpenters, masons, sculptors, glassworkers, and metalsmiths who constructed and decorated the buildings. Most of the architectural components of Gothic cathedrals appeared in earlier structures, but the way Gothic architects combined the elements made the buildings unique expressions of medieval faith. The essential ingredients of the Gothic "recipe" were rib vaults with pointed arches (see "The Gothic Rib Vault," page 342), flying buttresses, and huge colored-glass windows (see "Stained-Glass Windows," page 350). These and the other important Gothic architectural terms listed here are illustrated in Fig. 13-12.

- *Pinnacle* A sharply pointed ornament capping the piers or flying buttresses; also used on cathedral facades.
- *Flying buttresses* Masonry struts that transfer the thrust of the nave vaults across the roofs of the side aisles and ambulatory to a tall pier rising above the church's exterior wall. (Compare FIG. I-18, *right*.)
- *Vaulting web* The masonry blocks that fill the area between the ribs of a groin vault.
- *Diagonal rib* In plan, one of the ribs that form the X of a groin vault. In FIG. 13-4, the diagonal ribs are the lines *AC* and *DB*.
- *Transverse rib* A rib that crosses the nave or aisle at a 90-degree angle (lines *AB* and *DC* in FIG. 13-4).
- **Springing** The lowest stone of an arch; in Gothic vaulting, the lowest stone of a diagonal or transverse rib.
- Clerestory The windows below the vaults that form the nave elevation's uppermost level. By using flying buttresses and rib vaults on pointed arches, Gothic architects could build huge clerestory windows and
- 13-12 Cutaway view of a typical French Gothic cathedral (John Burge). (1) pinnacle, (2) flying buttress, (3) vaulting web, (4) diagonal rib,
- (5) transverse rib, (6) springing, (7) clerestory,
- (8) oculus, (9) lancet, (10) triforium, (11) nave arcade, (12) compound pier with responds.

Rib vaults with pointed arches, flying buttresses, and stained-glass windows are the major ingredients in the "recipe" for constructing Gothic cathedrals, but other elements also contributed to the distinctive "look" of these churches.

fill them with *stained glass* held in place by ornamental stonework called *tracery*.

- **Oculus** A small round window.
- **Lancet** A tall, narrow window crowned by a pointed arch.
- *Triforium* The story in the nave elevation consisting of arcades, usually *blind arcades* (FIG. 13-9), but occasionally filled with stained glass (FIG. I-2).
- *Nave arcade* The series of arches supported by piers separating the nave from the side aisles.
- Compound pier with shafts (responds) Also called the cluster pier, a pier with a group, or cluster, of attached shafts, or responds, extending to the springing of the vaults.

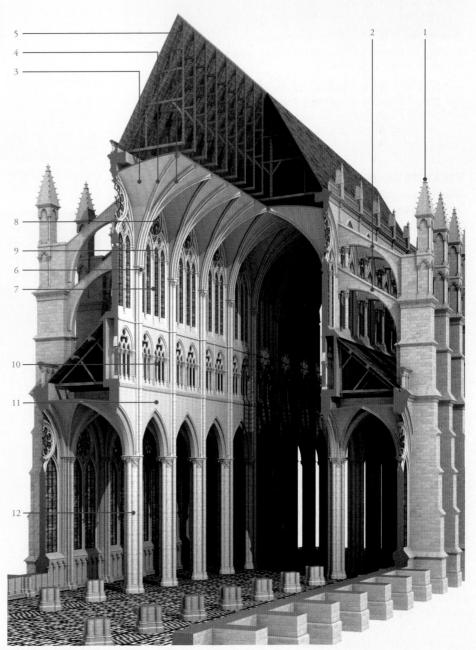

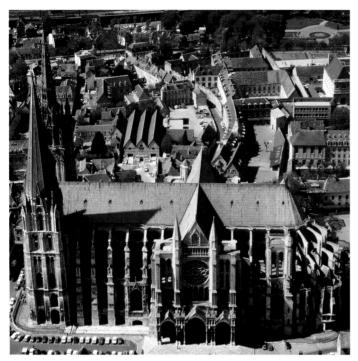

13-13 Aerial view of Chartres Cathedral (looking north), Chartres, France, as rebuilt after 1194.

Architectural historians consider the rebuilt Chartres Cathedral the first great monument of High Gothic architecture. It is the first church to have been planned from the beginning with flying buttresses.

CHARTRES AFTER 1194 Churches burned frequently in the Middle Ages (see "Timber Roofs," Chapter 12, page 313), and church officials often had to raise money suddenly for new building campaigns. In contrast to monastic churches, which usually were small and completed fairly quickly, construction of urban cathedrals often extended over decades and sometimes over centuries. Their financing depended largely on collections and public contributions (not always voluntary), and a lack of funds often interrupted building programs. Unforeseen events, such as wars, famines, or plagues, or friction between the town and cathedral authorities would often stop construction, which then might not resume for years. At Reims (FIG. 13-23), the clergy offered indulgences (pardons for sins committed) to those who helped underwrite the enormous cost of erecting the cathedral. The rebuilding of Chartres Cathedral (FIG. 13-13) after the devastating fire of 1194 took a relatively short 27 years, but at one point the townspeople revolted against the prospect of a heavier tax burden. They stormed the bishop's residence and drove him into exile for four years.

Chartres Cathedral's mid-12th-century west facade (FIG. 13-5) and the masonry of the crypt to the east were the only sections left standing after the 1194 conflagration. The crypt housed the most precious relic of Chartres—the mantle of the Virgin, which miraculously survived the fire. For reasons of piety and economy, the builders used the crypt for the foundation of the new structure. The retention of the crypt and west facade determined the new church's dimensions, but not its plan or elevation. Architectural historians usually consider the post-1194 Chartres Cathedral the first High Gothic building.

The Chartres plan (FIG. 13-14) reveals a new kind of organization. Rectangular nave bays replaced the square bays with sexpartite vaults and the alternate-support system, still present in Early Gothic churches such as Laon Cathedral (FIG. 13-9). The new system, in which a single square in each aisle (rather than two, as before) flanks a single rectangular unit in the nave, became the High Gothic norm.

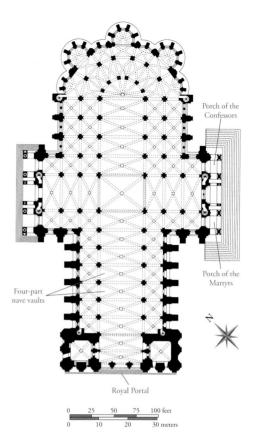

13-14 Plan of Chartres Cathedral, Chartres, France, as rebuilt after 1194 (after Paul Frankl).

The Chartres plan, in which a single square in each aisle (rather than two squares) flanks a single rectangular unit in the nave with a four-part vault, became the norm for High Gothic church architecture.

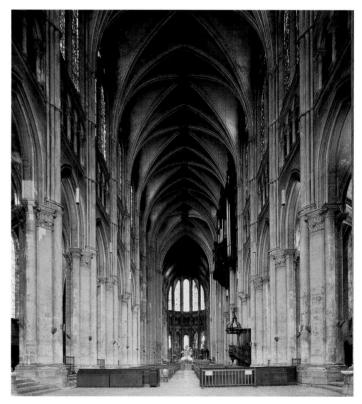

13-15 Interior of Chartres Cathedral (looking east), Chartres, France, begun 1194.

Chartres Cathedral became the model for High Gothic churches also in its tripartite elevation consisting of nave arcade, triforium, and clerestory with stained-glass windows almost as tall as the main arcade.

A change in vault design and the abandonment of the alternate-support system usually accompanied this new bay arrangement. The High Gothic nave vault, which covered just one bay and therefore could be braced more easily than its Early Gothic predecessor, had only four parts. The visual effect of these changes was to unify the interior (FIG. 13-15). The High Gothic architect aligned identical units so that viewers saw them in too rapid a sequence to perceive them as individual volumes of space. The level crowns of the successive nave vaults, which pointed arches made possible, enhanced this effect. The nave became a vast, continuous hall.

The 1194 Chartres Cathedral was also the first church to have been planned from the beginning with flying buttresses, another key High Gothic feature. The flying buttresses allowed the builders to eliminate the tribune above the aisle, which had partially braced Romanesque and Early Gothic naves (compare FIG. 13-10c with FIGS. 13-10a and 13-10b). The new High Gothic tripartite nave elevation consisted of arcade, triforium, and clerestory with greatly enlarged windows. The Chartres windows are almost as tall as the main arcade and consist of double lancets with a single crowning oculus. The strategic placement of flying buttresses permitted the construction of nave walls with so many voids that heavy masonry played a minor role.

CHARTRES STAINED GLASS Despite the vastly increased size of the clerestory windows, the Chartres nave (FIG. 13-15) is relatively dark. The explanation for this seeming contradiction is that light-suppressing colored glass fills the windows. The purpose of these windows was not to illuminate the interior with bright sunlight but to transform natural light into Suger's mystical lux nova (see "Stained-Glass Windows," page 350). Chartres retains almost the full complement of its original stained glass, which, although it has a dimming effect, transforms the character of the interior in dramatic fashion. Gothic churches that have lost their original stained-glass windows give a false impression of what their designers intended.

One Chartres window that survived the fire of 1194 and was subsequently reused in the High Gothic cathedral is the tall single lancet the French call Notre Dame de la Belle Verrière (Our Lady of the Beautiful Window, FIG. 13-16). The central section, depicting against a red background the Virgin Mary enthroned with the Christ Child in her lap, dates to about 1170. Glaziers added the framing angels seen against a blue ground when they reinstalled the window in the 13thcentury choir. The frontal composition is traditional, but Mary is now the beautiful, young, rather worldly Queen of Heaven, haloed, crowned, and accompanied by the dove of the Holy Spirit. Comparing this Virgin and Child with the Theotokos and Child (FIG. 9-19) of Hagia Sophia highlights not only the greater severity and aloofness of the Byzantine image but also the sharp difference between the lightreflecting mosaic medium and Gothic light-filtering stained glass. Gothic and Byzantine builders used light to transform the material world into the spiritual, but in opposite ways. In Gothic architecture, light entered from outside the building through a screen of stone-set colored glass. In Byzantine architecture, light reflected off myriad glass tesserae set into the thick masonry wall.

Chartres's 13th-century Gothic windows are even more spectacular than the *Belle Verrière* because, thanks to the introduction of flying buttresses, the builders could plan from the outset to fill entire walls with stained glass. The immense rose window (approximately 43 feet in diameter) and tall lancets of Chartres Cathedral's north transept (FIG. 13-1) were the gift of the French queen Blanche of Castile, around 1220. The royal motifs of yellow castles on a red ground and yellow *fleurs-de-lis*—three-petaled iris flowers—on a blue ground fill the eight narrow windows in the rose's lower spandrels. The iconography is also fitting for a queen. The enthroned Virgin and Child appear in the

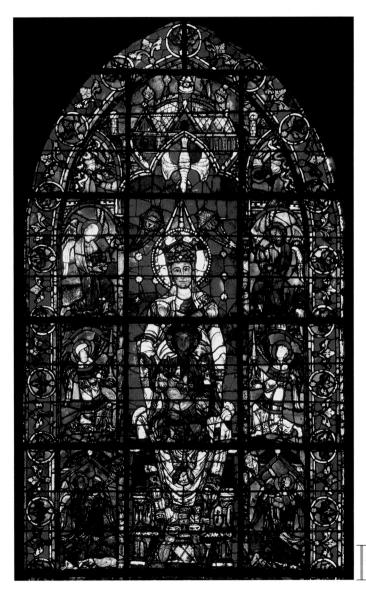

13-16 Virgin and Child and angels (*Notre Dame de la Belle Verrière*), detail of a window in the choir of Chartres Cathedral, Chartres, France, ca. 1170, with 13th-century side panels. Stained glass, full height 16'.

This stained-glass window miraculously survived the devastating Chartres fire of 1194. It has an armature of iron bands that forms a grid over the whole design, an Early Gothic characteristic.

roundel at the center of the rose, which resembles a gem-studded book cover or cloisonné brooch. Around her are four doves of the Holy Spirit and eight angels. Twelve square panels contain images of Old Testament kings, including David and Solomon (at the 12 and 1 o'clock positions respectively). These are the royal ancestors of Christ. Isaiah (11:1–3) had prophesied that the Messiah would come from the family of the patriarch Jesse, father of David. The genealogical "tree of Jesse" is a familiar motif in medieval art. Below, in the lancets, are Saint Anne and the baby Virgin. Flanking them are four of Christ's Old Testament ancestors, Melchizedek, David, Solomon, and Aaron, echoing the royal genealogy of the rose but at a larger scale. Many Gothic stained-glass windows also present narrative scenes, and their iconographical programs are sometimes as complex as those of the sculptured church portals.

The rose and lancets change in hue and intensity with the hours, turning solid architecture into a floating vision of the celestial heavens. Almost the entire mass of wall opens up into stained glass, held in place by an intricate stone armature of bar tracery. Here, the

Stained-Glass Windows

though not a Gothic invention, *stained-glass* windows are almost synonymous with Gothic architecture. No other age produced windows of such rich color and beauty. The technology of manufacturing colored glass is very old, however. Egyptian artists excelled at fashioning colorful glass objects for both home and tomb, and archaeologists have also uncovered thousands of colored-glass artifacts at classical sites. But Gothic artists used stained glass in new ways. In earlier eras, the clergy introduced color and religious iconography into church interiors with mural paintings and mosaics, often with magnificent effect. Stained-glass windows differ from those techniques in one all-important respect. They do not conceal walls. They replace them. And they transmit rather than reflect light, filtering and transforming the natural sunlight.

Abbot Suger called this colored light lux nova (see "Abbot Suger," page 341). Suger's contemporary, Hugh of Saint-Victor (1096–1142), a prominent Parisian theologian, also commented on the special mystical quality of stained-glass windows: "Stained-glass windows are the Holy Scriptures . . . and since their brilliance lets the splendor of the True Light pass into the church, they enlighten those inside." * William Durandus, bishop of Mende, expressed a similar sentiment at the end of the 13th century: "The glass windows in a church are Holy Scriptures, which expel the wind and the rain, that is, all things hurtful, but transmit the light of the True Sun, that is, God, into the hearts of the faithful." † As early as the fourth century, architects used colored glass for church windows, and the stained-glass windows of Saint-Denis (FIG. 13-3) already show a high degree of skill. According to Suger, they were "painted by the exquisite hands of many masters from different regions,"‡ proving that the art was well established at that time. In fact, several fine Romanesque examples survive.

The manufacture of stained-glass windows was costly and laborintensive. A Benedictine monk named Theophilus recorded the full process around 1100. First, the master designer drew the exact composition of the planned window on a wooden panel, indicating all the linear details and noting the colors for each section. Glassblowers provided flat sheets of glass of different colors to glaziers (glassworkers), who cut the windowpanes to the required size and shape with special iron shears. Glaziers produced an even greater range of colors by flashing (fusing one layer of colored glass to another). Next, painters added details such as faces, hands, hair, and clothing in enamel by tracing the master design on the wood panel through the colored glass. Then they heated the painted glass to fuse the enamel to the surface. At that point, the glaziers "leaded" the various fragments of glass—that is, they joined them by strips of lead called cames. The leading not only held the pieces together but also separated the colors to heighten the effect of the design as a whole. The

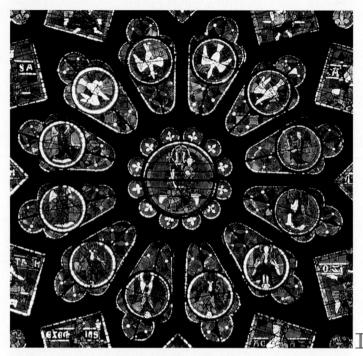

Detail of stained-glass rose window, north transept Chartres Cathedral, Chartres, France, ca. 1220 (see FIG. 13-1).

distinctive character of Gothic stained-glass windows is largely the result of this combination of fine linear details with broad flat expanses of color framed by black lead. Finally, the glassworkers strengthened the completed window with an armature of iron bands, which in the 12th century formed a grid over the whole design (FIG. 13-16). In the 13th century, the bands followed the outlines of the medallions and of the surrounding areas (FIGS. 13-1 and 13-25).

The form of the stone frames for the stained-glass windows also evolved. On Chartres Cathedral's 12th-century west facade (FIG. 13-5), plate tracery holds the rose window in place. The glass fills only the "punched holes" in the heavy ornamental stonework. Bar tracery, a later development, is much more slender. The 13th-century stained-glass windows (FIG. 13-1) of the Chartres transepts fill almost the entire opening, and the stonework is unobtrusive, more like delicate leading than masonry wall.

- * Hugh of Saint-Victor, Speculum de mysteriis ecclesiae, Sermon 2.
- [†] William Durandus, *Rationale divinorum officiorum*, 1.1.24. Translated by John Mason Neale and Benjamin Webb, *The Symbolism of Churches and Church Ornaments* (Leeds: T. W. Green, 1843), 28.
- [‡] Translated by Erwin Panofsky, *Abbot Suger*, 73.

Gothic passion for luminous colored light led to a most daring and successful attempt to subtract all superfluous material bulk just short of destabilizing the structure. That this vast, complex fabric of stone-set glass has maintained its structural integrity for almost 800 years attests to the Gothic builders' engineering genius.

CHARTRES SOUTH TRANSEPT The sculptures adorning the portals of the two new Chartres transepts erected after the 1194

fire are also prime examples of the new High Gothic spirit. As at Laon (FIG. 13-8) and Paris (FIG. 13-11), the Chartres transept portals project more forcefully from the church than do the Early Gothic portals of its west facade (compare FIGS. 13-5 and 13-13). Similarly, the statues of saints on the portal jambs are more independent of the architectural framework. Three figures (FIG. 13-17) from the Porch of the Confessors in the south transept reveal the great changes Gothic sculpture underwent since the Royal Portal statues (FIG. 13-7) of the

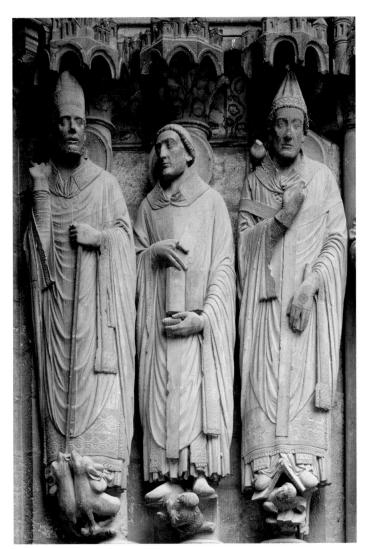

13-17 Saints Martin, Jerome, and Gregory, jamb statues, Porch of the Confessors (right doorway), south transept, Chartres Cathedral, Chartres, France, ca. 1220–1230.

In contrast to the Royal Portal statues (FIG. 13-7), the south-transept statues have individual personalities and turn slightly to left or right, breaking the rigid vertical lines of their 12th-century predecessors.

mid-12th century. These changes recall in many ways the revolutionary developments in ancient Greek sculpture during the transition from the Archaic to the Classical style (see Chapter 5). The south-transept statues date from 1220 to 1230 and represent Saints Martin, Jerome, and Gregory. Although the figures are still attached to columns, the architectural setting does not determine their poses as much as it did on the west portals. The saints communicate quietly with one another, like waiting dignitaries. They turn slightly toward and away from each other, breaking the rigid vertical lines that fix the Royal Portal figures immovably. The drapery folds are not stiff and shallow vertical accents, as on the west facade. The fabric falls and laps over the bodies in soft, if still regular, folds.

The treatment of the faces is even more remarkable. The sculptor gave the figures individualized features and distinctive personalities and clothed them in the period's liturgical costumes. Saint Martin is a tall, intense priest with gaunt features (compare the spiritually moved but not particularized face of the Moissac prophet in Fig. 12-11). Saint Jerome appears as a kindly, practical administrator-scholar, holding his copy of the Scriptures. At the right, the introspective Saint Gregory seems lost in thought as he listens to the dove

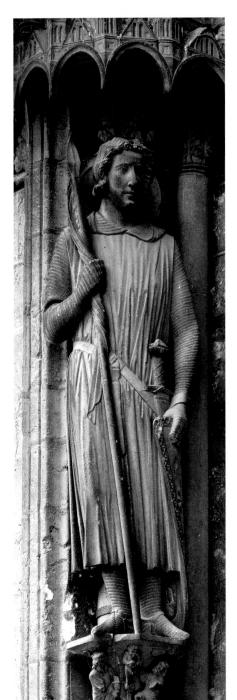

13-18 Saint Theodore, jamb statue, Porch of the Martyrs (left doorway), south transept, Chartres Cathedral, Chartres, France, ca. 1230.

Although the statue of Theodore is still attached to a column, the setting no longer determines its pose. The High Gothic sculptor portrayed the saint swinging out one hip, as in Greek statuary (FIG. 5-40).

of the Holy Ghost on his shoulder. Thus, the sculptor did not contrast the three men simply in terms of their poses, gestures, and attributes but as persons. Personality, revealed in human faces, makes the profound difference.

The south-transept figure of Saint Theodore (FIG. 13-18), the martyred warrior on the Porch of the Martyrs, presents an even sharper contrast with Early Gothic jamb statues. The sculptor portrayed Theodore as the ideal Christian knight and clothed him in the cloak and chain-mail armor of Gothic Crusaders. The handsome, long-haired youth holds his spear firmly in his right hand and rests his left hand on his shield. He turns his head to the left and swings out his hip to the right. The body's resulting torsion and pronounced sway call to mind Greek statuary, especially the contrapposto stance of Polykleitos's *Spear Bearer* (FIG. 5-40). The changes that occurred in 13th-century Gothic sculpture could appropriately be labeled a second "Classical revolution."

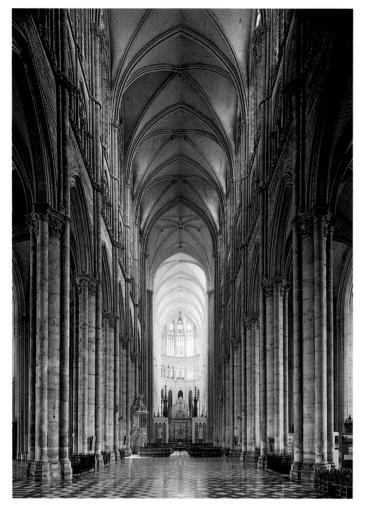

13-19 ROBERT DE LUZARCHES, THOMAS DE CORMONT, and RENAUD DE CORMONT, interior of Amiens Cathedral (looking east), Amiens, France, begun 1220.

The concept of a self-sustaining skeletal architecture reached full maturity at Amiens Cathedral. The four-part High Gothic vaults on pointed arches rise an astounding 144 feet above the nave floor.

AMIENS CATHEDRAL Chartres Cathedral was one of the most influential buildings in the history of architecture. Its builders set a pattern that many other Gothic architects followed, even if they refined the details. Construction of Amiens Cathedral (FIGS. 13-19 to 13-21) began in 1220, while work was still in progress at Chartres. The architects were Robert de Luzarches, Thomas de Cormont, and Renaud de Cormont. The builders finished the nave by 1236 and the radiating chapels by 1247, but work on the choir continued until almost 1270. The Amiens elevation (FIGS. 13-10d and 13-19) derived from the High Gothic formula of Chartres (FIGS. 13-10c and 13-15). But Amiens Cathedral's proportions are even more elegant, and the number and complexity of the lancet windows in both its clerestory and triforium are even greater. The whole design reflects the builders' confident use of the complete High Gothic structural vocabulary: the rectangular-bay system, the four-part rib vault, and a buttressing system that permitted almost complete dissolution of heavy masses and thick weight-bearing walls. At Amiens, the concept of a self-sustaining skeletal architecture reached full maturity. The remaining stretches of wall seem to serve no purpose other than to provide a weather screen for the interior (FIG. 13-20).

Amiens Cathedral is one of the most impressive examples of the French Gothic obsession with constructing ever taller churches. Using

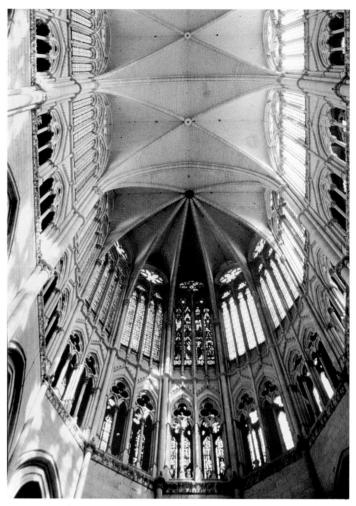

13-20 ROBERT DE LUZARCHES, THOMAS DE CORMONT, and RENAUD DE CORMONT, vaults, clerestory, and triforium of the choir of Amiens Cathedral, Amiens, France, begun 1220.

The Amiens choir vaults resemble a canopy suspended from bundled masts. The sunlight entering from the clerestory creates the effect of a buoyant lightness not normally associated with stone architecture.

their new skeletal frames of stone, French builders attempted goals almost beyond limit, pushing to new heights with increasingly slender supports. The nave vaults at Laon rise to a height of about 80 feet, at Paris 107 feet, and at Chartres 118 feet. Those at Amiens are 144 feet above the floor (FIG. 13-10). The tense, strong lines of the Amiens vault ribs converge at the colonnettes and speed down the shell-like walls to the compound piers. Almost every part of the superstructure has its corresponding element below. The overall effect is of effortless strength, of a buoyant lightness not normally associated with stone architecture. Viewed directly from below, the choir vaults (FIG. 13-20) seem like a canopy, tentlike and suspended from bundled masts. The light flooding in from the clerestory makes the vaults seem even more insubstantial. The effect recalls another great building, one utterly different from Amiens but where light also plays a defining role: Hagia Sophia (FIG. 9-4) in Constantinople. Once again, the designers reduced the building's physical mass by structural ingenuity and daring, and light further dematerializes what remains. If Hagia Sophia is the perfect expression of Byzantine spirituality in architecture, Amiens, with its soaring vaults and giant windows admitting divine colored light, is its Gothic counterpart.

Work began on the Amiens west facade (FIG. 13-21) at the same time as the nave (1220). Its lower parts reflect the influence of Laon

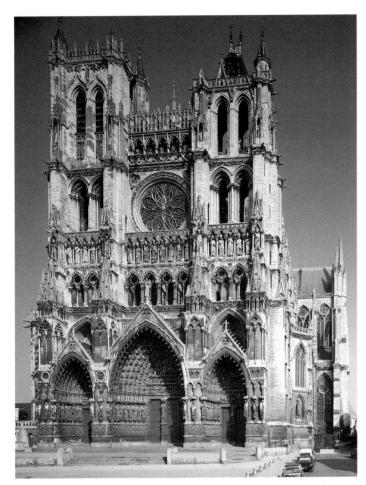

13-21 ROBERT DE LUZARCHES, THOMAS DE CORMONT, and RENAUD DE CORMONT, west facade of Amiens Cathedral, Amiens, France, begun 1220.

The deep piercing of the Amiens facade left few surfaces for decoration, but sculptors covered the remaining ones with colonnettes, pinnacles, and rosettes that nearly dissolve the structure's solid core.

Cathedral (FIG. 13-8) in the spacing of the funnel-like and gable-covered portals. But the Amiens builders punctured the upper parts of the facade to an even greater degree than did the Laon designer. The deep piercing of walls and towers at Amiens left few surfaces for decoration, but sculptors covered the ones that remained with a network of colonnettes, arches, pinnacles, rosettes, and other decorative stonework that visually screens and nearly dissolves the structure's solid core. Sculpture also extends to the areas above the portals, especially the band of statues (the so-called kings' gallery) running the full width of the facade directly below the rose window (with 15th-century tracery). The uneven towers were later additions. The shorter one dates from the 14th century, the taller one from the 15th century.

BEAU DIEU The most prominent statue on the Amiens facade is the Beau Dieu (Beautiful God; FIG. 13-22) on the central doorway's trumeau. The sculptor fully modeled Christ's figure, enveloping his body with massive drapery folds cascading from his waist. The statue stands freely and is as independent of its architectural setting as any Gothic facade statue ever was. Nonetheless, the sculptor still placed an architectural canopy over Christ's head. It is in the latest Gothic style, mimicking the east end of a 13th-century cathedral having a series of radiating chapels with elegant lancet windows. Above the canopy is the great central tympanum with the representation of Christ as Last Judge. The Beau Dieu, however, is a handsome, kindly

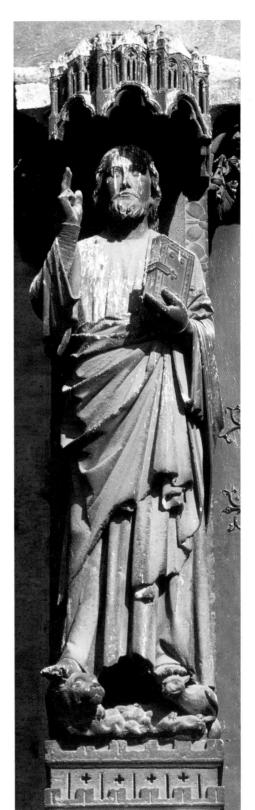

13-22 Christ (Beau Dieu), trumeau statue of central doorway, west facade, Amiens Cathedral, Amiens, France, ca. 1220–1235.

The Beau Dieu is a kindly figure who blesses all who enter Amiens Cathedral. He tramples a lion and dragon symbolizing the evil forces in the world. The Gothic Christ gives humankind hope in salvation.

figure who does not strike terror into sinners. Instead he blesses those who enter the church and tramples a lion and a dragon symbolizing the evil forces in the world. This image of Christ gives humankind hope in salvation. The *Beau Dieu* epitomizes the bearded, benevolent Gothic image of Christ that replaced the youthful Early Christian Christ (FIG. 8-8) and the stern Byzantine Pantokrator (FIGS. 9-1 and 9-25) as the preferred representation of the Savior in later European art. The figure's quiet grace and grandeur also contrast sharply with the emotional intensity of the twisting Romanesque prophet (FIG. 12-11) carved in relief on the Moissac trumeau.

13-23 West facade of Reims Cathedral, Reims, France, ca. 1225–1290.

The facade of Reims Cathedral displays the High Gothic architect's desire to reduce sheer mass and replace it with intricately framed voids. Stained-glass windows, not stone reliefs, fill the tympana.

REIMS CATHEDRAL Construction of Reims Cathedral (FIG. 13-23), where the coronations of the kings of France took place, began only a few years after work commenced at Amiens. The Reims builders carried the High Gothic style of the Amiens west facade still further, both architecturally and sculpturally. The two facades, although similar, display some significant differences. The kings' gallery of statues at Reims is above the great rose window, and the figures stand in taller and more ornate frames. In fact, the designer "stretched" every detail of the facade. The openings in the towers and those to the left and right of the rose window are taller, narrower, and more intricately decorated, and they more closely resemble the elegant lancets of the clerestory within. A pointed arch also frames the rose window itself, and the pinnacles over the portals are taller and more elaborate than those at Amiens. Most striking, however, is the treatment of the tympana over the doorways, where stained-glass windows replaced the stone relief sculpture of earlier facades. The contrast with Romanesque heavy masonry construction (FIG. 12-30) is extreme. But no less noteworthy is the rapid transformation of the Gothic facade since the 12th-century designs of Saint-Denis and Chartres (FIG. 13-5) and even Laon (FIG. 13-8).

Reims Cathedral is also a prime example of the High Gothic style in sculpture. The statues and reliefs of the west facade celebrate the Virgin Mary. Above the central gable, Mary is crowned as Queen of Heaven. On the trumeau, she appears in her role as the New Eve above reliefs depicting the Original Sin. The jamb statues relate episodes from the Infancy cycle (see "The Life of Jesus in Art," Chapter 8, pages 216–217), including the *Annunciation* and *Visitation* (FIG. 13-24). All four illustrated statues appear to be completely detached from their architectural background. The sculptors shrank the supporting columns into insignificance so that they in no way restrict the free and easy movements of the full-bodied figures. These 13th-century statue-columns contrast strikingly with those of the Early Gothic Royal Portal (FIG. 13-7), where the background columns occupy a volume equal to that of the figures.

The Reims statues also vividly illustrate that the sculptural ornamentation of Gothic cathedrals took decades to complete and required many sculptors often working in diverse styles. Art historians

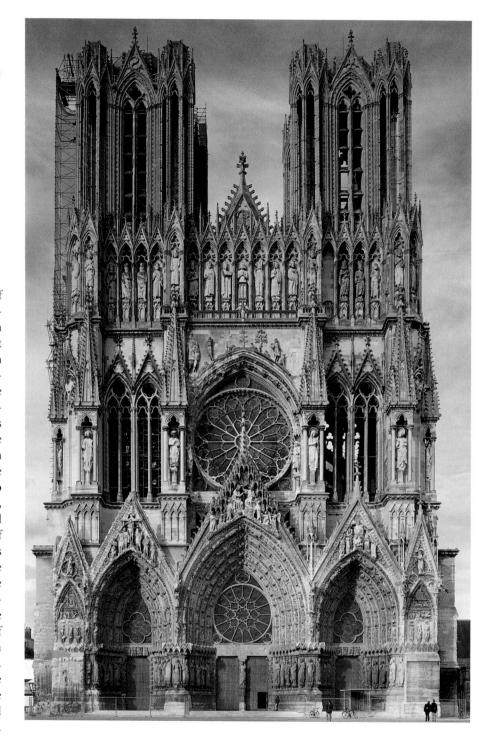

believe that three different sculptors carved the four statues in Fig. 13-24 at different times during the quarter century from 1230 to 1255. The *Visitation* group (Fig. 13-24, *right*) is the work of an artist who probably studied classical statuary. Reims was an ancient Roman city, and the heads of both Mary and Saint Elizabeth resemble Roman portraits. The Gothic statues are astonishing approximations of the classical naturalistic style and incorporate contrapposto postures that go far beyond the stance of the Chartres Saint Theodore (Fig. 13-18). The swaying of the hips is much more pronounced. The right legs bend, and the knees press through the rippling folds of the garments. The sculptor also set the figures' arms in motion. Mary and Elizabeth turn their faces toward each other, and they converse through gestures. In the Reims *Visitation* group, the formerly isolated Gothic jamb statues became actors in a biblical narrative.

The Annunciation group (FIG. 13-24, *left*) also features statues liberated from their architectural setting, but they are products of

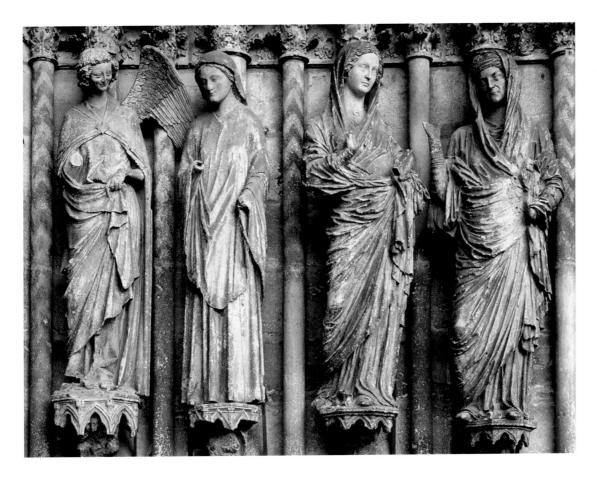

13-24 Annunciation and Visitation, jamb statues of central doorway, west facade, Reims Cathedral, Reims, France, ca. 1230–1255.

Different sculptors working in diverse styles carved the Reims jamb statues, but all detached their figures from the columns and set the bodies and arms in motion. The figures converse through gestures.

different workshops and one—the angel Gabriel—was first set in the left portal and then moved to its present location, which explains the stylistic dichotomy of the pair. Mary is a slender figure with severe drapery. The artist preferred broad expanses of fabric to the multiplicity of folds of the *Visitation* Mary. Gabriel, the latest of the four statues, has a much more elongated body and is far more animated. He exhibits the elegant style of the Parisian court at the middle of the 13th century. He pivots gracefully, almost as if dancing, and smiles broadly. Like a courtier, he exudes charm. Mary, in contrast, is serious and introspective and does not respond overtly to the news the angel has brought.

SAINTE-CHAPELLE, PARIS The stained-glass windows inserted into the portal tympana of Reims Cathedral exemplify the wall-dissolving High Gothic architectural style. The architect of Sainte-Chapelle (FIG. 13-25) in Paris extended this style to an entire building. Louis IX built Sainte-Chapelle, joined to the royal palace, as a repository for the crown of thorns and other relics of Christ's Passion he had purchased in 1239 from his cousin Baldwin II (r. 1228–1261), the last Latin emperor of Constantinople. The chapel is a master-piece of the so-called *Rayonnant* (radiant) style of the High Gothic age, which dominated the second half of the century. It was the preferred style of the royal Parisian court of Saint Louis (see "Louis IX, the Saintly King," page 360). Sainte-Chapelle's architect carried the dissolution of walls and the reduction of the bulk of the supports to the point that some 6,450 square feet of stained glass make up more

13-25 Interior of the upper chapel (looking northeast), Sainte-Chapelle, Paris, France, 1243–1248.

At Louis IX's Sainte-Chapelle, the architect succeeded in dissolving the walls to such an extent that 6,450 square feet of stained glass account for more than three-quarters of the Rayonnant Gothic structure.

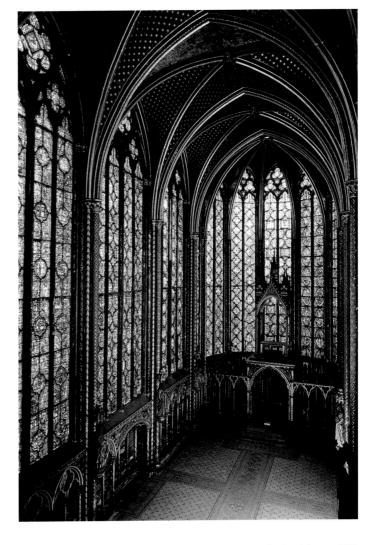

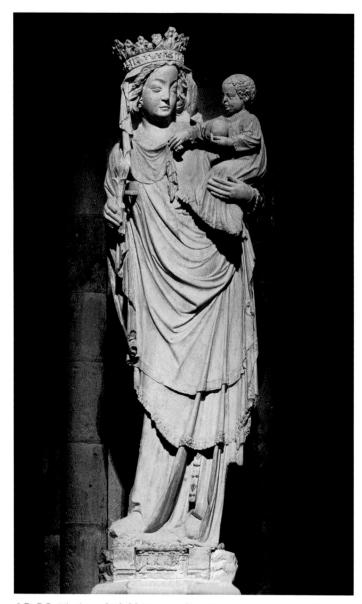

13-26 Virgin and Child (Virgin of Paris), Notre-Dame, Paris, France, early 14th century.

Late Gothic sculpture is elegant and mannered. Here, the solemnity of Early and High Gothic religious figures gave way to a tender and anecdotal portrayal of Mary and Jesus as royal mother and son.

than three-quarters of the structure. The supporting elements are hardly more than large *mullions*, or vertical stone bars. The emphasis is on the extreme slenderness of the architectural forms and on linearity in general. Although the chapel required restoration in the 19th century (after suffering damage during the French Revolution), it retains most of its original 13th-century stained glass. Sainte-Chapelle's enormous windows filter the light and fill the interior with an unearthly rose-violet atmosphere. Approximately 49 feet high and 15 feet wide, they were the largest designed up to their time.

VIRGIN OF PARIS The "court style" of Sainte-Chapelle has its pictorial parallel in the mannered elegance of the roughly contemporaneous Gabriel of the Reims Annunciation group (FIG. 13-24, left), but the style long outlived Saint Louis and his royal artists and architects. The best example of the court style in Late Gothic sculpture is the early-14th-century statue nicknamed the Virgin of Paris (FIG. 13-26) because of its location in Paris at Notre-Dame. The sculptor portrayed Mary in an exaggerated S-curve posture typical of Late Gothic sculpture. She is a worldly queen, decked out in royal garments and wearing

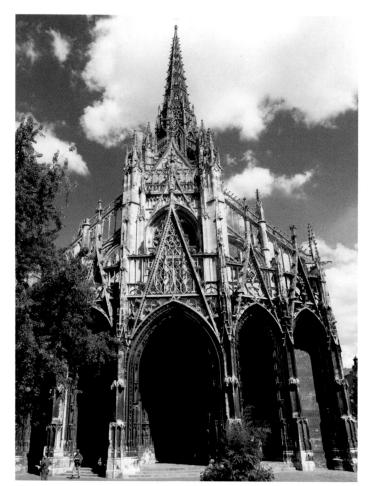

13-27 West facade of Saint-Maclou, Rouen, France, ca. 1500–1514.

Saint-Maclou is the masterpiece of Late Gothic Flamboyant architecture. Its ornate tracery features curves and countercurves that form brittle decorative webs masking the building's structure.

a heavy gem-encrusted crown. The Christ Child is equally richly attired and is very much the infant prince in the arms of his young mother. The tender, anecdotal characterization of mother and son represents a further humanization of the portrayal of religious figures in Gothic sculpture. Late Gothic statuary is very different in tone from the solemnity of most High Gothic figures, just as Late Classical Greek statues of the Olympian gods (compare FIG. 13-26 with FIG. 5-63) differ from High Classical depictions.

SAINT-MACLOU, ROUEN Late French Gothic architecture also represents a departure from the norms of High Gothic. The change from Rayonnant architecture to the so-called Flamboyant style (named for the flamelike appearance of its pointed bar tracery) occurred in the 14th century. The style reached its florid maturity nearly a century later in Normandy in the church of Saint-Maclou (FIG. 13-27) in Rouen, its capital. The church is tiny (only about 75 feet high and 180 feet long) compared with the cathedrals of the High Gothic age. Its facade breaks sharply from the High Gothic style (FIGS. 13-21 and 13-23) of the 13th century. The five portals (two of them false doors) bend outward in an arc. Ornate gables crown the doorways, pierced through and filled with wiry, "flickering" Flamboyant tracery made up of curves and countercurves that form brittle decorative webs and mask the building's structure. The transparency of the pinnacles over the doorways permits visitors to see the central rose window and the flying buttresses, even though they are set well back from the facade. The overlapping of all features, pierced as they are, confuses the structural lines and produces

13-28 Aerial view of the fortified town of Carcassonne, France. Bastions and towers, 12th–13th centuries, restored by Eugène Viollet-le-Duc in the 19th century.

Carcassonne provides a rare glimpse of what was once a familiar sight in Gothic France: a tight complex of castle, cathedral, and town with a crenellated and towered wall circuit for defense.

a bewildering complexity of views that is the hallmark of the Flamboyant style.

CARCASSONNE The Gothic period has been called "the age of great cathedrals," but people, of course, also needed and architects also built secular structures such as town halls, palaces, and private residences. In an age of frequent warfare, the feudal barons often constructed fortified castles in places enemies could not easily reach. Sometimes thick defensive wall circuits, or *ramparts*, enclosed entire towns. In time, however, purely defensive wars became obsolete due to the invention of artillery and improvements in siege craft. The fortress era gradually passed, and throughout Europe once-mighty ramparts fell into ruin.

One of the most famous Gothic fortified towns is Carcassonne (FIG. 13-28) in Languedoc in southern France. It was the regional center of resistance to the northern forces of royal France. Built on a hill bounded by the Aude River, Carcassonne had been fortified since Roman times. It had Visigothic walls dating from the 6th century, but in the 12th century masons reinforced them. Battlements (low parapets) with crenellations (composed of alternating solid merlons and open crenels) protected guards patrolling the stone ring surrounding the town. Carcassonne might be forced to surrender but could not easily be taken by storm. Within the town's double walls was a fortified castle (FIG. 13-28, left) with a massive attached keep, a secure tower that could serve as a place of last refuge. Balancing that center of secular power was the bishop's seat, the Cathedral of Saint-Nazaire (FIG. 13-28, right). The small church, built between 1269 and 1329, may have been the work of an architect brought in from northern France. In any case, Saint-Nazaire's builders were certainly familiar with the latest developments in architecture in the Île-de-France. Today, Carcassonne—as restored in the 19th century by Eugène VIOLLET-LE-DUC (1814–1879)—provides a rare glimpse of what was once a familiar sight in Gothic France: a tightly contained complex of castle, cathedral, and town within towered walls.

13-29 Hall of the cloth guild, Bruges, Belgium, begun 1230.

The Bruges cloth guild's meeting hall is an early example of a new type of secular architecture in the late Middle Ages. Its lofty tower competed for attention with the towers of the city's cathedral.

GUILD HALL, BRUGES One of the many signs of the growing secularization of urban life in the late Middle Ages was the erection of monumental meeting halls and warehouses for the increasing number of craft guilds being formed throughout Europe. An early example is the imposing market and guild hall (FIG. 13-29) of the

13-30 House of Jacques Coeur, Bourges, France, 1443–1451.

The house of the immensely wealthy Bourges financier Jacques Coeur is both a splendid example of Late Gothic architecture with elaborate tracery and a symbol of the period's new secular spirit.

clothmakers of Bruges, begun in 1230. Situated in the city's major square, it testifies to the important role of artisans and merchants in Gothic Europe. The design combines features of military (the corner "watchtowers" with their crenellations) and church (lancet windows with crowning oculi) architecture. The uppermost, octagonal portion of the tower with its flying buttresses and pinnacles dates to the 15th century, but even the origi-

nal two-story tower is taller than the rest of the hall. Lofty towers were a common feature of late medieval guild and town halls, designed to compete for attention and prestige with the towers of city cathedrals.

HOUSE OF JACQUES COEUR The fortunes of the new class of wealthy merchants who rose to prominence throughout Europe in the late Middle Ages may not have equaled those of the hereditary royalty, but their power and influence were still enormous. The career of the French financier Jacques Coeur (1395-1456) illustrates how enterprising private citizens could win-and quickly losewealth and power. Coeur had banking houses in every city of France and many cities abroad. He employed more than 300 agents and competed with the great trading republics of Italy. His merchant ships filled the Mediterranean, and with the papacy's permission, he imported spices and textiles from the Muslim Near East. He was the treasurer of King Charles VII (r. 1422-1461) of France and a friend of Pope Nicholas V (r. 1447–1455). In 1451, however, his enemies framed him on an absurd charge of having poisoned Agnes Sorel, the king's mistress. The judges who sentenced Coeur to prison and confiscated his vast wealth and property were among those who

owed him money. Coeur escaped in 1454 and made his way to Rome, where the pope warmly received him. He died of fever while leading a fleet of papal war galleys in the eastern Mediterranean.

Jacques Coeur's great town house still stands in his native city of Bourges. Built between 1443 and 1451 (with special permission to encroach upon the town ramparts), it is the best-preserved example of Late Gothic domestic architecture. The house's plan is irregular, with the units arranged around an open courtyard (FIG. 13-30). The service areas (maintenance shops, storage rooms, servants' quarters, and baths—a rare luxury in Gothic Europe) occupy the ground level. The upper stories house the great hall and auxiliary rooms used for offices and family living rooms. Over the main entrance is a private chapel. One of the towers served as a treasury. The exterior and interior facades have very steep pyramidal roofs of different heights. The decorative details include Flamboyant tracery and large pointed-arch stained-glass windows. An elegant canopied niche facing the street once housed a royal equestrian statue. A comparable statue of Coeur on horseback dominated the facade opening onto the interior courtyard. Jacques Coeur's house is both a splendid example of Late Gothic architecture and a monumental symbol of the period's new secular spirit.

Book Illumination and Luxury Arts

Paris's claim as the intellectual center of Gothic Europe (see "Scholasticism," page 344) did not rest solely on the stature of its university faculty and on the reputation of its architects, masons, sculptors, and stained-glass makers. The city was also a renowned center for the production of fine books. The famous Florentine poet Dante Alighieri (1265–1321), in fact, referred to Paris in his *Divine Comedy* of about 1310–1320 as the city famed for the art of illumination.² During the Gothic period, book manufacture shifted from monastic scriptoria shut off from the world to urban workshops of professional artists—and Paris had the most and best workshops. The owners of these new, for-profit secular businesses sold their products to the royal family, scholars, and prosperous merchants. The Parisian shops were the forerunners of modern publishing houses.

VILLARD DE HONNECOURT One of the most intriguing Parisian manuscripts preserved today was not, however, a book for sale but a personal sketchbook. Compiled by VILLARD DE HONNECOURT, an early-13th-century master mason, its pages contain details of buildings, plans of choirs with radiating chapels, church towers, lifting devices, a sawmill, stained-glass windows, and other subjects of obvious interest to architects and masons. But also sprinkled liberally

throughout the pages are drawings depicting religious and worldly figures, as well as animals, some realistic and others purely fantastic. On the page reproduced here (FIG. 13-31), Villard demonstrated the value of the *ars de geometria* ("art of geometry") to artists. He showed that both natural forms and buildings are based on simple geometric shapes such as the square, circle, and triangle. Even where he claimed to have drawn his animals from nature, he composed his figures around a skeleton not of bones but of abstract geometric forms. Geometry was, in Villard's words, "strong help in drawing figures."

GOD AS ARCHITECT Geometry also played a symbolic role in Gothic art and architecture. Gothic artists, architects, and theologians alike thought the triangle, for example, embodied the idea of the Trinity of God the Father, Christ, and the Holy Spirit. The circle, which has neither a beginning nor an end, symbolized the eternity of the one God. When Gothic architects based their designs on the art of geometry, building their forms out of abstract shapes laden with symbolic meaning, they believed they were working according to the divinely established laws of nature.

A vivid illustration of this concept appears as the frontispiece (FIG. 13-32) of a moralized Bible produced in Paris during the

13-31 VILLARD DE HONNECOURT, figures based on geometric shapes, folio 18 verso of a sketchbook, from Paris, France, ca. 1220–1235. Ink on vellum, $9\frac{1}{4}'' \times 6''$. Bibliothèque Nationale, Paris.

On this page from his private sketchbook, the master mason Villard de Honnecourt sought to demonstrate that simple geometric shapes are the basis of both natural forms and buildings.

13-32 God as architect of the world, folio 1 verso of a moralized Bible, from Paris, France, ca. 1220–1230. Ink, tempera, and gold leaf on vellum, $1' 1\frac{1}{2}'' \times 8\frac{1}{4}''$. Österreichische Nationalbibliothek, Vienna.

Paris was the intellectual capital of Europe and the center of production of fine books. This artist portrayed God as an industrious architect creating the universe using the same tools as Gothic builders.

Louis IX, the Saintly King

The royal patron behind the Parisian Rayonnant "court style" of Gothic art and architecture was King Louis IX (1214–1270; r. 1226–1270), grandson of Philip Augustus. Louis inherited the throne when he was only 12 years old, so until he reached adulthood six years later, his mother, Blanche of Castile (FIG. 13-33), granddaughter of Eleanor of Aquitaine (see "Romanesque Countesses, Queens, and Nuns," Chapter 12, page 326), served as France's regent.

The French regarded Louis as the ideal king, and 27 years after Louis's death, in 1297, Pope Boniface VIII (r. 1294–1303) declared him a saint. In his own time, Louis was revered for his piety, justice, truthfulness, and charity. His almsgiving and his donations to religious foundations were extravagant. He especially favored the *mendicant* (begging) orders, the Dominicans and Franciscans. He admired their poverty, piety, and self-sacrificing disregard of material things.

Louis launched two unsuccessful Crusades, the Seventh (1248–1254, when, in her son's absence, Blanche was again French regent) and the Eighth (1270). He died in Tunisia during the latter. As a crusading knight who lost his life in the service of the Church, Louis personified the chivalric virtues of courage, loyalty, and self-sacrifice. Saint Louis united in his person the best qualities of the Christian knight, the benevolent monarch, and the holy man. He became the model of medieval Christian kingship.

Louis's political accomplishments were also noteworthy. He subdued the unruly French barons, and between 1243 and 1314 no one seriously challenged the crown. He negotiated a treaty with Henry III, king of France's traditional enemy, England. Such was his reputation for integrity and just dealing that he served as arbiter in at least a dozen international disputes. So successful was he as peacekeeper

13-33 Blanche of Castile, Louis IX, and two monks, dedication page (folio 8 recto) of a moralized Bible, from Paris, France, 1226–1234. Ink, tempera, and gold leaf on vellum, $1'3'' \times 10\frac{1}{2}''$. Pierpont Morgan Library, New York.

The costly gold-leaf dedication page of this royal book depicts Saint Louis, his mother Blanche of Castile, and two monks. The younger monk is at work on the paired illustrations of a moralized Bible.

1 in.

that despite civil wars through most of the 13th century, international peace prevailed. Under Saint Louis, medieval France was at its most prosperous, and its art and architecture were admired and imitated throughout Europe.

1220s. Moralized Bibles are heavily illustrated, each page pairing paintings of Old and New Testament episodes with explanations of their moral significance. (The page reproduced here does not conform to this formula because it is the introduction to all that follows.) Above the illustration, the scribe wrote (in French rather than Latin): "Here God creates heaven and earth, the sun and moon, and all the elements." God appears as the architect of the world, shaping the universe with the aid of a compass. Within the perfect circle already created are the spherical sun and moon and the unformed matter that will become the earth once God applies the same geometric principles to it. In contrast to the biblical account of Creation, in which God created the sun, moon, and stars after the earth had been formed, and made the world by sheer force of will and a simple "Let there be" command, on this page the Gothic artist portrayed God as an industrious architect, creating the universe with some of the same tools mortal builders used.

BLANCHE OF CASTILE Not surprisingly, most of the finest Gothic books known today belonged to the French monarchy. Saint Louis in particular was an avid collector of both secular and religious books. The vast library he and his royal predecessors and successors formed eventually became the core of France's national library, the Bibliothèque Nationale. One of the books the royal family commissioned is a moralized Bible now in the collection of New York's Pierpont Morgan Library. Louis's mother, Blanche of Castile, ordered the Bible during her regency (1226–1234) for her teenage son. The dedication page (FIG. 13-33) has a costly gold background and depicts Blanche and Louis enthroned beneath triple-lobed arches and miniature cityscapes. The latter are comparable to the architectural canopies above the heads of contemporaneous French portal statues (FIG. 13-22). Below, in similar architectural frames, are a monk and a scribe. The older clergyman dictates a sacred text to

13-34 Abraham and the three angels, folio 7 verso of the *Psalter of Saint Louis*, from Paris, France, 1253–1270. Ink, tempera, and gold leaf on vellum, $5'' \times 3\frac{1}{2}''$. Bibliothèque Nationale, Paris.

The architectural settings in the *Psalter of Saint Louis* reflect the screenlike lightness and transparency of royal buildings such as Sainte-Chapelle (FIG. 13-25). The colors emulate those of stained glass.

can add initials and signs of division. Still another can arrange the leaves and attach the binding. Another of you can prepare the covers, the leather, the buckles and clasps. All sorts of assistance can be offered the scribe to help him pursue his work without interruption. He needs many things which can be prepared by others: parchment cut, flattened and ruled for script, ready ink and pens. You will always find something with which to help the scribe.³

The preparation of the illuminated pages also involved several hands. Some artists, for example, specialized in painting borders or initials. Only the workshop head or one of the most advanced assistants would paint the main figural scenes. Given this division of labor and the assembly-line nature of Gothic book production, it is astonishing how uniform the style is on a single page, as well as from page to page, in most illuminated manuscripts.

PSALTER OF SAINT LOUIS The golden background of Blanche's Bible is unusual and has no parallel in Gothic windows. But the radiance of stained glass probably inspired the glowing color of other 13th-century Parisian illuminated manuscripts. In some cases, masters in the same urban workshop produced both glass and books. Many art historians believe that the Psalter of Saint Louis (FIG. 13-34) is one of several books produced in Paris for Louis IX by artists associated with those who made the stained glass for his Sainte-Chapelle. Certainly, the painted architectural setting in Louis's book of Psalms reflects the pierced screenlike lightness and transparency of royal Rayonnant buildings such as Sainte-Chapelle. The intense colors, especially the blues, emulate stained glass. The lines in the borders resem-

The page from the *Psalter of Saint Louis* shown here (FIG. 13-34) represents Abraham and the three angels, the Old Testament story believed to prefigure the Christian Trinity (see "Jewish Subjects in Christian Art," Chapter 8, page 213). The Gothic artist included two episodes on the same page, separated by the tree of Mamre mentioned in the Bible. At the left, Abraham greets the three angels. In

ble leading. And the gables, pierced by rose windows with bar tracery,

are standard Rayonnant architectural features.

his young apprentice. The scribe already has divided his page into two columns of four roundels each, a format often used for the paired illustrations of moralized Bibles. The inspirations for such designs were probably the roundels of Gothic stained-glass windows (compare the borders of the *Belle Verrière* window, FIG. 13-16, at Chartres and the windows of Louis's own, later Sainte-Chapelle, FIG. 13-25).

The dedication page of Blanche of Castile's moralized Bible presents a very abbreviated portrayal of Gothic book production, similar to the view of a monastic scriptorium discussed earlier (FIG. 11-11). The manufacturing process used in the workshops of 13th-century Paris did not differ significantly from that of 10th-century Tábara. It involved many steps and numerous specialized artists, scribes, and assistants of varying skill levels. The Benedictine abbot Johannes Trithemius (1462–1516) described the way books were still made in his day in his treatise *In Praise of Scribes*:

If you do not know how to write, you still can assist the scribes in various ways. One of you can correct what another has written. Another can add the rubrics [headings] to the corrected text. A third

the other scene, he entertains them while his wife Sarah peers at them from a tent. The figures' delicate features and the linear wavy strands of their hair have parallels in Blanche of Castile's moralized Bible, as well as in Parisian stained glass. The elegant proportions, facial expressions, theatrical gestures, and swaying poses are characteristic of the Parisian court style admired throughout Europe. Compare, for example, the angel in the left foreground with the Gabriel statue (FIG. 13-24, *left*) of the Reims *Annunciation* group.

BREVIARY OF PHILIPPE LE BEL As in the Romanesque period, some Gothic manuscript illuminators signed their work. The names of others appear in royal accounts of payments made and similar official documents. One artist who produced books for the French court was Master Honoré, whose Parisian workshop was on the street known today as rue Boutebrie. Honoré illuminated a breviary (see "Medieval Books," Chapter 11, page 289) for Philippe le Bel (Philip the Fair, r. 1285–1314) in 1296. The page illustrated here (FIG. 13-35) features two Old Testament scenes involving David. In the upper panel, Samuel anoints the youthful David. Below, while King Saul looks on, David prepares to aim his slingshot at his most famous opponent, the giant Goliath (who already touches the wound on his forehead). Immediately to the right, David slays Goliath with his sword.

Master Honoré's linear treatment of hair, his figures' delicate hands and gestures, and their elegant swaying postures are typical of Parisian painting of the time. But this painter was much more interested than most of his colleagues in giving his figures sculptural volume and showing the play of light on their bodies. Honoré was not concerned with locating his figures in space, however. The Goliath panel in the *Breviary of Philippe le Bel* has a textilelike decorative background, and the feet of Honoré's figures frequently overlap the border. Compared with his contemporaries, Master Honoré pioneered naturalism in figure painting. But he still approached the art of book illumination as a decorator of two-dimensional pages. He did not embrace the classical notion that a painting should be an illusionistic window into a three-dimensional world.

BELLEVILLE BREVIARY David and Saul also are the subjects of a miniature painting at the top left of an elaborately decorated text page (FIG. 13-36) in the Belleville Breviary, which JEAN PUCELLE of Paris painted around 1325. Pucelle far exceeded Honoré and other French artists by placing his fully modeled figures in three-dimensional architectural settings rendered in convincing perspective. For example, he painted Saul as a weighty figure seated on a throne seen in a three-quarter view, and he meticulously depicted the receding coffers of the barrel vault over the young David's head. Such "stage sets" already had become commonplace in Italian painting, and scholars think Pucelle visited Italy and studied Duccio's work (FIGS. 14-10 and 14-11) in Siena. Pucelle's (or an assistant's) renditions of plants, a bird, butterflies, a dragonfly, a fish, a snail, and a monkey also reveal a keen interest in and close observation of the natural world. Nonetheless, in the Belleville Breviary, the text still dominates the figures, and the artist (and his patron) delighted in ornamental flourishes, fancy initial letters, and abstract patterns. In that respect, comparisons with monumental panel paintings are inappropriate. Pucelle's breviary remains firmly in the tradition of book illumination.

The *Belleville Breviary* is of special interest because Pucelle's name and those of some of his assistants appear at the end of the book, in a memorandum recording the payment they received for their work. Inscriptions in other Gothic illuminated books regularly state the production costs—the prices paid for materials, especially gold, and for the execution of initials, figures, flowery script, and

13-35 Master Honoré, David anointed by Samuel and battle of David and Goliath, folio 7 verso of the *Breviary of Philippe le Bel*, from Paris, France, 1296. Ink and tempera on vellum, $7\frac{7}{8}$ " $\times 4\frac{7}{8}$ ". Bibliothèque Nationale, Paris.

Master Honoré was one of the Parisian secular artists who produced books for the French monarchy. Notably, he gave his figures sculptural volume and showed the play of light on their bodies.

other embellishments. By this time, illuminators were professional guild members, and their personal reputation, as with modern "brand names," guaranteed the quality of their work. Although the cost of materials was still the major factor determining a book's price, individual skill and reputation increasingly decided the value of the illuminator's services. The centuries-old monopoly of the Christian Church in book production had ended.

VIRGIN OF JEANNE D'EVREUX The royal family also patronized goldsmiths, silversmiths, and other artists specializing in the production of luxury works in metal and enamel for churches, palaces, and private homes. Especially popular were statuettes of sacred figures, which the wealthy purchased either for private devotion or as gifts to churches. The Virgin Mary was a favored subject, reflecting her new prominence in the iconography of Gothic portal sculpture.

13-36 Jean Pucelle, David before Saul, folio 24 verso of the *Belleville Breviary*, from Paris, France, ca. 1325. Ink and tempera on vellum, $9\frac{1}{2}'' \times 6\frac{3}{4}''$. Bibliothèque Nationale, Paris.

Jean Pucelle's fully modeled figures in architectural settings rendered in convincing perspective reveal his study of contemporary painting in Italy. He was also a close observer of plants and fauna.

Perhaps the finest of these costly statuettes is the large silver-gilt figurine known as the Virgin of Jeanne d'Evreux (FIG. 13-37). The queen, wife of Charles IV (r. 1322-1328), donated the image of the Virgin and Child to the royal abbey church of Saint-Denis in 1339. Mary stands on a rectangular base decorated with enamel scenes of Christ's Passion. (Some art historians think the enamels are Jean Pucelle's work.) But no hint of grief appears in the beautiful young Mary's face. The Christ Child, also without a care in the world, playfully reaches for his mother. The elegant proportions of the two figures, Mary's emphatic swaying posture, the heavy drapery folds, and the intimate human characterization of mother and son are also features of the roughly contemporary Virgin of Paris (FIG. 13-26). The sculptor of large stone statues and the royal silversmith working at small scale approached the representation of the Virgin and Child in a similar fashion. In the Virgin of Jeanne d'Evreux, as in the Virgin of Paris, Mary appears not only as the Mother of Christ but also as the Queen of Heaven. The Saint-Denis Mary also originally had a crown on her head, and the scepter she holds is in the form of the fleur-delis, the French monarchy's floral emblem. The statuette also served

13-37 *Virgin of Jeanne d'Evreux*, from the abbey church of Saint-Denis, France, 1339. Silver gilt and enamel, $2' 3\frac{1}{2}''$ high. Louvre, Paris.

Queen Jeanne d'Evreux donated this luxurious reliquary-statuette to the royal abbey church of Saint-Denis. The intimate human characterization of the holy figures recalls that of the *Virgin of Paris* (FIG. 13-26).

as a reliquary. The Virgin's scepter contained hairs believed to come from Mary's head.

THE CASTLE OF LOVE Gothic artists produced luxurious objects for secular as well as religious contexts. Sometimes they decorated these costly pieces with stories of courtly love inspired by the romantic literature of the day, such as the famous story of Lancelot and Queen Guinevere, wife of King Arthur of Camelot. The French poet Chrétien de Troyes recorded their love affair in the late 12th century.

13-38 The Castle of Love and knights jousting, lid of a jewelry casket, from Paris, France, ca. 1330–1350. Ivory and iron, $4\frac{1}{2}'' \times 9\frac{3}{4}''$. Walters Art Museum, Baltimore.

French Gothic artists also produced luxurious objects for secular use. This jewelry casket features ivory reliefs inspired by the romantic literature of the day in which knights joust and storm the Castle of Love.

One of the most interesting objects of this type is a woman's jewelry box adorned with ivory relief panels. The theme of the panel illustrated here (FIG. 13-38) is related to the allegorical poem Romance of the Rose by Guillaume de Lorris, written about 1225-1235 and completed by Jean de Meung between 1275 and 1280. At the left the sculptor carved the allegory of the siege of the Castle of Love. Gothic knights attempt to capture love's fortress by shooting flowers from their bows and hurling baskets of roses over the walls from catapults. Among the castle's defenders is Cupid, who aims his arrow at one of the knights while a comrade scales the walls on a ladder. In the lid's two central sections, two knights joust on horseback. Several maidens survey the contest from a balcony and cheer the knights on, as trumpets blare. A youth in the crowd holds a hunting falcon. The sport was a favorite pastime of the leisure class in the late Middle Ages. At the right, the victorious knight receives his prize (a bouquet of roses) from a chastely dressed maiden on horseback. The scenes on the sides of the box include the famous medieval allegory of female virtue, the legend of the unicorn, a white horse with a single ivory horn. Only a virgin could attract the rare animal, and any woman who could do so thereby also demonstrated her moral purity. Religious themes may have monopolized artistic production for churches in the Gothic age, but secular themes figured prominently in private contexts. Unfortunately, very few examples of the latter survive.

GOTHIC OUTSIDE OF FRANCE

In 1269 the prior (deputy abbot) of the church of Saint Peter at Wimpfen-im-Tal in the German Rhineland hired "a very experienced architect who had recently come from the city of Paris" to rebuild his monastery church.⁴ The architect reconstructed the church *opere francigeno* ("in the French manner")—that is, in the Gothic style, the *opus modernum* of the Île-de-France. The Parisian Gothic style had begun to spread even earlier, but in the second half of the 13th century, the new style became dominant throughout western Europe. European architecture did not turn Gothic all at once or even uniformly. Almost everywhere, patrons and builders modified the Rayonnant court style of the Île-de-France according to local preferences. Because the old Romanesque traditions lingered on in many places, each area, marrying its local Romanesque design to the new style, developed its own brand of Gothic architecture.

England

Beginning with the Norman conquest in 1066 (see Chapter 12), French architectural styles quickly made an impact in England, but in the Gothic period, as in the Romanesque, no one could have mistaken an English church for a French one.

SALISBURY CATHEDRAL Salisbury Cathedral (FIGS. 13-39 to 13-41) embodies the essential characteristics of the English Gothic style. Begun in 1220, the same year work started on Amiens Cathedral (FIGS. 13-19 to 13-21), construction of Salisbury Cathedral required about 40 years. The two cathedrals are therefore almost exactly contemporaneous, and the differences between them are very instructive. Although Salisbury's facade has lancet windows and blind arcades with pointed arches, as well as statuary, it presents a striking contrast to French High Gothic designs (FIGS. 13-21 and 13-23). The English facade is a squat screen in front of the nave, wider than the building behind it. The soaring height of the French facades is absent. The Salisbury facade also does not correspond to

13-39 Aerial view of Salisbury Cathedral, Salisbury, England, 1220–1258; west facade completed 1265; spire ca. 1320–1330.

Exhibiting the distinctive regional features of English Gothic architecture, Salisbury Cathedral has a squat facade that is wider than the building behind it. The architects used flying buttresses sparingly.

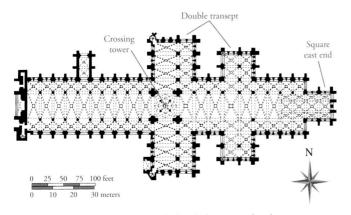

13-40 Plan of Salisbury Cathedral, Salisbury, England, 1220-1258.

The long rectilinear plan of Salisbury Cathedral, with its double transept and flat eastern end, is typically English. The four-part rib vaults of the nave follow the Chartres model (FIG. 13-14).

the three-part division of the interior (nave and two aisles). Different too is the emphasis on the great crossing tower (added about 1320–1330), which dominates the silhouette. Salisbury's height is modest compared with that of Amiens and Reims. And because height is not a decisive factor in the English building, the architect used the flying buttress sparingly and as a rigid prop, rather than as

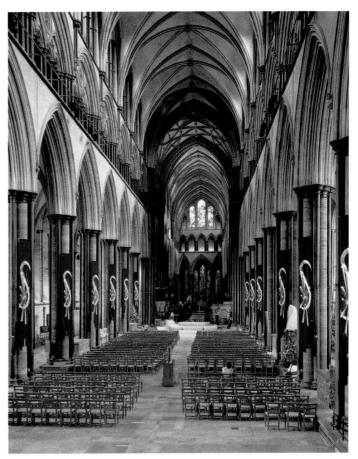

13-41 Interior of Salisbury Cathedral (looking east), Salisbury, England, 1220–1258.

Salisbury Cathedral's interior differs from contemporaneous French Gothic designs in the strong horizontal emphasis of its three-story elevation and the use of dark Purbeck marble for moldings.

an integral part of the vaulting system within the church. In short, the English builders adopted some of the superficial motifs of French Gothic architecture but did not embrace its structural logic or emphasis on height.

Equally distinctive is the long rectilinear plan (FIG. 13-40) with its double transept and flat eastern end. The latter feature was characteristic of Cistercian (FIG. 12-14) and English churches since Romanesque times. The interior (FIG. 13-41), although Gothic in its three-story elevation, pointed arches, four-part rib vaults, compound piers, and the tracery of the triforium, conspicuously departs from the French Gothic style. The pier colonnettes stop at the springing of the nave arches and do not connect with the vault ribs (compare FIGS. 13-19 and 13-20). Instead, the vault ribs rise from corbels in the triforium, producing a strong horizontal emphasis. Underscoring this horizontality is the rich color contrast between the light stone of the walls and vaults and the dark Purbeck marble used for the triforium moldings and corbels, compound pier responds, and other details.

GLOUCESTER CATHEDRAL Early on, English architecture found its native language in the elaboration of architectural pattern for its own sake (for example, the decorative patterning of the Romanesque piers of Durham Cathedral; FIG. 12-33, *left*). The pier, wall, and vault elements, still relatively simple at Salisbury, became increasingly complex and decorative in the 14th century, culminating in what architectural historians call the *Perpendicular* style. This

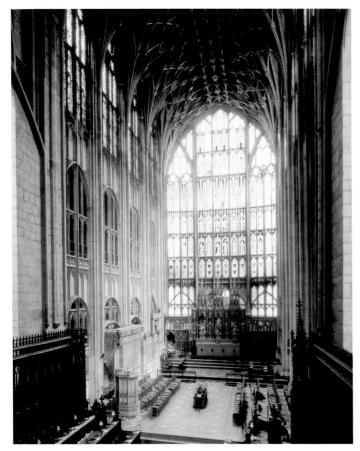

13-42 Choir of Gloucester Cathedral (looking east), Gloucester, England, 1332–1357.

The Perpendicular style of English Late Gothic architecture takes its name from the pronounced verticality of its decorative details. The multiplication of ribs in the vaults is also a characteristic feature.

late English Gothic style is on display in the choir (FIG. 13-42) of Gloucester Cathedral, remodeled about a century after Salisbury. The Perpendicular style takes its name from the pronounced verticality of its decorative details, in contrast to the horizontal emphasis of Salisbury and Early English Gothic.

A single enormous window divided into tiers of small windows of like shape and proportion fills the characteristically flat east end of Gloucester Cathedral. At the top, two slender lancets flank a wider central section that also ends in a pointed arch. The design has much in common with the screen facade of Salisbury, but the proportions are different. Vertical, as opposed to horizontal, lines dominate. In the choir wall, the architect also erased Salisbury's strong horizontal accents, as the vertical wall elements lift directly from the floor to the vaulting, unifying the walls with the vaults in the French manner. The vault ribs, which designers had begun to multiply soon after Salisbury, are at Gloucester a dense thicket of entirely ornamental strands serving no structural purpose. The choir, in fact, does not have any rib vaults at all but a continuous Romanesque barrel vault with applied Gothic ornament. In the Gloucester choir, the taste for decorative surfaces triumphed over structural clarity.

CHAPEL OF HENRY VII The structure-disguising and decorative qualities of the Perpendicular style became even more pronounced in its late phases. A primary example is the early-16th-century ceiling (FIG. **13-43**) of the chapel of Henry VII (r. 1485–1509) adjoining Westminster Abbey in London. Here, ROBERT and WILLIAM VERTUE turned the earlier English linear play of ribs into a kind of ar-

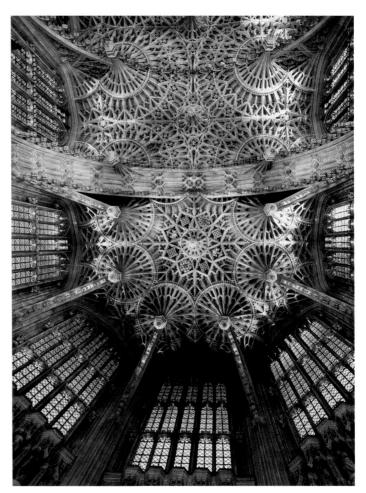

13-43 ROBERT and WILLIAM VERTUE, fan vaults of the chapel of Henry VII, Westminster Abbey, London, England, 1503–1519.

The chapel of Henry VII epitomizes the decorative and structuredisguising qualities of the Perpendicular style in the use of fan vaults with lacelike tracery and hanging pendants resembling stalactites.

chitectural embroidery. The architects pulled the ribs into uniquely English *fan vaults* (vaults with radiating ribs forming a fanlike pattern) with large hanging *pendants* resembling stalactites. The vault looks as if it had been some organic mass that hardened in the process of melting. Intricate tracery recalling lace overwhelms the cones hanging from the ceiling. The chapel represents the dissolution of structural Gothic into decorative fancy. The architects released the Gothic style's original lines from their function and multiplied them into the uninhibited architectural virtuosity and theatrics of the Perpendicular style. A contemporaneous phenomenon in France is the Flamboyant style of Saint-Maclou (FIG. 13-27) at Rouen.

ROYAL TOMBS Henry VII's chapel also houses the king's tomb in the form of a large stone coffin with sculpted portraits of Henry and his queen, Elizabeth of York, lying on their backs. This type of tomb is a familiar feature of the churches of Late Gothic England—indeed, of Late Gothic Europe. Though not strictly part of the architectural fabric, as are tombs set into niches in the church walls, freestanding tombs with recumbent images of the deceased are permanent and immovable units of church furniture. They preserve both the remains and the memory of the person entombed and testify to the deceased's piety as well as prominence.

Services for the dead were a vital part of the Christian liturgy. The Christian hope for salvation in the hereafter prompted the dying faithful to request masses sung, sometimes in perpetuity, for

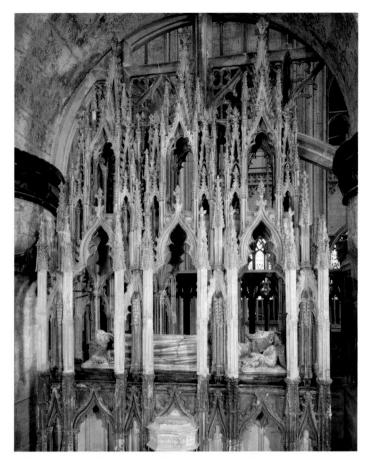

13-44 Tomb of Edward II, Gloucester Cathedral, Gloucester, England, ca. 1330–1335.

Edward II's tomb resembles a miniature Perpendicular English Gothic chapel with its forest of gables, ogee arches, and pinnacles. The shrinelike form suggests that the deceased is worthy of veneration.

the eternal repose of their souls. Toward that end, the highborn and wealthy endowed whole chapels for the chanting of masses (*chantries*), and made rich bequests of treasure and property to the Church. Many also required that their tombs be as near as possible to the choir or some other important location in the church. Sometimes, patrons built a chapel especially designed and endowed to house their tombs, such as Henry's chapel at Westminster Abbey. Freestanding tombs, accessible to church visitors, had a moral as well as a sepulchral and memorial purpose. The silent image of the deceased, cold and still, was a solemn reminder of human mortality, all the more effective because the remains of the person depicted were directly below the portrait. The tomb of an illustrious person could bring distinction, pilgrims, and patronage to a church, just as relics of saints attracted pilgrims from far and wide (see "Pilgrimages," Chapter 12, page 310).

An elaborate example of a freestanding tomb (FIG. **13-44**) is that of Edward II (r. 1307–1327), installed in Gloucester Cathedral several years after the king's murder. Edward III (r. 1327–1357) paid for the memorial to his father, who reposes in regal robes with his crown on his head. The sculptor portrayed the dead king as an idealized Christlike figure (compare FIG. **13-22**). On each side of Edward's head is an attentive angel tenderly touching his hair. At his feet is a guardian lion, emblem also of the king's strength and valor. An intricate Perpendicular Gothic canopy encases the coffin, forming a kind of miniature chapel protecting the deceased. It is a fine example of the English manner with its forest of delicate alabaster and

Purbeck marble gables, buttresses, and pinnacles. A distinctive feature is the use of *ogee arches* (arches made up of two double-curved lines meeting at a point), a characteristic Late Gothic form. Art historians often have compared tombs like Edward's to reliquaries. Indeed, the shrinelike frame and the church setting transform the deceased into a kind of saintly relic worthy of veneration.

Holy Roman Empire

The architecture of the Holy Roman Empire remained conservatively Romanesque well into the 13th century. In many German churches, the only Gothic feature was the rib vault, buttressed solely by the heavy masonry of the walls. By midcentury, though, the French Gothic style began to make a profound impact.

COLOGNE CATHEDRAL Cologne Cathedral (FIG. 13-45), begun in 1248 under the direction of Gerhard of Cologne, was not completed until more than 600 years later, making it one of the longest building projects on record. Work halted entirely from the mid-16th to the mid-19th centuries, when the 14th-century design for the facade was unexpectedly found. Gothic Revival architects (see Chapter 22) then completed the building according to the Gothic plans, adding the nave, towers, and facade to the east end that had stood alone for several centuries. The Gothic/Gothic

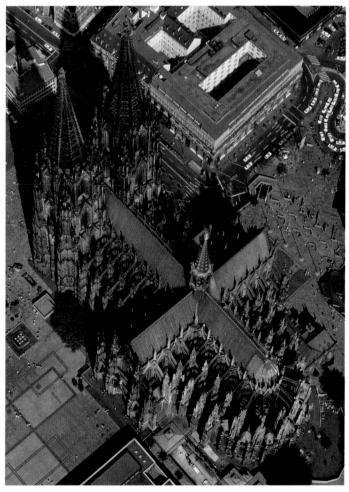

13-45 GERHARD OF COLOGNE, aerial view of Cologne Cathedral (looking northwest), Cologne, Germany, begun 1248; nave, facade, and towers completed 1880.

Cologne Cathedral, the largest church in northern Europe, took more than 600 years to build. Only the east end dates to the 13th century. The 19th-century portions follow the original Gothic plans.

13-46 GERHARD OF COLOGNE, interior of Cologne Cathedral (looking east), Cologne, Germany, choir completed 1322.

The nave of Cologne Cathedral is 422 feet long. The 150-foothigh choir, a taller variation on the Amiens Cathedral choir (FIG. 13-20), is a prime example of Gothic architects' quest for height.

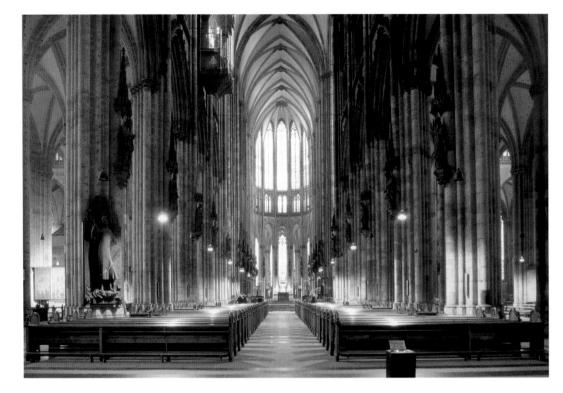

Revival structure is the largest cathedral in northern Europe and boasts a giant (422-footlong) nave (FIG. 13-46) with two aisles on each side.

The 150-foot-high 14th-century choir is a skillful variation of the Amiens Cathedral choir (FIGS. 13-19 and 13-20) design, with double lancets in the triforium and tall, slender single windows in the clerestory above and choir arcade below. Completed four decades after Gerhard's death but according to his plans, the choir expresses the Gothic quest for height even more emphatically than many French Gothic buildings. Despite the cathedral's seeming lack of substance, proof of its stability came during World War II, when the city of Cologne sustained extremely heavy aerial bombardments. The church survived the war by virtue of its Gothic skeletal design. Once the first few bomb blasts blew out all of its windows, subsequent explosions had no adverse effects, and the skeleton remained intact and structurally sound.

SAINT ELIZABETH, MARBURG A different type of design, also probably of French origin (FIG. 12-16, left) but developed especially in Germany, is the Hallenkirche, in which the aisles are the same height as the nave. Hall churches, consequently, have no tribune, triforium, or clerestory. An early German example of this type is the church of Saint Elizabeth (FIG. 13-47) at Marburg, built between 1235 and 1283. It incorporates French-inspired rib vaults with pointed arches and tall lancet windows. The facade has two spirecapped towers in the French manner but no tracery arcades or portal sculpture. Because the aisles provide much of the bracing for the nave vaults, the exterior of Saint Elizabeth is without the dramatic parade of flying buttresses that typically circles French Gothic churches. But the German interior, lighted by double rows of tall windows in the aisle walls, is more unified and free flowing, less narrow and divided, and more brightly illuminated than the interiors of French and English Gothic churches.

STRASBOURG CATHEDRAL In the German Rhineland, which the successors of the Carolingian and Ottonian emperors still ruled, work began in 1176 on a new cathedral for Strasbourg, today a French city. The apse, choir, and transepts were in place by around 1240. Stylistically, these sections of the new church are Romanesque. But the reliefs of the two south-transept portals are fully Gothic and reveal the impact of contemporary French sculpture, especially that of Reims.

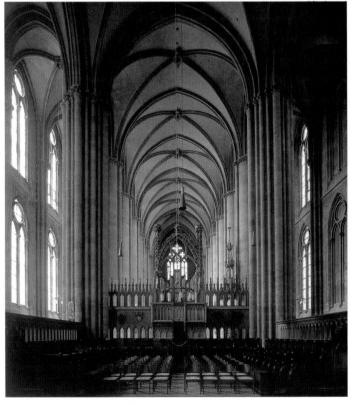

13-47 Interior of Saint Elizabeth (looking west), Marburg, Germany, 1235–1283.

This German church is an early example of a Hallenkirche, in which the aisles are the same height as the nave. Because of the tall windows in the aisle walls, sunlight brightly illuminates the interior.

The subject of the left tympanum (FIG. 13-48) is the death of the Virgin Mary. A comparison of the Strasbourg Mary on her deathbed with the Mary of the Reims *Visitation* group (FIG. 13-24, *right*) suggests that the German master had studied the recently installed French jamb statues. The 12 apostles gather around the

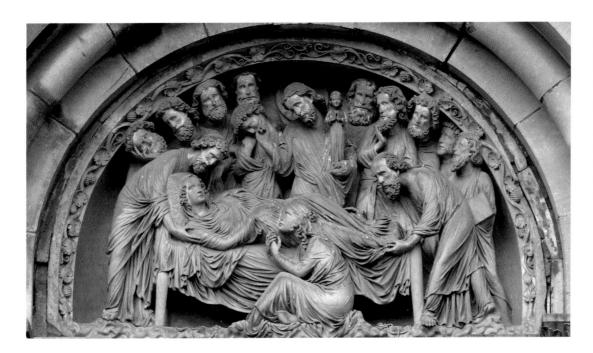

13-48 Death of the Virgin, tympanum of left doorway, south transept, Strasbourg Cathedral, Strasbourg, France, ca. 1230.

Stylistically akin to the *Visitation* group (FIG. 13-24, *right*) of Reims Cathedral, the figures in Strasbourg's south-transept tympanum express profound sorrow through dramatic poses and gestures.

Virgin, forming an arc of mourners well suited to the semicircular frame. The sculptor adjusted the heights of the figures to fit the available space (the apostles at the right are the shortest), and, as in many depictions of crowds throughout history, some of the figures have no legs or feet. At the center, Christ receives his mother's soul (the doll-like figure he holds in his left hand). Mary Magdalene, wringing her hands in grief, crouches beside the deathbed. The sorrowing figures express emotion in varying degrees of intensity, from serene resignation to gesturing agitation. The sculptor organized the group by dramatic pose and gesture but also by the rippling flow of deeply incised drapery that passes among the figures like a rhythmic electric pulse. The sculptor's objective was to imbue the sacred figures with human emotions and to stir emotional responses in observers. In Gothic France, as already noted, art became increasingly humanized and natural. In Gothic Germany, artists carried this humanizing trend even further by emphasizing passionate drama.

EKKEHARD AND UTA The Strasbourg style, with its feverish emotionalism, was particularly appropriate for narrating dramatic events in relief. The sculptor entrusted with the decoration of the west choir of Naumburg Cathedral faced a very different challenge. The task was to carve statues of the 12 benefactors of the original 11th-century church on the occasion of a new fundraising campaign. The vivid gestures and agitated faces in the Strasbourg tympanum contrast with the quiet solemnity of the Naumburg statues. Two of the figures (FIG. 13-49) stand out from the group because of their exceptional quality. They represent the margrave (military governor) Ekkehard II of Meissen and his wife Uta. The statues are attached to columns and stand beneath architectural canopies, following the pattern of French Gothic portal statuary. Their location indoors accounts for the preservation of much of the original paint. Ekkehard and Uta suggest the original appearance of the facade and transept sculptures of Gothic cathedrals.

13-49 Ekkehard and Uta, statues in the west choir, Naumburg Cathedral, Naumburg, Germany, ca. 1249–1255. Painted limestone, Ekkehard 6′ 2″ high.

The period costumes and individualized features of these donor portraits give the impression that Ekkehard and Uta posed for their statues, but they lived long before the Naumburg sculptor's time.

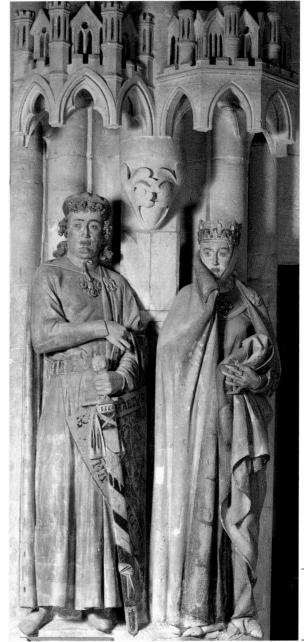

1 f

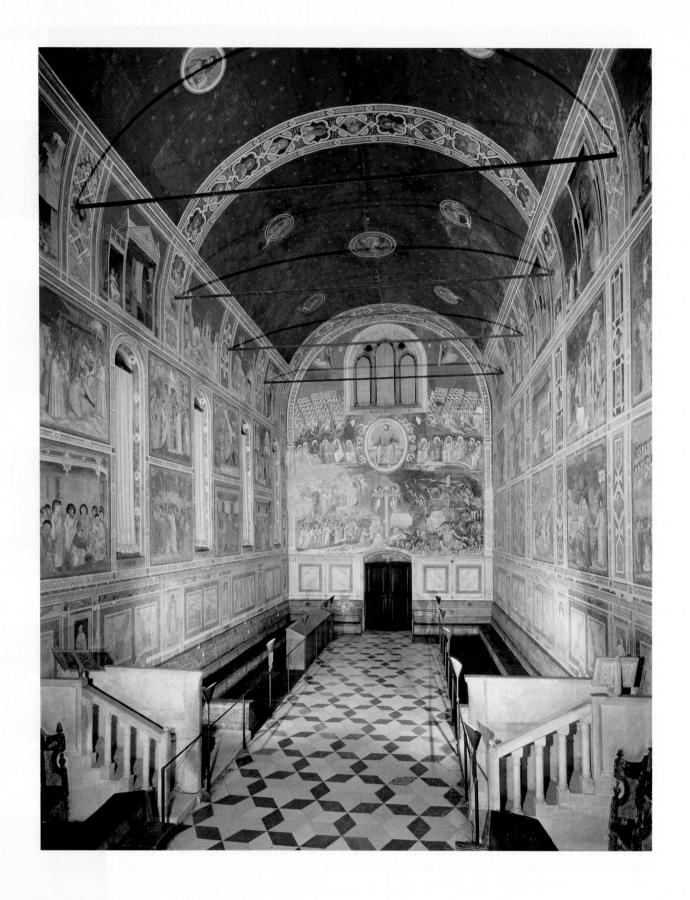

14-1 Giotto di Bondone, Arena Chapel (Cappella Scrovegni; interior looking west), Padua, Italy, 1305–1306.

Giotto, widely regarded as the first Renaissance painter, was a pioneer in pursuing a naturalistic approach to representation based on observation. The frescoes in the Arena Chapel show his art at its finest.

ITALY, 1200 TO 1400

When the Italian humanists of the 16th century condemned the art of the late Middle Ages in northern Europe as "Gothic" (see Chapter 13), they did so by comparing it with the contemporary art of Italy, which was a conscious revival of classical* art. Italian artists and scholars regarded medieval artworks as distortions of the noble art of the Greeks and Romans. But interest in the art of classical antiquity was not entirely absent during the medieval period, even in France, the center of the Gothic style. For example, on the west front of Reims Cathedral, the statues of Christian saints and angels (FIG. 13-24) reveal the unmistakable influence of Roman art on French sculptors. However, the classical revival that took root in Italy during the 13th and 14th centuries (MAP 14-1) was much more pervasive and long-lasting.

THE 13TH CENTURY

Italian admiration for classical art surfaced early on at the court of Frederick II, king of Sicily (r. 1197–1250) and Holy Roman Emperor (r. 1220–1250). Frederick's nostalgia for the past grandeur of Rome fostered a revival of Roman sculpture in Sicily and southern Italy not unlike the neoclassical *renovatio* (renewal) that Charlemagne encouraged in Germany four centuries earlier (see Chapter 11).

Sculpture

NICOLA PISANO The sculptor Nicola d'Apulia (Nicholas of Apulia), better known as NICOLA PISANO (active ca. 1258–1278) after his adopted city (see "Italian Artists' Names," page 376), received his early training in southern Italy under Frederick's rule. In 1250, Nicola traveled northward and eventually settled in Pisa. Then at the height of its political and economic power, Pisa was a magnet for artists seeking lucrative commissions. Nicola specialized in carving marble reliefs and ornamentation for large *pulpits* (raised platforms from which priests lead church services), completing the first (FIG. 14-2) in 1260 for Pisa's baptistery (FIG. 12-25, *left*). Some elements of the pulpit's design carried on medieval traditions (for example, the *trefoil arches* and the lions supporting some of the *columns*), but Nicola also incorporated

^{*} In *Art through the Ages* the adjective "Classical," with uppercase *C*, refers specifically to the Classical period of ancient Greece, 480–323 BCE. Lowercase "classical" refers to Greco-Roman antiquity in general, that is, the period treated in Chapters 5, 6, and 7.

Italian Artists' Names

n contemporary societies, people have become accustomed to a standardized method of identifying individuals, in part because of the proliferation of official documents such as driver's licenses, passports, and student identification cards. Given names are coupled with family names, although the order of the two (or more) names varies from country to country. This kind of regularity in names was not, however, the norm in premodern Italy. Many individuals were known by their place of birth or adopted hometown. Nicola Pisano was known as "Nicholas the Pisan," Giulio Romano was "Julius the Roman," and Domenico Veneziano was "the Venetian." Leonardo da Vinci ("Leonard from Vinci") hailed from the small town of Vinci.

Art historians therefore refer to these artists by their given name, not the name of their town: "Leonardo," not "da Vinci."

Nicknames were also common. Giorgione was "Big George." People usually referred to Tommaso di Cristoforo Fini as Masolino ("Little Thomas") to distinguish him from his more famous pupil Masaccio ("Brutish Thomas"). Guido di Pietro was called Fra Angelico (the Angelic Friar). Cenni di Pepo is remembered as Cimabue ("bull's head"). Names were also impermanent and could be changed at will. This flexibility has resulted in significant challenges for historians, who often must deal with archival documents and records that refer to the same artist by different names.

classical elements. The large, bushy *capitals* are a Gothic variation of the highly ornate *Corinthian capital*. The arches are round, as in Roman architecture, rather than pointed (*ogival*) as in Gothic buildings. And each of the large rectangular relief panels resembles the sculptured front of a Roman *sarcophagus*, or coffin (for example, FIG. 7-70).

The densely packed large-scale figures of the individual panels also seem to derive from the compositions found on Roman sarcophagi. One of these panels (FIG. 14-3) depicts scenes from the Infancy cycle of Christ (see "The Life of Jesus in Art," Chapter 8,

pages 216–217, or in the "Before 1300" section), including the *Annunciation* (top left), the *Nativity* (center and lower half), and the *Adoration of the Shepherds* (top right). Mary appears twice, and her size varies. The focus of the composition is the reclining Virgin of the *Nativity*, whose posture and drapery are reminiscent of those of the lid figures on Etruscan (FIGS. 6-5 and 6-15) and Roman (FIG. 7-61) sarcophagi. The face types, beards, and coiffures as well as the bulk and weight of Nicola's figures also reveal the influence of classical relief sculpture. Scholars have even been able to pinpoint the models of some of the pulpit figures on Roman sarcophagi in Pisa.

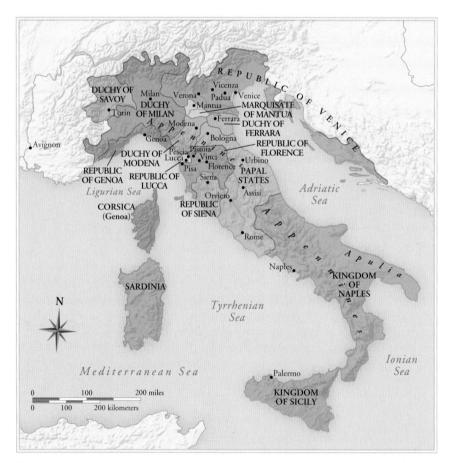

MAP 14-1 Italy around 1400.

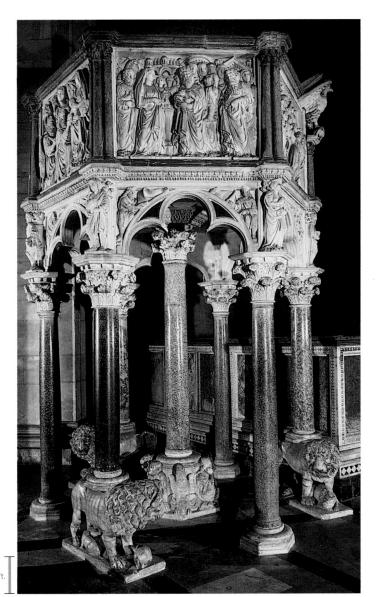

14-2 NICOLA PISANO, pulpit of the baptistery, Pisa, Italy, 1259–1260. Marble, 15' high.

Nicola Pisano's baptistery pulpit at Pisa retains many medieval design elements, for example, the trefoil arches and the lions supporting columns, but the panels draw on ancient Roman sarcophagus reliefs.

GIOVANNI PISANO Nicola Pisano's son, Giovanni Pisano (ca. 1250–1320), likewise became a sought-after sculptor of church pulpits. Giovanni's pulpit in Sant'Andrea at Pistoia also has a panel (FIG. 14-4) featuring the Nativity and related scenes. The son's version of the subject is in striking contrast to his father's thick carving and placid, almost stolid, presentation of the religious narrative. Giovanni arranged the figures loosely and dynamically. They twist and bend in excited animation, and the spaces that open deeply between them suggest their motion. In the Annunciation episode (top left), the Virgin shrinks from the angel's sudden appearance in a posture of alarm touched with humility. The same spasm of apprehension contracts her supple body as she reclines in the Nativity scene (center). The drama's principals share in a peculiar nervous agitation, as if they all suddenly are moved by spiritual passion. Only the shepherds and the sheep (right) do not yet experience the miraculous event. The swiftly turning, sinuous draperies, the slender figures they enfold, and the general emotionalism of the scene are features not found in Nicola Pisano's interpretation. The father worked in the classical tradition, the son in a style derived from French Gothic. Both styles were important ingredients in the formation of the distinctive and original art of 14th-century Italy.

Painting and Architecture

A third contributing component of 14th-century Italian art was the Byzantine tradition (see Chapter 9). Throughout the Middle Ages, the Byzantine style dominated Italian painting, but its influence was especially strong after the fall of Constantinople in 1204, which precipitated a migration of Byzantine artists to Italy.

14-3 NICOLA PISANO, Annunciation, Nativity, and Adoration of the Shepherds, relief panel on the baptistery pulpit, Pisa, Italy, 1259–1260. Marble, 2' $10'' \times 3'$ 9".

Classical sculpture inspired the face types, beards, coiffures, and draperies, as well as the bulk and weight of Nicola's figures. The Madonna of the *Nativity* resembles lid figures on Roman sarcophagi.

14-4 GIOVANNI PISANO, *Annunciation, Nativity, and Adoration of the Shepherds*, relief panel on the pulpit of Sant' Andrea, Pistoia, Italy, 1297–1301. Marble, 2' $10'' \times 3'$ 4''.

The French Gothic style had a greater influence on Giovanni Pisano, Nicola's son. Giovanni arranged his figures loosely and dynamically. They display a nervous agitation, as if moved by spiritual passion.

377

14-5 Bonaventura Berlinghieri, panel from the *Saint Francis Altarpiece*, San Francesco, Pescia, Italy, 1235. Tempera on wood, $5' \times 3' \times 6'$.

Berlinghieri was one of the leading painters working in the Italo-Byzantine style, or *maniera greca*. The frontal pose of Saint Francis and the use of gold leaf reveal the painter's Byzantine sources.

BONAVENTURA BERLINGHIERI

One of the leading painters working in the Italo-Byzantine style, or maniera greca (Greek style), was Bonaventura Berlin-GHIERI (active ca. 1235-1244) of Lucca. He created the Saint Francis Altarpiece (FIG. 14-5) for the church of San Francesco (Saint Francis) in Pescia in 1235. Painted in tempera on wood panel (see "Tempera and Oil Painting," Chapter 15, page 401), the altarpiece honors Saint Francis of Assisi (ca. 1181-1226). Francis wears the coarse clerical robe, tied at the waist with a rope, which became the costume of Franciscan monks. The saint displays the stigmata marks resembling Christ's wounds-that appeared on his hands and feet. Flanking Francis are two angels, whose frontal poses, prominent halos, and lack of modeling reveal the Byzantine roots of Berlinghieri's style. So too does his use of gold leaf (gold beaten into tissue-paper-thin sheets, then applied to surfaces), which emphasizes the image's flatness and spiritual nature. The narrative scenes that run along the sides of the panel provide an active contrast to the stiff formality of the large central image of Francis. At the upper left, taking pride of

place at the saint's right, Francis miraculously acquires the stigmata. Directly below, the saint preaches to the birds. These and the scenes depicting Francis's miracle cures strongly suggest that Berlinghieri's source was one or more Byzantine *illuminated manuscripts* (compare FIG. 9-17) having biblical narrative scenes.

Berlinghieri's Saint Francis Altarpiece also highlights the increasingly prominent role of religious orders in late medieval Italy (see "The Great Schism, Mendicant Orders, and Confraternities," page 379). Saint Francis's Franciscan order worked diligently to impress on the public the saint's valuable example and to demonstrate its monks' commitment to teaching and to alleviating suffering. Berlinghieri's Pescia altarpiece, painted nine years after Francis's death, is the earliest known signed and dated representation of the saint. Appropriately, the panel focuses on the aspects of the saint's life that the Franciscans wanted to promote, thereby making visible (and thus more credible) the legendary life of this holy man. Saint Francis believed he could get closer to God by rejecting worldly

goods, and to achieve this he stripped himself bare in a public square and committed himself to a strict life of fasting, prayer, and meditation. The appearance of stigmata on his hands and feet (clearly visible in the saint's frontal image, which resembles an *icon*) was perceived as God's blessing and led some followers to see Francis as a second Christ. Fittingly, four of the six narrative scenes on the altarpiece depict miraculous healings, connecting him more emphatically to Christ.

SANTA MARIA NOVELLA The increased importance of the mendicant orders during the 13th century led to the construction of large churches in Florence by the Franciscans (Santa Croce; FIG. I-3) and the Dominicans. The Florentine government and contributions from private citizens subsidized the commissioning of the Dominicans' Santa Maria Novella (FIG. **14-6**) around 1246. The large congregations these orders attracted necessitated the expansive scale of this church. Small *oculi* (round windows) and marble striping along

1 ft.

The Great Schism, Mendicant Orders, and Confraternities

n 1305 the College of Cardinals (the collective body of all cardinals) elected a French pope, Clement V, who settled in Avignon. Subsequent French popes remained in Avignon, despite their announced intentions to return to Rome. Understandably, this did not please the Italians, who saw Rome as the rightful capital of the universal church. The conflict between the French and Italians resulted in the election in 1378 of two popes— Clement VII, who resided in Avignon (and who does not appear in the Catholic Church's official list of popes), and Urban VI (r. 1378–1389), who remained in Rome. Thus began what became known as the Great Schism. After 40 years, the Holy Roman Emperor Sigismund (r. 1410–1437) convened a council that managed to resolve this crisis by electing a new Roman pope, Martin V (r. 1417–1431), who was acceptable to all.

The pope's absence from Italy during much of the 14th century (the Avignon papacy) contributed to an increase in prominence of monastic orders. The Augustinians, Carmelites, and Servites became very active, ensuring a constant religious presence in the daily life of Italians, but the largest and most influential monastic orders were the mendicants (begging friars)—the Franciscans, founded by Francis of Assisi (FIG. 14-5), and the Dominicans, founded by the Spaniard Dominic de Guzman (ca. 1170-1221). These mendicants renounced all worldly goods and committed themselves to spreading God's word, performing good deeds, and ministering to the sick and dying. The Dominicans, in particular, contributed significantly to establishing urban educational institutions. The Franciscans and Dominicans became very popular among Italian citizens because of their devotion to their faith and the more personal relationship with God they encouraged. Although both mendicant orders were working for the same purpose—the glory of God—a degree of rivalry nevertheless existed between the two. They established their churches on opposite sides of Florence—Santa Croce (FIG. I-3), the Franciscan church, on the eastern side, and the Dominicans' Santa Maria Novella (FIG. 14-6) on the western (MAP 16-1).

Confraternities, organizations consisting of laypersons who dedicated themselves to strict religious observance, also grew in popularity during the 14th and 15th centuries. The mission of confraternities included tending the sick, burying the dead, singing hymns, and per-

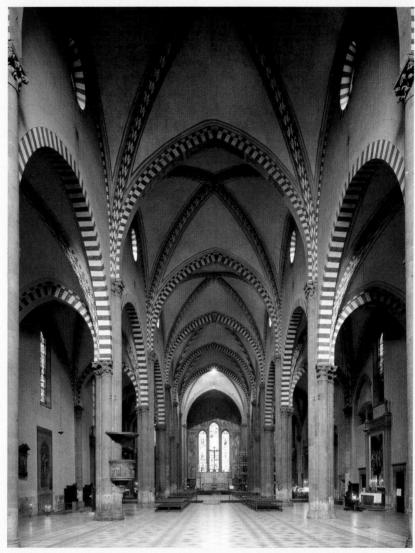

14-6 Nave of Santa Maria Novella, Florence, Italy, ca. 1246–1470.

The basilicas of Santa Maria Novella and Santa Croce (FIG. I-3) testify to the growing influence of the Dominican and Franciscan mendicant orders, respectively, in 13th-century Florence.

forming other good works. The confraternities as well as the mendicant orders continued to play an important role in Italian religious life through the 16th century. Further, the numerous artworks and monastic churches they commissioned ensured their enduring legacy.

the ogival arches punctuate the *nave*, or central *aisle*. (For the nomenclature of *basilican* church architecture, see FIG. 8-9 or in the "Before 1300" section.) Originally, a screen (*tramezzo*) placed across the nave separated the friars from the lay audience. The priests performed the *Mass* at separate altars on each side of the screen. Church officials removed this screen in the mid-16th century to encourage greater lay participation in the Mass.

CIMABUE One of the first artists to begin to break away from the Italo-Byzantine style that dominated 13th-century Italian painting was Cenni di Pepo, better known as CIMABUE (ca. 1240–1302). Although his works reveal the unmistakable influence of Gothic sculpture, Cimabue challenged some of the conventions that dominated late medieval art in pursuit of a new *naturalism*, the close observation of the natural world that was at the core of the classical

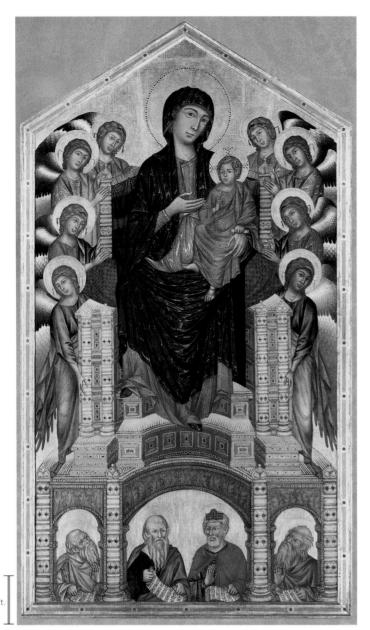

14-7 CIMABUE, *Madonna Enthroned with Angels and Prophets*, from Santa Trinità, Florence, Italy, ca. 1280–1290. Tempera and gold leaf on wood, 12' $7'' \times 7'$ 4''. Galleria degli Uffizi, Florence.

Cimabue was one of the first artists to break away from the Italo-Byzantine style. Although he relied on Byzantine models, Cimabue depicted the Madonna's massive throne as receding into space.

tradition. Cimabue's *Madonna Enthroned with Angels and Prophets* (FIG. **14-7**), created for the church of Santa Trinità (Holy Trinity) in Florence, nonetheless reveals the painter's reliance on Byzantine models for the composition as well as the gold background (compare FIG. **9-18**). Cimabue used the gold embellishments common to Byzantine art for the folds of the Madonna's robe, but they are no longer merely decorative patterns. Here they enhance the three-dimensionality of the drapery. Cimabue also constructed a deeper space for the Madonna and the surrounding figures to inhabit than is common in Byzantine art. The Virgin's throne, for example, is a massive structure that Cimabue convincingly depicted as receding into space. The overlapping bodies of the angels on each side of the throne and the half-length prophets who look outward or upward from beneath it reinforce the sense of depth.

THE 14TH CENTURY

In the 14th century, Italy consisted of numerous independent *city-states*, each corresponding to a geographic region centered on a major city (MAP 14-1). Most of the city-states, such as Venice, Florence, Lucca, and Siena, were republics. These republics were constitutional oligarchies—governed by executive bodies, advisory councils, and special commissions. Other powerful 14th-century states included the Papal States, the Kingdom of Naples, and the Duchies of Milan, Modena, Ferrara, and Savoy. As their names indicate, these states were politically distinct from the republics, but all the states shared in the prosperity of the period. The sources of wealth varied from state to state. Italy's port cities expanded maritime trade, whereas the economies of other cities depended on banking or the manufacture of arms or textiles.

The eruption of the Black Death (bubonic plague) in the late 1340s threatened this prosperity, however. Originating in China, the Black Death swept across the entire European continent. The most devastating natural disaster in European history, the plague killed between 25 and 50 percent of Europe's population in about five years. Italy was particularly hard hit. In large cities, where people lived in relatively close proximity, the death tolls climbed as high as 50 or 60 percent of the population. The Black Death had a significant effect on art. It stimulated religious bequests and encouraged the commissioning of devotional images. The focus on sickness and death also led to a burgeoning in hospital construction.

Another significant development in 14th-century Italy was the blossoming of a vernacular (commonly spoken) literature, which dramatically affected Italy's intellectual and cultural life. Latin remained the official language of church liturgy and state documents. However, the creation of an Italian vernacular literature (based on the Tuscan dialect common in Florence) expanded the audience for philosophical and intellectual concepts because of its greater accessibility. Dante Alighieri (1265–1321; author of *The Divine Comedy*), poet and scholar Francesco Petrarch (1304–1374), and Giovanni Boccaccio (1313–1375; author of *Decameron*) were among those most responsible for establishing this vernacular literature.

RENAISSANCE HUMANISM The development of a vernacular literature was one important sign that the essentially religious view of the world that dominated medieval Europe was about to change dramatically in what historians call the Renaissance. Although religion continued to occupy a primary position in the lives of Europeans, a growing concern with the natural world, the individual, and humanity's worldly existence characterized the Renaissance period the 14th through the 16th centuries. The word renaissance in French and English (rinascità in Italian) refers to a "rebirth" of art and culture. A revived interest in classical cultures—indeed, the veneration of classical antiquity as a model—was central to this rebirth. The notion that the Renaissance represented the restoration of the glorious past of Greece and Rome gave rise to the concept of the "Middle Ages" as the era spanning the time between antiquity and the Renaissance. The transition from the medieval to the Renaissance, though dramatic, did not come about abruptly, however. In fact, much that is medieval persisted in the Renaissance and in later periods.

Fundamental to the development of the Italian Renaissance was *humanism*, a concept that emerged during the 14th century and became a central component of Italian art and culture in the 15th and 16th centuries. Humanism was more a code of civil conduct, a theory of education, and a scholarly discipline than a philosophical system. As their name suggests, Italian humanists were concerned chiefly with human values and interests as distinct from—but not opposed to—religion's otherworldly values. Humanists pointed to

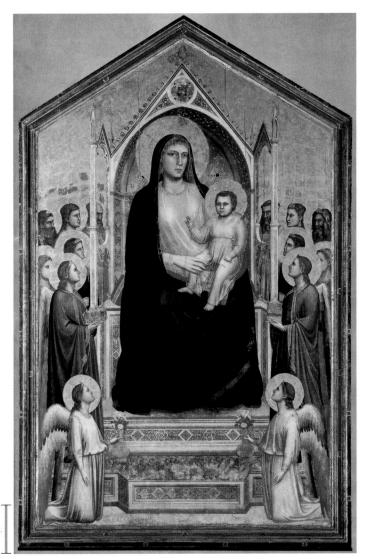

14-8 GIOTTO DI BONDONE, *Madonna Enthroned*, from the Church of Ognissanti, Florence, Italy, ca. 1310. Tempera and gold leaf on wood, 10' $8'' \times 6'$ 8''. Galleria degli Uffizi, Florence.

Giotto displaced the Byzantine style in Italian painting and revived the naturalism of classical art. His figures have substance, dimensionality, and bulk and give the illusion that they could throw shadows.

classical cultures as particularly praiseworthy. This enthusiasm for antiquity, represented by the elegant Latin of Cicero (106–43 BCE) and the Augustan age, involved study of Latin literature and a conscious emulation of what proponents thought were the Roman civic virtues. These included self-sacrificing service to the state, participation in government, defense of state institutions (especially the administration of justice), and stoic indifference to personal misfortune in the performance of duty. With the help of a new interest in and knowledge of Greek, the humanists of the late 14th and 15th centuries recovered a large part of the Greek as well as the Roman literature and philosophy that had been lost, left unnoticed, or cast aside in the Middle Ages. Indeed, classical cultures provided humanists with a model for living in this world, a model primarily of human focus that derived not from an authoritative and traditional religious dogma but from reason.

Ideally, humanists sought no material reward for services rendered. The sole reward for heroes of civic virtue was fame, just as the reward for leaders of the holy life was sainthood. For the educated, the lives of heroes and heroines of the past became as edifying as the

lives of the saints. Petrarch wrote a book on illustrious men, and his colleague Boccaccio complemented it with biographies of famous women—from Eve to his contemporary, Joanna, queen of Naples. Both Petrarch and Boccaccio were famous in their own day as poets, scholars, and men of letters—their achievements equivalent in honor to those of the heroes of civic virtue. In 1341 in Rome, Petrarch received the laurel wreath crown, the ancient symbol of victory and merit. The humanist cult of fame emphasized the importance of creative individuals and their role in contributing to the renown of the city-state and of all Italy.

Giotto

GIOTTO DI BONDONE (ca. 1266-1337) of Florence made a much more radical break with the past than did Cimabue. Art historians from Giorgio Vasari[†] to the present day have regarded Giotto as the first Renaissance painter, a pioneer in pursuing a naturalistic approach to representation based on observation. Scholars still debate the sources of Giotto's style, however. One formative influence must have been the work of the man Vasari said was his teacher, Cimabue, although Vasari lauded Giotto as having eclipsed Cimabue by abandoning the "crude maniera greca." Some late-13th-century murals in Rome with fully modeled figures of saints may also have influenced the young Giotto. French Gothic sculpture (which Giotto may have seen, but certainly familiar to him from the work of Giovanni Pisano, who had spent time in Paris) and ancient Roman art must also have contributed to Giotto's artistic education. Yet no mere synthesis of these varied influences could have produced the significant shift in artistic approach that has led some scholars to describe Giotto as the father of Western pictorial art. Renowned in his own day, he established a reputation that has never faltered. Regardless of the other influences on his artistic style, his true teacher was nature—the world of visible things.

Giotto's revolution in painting did not consist only of displacing the Byzantine style, establishing painting as a major art form for the next seven centuries, and restoring the naturalistic approach the ancients developed and medieval artists largely abandoned. He also inaugurated a method of pictorial expression based on observation and initiated an age that might be called "early scientific." By stressing the preeminence of sight for gaining knowledge of the world, Giotto and his successors contributed to the foundation of empirical science. They recognized that the visual world must be observed before it can be analyzed and understood. Praised in his own and later times for his fidelity to nature, Giotto was more than a mere imitator of it. He revealed nature while observing it and divining its visible order. In fact, he showed his generation a new way of seeing. With Giotto, Western artists turned resolutely toward the visible world as their source of knowledge of nature.

MADONNA ENTHRONED On nearly the same great scale as Cimabue's enthroned Madonna (FIG. 14-7) is Giotto's panel (FIG. 14-8) depicting the same subject, painted for the high altar of the Ognissanti (All Saints) church in Florence. Although still seen against the traditional gold background, Giotto's Madonna rests within her Gothic throne with the unshakable stability of an ancient

†Giorgio Vasari (1511–1574) established himself as both a painter and architect during the 16th century. However, people today usually associate him with his landmark book *Lives of the Most Eminent Painters, Sculptors, and Architects*, first published in 1550. Scholars long have considered this book a major source of information about Italian art and artists, although many of the details have proven inaccurate. Regardless, Vasari's *Lives* remains a tour de force—an ambitious, comprehensive book dedicated to recording the biographies of artists.

resco painting has a long history, particularly in the Mediterranean region, where the Minoans (FIGS. 4-7 to 4-9) used it as early as 1650 BCE. Fresco (Italian for "fresh") is a mural-painting technique that involves applying permanent limeproof pigments, diluted in water, on freshly laid lime plaster. Because the surface of the wall absorbs the pigments as the plaster dries, fresco is one of the most permanent painting techniques. The stable condition of frescoes such as those in the Arena Chapel (FIGS. 14-1 and 14-9) and in the Sistine Chapel (FIGS. 17-1, 17-18, and 17-19), now hundreds of years old, attest to the longevity of this painting method. The colors have remained vivid (although dirt and soot have necessitated cleaning) because of the chemically inert pigments the artists used. In addition to this buon fresco ("true" fresco) technique, artists used fresco secco (dry fresco). Fresco secco involves painting on dried lime plaster. Although the finished product visually approximates buon fresco, the plaster wall does not absorb the pigments, which simply adhere to the surface. Thus fresco secco does not have buon fresco's longevity.

The buon fresco process is time-consuming and demanding and requires several layers of plaster. Although buon fresco methods vary, generally the artist prepares the wall with a rough layer of lime plaster called the *arriccio* (brown coat). The artist then transfers the composition to the wall, usually by drawing directly on the arriccio with a burnt-orange pigment called *sinopia* (most popular during the 14th century) or by transferring a

cartoon (a full-sized preparatory drawing). Cartoons increased in usage in the 15th and 16th centuries, largely replacing sinopia underdrawings. Finally, the painter lays the *intonaco* (painting coat) smoothly over the drawing in sections (called *giornate*, Italian for "days") only as large as the artist expects to complete in that session. The buon fresco painter must apply the colors fairly quickly, because once the plaster is dry, it will no longer absorb the pigment. Any

Fresco Painting

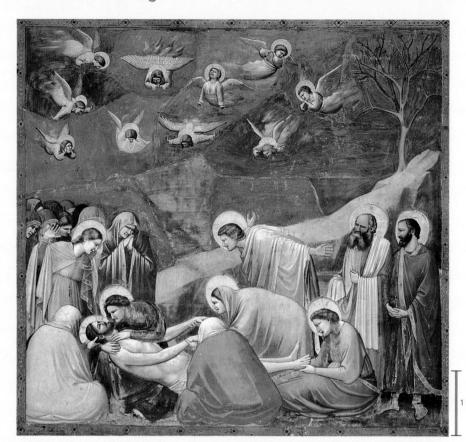

14-9 Giotto di Bondone, *Lamentation*, Arena Chapel (Cappella Scrovegni), Padua, Italy, ca. 1305. Fresco, 6' $6\frac{3}{4}'' \times 6' \frac{3}{4}''$.

In this fresco painted in several sections, Giotto used the diagonal slope of the rocky landscape to direct the viewer's attention toward the head of the sculpturesque figure of the dead Christ.

areas of the intonaco that remain unpainted after a session must be cut away so that fresh plaster can be applied for the next giornata.

In areas of high humidity, such as Venice, fresco was less appropriate because moisture is an obstacle to the drying process. Over the centuries, fresco became less popular, although it did experience a revival in the 1930s with the Mexican muralists (FIGS. 24-67 and 24-68).

marble goddess. Giotto replaced Cimabue's slender Virgin, fragile beneath the thin ripplings of her drapery, with a weighty, queenly mother. In Giotto's painting, the Madonna's body is not lost. It is asserted. Giotto even shows Mary's breasts pressing through the thin fabric of her white undergarment. Gold highlights have disappeared from her heavy robe. Giotto aimed, before all else, to construct a figure that has substance, dimensionality, and bulk—qualities suppressed in favor of a spiritual immateriality in Byzantine and Italo-Byzantine art. Works painted in the new style portray sculpturesque figures—projecting into the light and giving the illusion that they could throw shadows. Giotto's *Madonna Enthroned* marks the end of medieval painting in Italy and the beginning of a new naturalistic approach to art.

ARENA CHAPEL, PADUA To project onto a flat surface the illusion of solid bodies moving through space presents a double challenge. Constructing the illusion of a body also requires constructing the illusion of a space sufficiently ample to contain that body. In his *fresco* cycles (see "Fresco Painting," above), Giotto constantly strove to reconcile these two aspects of illusionistic painting. His murals in the Arena Chapel (Cappella Scrovegni; Fig. 14-1) at Padua show his art at its finest. Enrico Scrovegni, a wealthy Paduan banker, built the chapel on a site adjacent to his now-razed palace. Consecrated in 1305, the Arena Chapel takes its name from an ancient Roman amphitheater nearby. Scrovegni erected the chapel, which he intended for his family's private use, in part to expiate the bankers' sin of usury. Some scholars have suggested that Giotto him-

self may have been the chapel's architect because its design is so perfectly suited to its interior decoration.

The rectangular barrel-vaulted hall has six narrow windows only in its south wall (FIG. 14-1, left), which left the entire north wall an unbroken and well-illuminated surface for painting. The building seems to have been designed to provide Giotto with as much flat surface as possible for presenting one of the most impressive and complete Christian pictorial cycles ever rendered. In 38 framed pictures, arranged on three levels, the artist related the most poignant incidents from the lives of the Virgin and her parents, Joachim and Anna (top level), the life and mission of Christ (middle level), and his Passion, Crucifixion, and Resurrection (bottom level). These three pictorial levels rest on a coloristically neutral base. Imitation marble veneer-reminiscent of ancient Roman decoration (FIG. 7-51), which Giotto may have seen—alternates with the Virtues and Vices painted in grisaille (monochrome grays, often used for modeling in paintings) to resemble sculpture. The climactic event of the cycle of human salvation, the Last Judgment, covers most of the west wall above the chapel's entrance (FIG. 14-1).

The hall's vaulted ceiling is blue, an azure sky dotted with golden stars symbolic of Heaven. Medallions bearing images of Christ, Mary, and various prophets also appear on the vault. Giotto painted the same blue in the backgrounds of the narrative panels on the walls below. The color thereby functions as a unifying agent for the entire decorative scheme and renders the scenes more realistic.

Decorative borders frame the individual panels. They offer a striking contrast to the sparse simplicity of the images they surround. Subtly scaled to the chapel's space (only about half life-size), Giotto's stately and slow-moving actors present their dramas convincingly and with great restraint. Lamentation (FIG. 14-9) reveals the essentials of his style. In the presence of boldly foreshortened angels, seen head-on with their bodies receding into the background and darting about in hysterical grief, a congregation mourns over the dead body of the Savior just before its entombment. Mary cradles her son's body, while Mary Magdalene looks solemnly at the wounds in Christ's feet and Saint John the Evangelist throws his arms back dramatically. Giotto arranged a shallow stage for the figures, bounded by a thick diagonal rock incline that defines a horizontal ledge in the foreground. Though narrow, the ledge provides firm visual support for the figures, and the steep slope indicates the picture's dramatic focal point at the lower left. The rocky setting, which recalls that of a 12th-century Byzantine mural (FIG. 9-27), also links this scene with the adjoining one. Giotto connected the framed scenes throughout the fresco cycle with such formal elements. The figures are sculpturesque, simple, and weighty, but this mass did not preclude motion and emotion. Postures and gestures that might have been only rhetorical and mechanical convey, in Lamentation, a broad spectrum of grief. They range from Mary's almost fierce despair to the passionate outbursts of Mary Magdalene and John to the philosophical resignation of the two disciples at the right and the mute sorrow of the two hooded mourners in the foreground. Giotto constructed a kind of stage that served as a model for artists who depicted human dramas in many subsequent paintings. His style broke sharply from the isolated episodes and figures seen in art until the late 13th century. In Lamentation, a single event provokes an intense response. Painters before Giotto rarely attempted, let alone achieved, this combination of compositional complexity and emotional resonance.

The formal design of the *Lamentation* fresco—the way the figures are grouped within the constructed space—is worth close study. Each group has its own definition, and each contributes to the

rhythmic order of the composition. The strong diagonal of the rocky ledge, with its single dead tree (the tree of knowledge of good and evil, which withered at the fall of Adam), concentrates the viewer's attention on the group around the head of Christ, whose positioning is dynamically off center. The massive bulk of the seated mourner in the painting's left corner arrests and contains all movement beyond this group. The seated mourner to the right establishes a relation with the center figures, who, by gazes and gestures, draw the viewer's attention back to Christ's head. Figures seen from the back, which are frequent in Giotto's compositions, represent an innovation in the development away from the formal Italo-Byzantine style. These figures emphasize the foreground, aiding the visual placement of the intermediate figures farther back in space. This device, the very contradiction of the old frontality, in effect puts viewers behind the "observer figures," who, facing the action as spectators, reinforce the sense of stagecraft as a model for painting.

Giotto's new devices for depicting spatial depth and body mass could not, of course, have been possible without his management of light and shade. He shaded his figures to indicate both the direction of the light that illuminates them and the shadows (the diminished light), giving the figures volume. In *Lamentation*, light falls upon the upper surfaces of the figures (especially the two central bending figures) and passes down to dark in their draperies, separating the volumes one from the other and pushing one to the fore, the other to the rear. The graded continuum of light and shade, directed by an even, neutral light from a single steady source—not shown in the picture—was the first step toward the development of *chiaroscuro* (the use of contrasts of dark and light to produce modeling) in later Renaissance painting.

The stagelike settings made possible by Giotto's innovations in perspective (the depiction of three-dimensional objects in space on a two-dimensional surface) and lighting suited perfectly the dramatic narrative the Franciscans emphasized then as a principal method for educating the faithful in their religion. In the age of humanism, the old stylized presentations of the holy mysteries had evolved into what were called *mystery plays*. The drama of the Mass was extended into one- and two-act tableaus and scenes and then into simple narratives offered at church portals and in city squares. (Eventually, confraternities also presented more elaborate religious dramas called sacre rappresentazioni-holy representations.) The great increase in popular sermons addressed to huge city audiences prompted a public taste for narrative, recited as dramatically as possible. The arts of illusionistic painting, of drama, and of sermon rhetoric with all their theatrical flourishes developed simultaneously and were mutually influential. Giotto's art masterfully synthesized dramatic narrative, holy lesson, and truth to human experience in a visual idiom of his own invention, accessible to all. Not surprisingly, Giotto's frescoes served as textbooks for generations of Renaissance painters.

Siena

Among 14th-century Italian city-states, the Republics of Siena and Florence were the most powerful. Both Siena and Florence (the major cities of these two republics) were urban centers of bankers and merchants with widespread international contacts and large sums available for the commissioning of artworks (see "Artists' Guilds, Commissions, and Contracts," page 384).

DUCCIO The works of Duccio di Buoninsegna (active ca. 1278–1318) represent Sienese art in its supreme achievement. His most famous painting, the immense altarpiece called the *Maestà*

14-11 Duccio di Buoninsegna, Betrayal of Jesus, detail from the back of the Maestà altarpiece, from Siena Cathedral, Siena, Italy, 1309–1311. Tempera and gold leaf on wood, detail 1' $10\frac{1}{2}$ " × 3' 4". Museo dell'Opera del Duomo, Siena.

On the back of the *Maestà*, Duccio painted a religious drama in which the actors display a variety of individual emotions. Duccio here took a decisive step toward the humanization of religious subject matter.

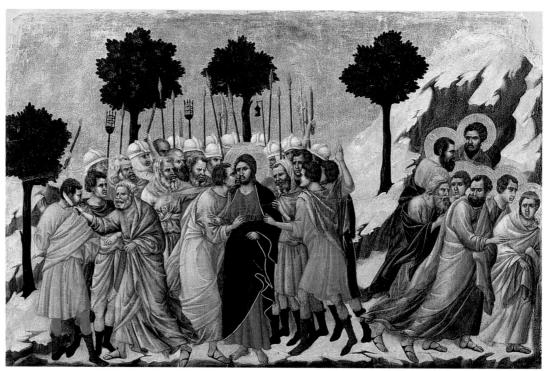

T_{1 in}

On the front panel of the Maestà, Duccio showed himself as the great master of the formal altarpiece. However, he allowed himself greater latitude for experimentation in the small accompanying panels, front and back. (Both sides of the altarpiece were always on view because the high altar stood at the very center of the sanctuary.) These images reveal Duccio's powers as a narrative painter. In the numerous panels on the back, he illustrated the later life of Christ—his ministry (on the predella), his Passion (on the main panel), and his Resurrection and appearances to the disciples (on the pinnacles). On one of the small panels, Betrayal of Jesus (FIG. 14-11), the artist represented several episodes of the event—the betrayal of Jesus by Judas's false kiss, the disciples fleeing in terror, and Peter cutting off the ear of the high priest's servant. Although the background, with its golden sky and rock formations, remains traditional, the style of the figures before it has changed quite radically. The bodies are not the flat frontal shapes of Italo-Byzantine art. Duccio imbued them with mass, modeled them with a range from light to dark, and arranged their draperies around them convincingly. Even more novel and striking is the way the figures seem to react to the central event. Through posture, gesture, and even facial expression, they display a variety of emotions. Duccio carefully differentiated among the anger of Peter, the malice of Judas (echoed in the faces of the throng about Jesus), and the apprehension and timidity of the fleeing disciples. These figures are actors in a religious drama that the artist interpreted in terms of thoroughly human actions and reactions. In this and similar narrative panels, Duccio took a decisive step toward the humanization of religious subject matter.

ORVIETO CATHEDRAL While Duccio was working on the *Maestà* for Siena Cathedral, a Sienese architect, LORENZO MAITANI, was called to Orvieto to design that city's cathedral (FIG. 14-12). The Orvieto *facade* imitates some elements of the French Gothic

14-12 LORENZO MAITANI, west facade of Orvieto Cathedral, Orvieto, Italy, begun 1310.

The pointed gables over the doorways, the rose window, and the large pinnacles derive from French architecture, but the facade of Orvieto Cathedral is merely a Gothic overlay masking a timber-roofed basilica.

architectural vocabulary (see Chapter 13), especially the pointed gables over the three doorways, the *rose window* and statues in niches in the upper zone, and the four large *pinnacles* that divide the facade into three bays. The outer pinnacles serve as miniature substitutes for the large northern European west-front towers. Maitani's facade, however, is merely a Gothic overlay masking a marble-revetted basil-

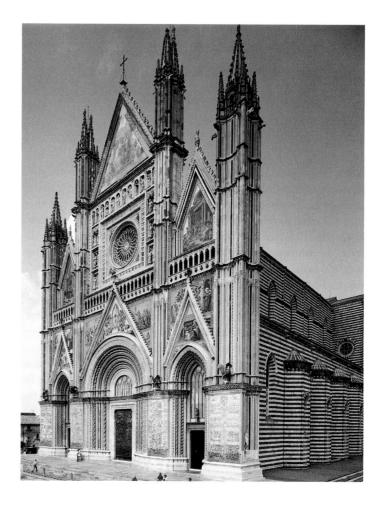

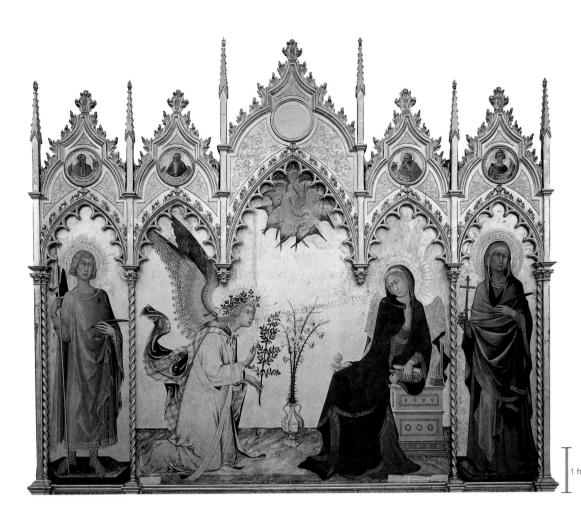

14-13 Simone Martini and Lippo Memmi(?), Annunciation altarpiece, from Siena Cathedral, Siena, Italy, 1333 (frame reconstructed in the 19th century). Tempera and gold leaf on wood, center panel $10' 1'' \times 8' 8\frac{3}{4}''$. Galleria degli Uffizi, Florence.

A pupil of Duccio, Martini was instrumental in the creation of the International Style. Its hallmarks are elegant shapes, radiant color, flowing line, and weightless figures in golden, spaceless settings.

ican structure in the Tuscan Romanesque tradition, as the three-quarter view of the cathedral in Fig. 14-12 reveals. Few Italian architects fully accepted the northern Gothic style. Some architectural historians even have questioned whether it is proper to speak of late medieval Italian buildings as Gothic structures. The Orvieto facade resembles a great altar screen, its single plane covered with carefully placed carved and painted ornament. In principle, Orvieto belongs with Pisa Cathedral (Fig. 12-25) and other Italian buildings rather than with the French cathedrals at Amiens (Fig. 13-21) and Reims (Fig. 13-23). Inside, Orvieto Cathedral has a timber-roofed nave with a two-story elevation (columnar *arcade* and *clerestory*) in the Early Christian manner. Both the *chancel arch* framing the semicircular *apse* and the nave arcade's arches are round as opposed to pointed.

SIMONE MARTINI Duccio's successors in the Sienese school also produced innovative works. Simone Martini (ca. 1285–1344) was a pupil of Duccio and may have assisted him in painting the Maestà. Martini was a close friend of Petrarch, and the poet praised him highly for his portrait of "Laura" (the woman to whom Petrarch dedicated his sonnets). Martini worked for the French kings in Naples and Sicily and, in his last years, produced paintings for the papal court at Avignon, where he came in contact with Northern European painters. By adapting the insubstantial but luxuriant patterns of the French Gothic manner to Sienese art and, in turn, by acquainting painters north of the Alps with the Sienese style, Martini was instrumental in creating the so-called International Style. This new style swept Europe during the late 14th and early 15th centuries because it appealed to the aristocratic taste for brilliant colors, lavish costumes, intricate ornamentation, and themes involving splendid processions.

Martini's Annunciation altarpiece (FIG. 14-13) features elegant shapes and radiant color, fluttering line, and weightless figures in a spaceless setting—all hallmarks of the artist's style. The complex etiquette of the European chivalric courts probably dictated the presentation. The angel Gabriel has just alighted, the breeze of his passage lifting his mantle, his iridescent wings still beating. The gold of his sumptuous gown is representative of the celestial realm from which he has descended to deliver his message. The Virgin, putting down her book of devotions, shrinks demurely from Gabriel's reverent genuflection, an appropriate gesture in the presence of royalty. She draws about her the deep blue, golden-hemmed mantle, the heraldic colors she wears as Queen of Heaven. Between the two figures is a vase of white lilies, symbolic of the Virgin's purity. Despite the Virgin's modesty and diffidence and the tremendous import of the angel's message, the scene subordinates drama to court ritual, and structural experimentation to surface splendor. The intricate tracery of the richly tooled (reconstructed) French Gothic-inspired frame and the elaborate punchwork halos, now a characteristic feature of Sienese panel painting, enhance the tactile magnificence of the Annunciation.

Simone Martini and his student and assistant, LIPPO MEMMI (active ca. 1317–1350), signed the altarpiece and dated it (1333). The latter's contribution to the *Annunciation* is still a matter of debate, but art historians now generally agree he painted the two lateral saints. These figures, which are reminiscent of the jamb statues of Gothic church portals, have greater solidity and lack the linear elegance of Martini's central pair. Given the nature of medieval and Renaissance workshop practices, it is often next to impossible to distinguish the master's hand from that of an assistant, especially if the master corrected or redid part of the latter's work (see "Artistic Training in Renaissance Italy," page 388).

Artistic Training in Renaissance Italy

n 14th- through 16th-century Italy, training to become a professional artist (earning membership in the appropriate guild) was a laborious and lengthy process. Because Italians perceived art as a trade, they expected artists to be trained as they would be in any other profession. Accordingly, aspiring artists started their training at an early age, anywhere from 7 to 15 years old. Their fathers would negotiate arrangements with specific master artists whereby each youth lived with a master for a specified number of years, usually five or six. During that time, they served as apprentices to the masters in the workshop, learning the trade. (This living arrangement served as a major obstacle for aspiring female artists, as it was considered inappropriate for young girls to live in a master's household.)

The skills apprentices learned varied with the type of studio they joined. Those apprenticed to painters learned to grind pigments, draw, prepare wood panels for painting, gild, and lay plaster for fresco. Sculptors in training learned to manipulate different materials (for example, wood, stone, *terracotta* [baked clay], wax, bronze, or stucco), although many sculpture workshops specialized in only one or two of these materials. For stone carving, apprentices learned their craft by blocking out the master's designs for statues.

The guilds supervised this rigorous training. They wanted not only to ensure their professional reputations by admitting only the most talented members but also to control the number of artists (to limit undue competition). Toward this end they frequently tried to regulate the number of apprentices working under a single master. Surely, the quality of the apprentices a master trained reflected the master's competence. When encouraging a prospective apprentice to join his studio, the Paduan painter Francesco Squarcione (1397–1468) boasted he could teach "the true art of perspective and everything necessary to the art of painting. . . . I made a man of Andrea Mantegna [see Chapter 16] who stayed with me and I will also do the same to you."*

As their skills developed, apprentices took on increasingly difficult tasks. After completing their apprenticeships, artists entered the appropriate guilds. For example, painters, who ground pigments, joined the guild of apothecaries; sculptors were members of the guild of stoneworkers; and goldsmiths entered the silk guild, because gold often was stretched into threads wound around silk for weaving. Such memberships served as certification of the artists' competence. Once "certified," artists often affiliated themselves with established workshops, as assistants to master artists. This was largely for practical reasons. New artists could not expect to receive many commissions, and the cost of establishing their own workshops was high. In any case, this arrangement was not permanent, and workshops were not necessarily static enterprises. Although well-established and respected studios existed, workshops could be organized around individual masters (with no set studio locations) or organized for a specific project, especially an extensive decoration program.

Generally, assistants were responsible for gilding frames and backgrounds, completing decorative work, and, occasionally, rendering architectural settings. Artists regarded figures, especially those central to the represented subject, as the most important and difficult parts of a painting, and the master therefore reserved these for himself. Sometimes assistants painted secondary or marginal figures, but only under the master's close supervision.

Eventually, of course, artists hoped to attract patrons and establish themselves as masters. Artists, who were largely anonymous during the medieval period, began to enjoy greater emancipation during the 15th and 16th centuries, when they rose in rank from artisan to artist-scientist. The value of their individual skills—and their reputations—became increasingly important to their patrons and clients.

* Quoted in Giuseppe Fiocco, Mantegna: La cappella Ovetari nella chiesa degli Eremitani (Milan: A. Pizzi, 1974), 7.

PIETRO LORENZETTI One of Duccio's students, PIETRO LORENZETTI (active 1320–1348), contributed significantly to the general experiments in pictorial realism that characterized the 14th century. Going well beyond his master, Lorenzetti achieved a remarkable degree of spatial illusionism in his large triptych (three-part panel painting) Birth of the Virgin (FIG. 14-14), created for the altar of Saint Savinus in Siena Cathedral. Lorenzetti painted the wooden architectural members that divide the panel as though they extend back into the painted space. Viewers seem to look through the wooden frame (apparently added later) into a boxlike stage, where the event takes place. That one of the vertical members cuts across one of the figures, blocking part of it from view, strengthens the illusion. In subsequent centuries, artists exploited this use of architectural elements to enhance the pictorial illusion that the painted figures are acting out a drama just a few feet away. This kind of pictorial illusionism characterized ancient Roman mural painting (FIGS. 7-18 and 7-19, right), but had not been practiced in Italy for a thousand years.

Lorenzetti's setting for his holy subject also represented a marked step in the advance of worldly realism. Saint Anne—who, like Nicola Pisano's Virgin of the *Nativity* (FIG. 14-3), resembles a reclining figure on the lid of a Roman sarcophagus (FIG. 7-61)—props herself up

wearily as the midwives wash the child and the women bring gifts. She is the center of an episode that occurs in an upper-class Italian house of the period. A number of carefully observed domestic details and the scene at the left, where Joachim eagerly awaits the news of the delivery, place the event in an actual household, as if viewers had moved the panels of the walls back and peered inside. Lorenzetti joined structural innovation in illusionistic space with the new curiosity that led to careful inspection and recording of what lay directly before the artist's eye in the everyday world.

PALAZZO PUBBLICO Not all Sienese painting of the early 14th century was religious in character. One of the most important fresco cycles of the period (discussed next) was a civic commission for Siena's Palazzo Pubblico ("public palace" or city hall). Siena was a proud commercial and political rival of Florence. As the secular center of the community, the civic meeting hall in the main square (the Campo, or Field; FIG. 14-15) was almost as great an object of civic pride as the city's cathedral. The Palazzo Pubblico has a slightly concave facade (to conform to the irregular shape of the Campo) and a gigantic tower visible from miles around. The imposing building and tower must have earned the admiration of Siena's citizens as well as of

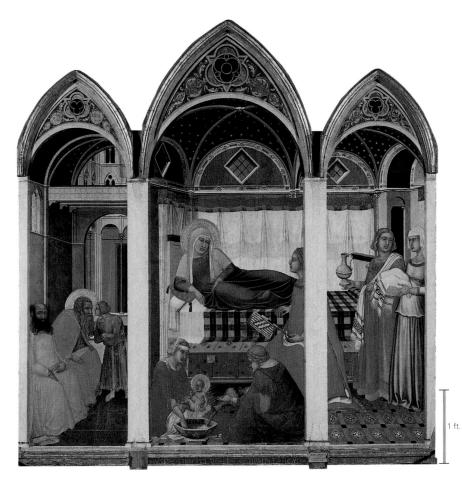

14-14 PIETRO LORENZETTI, *Birth of the Virgin*, from the altar of Saint Savinus, Siena Cathedral, Siena, Italy, 1342. Tempera on wood, 6' $1'' \times 5'$ 11''. Museo dell'Opera del Duomo, Siena.

In this triptych, Pietro Lorenzetti revived the pictorial illusionism of ancient Roman murals and painted the architectural members that divide the panel as though they extend back into the painted space.

14-15 Aerial view of the Campo with the Palazzo Pubblico, Siena, Italy, 1288–1309.

Siena's Palazzo Pubblico has a slightly concave facade and a gigantic tower visible from miles around. The tower served both as a defensive lookout over the countryside and a symbol of the city-state's power.

visitors to the city, inspiring in them respect for the republic's power and success. The tower served as lookout over the city and the countryside around it and as a bell tower (*campanile*) for ringing signals of all sorts to the populace. Siena, like other Italian city-states, had to defend itself against neighboring cities and often against kings and emperors. In addition, it had to be secure against the internal upheavals

common in the history of the Italian city-republics. Class struggle, feuds between rich and powerful families, and even uprisings of the whole populace against the city governors were constant threats. The heavy walls and *battlements* (fortified *parapets*) of the Italian town hall eloquently express how frequently the city governors needed to defend themselves against their own citizens. The Sienese tower, out

14-16 Ambrogio Lorenzetti, Peaceful City, detail from Effects of Good Government in the City and in the Country, Sala della Pace, Palazzo Pubblico, Siena, Italy, 1338–1339. Fresco.

In the Hall of Peace of Siena's city hall, Ambrogio Lorenzetti painted an illusionistic panorama of the bustling city. The fresco served as an allegory of good government in the Sienese republic.

of reach of most missiles, includes *machicolated galleries* (galleries with holes in their floors to allow the dumping of stones or hot liquids on enemies below) built out on *corbels* (projecting supporting architectural members) for defense of the tower's base.

AMBROGIO LORENZETTI The painter entrusted with the vast fresco program in Siena's Palazzo Pubblico was Pietro Lorenzetti's brother, Ambrogio Lorenzetti (active 1319–1348), who both elabo-

rated Pietro's advances in illusionistic representation in spectacular fashion and gave visual form to Sienese civic concerns. Ambrogio produced three frescoes for the walls of the Sala della Pace (Hall of Peace) in the Palazzo Pubblico: *Allegory of Good Government, Bad Government and the Effects of Bad Government in the City,* and *Effects of Good Government in the City and in the Country.* The turbulent politics of the Italian cities—the violent party struggles, the overthrow and reinstatement of governments—certainly would have called for solemn

14-17 Ambrogio Lorenzetti, Peaceful Country, detail from Effects of Good Government in the City and in the Country, Sala della Pace, Palazzo Pubblico, Siena, Italy, 1338–1339. Fresco.

This sweeping view of the Sienese countryside is one of the first appearances of landscape in Western art since antiquity. An allegorical figure of winged Security promises safety to all who live under the rule of law.

reminders of fair and just administration. And the city hall was just the place for paintings such as Ambrogio Lorenzetti's. Indeed, the leaders of the Sienese government who commissioned this fresco series had undertaken the "ordering and reformation of the whole city and countryside of Siena."

In Effects of Good Government in the City and in the Country, the artist depicted the urban and rural effects of good government. Peaceful City (FIG. 14-16) is a panoramic view of Siena, with its clustering palaces, markets, towers, churches, streets, and walls, reminiscent of the townscapes of ancient Roman murals (FIG. 7-19, left). The city's traffic moves peacefully, guild members ply their trades and crafts, and several radiant maidens, hand in hand, perform a graceful circling dance. Dancers were regular features of festive springtime rituals. Here, their presence also serves as a metaphor for a peaceful commonwealth. The artist fondly observed the life of his city, and its architecture gave him an opportunity to apply Sienese artists' rapidly growing knowledge of perspective.

As an entourage passes through the city gate to the countryside beyond its walls, Ambrogio Lorenzetti's *Peaceful Country* (FIG. **14-17**) presents a bird's-eye view of the undulating Tuscan countryside—its villas, castles, plowed farmlands, and peasants going about their seasonal occupations. An allegorical figure of Security hovers above the landscape, unfurling a scroll that promises safety to all who live under the rule of law. In this sweeping view of an actual countryside, *Peaceful Country* represents one of the first appearances of *landscape* in Western art since antiquity (FIG. **7-20**). Whereas earlier depictions were fairly generic, Lorenzetti particularized the landscape—as well as the city view—by careful observation and endowed the painting with the character of a specific place and environment.

The Black Death may have ended the careers of both Lorenzettis. They disappear from historical records in 1348, the year that brought so much horror to defenseless Europe.

Florence

Like Siena, the Republic of Florence was a dominant city-state during the 14th century. The historian Giovanni Villani (ca. 1270–1348), for example, described Florence as "the daughter and the creature of Rome," suggesting a preeminence inherited from the Roman Empire. Florentines were fiercely proud of what they perceived as their economic and cultural superiority. Florence controlled the textile industry in Italy, and the republic's gold *florin* was the standard coin of exchange everywhere in Europe.

FLORENCE CATHEDRAL Florentines translated their pride in their predominance into landmark buildings, such as Florence Cathedral (FIG. 14-18), recognized as the center for the most important religious observances in the city. Arnolfo di Cambio (ca. 1245–1302) began work on the cathedral in 1296. Intended as the "most beautiful and honorable church in Tuscany," this structure reveals the competitiveness Florentines felt with cities such as Siena and Pisa. Cathedral authorities planned for the church to hold the city's entire population, and although it holds only about 30,000 (Florence's population at the time was slightly less than 100,000), it seemed so large that even the noted architect Leon Battista Alberti (see Chapter 16) commented that it seemed to cover "all of Tuscany with its shade." The builders ornamented the church's surfaces, in the old Tuscan fashion, with marble-encrusted geometric designs, matching the cathedral's revetment (decorative wall paneling) to that

14-18 Arnolfo di Cambio and others, Florence Cathedral (aerial view looking northeast), Florence, Italy, begun 1296.

This basilican church with its marble-encrusted walls carries on the Tuscan Romanesque architectural tradition, linking Florence Cathedral more closely to Early Christian Italy than to contemporaneous France.

14-19 Arnolfo di Cambio and others, interior of Florence Cathedral (looking east), Florence, Italy, begun 1296.

Designed to hold 30,000 worshipers, Florence Cathedral has fewer but wider and deeper nave and aisle bays than do northern Gothic cathedrals. The result is an interior of unmatched spaciousness.

of the neighboring 11th-century Romanesque baptistery of San Giovanni (FIGS. 12-26 and 14-18, *bottom left*).

The vast gulf that separates Florence Cathedral from its northern European counterparts becomes evident in a comparison between the Italian church and a full-blown German representative of the High Gothic style, such as Cologne Cathedral (FIG. 13-45). Cologne Cathedral's emphatic stress on the vertical produces an awe-inspiring upward rush of almost unmatched vigor and intensity. The building has the character of an organic growth shooting heavenward, its toothed upper portions engaging the sky. The pierced, translucent stone tracery of the spires merges with the atmosphere. Florence Cathedral, in contrast, clings to the ground and has no aspirations toward flight. All emphasis is on the horizontal elements of the design, and the building rests firmly and massively earthbound. The clearly defined simple geometric volumes of the cathedral show no tendency to merge either into each other or into the sky.

Giotto di Bondone designed the cathedral's campanile in 1334. In keeping with Italian tradition (FIGS. 12-20 and 12-25), it stands apart from the church. In fact, it is essentially self-sufficient and could stand anywhere else in Florence without looking out of place. The same hardly can be said of the Cologne towers. They are essential elements of the building behind them, and it would be unthinkable to detach one of them and place it elsewhere. No individual element in the Cologne grouping seems capable of an independent existence. One form merges into the next in a series of rising movements that pull the

eye ever-upward and never permit it to rest until it reaches the sky. The Italian tower is entirely different. Neatly subdivided into cubic sections, Giotto's tower is the sum of its component parts. Not only could this tower be removed from the building without adverse effects, but also each of the parts—cleanly separated from each other by continuous moldings—seems capable of existing independently as an object of considerable aesthetic appeal. This compartmentalization is reminiscent of the Romanesque style, but it also forecasts the ideals of Renaissance architecture. Artists hoped to express structure in the clear, logical relationships of the component parts and to produce self-sufficient works that could exist in complete independence. Compared with Cologne's towers, Giotto's campanile has a cool and rational quality that appeals more to the intellect than to the emotions.

In Florence Cathedral's plan, the nave (FIG. 14-19) appears to have been added to the *crossing* complex almost as an afterthought. In fact, the nave was the first section to be built, mostly according to Arnolfo di Cambio's original plans (except for the vaulting). Midway through the 14th century, the Florentines redesigned the crossing to increase the cathedral's interior space. In its present form, the area beneath the *dome* is the design's focal point, and the nave leads to it. To visitors from north of the Alps, the nave may have seemed as strange as the plan. Neither has a northern European counterpart. The Florence nave *bays* are twice as deep as those of Amiens (FIG. 13-19), and the wide arcades permit the shallow aisles to become part of the central nave. The result is an interior of unmatched spaciousness. The accent here, as it is on the exterior, is on the horizontal elements. The substantial capitals of the *piers* prevent them from soaring into the vaults and emphasize their function as supports.

The facade of Florence Cathedral was not completed until the 19th century and then in a form much altered from its original design. In fact, until the 17th century, Italian builders exhibited little concern for the facades of their churches, and dozens remain unfinished to this day. One reason for this may be that Italian architects did not conceive the facades as integral parts of the structures but, as in the case of Orvieto Cathedral (FIG. 14-12), as screens that could be added to the church exterior at any time.

Pisa, Venice, and Milan

Italy's port cities—Genoa, Pisa, and Venice—controlled the ever busier and more extended avenues of maritime commerce that connected the West with the lands of Islam, with Byzantium and Russia, and overland with China. As a port city, Pisa established itself as a major shipping power and thus as a dominant Italian city-state. Yet Pisa was not immune from the disruption that the Black Death wreaked across all of Italy and Europe in the late 1340s. Concern with death was a significant theme in art even before the onset of the plague and became more prominent in the years after midcentury.

CAMPOSANTO, PISA Triumph of Death (FIG. 14-20) is a tour de force of death imagery. The creator of this large-scale (over 18 × 49 feet) fresco remains disputed. Some attribute the work to Francesco Traini (active ca. 1321–1363), while others argue for Buonamico Buffalmacco (active 1320–1336). Painted on the wall of the Camposanto (Holy Field), the enclosed burial ground adjacent to Pisa's cathedral (FIG. 12-25), the fresco captures the horrors of death and forces viewers to confront their mortality. In the left foreground (FIG. 14-20, left), young aristocrats, mounted in a stylish cavalcade, encounter three coffin-encased corpses in differing stages of decomposition. As the horror of the confrontation with death strikes them, the ladies turn away with delicate disgust, while a gentleman holds his nose (the animals, horses and dogs, sniff excitedly). At the far left, the hermit Saint Macarius unrolls a scroll bearing an inscription commenting on

14-20 Francesco Traini or Buonamico Buffalmacco, two details of *Triumph of Death*, 1330s. Full fresco, 18' 6" × 49' 2". Camposanto, Pisa. Befitting its location on a wall in Pisa's Camposanto, the enclosed burial ground adjacent to the city's cathedral, this fresco captures the horrors of death and forces viewers to confront their mortality.

the folly of pleasure and the inevitability of death. On the far right (FIG. **14-20**, *right*), ladies and gentlemen ignore dreadful realities, occupying themselves in an orange grove with music and amusements while all around them angels and demons struggle for the souls of the corpses heaped in the foreground.

In addition to these direct and straightforward scenes, the mural contains details that convey more subtle messages. For example, the painter depicted those who appear unprepared for death—and thus unlikely to achieve salvation—as wealthy and reveling in luxury. Given that the Dominicans—an order committed to a life of poverty—participated in the design for this fresco program, the imagery surely was a warning against greed and lust. Although *Triumph of Death* is a compilation of disparate scenes, the artist rendered each scene with natural-

ism and emotive power. It is an irony of history that as Western humanity drew both itself and the world into ever sharper visual focus, it perceived ever more clearly that corporeal things were perishable.

DOGE'S PALACE, VENICE One of the wealthiest cities of late medieval Italy—and of Europe—was Venice, renowned for its streets of water. Situated on a lagoon on the northeastern coast of Italy, Venice was secure from land attack and could rely on a powerful navy for protection against invasion from the sea. Internally, Venice was a tight corporation of ruling families who, for centuries, provided stable rule and fostered economic growth. The Venetian republic's seat of government was the Doge's (Duke's) Palace (FIG. 14-21). Begun around 1340–1345 and significantly remodeled

14-21 Doge's Palace, Venice, Italy, begun ca. 1340–1345; expanded and remodeled, 1424–1438.

The delicate patterning in cream- and rose-colored marbles, the pointed and ogee arches, and the quatrefoil medallions of the Doge's Palace constitute a distinctive Venetian variation of northern Gothic architecture.

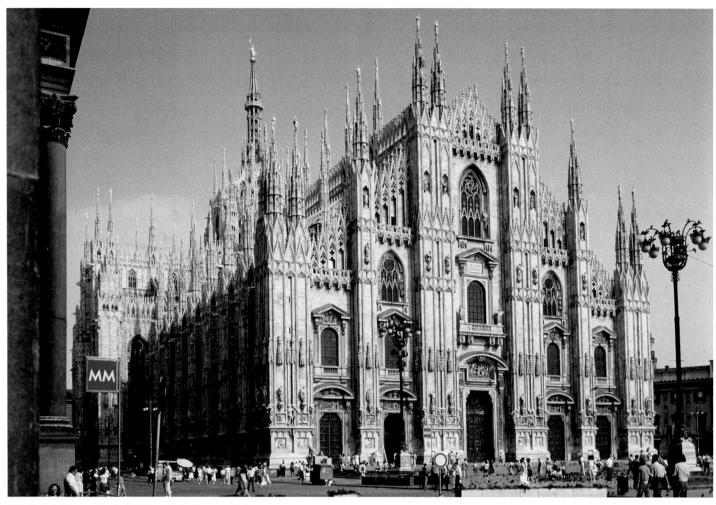

14-22 Milan Cathedral, Milan, Italy, begun 1386.

Milan Cathedral's elaborate facade is a confused mixture of Late Gothic pinnacles and tracery and Renaissance pediment-capped rectilinear portals. It marks the waning of the Gothic style.

after 1424, it was the most ornate public building in medieval Italy. In a stately march, the first level's short and heavy columns support rather severe pointed arches that look strong enough to carry the weight of the upper structure. Their rhythm doubles in the upper arcades, where slimmer columns carry *ogee arches* (made up of double-curving lines), which terminate in flamelike tips between medallions pierced with *quatrefoils* (cloverleaf-shaped). Each story is taller than the one beneath it, the topmost as high as the two lower arcades combined. Yet the building does not look top-heavy. This is due in part to the complete absence of articulation in the top story and in part to the walls' delicate patterning, in cream- and rose-colored marbles, which makes them appear paper-thin. The Doge's Palace represents a delightful and charming variant of Late Gothic architecture. Colorful, decorative, light and airy in appearance, the Venetian Gothic is ideally suited to Venice, which floats between water and air.

MILAN CATHEDRAL Since Romanesque times, northern European influences had been felt more strongly in Lombardy than in

the rest of Italy. When Milan's citizens decided to build their own cathedral (FIG. 14-22) in 1386, they invited experts from France, Germany, and England, as well as from Italy. These masters argued among themselves and with the city council, and no single architect ever played a dominant role. The result of this attempt at "architecture by committee" was, not surprisingly, a compromise. The building's proportions, particularly the nave's, became Italian (that is, wide in relation to height), and the surface decorations and details remained Gothic. Clearly derived from France are the cathedral's multitude of pinnacles and the elaborate tracery on the facade, flank, and transept. But long before the completion of the building, the new classical style of the Italian Renaissance had been well launched (see Chapter 16), and the Gothic design had become outdated. Thus, Milan Cathedral's elaborate facade represents a confused mixture of Late Gothic and Renaissance elements. With its pediment-capped rectilinear portals amid Gothic pinnacles, the cathedral stands as a symbol of the waning of the Gothic style and the advent of the Renaissance.

ITALY, 1200 TO 1400

THE 13TH CENTURY

- Diversity of style characterizes the art of 13th-century Italy, with some artists working in the newly revived classical tradition, some in the mode of Gothic France, and others in the maniera greca, or Italo-Byzantine style.
- Trained in southern Italy in the court style of Frederick II (r. 1197–1250), Nicola Pisano was a master sculptor who settled in Pisa and carved pulpits incorporating marble panels that, both stylistically and in individual motifs, depend on ancient Roman sarcophagi.
- Nicola's son, Giovanni Pisano, also was a sculptor of church pulpits, but his work more closely reflects the Gothic sculpture of France.
- The leading painters working in the Italo-Byzantine style were Bonaventura Berlinghieri and Cimabue. Both artists drew inspiration from Byzantine icons and illuminated manuscripts. Berlinghieri's Saint Francis Altarpiece is the earliest dated portrayal of Saint Francis of Assisi, who died in 1226.

THE 14TH CENTURY

- During the 14th century, Italy suffered the most devastating natural disaster in European history—the Black Death that swept through Europe—but it was also the time when Renaissance humanism took root. Although religion continued to occupy a primary position in Italian life, scholars and artists became much more concerned with the natural world.
- Giotto di Bondone of Florence, widely regarded as the first Renaissance painter, was a pioneer in pursuing a naturalistic approach to representation based on observation, which was at the core of the classical tradition in art. The Renaissance marked the rebirth of classical values in art and society.
- The greatest master of the Sienese school of painting was Duccio di Buoninsegna, whose *Maestà* still incorporates many elements of the *maniera greca*. He relaxed the frontality and rigidity of his figures, however, and in narrative scenes took a decisive step toward humanizing religious subject matter by depicting actors displaying individual emotions.
- Secular themes also came to the fore in 14th-century Italy, most notably in Ambrogio Lorenzetti's frescoes for Siena's Palazzo Pubblico. His depictions of the city and its surrounding countryside are among the first landscapes in Western art since antiquity.
- The 14th-century architecture of Italy underscores the regional character of late medieval art. Some architectural historians even have questioned whether it is proper to speak of Italian buildings of this period as Gothic structures. Orvieto Cathedral's facade, for example, imitates some elements of the French Gothic vocabulary, but it is merely an overlay masking a traditional timber-roofed structure with round arches in the nave arcade.

Nicola Pisano, Pisa baptistery pulpit, 1259–1260

Berlinghieri, Saint Francis Altarpiece, 1235

Giotto, Arena Chapel, Padua, ca. 1305

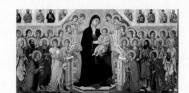

Duccio, *Maestà*, Siena Cathedral, 1308–1311

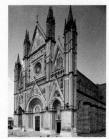

Orvieto Cathedral, begun 1310

NOTES

Chapter 8

1. Translated by Raymond Davis, *The Book of Pontiffs* (Liverpool: Liverpool University Press, 1989), 18–19.

Chapter 9

- Paulus Silentarius, Descriptio Sanctae Sophiae, 617–646. Translated by Cyril Mango, The Art of the Byzantine Empire, 312–1453: Sources and Documents (reprint of 1972 ed., Toronto: University of Toronto Press, 1986), 85–86.
- 2. Procopius, De aedificiis, 1.1.23ff. Translated by Mango, 74.
- 3. Paulus Silentarius, 489, 668. Translated by Mango, 83, 86.
- 4. Translated by Colin Luibheid, *Pseudo-Dionysius: The Complete Works* (New York: Paulist, 1987), 68ff.
- 5. Procopius, 1.1.23ff. Translated by Mango, 75.
- Libri Carolini 4.2. Translated by Herbert L. Kessler, Spiritual Seeing: Picturing God's Invisibility in Medieval Art (Philadelphia: University of Pennsylvania Press, 2000), 119.
- 7. Nina G. Garsoïan, "Later Byzantium," in John A. Garraty and Peter Gay, eds., *The Columbia History of the World* (New York: Harper & Row, 1972), 453.
- 8. Ibid., 460.

Chapter 1

- 1. Beowulf, 3162–3164, translated by Kevin Crossley-Holland (New York: Farrar, Straus & Giroux, 1968), 119.
- 2. Beowulf, 33.
- 3. Translated by Françoise Henry, The Book of Kells (New York: Knopf, 1974), 165.
- Translated by John W. Williams, in *The Art of Medieval Spain A.D. 500–1200* (New York: Metropolitan Museum of Art, 1993), 156.

5. Translated by Adam S. Cohen, *The Uta Codex* (University Park: Pennsylvania State University Press, 2000), 11, 41.

Chapter 12

- 1. Translated by Charles P. Parkhurst Jr., in Elizabeth G. Holt, *A Documentary History of Art*, 2d ed. (Princeton, N.J.: Princeton University Press, 1981), 1: 18.
- 2. Translated by Giovanna De Appolonia, Boston University.
- 3. Translated by Calvin B. Kendall, *The Allegory of the Church: Romanesque Portals and Their Verse Inscriptions* (Toronto: University of Toronto Press, 1998), 207.
- 4. Translated by John Williams, A Spanish Apocalypse: The Morgan Beatus Manuscript (New York: Braziller, 1991), 223.
- Bernard of Clairvaux, Apologia 12.28. Translated by Conrad Rudolph, The "Things of Greater Importance": Bernard of Clairvaux's Apologia and the Medieval Attitude toward Art (Philadelphia: University of Pennsylvania Press, 1990), 281, 283.
- Rule of Saint Benedict, 57.1. Translated by Timothy Fry, The Rule of St. Benedict (Collegeville, Minn.: Liturgical, 1981), 265.

Chapter 13

- Giorgio Vasari, Introduzione alle tre arti del disegno (1550), ch. 3. Translated by Paul Frankl, The Gothic: Literary Sources and Interpretation through Eight Centuries (Princeton, N.J.: Princeton University Press, 1960), 290–291, 859–860.
- 2. Dante, Divine Comedy, Purgatory, 11.81.
- Translated by Roland Behrendt, Johannes Trithemius, in Praise of Scribes: De laude scriptorum (Lawrence, Kans.: Coronado, 1974), 71.
- 4. Frankl, 55.

GLOSSARY

à la grecque—French, "in Greek style."

abacus—The uppermost portion of the *capital* of a *column*, usually a thin slab.

abbess—See abbey.

abbey—A religious community under the direction of an abbot (for monks) or an abbess (for nuns).

abbot—See abbey.

abrasion—The rubbing or grinding of stone or another material to produce a smooth finish.

acropolis—Greek, "high city." In ancient Greece, usually the site of the city's most important temple(s).

additive light — Natural light, or sunlight, the sum of all the wavelengths of the visible spectrum. See also subtractive light.

additive sculpture—A kind of sculpture technique in which materials (for example, clay) are built up or "added" to create form.

adobe—The clay used to make a kind of sun-dried mud brick of the same name; a building made of such brick.

agora—An open square or space used for public meetings or business in ancient Greek cities.

aisle—The portion of a *basilica* flanking the *nave* and separated from it by a row of *columns* or *piers*.

ala (pl. **alae**)—A rectangular recess at the back of the *atrium* of a Roman house.

altar frontal—A decorative panel on the front of a church altar.

altarpiece—A panel, painted or sculpted, situated above and behind an altar. See also *retable*.

alternate-support system—In church architecture, the use of alternating wall supports in the *nave*, usually *piers* and *columns* or *compound piers* of alternating form.

Amazonomachy—In Greek mythology, the battle between the Greeks and Amazons.

ambo—A church pulpit for biblical readings.

ambulatory—A covered walkway, outdoors (as in a church *cloister*) or indoors; especially the passageway around the *apse* and the *choir* of a church. In Buddhist architecture, the passageway leading around the *stupa* in a *chaitya hall*.

amphiprostyle—A classical temple plan in which the columns are placed across both the front and back but not along the sides.

amphitheater—Greek, "double theater." A Roman building type resembling two Greek theaters put together. The Roman amphitheater featured a continuous elliptical cavea around a central arena.

amphora—An ancient Greek two-handled jar used for general storage purposes, usually to hold wine or oil.

amulet—An object worn to ward off evil or to aid the wearer.

antae—The molded projecting ends of the walls forming the pronaos or opisthodomos of an ancient Greek temple.

ante legem—Latin, "before the law." In Christian thought, the period before Moses received the Ten Commandments. See also sub lege.

apadana—The great audience hall in ancient Persian palaces.

apostle—Greek, "messenger." One of the 12 disciples of Jesus.

apotheosis—Elevated to the rank of gods, or the ascent to heaven.

apoxyomenos—Greek, "athlete scraping oil from his body."

apse—A recess, usually semicircular, in the wall of a building, commonly found at the east end of a church

arcade—A series of arches supported by piers or columns.

arch—A curved structural member that spans an opening and is generally composed of wedgeshaped blocks (voussoirs) that transmit the downward pressure laterally. See also thrust.

Archaic—The artistic style of 600–480 BCE in Greece, characterized in part by the use of the *composite view* for painted and *relief* figures and of Egyptian stances for statues.

Archaic smile—The smile that appears on all *Archaic* Greek statues from about 570 to 480 BCE. The smile is the Archaic sculptor's way of indicating that the person portrayed is alive.

architrave—The *lintel* or lowest division of the *entablature*; also called the epistyle.

archivolt—The continuous molding framing an arch. In Romanesque or Gothic architecture, one of the series of concentric bands framing the tympanum.

arcuated—Arch-shaped.

arena—In a Roman amphitheater, the central area where bloody gladiatorial combats and other boisterous events took place. **armature**—The crossed, or diagonal, *arches* that form the skeletal framework of a *Gothic rib vault*. In sculpture, the framework for a clay form.

arriccio—In *fresco* painting, the first layer of rough lime plaster applied to the wall.

ashlar masonry—Carefully cut and regularly shaped blocks of stone used in construction, fitted together without mortar.

atlantid—A male figure that functions as a supporting *column*. See also *caryatid*.

atmospheric perspective—See perspective.

atrium—The central reception room of a Roman house that is partly open to the sky. Also the open, colonnaded court in front of and attached to a Christian basilica.

attic—The uppermost story of a building, *triumphal arch*, or city gate.

attribute—(n.) The distinctive identifying aspect of a person, for example, an object held, an associated animal, or a mark on the body. (v.) To make an attribution.

attribution—Assignment of a work to a maker or makers.

axial plan—See plan.

baldacchino—A canopy on *columns*, frequently built over an altar. The term derives from *baldacco*.

baptism—The Christian bathing ceremony in which an infant or a convert becomes a member of the Christian community.

baptistery—In Christian architecture, the building used for *baptism*, usually situated next to a church. Also, the designated area or hall within a church for baptismal rites.

bar tracery—See tracery.

Baroque—The traditional blanket designation for European art from 1600 to 1750. The stylistic term Baroque, which describes art that features dramatic theatricality and elaborate ornamentation in contrast to the simplicity and orderly rationality of Renaissance art, is most appropriately applied to Italian art of this period. The term derives from barroco.

barrel vault—See vault.

base—In ancient Greek architecture, the molded projecting lowest part of *Ionic* and *Corinthian columns*. (*Doric* columns do not have bases.)

basilica—In Roman architecture, a public building for legal and other civic proceedings, rectangular

in plan with an entrance usually on a long side. In Christian architecture, a church somewhat resembling the Roman basilica, usually entered from one end and with an *apse* at the other.

bas-relief—See relief.

battlement—A low parapet at the top of a circuit wall in a fortification.

bay—The space between two columns, or one unit in the *nave arcade* of a church; also, the passageway in an *arcuated* gate.

ben-ben—A pyramidal stone; a fetish of the Egyptian god Re.

benedictional—A Christian religious book containing bishops' blessings.

bilateral symmetry—Having the same forms on either side of a central axis.

bilingual vases—Experimental Greek vases produced for a short time in the late sixth century BCE; one side featured *black-figure* decoration, the other *red-figure*.

black-figure painting—In early Greek pottery, the silhouetting of dark figures against a light background of natural, reddish clay, with linear details incised through the silhouettes.

blind arcade—An *arcade* having no true openings, applied as decoration to a wall surface.

block statue—In ancient Egyptian sculpture, a cubic stone image with simplified body parts.

Book of Hours—A Christian religious book for private devotion containing prayers to be read at specified times of the day.

breviary—A Christian religious book of selected daily prayers and Psalms.

bucranium (pl. bucrania) — Latin, "bovine skull." A common motif in classical architectural ornament.

buon fresco—See fresco.

burin—A pointed tool used for engraving or incising. buttress—An exterior masonry structure that opposes the lateral thrust of an arch or a vault. A pier buttress is a solid mass of masonry. A flying buttress consists typically of an inclined member carried on an arch or a series of arches and a solid buttress to which it transmits lateral thrust.

Byzantine—The art, territory, history, and culture of the Eastern Christian Empire and its capital of Constantinople (ancient Byzantium).

caduceus—In ancient Greek mythology, a magical rod entwined with serpents, the attribute of Hermes (Roman, Mercury), the messenger of the gods.

caldarium—The hot-bath section of a Roman bathing establishment.

caliph(s)—Islamic rulers, regarded as successors of Muhammad.

calligrapher—One who practices calligraphy.

calligraphy—Greek, "beautiful writing." Handwriting or penmanship, especially elegant writing as a decorative art.

came—A lead strip in a *stained-glass* window that joins separate pieces of colored glass.

campanile—A bell tower of a church, usually, but not always, freestanding.

canon—A rule, for example, of proportion. The ancient Greeks considered beauty to be a matter of "correct" proportion and sought a canon of proportion, for the human figure and for buildings. The fifth-century BCE sculptor Polykleitos wrote the Canon, a treatise incorporating his formula for the perfectly proportioned statue.

canon table—A concordance, or matching, of the corresponding passages of the four Gospels as compiled by Eusebius of Caesarea in the fourth century.

canopic jar—In ancient Egypt, the container in which the organs of the deceased were placed for later burial with the mummy. capital — The uppermost member of a column, serving as a transition from the shaft to the lintel. In classical architecture, the form of the capital varies with the order.

Capitolium—An ancient Roman temple dedicated to the gods Jupiter, Juno, and Minerva.

cardo—The north-south street in a Roman town, intersecting the *decumanus* at right angles.

Caroline minuscule—The alphabet that *Carolingian* scribes perfected, from which the modern English alphabet was developed.

Carolingian (adj.)—Pertaining to the empire of Charlemagne (Latin, "Carolus Magnus") and his successors.

carpet page—In early medieval manuscripts, a decorative page resembling a textile.

cartoon—In painting, a full-size preliminary drawing from which a painting is made.

carving—A technique of sculpture in which the artist cuts away material (for example, from a stone block) in order to create a statue or a relief.

caryatid—A female figure that functions as a supporting *column*. See also *atlantid*.

castellum—See westwork.

casting—A sculptural technique in which the artist pours liquid metal, plaster, clay or another material into a mold. When the material dries, the sculptor removes the cast piece from the mold.

castrum—A Roman military encampment.

catacombs—Subterranean networks of rock-cut galleries and chambers designed as cemeteries for the burial of the dead.

cathedra—Latin, "seat." See cathedral.

cathedral—A bishop's church. The word derives from *cathedra*, referring to the bishop's chair.

cavea—Latin, "hollow place or cavity." The seating area in ancient Greek and Roman theaters and amphitheaters.

cella—The chamber at the center of an ancient temple; in a classical temple, the room (Greek, *naos*) in which the *cult statue* usually stood.

centaur—In ancient Greek mythology, a creature with the front or top half of a human and the back or bottom half of a horse.

centauromachy—In ancient Greek mythology, the battle between the Greeks and *centaurs*.

central plan—See plan.

cestrum—A small spatula used in *encaustic* painting. chamfer—The surface formed by cutting off a corner of a board or post; a bevel.

chancel arch—The arch separating the chancel (the apse or choir) or the transept from the nave of a basilica or church.

chantry—An endowed chapel for the chanting of the mass for the founder of the chapel.

chaplet—A metal pin used in hollow-casting to connect the *investment* with the clay core.

charun—An Etruscan death demon.

chiaroscuro—In drawing or painting, the treatment and use of light and dark, especially the gradations of light that produce the effect of modeling.

chimera — A monster of Greek invention with the head and body of a lion and the tail of a serpent. A second head, that of a goat, grows out of one side of the body.

chisel—A tool with a straight blade at one end for cutting and shaping stone or wood.

chiton—A Greek tunic, the essential (and often only) garment of both men and women, the other being the *himation*, or mantle.

choir—The space reserved for the clergy and singers in the church, usually east of the *transept* but, in some instances, extending into the *nave*. Christogram—The three initial letters (chi-rho-iota, or

★) of Christ's name in Greek, which came to serve as a monogram for Christ.

chronology—In art history, the dating of art objects and buildings.

chryselephantine—Fashioned of gold and ivory. **cire perdue**—See *lost-wax process*.

cista (pl. cistae) — An Etruscan cylindrical container made of sheet bronze with cast handles and feet, often with elaborately engraved bodies, used for women's toiletry articles.

city-state—An independent, self-governing city.

Classical—The art and culture of ancient Greece between 480 and 323 BCE. Lowercase *classical* refers more generally to Greco-Roman art and culture.

clerestory—The fenestrated part of a building that rises above the roofs of the other parts. The oldest known clerestories are Egyptian. In Roman basilicas and medieval churches, clerestories are the windows that form the nave's uppermost level below the timber ceiling or the vaults.

cloison—French, "partition." A cell made of metal wire or a narrow metal strip soldered edge-up to a metal base to hold *enamel*, semiprecious stones, pieces of colored glass, or glass paste fired to resemble sparkling jewels.

cloisonné—A decorative metalwork technique employing cloisons; also, decorative brickwork in later Byzantine architecture.

cloister—A monastery courtyard, usually with covered walks or *ambulatories* along its sides.

cluster pier—See compound pier.

codex (pl. codices)—Separate pages of vellum or parchment bound together at one side; the predecessor of the modern book. The codex superseded the rotulus. In Mesoamerica, a painted and inscribed book on long sheets of bark paper or deerskin coated with fine white plaster and folded into accordion-like pleats.

coffer—A sunken panel, often ornamental, in a *vault* or a ceiling.

collage—A composition made by combining on a flat surface various materials, such as newspaper, wallpaper, printed text and illustrations, photographs, and cloth.

colonnade—A series or row of *columns*, usually spanned by *lintels*.

colonnette—A thin column.

colophon—An inscription, usually on the last page, giving information about a book's manufacture. In Chinese painting, written texts on attached pieces of paper or silk.

color—The value, or tonality, of a color is the degree of its lightness or darkness. The intensity, or saturation, of a color is its purity, its brightness or dullness. See also primary colors, secondary colors, and complementary colors.

column— A vertical, weight-carrying architectural member, circular in cross-section and consisting of a base (sometimes omitted), a shaft, and a capital.

complementary colors—Those pairs of colors, such as red and green, that together embrace the entire spectrum. The complement of one of the three *primary colors* is a mixture of the other two.

compose—See composition.

Composite capital—A capital combining *Ionic* volutes and *Corinthian* acanthus leaves, first used by the ancient Romans.

composite view—A convention of representation in which part of a figure is shown in profile and another part of the same figure is shown frontally; also called twisted perspective.

- **composition**—The way in which an artist organizes *forms* in an artwork, either by placing shapes on a flat surface or arranging forms in space.
- **compound pier**—A *pier* with a group, or cluster, of attached *shafts*, or *responds*, especially characteristic of *Gothic* architecture.
- **conceptual representation**—The representation of the fundamental distinguishing properties of a person or object, not the way a figure or object appears in space and light at a specific moment. See *composite view*.
- concrete—A building material invented by the Romans and consisting of various proportions of lime mortar, volcanic sand, water, and small stones.
- confraternity—In Late Antiquity, an association of Christian families pooling funds to purchase property for burial. In late medieval Europe, an organization founded by laypersons who dedicated themselves to strict religious observances.
- **congregational mosque**—A city's main *mosque*, designed to accommodate the entire Muslim population for the Friday noonday prayer. Also called the great mosque or Friday mosque.
- connoisseur—An expert in attributing artworks to one artist rather than another. More generally, an expert on artistic style.
- consuls—In the Roman Republic, the two chief magistrates.
- **contour line**—In art, a continuous line defining the outer shape of an object.
- contrapposto The disposition of the human figure in which one part is turned in opposition to another part (usually hips and legs one way, shoulders and chest another), creating a counterpositioning of the body about its central axis. Sometimes called "weight shift" because the weight of the body tends to be thrown to one foot, creating tension on one side and relaxation on the other.
- corbel A projecting wall member used as a support for some element in the superstructure. Also, courses of stone or brick in which each course projects beyond the one beneath it. Two such walls, meeting at the topmost course, create a corbeled arch or corbeled vault.
- corbeled arch—See corbel.
- **corbeled vault**—A *vault* formed by the piling of stone blocks in horizontal *courses*, cantilevered inward until the two walls meet in an *arch*.
- Corinthian capital—A more ornate form than *Doric* or *Ionic;* it consists of a double row of acanthus leaves from which tendrils and flowers grow, wrapped around a bell-shaped *echinus*. Although this *capital* form is often cited as the distinguishing feature of the Corinthian *order*, no such order exists, in strict terms, but only this style of capital used in the *Ionic* order.
- cornice—The projecting, crowning member of the entablature framing the pediment; also, any crowning projection.
- **corona civica**—Latin, "civic crown." A Roman honorary wreath worn on the head.
- **course**—In masonry construction, a horizontal row of stone blocks.
- crenel—See crenellation.
- crenellation—Alternating solid merlons and open crenels in the notched tops of walls, as in battlements.
- **crossing**—The space in a *cruciform* church formed by the intersection of the *nave* and the *transept*.
- cross vault—See vault.
- crossing square—The area in a church formed by the intersection (*crossing*) of a *nave* and a *transept* of equal width, often used as a standard *module* of interior proportion.

- **crossing tower**—The tower over the *crossing* of a church.
- cruciform—Cross-shaped.
- Crusades—In medieval Europe, armed pilgrimages aimed at recapturing the Holy Land from the Muslims.
- crypt—A vaulted space under part of a building, wholly or partly underground; in churches, normally the portion under an apse.
- cubiculum (pl. cubicula)—A small cubicle or bedroom that opened onto the atrium of a Roman house. Also, a chamber in an Early Christian catacomb that served as a mortuary chapel.
- **cuerda seca**—A type of polychrome tilework used in decorating Islamic buildings.
- cuirass—A military leather breastplate.
- **cult statue**—The statue of the deity that stood in the *cella* of an ancient temple.
- **cuneiform**—Latin, "wedge-shaped." A system of writing used in ancient Mesopotamia, in which wedge-shaped characters were produced by pressing a *stylus* into a soft clay tablet, which was then baked or otherwise allowed to harden.
- **cuneus** (pl. **cunei**)—In ancient Greek and Roman theaters and *amphitheaters*, the wedge-shaped section of stone benches separated by stairs.
- cutaway—An architectural drawing that combines an exterior view with an interior view of part of a building.
- **Cycladic**—The prehistoric art of the Aegean Islands around Delos, excluding Crete.
- **Cyclopean masonry**—A method of stone construction, named after the mythical *Cyclopes*, using massive, irregular blocks without mortar, characteristic of the Bronze Age fortifications of Tiryns and other *Mycenaean* sites.
- **Cyclops** (pl. **Cyclopes**)—A mythical Greek one-eyed giant.
- cylinder seal—A cylindrical piece of stone usually about an inch or so in height, decorated with an incised design, so that a raised pattern is left when the seal is rolled over soft clay. In the ancient Near East, documents, storage jars, and other important possessions were signed, sealed, and identified in this way. Stamp seals are an earlier, flat form of seal used for similar purposes.
- **Daedalic**—The Greek *Orientalizing* sculptural style of the seventh century BCE named after the legendary artist Daedalus.
- damnatio memoriae—The Roman decree condemning those who ran afoul of the Senate. Those who suffered damnatio memoriae had their memorials demolished and their names erased from public inscriptions.
- **decumanus**—The east-west street in a Roman town, intersecting the *cardo* at right angles.
- **decursio**—The ritual circling of a Roman funerary pyre.
- Deësis—Greek, "supplication." An image of Christ flanked by the figures of the Virgin Mary and Saint John the Baptist, who intercede on behalf of humankind.
- **demos**—Greek, "the people," from which the word *democracy* is derived.
- demotic—Late Egyptian writing.
- **denarius**—The standard Roman silver coin from which the word *penny* ultimately derives.
- diagonal rib—See rib.
- diaphragm arch—A transverse, wall-bearing arch that divides a vault or a ceiling into compartments, providing a kind of firebreak.
- dictator—In the Roman Republic, the supreme magistrate with extraordinary powers, appointed during a crisis for a specified period. Julius Caesar

- eventually became *dictator perpetuo*, dictator for life.
- dictator perpetuo—See dictator.
- dipteral—See peristyle.
- diptych—A two-paneled painting or altarpiece; also, an ancient Roman, Early Christian, or Byzantine hinged writing tablet, often of ivory and carved on the external sides.
- **disputatio**—Latin, "logical argument." The philosophical methodology used in *Scholasticism*.
- documentary evidence—In art history, the examination of written sources in order to determine the date of an artwork, the circumstances of its creation, or the identity of the artist(s) who made it.
- doge—Duke; a ruler of the Republic of Venice, Italy.dome—A hemispherical vault; theoretically, an arch rotated on its vertical axis. In Mycenaean architecture, domes are beehive-shaped.
- domus-A Roman private house.
- Doric—One of the two systems (or *orders*) invented in ancient Greece for articulating the three units of the elevation of a *classical* building—the platform, the *colonnade*, and the superstructure (*entablature*). The Doric order is characterized by, among other features, *capitals* with funnel-shaped *echinuses*, *columns* without *bases*, and a *frieze* of *triglyphs* and *metopes*. See also *lonic*.
- doryphoros—Greek, "spear bearer."
- **double monastery**—A *monastery* for both monks and nuns.
- **dromos**—The passage leading to a *tholos tomb*.
- **drum**—One of the stacked cylindrical stones that form the *shaft* of a *column*. Also, the cylindrical wall that supports a *dome*.
- **echinus**—The convex element of a *capital* directly below the *abacus*.
- elevation—In architecture, a head-on view of an external or internal wall, showing its features and often other elements that would be visible beyond or before the wall.
- emblema—The central framed figural panel of a *mosaic* floor.
- embroidery—The technique of sewing threads onto a finished ground to form contrasting designs. Stem stitching employs short overlapping strands of thread to form jagged lines. Laid-and-couched work creates solid blocks of color.
- **enamel**—A decorative coating, usually colored, fused onto the surface of metal, glass, or ceramics.
- encaustic—A painting technique in which pigment is mixed with melted wax and applied to the surface while the mixture is hot.
- **engaged column**—A half-round *column* attached to a wall. See also *pilaster*.
- ensi—A Sumerian ruler.
- **entablature**—The part of a building above the *columns* and below the roof. The entablature has three parts: *architrave*, *frieze*, and *pediment*.
- entasis—The convex profile (an apparent swelling) in the *shaft* of a *column*.
- **Eucharist**—In Christianity, the partaking of the bread and wine, which believers hold to be either Christ himself or symbolic of him.
- evangelist—One of the four authors (Matthew, Mark, Luke, John) of the New Testament *Gospels*.
- exedra—Recessed area, usually semicircular.
- **facade**—Usually, the front of a building; also, the other sides when they are emphasized architecturally.
- **faience**—A low-fired opaque glasslike silicate.
- fan vault—See vault.
- fauces—Latin, "jaws." In a Roman house, the narrow foyer leading to the atrium.
- fenestrated—Having windows.

fenestration—The arrangement of the windows of a building.

feudalism—The medieval political, social, and economic system held together by the relationship between landholding *liege lords* and the *vassals* who were granted tenure of a portion of their land and in turn swore allegiance to the liege lord.

fibula (pl. **fibulae**)—A decorative pin, usually used to fasten garments.

findspot—Place where an artifact was found; provenance.

finial—A crowning ornament.

First Style mural—The earliest style of Roman mural painting. Also called the Masonry Style, because the aim of the artist was to imitate, using painted stucco relief, the appearance of costly marble panels.

Flamboyant — A Late French Gothic style of architecture superseding the Rayonnant style and named for the flamelike appearance of its pointed bar tracery.

flashing—In making stained-glass windows, fusing one layer of colored glass to another to produce a greater range of colors.

fleur-de-lis—A three-petaled iris flower; the royal flower of France.

florin—The denomination of gold coin of Renaissance Florence that became an international currency for trade.

flute or fluting—Vertical channeling, roughly semicircular in cross-section and used principally on columns and pilasters.

flying buttress—See buttress.

folio—A page of a manuscript or book.

foreshortening—The use of *perspective* to represent in art the apparent visual contraction of an object that extends back in space at an angle to the perpendicular plane of sight.

form—In art, an object's shape and structure, either in two dimensions (for example, a figure painted on a surface) or in three dimensions (such as a statue).

formal analysis—The visual analysis of artistic

forum—The public square of an ancient Roman city.

Fourth Style mural—In Roman mural painting, the Fourth Style marks a return to architectural illusionism, but the architectural vistas of the Fourth Style are irrational fantasies.

freedmen, freedwomen—In ancient and medieval society, men and women who had been freed from servitude, as opposed to having been born free.

freestanding sculpture—See sculpture in the round.
fresco—Painting on lime plaster, either dry (dry fresco, or fresco secco) or wet (true, or buon, fresco). In the latter method, the pigments are mixed with water and become chemically bound to the freshly laid lime plaster. Also, a painting executed in either method.

fresco secco—See fresco.

Friday mosque—See congregational mosque.

frieze—The part of the *entablature* between the *ar-chitrave* and the *cornice*; also, any sculptured or painted band in a building. See *register*.

frigidarium—The cold-bath section of a Roman bathing establishment.

genre—A style or category of art; also, a kind of painting that realistically depicts scenes from everyday life.

Geometric—The style of Greek art during the ninth and eighth centuries BCE, characterized by abstract geometric ornament and schematic figures. **gigantomachy**—In ancient Greek mythology, the battle between gods and giants.

giornata (pl. **giornate**)—Italian, "day." The section of plaster that a *fresco* painter expects to complete in one session.

gladiator—An ancient Roman professional fighter, usually a slave, who competed in an *amphitheater*.

glaze—A vitreous coating applied to pottery to seal and decorate the surface; it may be colored, transparent, or opaque, and glossy or *matte*. In oil painting, a thin, transparent, or semitransparent layer applied over a color to alter it slightly.

glazier—A glassworker.

gold leaf—Gold beaten into tissue-paper-thin sheets that then can be applied to surfaces.

gorgon — In ancient Greek mythology, a hideous female demon with snake hair. Medusa, the most famous gorgon, was capable of turning anyone who gazed at her into stone.

Gospels—The four New Testament books that relate the life and teachings of Jesus.

Gothic—Originally a derogatory term named after the Goths, used to describe the history, culture, and art of western Europe in the 12th to 14th centuries. Typically divided into periods designated Early (1140–1194), High (1194–1300), and Late (1300–1500).

granulation—A decorative technique in which tiny metal balls (granules) are fused to a metal surface.great mosque—See congregational mosque.

Greek cross—A cross with four arms of equal length.
grisaille—A monochrome painting done mainly in
neutral grays to simulate sculpture.

groin—The edge formed by the intersection of two barrel vaults.

groin vault—See vault.

ground line—In paintings and reliefs, a painted or carved baseline on which figures appear to stand.

guild—An association of merchants, craftspersons, or scholars in medieval and Renaissance Europe.

hall church—See Hallenkirche.

Hallenkirche—German, "hall church." A church design favored in Germany, but also used elsewhere, in which the aisles rise to the same height as the nave.

Helladic—The prehistoric art of the Greek mainland (*Hellas* in Greek).

Hellas—The ancient name of Greece.

Hellenes (adj. **Hellenic**)—The name the ancient Greeks called themselves as the people of *Hellas*.

Hellenistic—The term given to the art and culture of the roughly three centuries between the death of Alexander the Great in 323 BCE and the death of Queen Cleopatra in 30 BCE, when Egypt became a Roman province.

henge—An arrangement of *megalithic* stones in a circle, often surrounded by a ditch.

heraldic composition—A *composition* that is symmetrical on either side of a central figure.

herm—A bust on a quadrangular pillar.

Hiberno-Saxon—An art style that flourished in the monasteries of the British Isles in the early Middle Ages. Also called Insular.

hierarchy of scale—An artistic convention in which greater size indicates greater importance.

hieroglyphic—A system of writing using symbols or pictures.

high relief—See relief.

Hijra—The flight of Muhammad from Mecca to Medina in 622, the year from which Islam dates its beginnings.

himation—An ancient Greek mantle worn by men and women over the *chiton* and draped in various ways. **Hippodamian plan**—A city *plan* devised by Hippodamos of Miletos ca. 466 BCE, in which a strict grid was imposed on a site, regardless of the terrain, so that all streets would meet at right angles.

historiated—Ornamented with representations, such as plants, animals, or human figures, that have a narrative—as distinct from a purely decorative—function

hubris—Greek, "arrogant pride."

hue—The name of a *color*. See also *primary colors*, *secondary colors*, and *complementary colors*.

humanism—In the Renaissance, an emphasis on education and on expanding knowledge (especially of classical antiquity), the exploration of individual potential and a desire to excel, and a commitment to civic responsibility and moral duty.

hydria—An ancient Greek three-handled water pitcher.

hypaethral—A building having no *pediment* or roof, open to the sky.

hypostyle hall—A hall with a roof supported by *columns*.

icon—A portrait or image; especially in Byzantine churches, a panel with a painting of sacred personages that are objects of veneration. In the visual arts, a painting, a piece of sculpture, or even a building regarded as an object of veneration.

iconoclasm—The destruction of religious or sacred images. In Byzantium, the period from 726 to 843 when there was an imperial ban on such images. The destroyers of images were known as iconoclasts. Those who opposed such a ban were known as iconophiles.

iconoclast—See iconoclasm.

iconography—Greek, the "writing of images." The term refers both to the content, or subject, of an artwork and to the study of content in art. It also includes the study of the symbolic, often religious, meaning of objects, persons, or events depicted in works of art.

iconophile—See iconoclasm.

iconostasis—Greek, "icon stand." In Byzantine churches, a screen or a partition, with doors and many tiers of *icons*, separating the sanctuary from the main body of the church.

illuminated manuscript—A luxurious handmade book with painted illustrations and decorations.

illusionism (adj. illusionistic)—The representation of the three-dimensional world on a two-dimensional surface in a manner that creates the illusion that the person, object, or place represented is threedimensional. See also perspective.

imagines—In ancient Rome, wax portraits of ancestors.imam—In Islam, the leader of collective worship.

imperator—Latin, "commander in chief," from which the word *emperor* derives.

impluvium—In a Roman house, the basin located in the *atrium* that collected rainwater.

in antis—In ancient Greek architecture, the area between the *antae*.

incise—To cut into a surface with a sharp instrument; also, a method of decoration, especially on metal and pottery.

incrustation—Wall decoration consisting of bright panels of different colors.

indulgence—A religious pardon for a sin committed. insula (pl. insulae)—In Roman architecture, a multistory apartment house, usually made of brickfaced concrete; also refers to an entire city block.

Insular—See *Hiberno-Saxon*.

intensity—See color.

interaxial or intercolumniation—The distance between the center of the lowest *drum* of a *column* and the center of the next. intercolumniation—See interaxial.

internal evidence—In art history, the examination of what an artwork represents (people, clothing, hairstyles, and so on) in order to determine its date. Also, the examination of the style of an artwork to identify the artist who created it.

International Style—A *style* of 14th- and 15th-century painting begun by Simone Martini, who adapted the French *Gothic* manner to Sienese art fused with influences from Northern Europe. This style appealed to the aristocracy because of its brilliant color, lavish costumes, intricate ornamentation, and themes involving splendid processions of knights and ladies. Also, a style of 20th-century architecture associated with Le Corbusier, whose elegance of design came to influence the look of modern office buildings and skyscrapers.

intonaco — In fresco painting, the last layer of smooth lime plaster applied to the wall; the painting layer.

investment—In hollow-casting, the final clay mold applied to the exterior of the wax model.

Ionic—One of the two systems (or orders) invented in ancient Greece for articulating the three units of the elevation of a classical building: the platform, the colonnade, and the superstructure (entablature). The Ionic order is characterized by, among other features, volutes, capitals, columns with bases, and an uninterrupted frieze.

iwan—In Islamic architecture, a *vaulted* rectangular recess opening onto a courtyard.

jambs—In architecture, the side posts of a doorway.
 ka—In ancient Egypt, the immortal human life force.
 Kaaba—Arabic, "cube." A small cubical building in Mecca, the Islamic world's symbolic center.

keep—A fortified tower in a castle that served as a place of last refuge.

kline (pl. klinai)—A couch or funerary bed. A type of sarcophagus with a reclining portrait of the deceased on its lid.

Koran—Islam's sacred book, composed of *surahs* (chapters) divided into verses.

kore (pl. **korai**)—Greek, "young woman." An *Archaic* Greek statue of a young woman.

kouros (pl. **kouroi**)—Greek, "young man." An *Archaic* Greek statue of a young man.

krater—An ancient Greek wide-mouthed bowl for mixing wine and water.

Kufic—An early form of Arabic script, characterized by angularity, with the uprights forming almost right angles with the baseline.

labyrinth — Maze. The English word derives from the mazelike plan of the *Minoan* palace at Knossos.

laid-and-couched work—See embroidery.

lamassu—Assyrian guardian in the form of a manheaded winged bull.

lancet—In *Gothic* architecture, a tall narrow window ending in a *pointed arch*.

landscape—A picture showing natural scenery, without narrative content.

lateral section—See section.

leading—In the manufacture of stained-glass windows, the joining of colored glass pieces using lead cames.

lectionary—A book containing passages from the Gospels, arranged in the sequence that they are to be read during the celebration of religious services, including the Mass, throughout the year.

lekythos (pl. **lekythoi**)—A flask containing perfumed oil; lekythoi were often placed in Greek graves as offerings to the deceased.

liege lord—In *feudalism*, a landowner who grants tenure of a portion of his land to a *vassal*.

line—The extension of a point along a path, made concrete in art by drawing on or chiseling into a *plane*.

linear perspective—See perspective.

lintel—A horizontal *beam* used to span an opening. **liturgy** (adj. **liturgical**)—The official ritual of public worship.

loculi—Openings in the walls of *catacombs* to receive the dead.

longitudinal plan—See plan.

longitudinal section—See section.

lost-wax (cire perdue) process—A bronze-casting method in which a figure is modeled in wax and covered with clay; the whole is fired, melting away the wax (French, cire perdue) and hardening the clay, which then becomes a mold for molten metal.

low relief—See relief.

lunette—A semicircular area (with the flat side down) in a wall over a door, niche, or window; also, a painting or *relief* with a semicircular frame.

lux nova—Latin, "new light." Abbot Suger's term for the light that enters a *Gothic* church through stained-glass windows.

machicolated gallery—A gallery in a defensive tower with holes in the floor to allow stones or hot liquids to be dumped on enemies below.

madrasa—An Islamic theological college adjoining and often containing a *mosque*.

magus (pl. magi)—One of the three wise men from the East who presented gifts to the infant Jesus.mandorla—An almond-shaped *nimbus* surround-

ing the figure of Christ or other sacred figure.

maniera—Italian, "style" or "manner." See Mannerism.

maniera greca—Italian, "Greek manner." The Italo-Byzantine painting style of the 13th century. manor—In feudalism, the estate of a liege lord.

maqsura—In some *mosques*, a screened area in front of the *mihrab* reserved for a ruler.

martyr—A person who chooses to die rather than deny his or her religious belief. See also *saint*.

martyrium—A shrine to a Christian martyr *saint*. Masonry Style—See *First Style mural*.

mass—The bulk, density, and weight of matter in space.

Mass — The Catholic and Orthodox ritual in which believers understand that Christ's redeeming sacrifice on the cross is repeated when the priest consecrates the bread and wine in the Eucharist.

mastaba—Arabic, "bench." An ancient Egyptian rectangular brick or stone structure with sloping sides erected over a subterranean tomb chamber connected with the outside by a shaft.

mausoleum—A monumental tomb. The name derives from the mid-fourth-century BCE tomb of Mausolos at Halikarnassos, one of the Seven Wonders of the ancient world.

meander—An ornament, usually in bands but also covering broad surfaces, consisting of interlocking geometric motifs. An ornamental pattern of contiguous straight lines joined usually at right angles.

medium (pl. media)—The material (for example, marble, bronze, clay, *fresco*) in which an artist works; also, in painting, the vehicle (usually liquid) that carries the pigment.

megalith (adj. megalithic)—Greek, "great stone." A large, roughly hewn stone used in the construction of monumental prehistoric structures.

megaron—The large reception hall and throne room in a *Mycenaean* palace, fronted by an open, two-columned porch.

mendicants—In medieval Europe, friars belonging to the Franciscan and Dominican orders, who re-

nounced all worldly goods, lived by contributions of laypersons (the word *mendicant* means "beggar"), and devoted themselves to preaching, teaching, and doing good works.

menorah—In antiquity, the Jewish sacred sevenbranched candelabrum.

merlon—See crenellation.

Mesolithic—The "middle" Stone Age, between the *Paleolithic* and the *Neolithic* ages.

Messiah—The savior of the Jews prophesied in the Old Testament. Christians believe that Jesus of Nazareth was the Messiah.

metamatics—The name Swiss artist Jean Tinguely gave to the motor-driven devices he constructed to produce instant abstract paintings.

metope—The square panel between the *triglyphs* in a *Doric frieze*, often sculpted in *relief*.

mihrab—A semicircular niche set into the *qibla* wall of a *mosque*.

minaret—Â distinctive feature of *mosque* architecture, a tower from which the faithful are called to worship.

minbar—In a mosque, the pulpit on which the imam

Minoan—The prehistoric art of Crete, named after the legendary King Minos of Knossos.

Minotaur— The mythical beast, half man and half bull, that inhabited the *labyrinth* of the *Minoan* palace at Knossos.

modeling—The shaping or fashioning of threedimensional forms in a soft material, such as clay; also, the gradations of light and shade reflected from the surfaces of matter in space, or the illusion of such gradations produced by alterations of value in a drawing, painting, or print.

module (adj. modular) — A basic unit of which the dimensions of the major parts of a work are multiples. The principle is used in sculpture and other art forms, but it is most often employed in architecture, where the module may be the dimensions of an important part of a building, such as the diameter of a column.

mold—A hollow form for *casting*.

molding—In architecture, a continuous, narrow surface (projecting or recessed, plain or ornamented) designed to break up a surface, to accent, or to decorate.

monastery—A group of buildings in which monks live together, set apart from the secular community of a town.

monastic—Relating to life in a monastery.

monastic order—An organization of monks living according to the same rules, for example, the Benedictine, Franciscan, and Dominican orders.

monochrome (adj. monochromatic) — One color. monolith (adj. monolithic) — A stone *column shaft* that is all in one piece (not composed of *drums*); a large, single block or piece of stone used in *megalithic* structures. Also, a colossal statue carved from a single piece of stone.

monotheism—The worship of one all-powerful god.
moralized Bible—A heavily illustrated Bible, each
page pairing paintings of Old and New Testament episodes with explanations of their moral
significance.

mortuary temple—In Egyptian architecture, a temple erected for the worship of a deceased *pharaoh*.

mosaic — Patterns or pictures made by embedding small pieces (tesserae) of stone or glass in cement on surfaces such as walls and floors; also, the technique of making such works.

mosaic tilework—An Islamic decorative technique in which large ceramic panels are fired, cut into smaller pieces, and set in plaster.

moschophoros—Greek, "calf bearer."

mosque—The Islamic building for collective worship. From the Arabic word *masjid*, meaning a "place for bowing down."

Mozarabic—Referring to the Christian culture of northern Spain during the time Islamic *caliphs* ruled southern Spain.

Muhaqqaq—A cursive style of Islamic *calligraphy*. **mullion**—A vertical member that divides a window

mullion—A vertical member that divides a window or that separates one window from another.

mummification—A technique used by ancient Egyptians to preserve human bodies so that they may serve as the eternal home of the immortal *ka*.

muqarnas—Stucco decorations of Islamic buildings in which stalactite-like forms break a structure's solidity.

mural—A wall painting.

Mycenaean—The prehistoric art of the Late Helladic period in Greece, named after the citadel of Mycenae.

mystery play—A dramatic enactment of the holy mysteries of the Christian faith performed at church portals and in city squares.

naos—See cella.

narthex—A porch or vestibule of a church, generally colonnaded or arcaded and preceding the nave.

natatio—The swimming pool in a Roman bathing establishment.

naturalism—The style of painted or sculptured representation based on close observation of the natural world that was at the core of the classical tradition.

nave—The central area of an ancient Roman basilica or of a church, demarcated from aisles by piers or columns.

nave arcade—In *basilica* architecture, the series of *arches* supported by *piers* or *columns* separating the *nave* from the *aisles*.

necropolis—Greek, "city of the dead." A large burial area or cemetery.

nemes—In ancient Egypt, the linen headdress worn by the *pharaoh*, with the *uraeus* cobra of kingship on the front.

Neolithic—The "new" Stone Age.

niello—A black metallic alloy.

nimbus—A halo or aureole appearing around the head of a holy figure to signify divinity.

Nun—In ancient Egypt, the primeval waters from which the creator god emerged.

nymphs—In *classical* mythology, female divinities of springs, caves, and woods.

oculus (pl. oculi) — Latin, "eye." The round central opening of a *dome*. Also, a small round window in a *Gothic cathedral*.

odalisque—A woman in a Turkish harem.

ogee arch—An *arch* composed of two doublecurving lines meeting at a point.

ogive (adj. **ogival**)—The diagonal *rib* of a *Gothic vault*; a pointed, or Gothic, *arch*.

Olympiad—The four-year period defined by the staging of the Olympic Games in ancient Greece.

opere francigeno—See opus francigenum.

opisthodomos—In ancient Greek architecture, a porch at the rear of a temple, set against the blank back wall of the cella.

optical mixture—The visual effect of juxtaposed complementary colors.

opus francigenum — Latin, "French work." Architecture in the style of *Gothic* France; opere francigeno (adj.), "in the French manner."

opus modernum—Latin, "modern work." The late medieval term for *Gothic* art and architecture. Also called *opus francigenum*.

orant—In Early Christian art, a figure with both arms raised in the ancient gesture of prayer.

oratory—The church of a Christian *monastery*.

orbiculum—A disklike opening.

orchestra—Greek, "dancing place." In ancient Greek theaters, the circular piece of earth with a hard and level surface on which the performance took place.

order—In classical architecture, a style represented by a characteristic design of the columns and entablature. See also superimposed orders.

Orientalizing — The early phase of Archaic Greek art (seventh century BCE), so named because of the adoption of forms and motifs from the ancient Near East and Egypt. See also Daedalic.

orthogonal plan—The imposition of a strict grid *plan* on a site, regardless of the terrain, so that all streets meet at right angles. See also *Hippodamian plan*.

Ottonian (adj.)—Pertaining to the empire of Otto I and his successors.

oxidizing—The first phase of the ancient Greek ceramic firing process, which turned both the pot and the clay *slip* red. During the second (reducing) phase, the oxygen supply into the kiln was shut off, and both pot and slip turned black. In the final (reoxidizing) phase, the pot's coarser material reabsorbed oxygen and became red again, whereas the smoother slip did not and remained black.

palaestra—An ancient Greek and Roman exercise area, usually framed by a colonnade. In Greece, the palaestra was an independent building; in Rome, palaestras were also frequently incorporated into a bathing complex.

Paleolithic—The "old" Stone Age, during which humankind produced the first sculptures and paintings.

palette—A thin board with a thumb hole at one end on which an artist lays and mixes colors; any surface so used. Also, the colors or kinds of colors characteristically used by an artist. In ancient Egypt, a slate slab used for preparing makeup.

Pantokrator—Greek, "ruler of all." Christ as ruler and judge of heaven and earth.

papyrus—A plant native to Egypt and adjacent lands used to make paperlike writing material; also, the material or any writing on it.

parapet—A low, protective wall along the edge of a balcony, roof, or bastion.

parchment—Lambskin prepared as a surface for painting or writing.

parekklesion—The side chapel in a Byzantine church. parthenos—Greek, "virgin." The epithet of Athena, the virgin goddess.

passage grave—A prehistoric tomb with a long stone corridor leading to a burial chamber covered by a great tumulus.

paten—A large shallow bowl or plate for the bread used in the *Eucharist*.

patrician—A Roman freeborn landowner.

patron—The person or entity that pays an artist to produce individual artworks or employs an artist on a continuing basis.

pebble mosaic—A *mosaic* made of irregularly shaped stones of various colors.

pectoral—An ornament worn on the chest.

pediment—In classical architecture, the triangular space (gable) at the end of a building, formed by the ends of the sloping roof above the colonnade; also, an ornamental feature having this shape.

pendant—The large hanging terminal element of a *Gothic* fan *vault*.

pendentive—A concave, triangular section of a hemisphere, four of which provide the transition from a square area to the circular base of a covering *dome*. Although pendentives appear to be hanging (pendant) from the dome, they in fact support it. **Pentateuch**—The first five books of the Old Testament.

peplos—A simple, long belted garment of wool worn by women in ancient Greece.

period style—See style.

peripteral—See peristyle.

peristyle—In *classical* architecture, a *colonnade* all around the *cella* and its porch(es). A peripteral colonnade consists of a single row of *columns* on all sides; a dipteral colonnade has a double row all around.

Perpendicular—A Late English *Gothic* style of architecture distinguished by the pronounced verticality of its decorative details.

personal style—See style.

personification—An abstract idea represented in bodily form.

perspective (adj. perspectival)—A method of presenting an illusion of the three-dimensional world on a two-dimensional surface. In linear perspective, the most common type, all parallel lines or surface edges converge on one, two, or three vanishing points located with reference to the eye level of the viewer (the horizon line of the picture), and associated objects are rendered smaller the farther from the viewer they are intended to seem. Atmospheric, or aerial, perspective creates the illusion of distance by the greater diminution of color intensity, the shift in color toward an almost neutral blue, and the blurring of contours as the intended distance between eye and object increases.

pharaoh (adj. **pharaonic**)—An ancient Egyptian king.

physical evidence—In art history, the examination of the materials used to produce an artwork in order to determine its date.

pictograph—A picture, usually stylized, that represents an idea; also, writing using such means; also, painting on rock. See also *hieroglyphic*.

pier—A vertical, freestanding masonry support.

Pietà—A painted or sculpted representation of the Virgin Mary mourning over the body of the dead Christ.

pilaster—A flat, rectangular, vertical member projecting from a wall of which it forms a part. It usually has a base and a capital and is often fluted.

pillar—Usually a weight-carrying member, such as a pier or a column; sometimes an isolated, freestanding structure used for commemorative purposes.

pinakotheke—Greek, "picture gallery." An ancient Greek building for the display of paintings on wood panels.

pinnacle—In *Gothic* churches, a sharply pointed ornament capping the *piers* or flying *buttresses*; also used on church *facades*.

plan—The horizontal arrangement of the parts of a building or of the buildings and streets of a city or town, or a drawing or diagram showing such an arrangement. In an axial plan, the parts of a building are organized longitudinally, or along a given axis; in a central plan, the parts of the structure are of equal or almost equal dimensions around the center.

plane—A flat surface.

plate tracery—See tracery.

platero—See Plateresque.

plebeian—The Roman social class that included small farmers, merchants, and freed slaves.

pointed arch—A narrow *arch* of pointed profile, in contrast to a semicircular arch.

polis (pl. **poleis**)—An independent *city-state* in ancient Greece.

polytheism—The belief in multiple gods.

- pontifex maximus—Latin, "chief priest." The high priest of the Roman state religion, often the emperor himself.
- portico-A roofed colonnade; also an entrance porch.
- post-and-lintel system—A system of construction in which two posts support a lintel.
- predella—The narrow ledge on which an altarpiece rests on an altar.
- prefiguration—In Early Christian art, the depiction of Old Testament persons and events as prophetic forerunners of Christ and New Testament events.
- primary colors—Red, yellow, and blue—the colors from which all other colors may be derived.
- princeps—Latin, "first citizen." The title Augustus and his successors as Roman emperor used to distinguish themselves from Hellenistic monarchs.
- pronaos—The space, or porch, in front of the cella, or naos, of an ancient Greek temple.
- proportion—The relationship in size of the parts of persons, buildings, or objects, often based on a
- prostyle—A classical temple plan in which the columns are only in front of the cella and not on the sides or back.
- provenance—Origin or source; findspot.
- **psalter**—A book containing the Psalms.
- pseudoperipteral—In Roman architecture, a pseudoperipteral temple has a series of engaged columns all around the sides and back of the cella to give the appearance of a peripteral colonnade.
- pulpit—A raised platform in a church on which a priest stands while leading the religious service.
- punchwork—Tooled decorative work in gold leaf.
- putto (pl. putti)—A cherubic young boy.
- pylon—The wide entrance gateway of an Egyptian temple, characterized by its sloping walls.
- qibla—The direction (toward Mecca) Muslims face when praying.
- quadrant arch—An arch whose curve extends for one quarter of a circle's circumference.
- quatrefoil—A shape or plan in which the parts assume the form of a cloverleaf.
- radiating chapels—In medieval churches, chapels for the display of relics that opened directly onto the *ambulatory* and the *transept*.
- radiocarbon dating—A method of measuring the decay rate of carbon isotopes in organic matter to determine the age of organic materials such as wood and fiber.
- raking cornice—The cornice on the sloping sides of a pediment.
- ramparts—Defensive wall circuits.
- Rayonnant—The "radiant" style of Gothic architecture, dominant in the second half of the 13th century and associated with the French royal court of Louis IX at Paris.
- red-figure painting—In later Greek pottery, the silhouetting of red figures against a black background, with painted linear details; the reverse of black-figure painting.
- **reducing**—See *oxidizing*. **refectory**—The dining hall of a Christian *monastery*. regional style—See style.
- register—One of a series of superimposed bands or friezes in a pictorial narrative, or the particular levels on which motifs are placed.
- relics—The body parts, clothing, or objects associated with a holy figure, such as the Buddha or Christ or a Christian saint.
- relief—In sculpture, figures projecting from a background of which they are part. The degree of relief is designated high, low (bas), or sunken. In the last, the artist cuts the design into the surface

- so that the highest projecting parts of the image are no higher than the surface itself. See also repoussé.
- relieving triangle—In Mycenaean architecture, the triangular opening above the lintel that serves to lighten the weight to be carried by the lintel itself. reliquary—A container for holding relics.
- Renaissance—French, "rebirth." The term used to describe the history, culture, and art of 14th-through 16th-century western Europe during which artists consciously revived the classical style.
- renovatio—Latin, "renewal." During the Carolingian period, Charlemagne sought to revive the culture of ancient Rome (renovatio imperi Romani).
- reoxidizing—See oxidizing.
- repoussé—Formed in relief by beating a metal plate from the back, leaving the impression on the face. The metal sheet is hammered into a hollow mold of wood or some other pliable material and finished with a graver. See also relief.
- respond—An engaged column, pilaster, or similar element that either projects from a compound pier or some other supporting device or is bonded to a wall and carries one end of an arch.
- retable—An architectural screen or wall above and behind an altar, usually containing painting, sculpture, carving, or other decorations. See also altarpiece.
- revetment—In architecture, a wall covering or facing. rib—A relatively slender, molded masonry arch that projects from a surface. In Gothic architecture, the ribs form the framework of the vaulting. A diagonal rib is one of the ribs that form the X of a groin vault. A transverse rib crosses the nave or aisle at a 90-degree angle.
- rib vault—A vault in which the diagonal and transverse ribs compose a structural skeleton that partially supports the masonry web between them.
- ridgepole—The beam running the length of a building below the peak of the gabled roof.
- Romanesque—"Roman-like." A term used to describe the history, culture, and art of medieval western Europe from ca. 1050 to ca. 1200.
- rose window—A circular stained-glass window.
- rotulus—The manuscript scroll used by Egyptians, Greeks, Etruscans, and Romans; predecessor of the codex.
- roundel—See tondo.
- rusticate (n. rustication)—To give a rustic appearance by roughening the surfaces and beveling the edges of stone blocks to emphasize the joints between them. Rustication is a technique employed in ancient Roman architecture, and was also popular during the *Renaissance*, especially for stone courses at the ground-floor level.
- sacra rappresentazione (pl. sacre rappresentazioni)—Italian, "holy representation." A more elaborate version of a mystery play performed for a lay audience by a confraternity.
- sacramentary—A Christian religious book incorporating the prayers priests recite during Mass.
- saint—From the Latin word sanctus, meaning "made holy by God." Applied to persons who suffered and died for their Christian faith or who merited reverence for their Christian devotion while alive. In the Roman Catholic Church, a worthy deceased Catholic who is canonized by the pope.
- sarcophagus (pl. sarcophagi)—Latin, "consumer of flesh." A coffin, usually of stone.
- saturation—See color.
- satyr—A Greek mythological follower of Dionysos having a man's upper body, a goat's hindquarters and horns, and a horse's ears and tail.
- **scarab**—An Egyptian gem in the shape of a beetle.

- Scholasticism—The Gothic school of philosophy in which scholars applied Aristotle's system of rational inquiry to the interpretation of religious
- school—A chronological and stylistic classification of works of art with a stipulation of place.
- scriptorium (pl. scriptoria)—The writing studio of a monastery.
- sculpture in the round—Freestanding figures, carved or modeled in three dimensions.
- secco—Italian, "dry." See also fresco.
- Second Style mural—The style of Roman mural painting in which the aim was to dissolve the confining walls of a room and replace them with the illusion of a three-dimensional world constructed in the artist's imagination.
- secondary colors—Orange, green, and purple, obtained by mixing pairs of primary colors (red, yellow, blue).
- section—In architecture, a diagram or representation of a part of a structure or building along an imaginary plane that passes through it vertically. Drawings showing a theoretical slice across a structure's width are lateral sections. Those cutting through a building's length are longitudinal sections. See also elevation and cutaway.
- sedes sapientiae—Latin, "throne of wisdom." A Romanesque sculptural type depicting the Virgin Mary with the Christ Child in her lap.
- senate—Latin senatus, "council of elders." The Senate was the main legislative body in Roman constitutional government.
- serdab—A small concealed chamber in an Egyptian mastaba for the statue of the deceased.
- Severe Style—The Early Classical style of Greek sculpture, ca. 480-450 BCE.
- **sexpartite vault**—See *vault*.
- **shaft**—The tall, cylindrical part of a *column* between the capital and the base.
- signoria—The governing body in the Republic of Florence.
- sinopia—A burnt-orange pigment used in fresco painting to transfer a cartoon to the arriccio before the artist paints the plaster.
- siren—In ancient Greek mythology, a creature that was part bird and part woman.
- **skene**—Greek, "stage." The stage of a *classical* theater. **skenographia**—Greek, "scene painting"; the Greek term for perspective painting.
- skiagraphia—Greek, "shadow painting." The Greek term for shading, said to have been invented by Apollodoros, an Athenian painter of the fifth century BCE.
- slip—A mixture of fine clay and water used in ceramic decoration.
- space—In art history, both the actual area an object occupies or a building encloses, and the illusionistic representation of space in painting and sculpture.
- **spandrel**—The roughly triangular space enclosed by the curves of adjacent arches and a horizontal member connecting their vertexes; also, the space enclosed by the curve of an arch and an enclosing right angle. The area between the arch proper and the framing columns and entablature.
- spectrum—The range or band of visible colors in natural light.
- sphinx—A mythical Egyptian beast with the body of a lion and the head of a human.
- **springing**—The lowest stone of an *arch*, resting on the impost block. In Gothic vaulting, the lowest stone of a diagonal or transverse rib.
- squinch—An architectural device used as a transition from a square to a polygonal or circular base

403

for a *dome*. It may be composed of *lintels*, *corbels*, or *arches*.

stained glass—In *Gothic* architecture, the colored glass used for windows.

stamp seal—See cylinder seal.

statue—A three-dimensional sculpture.

stave—A wedge-shaped timber; vertically placed staves embellish the architectural features of a building.

stele (pl. **stelae**)—A carved stone slab used to mark graves or to commemorate historical events.

stem stitching—See embroidery.

stigmata—In Christian art, the wounds Christ received at his crucifixion that miraculously appear on the body of a saint.

still life—A picture depicting an arrangement of inanimate objects.

stoa—In ancient Greek architecture, an open building with a roof supported by a row of columns parallel to the back wall. A covered colonnade or portico.

Stoic—A philosophical school of ancient Greece, named after the *stoas* in which the philosophers

strategos—Greek, "general."

strigil—A tool Greek athletes used to scrape oil from their bodies after exercising.

stucco—A type of plaster used as a coating on exterior and interior walls. Also used as a sculptural medium.

style—A distinctive artistic manner. Period style is the characteristic style of a specific time. Regional style is the style of a particular geographical area. Personal style is an individual artist's unique manner.

stylistic evidence—In art history, the examination of the *style* of an artwork in order to determine its date or the identity of the artist.

stylobate—The uppermost course of the platform of a classical Greek temple, which supports the columns.

stylus—A needlelike tool used in engraving and incising: also, an ancient writing instrument used to inscribe clay or wax tablets.

sub gracia—Latin, "under grace." In Christian thought, the period after the coming of Christ.

sub lege—Latin, "under the law." In Christian thought, the period after Moses received the Ten Commandments and before the coming of Christ. See also sub gracia.

subtractive light—The painter's light in art; the light reflected from pigments and objects. See also additive light.

subtractive sculpture—A kind of sculpture technique in which materials are taken away from the original mass; carving.

sultan—A Muslim ruler.

sunken relief—See relief.

Sunnah — The collection of the Prophet Muhammad's moral sayings and descriptions of his deeds.

superimposed orders—Orders of architecture that are placed one above another in an arcaded or colonnaded building, usually in the following sequence: Doric (the first story), Ionic, and Corinthian. Superimposed orders are found in later Greek architecture and were used widely by Roman and Renaissance builders.

surah—A chapter of the Koran, divided into verses.symbol—An image that stands for another image or encapsulates an idea.

symmetria—Greek, "commensurability of parts." Polykleitos's treatise on his *canon* of proportions incorporated the principle of symmetria.

symposium—An ancient Greek banquet attended solely by men (and female servants and prostitutes).

taberna—In Roman architecture, a single-room shop usually covered by a barrel *vault*.

tablinum—The study or office in a Roman house. tapestry—A weaving technique in which the weft

threads are packed densely over the warp threads so that the designs are woven directly into the fabric.

technique—The processes artists employ to create *form*, as well as the distinctive, personal ways in which they handle their materials and tools.

tempera—A technique of painting using pigment mixed with egg yolk, glue, or casein; also, the medium itself.

templon—The columnar screen separating the sanctuary from the main body of a Byzantine church.

tephra—The volcanic ash produced by the eruption on the *Cycladic* island of Thera.

tepidarium—The warm-bath section of a Roman bathing establishment.

terracotta—Hard-baked clay, used for sculpture and as a building material. It may be *glazed* or painted.

tessera (pl. **tesserae**)—Greek, "cube." A tiny stone or piece of glass cut to the desired shape and size for use in forming a *mosaic*.

tetrarch—One of four corulers.

tetrarchy—Greek, "rule by four." A type of Roman government established in the late third century CE by Diocletian in an attempt to foster order by sharing power with potential rivals.

texture—The quality of a surface (rough, smooth, hard, soft, shiny, dull) as revealed by light. In represented texture, a painter depicts an object as having a certain texture even though the paint is the actual texture.

theatron—Greek, "place for seeing." In ancient Greek theaters, the slope overlooking the *orchestra* on which the spectators sat.

Theotokos—Greek, "she who bore God." The Virgin Mary, the mother of Jesus.

Third Style mural—In Roman mural painting, the style in which delicate linear fantasies were sketched on predominantly monochromatic backgrounds.

tholos (pl. **tholoi**)—A temple with a circular plan. Also, the burial chamber of a *tholos tomb*.

tholos tomb—In *Mycenaean* architecture, a beehive-shaped tomb with a circular plan.

thrust—The outward force exerted by an *arch* or a *vault* that must be counterbalanced by a *buttress*.

tonality— See color. tondo (pl. tondi)—A circular painting or relief

sculpture.

Torah—The Hebrew religious scroll containing the

Pentateuch.

torque—The distinctive necklace worn by the Gauls.

tracery—Ornamental stonework for holding stained glass in place, characteristic of Gothic cathedrals. In plate tracery, the glass fills only the "punched holes" in the heavy ornamental stonework. In bar tracery, the stained-glass windows fill almost the entire opening, and the stonework is unobtrusive.

tramezzo—A screen placed across the *nave* of a church to separate the clergy from the lay audience.

transept—The part of a church with an axis that crosses the *nave* at a right angle.

transverse arch—An *arch* separating one *vaulted bay* from the next.

transverse barrel vault—In medieval architecture, a semicylindrical *vault* oriented at a 90-degree angle to the *nave* of a church.

transverse rib—See rib.

treasury—In ancient Greece, a small building set up for the safe storage of *votive offerings*.

trefoil—A cloverlike ornament or symbol with stylized leaves in groups of three.

tribune—In church architecture, a gallery over the inner *aisle* flanking the *nave*.

triclinium—The dining room of a Roman house.

trident—The three-pronged pitchfork associated with the ancient Greek sea god Poseidon (Roman, Neptune).

triforium—In a Gothic cathedral, the blind arcaded gallery below the clerestory; occasionally, the arcades are filled with stained glass.

triglyph—A triple projecting, grooved member of a *Doric frieze* that alternates with *metopes*.

trilithons—A pair of *monoliths* topped with a *lintel*; found in *megalithic* structures.

Trinity—In Christianity, God the Father, his son Jesus Christ, and the Holy Spirit.

tripod—An ancient Greek deep bowl on a tall three-legged stand.

triptych—A three-paneled painting, ivory plaque, or altarpiece. Also, a small, portable shrine with hinged wings used for private devotion.

trumeau—In church architecture, the pillar or center post supporting the lintel in the middle of the doorway.

tubicen—Latin, "trumpet player."

tumulus (pl. tumuli)—Latin, "burial mound." In Etruscan architecture, tumuli cover one or more subterranean multichambered tombs cut out of the local tufa (limestone). Also characteristic of the Japanese Kofun period of the third and fourth centuries.

tunnel vault—See vault.

turris—See westwork.

Tuscan column—The standard type of Etruscan *column*. It resembles ancient Greek *Doric* columns but is made of wood, is unfluted, and has a *base*. Also a popular motif in *Renaissance* and *Baroque* architecture.

twisted perspective—See composite view.

tympanum (pl. **tympana**)—The space enclosed by a *lintel* and an *arch* over a doorway.

typology—In Christian theology, the recognition of concordances between events, especially between episodes in the Old and New Testaments.

uraeus—An Egyptian cobra; one of the emblems of *pharaonic* kingship.

ushabti—In ancient Egypt, a figurine placed in a tomb to act as a servant to the deceased in the afterlife.

valley temple—The temple closest to the Nile River associated with each of the Great Pyramids at Gizeh in ancient Egypt.

value—See color.

vassal—In feudalism, a person who swears allegiance to a liege lord and renders him military service in return for tenure of a portion of the lord's land.

vault (adj. vaulted) — A masonry roof or ceiling constructed on the arch principle, or a concrete roof of the same shape. A barrel (or tunnel) vault, semicylindrical in cross-section, is in effect a deep arch or an uninterrupted series of arches, one behind the other, over an oblong space. A quadrant vault is a half-barrel vault. A groin (or cross) vault is formed at the point at which two barrel vaults intersect at right angles. In a ribbed vault, there is a framework of ribs or arches under the intersections of the vaulting sections. A sexpartite vault is one whose ribs divide the vault into six compartments. A fan vault is a vault characteristic of English Perpendicular Gothic architecture, in which radiating ribs form a fanlike pattern.

vaulting web—See web.

velarium—In a Roman amphitheater, the cloth awning that could be rolled down from the top of the cavea to shield spectators from sun or rain.

- **vellum**—Calfskin prepared as a surface for writing or painting.
- **venationes**—Ancient Roman wild animal hunts staged in an *amphitheater*.
- veristic—True to natural appearance; superrealistic. vita contemplativa—Latin, "contemplative life." The secluded spiritual life of monks and nuns.
- **volume**—The *space* that *mass* organizes, divides, or encloses.
- volute—A spiral, scroll-like form characteristic of the ancient Greek *Ionic* and the Roman *Composite capital*. votive offering—A gift of gratitude to a deity.
- **voussoir**—A wedge-shaped stone block used in the construction of a true *arch*. The central voussoir, which sets the arch, is called the keystone.
- warp—The vertical threads of a loom or cloth.
- **web**—The masonry blocks that fill the area between the *ribs* of a *groin vault*. Also called vaulting web.
- wedjat—The eye of the Egyptian falcon-god Horus, a powerful *amulet*.
- **weld**—To join metal parts by heating, as in assembling the separate parts of a *statue* made by *casting*.
- **westwork**—German, "western entrance structure." The *facade* and towers at the western end of a medieval
- church, principally in Germany. In contemporary documents the westwork is called a castellum (Latin, "castle" or "fortress") or turris ("tower").
- white-ground painting—An ancient Greek vasepainting *technique* in which the pot was first covered with a *slip* of very fine white clay, over which black *glaze* was used to outline figures, and diluted brown, purple, red, and white were used to color them.
- **ziggurat**—In ancient Mesopotamian architecture, a monumental platform for a temple.

405

BIBLIOGRAPHY

This list of books is very selective but comprehensive enough to satisfy the reading interests of the beginning art history student and general reader. The resources listed range from works that are valuable primarily for their reproductions to those that are scholarly surveys of schools and periods or monographs on individual artists. The emphasis is on recent in-print books and on books likely to be found in college and municipal libraries. No entries for periodical articles appear, but the bibliography begins with a list of some of the major journals that publish art historical scholarship in English.

SELECTED PERIODICALS

African Arts American Art American Indian Art American Journal of Archaeology Antiquity Archaeology Archives of American Art Archives of Asian Art Ars Orientalis Art Bulletin Art History Art in America Art Iournal Artforum International Burlington Magazine Gesta History of Photography Journal of Roman Archaeology Journal of the Society of Architectural Historians Journal of the Warburg and Courtauld Institutes Latin American Antiquity Oxford Art Journal Women's Art Journal

GENERAL STUDIES

- Baxandall, Michael. *Patterns of Intention: On the Historical Explanation of Pictures*. New Haven, Conn.: Yale University Press, 1985.
- Bindman, David, ed. The Thames & Hudson Encyclopedia of British Art. London: Thames & Hudson, 1988.
- Boström, Antonia. *The Encyclopedia of Sculpture*. 3 vols. London: Routledge, 2003.
- Broude, Norma, and Mary D. Garrard, eds. *The Expanding Discourse: Feminism and Art History.* New York: Harper Collins, 1992.
- Bryson, Norman. Vision and Painting: The Logic of the Gaze. New Haven, Conn.: Yale University Press, 1983.
- Bryson, Norman, Michael Ann Holly, and Keith Moxey. Visual Theory: Painting and Interpretation. New York: Cambridge University Press, 1991.
- Büttner, Nils. *Landscape Painting: A History*. New York: Abbeville, 2006.
- Chadwick, Whitney. *Women, Art, and Society.* 4th ed. New York: Thames & Hudson, 2007.

- Cheetham, Mark A., Michael Ann Holly, and Keith Moxey, eds. *The Subjects of Art History: Historical Objects in Contemporary Perspective.* New York: Cambridge University Press, 1998.
- Chilvers, Ian, and Harold Osborne, eds. *The Oxford Dictionary of Art.* 3d ed. New York: Oxford University Press, 2004.
- Corbin, George A. Native Arts of North America, Africa, and the South Pacific: An Introduction. New York: Harper Collins, 1988.
- Crouch, Dora P., and June G. Johnson. *Traditions in Architecture: Africa, America, Asia, and Oceania*. New York: Oxford University Press, 2000.
- Curl, James Stevens. Oxford Dictionary of Architecture and Landscape Architecture. 2d ed. New York: Oxford University Press, 2006.
- *Encyclopedia of World Art.* 17 vols. New York: McGraw-Hill, 1959–1987.
- Fielding, Mantle. *Dictionary of American Painters, Sculptors, and Engravers.* 2d ed. Poughkeepsie, N.Y.: Apollo, 1986.
- Fine, Sylvia Honig. Women and Art: A History of Women Painters and Sculptors from the Renaissance to the 20th Century. Rev. ed. Montclair, N.J.: Alanheld & Schram, 1978.
- Fleming, John, Hugh Honour, and Nikolaus Pevsner. The Penguin Dictionary of Architecture and Landscape Architecture. 5th ed. New York: Penguin,
- Frazier, Nancy. *The Penguin Concise Dictionary of Art History*. New York: Penguin, 2000.
- Freedberg, David. *The Power of Images: Studies in the History and Theory of Response.* Chicago: University of Chicago Press, 1989.
- Gaze, Delia., ed. *Dictionary of Women Artists.* 2 vols. London: Routledge, 1997.
- Hall, James. Illustrated Dictionary of Subjects and Symbols in Eastern and Western Art. New York: Icon Editions, 1994.
- Harris, Anne Sutherland, and Linda Nochlin. *Women Artists:* 1550–1950. Los Angeles: Los Angeles County Museum of Art; New York: Knopf, 1977.
- Hauser, Arnold. *The Sociology of Art.* Chicago: University of Chicago Press, 1982.
- Hults, Linda C. The Print in the Western World: An Introductory History. Madison: University of Wisconsin Press, 1996.

- Kemp, Martin. The Science of Art: Optical Themes in Western Art from Brunelleschi to Seurat. New Haven, Conn.: Yale University Press, 1990.
- Kostof, Spiro, and Gregory Castillo. *A History of Architecture: Settings and Rituals.* 2d ed. Oxford: Oxford University Press, 1995.
- Kultermann, Udo. *The History of Art History.* New York: Abaris, 1993.
- Lucie-Smith, Edward. *The Thames & Hudson Dictionary of Art Terms*. 2d ed. New York: Thames & Hudson, 2004.
- Moffett, Marian, Michael Fazio, and Lawrence Wadehouse. *A World History of Architecture*. Boston: McGraw-Hill, 2004.
- Murray, Peter, and Linda Murray. *A Dictionary of Art and Artists*. 7th ed. New York: Penguin, 1998.
- Nelson, Robert S., and Richard Shiff, eds. *Critical Terms* for Art History. Chicago: University of Chicago Press, 1996.
- Penny, Nicholas. *The Materials of Sculpture*. New Haven, Conn.: Yale University Press, 1993.
- Pevsner, Nikolaus. *A History of Building Types*. London: Thames & Hudson, 1987. Reprint of 1979 ed.
- ——. An Outline of European Architecture. 8th ed. Baltimore: Penguin, 1974.
- Pierce, James Smith. *From Abacus to Zeus: A Hand-book of Art History.* 7th ed. Upper Saddle River, N.J.: Pearson Prentice Hall, 1998.
- Placzek, Adolf K., ed. *Macmillan Encyclopedia of Architects.* 4 vols. New York: Macmillan, 1982.
- Podro, Michael. *The Critical Historians of Art.* New Haven, Conn.: Yale University Press, 1982.
- Pollock, Griselda. Vision and Difference: Femininity, Feminism, and Histories of Art. London: Routledge, 1988.
- Preziosi, Donald, ed. *The Art of Art History: A Critical Anthology.* New York: Oxford University Press, 1998
- Read, Herbert. The Thames & Hudson Dictionary of Art and Artists. Rev. ed. New York: Thames & Hudson, 1994.
- Reid, Jane D. *The Oxford Guide to Classical Mythology in the Arts 1300–1990s.* 2 vols. New York: Oxford University Press, 1993.
- Roth, Leland M. *Understanding Architecture: Its Elements, History, and Meaning.* 2d ed. Boulder, Colo.: Westview, 2006.

- Schama, Simon. *The Power of Art*. New York: Ecco, 2006. Slatkin, Wendy. *Women Artists in History: From Antiquity to the 20th Century.* 4th ed. Upper Saddle River, N.J.: Prentice Hall, 2000.
- Steer, John, and Antony White. Atlas of Western Art History: Artists, Sites, and Monuments from Ancient Greece to the Modern Age. New York: Facts on File, 1994.
- Stratton, Arthur. *The Orders of Architecture: Greek, Roman, and Renaissance*. London: Studio, 1986.
- Sutton, Ian. Western Architecture: From Ancient Greece to the Present. New York: Thames & Hudson, 1999.
- Trachtenberg, Marvin, and Isabelle Hyman. *Architecture, from Prehistory to Post-Modernism.* 2d ed. Upper Saddle River, N.J.: Prentice Hall, 2003.
- Turner, Jane, ed. *The Dictionary of Art.* 34 vols. New ed. New York: Oxford University Press, 2003.
- Wittkower, Rudolf. *Sculpture Processes and Principles*. New York: Harper & Row, 1977.
- Wren, Linnea H., and Janine M. Carter, eds. Perspectives on Western Art: Source Documents and Readings from the Ancient Near East through the Middle Ages. New York: Harper & Row, 1987.

CHAPTER 8: LATE ANTIQUITY

- Bowersock, G. W., Peter Brown, and Oleg Grabar, eds. *Late Antiquity: A Guide to the Postclassical World*. Cambridge, Mass.: Harvard University Press, 1998.
- Elsner, Jaś. Art and the Roman Viewer: The Transformation of Art from the Pagan World to Christianity. New York: Cambridge University Press, 1995.
- ——. Imperial Rome and Christian Triumph. New York: Oxford University Press, 1998.
- Finney, Paul Corby. The Invisible God: The Earliest Christians on Art. New York: Oxford University Press, 1994.
- Grabar, André. *The Beginnings of Christian Art*, 200–395. London: Thames & Hudson, 1967.
- ——. *Christian Iconography.* Princeton, N.J.: Princeton University Press, 1980.
- Gutmann, Joseph. Sacred Images: Studies in Jewish Art from Antiquity to the Middle Ages. Northampton, Mass.: Variorum, 1989.
- Janes, Dominic. God and Gold in Late Antiquity. New York: Cambridge University Press, 1998.
- Jensen, Robin Margaret. *Understanding Early Christian Art.* New York: Routledge, 2000.
- Koch, Guntram. Early Christian Art and Architecture. London: SCM, 1996.
- Krautheimer, Richard. Rome, Profile of a City: 312–1308. Princeton, N.J.: Princeton University Press, 1980.
- Krautheimer, Richard, and Slobodan Curcić. *Early Christian and Byzantine Architecture*. 4th ed. New Haven, Conn.: Yale University Press, 1986.
- Lowden, John. *Early Christian and Byzantine Art*. London: Phaidon, 1997.
- Mathews, Thomas P. *The Clash of Gods: A Reinterpretation of Early Christian Art.* Rev. ed. Princeton, N.J.: Princeton University Press, 1999.
- Milburn, Robert. *Early Christian Art and Architecture*. Berkeley: University of California Press, 1988.
- Nicolai, Vincenzo Fiocchi, Fabrizio Bisconti, and Danilo Mazzoleni. The Christian Catacombs of Rome: History, Decoration, Inscriptions. Regensburg: Schnell & Steiner, 2006.
- Perkins, Ann Louise. *The Art of Dura-Europos*. Oxford: Clarendon, 1973.

- Volbach, Wolfgang, and Max Hirmer. *Early Christian Art*. New York: Abrams, 1962.
- Webster, Leslie, and Michelle Brown, eds. *The Transformation of the Roman World*, AD 400–900. Berkeley: University of California Press, 1997.
- Weitzmann, Kurt. *Late Antique and Early Christian Book Illumination*. New York: Braziller, 1977.
- ——, ed. Age of Spirituality: Late Antique and Early Christian Art, Third to Seventh Century. New York: Metropolitan Museum of Art, 1979.

CHAPTER 9: BYZANTIUM

- Barber, Charles. Figure and Likeness: On the Limits of Representation in Byzantine Iconoclasm. Princeton, N.J.: Princeton University Press, 2002.
- Borsook, Eve. Messages in Mosaic: The Royal Programmes of Norman Sicily. Oxford: Clarendon, 1990
- Cormack, Robin. *Byzantine Art.* New York: Oxford University Press, 2000.
- ———. Painting the Soul: Icons, Death Masks, and Shrouds. London: Reaktion, 1997.
- ——. Writing in Gold: Byzantine Society and Its Icons. New York: Oxford University Press, 1985.
- Cutler, Anthony. The Hand of the Master: Craftsmanship, Ivory, and Society in Byzantium, 9th–11th Centuries. Princeton, N.J.: Princeton University Press, 1994.
- Demus, Otto. *The Mosaic Decoration of San Marco, Venice.* Chicago: University of Chicago Press, 1990.
- Evans, Helen C., and William D. Wixom, eds. *The Glory of Byzantium: Art and Culture of the Middle Byzantine Era AD 843–1261*. New York: Metropolitan Museum of Art, 1997.
- Grabar, André. *The Golden Age of Justinian: From the Death of Theodosius to the Rise of Islam.* New York: Odyssey, 1967.
- Grabar, André, and Manolis Chatzidakis. Greek Mosaics of the Byzantine Period. New York: New American Library, 1964.
- Lowden, John. *Early Christian and Byzantine Art.* London: Phaidon, 1997.
- Maguire, Henry. Art and Eloquence in Byzantium. Princeton, N.J.: Princeton University Press, 1981.
- ——. The Icons of Their Bodies: Saints and Their Images in Byzantium. Princeton, N.J.: Princeton University Press, 1996.
- Mainstone, Rowland J. Hagia Sophia: Architecture, Structure, and Liturgy of Justinian's Great Church. London: Thames & Hudson, 1988.
- Mango, Cyril. Art of the Byzantine Empire, 312–1453: Sources and Documents. Toronto: University of Toronto Press, 1986. Reprint of 1972 ed.
- ——. *Byzantine Architecture*. New York: Electa/Rizzoli, 1985.
- Mark, Robert, and Ahmet S. Cakmak, eds. *Hagia Sophia from the Age of Justinian to the Present*. New York: Cambridge University Press, 1992.
- Mathews, Thomas F. *Byzantium: From Antiquity to the Renaissance.* New York: Abrams, 1998.
- Ousterhout, Robert. *Master Builders of Byzantium*. Princeton, N.J.: Princeton University Press, 2000.
- Pelikan, Jaroslav. Imago Dei: The Byzantine Apologia for Icons. Princeton, N.J.: Princeton University Press, 1990.
- Rodley, Lyn. Byzantine Art and Architecture: An Introduction. New York: Cambridge University Press, 1994.

- Von Simson, Otto G. Sacred Fortress: Byzantine Art and Statecraft in Ravenna. Princeton, N.J.: Princeton University Press, 1986.
- Weitzmann, Kurt. The Icon. New York: Dorset, 1987.

CHAPTER 10: THE ISLAMIC WORLD

- Allan, James, and Sheila R. Canby. Hunt for Paradise: Court Arts of Safavid Iran 1501–76. Geneva: Skira, 2004.
- Atil, Esin. *The Age of Sultan Suleyman the Magnificent.* Washington, D.C.: National Gallery of Art, 1987.
- Baker, Patricia L. *Islamic Textiles*. London: British Museum, 1995.
- Blair, Sheila S., and Jonathan Bloom. *The Art and Architecture of Islam 1250–1800*. New Haven, Conn.: Yale University Press, 1994.
- Bloom, Jonathan, and Sheila S. Blair. *Islamic Arts*. London: Phaidon, 1997.
- Brend, Barbara. *Islamic Art.* Cambridge, Mass.: Harvard University Press, 1991.
- Canby, Sheila R. *Persian Painting*. London: British Museum, 1993.
- Dodds, Jerrilynn D., ed. Al-Andalus: The Art of Islamic Spain. New York: Metropolitan Museum of Art, 1992.
- Ettinghausen, Richard, Oleg Grabar, and Marilyn Jenkins-Madina. *The Art and Architecture of Islam,* 650–1250. Rev. ed. New Haven, Conn.: Yale University Press, 2001.
- Ferrier, Ronald W., ed. *The Arts of Persia*. New Haven, Conn.: Yale University Press, 1989.
- Frishman, Martin, and Hasan-Uddin Khan. The Mosque: History, Architectural Development, and Regional Diversity. New York: Thames & Hudson, 1994.
- Goodwin, Godfrey. *A History of Ottoman Architecture*. 2d ed. New York: Thames & Hudson, 1987.
- Grabar, Oleg. *The Alhambra*. Cambridge, Mass.: Harvard University Press, 1978.
- -----. The Formation of Islamic Art. Rev. ed. New Haven, Conn.: Yale University Press, 1987.
- Grube, Ernst J. Architecture of the Islamic World: Its History and Social Meaning. 2d ed. New York: Thames & Hudson, 1984.
- Hattstein, Markus, and Peter Delius, eds. *Islam: Art and Architecture.* Cologne: Könemann, 2000.
- Hillenbrand, Robert. Islamic Architecture: Form, Function, Meaning. Edinburgh: Edinburgh University Press, 1994.
- ——. *Islamic Art and Architecture.* New York: Thames & Hudson, 1999.
- Irwin, Robert. *Islamic Art in Context: Art, Architecture, and the Literary World.* New York: Abrams, 1997.
- Michell, George, ed. *Architecture of the Islamic World*. New York: Thames & Hudson, 1978.
- Necipoglu, Gulru. *The Age of Sinan: Architectural Culture in the Ottoman Empire*. Princeton, N.J.: Princeton University Press, 2005.
- Porter, Venetia. *Islamic Tiles*. London: British Museum, 1995.
- Robinson, Frank. *Atlas of the Islamic World*. Oxford: Equinox, 1982.
- Schimmel, Annemarie. *Calligraphy and Islamic Culture*. New York: New York University Press, 1984.
- Stierlin, Henri. *Islam I: Early Architecture from Bagh-dad to Cordoba*. Cologne: Taschen, 1996.
- ------. Islamic Art and Architecture from Isfahan to the Taj Mahal. New York: Thames & Hudson, 2002.

- Ward, Rachel M. *Islamic Metalwork*. New York: Thames & Hudson, 1993.
- Welch, Anthony. *Calligraphy in the Arts of the Islamic World*. Austin: University of Texas Press, 1979.

Chapter 11: Early Medieval Europe

- Alexander, Jonathan J. G. *Insular Manuscripts, Sixth to the Ninth Century.* London: Miller, 1978.
- The Art of Medieval Spain, AD 500–1200. New York: Metropolitan Museum of Art, 1993.
- Backhouse, Janet, D. H. Turner, and Leslie Webster, eds. *The Golden Age of Anglo-Saxon Art*, 966–1066. Bloomington: Indiana University Press, 1984.
- Barral i Altet, Xavier. *The Early Middle Ages: From Late Antiquity to AD 1000*. Cologne: Taschen, 1997.
- Brown, Katharine Reynolds, Dafydd Kidd, and Charles T. Little, eds. *From Attila to Charlemagne*. New York: Metropolitan Museum of Art, 2000.
- Collins, Roger. *Early Medieval Europe*, 300–1000. New York: St. Martin's, 1991.
- Conant, Kenneth J. Carolingian and Romanesque Architecture, 800–1200. 4th ed. New Haven, Conn.: Yale University Press, 1992.
- Davis-Weyer, Caecilia. *Early Medieval Art, 300–1150:*Sources and Documents. Toronto: University of Toronto Press, 1986. Reprint of 1971 ed.
- Diebold, William J. Word and Image: An Introduction to Early Medieval Art. Boulder, Colo.: Westview Press, 2000.
- Dodwell, Charles R. *Anglo-Saxon Art: A New Perspective*. Ithaca, N.Y.: Cornell University Press, 1982.
- ——. *The Pictorial Arts of the West, 800–1200.* New Haven, Conn.: Yale University Press, 1993.
- Harbison, Peter. *The Golden Age of Irish Art: The Medieval Achievement 600–1200.* New York: Thames & Hudson, 1999.
- Henderson, George. From Durrow to Kells: The Insular Gospel-Books, 650–800. London: Thames & Hudson, 1987.
- Hubert, Jean, Jean Porcher, and Wolfgang Fritz Volbach. The Carolingian Renaissance. New York: Braziller, 1970.
- ——. Europe of the Invasions. New York: Braziller, 1969.
- Klindt-Jensen, Ole, and David M. Wilson. *Viking Art.* 2d ed. Minneapolis: University of Minnesota Press, 1980.
- Mayr-Harting, Henry. *Ottonian Book Illumination: An Historical Study.* 2 vols. London: Miller, 1991–1993.
- McClendon, Charles. *The Origins of Medieval Architecture: Building in Europe*, AD 600–900. New Haven, Conn.: Yale University Press, 2005.
- Megaw, Ruth, and John Vincent Megaw. *Celtic Art:*From Its Beginning to the Book of Kells. New York:
 Thames & Hudson, 1989.
- Mütherich, Florentine, and Joachim E. Gaehde. *Carolingian Painting*. New York: Braziller, 1976.
- Nees, Lawrence J. *Early Medieval Art.* New York: Oxford University Press, 2002.
- Nordenfalk, Carl. Celtic and Anglo-Saxon Painting: Book Illumination in the British Isles, 600–800. New York: Braziller, 1977.
- O'Brien, Jacqueline, and Peter Harbison. Ancient Ireland: From Prehistory to the Middle Ages. New York: Oxford University Press, 2000.
- Richardson, Hilary, and John Scarry. *An Introduction to Irish High Crosses*. Dublin: Mercier, 1996.
- Stalley, Roger. *Early Medieval Architecture*. New York: Oxford University Press, 1999.

Wilson, David M. Anglo-Saxon Art: From the Seventh Century to the Norman Conquest. London: Thames & Hudson, 1984.

Chapter 12: Romanesque Europe

- Armi, C. Edson. Masons and Sculptors in Romanesque Burgundy: The New Aesthetics of Cluny III. 2 vols. University Park: Pennsylvania State University Press, 1983.
- Barral i Altet, Xavier. *The Romanesque: Towns, Cathedrals, and Monasteries*. Cologne: Taschen, 1998.
- Cahn, Walter. *Romanesque Bible Illumination*. Ithaca, N.Y.: Cornell University Press, 1982.
- ——. Romanesque Manuscripts: The Twelfth Century. 2 vols. London: Miller, 1998.
- Conant, Kenneth J. Carolingian and Romanesque Architecture, 800–1200. 4th ed. New Haven, Conn.: Yale University Press, 1992.
- Demus, Otto. *Romanesque Mural Painting*. New York: Thames & Hudson, 1970.
- Dodwell, Charles R. *The Pictorial Arts of the West*, 800–1200. New Haven, Conn.: Yale University Press, 1993.
- Fergusson, Peter. Architecture of Solitude: Cistercian Abbeys in Twelfth-Century Europe. Princeton, N.J.: Princeton University Press, 1984.
- Grape, Wolfgang. *The Bayeux Tapestry: Monument to a Norman Triumph*. New York: Prestel, 1994.
- Hearn, Millard F. Romanesque Sculpture: The Revival of Monumental Stone Sculpture in the Eleventh and Twelfth Centuries. Ithaca, N.Y.: Cornell University Press, 1981.
- Kahn, Deborah, ed. *The Romanesque Frieze and Its Spectator*. London: Miller, 1992.
- Male, Émile. Religious Art in France: The Twelfth Century. Rev. ed. Princeton, N.J.: Princeton University Press, 1978.
- Minne-Sève, Viviane, and Hervé Kergall. Romanesque and Gothic France: Architecture and Sculpture. New York: Abrams, 2000.
- Nichols, Stephen G. Romanesque Signs: Early Medieval Narrative and Iconography. New Haven, Conn.: Yale University Press, 1983.
- Nordenfalk, Carl. *Early Medieval Book Illumination*. New York: Rizzoli, 1988.
- Petzold, Andreas. *Romanesque Art*. New York: Abrams, 1995.
- Schapiro, Meyer. *The Sculpture of Moissac*. New York: Thames & Hudson, 1985.
- Stalley, Roger. *Early Medieval Architecture*. New York: Oxford University Press, 1999.
- Tate, Robert B., and Marcus Tate. *The Pilgrim Route to Santiago*. Oxford: Phaidon, 1987.
- Toman, Rolf, ed. *Romanesque: Architecture, Sculpture, Painting.* Cologne: Könemann, 1997.
- Zarnecki, George, Janet Holt, and Tristram Holland, eds. *English Romanesque Art, 1066–1200.* London: Weidenfeld & Nicolson, 1984.

Chapter 13: Gothic Europe

- Bony, Jean. *The English Decorated Style: Gothic Architecture Transformed, 1250–1350.* Ithaca, N.Y.: Cornell University Press, 1979.
- ——. French Gothic Architecture of the Twelfth and Thirteenth Centuries. Berkeley: University of California Press, 1983.
- Branner, Robert. *Manuscript Painting in Paris during* the Reign of St. Louis. Berkeley: University of California Press, 1977.

- ———. St. Louis and the Court Style in Gothic Architecture. London: Zwemmer, 1965.
- —, ed. Chartres Cathedral. New York: Norton,
- Brown, Sarah, and David O'Connor. *Glass-Painters* (*Medieval Craftsmen*). Toronto: University of Toronto Press, 1991.
- Camille, Michael. *Gothic Art: Glorious Visions*. New York: Abrams, 1996.
- The Gothic Idol: Ideology and Image-Making in Medieval Art. New York: Cambridge University Press, 1989.
- Courtenay, Lynn T., ed. *The Engineering of Medieval Cathedrals*. Aldershot: Scolar, 1997.
- Erlande-Brandenburg, Alain. *The Cathedral: The Social and Architectural Dynamics of Construction*. New York: Cambridge University Press, 1994.
- Favier, Jean. *The World of Chartres*. New York: Abrams, 1990.
- Fitchen, John. *The Construction of Gothic Cathedrals:*A Study of Medieval Vault Erection. Chicago: University of Chicago Press, 1981.
- Frankl, Paul, and Paul Crossley. *Gothic Architecture*. New Haven, Conn.: Yale University Press, 2000.
- The Gothic: Literary Sources and Interpretations through Eight Centuries. Princeton, N.J.: Princeton University Press, 1960.
- Frisch, Teresa G. *Gothic Art 1140–c. 1450: Sources and Documents.* Toronto: University of Toronto Press, 1987. Reprint of 1971 ed.
- Gerson, Paula, ed. *Abbot Suger and Saint-Denis*. New York: Metropolitan Museum of Art, 1986.
- Grodecki, Louis. *Gothic Architecture*. New York: Electa/Rizzoli, 1985.
- Grodecki, Louis, and Catherine Brisac. *Gothic Stained Glass*, *1200–1300*. Ithaca, N.Y.: Cornell University Press, 1985.
- Jantzen, Hans. High Gothic: The Classic Cathedrals of Chartres, Reims, Amiens. Princeton, N.J.: Princeton University Press, 1984.
- Male, Émile. Religious Art in France: The Thirteenth Century. Rev. ed. Princeton, N.J.: Princeton University Press, 1984.
- Minne-Sève, Viviane, and Hervé Kergall. Romanesque and Gothic France: Architecture and Sculpture. New York: Abrams, 2000.
- Nussbaum, Norbert. German Gothic Church Architecture. New Haven, Conn.: Yale University Press, 2000.
- Panofsky, Erwin. *Abbot Suger on the Abbey Church of St. Denis and Its Art Treasures.* 2d ed. Princeton, N.J.: Princeton University Press, 1979.
- Radding, Charles M., and William W. Clark. *Medieval Architecture, Medieval Learning.* New Haven, Conn.: Yale University Press, 1992.
- Rudolph, Conrad. Artistic Change at St-Denis: Abbot Suger's Program and the Early Twelfth-Century Controversy over Art. Princeton, N.J.: Princeton University Press, 1990.
- Sauerländer, Willibald, and Max Hirmer. *Gothic Sculpture in France*, 1140–1270. New York: Abrams, 1973.
- Scott, Robert A. The Gothic Enterprise: A Guide to Understanding the Medieval Cathedral. Berkeley and Los Angeles: University of California Press, 2003.
- Simson, Otto G. von. *The Gothic Cathedral: Origins of Gothic Architecture and the Medieval Concept of Order.* 3d ed. Princeton, N.J.: Princeton University Press, 1988.
- Toman, Rolf, ed. *The Art of Gothic: Architecture, Sculpture, Painting.* Cologne: Könemann, 1999.

- Williamson, Paul. *Gothic Sculpture*, 1140–1300. New Haven, Conn.: Yale University Press, 1995.
- Wilson, Christopher. *The Gothic Cathedral: The Architecture of the Great Church*, 1130–1530. London: Thames & Hudson, 1990.

RENAISSANCE ART, GENERAL

- Adams, Laurie Schneider. *Italian Renaissance Art.* Boulder, Colo.: Westview, 2001.
- Andrés, Glenn M., John M. Hunisak, and Richard Turner. The Art of Florence. 2 vols. New York: Abbeville, 1988.
- Campbell, Gordon. *Renaissance Art and Architecture*. New York: Oxford University Press, 2005.
- Campbell, Lorne. Renaissance Portraits: European Portrait-Painting in the Fourteenth, Fifteenth, and Sixteenth Centuries. New Haven, Conn.: Yale University Press, 1990.
- Cole, Bruce. Italian Art, 1250–1550: The Relation of Renaissance Art to Life and Society. New York: Harper & Row, 1987.
- The Renaissance Artist at Work: From Pisano to Titian. New York: Harper Collins, 1983,
- Frommel, Christoph Luitpold. The Architecture of the Italian Renaissance. London: Thames & Hudson, 2007.
- Hall, Marcia B. Color and Meaning: Practice and Theory in Renaissance Painting. Cambridge: Cambridge University Press, 1992.
- Hartt, Frederick, and David G. Wilkins. History of Italian Renaissance Art. 6th ed. Upper Saddle River, N.J.: Prentice Hall, 2006.
- Haskell, Francis, and Nicholas Penny. Taste and the Antique: The Lure of Classical Sculpture 1500–1900.
 New Haven, Conn.: Yale University Press, 1981.
- Kent, F. W., and Patricia Simons, eds. Patronage, Art, and Society in Renaissance Italy. Canberra: Hu-

- manities Research Centre and Clarendon Press,
- Levey, Michael. *Florence: A Portrait*. Cambridge, Mass.: Harvard University Press, 1998.
- Lubbock, Jules. Storytelling in Christian Art from Giotto to Donatello. New Haven, Conn.: Yale University Press, 2006.
- Paoletti, John T., and Gary M. Radke. *Art, Power, and Patronage in Renaissance Italy.* Upper Saddle River, N.J.: Prentice Hall, 2005.
- Pope-Hennessy, John. *Introduction to Italian Sculpture*. 3d ed. 3 vols. New York: Phaidon, 1986.
- Richardson, Carol M., Kim W. Woods, and Michael W. Franklin. *Renaissance Art Reconsidered: An Anthology of Primary Sources*. Oxford: Blackwell, 2007
- Smith, Jeffrey Chipps. *The Northern Renaissance*. New York: Phaidon, 2004.
- Snyder, James, Larry Silver, and Henry Luttikhuizen. Northern Renaissance Art: Painting, Sculpture, the Graphic Arts from 1350 to 1575. Upper Saddle River, N.J.: Prentice Hall, 2005.
- Thomson, David. Renaissance Architecture: Critics, Patrons, and Luxury. Manchester: Manchester University Press, 1993.
- Wittkower, Rudolf. Architectural Principles in the Age of Humanism. 4th ed. London: Academy, 1988.

Chapter 14: Italy, 1200 to 1400

- Bomford, David. Art in the Making: Italian Painting before 1400. London: National Gallery, 1989.
- Borsook, Eve, and Fiorelli Superbi Gioffredi. Italian Altarpieces 1250–1550: Function and Design. Oxford: Clarendon, 1994.
- Cole, Bruce. Sienese Painting: From Its Origins to the Fifteenth Century. New York: Harper Collins, 1987.

- Hills, Paul. *The Light of Early Italian Painting*. New Haven, Conn.: Yale University Press, 1987.
- Maginnis, Hayden B. J. *Painting in the Age of Giotto: A Historical Reevaluation.* University Park: Pennsylvania State University Press, 1997.
- . The World of the Early Sienese Painter. University Park: Pennsylvania State University Press, 2001.
- Meiss, Millard. Painting in Florence and Siena after the Black Death. Princeton, N.J.: Princeton University Press, 1976.
- Moskowitz, Anita Fiderer. *Italian Gothic Sculpture, c. 1250–c. 1400.* Cambridge: Cambridge University Press, 2001.
- Norman, Diana, ed. *Siena, Florence, and Padua: Art, Society, and Religion 1280–1400.* New Haven, Conn.: Yale University Press, 1995.
- Pope-Hennessy, John. *Italian Gothic Sculpture*. 3d ed. Oxford: Phaidon, 1986.
- Stubblebine, James H. Duccio di Buoninsegna and His School. Princeton, N.J.: Princeton University Press, 1979.
- White, John. Art and Architecture in Italy: 1250–1400.
 3d ed. New Haven, Conn.: Yale University Press,
 1993.
- ------. Duccio: Tuscan Art and the Medieval Work-shop. London: Thames & Hudson, 1979.

CREDITS

Chapter 8—8-1: © Cameraphoto Arte, Venice/Art Resource, NY; 8-2: © Erich Lessing/Art Resource, NY; 8-3: © Art Resource, NY; 8-5: Pontificia Commissione per l'Archeologia Sacra; 8-6: Photo by Darius Arya; 8-7: Foto Archivio di San Pietro in Vaticano; 8-8: Courtesy Saskia Ltd., © Dr. Ron Wiedenhoeft; 8-10: Courtesy Saskia Ltd., © Dr. Ron Wiedenhoeft; 8-11: © Scala/Art Resource, NY; 8-13: Canali Photobank, Italy; 8-14: © Scala/Art Resource, NY; 8-15: © Vanni/Art Resource, NY; 8-16: © Scala/Art Resource, NY; 8-17: © Scala/Art Resource, NY; 8-18: © Scala/Art Resource, NY; 8-19: Copyright © Biblioteca Apostolica Vaticana; 8-20: Österreichische Nationalbibliothek, Vienna, Bildarchiv. folio 7 recto of the Vienna Genesis; 8-21: © Scala/Art Resource, NY; 8-22: © British Museum/HIP/Art Resource, NY; 8-23: © Victoria & Albert Museum, London, UK/The Bridgeman Art Library, NY.

Chapter 9—9-1: The Art Archive/Dagli Orti; 9-2: © Yann Arthus-Bertrand/CORBIS; 9-4: Photo, Henri Stierlin; 9-6: Archivio e Studio Folco Quilici, Roma; 9-8: Canali Photobank, Italy; 9-9: © Scala/Art Resource, NY; 9-10: Canali Photobank, Italy; 9-11: Canali Photobank, Italy; 9-11: © Scala/Art Resource, NY; 9-13: © Ronald Sheraton/Ancient Art and Architecture Collection Ltd.; 9-14: © Réunion des Musées Nationaux/Art Resource, NY; 9-15: © British Museum/HIP/Art Resource, NY; 9-16: Österreichische Nationalbibliothek, Vienna, Bildarchiv, Cod.med.gr. 1, fol. 6v; 9-17: Firenze, Biblioteca Medicea Laurenziana, Ms. Laur. Plut. 1.56, c. 13v; 9-18: © Ronald Sheraton/Ancient Art and Architecture Collection Ltd.; 9-19: © Erich Lessing/Art Resource, NY; 9-20: © Scala/Art Resource, NY; 9-22: © Vanni/Art Resource, NY; 9-23: Studio Kontos; 9-24: © Alinari/Art Resource, NY; 9-25: © Scala/Art Resource, NY; 9-26: © Réunion des Musées Nationaux/Art Resource, NY; 9-27: Josephine Powell; 9-28: © Snark/Art Resource, NY; 9-29: © Scala/Art Resource, NY; 9-30: Kariye Camii, Istanbul, Turkey, © Held Collection/The Bridgeman Art Library, NY; 9-31: Con Gallery of Saint Clement, Ohrid; 9-32: © Erich Lessing/Art Resource, NY; 9-33: © Scala/Art Resource, NY; 9-33: © Scala/Art

Chapter 10—10-1: The Art Archive/Dagli Orti; 10-2: © Moshe Shai/CORBIS; 10-3: © Erich Lessing/
Art Resource, NY; 10-4: Photo Archives Skira, Geneva, Switzerland; 10-5: Photo, Henri Stierlin; 10-7:
® Bildarchiv Preussischer Kulturbesitz/Art Resource, NY; 10-8a: © Yann Arthus-Bertrand/CORBIS; 10-9:
Photo, Henri Stierlin; 10-10: © E. Simanor/Robert Harding Picture Library; 10-11: www.bednorz-photo.de; 10-12: www.bednorz-photo.de; 10-13: © Adam Woolfit/Robert Harding Picture Library; 10-14: © Musée
Lorrain, Nancy, France/photo G. Mangin; 10-15: © The State Hermitage Museum, St. Petersburg; 10-16:
© The Trustees of the Chester Beatty Library, Dublin; 10-17: © Toyohiro Yamada/Getty Images/Taxi; 10-18:
Photo, Henri Stierlin; 10-20: Photo, Henri Stierlin; 10-21: Photo, Henri Stierlin; 10-22: Photo Henri Stierlin; 10-22: Photo Henri Stierlin; 10-25: Metropolitan Museum of Art, Harris Brisbane Dick Fund, 1939
(39.20) Photograph © 1982 The Metropolitan Museum of Art, Harris Brisbane Dick Fund, 1939
(39.20) Photograph © 1982 The Metropolitan Museum of Art, 10-26: © Erich Lessing/Art Resource, NY; 10-27: AKTC 2005.01 [M200] © Aga Khan Trust for Culture, formerly in the collection of Prince and Princess Sadruddin Aga Khan; 10-28: © Victoria & Albert Museum, London/Art Resource, NY; 10-29:
© Copyright the Trustees of The British Museum; 10-30: © Réunion des Musées Nationaux/Art Resource, NY; 10-31: Freer Gallery of Art Washington, D.C., Purchase, F1941.10.

Chapter 11—11-1: © British Library/HIP/Art Resource, NY; 11-2: © Réunion des Musées Nationaux/
Art Resource, NY; 11-3: © British Museum/HIP/Art Resource, NY; 11-4: University Museum of National
Antiquities, Oslo, Norway. Eirik Irgens Johnsen; 11-5: © Erich Lessing/Art Resource, NY; 11-6: © The Board
of Trinity College, Dublin, Ireland/The Bridgeman Art Library, NY; 11-7: akg-images/British Library; 11-8:
© The Board of Trinity College, Dublin, Ireland/The Bridgeman Art Library, NY; 11-9: Courtesy Saskia Ltd.,
© Dr. Ron Wiedenhoeft; 11-10: The Art Archive/Dagli Orti; 11-11: Archivo Historico Nacional, Madrid;
11-12: © Louvre, Paris, France, Lauros/Giraudon/The Bridgeman Art Library, NY; 11-13: Kunsthistorisches
Museums, Wien; 11-14: © Erich Lessing/Art Resource, NY; 11-15: University Library, Utrecht; 11-16: © The
Pierpont Morgan Library/Art Resource, NY; 11-18: © Aachen Cathedral, Aachen, Germany, Bildarchiv
Steffens/The Bridgeman Art Library, NY; 11-19: akg-images; 11-20: www.bednorz-photo.de; 11-21:
www.bednorz-photo.de; 11-22: www.bednorz-photo.de; 11-21: www.bednorz-photo.de; 11-21: www.bednorz-photo.de; 11-22: www.bednorz-photo.de; 11-26: Photo: Dom-Museum, Hildesheim (Frank

Tomio); 11-25: Photo: Dom-Museum, Hildesheim (Frank Tomio); 11-26: Rheinisches Bildarchiv; 11-27: Bayerische Staatsbibliothek, Munich; 11-28: Bayerische Staatsbibliothek, Munich; 11-29: Bayerische Staatsbibliothek, Munich.

Chapter 12—12-1: © Vanni/Art Resource, NY; 12-2: Claude Huber; 12-4: Jean Dieuzaide; 12-6: akg-images/Stefan Drechsel; 12-7: The Art Archive /Dagli Orti; 12-9a: © Michael Busselle/ Robert Harding Picture Library; 12-9b: © St. Pierre, Moissac, France, Peter Willi/The Bridgeman Art Library, NY; 12-11: akg-images/Elizabeth Disney; 12-12: akg-images/Paul M.R. Maeyaert; 12-13: Hervé Champollion/ akg-images; 12-14: www.bednorz-photo.de; 12-15: © Erich Lessing/Art Resource, NY; 12-16a: www.bednorz-photo.de; 12-16b: © Vanni/Art Resource, NY; 12-17: Museum of Fine Arts, Boston, Maria Antoinette Evans Fund, 21.1285. Photograph © 2008 Museum of Fine Arts, Boston; 12-18: The Metropolitan Museum of Art, Gift of J. Pierpont Morgan, 1916. (16.32.194) Photograph © 1999 The Metropolitan Museum of Art; 12-19: © Florian Monheim, www.bildarchiv-monheim.de; 12-20: Pubbli Aer Foto; 12-21: Canali Photobank, Italy; 12-22: Abtei St. Hildegard; 12-23: © Scala/Art Resource, NY; 12-26: akg-images/Rabatti-Domingie; 12-27: © Massimo Listri/CORBIS; 12-28: www.bednorz-photo.de; 12-29: www.bednorz-photo.de; 12-30: Universal Art Images; 12-31: © Anthony Scilalia/Art Resource, NY; 12-36: Massimo Listri/CORBIS; 12-28: myrus descence, NY; 12-36: The Master and Fellows of Corpus Christi College, Cambridge, England. MS R.17.1.f.283, Eadwine the Scribe.

Chapter 13—13-1: @ Angelo Hornak/CORBIS; 13-3: www.bednorz-photo.de; 13-5: @ Vanni/Art Resource, NY; 13-6: @ Vanni/Art Resource, NY; 13-7: @ SuperStock, Inc./SuperStock; 13-8: @ Angelo Hornak/CORBIS; 13-9: Courtesy Saskia Ltd., © Dr. Ron Wiedenhoeft; 13-11: Hirmer Fotoarchiv, Munich; 13-13: © Marc Garanger/CORBIS; 13-15: © Chartres Cathedral, Chartres, France, Paul Maeyaert/The Bridgeman Art Library, NY; 13-16: © Giraudon/Art Resource, NY; Page 350: © Angelo Hornak/CORBIS; 13-17: www.bednorz-photo.de; 13-18: © Anthony Scibilia/Art Resource, NY; 13-19: Hirmer Fotoarchiv, Munich: 13-20: @ Anthony Scibilia/Art Resource, NY: 13-21: Hirmer Fotoarchiy, Munich: 13-22: @ Anthony Scibilia/Art Resource, NY; 13-23: www.bednorz-photo.de; 13-24: © Scala/Art Resource, NY; 13-25: © Giraudon/Art Resource, NY; 13-26: www.bednorz-photo.de; 13-27: Courtesy Saskia Ltd., © Dr. Ron Wiedenhoeft; 13-28: @ Adam Woolfitt/CORBIS; 13-29: www.bednorz-photo.de; 13-30: @ Giraudon/Art Resource, NY; 13-32: Österreichische Nationalbibliothek, Vienna. Bildarchiv. folio 1 verso of a moralized Bible; 13-31: Bibliotheque Nationale, Paris, France; 13-33: © The Pierpont Morgan Library/Art Resource, NY; 13-34: Bibliotheque Nationale, Paris, France; 13-35: Bibliotheque Nationale, Paris, France; 13-36: © Snark/ Art Resource, NY; 13-37: © Réunion des Musées Nationaux/Art Resource, NY; 13-38: Photo © The Walters Art Museum, Baltimore. Acquired by Henry Walters, 1923. Accession No. 71.264; 13-39: © English Heritage; 13-41: @ Archivo Iconografico, S.A./CORBIS; 13-42: @ Scala/Art Resource, NY; 13-43: @ Werner Forman/ CORBIS: 13-44: @ Angelo Hornak/CORBIS: 13-45: @ Felix Zaska/CORBIS: 13-46: @ Svenia-Foto/zefa/ CORBIS; 13-47: www.bednorz-photo.de; 13-48: www.bednorz-photo.de; 13-49: www.bednorz-photo.de; 13-50: © Erich Lessing/Art Resource, NY; 13-51: © Erich Lessing/Art Resource, NY; 13-52: © Erich Lessing/ Art Resource, NY; 13-53: @ Erich Lessing/Art Resource, NY.

Chapter 14—14-1: © Scala/Art Resource, NY; 14-2: Canali Photobank, Italy; 14-3: © Scala/Art Resource, NY; 14-4: © Scala/Art Resource, NY; 14-4: © Scala/Art Resource, NY; 14-6: © Scala/Art Resource, NY; 14-6: Photo by Ralph Lieberman; 14-7: © Scala/Art Resource, NY; 14-8: © Summerfield Press/CORBIS; 14-9: © Scala/Art Resource, NY; 14-10: © Scala/Art Resource, NY; 14-11: © Scala/Art Resource, NY; 14-12: Canali Photobank, Italy; 14-13: Canali Photobank, Italy; 14-14: © Scala/Art Resource, NY; 14-15: © MUZZI FABIO/CORBIS SYGMA; 14-16: © Scala/Art Resource, NY; 14-17: © Scala/Art Resource, NY; 14-18: © MUZZI FABIO/CORBIS SYGMA; 14-19: Photo by Ralph Lieberman; 14-20 both: © Scala/Art Resource, NY; 14-21: www.bednorz-photo.de; 14-22: © Scala/Art Resource, NY.

INDEX

Boldface names refer to artists. Page numbers in italics refer to illustrations.

Aachen, 294, 295, 305; Palatine Chapel, 252, 297, 297, 299, 300, 329 Abbasids, 262, 267, 268, 273, 276, 283 Abbey of Citeaux, 317, 321 Abd al-Malik, 264; Dome of the Rock and, 262, 263 Abd al-Rahman, 268, 283 Abelard, Peter: and Scholasticism, 344 Abraham and Lot, mosaic of, 221, 221 Adam and Eve, 214, 256, 288, 302, 327; art about, 213; death of, 251 Adam and Eve (Wiligelmo), 330, 330 Adoration of the Shepherds (Giovanni Pisano), 377 Adoration of the Shepherds (Nicola Pisano), 376, 377 Aeneid (Vergil), 224 Agra, Taj Mahal, 262 Alaric, King, 221, 229 Alberti, Leon Battista, 392 Alexander, Saint: reliquary of, 327-328, 327 Alexander II, Pope, 328 Alexander the Great: Dura-Europos and, 209 Alexandria, 247; abandonment of, 261 Alhambra, Granada (Spain), 260, 272-273, 283 Allegory of Good Government (Lorenzetti), 390 Altarpieces, 371, 378 Ambrose, Saint, 325 Amiens Cathedral (France) (Luzarches, Cormont, and Cormont), 352-353, 354, 364, 365, 373, 387, 392; choir of, 352, 368; interior of, 352; west facade of, 353 Amon, Saint: relics of, 270 Anastasis, 251, 256, 256 Anastasius I, 287 Anatolia, 255

Angel Gabriel, 258, 355, 356, 362

245, 247

Angelico, Fra (Guido di Pietro), 376

Anicia Juliana, 244, 245; portrait of,

Anicia Juliana between Magnanimity

and Prudence, 245

Animal-head post (Viking ship), 288, 288 Anne, Saint, 349, 388 Annunciation, 216, 257, 257, 305, 305 Annunciation (Giovanni Pisano), 377, 377 Annunciation (Martini and Memmi), 387, 387 Annunciation (Nicola Pisano), 371, 377 Annunciation group (Reims Cathedral), 354-355, 355, 356, 362 Annunciation to the Shepherds, 305 Antelami, Benedetto, 335; work of, 330-331, 331 Anthemius of Tralles: work of, 233-234, 233, 234 Anthony, Saint, 242 Antioch, 247 Apocalypse, 290, 318, 322, 323, 344 Apollinaris, Saint, 241 Apprentices, 388 Aqueducts, 264 Ara Pacis Augustae (Altar of Augustan Peace), 240 Arcadius, 221, 231 Arch of Constantine, 211 Arch of Septimius Severus, 211 Archaic period (Greece): art of, 351 Archangel Michael, ivory of, 244 Arches, 235, 273; chancel, 387; diaphragm, 330, 330; ogee, 367, 393; ogival, 342; pointed, 321, 342, 342, 347; semicircular, 342, 342; transverse, 314, 333, 342 Ardabil carpets, 280 Arena Chapel (Giotto), 374, 382-383 Aristotle, 262, 344 Arnolfo di Cambio: work of, 391-392, 392 Arte de Calimala, 384 Arte della Lana, 384 Ascension of Christ, Rabbula Gospels,

245, *245* Ashlar masonry, 235

Atrium, 298

Athena Parthenos (Phidias), 227

Athens: Parthenon, 228

Augustine, Saint, 213 Augustus, Emperor, 224, 240 Aula Palatina, 219 Autun: pilgrimage to, 310, 320; Saint-Lazare, 318, 319 Ayyubids, 282, 283 Babylon: Tower of Babel, 268 Bad Government and the Effects of Bad Government in the City (Lorenzetti), 390 Baghdad, 262, 266-267 Bamberg Cathedral, 305, 370, 373; statue at, 370 Bamberg Rider, 370, 370 Banos de Cerrato, San Juan Bautista, 293, 293 Baptismal font (Rainer of Huy), 327 Baptistère de Saint Louis (Muhammad ibn al-Zayn), 281-282, 281 Barberini, Cardinal, 242 Barberini Ivory, 242, 243, 243, 244 Baroque: architecture of, 218

Bayeux Cathedral, 335
Bayeux Tapestry, 334, 335, 337; details from, 334
Beatus of Liébana, Abbot, 293, 318
Beau Dieu, 353, 353
Belisarius, 232, 235, 236
Belleville Breviary (Pucelle), 362; folio from, 363
Benedict (Benedict of Nursia), Saint:

rule of, 298, 314, 317, 336 Benedictines, 298, 317, 371

Beowulf, 286, 287

Basil I, 247, 259

Basilica, 311, 324

Basilica of Constantine, 233

Basilica Ulpia, 219, 300

Baths of Caracalla, 233

Berbers, 272

Berlinghieri, Bonaventura, 395; work of, 378, 378

Bernard of Clairvaux, Abbot, 317, 318, 319, 321, 337; Abelard and, 344; Alexander reliquary and, 328; on

cloister sculpture, 316; Hildegard and, 326; Knights Templar and, 320 Berno of Baume, 314 Bernward of Hildesheim, 300, 301, 330; commission by, 302, 303; Hildesheim doors and, 302 Bethlehem, 215, 255, 282 Betrayal of Jesus (Duccio di Buoninsegna), 386, 386 Bible, 288, 359 Bibliothèque Nationale, 360 Bihzad: work of, 278-279, 278 Birth of the Virgin (Lorenzetti), 388, 389 Black Death, 339, 380, 391, 392, 395 Blanche of Castile, 349, 360-361, 362 Blind arcades, 268 Boccaccio, Giovanni, 380, 381 Boniface VIII, Pope, 360 Book of Durrow, 288-290, 291; folio from, 290 Book of Kells, 291-292, 292 Book of the Pontiffs, 219 Books: Christian Church and, 288; making, 361; medieval, 225, 288 Bourges, House of Jacques Coeur, 358, 358, 373 Brass canteens, 282, 282 Breviary of Philippe le Bel (Master Honoré), 362; folio from, 362 British Museum, 297 Bruges, Guild hall, 357-358, 357 Bubonic plague. See Black Death Buffalmacco, Buonamico: work of, 392-393, 393 Bukhara, Samanid Mausoleum, 268, 268, 275 Burial mounds, 286, 287 Bury Bible, 335-336; folio from, 335 Bustan (Sadi), Bihzad and, 278-279 Byzantine architecture, 235, 352 Byzantine art, 232, 306, 307, 382; churches and, 220, 299; Early Christian art and, 236, 240; golden

age of, 259; Greco-Roman roots of,

Byzantine culture, renovation of, 247

248; Middle Ages and, 243; painting, 242–245, 247, 258; style, 340

Byzantine Empire, 288; collapse of, 261; map of, 232 Byzantine Orthodox Church, 255 Byzantium, 231, 256, 286, 297; end of, 256; Islam and, 261; religious/ cultural mission of, 255 Caen, Saint-Etienne, 331-332, 331, 332, 337 342 346 Cairo, Mausoleum of Sultan Hasan, 273, 273 Calligraphy, 260, 270, 272, 278, 281, 283; described, 271; tilework and, 277 Cambrensis, Giraldus, 292 Campo, 388; aerial view of, 389 Camposanto, Pisa, 392-393 Canterbury Cathedral, fire at, 313 Capitals: composite, 330; Corinthian, 376 Caracalla: baths of, 233 Carcassonne, 373; Cathedral of Saint-Nazaire, 357, 357 Carolingian alphabet, 294 Carolingian architecture, 297-299, 307, 313 Carolingian art, 293-299, 307, 309 Carolingian Empire, 370; map of, 286 Carolingian Renaissance, 294 Carolus Magnus, 293 Carpet pages, 284, 288, 307 Carpets, 270, 280, 283 Cartoons, 382 Castle of Love, The, 363-364, 364 Catacomb of Saints Peter and Marcellinus, 213; cubiculum in, 212,212 Catacombs, 211-215, 229 Cathedral School of Chartres, 343 Cathedral School of Paris, 344 Cenni de Pepo. See Cimabue Central-plan buildings, 219-220, 235, 265, 329, 337; first examples of, 275 Cerveteri: Banditaccia necropolis, 211 Chapel of Henry VII (Vertue and Vertue), 366, 366, 373 Charlemagne (Charles the Great), 261, 267, 286, 296, 298, 303, 305, 306, 307, 329, 340; architecture and, 297, 299; arts/culture and, 295; burial of, 300; equestrian portrait of, 294, 294; Leo III and, 293; Lombards and, 325; official seal of, 294; renovatio of, 375 Charles IV, King, 363 Charles VII, King, 358 Charles the Bald, 296, 300; equestrian portrait of, 294, 294 Chartres Cathedral, 338, 343-344, 343, 345, 348-349, 348, 350-351, 350, 352, 354, 373; aerial view of, 348; after 1194, 348-349; influence of, 352; plan of, 347, 348, 349; rose window at, 338, 350, 350; Royal Portal, 343-344, 343, 344, 345, 346, 350-351, 354, 373; south transept of, 350-351; west facade of, 343

Chiaroscuro: development of, 383 Christ (Jesus), 213, 221, 224, 228, 255, 290; baptism of, 213, 214; childhood of, 216; crucifixion of, 229; death of, 226, 254; images of, 246; incarnation of, 216; life of, 216-217, 223, 303, 383; martyrdom of, 240; passion of, 217, 255; prefiguration of, 212; transfiguration of, 241, 242, 245 Christ as Good Shepherd, 212, 212, 213, 214, 215; mosaic of, 222, 222 Christ as Last Judge, 317, 318, 337, 353 Christ as Pantokrator, 230, 250, 252, 259 Christ as Savior of Souls, 257, 257 Christ before Pilate, 226 Christ in Majesty, 314, 322 Christian art: Constantine and, 229; Jewish subjects in, 213 Christian community house, 211, 229; cutaway view of, 211 Christianity, 210; establishment of, 211; Islam and, 263; missionaries and, 284; patronage of, 372; recognition of, 232; Roman Empire and, 285; sponsorship of, 215; Visigoths and, 293 Chronica (Gervase of Canterbury), 313 Church of Christ in Chora, 256, 257, 259; fresco from, 256 Church of the Dormition, 250; mosaic from, 230, 250 Church of the Holy Apostles, 251 Church of the Holy Sepulchre, 262, 310 Church of the Holy Wisdom. See Hagia Sophia Church of the Theotokos, 249; plan of, 248 Church of the Virgin, 242; mosaic from, 242 Cimabue (Cenni de Pepo), 376, 381, 382, 395; contract with, 384; work of, 379-380, 380 Cistercians, 298, 316, 317, 321, 337, 365; Crusades and, 320 City of God, 339 City of Peace, 267 City-states: Italian, 380, 381, 385, 389 Classical art: revival of, 375 Classical Greece, 309 Classical order, 339, 351, 395; Renaissance and, 395 Clement, Saint: icon from, 257, 257 Clement V, Pope, 379 Clement VII, Pope, 379 Clerestory, 324, 345, 346, 347; described, 347 Cloisonné technique, 249, 287, 307 Cloisters, 315, 316; detail from, 316; view of, 316 Cluniac order, 314, 317, 337 Cluny III, 314-315, 317, 321, 323, 324; restored cutaway view of, 315 Codices, 225, 304-305, 305 Coeur, Jacques: house of, 358, 358, 373

College of Cardinals, Great Schism

and, 379

Cologne Cathedral (Gerhard of Cologne), 323, 367-368, 367, 372, 373, 392; choir of, 367, 368; Gero crucifix and, 303-304 Columba, Saint, 288 Columbus, Christopher, 288 Column of Trajan, 296, 303, 334, 335 Columns: engaged, 268, 314 Commentarii (Ghiberti), 339 Commentary on the Apocalypse (Beatus), 293, 318; colophon of, 293 Confraternities, 212, 379, 384 Confronting lions and palm tree (textile), 270 Constantine I ("the Great"), 218, 228, 246, 293, 328, 372; baptism of, 214, 229; Christian art and, 229; Christianity and, 215, 232; Constantinople and, 229; edict by, 211; iconographic tradition and, 306; New Rome and, 231; Santa Constanza and, 220 Constantine XI, 231 Constantinian churches, 215, 218-220 Constantinople, 221, 232, 252, 328; attacks on, 247; Basilica of Constantine, 233; building/ restoration in, 259; Church of Christ in Chora, 256, 256, 257, 259; Church of Saints Sergius and Bacchus, 236; Church of the Holy Apostles, 251; Church of the Holy Sepulchre, 262, 310; Constantine and, 229; Crusaders in, 255, 259; establishment of, 231; fall of, 258, 377; Hagia Sophia, 233-234, 233, 235, 244, 247-248, 249, 259, 274, 275, 283, 297, 349, 352; Ottoman Turks and, 231, 256, 259, 261, 275, 283; patriarch of, 240; Ravenna and, 236 Córdoba, 272, 283, 293; Great Mosque, 268-269, 268, 269, 283 Cormont, Renaud de: work of, 352, 352, 353 Cormont, Thomas de: work of, 352, 352, 353 Coronation Gospels, 295, 327; folio of, 295 Corvey, 299; westwork of, 299, 300 Council of Clermont, 320 Council of Ephesus, 221 Court of Gayumars (Sultan-Muhammad), 279 Crossing square, 299 Crossing towers, 222, 324, 325 Crucifixion, 214-215, 226, 228, 235, 250, 251, 290, 292, 296, 302; art about, 217; mosaic of, 250; representation of, 227 Cruciform, 222, 251 Crusades, 255, 259, 282, 316, 319, 320, 328, 341, 360 Ctesiphon, 267, 273 Cubiculum, 212, 212 Cult statues, 215 Cupid (Eros, Amor), 364 Cuthbert, Saint, 291

Damascus, Great Mosque, 264-265, 264, 265 Dante Alighieri, 359, 380, 385 Daphni, Church of the Dormition, 230, 250, 250 Daphni Crucifixion, 250, 250 Daphni Pantokrator, 250 David and Samuel, mural of, 211, 224 David composing the Psalms, 254 Death of the Virgin, Strasbourg, 369 Decameron (Boccaccio), 380 Delhi sultanate, 262 Diocletian, 220, 231; Christianity and, 211; mausoleum of, 329; palace of, 266 Dionysius, Saint, 340 Dioscurides, 224 Dioskorides (Vienna), 244 Diptych of the Symmachi, 228; leaf Disibodenberg, double monastery Divine Comedy (Dante), 359, 380 Doge's Palace, 393-394, 393 Dome of the Rock, 262, 264, 271, 283; aerial view of, 263; interior of, 264; mosaics at, 265, 277 Domes: muqarnas, 272-273, 272 Dominicans, 360, 378, 393; influence of, 379 Doryphoros (Spear Bearer) (Polykleitos), 351 Duccio di Buoninsegna, 362, 387, 388, 395; contract with, 384; work of, 383, 385–386, 385, 386 Dura-Europos, 209-211, 215; Christian community house, 211, 211, 229; murals at, 211, 211; synagogue, 210-211, 210, 224, 229 Durandus, William, bishop of Mende: on stained-glass windows, 350 Durham Cathedral, 332-333, 337, 365; interior/lateral section of, 333; plan of, 333, 333; vaults of, 342 Durrow Gospels, 289-290 Eadwine Psalter (Eadwine the Scribe), 336; folio from, 336 Eadwine the Scribe: work of, 336, 336 Early Byzantine, 251; architecture of, 232-242; art of, 232-247, 259; mosaics of, 232-242 Early Christian: architecture, 215, 218-224; art, 229, 232, 236, 240, 242, 294, 296, 307; mosaics, 215, 218-224; painting, 212; sculpture, 213-215 Early Gothic: architecture, 341, 343, 345, 348, 349, 350; sculpture, 343 Early Islamic: architecture, 262, 264-269, 272; art, 262-271, 272 Early Medieval period: art of, 285 Ebbo Gospels, 295, 296, 327; folio of, 295 Ecclesius, Bishop, 236, 238, 252 Eclecticism, Byzantine, 257, 258, 259

Edict of Milan, 211

Chi-rho-iota (XPI) page, 292, 292

Edirne: Mosque of Selim II, 274, 274, 275, 283 Edward II, King: tomb of, 367, 367 Edward III, King, 367 Edward the Confessor, 335 Effects of Good Government in the City and in the Country (Lorenzetti), 390-391; detail from, 390 Egypt: Roman Empire and, 253 Ekkehard II, statue of, 369-370, 369 Eleanor of Aquitaine, 326, 341, 360 Embroidery, 334 Emeterius, 318; work of, 293, 293 English Gothic: architecture, 364-367 English Romanesque: architecture, 331-333; art, 331-336, 337; painting, 333, 335-336 Etruscan tombs, 211, 318 Etruscans, 221, 328 Eugenius III, Pope, 326 Europe, map of, 340 Eusebius of Caesarea, 288 Eventius, Saint, 328 Ewer in the form of a bird (Sulayman), 270 Ewers, 270, 270 Fatimids, 262, 283 Ferdinand, King, 261 Feudalism, 309 Fibula, 286 Fidenza Cathedral, 330, 331 Flamboyant style, 356, 357, 358, 366, 373

Florence, 380, 383, 385; architecture in, 391-392; Florence Cathedral, 384, 391-392, 392; San Giovanni, 329, 329, 391, 392; San Miniato al Monte, 330, 330; Santa Croce, 222, 379; Santa Maria Novella, 378-379, 379, 384 Florence Cathedral (Arnolfo di Cambio), 384, 391-392; interior of, 392 Flying buttresses, 338, 346, 347, 365, 373; described, 347 Fontenay, Notre-Dame abbey church, 321, 323 Forum of Trajan (Apollodorus of Damascus), 219 Four Evangelists, 216, 245, 290, 307, 314 Foy, Saint, 310 Fra Angelico. See Angelico, Fra Francis of Assisi, Saint, 378, 379;

portrayal of, 395 Franciscans, 360, 378; influence of, 379; perspective and, 383 Franks, 236, 261, 285, 293, 307 Frederick II, 375, 395; equestrian portrait of, 370 French Gothic, 365, 395; architectural decoration, 340-358; architecture, 337, 340-358, 373; art, 340-364, 373 French Revolution, 342, 356 French Romanesque: architecture, 311-321; sculpture, 311-321 Fresco painting, 382 Funerary art, 211-215

Galerius, edict by, 211 Galla Placidia, mausoleum of, 208, 222, 222, 224, 241 Garden of Eden, 302 Gayumars, King (Iran), 279 Gelduinus, Bernardus, 314, 335; work Genghis Khan, 273, 275, 278 George, Saint, 247, 370; icon of, 246 Gerhard of Cologne: work of, 367-368, 367, 368 Gernrode, Saint Cyriakus, 300, 300, 311,344 Gero, Archbishop, 303, 323 Gero crucifix, 303-304, 303, 307 Gervase of Canterbury, 313, 314 Ghiberti, Lorenzo: Middle Ages of, 374, 381-383, 381, 382 Gislebertus, 335; work of, 319, 319

Giotto di Bondone, 385, 392, 395; work Giulio Romano, 376

Gloucester Cathedral, 365-366; choir of, 366, 366 God as architect of world, 359-360, 359 Gordion, mosaics at, 223 Gospel Book of Charlemagne. See Coronation Gospels

Gospel Book of Otto III, 305-306; folio from, 306

Gothic architecture, 333, 346, 367-368; Scholasticism and, 344; stainedglass windows and, 350

Gothic cathedrals, 339, 346, 392; elements of, 347, 347; nave elevations of, 346

Gothic style, 340, 375, 387; decline of, 394

Goths, 285, 307, 339

Granada (Spain), 261; Alhambra, 260, 272-273, 272, 283

Great Mosque, Córdoba, 268-269, 283; dome of, 269; prayer hall of, 268

Great Mosque, Damascus, 264-265; aerial view of, 265; mosaics of, 264, 264, 265

Great Mosque, Isfahan, 275-276; aerial view of, 275; plan of, 276

Great Mosque, Kairouan, 267; aerial view of, 267; plan of, 267

Great Mosque, Samarra, 267; maqsura of, 269; minaret of, 267

Great Schism, 339, 379

Greco-Roman art, 339

Greek cross, 251, 259

Greek temples, 318

Gregory, Saint, 321; statue of, 351, 351 Gregory the Great, Pope, 321, 326

Guido di Pietro. See Angelico, Fra Guild hall, 357-358, 357

Guilds, 339; described, 384; training by, 388

Hagia Sophia (Anthemius of Tralles and Isidorus of Miletus), 233-234, 233, 244, 247-248, 274, 275, 283, 349, 352; design of, 235; dome of, 249;

imperial gallery at, 297; mosaics at, 259; pendentives at, 235; plan and cutaway view of, 233 Hall church. See Hallenkirche Hall of the Two Sisters, 272, 272 Hallenkirche, 322, 368 Harbaville Triptych, 253, 255 Hasan, Sultan, 274, 276, 278, 283; mausoleum of, 273 Henry II, King, 305, 306, 326; death of, 300 Henry III, King, 360 Henry IV, King, 324 Henry VII, King: chapel of, 366, 366

Hiberno-Saxon art, 284, 288-289, 290, 307, 309, 321, 333 High Classical period, 356

High Cross of Muiredach (Ireland), 292, 292

High Gothic, 343, 350, 356, 373, 392; architecture of, 348, 349, 352, 354, 355

Hildegard of Bingen, 326-327, 326 Hildesheim, 300-301; column and doors, 303, 303; Saint Michael's, 300, 301, 302, 307, 317, 324, 330

Holy Roman Empire, 243, 294, 337, 340; architecture of, 323-325, 367-372, 373; art of, 323-328; founding of, 293

Honnecourt, Villard de: sketchbook by, 359, 359

Honoré, Master: work of, 362, 362 Honorius, 221, 222, 229, 231 Hosios Loukas, 252, 259; Church of the Theotokos, 248, 249; Katholikon, 248, 248, 249, 250

House of Jacques Coeur, 358, 358, 373 Hugh of Saint-Victor, on stained-glass windows, 350

Hugo, Master, 335, 336; work of, 335 Humanism: Italian, 375; Renaissance, 380-381, 395 Hundred Years' War, 339 Hypostyle hall, 265, 267, 268, 283

Iconoclasm, 246, 259; end of, 247, 248, 249

Iconoclasts, 246, 248; iconophiles and, 247, 259

Iconography, 306

Iconophiles, 246; iconoclasts and, 247, 259

Iconostasis, 257, 259 Icons, 246, 248, 255, 257; Byzantine, 246, 247, 304, 395; Early Byzantine, 257-258, 259; opposition to, 246; veneration of, 246, 247

Île-de-France, 341, 343, 357, 364 Île-de-la-Cité, 346

Illumination, 253, 288, 294, 295, 305, 326, 359, 373, 378, 395; Gothic, 359-364; Late Antique, 224-226; preparation of, 361

Illusionism, 247, 257, 307; pictorial, 388, 389

Imam Mosque, tilework in, 277

International Style, 387 Introduction to the Three Arts of Design (Vasari), 339 Iona Island, 288, 291 Isaac, 214; art about, 213 Isabella, Queen, 261 Isfahan: Great Mosque, 275-276, 275, 276; Shahi Mosque, 276, 277 Isidorus of Miletus: work of, 233-234, 233, 234

Islam, 231, 392; Byzantium and, 261; Judaism/Christianity and, 262, 263; Muhammad and, 263; rise of, 261; Spain and, 293

Islamic architecture, 283, 307 Islamic world, map of, 262 Italian Renaissance, 339; architecture of, 218; humanism and, 380 Italian Romanesque: architecture of, 328-331, 337; art of, 328-331, 337;

sculpture of, 328-331 Italo-Byzantine art, 382, 383, 395 Italy, map of, 376 Ivory carving, 243, 244; Byzantine,

242-245, 247, 253-255; Late Antique, 226-228

Iwans, 265, 276, 283

Jambs, 318, 344, 345, 351, 351, 354, 355, 355, 368; described, 317 James, Saint: shrine of, 310 Jerome, Saint, 288, 336; statue of, 351, 351

Jerusalem, 247, 282; Dome of the Rock, 262, 263, 264, 264, 265, 271, 277, 283; Islam in, 283; pilgrimage to, 310, 318; Temple of Solomon, 233, 262

Jesus. See Christ

John, Saint, 254, 297; Apocalypse and, 323; gospel of, 250 John the Baptist, 216, 251, 253, 255, 256 John the Evangelist, 217, 245, 383 John the Lydian, on Theodora, 240 Jonah, 212, 212, 213, 215 Judaism, 210, 215; Christianity and, 262; Islam and, 262, 263 Judas, 217, 226, 386 Junius Bassus sarcophagus, 214–215 Justinian, 221, 239, 251, 294; blessing for, 243; Byzantine art and, 232, 233, 259; Christianity and, 232; Constantinople and, 232, 259; ivory carving of, 243; mosaic of, 239; Mount Sinai and, 241, 242, 259;

Kairouan, Great Mosque, 267, 267 Kairye Museum, fresco from, 256 Katholikon, 248, 248; interior of, 249; mosaic at, 250; plan of, 248 King David (Antelami), 330, 331 King Solomon's Temple, 327 Klosterneuburg Altar (Nicholas of Verdun), 371, 372 Knights Templar, 320

portrait of, 252; Ravenna and, 236,

259; Theodora and, 237, 240

Koran (Qur'an), 263, 265, 277, 283; calligraphy for, 271; page from, 271 La Madeleine, church of, Vézelay, 319-320; tympanum of, 319 Lamentation (Giotto), 382, 383 Lamentation over the dead Christ, 254 Laon Cathedral, 347, 348, 350, 352-353, 354, 373; facade of, 345, 346; interior of, 345; nave elevation of, 346 Lars Pulena, 225 Last Judgment, 250, 290, 292, 343, 344, 383 Last Judgment (Gislebertus), 319, 319 Last Supper, 217, 290 Late Antiquity, 211, 255, 302; art of, 221, 232, 262, 264, 307; painting of, 305; plans of, 222; religious crosscurrents of, 209 Late Byzantine: art of, 255-258, 259; painting of, 256-258 Late Classical period, 356 Late Gothic, 366, 367, 373; architecture of, 394 Late Roman Empire, 299 Later Islamic architecture and art, 272-282 Lawrence, Saint, 222 Leaning Tower: Pisa Cathedral and, 329 Lectionary of Henry II, 305; folio from, 305 Leo III, Emperor: iconoclasm and, 247, 259 Leo III, Pope, 293, 307 Leonardo da Vinci, 376 Lepcis Magna, Arch of Septimus Severus, 211 Lérida, Santa María de Mur, 322-323 Liber pontificalis, 219 Lindau Gospels, 296, 304; front cover of, 296 Lindisfarne Gospels, 291, 295; carpet page of, 284; Saint Matthew from, 291 Lions and Old Testament prophet, 318 Lives of the Most Eminent Painters, Sculptors, and Architects (Vasari), 381 Lombards, 235, 285-286, 293, 306, 323, 325; Ravenna and, 251 Lombardy, 325, 326, 328, 394 London: Chapel of Henry VII, 366, 366, 373; Westminster Abbey, 335, 367 Longinus, 217, 250 Lorenzetti, Ambrogio, 395; work of,

Lorenzetti, Pietro, 390; work of, Louis IX, King, 282, 361; Crusades and, 360; Rayonnant style and, 360, 373; Sainte-Chapelle and, 355 Louis VI, King: Suger and, 341 Louis VII, King, 319, 326; Suger and,

Lux nova, 338, 342, 373 Luxury arts: Gothic, 359-364; Islamic, 270-271, 278-282; Late Antique, Luzarches, Robert de: work of, 352, 352, 353 Macedonian Renaissance, 254, 255 Macedonians, 248, 255 Machicolated galleries, 390 Madonna, 377, 380 Madonna Enthroned (Giotto), 381-382, 381 Madonna Enthroned with Angels and Prophets (Cimabue), 380, 380, 381 Madrasa Imami, 277-278; mihrab from, 277 Madrasa-mosque-mausoleum complex, 273, 273; plan of, 273 Maestà (Duccio di Buoninsegna), 383, 384, 385–386, 385, 386, 387, 395 Maitani, Lorenzo: work of, 386-387, 387 Malik Shah I, Sultan, 275, 276 Malwiya Minaret, 267-268, 267 Mamluks, 273, 278, 281, 283 Maniera greca, 378, 381, 395 Mantegna, Andrea, 388 Manuscript painting, 242 Maqsud of Kashan, 280; carpet by, 280 Maqsura, 265, 269, 269, 276 Marburg, Saint Elizabeth church at, 368, 368 Marcus Aurelius, 243; Dura and, 209; portrait of, 294 Mark, Saint: relics of, 251 Martin, Saint, 310, 313; statue of, 351, 351 Martin V, Pope: Great Schism and, 379 Martini, Simone: work of, 387, 387 Martyrdom, 212, 215, 310 Martyrium, 251 Mary. See Virgin Mary Mary Magdalene, 217, 302, 310, 319, 369, 383 Masaccio (Tommaso di ser Giovanni di Mone Cassai), 376 Mass, 235, 379 Matthew, Saint, 291, 292, 295, 296, 318; folio of, 295; symbol of, 290, 290, 291 Mausoleum of Galla Placidia, 222, 241; interior of, 208; mosaic from,

222, 224 Mausoleum of Sultan Hasan, 273; plan of, 273 Maxentius, 215 Maximianus, Bishop, 236, 237; mosaic of, 239 Mecca, 262, 263, 264, 265, 273 Medina, 263, 265, 267, 268, 270 Mediterranean, maps of, 210 Memmi, Lippo: work of, 387, 387 Mendicant orders, 360, 378, 379 Merovingian fibulae, 286, 286, 287 Merovingians, 285, 286, 307

to, 263

Metalwork, 287, 328, 337, 371, 373; Muhammad V, 272 Celtic/Anglo-Saxon, 292; Islamic, Muhammad ibn al-Zayn, 283; work Michael, Archangel: ivory panel of, 244 Muiredach, cross of, 292, 292 Michael the Archangel, Saint: ivory panel of, 244 Michael VIII Paleologus, 256, 259 Michelangelo Buonarroti, 275 Middle Ages, 285, 286, 309; Byzantine art and, 243; concept of, 380; condemnation of, 375; decline during, 339; historical narrative art in, 337 Middle Byzantine: architecture of, 247-252; art of, 247-255, 259; churches, 248, 259; ivory carving, 253-255; mosaics, 247-252; painting, 253-255 Mihrabs, 265, 267, 269, 276, 277, 277, 278 Milan, 380; art of, 392-394; Cathedral of, 394, 394; Sant'Ambrogio, 324, 325, 325, 332, 337 Minarets, 233, 265, 267-268, 267, 275, 277 Minoans: painting of, 382 Minor arts, 224, 286, 372 Miracle of the loaves and fishes, 224 Modena Cathedral, 330; frieze from, 330 Moissac: pilgrimage to, 320; Saint-Pierre, 308, 315-318, 316, 318, 331, 351, 353 Monasteries, 288, 298, 309 Monastic orders, 241, 242, 379; patronage by, 384 Mongols, 255, 275 Monophysite heresy, 232, 247 Monreale cathedral, 253, 323; mosaics at, 252, 252 Moralia in Job (Saint Gregory), 321-322; folio from, 321 Moralized Bibles, 360, 361, 373 Morgan Madonna, 323, 323 Mosaics, 229, 277, 283, 305; beginning of, 223; Early Byzantine, 232-242; Early Christian, 215, 218-224; Islamic, 264; pebble, 223 Moses expounding the Law (Master Hugo), 335 Mosque lamps, 280-281 Mosque of Selim II, 274, 275, 283; interior of, 274; Sinan and, 274 Mosques: architecture of, 264, 265; types of, 265 Mother of God, 221, 242, 245, 258; images of, 246; mosaic of, 259. See also Virgin Mary Mount of Olives, 217, 245 Mount Sinai, 241-242, 257, 259; Church of the Virgin, 242, 242; icons and, 247, 248, 255; Saint Catherine's monastery, 241, 242, 247 Mshatta, Umayyad Palace, 266, 266 Muhammad, 261, 262, 270; burials and, 268; death of, 263; house of, 265, 267; Islam and, 263; opposition

Mugarnas, 272–273, 272, 277, 283 Mural painting, 382; Pompeiian, 224 Mystery plays, 383 Naples, 380 Napoleon Bonaparte, 294 Nativity (Giovanni Pisano), 377, 377 Nativity (Nicola Pisano), 376, 377, 388 Naturalism, 255, 259, 395; Cimabue and, 379; Master Honoré and, 362 Naumburg Cathedral, 369, 370, 373; statues at, 369 Nave, 346 Neptune (Poseidon), 216 Nerezi, 253-254; Saint Pantaleimon, 253, 254 New Rome, 215, 231, 232; emperors of, 243 New Saint Peter's (Bramante), 315 New Testament, 210, 212, 214, 216; Christian art and, 213; figures from, 317 Nicholas of Verdun, 373; work of, 371-372, 371, 372 Nicodemus, 217, 254 Nika revolt, 232, 233, 240 Norman Romanesque: architecture, 331-333; art, 331-336, 337; painting, 333, 335-336 Normans, 288; Islamic art and, 252 Notre-Dame, Paris, 344, 346, 346, 350 Notre-Dame abbey church, Fontenay, 323; interior of, 321 Notre Dame de la Belle Verrière, 349, 361; detail from, 349 Notre-Dame-des-Fonts, baptismal font from, 327, 327 Old farmer of Corycus, The, 225 Old Saint Peter's, 218-219; Christian art at, 229; cutaway view/plan of, 218 Old Testament, 210, 212, 214, 216; Christian art and, 213; figures from, 317; statues of, 344 Olympic Games, 221 Orpheus, 255 Orvieto Cathedral (Maitani), 386-387, 386, 392, 395 Oseberg ship burial, 288; animal-head post from, 288 Osman I, 275, 283 Ostrogoths, 221, 223, 232, 285 Otto I, 300, 306 Otto II, 306, 328; Theophanu and, 305, 307 Otto III, 300, 302, 305; portrayal of, 306, 306 Ottoman Empire: architecture of, 275; rise of, 275, 283 Ottoman Turks, 278; Constantinople and, 231, 256, 259, 261, 275, 283 Ottonians, 300; architecture of, 300-301, 307; art of, 300-306, 307,

of, 281-282, 281

341

Louvre, 344

Luke, Saint, 249

390-391, 390

388, 389

309, 317; painting of, 302-306, 307; sculpture of, 302-306, 307 Pachomius, Saint: monastic movement and, 242 Padua, Arena Chapel, 374, 382-383 Paganism, 228, 232 Palace of the Lions, 260, 272, 272 Palatine Chapel, 252, 297, 299, 300, 329; interior of, 297; restored plan of, 297 Palazzo Pubblico, 395; aerial view of, 389; painting for, 388-391 Pantheon, Rome, 220, 233, 234, 329 Pantokrator, 230, 250, 252, 252, 259, 353 Papal States, 380 Papyrus, 225 Paris: Louvre, 344; Notre-Dame, 344, 346, 346, 350; Sainte-Chapelle, 355-356, 355, 361 Paris Psalter, 254-255, 259; folio from, 254 Parma Cathedral, 330 Parthenon, 228 Parthians, 209 Patronage, 372, 384 Patrons, 384 Paul, Saint, 214, 215, 287, 290 Paul the Silentiary, on Hagia Sophia, 233-234 Peaceful City (Lorenzetti), 390, 391 Peaceful Country (Lorenzetti), 390, 391 Pendentives, 234, 235, 235, 249 Pentateuch, 288, 322 Pentecost and Mission of the Apostles, 319 Perpendicular style, 365, 366, 367, 373 Perspective, 383, 391 Peter, Saint, 214, 215, 218, 219, 290, 386; statue of, 243 Petrarch, Francesco, 380, 381, 385, 387 Phidias: work of, 227 Philip II Augustus, King, 320, 344, 360 Pierpont Morgan Library, 360 Pietà, 370 Pilgrimage churches, 312, 313 Pilgrimages, 310, 311, 312, 314, 320, 337 Pilgrim's Guide to Santiago de Compostela, 310

Pisa: art of, 392–394; Camposanto, 392–393; Crusades and, 320; Leaning Tower, 329

Pisa Cathedral, 328–329, 328, 330, 337, 387; baptistery of, 375, 377; construction of, 329

Pisano, Giovanni, 381, 394; work of, 377, 377

Pisano, Nicola (Nicola d'Apulia), 377, 388, 395; work of, 375–376, *377*

Polykleitos, 351 Porch of the Confessors, 350, 351 Porch of the Martyrs, 351 Portals, 308, 317–318, 318; parts

Portals, 308, 317–318, 318; parts of, 317; Romanesque, 317, 317, 323; stone, 317; wooden, 289
Portraiture, 294

Poseidon (Neptune), 216 Prague, Saint Vitus Cathedral, 340 Procopius, 232, 234, 243

Psalter of Saint Louis, 361–362;
folio from, 361

Psalters, 288

Pucelle, Jean: work of, 362, 363 Purse cover, 287

Queen of Heaven, 344, 349, 354, 363, 385, 387 Qur'an. *See* Koran

Rabbula Gospels, 245, 247; folio from, 245
Radiating chapels, 312, 313, 315

Radiating chapels, 312, 313, 315, 337, 341

Rainer of Huy, 335, 337; work of, 327, 327

Ravenna, 221–224, 226, 229, 231, 235–236, 251, 253, 254; Constantinople and, 236; Mausoleum of Galla Placidia, 208, 222, 224, 241; mosaics at, 244, 259; San Vitale, 236–237, 236, 237, 238, 239, 240, 241, 249, 252, 262, 286, 297, 329; Sant'Apollinare in Classe, 240–241, 241; Sant'Apollinare Nuovo, 223–224, 224, 224, 226, 229

Rayonnant style, 355, 356, 360, 373 Realism, 388

Reims Cathedral, 354–355, 365, 368, 373, 375; jamb statues at, 355; west facade of, 354

Relics, 219, 251, 270; cult of, 310; veneration of, 323. *See also* Reliquaries

Reliquaries, 304, 327–328, 327, 367 Renaissance, 216, 231, 285, 286; classical tradition and, 395; style, 394

Renaissance architecture, 392, 394 Renaissance Italy, 243, 285; artistic training in, 388

Repoussé, 224, 225

Resurrection, 212, 213, 217, 251, 302, 304, 383, 386

Richard the Lionhearted, 318, 320, 326 Roman Empire, 247, 297; barbarians and, 285; Christianity and, 285; diversity of, 209

Romanesque period, 297, 300, 306, 308, 309, 339, 340, 344, 373; architecture of, 325; art of, 317, 321–323, 337; regional diversity of, 311; sculpture of, 337; Tuscan, 387, 392

Rome: Arch of Constantine, 211;
Basilica Ulpia, 219, 300; Baths of
Caracalla, 233; Catacomb of Saints
Peter and Marcellinus, 212, 212,
213; Column of Trajan, 296, 303,
334, 335; fall of, 231, 307; Forum of
Trajan, 219; New Saint Peter's, 315;
Old Saint Peter's, 218–219, 218, 229;
Pantheon, 220, 233, 234, 329; Saint
Paul's, 299, 310; Saint Peter's, 299,
310; Saint Peter's basilica, 293, 306;
Santa Constanza, 219–221, 220, 222,
235, 249, 264, 329; Santa Maria

Maggiore, 221, 221, 223, 225, 229; Santa Sabina, 219, 302, 317 Romulus and Remus, 263 Rose windows, 338, 342, 345, 350, 350, 386 Rossano Gospels, 226; folio from, 226

Röttgen Pietà, 370–371, 371 Rouen: Saint-Maclou, 356–357, 366, 373 Royal Portal, Chartres, 343, 346, 354, 373; jamb statues of, 344, 345,

350–351 **Rublyev, Andrei:** work of, 258, *258*, 259 Rule of Saint Benedict, 298, 314,

Safavids (Iran), 277, 278, 279, 283 Saint Agnes church, 220 Saint Catherine's monastery, 241; icons at, 247; mosaic from, 242

317, 336

Saint Cyriakus, 300, 311, 324; nave of, *300*

Saint-Denis, 345, 346, 354, 363; ambulatory/radiating chapels of, 341; cross at, 371; French Gothic and, 340; plan of, 340; rebuilding of, 341; stained-glass windows of, 350; Suger and, 340–342, 344, 371, 372, 373; vaults at, 342

Saint Edmunds abbey, *Bury Bible* and, 335

Saint Elizabeth, 368; interior of, 368 Saint-Étienne, Caen, 331–332, 332, 337; plan of, 332; vaults at, 342; west facade of, 331, 342, 346

Saint-Étienne, Vignory, 311–312, 314; interior of, 311; plan of, 311

Saint Francis Altarpiece (Berlinghieri), 378, 378, 395

Saint Gall monastery, 298–299, 301, 313; plan of, *298*

Saint James: naves of, 323; shrine of, 313, 315, 322, 337

Saint-Lazare, Autun, 318; tympanum at, 319

Saint-Maclou, Rouen, 356–357, 366, 373 Saint Mark's, Venice, 250–251, 252, 256; construction of, 329; interior of, 251

Saint Matthias, monastery of, 326–327 Saint Michael's, Hildesheim, 300, 301, 307, 317, 324, 330; doors of, 302; longitudinal section/plan of, 301 Saint-Nazaire, 357

Saint Pantaleimon, 253; wall painting from, 254

Saint Paul's, Rome, 299, 310 Saint Peter, Wimpfen-im-Tal, 364 Saint Peter's, Rome, 299; pilgrims at, 310. See also New Saint Peter's; Old Saint Peter's

Saint Peter's basilica, Rome, 293, 306 Saint-Pierre, Moissac, 315–317, 331, 351, 353; cloister at, 316; south portal of, 308, 317–318, 318 Saint-Savin-sur-Gartempe, 322;

nave/vault of, 322 Saint Savinus, altar of, 389 Saint-Sernin, 312–313, 315, 323, 324, 325; aerial view of, *312*; interior of, *312*; plan for, *312*; relief from, *314*, 317, 330

Saint-Thierry, 316

Saint Vitus Cathedral, 340

Sainte-Chapelle, 355–356, 361; interior of, *355*

Saints Sergius and Bacchus, Church of, 236

Sala della Pace, 390

Salians, 323, 328, 337

Salisbury Cathedral, 364–365, 366; aerial view of, 365; interior of, 365; plan of, 365

Samanid Mausoleum, 268, 268, 275 Samarra: Great Mosque, 267, 267, 269; Malwiya Minaret, 267–268, 267

Samuel anointing David, mural of, *211*, 224

San Francesco, Pescia: altarpiece for, 378

San Giovanni, baptistery of, 329, *329*, *391*, 392

San Juan Bautista, 293, 293

San Miniato al Monte, 330; interior of, 330

San Salvador de Tábara, 293; tower/scriptorium of, 293

San Vitale, 236–237, 241, 252, 262, 286, 329; aerial view of, 236; choir/apse of, 238; interior of, 237; mosaic from, 239; plan of, 236, 249, 297; procession at, 240

Santa Constanza, 219–221, 222, 235, 264, 329; interior of, *220*; plan of, *220*, 249; vault mosaic of, *220*

Santa Croce, 222, 379

Santa Cruz de la Serós, portal at, 317 Santa Maria Antiqua Sarcophagus, 213–214

Santa María de Mur, 322–323; apse of, *322*

Santa Maria Maggiore, 221, 223; mosaic at, *221*, 225, 229

Santa Maria Novella (Alberti), 384; construction of, 378–379; nave of, 379

Santa Sabina, 219, *219*, 302, 317 Santa Trinità, 380

Sant'Ambrogio, 325, 332, 337; aerial view of, 324; interior of, 325

Sant'Andrea (Alberti): pulpit at, 377 Sant'Apollinare in Classe, 240–241; mosaic at, 241

Sant'Apollinare Nuovo, 223–224, 226; interior of, 223; mosaic from, 224, 229

Santiago de Compostela, 313, 322, 323, 324, 337; pilgrimage to, 310, 315, 318

Saracens, 255, 256, 300

Sarcophagi, 229, 376, 377, 394; Asiatic, 214; Early Christian, 213, 213, 214, 214, 215; pagan, 213

Sasanians, 209, 232, 247, 261; architecture of, 273, 342

Saturninus, Saint, 310, 314 Savinus, Saint: altar of, 388 Sayf al-Din Tuquztimur, lamp for, 280-281, 281 Scandinavia, Christian art in, 288-293, 307 Scholasticism, Gothic art/architecture and, 344 Schoolmen, 344 Scivias (Hildegard of Bingen), 326, 327; folio from, 326 Scriptoria, 293, 307, 326, 373 Seals: official, 294 Second Commandment, 210, 215, 229, 246, 323 Seduction of Yusuf (Bihzad), 278 Selim II, 275, 279; mosque of, 274 Shahi Mosque, 277; winter prayer hall of, 276 Shahnama (Book of Kings), 279 Shrine of the Three Kings (Nicholas of Verdun), 372, 372 Siena, 380; art of, 383, 385-391; Palazzo Pubblico, 388-391, 389, 395 Siena Cathedral, 385, 386; altar for, 388; Duccio di Buoninsegna and, 384 Silk: textiles, 270, 270 Silk Road, 270 Sinan the Great, 278, 279; Mosque of Selim II and, 274, 283; work of, 274, 274, 275 Sistine Chapel: frescoes at, 382 Sorel, Agnès, 358 Spanish art styles: Romanesque, 311-321 Speyer Cathedral, 324-325, 332, 337, 340; interior of, 324 Squinches, in architecture, 235, 235 Stained-glass windows, 338, 342, 347, 349, 373; described, 350 Stave church, 288, 289 Stephen, Saint, 311 Strasbourg Cathedral, 368-369; tympanum at, 369, 369

Suger, Abbot, 343; lux nova and, 338,

344, 371, 372, 373

349, 350; Saint-Denis and, 340-342,

Sultan-Muhammad: work of, 279, 279 Sultanate of Delhi, 262 Sutton Hoo ship burial, 286–288; purse cover from, 287 Synagogue paintings, 210-211, 210, 211 Tahmasp, Shah, and carpet weaving, 280, 283 Taj Mahal, 262 Tapestries, 334, 335, 337; described, 334 Temple of Solomon, 233, 262 Ten Commandments, 241 Textiles, 270 Theodolus, Saint, 328 Theodora, 239; Justinian and, 237, 240; life of, 240; mosaic of, 239; portrait of, 252 Theodore, Saint, 247, 354; icon of, 246; statue of, 351 Theodoric, 221, 223, 236, 285; equestrian statue of, 297; palacechurch of, 240; portrait of, 294-295; Ravenna and, 235 Theodosius I, 221, 224, 231; Christianity and, 229, 232 Theophanu, 328; Otto II and, 305, 307; story of, 306 Theotokos, 242, 247-248, 247, 248, 249, 252, 253, 255, 323, 343, 349, 370; icon of, 246; mosaic of, 259 Theotokos, Hagia Sophia, 247-248, 247 Theotokos and Child, 252, 349 Tholos: tombs, 220 Three angels (Rublyev), 258, 258 Tilework, Islamic cuerda seca, 276, 277, 283 Timur (Tamerlane), 278 Timurids, 278, 279, 283 Titus: Temple of Solomon and, 262 Toulouse, 310; Saint-Sernin church, 312-313, 312, 314, 315, 317, 323, 324, 325, 330 Tower of Babel, 268 Traini, Francesco: work of,

392-393, 393

Sulayman: work of, 270, 270

Trajan, 243; forum of, 300 Trajan Decius, 211 Transfiguration of Christ, 216, 242, 242, 245, 290 Trier, Aula Palatina, 209 Triforium, 345-346, 345, 347, 349, 352, 365, 368, 373; described, 347 Triptychs, 253, 388 Triumph of Death (Traini or Buffalmaccio), 392-393, 393 Trumeau, 318, 318, 331, 353; described, 317 Tumulus, 286 Tuscany, Romanesque art and society in, 326, 328, 387, 392 Tympanum, 318, 319, 319, 369; described, 317 Umayyad dynasty, 262, 264, 266, 268, 272, 273, 283 Umayyad Palace, 266; frieze of, 266 Uta Codex, 304-305; folio of, 304 Utrecht Psalter, 296, 297, 302;

Vasari, Giorgio: on Gothic art, 339; work of, 381 Vatican City: Sistine Chapel, 382 Vatican Hill, 218 Vatican Vergil, 224; folio from, 225 Vaults, 322; barrel (tunnel), 222, 321, 323–324, 337, 366, 383; fan, 366, 373; Gothic, 342; groin (cross), 313, 324, 324, 325, 325, 332, 333, 337; nave, 332, 333, 347, 349; rib, 332, 333, 342, 342, 342, 345, 347, 365, 366, 367, 373; Romanesque, 342;

Venice, 380; art of, 392–394; Doge's Palace, 393–394, *393*; independence of, 251; Saint Mark's, 250–251, *251*, 252, 256, 329

sexpartite, 332, 346

Vertue, Robert and William: work of, 366, 366 Vézelay, La Madeleine church, 319–320, 319 Victory, portraval in art, 243, 244 Vienna Dioskorides, 244-245, 245, 247 Vienna Genesis, 224-226, 229 Vignory, 313; Saint-Étienne church, 311-312, 311, 314 Vikings, 252, 286, 300, 335, 337; art of, 288, 307 Viollet-le-Duc, Eugène: work of, 357, 357 Virgin and Child, 247-248, 247, 255, 255, 323, 323, 349, 349, 356, 363, 363, 385 Virgin and Child, Hagia Sophia, 247-248, 247 Virgin and Child Enthroned with the Saints (Duccio di Buoninsegna), 385 Virgin Mary, 216, 217; Annunciation and, 258; ascension of, 250; church dedicated to, 221, 242, 244; Crucifixion and, 228, 250; cult of, 343; death of, 368; icon of, 246, 257; portrayal of, 291; as Virgin of Compassion, 255 Virgin of Jeanne d'Evreux, 362-363, 363 Virgin of Paris, 356, 356, 363 Visigoths, 221, 268, 285, 293; architecture of, 269, 307; Christianity and, 293 Visitation group, Reims Cathedral, 354, 355, 355, 368 Vitalis, Saint, 236, 238

Warrior, as theme in art: lords, art of, 285–288, 307
Westminster Abbey, 335, 367
Westworks, 299, 299, 300, 307, 331, 342
Wiligelmo, 335; work of, 330, 330
William II, 252
William of Normandy (William the Conqueror), 288, 331, 335, 337

Vladimir Virgin, 255, 255

Ziggurats, 268 Zoomorphic forms, 264, 265, 270, 283, 291, 307